CRAFTING MEXICO

RICK A. LÓPEZ

CRAFTING MEXICO

Intellectuals,
Artisans, and
the State after
the Revolution

Duke University Press Durham and London 2010

© 2010 Duke University Press

All rights reserved.

Printed in the United States of America on acid-free paper ∞

Designed by Heather Hensley

Typeset in Warnock Pro by Tseng Information Systems, Inc.

Library of Congress Cataloging-in-Publication Data appear on the last printed page of this book.

Duke University Press gratefully acknowledges the support of The Trustees of Amherst College, who provided funds toward the production of this book.

CONTENTS

LIST OF ILLUSTRATIONS

Plates

ACKNOWLEDGMENTS

I want first to thank María Palomar for helping me get started on my research in Mexico. Others who were vital to the early stages of research, some of them more than they realize, were Alicia Azuela, Ruth Lechuga, Guillermo Andrade López, Gutierre Aceves Píña, Rubén Páez Kano, Stephen Vollmer, James Kessinides, Daniela Spenser, Roger Bartra, and Karen Cordero Reiman.

In the Mexican archives I often was searching for materials that sometimes not even the archivists knew they possessed. The staff at the various institutions were remarkably helpful and patient as I requested one dusty unorganized box after another. I particularly want to thank Roberto Pérez Aguilar at the AHSEP, Leticia Fuentes at the Biblioteca Lerdo de Tejada, and Gerardo Rivas at the Centro de Documentación at INAH. My thanks to Reeve Lindbergh for generously granting me access to the Morrow Family Archives at Smith College and to Rosa Zarate Uribe for helping me to learn more about her mother. I also want to express my gratitude to the people of Olinalá for sharing with me their memories and for welcoming me into their community and homes. In Olinalá I would like to single out Donasiano Ayala Mejía, Bernardo Rosendo, Concepción Ventura Pérez, Esteban Ayala Mejía, and Felicitas Ayala Martínez for providing me with a base in the community.

At Yale, in Mexico, and elsewhere, I have benefited from the insights, support, and collaboration of many friends and colleagues, including Kevin Repp, Jim Scott, Raymond Craib, Patricia Pessar, Mark Overmyer Velázquez, Stuart Schwartz, Jennifer Johnson, Nora Crespo, Susan Danly, Jeffrey Rubin, Patricia González, Esperanza Balderas, Laura Lovett, Pilar Fosado, Mauricio Tenorio, Alec Dawson, Michael Denning, Gabriela Soto Laveaga, Amy Chazkel, Emilia Viotti da Costa, Viviane Mahieux, Robin Greeley, Adriana Zavala, Sarah Buck, Andrew Sackett, Steve Bachelor, Marni Sandweiss, the editors and anonymous reviewers working through

the HAHR and Duke University Press, and my colleagues at Amherst and within the Five Colleges. Each of you helped to make this a better book. I especially want to thank Mary Kay Vaughan for her invaluable feedback on the manuscript. My greatest debt of gratitude goes to Gil Joseph, who has provided the highest example of what it means to be a dedicated scholar, a supportive colleague, and a committed teacher.

The importance of emotional and intellectual encouragement cannot be overestimated, but neither can the need for funding and institutional support. Funds for preliminary planning and preparation came from the Henry Hart Rice Fellowship program, the Yale Council for International and Area Studies, the Yale Program in Agrarian Studies, the Mellon Foundation, the Amherst Memorial Fund, and the Dorothy Danforth Compton Fellowship program. My research in Mexico was supported by a Social Science Research Council International Dissertation Research Fellowship, a Fulbright Dissertation Research Fellowship, and an Amherst College Faculty Research Award funded by the H. Axel Schupf '57 Fund for Intellectual Life. For the time and the peace of mind to think and write I thank the J. Paul Getty Postdoctoral Fellowship in the History of Art and the Humanities; the Ford Foundation Diversity Fellowship; the Copeland Fellowship in Residence Class of 1952 and the Dean Eugene S. Wilson Faculty Development Fellowship of Amherst College; and the Mellon Postdoctoral Fellowship in History at Northwestern University.

Sections of this book have been published previously. Much of chapter 1 appeared as "The India Bonita Contest of 1921 and the Ethnicization of Mexican National Culture," *Hispanic American Historical Review* 82 (2) (May 2002): 291–328. A condensed version of chapter 2 appeared as "The Noche Mexicana and the Exhibition of Popular Art: 'Two Ways of Exalting Indianness,'" in *The Eagle and the Virgin: National Identity, Memory and Utopia in Mexico, 1920–1940*, edited by Mary Kay Vaughan and Stephen Lewis (Durham: Duke University Press, 2006). Throughout this book, unless otherwise indicated, all interviews have been conducted by the author.

Finally, without the love of my family nothing would have been possible. Thank you to my wife, Amanda, for encouraging me throughout my research and writing, and for sharing your passion for art and your love of life. Thank you to my children Amaya Natalia and Diego Délano for filling every day with joy. And thank you to my parents Alejandro and Yolanda for giving me roots, a lifetime of love and support, and the freedom to find my own way.

Nation Formation, Popular Art, and the Search for a Mexican Aesthetic

If you know in advance that the African or Iranian or Chinese or Jewish or German experience is fundamentally integral, coherent, [and] separate . . . you first of all posit as essential something which . . . is both historically created and the result of interpretation—namely the existence of Africanness, Jewishness, or Germanness. . . . And second, you are likely as a consequence to defend the essence of experience itself rather than promote full knowledge of it and its entanglements and dependencies on other knowledges.

EDWARD SAID, *CULTURE AND IMPERIALISM*

An oversized lacquered dowry chest, or *baúl*, identified as "the Baúl of the Future," sits in the atrium of El Papalote, the Mexico City children's museum (plate 1). In 1998 El Papalote invited children from across the nation to fill the trunk with letters, drawings, photographs, paintings, and videos. In 2050 children from a new generation will reopen the sealed chest to commune with their predecessors from 1998. But this *baúl* is no mere time capsule. Exquisitely lacquered by the artisans of Olinalá in the *rayado* (etched) style for which the community is famous, the container itself is part of the dowry. The meter-and-a-half-tall lacquered chest and the distinctive aroma of chia oil that will infuse the objects within stand as a cultural legacy in their own right. Through them the children of 2050 might situate themselves as inheritors of a cultural nation that traces from the preconquest era when the artisans of Olinalá high in the Montaña de Guerrero lacquered gourds for the Aztec lords of Tenochtitlán to our

own day when Olinaltecan lacquer wins international laurels as a distinctly Mexican art. The true dowry, then, is not the incidental objects within the chest but the narratives of *mexicanidad* that encase these objects.

By choosing an Olinaltecan *rayado*-style lacquered chest as a repository for the national identity, the museum has tapped into weighty narratives of primordialist nationality rooted in a myth of seamless *mestizaje*. The *baúl* is not the only embodiment of an "ethnicized" view of *mexicanidad*. Parallel expressions include *ballet folklorico*, vernacular music, and such handicrafts as textiles, basketry, ceramics, wooden toys, and ritual masks. The national form perpetuated by such expressions is not born out of the past as organically as one might presume. Through analysis of this ethnicized vision of the nation after the revolution of 1910–20, this book helps explain how Mexico transformed from a regionally and culturally fragmented country into a modern nation-state with an inclusive and compelling national identity. Its findings reach beyond Mexico with broad implications for how we conceptualize processes of national cultural integration.

Revolution as Cultural Transformation

Prior to the revolution, Mexico's middle and upper classes along with foreign visitors and state officials dismissed popular art as embarrassing evidence of backwardness. This same art, after the revolution, emerged as a proud symbol of Mexico's authentic national identity. To make sense of this transition it is necessary to situate it within Mexico's long-term process of nation formation.

Creole (American-born descendents of Europeans) subjects of the Spanish Crown already had developed a patriotic sense of themselves as *nosotros los Americanos* by the late eighteenth century, before the collapse of the empire. However, even as these late-eighteenth- and early-nineteenth-century Creoles esteemed and lay claim to Mexico's Aztec archaeological past, their interest did not extend to living indigenous groups.[1] When Mexico won its independence from Spain in 1821, many indigenous communities sought political self-determination and a stake in the liberal state structure of the new republic. Their "alternative" liberalism clashed with the "official" liberal ideas of the predominantly Creole elite.[2] The ruling class, despite its own internecine conflicts, struggled to keep the various states and regions unified and to affirm its place at the political helm. To

the degree that Creole elites did forge a nationalist spirit, they generally envisioned the nation as confined to themselves and their acculturated mestizo brethren. The popular classes were largely excluded. To the extent that the elite included the popular classes, they saw them as subjects who, under the best of circumstances, might become civilized enough to embrace elitist notions of civilization, not as agents entitled to demand an expansion or revision of the national identity. Francisco Pimentel, one of the most prominent intellectuals of the mid-nineteenth century, for instance, argued that until indigenous people shed every trace of their own culture (which Pimentel saw not even as culture, properly speaking, but rather as an incoherent amalgamation of preconquest detritus and superstitions) and adopted every practice and habit of thought of the Creole, they could never be part of the Mexican nation.[3]

In the last part of the nineteenth century Mexico's first president of indigenous extraction, Benito Juárez, and his mestizo successor, Porfirio Díaz, presided over a triumphalist circle of intellectuals intent on instituting political and economic modernization. They strengthened the central state at the expense of rural communities and regional caudillos—though never as absolutely as they had wished—and they refuted the negative views of foreigners who looked down on Mexico as uncivilized, chaotic, and incapable of self-government. In place of these negative characterizations, they constructed a narrative of a country possessed of all the hallmarks of civilization and progress, moving steadily toward modernity in a manner that paralleled the development of Britain, France, and the United States. These nationalists, whom the historian Mauricio Tenorio has dubbed "wizards" for their ability to recast Mexican history, included such luminaries as Vicente Riva Palacios, Manuel Payno, and Justo Sierra. The historical anthropologist Claudio Lomnitz is careful to point out that these luminaries and state officials focused their energy on their fellow elite and the small middle class, whom they hoped to unify around an optimistic vision of the country. They were not concerned with the masses, except as a source of labor that, while necessary for Mexico's development, remained a national embarrassment and a hotbed for potential disruption. These so-called wizards dreamt of overcoming complex regional notions of race and ethnicity in favor of a single, national, racial and social hierarchy with themselves at the pinnacle. And so, rather than counter foreign racism, they displaced the defects that foreigners had attributed to all Mexicans onto the popular

classes, above all those whom they identified as indigenous. In this manner, elites imposed on the country a peculiar ideal of "universal" modernity, tweaked to accommodate their own elitist nationalism, while assuring themselves and the world that "modern Mexico" existed apart from the "backward Indians." They readily co-opted symbols of ancient Aztec splendor while insisting that contemporary indigenous people were not part of this Mexican nation, and that the only way they could become so would be to embrace a model of cultural evolution that mandated the rejection of their indigenous and *campesino* identities and practices.[4]

To dispel lingering doubts regarding the success of Mexico's cultural and economic evolution, the country's elite, like modernizers across the Americas, rebuilt their capital city in the image of Paris—the epitome of "universal" civilization and modernity—and sent many of their finest artists, writers, and scientists to study in the City of Light. This "Francophile progressive" vision, to borrow a phrase from the historian Barbara Tanenbaum, found its aesthetic culmination in the inauguration of the Angel of Independence on the eve of the country's centennial. Designed by a French-trained architect, inspired by Paris's Place de Vendôme, and adorned with bronzes cast in Italy, the monument ascribed entirely to the dominant universalist aesthetic. Erected on the Paseo de la Reforma (Mexico's own version of Paris's Avenue des Champs Elysées, which itself had been transformed by the ruthless destruction and reconstruction projects overseen by Baron Georges-Eugène Haussmann), the Angel projected Mexico as a modernizing child of Europe (figures 1 and 2).

The Angel, along with the rest of the Paseo de la Reforma, claimed public space for the middle and upper classes and made clear to the masses their exclusion from the physical and discursive space of the modern Mexican nation. The only place indigenous people had in this imagined nation was as archaeological remnants of the past destined for extinction (figure 3).[5]

Shortly after the "wizards" enshrined their vision of Mexico on the main boulevard, the people whose existence the monument had denied revolted, joined by regional leaders and middle-class reformers whose political ambitions Díaz had thwarted. Mexico dissolved into a ten-year popular revolution. The novelist and political commentator Carlos Fuentes may be correct when he argues that the most enduring outcome of the ten-year conflict has been the cultural transformation and nationalist self-

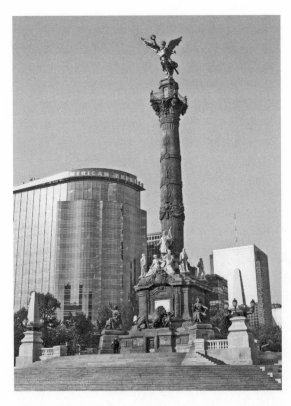

1. Angel of Independence, completed 1910. Mexico City. Photo by author.

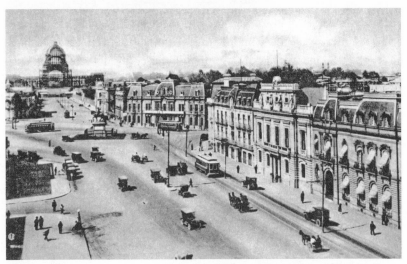

2. Mexico City, circa 1910. Intersection of Reforma and Avenida de la Repúblic. © Brown Brothers. Used by permission.

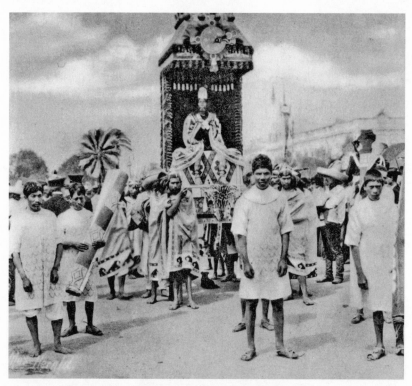

3. Indians in the Centennial Parade, 1910. © Brown Brothers. Used by permission.

discovery that came in its wake.[6] With the hope of never having to re-live such a crisis, a new generation of nationalists formulated the ideal of forging the masses into an ethnicized and culturally unified modern nation. This study's use of the term *postrevolutionary* is not a comment on the question of when the revolution ended; rather, the intent is to highlight a historical moment when intellectuals, state officials, artists, reformers, and sectors of the popular classes seized on the recent popular upheaval as an opportunity to formulate a new set of cultural ideals, as well as re-packaging many Porfirian ideals and infusing them with new urgency. The term *postrevolutionary* allows an analysis of how individuals and groups saw the revolution as a mandate for the sometimes-radical reformulation of prerevolutionary objectives, and sometimes as cover for the perpetua-tion of objectives that differed little, if at all, from the Porfirian ideals that postrevolutionary leaders openly scorned.

While the revolution of 1910–20 may have been less politically and eco-

nomically revolutionary than once thought, and while postrevolutionary nationalists were products of Porfirian modernization and intellectual tradition more than they cared to admit, culturally speaking the revolution proved transformative. Postrevolutionary intellectuals saw themselves as presenting a radical alternative to Porfirian claims of steady evolution. They mocked their predecessors' designs as a mere veneer of modernity and called instead for a form of modernization tailored to the country's unique cultural, racial, and political realities. Mexico, they argued, needed a depth of unity that could not be attained merely by compelling the masses to ascribe to elite culture and prejudice; real unity could come only by rallying around the "authentic" culture of the people.

I am not arguing that postrevolutionaries invented the ideal of an integrated Mexican nation, or that theirs were the first steps toward framing a nationalist aesthetic. They tapped into previous currents of thought, and into some of the changes that had been set in motion by expanding consumerism and transportation under Díaz.[7] What set postrevolutionaries apart from their predecessors was that they celebrated the living indigenous heritage as a vital component, even the foundation, of Mexico's authentic national identity. Postrevolutionary nationalists incorrectly presumed at that time that their success resulted from their ability to grasp at last the "real Mexico." The success of their endeavor is undeniable, but, as I explain later, this was not on account of having unlocked the true essence of the nation, as its proponents claimed. Rather, the success was born out of the manner in which diverse cultural projects intersected with economic and political developments, and most importantly, because of the ways the endeavor transformed the political, economic, and cultural terrain on the local level, within rural and urban communities across Mexico. Only with hindsight are we able to begin to trace out the unanticipated, and sometimes surprising, processes that lay at the heart of Mexico's successful push toward national cultural integration.

As postrevolutionary intellectuals and reformers set out to learn about and integrate the people, they confronted dozens of different languages and ethnicities and a poor system of transportation and communication. They looked on the fragmented population as an overwhelmingly indigenous *campesinado* (which translates inexactly as "peasantry"). Moreover, the historian Ricardo Pérez Montfort notes that though nationalists drew on both rural and urban sectors of society, they defined the national "we"

as rooted in the "rural, provincial, poor" and "marginal" masses who, in their view, made up the "majority."[8]

Scholars sometimes look to José Vasconcelos's *Raza cosmica*, published in 1925, as a statement that condenses postrevolutionary nationalists' aspirations. Far more influential, as well as more reflective of the mood of the time, however, was the anthropologist Manuel Gamio's *Forjando patria* (literally "forging the fatherland," though Gamio used the term figuratively to mean forging nationhood), published in 1916. His study redirected ongoing debates toward a call for a state-led political and cultural transformation. Gamio argued that prior to the revolution the government had deluded itself into believing its own claim that Mexico was moving toward becoming like Europe. This self-delusion, he argued, led to an underestimation of the size, character, and needs of the indigenous population. Government censuses claimed that the indigenous percentage of the population plummeted from 38 percent in the 1860s to around 20 percent by the time of his book. He later complained that even after the revolution the government persisted in miscounting the indigenous population, such that by 1930 government figures would claim that the indigenous population had declined to a mere 14 percent. Gamio insisted that attention to culture, rather than just language, would reveal that at least 75 percent of the population should be recognized as indigenous. The remaining 25 percent, he argued, composed a small white elite that functioned like a class of parasites that should be considered "foreign," and a white and mestizo middle class divided between those who harmoniously blended indigenous and European cultures and those who followed the cultural orientation of the Europeanized elite.[9]

Gamio argued that because Porfirian policies of unilateral assimilation had failed to "penetrate beyond his [the Indian's] outer skin . . . the body and soul of the Indian has remained." The state would continue to fail to *forjar patria* unless it acknowledged that most people's cultural assumptions and worldviews were indigenous. Gamio shared his predecessors' view of the indigenous population as degenerate, along with their insistence that the state should take the lead in solving the "Indian problem." But he refuted their assumption that indigenous culture was on the road to extinction in the face of modernity. What Mexico needed, in his view, was revolutionary action in the form of a "new conquest" that would focus not on externalities but on fully integrating the masses by transforming them

and the nation from the inside out.[10] Gamio acted not out of faith in indigenous people or their culture but out of his conviction that to achieve stability and modernization Mexico needed national integration and cultural transformation. Such integration could be achieved, he argued, only by ethnicizing the national identity.

The influential educator Moisés Sáenz similarly pronounced in 1929 that "Mexico is an Indian country" and the realization of this "basic fact" must serve as the first step toward national integration.[11] Only by understanding the population's fundamentally indigenous character, he claimed, could cultural and political leaders create a unified nation and cut a walkable path leading to Mexican modernization. Indians had to change, but so too did non-Indians (albeit to a lesser extent), so as to create an inclusive and genuinely Mexican national culture.[12] This position, articulated by Gamio and Sáenz, guided the intelligentsia of the 1920s and 1930s as it set out to "discover" and exalt popular traditions and aesthetics as embodiments of Mexican cultural nationality. The art historian Olivier Debroise has noted that though nationalists before the revolution had "detested" things indigenous, after the revolution they seized upon them as the "least foreign" cultural element within Mexico."[13]

Sáenz in the 1920s described this postrevolutionary movement as the "Indianization" of Mexico's nationality, and recently the historian Mary Kay Vaughan has called it "the browning of the nation."[14] This study describes this process using the term *ethnicization*, so as to capture the fluidity and contested nature of this embrace of indigenousness as part of the national identity, even as the Asian and black presence was erased and prejudice against indigenous people was continually reconstituted. The term also highlights the extent to which intellectuals and artists seized on the revolution as a mandate to study contemporary indigenousness and make it part of the discussion on national identity.[15]

This embrace of indigenousness contained within it at least two forms of destabilizing contestation. The first is evidenced by nationalists' tendency to esteem select aspects of indigenous culture at the same time that they denigrated other aspects and even the people themselves. In the process of denigrating indigenous practices, moreover, they claimed that such things as poor hygiene, squalid living conditions, and illiteracy, rather than being merely products of poverty and racism, had become integral aspects of indigenous culture.[16] As public schools in the 1930s tried to

improve Indians by teaching them indigenous dances from the far corners of Mexico, for instance, they pressured those same students to abandon their local traditions, including not only such imposed "traditions" as poor hygiene but also their native language and folk religious practices. In short, they insisted that the students abandon many locally rooted practices (which teachers and reformers looked down on as rife with degeneracy and superstition) in exchange for ethnicized practices that had been sanitized through a process of nationalization.

The second form of contestation within the embrace of indigenousness lay in the inherent non-fixity of "Indian." Gamio's contemporaries agreed with his argument that most of those whom the census classified as mestizos on the basis of language were, in terms of their culture and their supposed level of modernity, more indigenous than they were European. To successfully *forjar patria* one had to recognize that the masses were overwhelmingly indigenous. Attempts to define what this meant and to act on it accentuated the constant slippage and strategic ambiguity among the categories of Indian, mestizo, and *campesino*. The legacy of postrevolutionaries' efforts to cast popular practices as "Indian" continues to present a challenge to scholars studying rural popular groups of the 1920s and 1930s. In his study of the Ministry of Education's 1930s formulation of the "peasant problem," Guillermo Palacios, for instance, alternates between the terms *campesinos* and *indo-campesinos* without addressing how these two categories related to one another.[17] His dilemma is a common one that this study attempts to address but does not claim to resolve.

Scholars often discuss *mestizaje* narrowly as a process of de-Indianization and claim that postrevolutionary intellectuals and the state focused on "the erasure of indigenous culture" and the enshrinement of "Mexico as a one-race nation."[18] Such an interpretation underestimates the degree to which intellectuals, following the example of Gamio, viewed indigenousness and *mestizaje* not as absolutes but as degrees.[19] Through strategic slippage between "Indian" and "mestizo," intellectuals and state officials of the 1920s and 1930s made claims about Mexico's inherent unity at the same time that they emphasized its diversity, what the historian of India Gyan Prakash has termed "unity in diversity."[20] Once this idea of unity in diversity was put into place, it was not seriously challenged until intellectuals of the late 1930s became disillusioned with its potential. Gamio, for example, had insisted on the need to "Indianize Mexico," but by the end of

the 1930s he switched to a virulently negative stance regarding the indige-
nous "race." Even the leftist, populist, *indigenista* president Lazaro Cár-
denas (1934–40) by the end of his term became convinced that reformers
should turn their attention toward "mexicaniz[ing] the Indians instead of
indianizing Mexico."[21] As disillusionment spread, government funding for
certain kinds of projects dried up; yet many intellectuals continued to em-
brace the ideal of unity in diversity and continued to find ways to act on
that ideal, often through collaboration with foreign intellectuals and insti-
tutions.

Even as postrevolutionaries in the 1920s and 1930s viewed Indianness as
fluid they simultaneously countered this fluidity with an insistence on the
applicability of fixed categories. Anthropologists had led the way in accom-
modating fluidity within definitions of Indianness. But as they succeeded
in elevating their field to the status of the premier nationalist science,
they put themselves in the position of having to generate hard numbers
to prove that their work was showing results. And so, even as intellectuals
and researchers refuted fixed notions of race and blurred the line between
mestizo and indigenous, they also felt pressure to harden racial distinc-
tions by using "objective" criteria such as cranial measurements that they
claimed could help determine who was and who was not "really" Indian.
The anthropologist Lynn Stephen correctly observes that even today, as
researchers find themselves compelled to provide hard numbers, assig-
nations "of ethnicity . . . by the Mexican government continue to rely on
trait recognition and certification by experts of indigenous legitimacy."[22]
What emerged in the late 1930s, and which found reinforcement in sub-
sequent decades, was a situation in which elites and the state tended to
accept broad definitions of Indianness when such breadth served their
own interests, denigrated subordinate groups, or justified state interven-
tion; but they proved less accommodating when definitions of Indianness
were linked to allocations of funds and resources, or when they were used
to honor indigenous people, or else were used by indigenous people them-
selves as a basis for demanding rights or benefits.

The tension between exaltation and denigration and between fluidity
and fixity is irresolvable, and this irresolution goes to the heart of the post-
revolutionary cultural nationalist movement. Any effort by this or other
studies to rigidly fix categories of "Indian" or "mestizo" would be ahis-
torical, artificial, and even deceptive. A better approach is to question the

ways slippage has been used historically, while avoiding imposing artificial fixity on categories that are the products and embodiments of complex historical fluidity. Thinking in terms of "ethnicization" can keep the attention on cultural processes of ethnic formation, and on the particular ways historical actors have struggled over and attempted to fix or contest particular understandings of "Indian," "white," "mestizo," and "campesino" and thereby enrich our understanding of how such categories contributed to the construction and contestation of power relations and structures of hegemony in postrevolutionary Mexico.

State and Nation Formation

State formation and nation formation are related processes and have been mutually reinforcing, but they are not the same thing. The *state*, as it is understood in this study, refers to the apparatus of governance that institutes particular structures of domination and political participation. It finds expression through regulations, laws, courts, police, bureaucracies, ordinances, property rules, cadastral surveys, census taking, military activity, public schools, voting, town councils, government patronage, diplomatic representatives and treaties, systems of taxation and wealth redistribution, and so forth. The last two decades have seen major advances in our understanding of the state. Latin America in particular has seen the emergence of an outstanding literature on the role that popular groups have played in state formation and how the state has gained popular legitimacy and negotiated the terms of its rule.[23]

The term *nation*, too, has a long history, though it is only in the modern era that *nation* acquired the expectation that it include all the people born or raised within the territory claimed by a state, and that subjects of the state should subordinate their regional and ethnic identities (and the power relations that animate these identities) to a transcendent sense of belonging and metaphysical unity.[24] It is important to note that in Latin America, and in Mexico in particular, the state preceded the nation. This brought the expectation that, rather than creating new states around ethnic solidarities, the nation should conform to the political territory claimed by the state. In this view "organic" ethnicities presented obstacles to, not seeds for, nation-state formation.[25]

Postrevolutionary nationalists inherited a country shaped by centuries of state formation but anemic nation formation. Mexicans across the

country had a stake in the political system, and they negotiated this stake through cultural as well as political and economic forms of contestation. But there was only a thin and uneven spirit of all groups being a single people united by a shared culture and common ideals. When they set out to forge such bonds among the population, postrevolutionary nationalists focused on the development of primordial rather than merely instrumental (political) bonds with one another. In essence, they tried to remake the fragmented Mexican population into something that might perceive itself as a sort of "Mexican race" and, to some degree, make state, nation, and race into one modern, unifying nationalist, and primordialist reality. While there were previous efforts, particularly under Díaz, to unite the population around the ideals of progress and civilization, it was only with the revolution that Mexico saw a significant movement to remake the population into a *nation-state*, in the full meaning of both halves of the term. This is not to suggest that no prior bonds existed among the population nor that postrevolutionaries created their ideas and ideals *ex nihilo*—without doubt, they built on tendencies already under way, even as they pushed in new directions. At issue is the effort after the revolution to transform existing bonds and to broaden and redefine the *nation*.

The push toward the construction of a "modern Mexican nation," in which everyone born within the borders claimed by the state shares a common culture and a spirit of solidarity (or, at least, a shared discourse of contestation), was built on historical precedent, including prerevolutionary patriotism and social projects, but, as I argue in the chapters that follow, it was, in large measure, a postrevolutionary phenomenon. The historian David Brading has made clear that the liberals who came into power after Mexican independence "were Westernisers, not Slavophiles," by which he means that compared to postrevolutionary nationalists they were modernizing patriots with comparatively little or no "theory of nationality."[26] The historian Mauricio Tenorio similarly has argued that nineteenth- and early-twentieth-century political elites held no expectation that all persons in the Mexican political territory be Mexicans, in the cultural sense, only that they be linked economically and politically to major cities and markets, and that elites be relatively united and committed to modernizing the patria.[27] Similarly, the historian Alan Knight has noted that even at the start of the twentieth century, just before the Mexican revolution, the Porfirian dictatorship delayed the problem of nationhood by devising a

"hollow shell" of governance. Within this "hollow shell" state leaders concerned themselves with political domination and economic production, not with the formation of a unified cultural nation.[28] Prior to the revolution, then, the dominant idea of a Mexican nation was that of the elite and middle class whose solidarity derived from class interests, a shared vision of universal modernity, and a desire to monopolize control of the state whose tentacles extended into all corners of the republic.

In a landmark debate the scholar Anthony Smith has argued that historians of nationalism should not be distracted by the exclusion of the majority of the population; the emergence of an ethnic or nationalist consciousness among a small, elite literati is sufficient, he argued, to constitute a nation. The political scientist Walker Connor countered that a nation is nothing if not a mass phenomenon. While sidestepping typological debates over whether or not particular configurations are really nations, this study seeks to understand the shift within Mexico from the kind of narrow, exclusionary, elite nation described by Smith to something broad-based and inclusive along the lines described by Connor.[29] The question is how the Mexican nation shifted from a narrow ideal into a mass-based ethnicized and inclusive identity that most Mexicans and foreigners today take for granted.

The Aesthetics of Nation Formation

Benedict Anderson has drawn our attention to the importance of such things as print capitalism and national language in shaping a national community.[30] Yet, in the hands of the largely Creole elite of nineteenth-century Mexico, print capitalism and the Spanish language became not mechanisms for integration but tools for creating and defending a narrow, exclusionary definition of the nation. If print and language succeeded in consolidating the Creole elite rather than in creating an inclusive nation, what tools *did* contribute to a broad-based nationality? Part of the answer lies in art and aesthetics, particularly in vernacular expressions such as dance, music, folktales, and handicrafts. Edward Said astutely points out that it is "the *practice* of a national culture . . . from folktales and heroes to epic poetry, novels, and drama" that gives meaning and substance to the national collectivity.[31] While Said correctly points to the importance of the practice of national culture (particularly oral and written narration),

he, like Anderson, overlooks the importance of visual aesthetics. Historians of Latin America have yet to analyze adequately the connection between visual aesthetics and nation formation. Serge Gruzinski has studied what he has described as "the evolution of the *imaginaires*" as well as the "ambiguity and misunderstanding" that often is "aroused by images" in the context of cultural encounters.[32] I argue that the embedding and communication of meaning is accomplished not just through the representational imagery that Gruzinski analyzes but also through abstract aesthetic norms; and that these, even as they serve as vehicles of communication, can be rife with ambiguity and misunderstandings. Attention to aesthetics rather than representations can help us understand how art has served not just as a medium of conquest, resistance, and *mestizaje* but also of nation formation, accommodation, and solidarity.

After winning independence from Spain in the early nineteenth century, national and regional elites took an interest in the daily lives and settings of Mexico. Artists painted, wrote about, and later photographed people and places that struck them as distinctively Mexican. Later in the century the landscape painter José María Velasco depicted recognizable landscapes from the central valley and Tehuantepec and, at the time of the outbreak of the revolution, Saturnino Herrán incorporated regional types and their accoutrements into his paintings. By the start of the twentieth century the commercialization of regional types and vernacular music through picture postcards, urban theater houses, and troubadour performances had become commonplace. None of these efforts during the nineteenth or early twentieth centuries, however, called for a shift within the aesthetic canon. Middle- and upper-class people's interest in things Mexican, moreover, remained marginal compared to their strong interest in European goods and styles. Their primary aesthetic orientation remained directed overtly toward Europe.

It was only after the revolution that Mexican artists and cultural leaders began calling for an aesthetic reorientation. This, in turn, was inseparable from the larger project of forging a distinctive and inclusive nationality. Postrevolutionary intellectuals and artists pushed the previous interest in folkway further than had their predecessors. Some validated vernacular aesthetics as the heart of authentic *mexicanidad*, while others esteemed them primarily as an entry point for understanding and then "scientifi-

cally" altering the worldview of the popular classes. As they celebrated popular aesthetics as a tool for transforming the masses into Mexicans, nationalists agreed that by intervening in the production and marketing of popular art they could induce changes that went beyond the works of art themselves, into the most basic cultural mindset of the *campesinado* so as to set Mexico down the path toward genuine cultural integration and modernization. Gamio, for instance, argued that only when "the middle class and the *indígena* have the same artistic taste" will Mexico "find cultural redemption" and unity.[33] The artists Diego Rivera, Roberto Montenegro, and Gerardo Murrillo (aka Doctor Atl), the politician Alberto Pani, the composer Carlos Chávez, the journalist Rafael Pérez Taylor, the educators Moisés Sáenz and Esperanza Bringas, and the anthropologists Manuel Gamio and Miguel Othón de Mendizábal each contributed to this ethnicization of Mexican identity, emphasized the importance of aesthetics, and carried this concern into the shaping of state cultural and political institutions.

Scholars who have added to our understanding of this process of consolidating a nationalist aesthetic include Ricardo Pérez Montfort, whose pioneering work has traced stereotypes and media representations of *mexicanidad*; Enrique Florescano, who has fueled an entire subfield focusing on the history of Mexico's cultural patrimony; and Néstor García Canclini, who has brought theoretical dynamism to the study of cultural modernity in Latin America. Most recently, contributors to a volume edited by Mary Kay Vaughan and Steve Lewis have united these concerns with an interest in postrevolutionary nation formation.[34]

Remarkably, the new aesthetic vocabulary took form at a time when Mexico had only a thinly developed mass media. As García Canclini observes, the Mexican situation was "unlike that of any other Latin American country" in that even before the full development of "mass communication and tourism" it achieved a context in which "the artesanias of different ethnic groups, historical symbols, and regional ways of thinking transcended their localities" to become nationally unifying.[35] The chapters that follow help explain why and how it gained hold so quickly and profoundly and how it was intimately entangled with the process of national integration. The ideal of an inclusive, ethnicized Mexican nation became relevant to people's experience not as an imposed false consciousness but as a col-

lection of intersecting discourses and practices rooted in daily economic, political, and cultural conflicts.

The Transnational and Local Dimension of
Nation Formation and Mexican Modernism

This study abandons the tendency to treat Mexican national culture as though it were created only by Mexican nationals within a context somehow cut off from international currents. In the epigraph to this chapter Edward Said is correct when he argues that "partly because of empire, all cultures are involved in one another, none is singular and pure, all are hybrid . . . and unmonolithic."[36] Recognition of this unmonolithicness helps move us beyond stale debates over whether particular cultural formations were foreign or national and look instead at the particular ways diverse cultural formations emerged and articulated, or interlinked, with one another.[37] Categories of "foreign" or "national" were contingent, tied to changing ways of contesting balances of power, and perpetually in need of reanimation. A satisfactory analysis of foreignness and Mexicanness, therefore, must account for how such categories as foreign, national, Mexican, culturally imperialist, authentic, imposed, and indigenous were delimited, how they were historically constructed in relation to one another within structures of inequality, and how they intersected with people's lives.[38]

There is an important difference between an international approach that recognizes exchanges between countries and a transnational approach that eschews treating nation-states as unproblematic monoliths. A transnational approach draws attention to the fact that, while membership in a particular nation-state is crucial in terms of point of view and access to resources, national identities are forged through intimate interactions that continually constitute (even as they confound) definitions of what is "foreign" and what is "national." While much scholarship on the U.S.–Mexican borderland incorporates such a perspective, often drawing directly or indirectly on Peter Sahlin's pioneering work on the Pyrenees, scholarship that looks at modern Mexico beyond the frontier has drawn less readily on the insights offered by such an approach.[39] The art historian Alicia Azuela has taken steps in this direction in her work on muralism, and García Canclini and the contributors to a volume on post-1940 Mexico edited by Gilbert

Joseph, Anne Rubenstein, and Eric Zolov have considered some of its impacts in terms of mass cultural flows.[40]

The chapters that follow draw particular attention to the ways non-Mexicans became involved intimately in formulating and implementing the Mexican nationalist project. These included such figures as the Austrian chemist-turned-art curator Count René d'Harnoncourt, the Spanish-born stage star María Conesa, the U.S. economist Stuart Chase, the Austrian American historian Frank Tannenbaum, the American expatriate art dealer Frederick Davis, the Mexican American anthropologist/art historian Anita Brenner, the Russian dancer and choreographer Anna Pavlova, the Dominican essayist Pedro Henríquez Ureña, the Nicaragüense economist and cultural critic Francisco Zamora, the U.S. folklorist Frances Toor, and the U.S. ambassador to Mexico Dwight Morrow. Through collaboration between such figures and Mexican nationalists (many of whom were just returning from extended periods of study in Europe or the United States) the postrevolutionary process of nation formation emerged as profoundly transnational.

Not only was the exaltation of the peasantry as the bedrock of national identity a transnational process but it was not unique to Mexico. Mexicans and resident foreigners partook of a global shift away from a narrow model of universal civilization toward a view of "world civilization as the product of national cultures, each of which played a special role."[41] The Uruguayan Enríque Rodó preceded the Mexican movement in 1900 when he assigned to Latin America a special place within world civilization. He argued that Europe and the United States had given industrialization and science to the world. But now that this industrialization and positivist faith in science threatened to rob civilization of its humanity, he called on Latin Americans to counterbalance these with a return to humanist values.[42] Latin American intellectuals described their wave of nativism as a break with European cultural dominance, yet during those same years Europeans were breaking with their own nineteenth-century practices. The movement in Mexico found parallels not just in Europe, but across the globe, from Russia and India in the east to Peru in the south.[43]

While Mexico was not alone it its surge of cultural nationalism, or even in its exaltation of its peasantry, the particular way Mexican elites interacted with the peasantry and the outcomes of this interaction were distinctive. Moreover, even as Mexicans shared their European counterparts'

emphasis on rediscovering the national essence through a focus on the peasantry, they did so for distinctive reasons. French and German cultural nationalists sought an antidote to their supposed overmodernization in the context of anxieties over the transition from agricultural to industrial societies. Mexico, by contrast, was closer to the experience of Italy and Spain, which had yet to achieve the level of modernization that supposedly was a prerequisite for the cultural anxieties that underlay cultural modernism—though, as 1920s Mexican anxieties over flappers (discussed in chapter 1) and the rise of such artistic movements as *estridentismo* demonstrate, this conflict between modernization and modernism was by no means absent. Moreover, it is important to keep in mind that Mexicans' concerns about their country's delay along the path leading toward modernization and cultural integration was based on an overestimation of the level to which these had been achieved in such countries as France.[44] In the end, what Mexican cultural nationalists searched for was not a balm for overmodernization but a way to accelerate their modernization.

The rise of cultural modernism in Mexico, and probably in other countries, owed less to the level of modernization than the resiliency of the old order against which modernists could define themselves. As the historian and sociologist Perry Anderson astutely argues, it was the "persistence of the *anciens régimes*, and the academicism concomitant with them" that "provided a critical range of cultural values against which insurgent forms of art could measure themselves." In such a context, even as modernists set themselves in opposition to the old cultural order, they relied on the values, practices, and training they had acquired through that very order, since these "afforded a set of available codes and resources" with which to formulate their critique.[45]

Perry's insight reminds us that cultural revolutionaries relied on the Porfiriato not only as a foil for their construction of their ideals but also as a source of training, assumptions, values, codes, and norms for formulating and articulating their vision. As such, to formulate a departure from Porfirian ideals, revolutionaries drew on the codes, and often even the same goals and objects, of the system they claimed to oppose. It is not surprising, then, that the postrevolutionary critique of Díaz was not that he had overmodernized Mexico but that he had relied on methods and assumptions that failed to modernize it adequately. Central to this shortfall, in their view, was Porfirians' failure to understand the Mexican population

and integrate it into a nation. What they now pursued instead was what Carlos Fuentes has described as the biggest attempt in Mexican history "to recognize the cultural totality of the country, none of whose components should be sacrificed."[46] The result, they hoped, would be a cohesive nation-state more durable than anything Díaz could have accomplished.

Promoters of nation-building drew on and contributed to political leaders' efforts to consolidate the rule of the postrevolutionary state first under Venustiano Carranza during the revolution, but more enduringly during the presidency of Alvaro Obregón (1920–24), and then, after 1929, under the expanding authority of the ruling party. In turn, political leaders beginning with Carranza and Obregón, through the Maximato, the presidency of Lázaro Cárdenas, and up through Luis Echeverría in the 1970s recognized the utility of the cultural nationalist project and offered a certain amount of official patronage and institutional backing. That said, the movement for nation formation never was simply a tool to support state formation.

Intellectuals, artists and researchers as diverse as Manuel Gamio, Esperanza Bringas, Diego Rivera, Gerardo Murrillo, Roberto Montenegro, and Rafael Pérez Taylor did not fall ideologically into lock-step with one another, much less with the politicians. Neither were they merely cogs in some sort of a state project. Nationalists may have dreamed of imposing their ideas on the populace, but the reality was that their relationship to the state was unstable, and the state frustrated intellectuals with its lack of a clear or consistent cultural policy. This did not mean that these intellectuals lacked impact. On the contrary, the instability of their linkage gave their project the appearance of inevitability, as though it were cultural destiny born out of Mexico's distinctive past, rather than the project of a particular sector of society.

While the elites were indispensable, the strength of Mexico's cultural bond is not attributable to the elite project alone. It is born of the dynamic relation that emerged between transnational flows, the elite nationalist project, and local experience in such places as Olinalá, physically isolated in the northern Montaña region of Guerrero in southern Mexico. From the 1920s through today the lacquered boxes and gourds of Olinalá have enjoyed a reputation as among the most Mexican of Mexico's arts. In 1994 the World Trade Organization even granted Mexico a GI (Geographical Indicator) on the name "Olinalá." A GI is a patent on a name place in relation

to a particular product, for example, "Champagne" to designate the kind of wine peculiar to the Champagne region of France. Mexico currently owns seven such GIs, including "Tequila," and was one of the first countries to extend GI law from food into handicrafts, winning patents on "Olinalá" and "Talavera." Olinalá is not necessarily the most important artisan community in Mexico, but since the time of the revolution it has held a certain pride of place.

In a bottom-up study of the artisans of Olinalá, the second part of this book reveals some of the unanticipated ways a rural community became integrated into national and international political, cultural, and economic transformations.[47] The chapters on Olinalá do not constitute a community study in the usual sense. Instead, they provide an analysis of how local, regional, national, and transnational processes intersected on the local level and within the intimate power dynamics and class conflicts that shaped the artisans' lives. The analysis shows how discourses and state and private initiatives impacted rural Mexicans, transforming ethnicized *mexicanidad* from an elite discourse into quotidian popular practice.

Olinalá's interaction with the "center" began long before the revolution. From the Aztec empire to the postrevolutionary nation, Olinaltecos regularly used their fluctuating lines of contact to imperial and national centers and states to struggle over the place and meaning of their art. By the end of the nineteenth century, in the face of a declining regional market for their crafts and growing pressure for cheap labor to support the expanding sugar industry, Olinaltecos almost abandoned lacquer production. During the revolution they revived their art in the context of a brutal local struggle for survival and political and economic power. Then, with the rise of the postrevolutionary nationalist discourse, they forged a new kind of relationship with the center that enabled them to redefine their lacquer industry as an authentic Mexican popular art and themselves as rightful indigenous beneficiaries of a state-led nationalist transformation.

The story of why and how they were able to redefine themselves and their art in this way should inform how we think about processes of national integration, and our understanding of the role of aesthetics and popular art in the cultural-nationalist movement. By linking the elite narrative to the local power struggles in Olinalá and the lives of humble artisans such as Juvencio Ayala (well remembered locally, but unknown outside Olinalá), Concepción Ventura Pérez (whose crafts became nationally

emblematic of Mexican popular art in the 1930s but who rarely is recognized even on the local level), this study argues that part of the strength of the national glue that binds the population lies in the idiosyncratic and hotly negotiated structures of power and the contours of conflict through which individuals and communities gained a stake in the emergence of the nationalist aesthetic.

The book's focus on Olinalá is not a suggestion that this community is somehow archetypal. When Luis González y González explained his choice of San José de Gracia as the focus of his famous *microhistoria*, he described it as "an unknown point in space" that maps rarely depict in "its correct location." The same can be said of Olinalá. But where San José de Gracía had no place in the "consciousness of the Mexican republic" prior to González's study, the artisan community of Olinalá loomed large, with myth preceding and often standing in for the town's reality.[48] The promotion of an ethnicized nationality helped transform Mexico's population into a nation, but the project did not unfold uniformly, and its reasons for success were often different than what elites imagined. Moreover, its level of success varied by locality. Elites assumed that national integration resulted from their having at last achieved a genuine understanding of the "real" Mexico, closing the gap between elite and popular (a gap that Guillermo Bonfil Batalla in the 1980s and the EZLN in the 1990s have shown persists despite claims to the contrary). The success of integration is owed not to the perfection of some sort of top-down control but to the idiosyncratic ways localities engaged and grounded the elite project within their own communities. Each region engaged the ethnicized identity emanating from central Mexico in its own manner as it became integrated into the cultural nation. In north and north-central Mexico, such as Monterrey and Guanajuato, for example, locals often forged their regional identity through rejection of the indigenous presence, but they could no longer presume that indigenous people stood apart from the nation. Even as they continued to exert regional cultural autonomy, they came to define themselves in dialogue with the ethnicized identity emerging out of central and southern Mexico, which they took to be the dominant culture.[49] Were the present study of ethnicization, aesthetics, and nation formation to have focused on one of these localities instead of Olinalá, no doubt it would have developed a distinct explanation of how elements came together within that particular locality to help integrate it into the nation. However, the

broader framework of an emerging ethnicized nationality and the need for locals to reshape local and regional identities in relation to this newly hegemonic national form would remain consistent. And so, while Olinalá was at once typical, it also was extraordinary and, like González's beloved San José, parts of its story "can be said to be true" only of Olinalá.[50]

In the epigraph to this introduction, Edward Said notes the danger of reifying the existence of "integral, coherent" national identities. Such reification, he warns, naturalizes the existence of such identities and inspires one to defend their supposed innate qualities rather than interrogate the historical construction and implications of their formation, what Michel Foucault has termed their "archaeology."[51] This study takes the postrevolutionary validation of popular art as an entry point from which to trace the historical genealogy of an ethnicized *mexicanidad*, revealing its connection to national integration. The goal of culturally integrating populations around the globe into stable nation-states has been a preoccupation of the twentieth century and remains so today, especially in the context of ongoing interethnic conflagrations throughout the world. The Mexican case can help us to better understand these complex processes and their relationship to state formation, and to grasp why, in Mexico's case, it has proven remarkably successful despite (and even because of) deep-seated contradictions, inequalities, and internal tensions.

The text is divided into two parts. The first traces the emergence of a nationalist discourse of ethnicized *mexicanidad*, explains why and how nationalists turned to visual aesthetics and popular art, and examines the process by which this discourse became institutionalized and with what consequences. Chapters 1 and 2 draw on state and private archives as well as media (newspapers, magazines, television, and radio), art, and oral interviews to trace the rocky emergence of an ethnicized nationalist aesthetic. Chapter 3 considers the place of foreign-Mexican collaboration in the discovery and validation of popular art as part of a postrevolutionary *mexicanidad*. It shows how a transnational perspective is vital to any effort to understand the tensions and contradictions that infuse Mexican national identity.

Chapters 4 through 6 focus on the changing place of intellectuals in the institutionalization of the postrevolutionary cultural movement, and on

the uneasy relationship between popular art and the market. The most important documents come from a rich archive that had been gathering dust in a warehouse in the outskirts of Mexico City, which historians have not tapped until now. The archive, today housed in the INAH's Subdirección de Documentación, offers unrivaled insight into intellectual projects of the 1920s and 1930s and, used in conjunction with other state and private archives such as those held at the Instituto Nacional de Bellas Artes, fills in a missing period in our understanding of the emergence of Mexico's major cultural and research institutions. Chapter 4 untangles how disparate intellectual initiatives competing for state support in the 1920s gave way in the 1930s to an organized state cultural project. Chapter 5 traces tensions between the market, institutions, and nationalist ideals. It focuses on the evolution of the Museo de Artes Populares, an institution that united autonomous intellectual initiatives with an increasingly bureaucratic and institutionalized postrevolutionary state. Chapter 6 analyzes the changing role of the state in the marketing of Mexican popular arts between the 1920s and the 1970s, ending with the emergence of Fonart. It stresses the importance of understanding the evolution of cultural institutions rather than relying on a periodization defined by changing presidential administrations.

Part II draws on state and church archives, ethnographic accounts, travelers' reports, census and state records, anthropological and archaeological studies, oral interviews, and object analysis to show how these broad discursive, political, and economic shifts impacted people's daily lives in Olinalá, and how local people, in turn, helped consolidate the nation. This was one of the first artisan communities valorized as quintessentially Mexican and today remains important to the nationalist imagination. By tying together local experience with national and transnational trends, the chapters of this section shed light on how one community became integrated into an ethnicized national identity, and on the profound contradic-tions that continue to plague nationalist discourse and ethnic and national identities. These chapters argue that the success of Mexico's national integration and its national identity lies in the ways it has intersected with local identities and social struggles, and in the way particular aesthetic ideals have penetrated debates over *mexicanidad*. The Mexican scholar Victoria Novelo has pointed out that today the idea "that Mexico is a land

of handicrafts . . . is something taken for granted by the people of Mexico" and by foreigners. More than that, "artesanías have become a symbol of *mexicanidad*."[52] The chapters of this book consider how this came to pass and argue that it has been inseparable from processes of ethnicization and national integration.

PART I · Indianness and the Postrevolutionary Mexican Nation

Ethnicizing the Nation
The India Bonita Contest of 1921

The public cheered on 18 September 1921, as María Bibiana Uribe, a humble housecleaner from Necaxa, Puebla, paraded down the main avenue of Mexico City. The next day leading intellectuals, high society, and politicians—including the Mexican president, Alvaro Obregón—joined middle- and working-class spectators as they crowded into one of the capital's finest theaters for her coronation. A few months earlier no one predicted that the crowning of the India Bonita (Beautiful Indian) would become such a sensation. The contest leading up to Bibiana's election had confronted a reluctant public, such that the anthropologist Manuel Gamio, widely recognized as an expert on indigenous culture and a leading voice for nation-formation, felt the need to explain in a newspaper article how an indigenous woman possibly could be considered beautiful. Who was Bibiana, and why had this humble woman become the focus of so much public attention? And why had it been necessary to convince the reading public of Mexico, one of the most indigenous and mestizo countries in the Americas, that an indigenous woman could be considered beautiful? The answers begin to emerge if we look beyond the common assumption that Mexico's national identity has emerged from the gradual and seamless interweaving of Indians and Europeans into a mestizo, or racially and culturally mixed, society. This chapter focuses on the India Bonita Contest of 1921 as a lens for understanding early 1920s postrevolutionary nation-formation and gendered constructions of Indianness. It does not claim that the con-

test had a transformative impact on the course of Mexican history, only that it is particularly revealing about the goals, methods, and contradictions inherent in the broader movement to ethnicize national identity and to bring indigenous peoples into the national fold.

The projects of ethnicization and integration were responses to the recent revolution, which had revealed and even exacerbated the deep fragmentation of the population. In 1921 fighters at last began to lay down their arms and the new president, the northern general Alvaro Obregón, began to reestablish state authority. Intellectuals and politicians set out to unify Mexico's population as a nation so as to forestall a new cycle of social disintegration and to initiate an era of modernization. This was the period when the educator and soon-to-be minister of education José Vasconcelos, often hailed as a father of the Mexican renaissance, traveled to many of the federal states to convince legislators to ratify the creation of a federal education system (which would extend public education and the nationalist project into the rural corners of Mexico). Obregón announced the creation of the Escuela de Verano (Summer School for Foreigners) at the National University in Mexico City, which would soon become a launching ground for studies of popular culture and a key institution for better understanding "the Mexican people." The secretary of transportation and communications, after a drawn-out debate over whether Mexico needed roads, announced plans for new highways to tie together the regions of the country. This was also the time when an effort to name a national tree led to public debate about whether the *ahuehuete* or the ceiba was more distinctly Mexican.[1] Such initiatives were very different from one another and of radically different scales, but they all were steps toward uniting the population around a common identity.

In their search for an authentic national culture around which to unite the population, so as to move the country toward its own distinctive form of modernity, nationalists looked to the grounded experiences and worldviews of the masses. They debated which aspects of popular and indigenous culture merited celebration and which should be extirpated due to their "backwardness." A growing number of nationalists focused overtly upon contemporary (as opposed to archaeological) Indianness as the thread that could unite the people and, at the same time, distinguish Mexico among a global family of nation-states. They chastised those who rejected the coun-

try's Indianness, charging them with "foreignness" and insufficient nationalist zeal.

This indigenous-oriented nationalism found expression in such events as the India Bonita Contest, but it was not the dominant discourse. In fact, many civic leaders refused to link the idea of national identity to living indigenous cultures, preferring a continued focus on Hispanic roots and the preconquest Maya and Aztec past. Others, such as Vasconcelos, advocated a form of *mestizaje* that evaded or minimized the need to validate the idea of "Indianness."[2] It was not yet clear whether the pro-indigenous discourse would prove compelling. Moreover, even as the India Bonita Contest spoke to this emerging project of ethnicized cultural nation building, it was not an uncompromised nationalist act. As will become clear, part of the reason the former revolutionary Félix Palavicini initiated the contest was to draw public attention to his newspaper *El Universal*. Theater houses, artists, and intellectuals subsequently joined forces with the contest, blending cultural nationalism with commercial self-promotion. Each of these tapped into the mood of the time by speaking to commonly held assumptions, while working to alter those assumptions. The contest also tapped into gendered concerns about the recent urban influx of potentially "unassimilable" indigenous migrants displaced by the economic, political, and social upheavals during the revolution.[3] Not only was the pro-indigenous position not the dominant discourse and not a result of uncompromised nationalism but it was not even necessarily a state discourse. Too often, postrevolutionary cultural change has been attributed narrowly to a "state project" when, in fact, at the start of the 1920s the state was too weak to formulate or enforce such a project. This chapter reveals the role of nonstate actors and urban mass culture in ethnicizing national culture as part of the broader movement toward integration. It also shows when and why the state did become involved, and with what consequences.

In 1921, then, the project to promote living Indian culture as central to Mexican identity was not the dominant discourse, nor was it promoted out of selfless nationalism; neither was it simply a "state project." Yet the project certainly earned attention as novel, and it did sell newspapers, and the India Bonita Contest did capture the public imagination. Most importantly, it gained the support of the postrevolutionary intellectuals who would dominate government departments during the 1920s. Finally,

it was a movement that assigned a central place to popular aesthetics, and that eventually would catapult this sense of aesthetic nationalism into the realm of "commonsense."

One of the first people to come to mind upon mention of postrevolutionary aesthetics is the artist Diego Rivera. As Pete Hamill aptly states in his study of the muralist, Rivera used his art to unify "a people long fractured by history, language, racism, religious and political schism. He said in his art: you are all Mexico."[4] But, while Rivera may have been the most elegant, or at least the best remembered, promoter of this nativist aesthetic language, he did not invent it. At the moment when Rivera, who had been at the center of the artistic debates of Paris, barely was stepping off the boat from Europe armed with his Cubist and Cézannesque canvases, the India Bonita Contest already had become a media sensation. It was only after his entry into this energized milieu that Rivera began to develop the nativist style that he later would make public in his 1923–28 mural on the walls of the Ministry of Public Education. Less-remembered figures are at least as important as Rivera. It was their blend of nativism and cosmopolitanism that propelled the desire to learn about, interpret, and celebrate the faces, cultures, and aesthetic that Rivera has immortalized. The contest offers a glimpse into these people's activities. It also offers insights into the limitations and contradictions of the movement they created, reinforcing the argument by the historians Mary Kay Vaughan, Heather Fowler-Salamini, and Katherine Bliss that from the perspective of women, "the Mexican Revolution was not so much a revolution" as "a 'patriarchal event' that largely consolidated male authority at all social levels."[5] This is not to imply that gender and ethnic relations remained unchanged or that they merely hardened Porfirian conventions. Rather, my intent is to begin to chart how aesthetics contributed to these changes and continuities, and how shared assumptions about the interconnections among gender, ethnicity, and nation became normalized through the movement for cultural integration around an ethnicized national identity.

El Concurso de la India Bonita

The India Bonita Contest began in January 1921 when Félix Palavicini, founder and director of the prominent periodical *El Universal*, told his staff to celebrate Mexico's centennial with a contest that would bring attention and sympathy to indigenous people as *part* of Mexico so as to make

them an important concern for cultural and political leaders. Palavicini had founded *El Universal* at the end of 1916, during the revolution, as a model for the emerging liberal free press and as an advocate for a strong central government. The newspaper served initially as a mouthpiece for Carranza's constitutionalist cause, but by 1920 it had become an independent news source with its own political agenda that it publicized regularly. By quickly adopting telegraph technology, the newspaper became a leader in national coverage.[6] In January 1921 Palavicini matched his efforts at national coverage with an overt campaign advocating national cultural unification. He argued that unless marginalized indigenous people received a stake in Mexico, they might launch another revolution or be lured into Soviet Communism.[7] Palavicini conceived of the India Bonita Contest as a capitalist venture aimed at unifying the nation by creating a place for Indianness within this emerging national community.

In the public announcement for the India Bonita Contest, *El Universal* stated that it had long been the custom to award prizes for the beauty of a woman or for the inspiration of a poet, but no periodical or magazine had ever thought to adorn its pages with the "strong and beautiful faces" of the Indians of the Mexican "lower class." As the announcement suggests, visuality was crucial to the contest organizers' efforts to find a place for indigenous people within the emerging national culture. This was not Palavicini's first effort to link aesthetics and populism. Six years earlier, in October 1914, as minister of education under Venustiano Carranza, he had called for the creation of a Department of Fine Art charged with "democratizing art without watering it down, so as to make it useful for the popular classes."[8] The difference between his position in 1914 and what he now was trying to do in 1921 was that, whereas previously he simply sought to deepen the Porfirian goal of compelling the masses to assimilate into a fundamentally Europeanized nation, now he argued that the nation itself had to change to accommodate indigenous people. Through the India Bonita Contest he hoped to advance his political and cultural goals while edging out *El Universal*'s main commercial rival, *Excélsior*.

Palavicini put Rafael Pérez Taylor, working under the pseudonym Hipólito Seijas, in charge of getting the contest off the ground. Pérez Taylor, who stood to the political left of Palavicini, had taken an early interest in politics while growing up in a middle-class family on the outskirts of Mexico City. He had joined the Partido Liberal Constitucional Progresista

and supported the presidential candidacy of Francisco Madero against the dictatorship of Porfirio Díaz in 1910. In 1914, during the revolution, he helped revive the radical anarcho syndicalist labor union known as the Casa del Obrero Mundial, first founded in 1912. Together with the Zapatista socialist intellectual Antonio Díaz Soto y Gama, Pérez Taylor tried to persuade the Casa to maintain its autonomy while endorsing the Zapatistas and the Convención de Aguascalientes. His effort failed when Gerardo Murillo (who went by the name of Doctor Atl), convinced the Casa to subordinate itself to Carranza and then organized the workers into the Red Battalions to fight against the Zapatistas and Villistas. After the revolution, Pérez Taylor continued his political advocacy, but through journalism and the arts rather than labor organizing. By 1920 he had developed a reputation as a leading journalist, theater and film critic, and political advocate.[9] With the India Bonita contest Pérez Taylor saw an opportunity to test the boundaries between theater, politics, and journalism.

In 1921, as head of the contest, Pérez Taylor led his staff into the outdoor markets on the edges of Mexico City in search of *indias bonitas.* He complained that their efforts to recruit contestants were met with evasion, even hostility, on account of rigid social and language barriers that he claimed separated indigenous people from urban white and mestizo society. Because Pérez Taylor and his team spoke no indigenous languages, they found themselves unable to communicate with the women they approached. Despite several days in the outlying communities, they failed to enroll a single *indígena.*

In search of a new strategy he abandoned outlying communities in favor of marketplaces within the city's indigenous *barrios* to search for *gatitas.* In the parlance of the time, white male middle- and upper-class urbanites used the depreciative sobriquet *gatita*, literally "kitten," to refer to young indigenous girls, usually of rural origin, who developed ties with wealthy households in the city through such menial employment as shopping at outdoor markets, grinding corn into *nixtamal*, or cleaning houses. The term often carried a licentious connotation, suggesting naïve sexual allure. As one author explained at the time, "Some gatas are simply gatas" smelling of onions and roses, but "others are gatitas from Angora."[10] Pérez Taylor reasoned that because *gatitas* had experience with urban whites they might possess working knowledge of Spanish and perhaps be willing to talk to the organizers. These *gatitas*, in other words, would be sufficiently

exotic for the purposes of the contest, but not so "Other" as to be inaccessible.

After less than an hour of combing through the women who tended the vending stalls and hunched over *metates* in the market section of the neighborhood of San Antonio Abad, Pérez Taylor found a potential candidate and convinced her to allow his team to take her photo and enroll her into the contest. He soon netted other recruits in a similar manner, but this was so slow and cumbersome that he decided to encourage his readers to take on the role of recruiters. Relying on readers also gave Pérez Taylor an easy way to extend his call beyond the capital into provincial centers like Oaxaca, Guanajuato, and Jalapa.

The newspaper did not encourage girls to enroll themselves (though some girls, such as Dolores Navarro, an eighteen-year-old housekeeper in Mexico City, did so on their own). Instead it urged any reader who had an *india bonita* in their hire to send in her photo. It also encouraged photographers to "go out to the picturesque populations within their state to search the peasant huts and the cane fields for candidates."[11] By managing the contest in this way, *El Universal* cast nonindigenous people, especially men, as protagonists who delved into the dark corners of the country to discover and publicize its passive Indian wonders. When the newspaper published the photos, the accompanying profiles regularly listed the name of the discoverer before the name of the girl herself (which occasionally was omitted altogether).

The newspaper's recruitment strategy revealed ambivalence about acknowledging any agency on the part of female indigenous subjects. Though they frequently debated whether particular girls were really indigenous and by what criteria, not once did the contest organizers ask the girls how they defined themselves. They advocated the inclusion of Indianness as part of the Mexican national identity, but relegated indigenous people, above all, indigenous women, to a subservient and objectified place in the nation. Moreover, despite the fact that most of the contestants were recruited from urban areas, the contest continued to define indigenousness as fundamentally rural.

Efforts to broaden recruitment did not go smoothly. It seems that initially the public simply did not understand what *El Universal* meant by "Indias" who were "Bonitas." Some readers explicitly mocked the very idea of indigenous beauty. One, for instance, submitted a photo of a coarse man

dressed as an *indígena*. A more common means of subverting the notion of indigenous beauty was to submit photos of white or mestiza contestants dressed up in folkloric garb as *chinas poblanas* and *tehuanas*.[12] These two regional types had attracted urban interest since the nineteenth century. The popularity of the *china poblana*, a regional style of dress from the state of Puebla, had become firmly established by the late nineteenth century. Usually the *china poblana* came paired with the *charro* (a masculine stereotype characterized by a broad hat and tight pants, rooted in the rural landowning elite, though in some circumstances it denoted the *revolucionario*, and now is most often associated with Mexican *mariachis*, roving troupes of musicians playing *ranchera* music). The *tehuana* was a female type attired in the style of the Isthmus of Tehuantepec in Southern Mexico, characterized by a large pleated headpiece circling the face. Like the *china* and *charro*, it drew links to a mythical past. During the second half of the nineteenth century the *tehuana* operated in Oaxaca as a symbol of race, indigenous heritage, and regional identity. By the start of the 1920s the *china poblana* and the *tehuana* were denoted by style of dress, with little connection to race or ethnicity. Because *tehuana* and *china poblana* outfits were culturally and politically safe and racially neutral, they provided a nonthreatening way to celebrate popular culture. They invoked a romanticized aristocratic past, while inviting comparisons to European folk regionalism. Before the *china poblana* and *tehuana* vogue reached new heights in the 1920s, they already were ubiquitous in festivals, revue theater, film, and public cultural events. Mexico's elite also adopted these outfits to celebrate national holidays, and by 1921 these styles had become so generalized that even members of the United States diplomatic and business colony, with a reputation for being insulated from Mexican culture, donned *china poblana* outfits for their celebrations of the Fourth of July.[13] There was nothing particularly novel or revolutionary about the *china poblana* and the *tehuana*, which largely had been emptied of racial or social class implications. The India Bonita contest, by contrast, injected debates over race and class into the postrevolutionary discussion.

Palavicini and Pérez Taylor found submissions of white women dressed as *tehuanas* and *chinas poblanas* frustrating because they undermined their efforts to focus on the humble *india* or to draw attention to Mexico's racial diversity, its cultural fragmentation, and the aesthetic gulf dividing "urban whites" from "rural Indians." Integrating notions of Indianness and

what I would term "public beauty," it seems, did not come easily to readers and it could not be done without entanglement with long-standing regional and national types.

To reorient public opinion about the place of indigenous people within the Mexican nation, Pérez Taylor conducted the India Bonita Contest much like an education campaign, periodically providing the public with examples, practice, and reenforcement. He declared that the newspaper sought "indias legítimas" who were "bonitas." As *El Universal* identified suitable examples, it published portraits along with short explanations of how the depicted subjects related to the promoted ideals. The newspaper explicitly stated some of the characteristics that organizers sought, such as an oval face, dark skin, braids, perfect teeth, and a "serene" expression. For the promoters these were not just signs of Indianness but specifically *positive* indigenous characteristics. This becomes clear if we compare these idealizations to typical characterizations of indigenous people within the popular press: hunched, blank-eyed, disheveled, graceless, filthy, and with thick red drooping lips (see figure 16 in chapter 3). The published photos and written profiles demonstrated not only what the organizers considered Indian but what they thought beauty might mean in relation to indigenous people.

El Universal stated that it published all "acceptable" photo entries, with the implication that some photos were "not acceptable." At first, I assumed that "unacceptable" specifically referred to joke entries that ridiculed the idea that an *indígena* could be beautiful, or portraits of white contestants with no trace of indigenous features. But organizers urged those who had submitted unacceptable entries to send new photos. The problem, it seems, was with the photos not the contestants. This led to speculation that perhaps unacceptable meant blurred photos. Yet a closer reading of the daily entries shows that there was more to it. On 25 March 1921 *El Universal* published a photo that Josefa A. de Morales of Huachinango, Puebla, submitted of her goddaughter. The caption detailed each part of the contestant's indigenous outfit, stressing that she made all of it herself. It explained also that this was the second photo that de Morales had submitted of the very same contestant and that the previous photo had been unacceptable because it was not "natural." "Unacceptable," then, seems to have been linked to being not "natural." Did this mean that it was too formal, too staged? Since photographers had staged many of the published

photos in studios, and the newspaper even offered small prizes for the best staged portraits, formality was not the problem. In this case, *El Universal* noted that once de Morales sent in a more natural photo, the contestant was accepted. This contestant was María Bibiana Uribe, who went on to win the contest. The problem with the original photo seems to have been that, in it, the contestant did not carry the outward markers of how an indigenous woman was supposed to look. Perhaps the original photo depicted her wearing nonindigenous street clothes, or maybe she wore rouge and lipstick (the chapter will return later to the topic of make-up), or maybe she had her hair up instead of in braids. One way or another the original photograph of Bibiana had violated the contest organizers' definition of authentic indigenousness.

To help outside entries meet its criteria, Pérez Taylor occasionally presented examples of what he had in mind. But each time the entries strayed again toward white women disguised in folkloric dress or *indias* whom the sponsors did not consider *bonitas* or who did not carry the appropriate markers. By the later months of the submission period—which ran from January through August—submissions strayed less from the organizers' expectations, and fewer lessons in Indianness and nonwhite public beauty were necessary. By the final weeks of the contest, as the newspaper overcame the public's reluctance, the number of daily submissions swelled until *El Universal* had to dispense with the written profiles just to accommodate them all. For the India Bonita Contest, publication of photos and repeated training of the audience were vital. Without them there could be no consensus building about the subject.

The peculiar way the newspaper managed the India Bonita Contest becomes even clearer when we compare it to how the same newspaper promoted the concurrent Concurso Universal de Belleza. The search for Miss Mexico relied upon a normalized discourse of beauty such that a simple call for Mexican beauties resulted in a barrage of acceptable submissions. No training of the audience was necessary. Organizers, readers, and participants relied on a shared knowledge about what constituted "universal beauty," and no one found it necessary to explain why only white women were included among the finalists.[14] Moreover, whereas in this contest organizers praised the elegance of a pose or the impression of a smile, in the India Bonita Contest they talked, instead, about braids, pure race, passive attitudes, mispronounced Spanish, typical Indian clothes, innocence

and awkwardness, prayers to the Virgin, grinding of corn, and humble social stations.

Through the India Bonita Contest, then, *El Universal* tried to value Indianness but remained unwilling to publicly promote indigenous beauty as on the same level, or even of the same type, as white beauty. This ambivalence became even clearer when the newspaper announced the ten finalists. Backtracking on Pérez Taylor's earlier claim that these "indias" were indeed "bonitas," the newspaper now insisted that in selecting these finalists, "the judges considered only the Indian features of the contestants, and in no way were they guided by beauty or personality."[15]

Shortly before the newspaper selected the contest judges, a columnist expressed concern that judges might choose the whitest, least indigenous of the contestants, the one who most approximated the Western ideal of beauty. This, he feared, would undermine the intent of the contest. Foreigners seemed to him less tainted by the anti-indigenous prejudice that the Mexican middle and upper classes supposedly were taught since childhood. In his view, this made foreigners more open to Mexican indigenous culture—the "real" Mexico—and to popular aesthetics, and thereby able to serve as better judges. Though the contest organizers decided not to follow the columnist's suggestion regarding foreigners, they shared some of his concerns, as demonstrated by their decision to include as judges Jorge Enciso (a nativist artist who avidly promoted things Mexican and valorized indigenous culture), Manuel Gamio (an anthropologist committed to incorporating the native population), Rafael Pérez Taylor (architect of the contest and future head of the Federal Department of Fine Arts and then the National Museum), and, rounding out the panel, Carlos Ortega and Aurelio González Carrasco (recognized authorities in dance and theater who produced revues and zarzuelas [light operas]). The newspaper assured readers that these judges were well qualified to "differentiate perfectly the physical traits of a *criolla* (a Mexican of European lineage) from those of an *indígena*."[16]

The panel of five judges met near the end of July 1921 to examine hundreds of photographs, from which they selected ten finalists to invite to Mexico City at the newspaper's expense. A group photo of the finalists (figure 4) reveals ten young women seated in two rows, all dressed in regional clothing.

Compared to the pool of contestants as a whole, these finalists appear

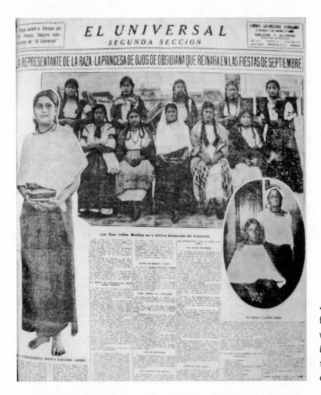

4. María Bibiana Uribe, finalists, and Bibiana with her grandmother. *El Universal*, 2 August 1921. Biblioteca Lerdo de Tejada.

strikingly similar to one another, suggesting the judges' narrow definition of an authentic Indian. Physical criteria, however, were not the sole measure. The majority of submissions had been of girls working in urban markets, yet most of the finalists were servants from the countryside, suggesting that the judges also expected *indias legítimas* to be subservient and rural.

El Universal brought the finalists to Mexico City on the first of August. They arrived in traditional attire, except for Ignacia Guerrero, who sported urban stylish clothing. Then, at 5 p.m., something fascinating happened. Gamio came out to greet them, then directed the chaperones to wait while he and a female assistant led the girls to a back room. There, according to Bibiana in an interview late in her life, his assistant wiped each contestant's face with a moist white towel. Why? To see who was wearing make-up. Most of them, in fact, were found to be using make-up, and they were told to remove it so as to appear natural before the judges. Once the girls were purged of outward signs of modern artifice, cosmopolitanism, and

consumerism, they were lined up to be judged in person. Some judges favored the green-eyed Ignacia Guerrero. But the Columbia University Ph.D., Franz Boas–trained anthropologist Manuel Gamio insisted that no one with light-colored eyes could be considered a real *indígena*. Gamio's key qualification as a member of the judging panel was his supposed ability to identify authentic indigenous characteristics with scientific precision. Earlier that year, Gamio had written an article that melded his cultural politics with a critique of dominant notions of universal beauty. In that article he argued:

> The classic model of physical beauty, the Greek model, does not exist, nor has it ever existed in Mexico. For lack of this aesthetic ideal, we have substituted the White physical type of Hispanic origin. But this is a crass error because Whites make up only a small part of the Mexican popu-lation, and they are physically different from the majority; moreover, there is no evidence that Whites are more attractive than Indians or Mestizos. We should not establish exclusive canons of beauty. [Indige-nous and mestizo beauty] must be aesthetically analyzed, made known, and understood.[17]

Gamio stood firm, and María Bibiana won with a vote of three to two.

Treating the announcement of the winner as the culmination of an edu-cation process, *El Universal* published Gamio's explanation of why the public should accept the notion of indigenous beauty, and how to judge such beauty. And, alongside its proclamation of Bibiana as the winner, the newspaper included a statement from the panel of judges explaining that she won because she epitomized "all of the characteristics of her race: a brown complexion, black eyes, short stature, delicate hands and feet, straight black hair, and so forth."[18] Each of the other judges then offered his own elaboration. Carlos Ortega argued that to crown and fete a queen of aboriginal beauty was a meritorious act that vindicated a "repressed, de-spised, and forgotten caste that has been ignored by Mexican artists, musi-cians and writers." Jorge Enciso added that until now Mexicans had never recognized the worth of the Indian. This contest, he said, was a nationalist act that reminded the public that, though oppressed, Indians remained a vital part of Mexico.

Gamio stressed that the contest marked an important first step toward bringing Indians into the national fold. He insisted that, because of the

social importance of the contest, it was crucial that the winner be an authentic Indian. He guaranteed us that María Bibiana Uribe was the real thing. Should anyone doubt his judgment, he was prepared to compare her physical measurements to Jenk's Anthropomorphic Index, a table of the ideal bodily measurement of each race. In the judging, then, the contest combined scientific racism with cultural relativism and a modernist obsession with authenticity, blending the three to lay a foundation upon which to elevate Mexican Indianness. Anxieties about modern clothing, photographic "naturalness," and make-up suggest, moreover, the ways that this modernist and nationalist invocation of authenticity operated as a gendered discourse that limited indigenous women's control over their own bodies and self-representation.[19]

Heartened by the judges' selection of María Bibiana Uribe, *El Universal* declared with renewed enthusiasm that the India Bonita Contest was "as much a realization of beauty as an example of civic education, because it contributes to the current movement to affirm national unity by identifying . . . with all the components of the Mexican races."[20] From that point forward the contest grew beyond the direct control of *El Universal* to become a media and public cultural nationalist sensation.

Representing the India Bonita: Media and the Arts

The day after the judges selected the winner *El Universal* ran a large front-page photo of fifteen-year-old María Bibiana Uribe from the Sierra de Puebla. One of the accompanying articles lauded her rural origins, her homemade indigenous outfit (her *tixtle*, her *quixquematl*, etc.), her language ("Mexicano" [Náhuatl]), and the specifics of her racial lineage ("Aztec").[21] The next page included a full-length image (figure 5) of Bibiana in bare feet holding a lacquered bowl from Olinalá, Guerrero, which was beginning to gain popularity as an authentically Mexican style of artisanship (see chapters 7 and 8).

Though Bibiana would later explain that the photographer had handed her that bowl as a studio prop, *El Universal*, perhaps to highlight her aesthetic authenticity, described the bowl as belonging to her. An accompanying article encouraged readers to picture her wearing the bowl on her head to protect her from the sun—it was common among indigenous peasants in Central Mexico at the time to wear Olinaltecan lacquered gourd bowls in this manner—and using it to scoop drinking water from moun-

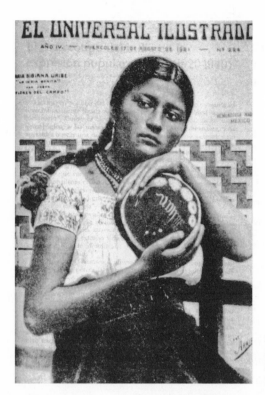

5. María Bibiana Uribe holding a gourd from Olinalá. *El Universal Ilustrado*, 17 August 1921. Biblioteca Lerdo de Tejada.

tain springs during her long walks in the woods. The article concluded that María Bibiana was a shy rural Indian girl about to receive public fame beyond her provincial imagination, a "fortunate Cinderella who brings with her all the grace of our lakes, our sky, our countryside, our forests. . . . This pretty and fortunate little Indian girl brings with her" all the good of the nation.

As soon as the judges had voted, the journalist Fernando Ramírez de Aguilar, who wrote under the nom de plume Jacobo Dalevuelta, interviewed María Bibiana. Ramírez had grown up poor in Oaxaca, then studied education, but rather than use his teaching credentials he went to Mexico City to become a writer. When the revolution erupted he became the frontline reporter for the newspaper *El Imparcial* before Palavicini invited him to join the editorial board of *El Universal*, which became his springboard for lifelong fame as a writer and reporter (today his hometown of Oaxaca City even has a downtown street named after him) known for his unique blend of literary snobbishness and exaltation of regional stereotypes, above

all the *charro*.[22] On this occasion he recounted that when he asked María Bibiana for her age, she responded, "I don't know, Sir, I have no idea." At first this gave him pause, he claimed, but upon further reflection he realized that there was no reason she should know her age:

> What difference does it make to her whether she is fifteen or twenty? In her forests, under the protective shadow of giant pine groves, surrounded by the exquisite aroma of gardenias, this mountain-girl contemplates the natural world that has bestowed upon her such beauties. Bibiana lives in peace and tranquility, rising early and meeting the sun and moving through the morning breeze. She strolls through the woods singing the song of life, watching the love of the birds nesting in the swaying boughs. Picking flowers as she goes, to carry them to her village church.[23]

With this he cast the ideal Mexican Indian as naïve, primeval, and close to the earth.

Neither the contest nor the broader postrevolutionary movement of which it was a part aspired to reconstitute the preconquest Indian. Their ideal was an Indian already subjugated by centuries of Spanish rule, in need of benevolent uplift in the name of the Mexican revolution. Such Indians, they presumed, already had been set down the path toward *mexicanidad* and *mestizaje* but had lost their way due to the cruelty and exploitation of the colonial system and rapacious mine owners and landlords. This is the ideal Indian evoked by Ramírez in a distinctly gendered idiom. He emphasizes Bibiana's malleability, her childlike manner, and her naïveté. In other parts of the interview he even renders her speech in a ridiculous indigenous accent. We see this, for example, when he asks Bibiana if she was happy:

> Are you happy, Bibiana? [¿Eres feliz, Bibiana?]
>
> Well ... who knows, sir, who knows [Pos ... quen save, señor quen save].
>
> Do you know what it is to be happy? [Sabes lo que es ser feliz.]
>
> No, sir, what is that? [No, señor ¿Queue's eso?][24]

By caricaturing her speech as bumpkinish with exaggerated indigenous mispronunciations he emphasizes her simplicity, exoticness, and lack of education. Moreover, he encouraged readers to think of her as so deeply

melancholy—a trait consistently attributed to indigenous people—that she had never before pondered the meaning of happiness.[25] Her introduction to the idea of happiness emerges as a step toward her own, and through her all indigenous peoples,' union with the blessings of the Western tradition and toward the fulfillment of a genuine *mestizaje*.

The popularity of the India Bonita Contest catapulted María Bibiana Uribe into the center of Mexico City social circles. Invitations poured in for her to appear at theater performances, concerts, and dinner parties. Artists penned, published, and performed musical scores, plays, songs, and poems in her honor. From August through October María Bibiana, often accompanied by her court of runners-up, made dozens of appearances at public celebrations, government events, and all the major theater houses, including Esperanza Arco Iris, Eslava, Colón, Arbeu, Principal-Folies Tarazona, Casino, Lírico, San Juan de Letrán, Venecia, Trianon, and Lux, each time drawing capacity crowds. On the evening of September 14 alone Bibiana made six different special appearances to promote the debut of a film by Paramount Pictures titled *Se Llamaba María* (María Was Her Name), which documented her selection and sudden fame.[26]

In the middle of September Alfonso Esparza Oteo won a song-writing contest sponsored by a local radio station. Capitalizing on the popularity of the contest, he titled his foxtrot "La India Bonita." The score filled an entire page of *El Universal*, flanked by portraits of the composer and of María Bibiana. Esparza Oteo had trained under the renowned nationalist composer Manuel Ponce and had already attracted attention for his work on zarzuelas and revues. With this new hit, he became well known in Mexico City music circles and went on to even larger success. Despite being titled "La India Bonita," Oteo's foxtrot was meant for consumption by self-consciously modern white and mestizo urbanites, not for the dancing pleasure of María Bibiana Uribe. Another famous composer and bandmaster, Miguel Lerdo de Tejada (whose fame traced back to the 1880s), wrote and performed a separate piece also titled "La India Bonita."[27] Many others artists followed, scoring songs, plays, and dances dedicated to the India Bonita María Bibiana Uribe.

It is impossible to know what working-class and indigenous people made of Bibiana. But it does seem that for every elite play, song, or poem composed in her honor, there was also a working-class bar, milk-stand, or corner snack shop named for her. One such bar took its name from the

contest and adorned its exterior with murals depicting organizers recruiting *indias*. The bar was a pulqueria that served the native maguey beer to a predominantly indigenous clientele. Such establishments prohibited the entry of women, including indigenous women such as Bibiana. As Esparza Oteo celebrated the contest in the form of a foxtrot that excluded Bibiana based on her class and ethnicity, so this bar excluded her based on her gender. Bibiana found that the celebration of her crowning did not enable her to break barriers of race, class, or gender. On the contrary, the celebration celebrated the link between race and nation by reinforcing gendered forms of exclusion.

Revue theater, similarly to pulqueria murals, played on current events.[28] By looking at these theater performances, we can gain an appreciation for the contradictions and hesitancies that were woven throughout efforts to promote a positive opinion of indigenous and peasant cultures. When the India Bonita Contest became a public sensation, revue theater houses exploited this popularity by playing on national types and scenery while maintaining their signature political edge. Then, after Bibiana was selected as the winner, these playhouses used her to promote their productions. The most overt way they did this was by hiring her for heavily promoted special appearances between skits. In return they promised her as much as 50 percent of the box for the night, which was a large sum considering that most of these were sold-out events. At one point, when her bookings became too tightly scheduled, she missed an advertised appearance. The desperate theater manager struggled to restore order as the audience broke into jeers of protest.

Theaters further capitalized upon the contest by taking it as inspiration for new skits. Like United States late-night shows of today, revues' political commentaries were edgy, but they avoided clear political positions in favor of isolated jabs and satire. They commented on urban and rural types and advocated for the movement toward national integration and postrevolutionary political programs, but they generally avoided overt references to political marginalization or class oppression. We can see this, for example, in a series of skits called *Mexicanarías* directed by Alejandro Michel and Javier Navarro, which became one of the most successful revues of the year and was notable for its attempt to deal with indigenous people in a less slapstick or derogatory manner. One dialogue in the play even insisted that the real Mexico was to be found in the mountains, among the *indios*.

Unfortunately, the little the play did to positively portray native peoples was undermined by its closing monologue delivered in a supposedly indigenous dialect that, like Ramírez's interview with Bibiana, lampooned natives as ignorant bumpkins.[29] Then there was *El Indio Bonito*, which played more directly upon the India Bonita Contest. It was about a handsome young indigenous man named Jorge who abandons his philandering lifestyle after hearing about *El Universal*'s India Bonita, played by the famous Lupita Rivas Cacho. Jorge spends most of the play courting her and, in the end, the couple weds and moves to Xochimilco (the most recognizably Indian town for contemporary Mexico City urbanites), where they build a home on a *chinampa*.[30]

An even more interesting play was *Antojitos mexicanos* (Mexican Snacks, Little Tastes of Mexico, or, more figuratively, Little Mexican Whimsies), which playfully depicted a *charro* sampling exquisitely prepared regional dishes served by *chinas poblanas*, *tehuanas*, and *campesinas*. The *charro*'s overindulgence in this rich variety ends in a bout of indigestion as each regional dish dances back across the stage, reminding him of the cause of his malady and perhaps warning the audience about the potential hazard of the movement for an inclusive Mexico.[31]

And then there was Julio Sesto's *La India Bonita*. This Teatro Colón production starred the legendary María Consea, famous for her impressions of *charros*, *chinas poblanas*, *tehuanas*, and *revolucionarias*. Born in Spain in 1892 and trained as a child in Barcelona and Paris, she arrived in Mexico in 1901 by way of Cuba and New York City. Nicknamed the "gatita blanca de oro" (the white *gatita* of gold) Conesa was a masterful promoter who transformed revues in Mexico from low-budget, frivolous affairs into major productions that drew large audiences. She was known for infusing her plays with nationalist political content, folk music, popular dances, and regional types, and for igniting a controversy in the 1910 centennial when she appeared on stage in front of Díaz to sing the national anthem wearing a *china poblana* skirt embroidered with the Mexican eagle, a sacred nationalist symbol reserved for the flag. Eleven years later the Spanish actress transformed herself from an ethnically ambiguous *china poblana* into the personification of the nationalized *indígena mexicana*.

In a review of her performance in Sesto's *La India Bonita* in 1921, a critic confessed that initially he worried it simply would parody the India Bonita Contest but was pleasantly surprised to discover that it was a serious per-

formance. Another reviewer glibly noted that, though revue humor was not to his taste, he was delighted to see a play about an *india* rather than the overdone themes of crazy town councils, President Obregón's garbanzo beans, potholes in the city, *gringos*, drunken riffraff, and *marijuanos*. He also was happy that the performers were not following the "tasteless practice" of adopting a "ridiculous" manner of speech intended to imitate indigenous people's Spanish. Another commentator called it one of the best plays of the year. He praised its challenging depiction of *la india mexicana*, which, rather than disappoint with "a production-line depiction of a *mestiza*, an opulent *tehuana*, or an enticing *gatita china poblana*" instead offers the audience "a plain poor Indian girl belonging to the indigenous races of the Republic."[32]

Part of the reason revue productions readily embraced the India Bonita as fodder was that they already made it a practice to engage topics and images defined as *típico*. We see this, for instance, in the work of Javier Navarro and Germán Bilbao (like Conesa, a Spaniard with an eye for Mexican vernacular). Navarro and Bilbao already were coming off a string of successes, including *Peluquería nacional* and *El mundo en la mano*, when they had their smash hit *Mexicanarías*. They built all of their productions around lively skits designed to capture "typical" Mexican scenarios and regional stereotypes and made generous use of colorful costumes and exuberant renditions of provincial dance styles. Navarro and Bilbao argued that Mexico's rural traditions and styles offered sufficient variety and richness that the country could easily develop its own nationalist style, independent of Spanish and French theater.

These and other producers of *género chico* were soon joined by left-leaning artists searching for a nationalist aesthetic that valued living Indians as *muy mexicano* (very Mexican). It was at this time, for example, that Diego Rivera arrived from Europe. Drawn into the nationalist self-discovery already under way, he announced that the kind of authentic essence that escaped European artists was found everywhere in Mexico but remained unappreciated and poorly understood.[33] He would become even more convinced three months later when Minister of Education José Vasconcelos, who was frustrated by the lack of Mexicanness in Rivera's art at that time, compelled him to take what would become the first of many travels to the country's rural corners to discover the "real" Mexico. Jorge Enciso, Roberto Montenegro, Doctor Atl (Gerardo Murillo), Adolfo Best

Maugard, and many others likewise were returning from Parisian, Spanish, and Italian avant-garde circles to experiment with how the modernist notions they helped develop in Europe might relate to postrevolutionary Mexico. These artists dedicated themselves to forging a cultural nativist orientation that identified particular aesthetic traditions as indigenous and valorized them as *muy mexicano.*

Some critics were unimpressed by this nationalist fascination with *lo popular.* A critic who went by the pseudonym Júbilo, for instance, complained that now "even theater has suffered from the influence of the *mexicanismo* that is attacking us like a frightening epidemic under the pretext of patriotic [centennial] festivities that, in the end, have been nothing but a nuisance and a bore [*una lata*]."[34] Despite such criticism even Júbilo could not resist praising many of the recent events and the capital's new nationalist interest in regionalism.

The mood of the time was best captured by another journalist who declared: "Our artistic revolution consists . . . in separating ourselves from the foreign, in moving away from foreign influence to marshal our own artistic manifestations toward something genuinely created and developed by the people." Musicians, he argued, were gaining interest in Mexican music, painters were starting to look at the country and people around them, and even literature was finding its own direction: "We have begun to turn our eyes to what is ours [empezamos a volver los ojos a lo nuestro]." As the greatest evidence of this change in orientation, he cited the India Bonita Contest and the Exhibition of Popular Art (see chapter 2). "All of this is just a start," he wrote, "a great beginning. Later, when '*mexicanismo*' is more profound, it will be more sincere. Then we will see—ever more rooted in our customs and arts—*lo mexicano.*"[35]

The State, the Public, and the India Bonita

Though recent studies have tempered the historical revisionist view of the Mexican state as Leviathan, many scholars continue to exaggerate the initiative and intentionality of the state regarding the county's postrevolutionary cultural transformation. In the movement to exalt the indigenous culture, we find that the state was actually something of a Johnny-come-lately. When it did become involved, it was at the behest of intellectuals, artists, and commercial interests who courted government support.

In the case of the India Bonita Contest it was not until months after it

had already become a public success that the state finally joined in by creating its own centennial program and then incorporating the already under way contest. Despite being a latecomer, the state entered with gusto and deep pockets. Porfirio Díaz had celebrated the centennial extravagantly in 1910 (see introduction); but now nationalists sought to commemorate it anew, taking the 1910 precedent as both an organizational guide and as conceptual antithesis as they stamped upon the new commemoration their own emerging postrevolutionary ideals.[36] Like its Porfirian predecessor, the 1921 program included theater, opera, ballet, and parades, but organizers tried to encourage a populist orientation and an ethnicized interpretation of the nation.[37]

As the organizing committee incorporated the India Bonita Contest into the calendar of events, government officials went out of their way to be identified with the winner. The day after the judges elected María Bibiana, Minister of Foreign Relations Alberto Pani invited her to his home for a party in her honor. Attendees included prominent politicians, businessmen, artists, and high society, including Plutarco Elías Calles, Adolfo de la Huerta, Aarón Sáenz, and José Vasconcelos.[38] Paternalist condescension became obvious in the guests' objectification of Bibiana, and in the way reporters sneeringly contrasted her dark skin and course manners with the white skin, silk furniture, and refined manners among which she now found herself.

The public joined in this celebration when the centennial parade filed down Avenida de la Reforma and through downtown Mexico City. Bibiana rode high upon *El Universal*'s float surrounded by her court and drawn by six oxen flanked by *charros* (figure 6). *El Universal* decorated the float with an Aztec calendar and *nopal* cactuses and emblazoned across the back "PRO-RAZA." Reporters claimed that Bibiana delighted in showing off her regional costume and her clutch of wildflowers, "enjoying intensely the attention" and supposedly "aware of herself as representing the lofty glorification of all the heroic and struggling races of Indian Mexico."[39] President Obregón paused the parade to award Bibiana a necklace made of centennial medallions. As her float continued down the avenues her *charro* escorts gave her handkerchiefs to wipe the beads of sweat from her forehead as the crowd showered her in flowers, confetti, and streamers. The media and the public responded positively to the event, but one columnist judged the whole thing to be a *cursi* (tacky) affair because of the gaudy float and

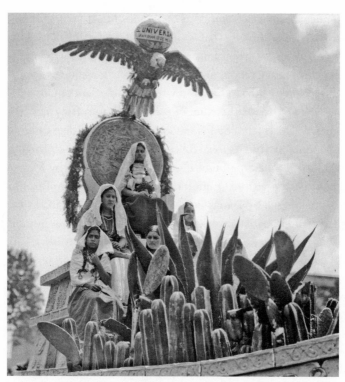

6. María Bibiana Uribe atop the "El Universal" float. © 10899. CND. SINAFO-Fototeca Nacional del INAH. Used by permission.

"fake" *charros*. It was rumored, he intimated, that these *charros* were nothing more than typewriter repairmen from Mexico City. Another reporter similarly evinced their ambiguity as real *charros* when he referred to them not as *charros* but as strong, dark Indians—the inverse of the *charro* ideal of the time.[40] As we will see later, this anxiety about inauthenticity among national types would resurface in attacks upon the India Bonita herself.

A week after the parade, María Bibiana was officially crowned in Teatro Esperanza Iris before a sold-out crowd that included President Obregón, all the government ministers, and most of the international envoys sent to the centennial from Asia, Europe, and the Americas. This was her second crowning. The first had been a month earlier, with President Obregón and others in attendance. Now that the event was linked to the state, the coronation was reenacted to further meld the cultural nationalist movement with the Obregonista regime. In the invitation the newspaper en-

couraged attendees to arrive costumed as members of the popular classes, though photos of the event reveal that few complied, preferring black suits and fashionable dresses.[41] During a procession that carried Bibiana to the theater for her coronation, Obregón decided to walk alongside the presidential carriage, relinquishing to her his own seat beside Señora Obregón. At the theater, she sat beside the chief of state (later admitting that she had been somewhat distracted by his missing arm) as the stage came to life with troubadours playing regional folk songs, and then a performance of "La Borrachita," "La Paloma Blanca," and other standards by Miguel Lerdo de Tejada's *charro*-attired Orquesta Típica del Centenario. This was followed by a monologue by Tomás Perrín praising María Bibiana as the representative of all the native races in Mexico, emphasizing her humble background, her simple ways, and her sudden exposure to the Mexico City limelight. He lamented that Indians had been treated as a marginalized, exploited underclass and hoped that the India Bonita Contest might inspire change through a new consciousness. Next came Sesto's *La India Bonita*, followed by zarzuelas and a poetry reading.

In short order the famous theater actor Leopoldo Berestáin came on stage to play an ignorant Indian attempting to eulogize the India Bonita. Along with fellow Spaniard María Conesa, Berestáin was one of Mexico's most famous stage actors, renowned for his characterization of regional types. On this occasion he appeared dressed as a stereotypical indigenous peasant with a wide *sombrero*. His diction and accent created an insulting caricature of indigenous people's Spanish, highlighted by a feigned lack of common sense. The eulogy above all mirthfully derided the very notion that an indigenous person might be capable of honoring anyone, even a fellow *indígena*. If indigenous people were to be honored, his performance made clear, it should be by urban whites and *mestizos*, not by other *indígenas*.

At the end of the evening President Obregón announced that through María Bibiana the entire Indian race was being honored. He introduced Don Andrés Fernández, a prominent member of the Spanish expatriate community, explaining that he would serve as Bibiana's godfather. Fernández promised to pay for her education at the same finishing school where he sent his daughters. He also offered to safeguard Bibiana's prize money until she reached the responsible age of twenty-one. Félix Palavicini explained that, by taking on the role of Bibiana's godfather, the Spaniard Fer-

nández fulfilled the ideal of *mestizaje,* the cultural blending of indigenous and Spanish culture.

Escorts then rushed María Bibiana out an emergency exit to escape the pressing crowd determined to touch at least the hem of her sleeve.[42] After the event, theaters and public events swept Bibiana into an even more hectic stream of engagements such that one columnist declared, perhaps without too much exaggeration, that the contest, with its glorification of the "raza indígena," had become one of the major events of the centennial and the season.[43]

Another reporter expressed optimism that the fact that the contest had struck a chord in society might augur well for the will of the public to forge a union between the two races and for the glorification of living Indians as the basis for "Mexican nationality."[44] The image of the India Bonita personified the promise of mutual transformation as rural Indians became integrated into "modern" Mexican society. But neither the contest nor the state invited Bibiana, peasants, or indigenous people more broadly to contribute to the construction of new cultural and political discourses. María Bibiana was not called upon to teach the public or state officials anything about "Indian Mexico." Nor did she have the opportunity to comment on what role she thought rural Mexicans should play in national society. Instead, she was there passively to approve of the displays of Indianness enacted before her, to affirm that the emerging movement to incorporate the indigenous population was a welcome project based on a true understanding of the Mexican Indian.[45]

The media-promoted India Bonita contest was an early component of the movement led by individuals and commercial promoters, joined by the state, to learn about and unite the population and to forge an ethnicized national identity. Equally important, the contest extended the nationalist project into the realm of aesthetics and the policing of the female indigenous body, which would continue to shape narrations of ethnicity, class, and collective identity.[46] Emerging idioms of aesthetic valuation and performativity, and the ways they were read onto the human body, were integral to the broader project of dominating the diverse populations that lay within the mapped boundaries of Mexico and defining them in relation to centralizing political and cultural authorities. It might come as no surprise, then, that after her selection María Bibiana found herself confined to a passive role as officials and the public eagerly used her as a blank slate upon

which to inscribe their own fantasies about the role that Indians should play in postrevolutionary society.

The Gendered Trap of Authenticity in Postrevolutionary Mexico

One of the stars of the coronation was María Conesa, the lead figure in Sesto's *India Bonita*. In side-by-side photos published in *El Universal* we see María Bibiana wearing a simple *rebozo* (shawl), holding a lacquered *batea* (a kind of broad gourd bowl) from Uruapan, Michoacán, and Conesa dressed to the nines in folkloric garb and braids.[47] Another photo shows an even tighter pairing, with Conesa and Bibiana side by side in the same frame (figure 7).

Early in the contest, Pérez Taylor expressed concern about what he feared might prove to be an unbridgeable chasm between "modern Mexico" and "Indian Mexico." These photos make a visual claim that the contest and the media frenzy around it had at last created a union between these two sectors of society. In effect Bibiana represented the "authentic" India Bonita, whose authenticity resided in her supposedly unselfconscious Indianness, and Conesa stood as the self-created and more readily consumed simula-cra—María Bibiana as the raw material, and María Conesa as the manufactured *nationalized* type. Conesa, in this context, stands as the translator of indigenous "Otherness," able to make Indianness less alien to urban consumers.

The image conveys the presumption that Conesa, as a non-*indígena*, possesses some agency over her self-representation, while Bibiana, as the authentic Indian, is the product of childlike lack of self-consciousness. Despite the confines imposed by patriarchal norms, for María Conesa the indigenous costume was something that she could slip out of should she prefer to take on some other persona, whether on the stage or in her daily life (figure 8). Bibiana, as the prototype, is denied this measure of self-creation, and any attempt to express self-consciousness about her role or to step outside of it called into question her authenticity. Agency and adaptability, in this context, were the exclusive domain of those constructed as modern Mexicans, such as Conesa, while bastions of authenticity, such as Bibiana, were denied the possibility of choice in their modes of self-creation.

That an indigenous woman such as María Bibiana might present herself as a modern woman while preserving her image as authentically indigenous was almost unthinkable. Authentic indigenous women were

7. María Bibiana Uribe (left) and María Conesa (right). *El Universal*, 26 September 1921. Biblioteca Lerdo de Tejada.

supposed to stand as comforting symbols of the endurance of patriarchal norms and traditional ethnic hierarchy. Diego Rivera in his first mural in the new nationalist style, mocked flappers (*chicas modernas*) as un-Mexican sell-outs. Notice in plate 2 his portrayal of the flapper, looked at askance by the proud *indígena* behind her. The historian Kathy Peiss has noted that for a woman at that time in the United States to wear make-up and orient herself toward a self-consciously modern lifestyle such as that of the flapper implied "a degree of agency, self-creation, and pleasure in self-representation."[48] It was this kind of agency that Rivera's idealized *indígena* eyes disapprovingly. Rivera reserved his most caustic condemnation, however, for indigenous women who tried to exercise a similar level of self-representation. In a detail of another of his murals from his 1923–28 SEP cycle (plate 3), he depicts two flappers side by side, one white, the other indigenous. While he mocks the white *chica moderna*, he is brutal toward the *indígena* in garish pinks wearing too much rouge even for a flapper. Comparison of this to Rivera's other depictions of indigenous

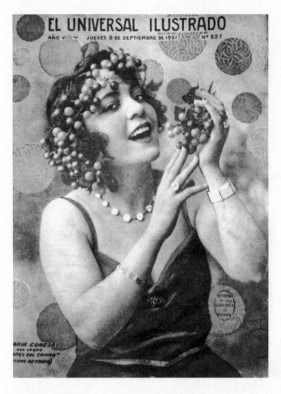

EL UNIVERSAL ILUSTRADO

AÑO V ~ JUEVES 8 DE SEPTIEMBRE DE 1921 ~ Nº 227

8. María Conesa. Cover,
El Universal Ilustrado, 8 September
1921. Biblioteca Lerdo de Tejada.

women as bastions of authenticity suggest his view that an *indígena* pre-
senting herself as a *chica moderna* would succeed only in betraying her
own heritage and shaming the nation.[49]

This is not to argue that the *india* is stereotyped into primitive stasis
while the white *chica moderna* is allowed to flourish. Rather, the *chica mo-
derna* and the "authentic Mexican *indígena*" both were gendered products
of contestations over the impact of consumer culture and cosmopolitan-
ism, but they were seen as possessing different relationships to moder-
nity and tradition. The authentic *indígena* was constructed as an infantil-
ized ideal incapable of agency or self-creation: as a passive embodiment
of nationalized indigenousness, and as fodder for use by "modern" white
and mestizo urbanites in their construction of an authentic, ethnicized,
national identity.

The columnist Rafael López reinforced the construction of the *indí-
gena* as separate from modernity when he underscored the supposed in-
congruence between Bibiana, whom he defined as a primitive indigenous

peasant girl, and the prizes she received: "Glory . . . carelessly has showered María Bibiana with the most exquisite things. It has given her henna from Pravia to moisten hair accustomed only to the pure odorless water of mountain springs" and "a wristwatch, to count her brief minutes of happiness. It offers customized stationery to one who . . . is surely ignorant of the invention of vowels" (the popular press caricatured indigenous people as speaking only in garbled consonants). With this, the columnist critiqued what he saw as the incompatibility between an *indígena*, on the one hand, and the modern world of luxury, consumer culture, and shiftable self-representation, on the other. He goes on to ask how far people would go in showering Bibiana with rewards incompatible with her station. Would "glorious chance" inopportunely "nudge her into diplomacy and maybe call upon her to give some opinion about the world's problems"?[50] With this he merges his discussion of the need to isolate the indigenous *indígena* from modern consumer culture with a warning that women's participation in self-creation through consumption might culminate in a threat to patriarchal structures. Beyond serving as a model for indigenous and nationalist authenticity, then, the India Bonita served also as a conservative ideal of Mexican femininity, set in opposition to what elites criticized as the masculine styles and habits of the *chica moderna*. The contest, as the art historian Adriana Zavala argues, encouraged Mexican women not to be "revolutionary, much less modern, but, rather traditional, docile, pretty, and confined to the domestic sphere." Even as reformers claimed to embrace a radical vision of society, they reformulated rather than challenged structures of ethnic and class prejudice and gendered power relations, and they used the image of the passive *indígena* and the transgressive *chica moderna* to police the behavior of indigenous women, and of Mexican women more broadly.[51]

The media- and state-promoted image of the India Bonita claimed to encompass a genuine understanding of the realities of indigenous people and give them a meaningful stake in the nation; instead it reinforced ethnic and gender domination. Moreover, promoters erased who Bibiana was as a person by removing from sight the challenges she faced in her real life. According to her daughter, Rosa Zarate Uribe, María Bibiana was an "uneducated *indígena*" who could not understand the value of money and therefore was easy prey for unscrupulous relatives and other predators. The first of these misfortunes was that her Spanish godfather never fulfilled his

promise to educate her. This can be explained by his discovery that María Bibiana Uribe was already pregnant when she received her crown. This early pregnancy outside of wedlock contradicted the romantic, virginal image of the India Bonita constructed by *El Universal* and by the state, even though it was the norm among the indigenous population from the Sierra de Puebla at that time (as it still is in many rural regions), and it would have posed an embarrassment to Don Fernández had he sent her, as promised, to the boarding school alongside his own daughters. Beyond losing the opportunity for an education, Bibiana also lost almost every centavo of her 10,000 pesos of cash and prizes (which included jewelry of various types, artwork, a mattress, perfumes, scented soaps, and a range of other items).[52] As a young woman, she was given little control over her own funds, and she had little experience to guide her use of those funds she did control. Having quickly lost all of her winnings, she married the father of her child (her first of six children with four different fathers). To make a living she resumed her previous work as a laundress and house cleaner.

Despite these setbacks, María Bibiana, who lived well into her eighties, never felt that she had been used, nor did she complain about what might have been. She took pride in having been the India Bonita, jokingly referring to herself as "La Chingona" (The Bad Ass). Later, when India Bonita Contests became common throughout Latin America and even in her hometown of Necaxa, she confidently declared that she was the *pionera*, and that these were mere copies of what she had accomplished.[53] In almost every aspect of her life before, during, and after the contest, her reality departed from the ideal promoted by *El Universal* and by the Obregón regime, though it was a reality that would have been familiar to other indigenous women.

The reading public learned a few aspects of Bibiana's daily life shortly after the contest thanks to *Excélsior*, *El Universal*'s main competitor. In a highly competitive market for readership, *Excélsior* stumbled in its efforts to rival the public attention that *El Universal* generated with the India Bonita Contest. It struck back by denouncing María Bibiana Uribe and the whole contest as a fraud. *Excélsior* declared that its rival had betrayed the public's trust by selecting a mestiza and passing her off as an Indian. María Bibiana had already become assimilated through her work as a servant, the newspaper charged, and some of her relatives, it claimed, spoke Spanish. She supposedly now sat in her hometown of San Andrés Tenango laughing

at the *catrines* (urban toffs or dandies) she had hoodwinked with the complicity of *El Universal*. *Excélsior* even claimed that Bibiana was fluent in Spanish and therefore could not possibly be a real Indian. More damning was the newspaper's charge that the India Bonita had been spotted in her hometown wearing patent leather shoes, and perhaps even store-bought clothes.

Excélsior's charges and their continued reverberation are revealing for at least four reasons. Since the late colonial era, Mexico's elites had been disconnected from the lives and struggles of the masses, but they had prided themselves with the conceit that, unlike foreign imperialist interlopers, they possessed a genuine connection to and knowledge of the people and land over which they claimed exclusive rights of rule.[54] Through the India Bonita Contest they reaffirmed this conceit. In the midst of widespread denunciations of Porfirians as no better than the foreigners, *Excélsior* deftly preyed upon elite and middle-class fears of being played the fool, of being exposed as gullible outsiders in their own homeland.

Second, *Excélsior*'s accusation, which was later unwittingly perpetuated by Minister of Education Moisés Sáenz and others, makes clear the contexts in which elites did or did not challenge the application of the term "indigenous." The assumption that Indianness and backwardness went hand in hand made it easy to attribute negative traits to "Indians" without any fear that their attribution of "Indian" might by challenged. But any honors or benefits given to individuals *as* Indians were vulnerable to charges of inauthenticity.

Third, the charges reveal the extent to which cultural elites saw indigenousness and modernity as fundamentally incompatible, above all in relation to the female body. As Rivera's mural depictions of *chicas modernas* make clear, any suggestion that an indigenous woman might be capable of acting as an agent of modernity risked denunciation. Moreover, any attempts by an indigenous woman to use her body as a symbol of her own modernity clashed with efforts by elites to impose nationalist, anti-imperialist, patriarchal discourses onto her physiognomy, actions, and accoutrements.[55] Even though whites and mestizos were treated as capable of balancing modernity and tradition, the only appropriate response Bibiana was allowed to have toward modernity and things foreign was naïve awe, preferably in such a way as to amuse the urban reading public and to inspire paternalistic sympathy for the "backward" indigenous masses.

9. Apotheosis of the India Bonita. *El Universal*, 26 September 1921. Biblioteca Lerdo de Tejada.

Finally, *Excélsior*'s charges reveal the bind of indigenous people in general and indigenous women in particular. María Bibiana, as charged, did wear modern clothes and patent leather shoes before the contest. Most of the time she wore her homespuns, but for her work as a servant in the home of members of the local elite she was required to wear her store-bought uniform. Ironically, by wearing this uniform, a symbol of the wealth, refinement, and hygiene of her employers, by being the servant that dominant society expected her to be, she compromised her own ability to stand as a pristine example of indigenous authenticity, symbol of the new postrevolutionary cultural nation and icon of the nationalist imagination.

While nationalists, artists, and opportunists used the contest to promote an ethnicized national identity, they expected all but the most authentic of Indians to disappear into the emerging unified, mestizo nation. *El Universal* conveyed this expectation heavy-handedly in a late-August event dubbed "The Apotheosis of the India Bonita." A photo of the event (figure 9) shows Bibiana piously dressed on a pedestal before a radiating areola reminiscent of that which surrounds the Virgin of Guadalupe.

Before her sits a *sarape*-draped table and to her sides stand *charros*

and white elites. She embodies the pristine ideal, apotheosized to take her place as part of the European-Indian-mestizo trinity of the Mexican nation. Her runners-up recline in the foreground. By making it to the finals, each runner-up had earned recognition for approximating the indigenous ideal. But now that Bibiana had been declared the supreme indigenous ideal, these runners-up shed their regional indigenous peasant costumes in favor of nationalized *china poblana* outfits, and, in the process, they were transmogrified into mestizas. They now were permitted, and perhaps even encouraged, to wear make-up, while Bibiana continued to appear in her "natural state." Their mutation encapsulates the hope that other indigenous people might similarly be changed into modern mestizos without sacrificing their grounding in postrevolutionary ethnicized authenticity. Bibiana stands elevated as the model of Indianness—disempowered, feminine, innocent, agentless, authentic, and ready to be held up alongside Mexico's Spanish heritage so as to forge transcendent *mestizaje*.

The Apotheosis of the India Bonita idealized not just any *mestizaje* but specifically *Mexican mestizaje*. The columnist Rafael López made this clear when he travestied what life might be like for Bibiana if she accepted the marriage proposal of Earl Cleaves, a North American railroad worker from Chadron, Nebraska, who had asked for her hand. López warned that "this marriage proposal threatens María Bibiana with a real robbery." He imagines her trying to adjust to life in Nebraska betrothed to this English-speaking, tobacco-chewing, Anglo-American. Her nostalgia for her native forest and streams would be only the start of her sorrows. "In place of her open stove and ancestral *comal* [tortilla griddle] . . . María Bibiana would encounter a cheap stove" that she would mistake for the organ of "her village church with its bell-tower crowned on cheerful mornings by praying swallows. She would not even have the consolation of savoring her faithful spiced *atole* paired with delicious refried beans and exquisite mole poblano; her little teeth soon would suffer from decay caused by KORN FLAKES [*sic*], mustard and bloody steaks." She would pass sad evenings searching "Chadron for a place to be alone with her incurable nostalgia. She would head out in her SWATER [*sic*]" to "search in vain. The only confidantes, and the only succor for her sadness . . . would be three banks, six grocery stores; and, blocking the horizon, the austere architectural lines" of the local school. "No María Bibiana, don't let yourself be fooled by this suitor . . . This mestizaje that he offers to you is unworthy of your indige-

nous heritage and an affront to most of your admirers and the people of your country . . . You would be happier in Tenango, married, as God commands, to another little Mexican Indian [*indio mexicanito*] . . . Let your suitor console himself with a wad of Virginia chewing tobacco." Let "him suffer; it is for the best."[56]

Conclusions: The India Bonita Contest and Mexican Identity

The India Bonita Contest of 1921 occurred as part of the growing interest in creating and valorizing the Mexican Indian, ripe for redemption and incorporation into an ethnicized nation. Even such holdouts as Vasconcelos (who lamented Mexico's pluralistic and heavily indigenous reality) or the cultural critic Francisco Zamora (a leftist intellectual and journalist who praised Mexico's popular traditions, but complained that they had to be brought to the city, since the countryside was too dull and uncivilized to spend time in) recognized, however ambivalently, that a unilateral movement toward either European or middle-class urban culture was unfeasible.[57] An emerging consensus among intellectuals and state officials held that Mexico needed a collective personality rooted in the culture of the rural popular classes, and that it should include everyone living within the political boundaries. Rather than a by-product of state formation, the ethnicization of *mexicanidad* and the movement toward cultural integration emerged from the intersections between state and popular experience, between media and the arts, between constructions of modernity and tradition, between nationalism and the market, between race and gender, and between the nativist desire to celebrate the peasantry and the irresistible attraction of cosmopolitanism.

Cultural elites celebrated the "Indian" masses but they did not see them as capable of planning for the nation's future, nor did they invite them to formulate their own national-level political discourses. Instead, they expected them and the rest of the popular classes to conform to the evolving discourses developed by their social and cultural superiors.[58] They presumed that, once the masses could be recognized as indigenous, they could be brought into the national fold as passive embodiments of Mexican authenticity, then modernized into mestizos capable of blending the best of their presumed indigenous heritage with the best of Western modernity. Through this process, nationalists hoped to set Mexico on the path toward its own distinctive, deeply rooted, modernization. It was in this climate

that the India Bonita became a symbol of the promise of postrevolutionary Mexican society—both the embodiment of Mexico's present, and the image of the ideal recipient of postrevolutionary transformation (a transformation to be managed from the urban center in the name of an immature, tractable, and grateful rural population).

Today, through a complex process of remembering and forgetting, these discourses have become entrenched in assumptions about the relationship between Indianness and Mexicanness. This became clear, for instance, in the filming in 1987 of Televisa's *Nuestro Mundo* when the host Guillermo Ochoa introduced his guest as La India Bonita María Bibiana Uribe, *winner of the first Miss Mexico competition.* He drew attention to her colorfully ribboned braids, indigenous-style outfit, and bare feet, explaining that she chose to come on the show this way so as to appear before the Mexican public just as she had sixty-six years earlier when she became the first Miss Mexico.[59] Televisa unintentionally conflated the Miss Mexico beauty pageant (which excluded indigenous participants) with the overtly indigenous India Bonita Contest (which had been billed as the "first entirely racial contest"); and it did so in such a way that expunged racist realities from nationalist memory.[60] In 1991 an equally revealing confusion emerged in Chapultepec Castle in Mexico City when curators encountered a large photograph of Bibiana in the collection. Presuming that it was a portrait of some forgotten early Mexican film star, they incorporated it into an exhibition that celebrated Mexican film stars of the 1920s. The reality of the 1920s was such that mainstream notions of universal beauty were tightly bound by racism (as they remain today, as revealed by beauty pageants that continue to exclude indigenous women), and when an Indian was needed in a movie or play, he or she was played by a white actor in a folkloric costume and brown make-up in a manner reminiscent of U.S. vaudevillian blackface. Such is the transformation in popular perceptions of the place of indigenousness in Mexican history and national identity that by the late 1980s and early 1990s the public, media, and art world had come to accept the false notion that, because Mexico in the past was somehow more indigenous than in the present, that it follows that it would have been unremarkable in the 1920s for an indigenous woman to be crowned the first Mexican beauty queen or to have achieved fame as a star of Mexico's silver stage.

Such confusions testify to the legacy of the cultural movement begun

in the 1920s. Ideas of Indianness have become naturalized as part of Mexican national identity. This has brought with it amnesia about past debates over whether indigenous peoples and their culture even had a place within modern Mexican national identity. Recollections of messy, contradictory beginnings, racially segregated beauty contests, and racist performances have been erased from popular readings of Mexico's cultural past. In their place have arisen invented memories of a seamless legacy of *mestizaje*.

〰

Popular Art and the Staging of Indianness

After watching the revolution from afar, Roberto Montenegro, Jorge Enciso, Gerardo Murillo (who went by the name Doctor Atl), and Adolfo Best Maugard answered the patriotic call to help rebuild the nation. They returned to Mexico with new eyes, fascinated above all with its distinctive indigenous qualities. In 1921 they translated their newfound spirit of cultural nationalism into the Noche Mexicana (Mexican Night) and the Exhibition of Popular Art as part of the massive state-sponsored celebration of the centennial of independence. Like the India Bonita Contest, both of these events contributed to the experimental search for an indigenous-based national identity and, by tapping into global cultural currents that stretched across the Americas, Europe, and Asia, they recast native craft industries from symbols of peasant backwardness into integral components of national identity. Unlike the India Bonita Contest, they expressed deep ambivalence about the emerging media market and consumer culture upon which they relied. And even as the two enterprises had much in common with one another, they clashed in their assumptions about the relationship between Indianness and Mexicanness.

Staging the Popular

Unlike the India Bonita Contest, which became a success even before the state incorporated it into the official centennial program, the Noche Mexicana and the Exhibition of Popular Art were born of state patronage. In mid-May 1921, after the newspaper *El Universal*

and other private organizations had generated public excitement around the upcoming centennial, the new minister of foreign relations, Alberto Pani, proposed to the president that the recently stabilized state take the organizational and financial reins for the upcoming commemoration. This set the stage for the two events and for the tensions they would contain.

Pani hailed from the economic and political elite of Aguascalientes. During the revolution he declared himself a partisan of the liberal reformer Francisco Madero. After Díaz stepped down in 1911 he served as the under-secretary of public education and fine arts, then as director of public works for the Federal District. In 1917 he served President Venustiano Carranza as the first director of the newly established Ministry of Industry and Commerce before departing in 1918 as ambassador to France, where he amassed a remarkable collection of European art.[1] He returned in 1921 to serve as Obregón's minister of foreign relations and would go on to reorganize the country's financial system, remaining active in national politics and as a patron of the arts until his death in 1955.

During the revolution he had stressed the need to study the languages, aesthetics, and practices of the population as a step toward national unity under a strong central state. To critics, he conceded that rural Mexican cultures were crude and splintered, and that it might take many years of concerted effort to transform this fragmentation into a common culture. The difficulty of the task, in his view, made imperative the kind of sustained backing that he felt only the government could supply. Sponsorship of a popular-oriented centennial celebration in 1921, he hoped, would be only the beginning of sustained state involvement in the process of cultural integration.[2]

José Vasconcelos, soon to be appointed director of the Ministry of Public Education (known as SEP), ridiculed the centennial proposal, claiming that it merely confirmed Pani's idiocy. A writer, philosopher, educator, and politician, Vasconcelos is still remembered as one of the most influential cultural leaders in modern Mexico, celebrated for spearheading the break with positivism, expanding public education, and launching the Mexican renaissance. Born in Oaxaca, then raised in different locations across Mexico, including on the U.S.–Mexican border, he was a leading member of the antipositivist group Ateneo de Juventud (1909–14) and, during the revolution, a vocal supporter of Madero. Under Madero he reformed the National Preparatory School, which had been a symbol of positivist edu-

cation. When General Victoriano Huerta overthrew Madero in 1913, Vasconcelos went to Paris to derail a French loan. To prevent Huerta from floating the loan on the open market in Europe, he worked with Dr. Atl that year on the anti-Huerta magazine *La révolution au Mexique.* Later Obregón named him rector of the National University before nominating him to head the new Ministry of Public Education. As minister of education he would underwrite the birth of muralism and make the new ministry a haven for intellectuals and artists eager to turn their ideas into action.[3]

Vasconcelos became angry when Obregón, supposedly under the spell of Pani, ordered the cabinet to appoint a centennial planning committee. Obregón saw in the proposed celebrations an opportunity to burnish his administration's populist image and promote the new state as champion of the emerging ethnicized nationality. Vasconcelos claimed to have refused to participate, as he "had no time for *fiestas,* since in his department there was work to be done." The others—Minister of State (Secretario de Gobernación) Plutarco Elías Calles and Minister of Finance (Secretario de Hacienda) Adolfo de la Huerta—were more receptive. By mid-May they had assembled a distinguished committee composed of intellectual luminaries. The career diplomat Emiliano López Figueroa presided. He was seconded by the carrancista agronomist, former congressman, and future statistician and diplomat Juan de Dios Bojórquez (who would depart later that year to act as ambassador to Honduras, then Guatemala, and, eventually, Cuba). Martín Luis Guzmán, who would go on to become one of the country's most renowned authors, served as secretary. The group's treasurer was Carlos Argüelles, who earlier had served as treasurer for Obregón's presidential campaign and would in the near future emerge as an important political ally of De la Huerta in a failed rebellion against Obregón in 1923. The new committee had just four months to coordinate one of the largest public displays in Mexican history. Invitations went out to foreign envoys, and after intense public debate Obregón won passage of a controversial one-time tax on middle- and upper-income earners to fund the September events.[4]

To contrast the month-long commemoration with the Porfirian centennial of 1910, which they saw as elitist, committee members touted that it would be "essentially popular in character." Yet it was unclear what they meant by "popular." Some of the events, such as street parades, were popular in terms of access. Others like bullfights, circuses, and sporting events

were popular in that they had a proven appeal to nonelite audiences. As September drew near, promoters and journalists asserted that to host spectacles that were physically accessible or that had mass appeal was not enough. The centennial needed events born out of popular culture (folk and indigenous culture), and, to the extent possible, specifically rooted in *rural* practices. Even the newspaper *Excélsior*, skeptical of the populist orientation, affirmed the wisdom of celebrating folkways rather than the *cursi* (pretentious and tacky) European styles that had dominated the 1910 event.[5]

But who were these popular classes of whom everyone spoke, and how would their culture make the events more Mexican? This question posed a problem not only for the celebrations but also for the postrevolutionary regime whose very mandate was based on its supposed advocacy of the popular classes that had fought during the revolution. Debates centered on what it meant to be Mexican. While some scholars have presumed that postrevolutionary cultural politics were dominated by Hispanophobia, the reality is that the mainstream perspective among the elite and middle class in Mexico City remained focused on the Spanish colonial heritage and romanticized portrayals of the pre-Hispanic past, rather than living indigenous cultures. A brief glance at the prerevolutionary statuary along Paseo de la Reforma, which enshrined this view, sufficed to confirm that there was nothing particularly postrevolutionary about exaltation of Mexico's Spanish, Aztec, or Mayan roots.

What was new was the populist discourse that placed contemporary indigenous culture at the center of postrevolutionary national identity. This spawned a search for an aesthetic language that might encapsulate this new orientation. The Noche Mexicana and the Exhibition of Popular Art were among the centennial events that focused most directly on this emerging interpretation. As they celebrated folkloric expressions they conflated campesinos and Indians, and though some of the arts they drew upon had urban roots and grew out of mestizo or even Spanish practices, they generalized the forms they celebrated as coming from "rural Indians."

A "Germ for Artistic Expression"

In August 1921 the Centennial Committee contracted Adolfo Best Maugard to plan a garden party that would tout Mexico's technological modernity by highlighting recent improvements to Chapultepec Park, such as

paved roads and electric lighting. Such an event would have differed little from earlier celebrations of modernity coordinated by the Porfirian *científico* José Ives Limantour. But Best Maugard had bigger plans. He transformed the staid garden party into an exuberant outpouring of postrevolutionary nationalism modeled after *ferias* (regional fairs) and christened it "La Noche Mexicana."[6]

Best, a cosmopolitan artist born into an elite family, aspired to aesthetic rather than political or social ideals. In New York City he had worked for the Columbia University anthropologist Franz Boas, who was a pioneer in theories of cultural relativism. After drawing hundreds of illustrations of pre-Hispanic pottery shards, Best became convinced that all art in the world derived from seven basic motifs and that authentically Mexican art resulted from a distinctive combination of these motifs. Then, while traveling within European avant-garde circles, he looked to German and Russian neoromantic nationalism and developed an interest in the idea of popular traditions as carriers of the collective spirit.[7] Best drew inspiration from these ideas as he remade a modest, old-fashioned garden party into a grand experiment to unite cosmopolitan modernism, romantic primitivism and postrevolutionary nationalism. He strove for nothing less than a new aesthetic vocabulary of *mexicanidad*.

Reporters recounted that thousands of people from all walks of life packed into the Noche Mexicana, which was free to the general public. Attendees included President Obregón, government officials, artists and literati, foreign envoys, and members of prominent Mexican families. Visitors strolled along the recently paved paths under newly installed electric street lights and hundreds of small illuminated stars hanging from the trees. At each street corner they encountered stages upon which Yucatecan troubadours, dancing *charros* and *chinas poblanas*, and Yaqui performers mesmerized the audience with "exotic" performances. Guests visited the many booths from which elite women dressed in regional folkloric costumes raised funds for Cruz Blanca by selling working-class and peasant food served on ceramics from Guadalajara and Texcoco and "refreshments of the kind classically prepared in *tapatío* clay jugs [from Tonalá outside of Guadalajara] then served in gourds beautifully decorated by the Indians of Pátzcuaro." Best made certain that each booth was "authentically" decorated "with blankets, woven mats, shawls, flags, and all those art objects that are typical of the Mexican nation." By including these regional deco-

rations, ceramics, and foods in the Noche Mexicana, he elevated them to the status of symbols of authentic *mexicanidad.*

After dark, fireworks announced the evening's main event. Audiences pressed to the lake's edge to view the brightly lit island stage upon which performers attired as *tehuanas* danced to the sounds of Miguel Lerdo de Tejada's 350-member Orquesta Típica del Centenario. A replica of the volcano Popocatépetl then erupted upon the waters with lights and pyrotechnics, followed by an overflight of planes trailed by multicolored flames. Clapping hands, bold strings, and stomping feet then drew attention back to the main stage for *Fantasía Mexicana* (the title of which played upon the double meaning of *fantasía* as both *fantasy* and *medley*) in which over a hundred (by some accounts, as many as six hundred) colorfully adorned *chinas poblanas* and *charros* burst into modernized renditions of the *jarabe tapatío* and other folk dances. After the excitement of the *jarabe tapatío*, the crowds poured back into the park as escorts led dignitaries to boats to pass the last of the evening relaxing on the water. The torch-bearing *china poblana* escorts then joined other costumed dancers who milled among the throngs to add a final folkloric flourish to the night.

Fantasía Mexicana, the centerpiece of the night, had been created the previous year as a small avant-garde performance in New York City (figure 10 and plate 4). Best recruited Katherine Anne Porter, who would go on to become one of the most important fiction writers in the United States (for more on Best's connections to Porter, see chapter 3), to script a storyline set in Xochimilco while he created the scenery. For the music and choreography he teamed up with the revue and zarzuela composer Manuel Castro Padilla and the choreographer/dancer Anna Pavlova of the Ballet Russes, who extrapolated upon the *jarabe tapatío*. The *jarabe tapatío* traced back to colonial-era Jalisco but until 1920 had remained a regional dance and a vaudeville act. After the 1920 performance in New York City, and in anticipation of the 1921 show in Mexico, Best hired the dancers/choreographers María Cristina Pereda and her brother Armando to expand Pavlova's avant-garde performance into a massive folkloric outpouring danced by several hundred couples. Later, in 1929, the sisters Gloria and Nellie Campobello would rework it again into the form most familiar to us today, which the Ministry of Education performed frequently to stadium audiences. Though Nellie Campobello is best known today for her literary vignettes on Villismo, she and her sister emerged at that time as

10. *Fantasía Mexicana*, set by Adolfo Best Maugard; choreography by Anna Pavlova. Frances Toor, *Mexican Folkways* 6 (1) (1930): 323. Courtesy of Yale University Library.

successful choreographers whose renditions of *jarabes* and other popular dances spread across Mexico through the public school system.

In September 1921 the Noche Mexicana was novel in scale and bold in the way it merged standard nationalist forms such as the *china poblana* and *charro* with previously disparaged indigenousness and popular art. Best united these disparate ingredients into a single vocabulary of *mexicanidad* and tied this to the Obregonista state. A commentator declared the result unprecedented, magical, and "genuinely Mexican." Another felt that the "soul of the Republic," which had been "almost forgotten by our foreign-oriented intellectuals," now has been rediscovered and made palpable by Best's Noche Mexicana and by the Exhibition of Popular Art. Such was Best's triumph that the Noche Mexicana won two complete repeat performances during September and October (one of which was reserved for an exclusive crowd).[8] Previously, artists had experimented with ways to introduce contemporary indigenous peoples into their artistic repertoires, but they did not transcend conventions of European academicism. Even the best of these artists, such as Saturnino Herrán, could imagine indigenous people as part of the nation only by placing them within a classicized

Western aesthetic (plate 5). Best's Noche Mexicana took a comparatively radical stance, proposing a distinctive aesthetic language inspired by the popular art of Mexico's "Indian classes."[9] Best operated within what the historian Partha Chatterjee has described as a postcolonial "desire to construct an aesthetic form that was modern and national, and yet recognizably different from the Western."[10] Through the Noche Mexicana Best strove to demonstrate how popular aesthetics, when filtered and refined by modernist cosmopolitan artists, could offer up an authentic expression of the Mexican nation.

Criticism of the *Fantasía Mexicana* by intellectual and artistic elites and the middle class prompted one of the most respected critics, Francisco Zamora, to raise his pen in Best's defense. Zamora, born in 1890 into a leftist family that hailed from Nicaragua, recently had established himself in Mexico as a journalist and a critic of film and theater. He later married Cube Bonifant (one of the first women to succeed as a journalist in Mexico's mainstream media) and enjoyed a twenty-five-year career as a professor of economics at the national university. Together with his younger brother Adolfo, he argued against postrevolutionary complacency, insisting that the end of the fighting should signal the beginning, not the close, of the revolutionary transformation. In 1940 he became a thorn in the side of President Manuel Avila Camacho, whom he criticized for eviscerating reforms initiated by President Lázaro Cárdenas.[11] In 1921, at the time of the Noche Mexicana, Zamora was best known as a theater and film critic working under the nom de plume Jerónimo Coignard. Writing of the Noche Mexicana (and *Fantasía Mexicana*'s subsequent restaging in the Teatro Arbeu), he conceded that the dances were not great, but he refuted charges that they were "una lata" (a tedious bore) as "certain snobbish theater critics" had charged. The problem, he explained, was that Best called them "ballet" and this led the audience to expect more than dances based on Mexico's folk traditions could deliver. He agreed that classical ballet would have been a more refined choice, but he countered that such a performance would have offered nothing new to the audience. *Fantasía Mexicana*, by contrast, was based on the "manner of Mexico," which, he argued, made it both novel and praiseworthy.[12]

Zamora unwittingly also found himself pressed into the role of apologist for vernacular art. He lamented the low regard that the middle and upper classes held for things "truly" Mexican, arguing that these classes

lived "in the reflected images of other people, who we have imitated as if we had no aesthetic traditions of our own." This represented an unfortunate loss for the nation, he argued, because apart from Europeanized art, "each country has its own vigorous manifestations, its own peculiar art born from the spontaneity and primitiveness of the humble classes." He complained that everyone loved Russian ballet, which takes its inspiration from popular Russian dances, but when Best created a dance performance based on "what is ours we see it as disconcerting and weird." To break away from foreign influences, he argued, Mexico's professional artists must set out to appropriate the expression of their own lower classes just as European artists had done with theirs. Echoing the earlier sentiments of Pani, but carrying them soundly into the realm of art, he conceded that the aesthetic expression of the popular classes was crude and unformed, but he maintained that it provided "the germ for artistic expression, ready to be developed and refined by men of talent" who could use it as the inspiration for a nationalist art that would remain "faithful to the sentiments and thought of the popular soul of Mexico." Zamora argued that *Fantasía Mexicana* together with the Exhibition of Popular Art needed to be understood as a revolutionary first step toward Mexico's nationalist modernity and aesthetic liberation.[13]

On one level Zamora's suggestion may strike us as antihegemonic in that it challenged naturalized assumptions about the superiority of European culture. But this is countered by his assumption that popular aesthetics became worthy only after they had been reformed by nationalist elites guided by cosmopolitan sensibilities. The "decorative arts of our anonymous artisans, the songs of our unknown musicians," and "the traditional dances of our indigenous collectivities," he argued, offered themselves as raw materials that "men of talent" could take as inspiration in the creation of real art. Ironically his argument was that the only way to separate from Europe, was to imitate European romantic modernism. The historian of nationalism John Hutchinson reminds us that as European romantics drew upon vernacular sources, they "pioneered a general vernacularization of high culture, creating a unified field of exchange" by which "educated elites sought to integrate society" through the "resurrection of the *Volkgeist* that expressed the unique genius of the nation in all its plenitude." Romantics claimed that because "of national decay, this *Volkgeist* was submerged and lost to sophisticated society, but the remnants could

be found in the untamed imaginative life of the rural folk living close to nature." Artists assumed a special role in this nationalist resurrection of the collective *Volkgeist*. Like his European counterparts, Best argued that "creative artists" should not try to "simply reproduce the past: they had to create new cultural genres and institutions appropriate to their changing society."[14] Even as Best and Zamora looked to popular arts for inspiration, they had no abiding interest in the problems faced by the lower classes. And they certainly did not feel that Mexico's rural masses, whom they identified broadly as indigenous, could or should have any control over their symbolic place in national culture. It was up to elite artists and the intelligentsia to recover this indigenous essence and package in such a way as to turn it into a form of art around which they could mold an ethnicized national identity.

José Vasconcelos, who left an unmistakable stamp upon 1920s culture, shared this perspective. Like Best and Zamora, he tempered his populism with an unbending cultural elitism. As minister of public education (1921–24) Vasconcelos lent tepid ministerial support to early efforts by Doctor Atl, Roberto Montenegro, Gabriel Fernández Ledesma, Jorge Enciso, and others to promote popular crafts. He encouraged artists to learn about and draw upon popular aesthetics, but rejected the claims of some of his contemporaries that vernacular expressions were "art." His hesitation regarding handicrafts may have owed something to his mutual antagonism with Doctor Atl, who was one of the most avid promoters of popular art. The two men had worked together in Paris, but they became rivals competing over the helm of Mexico's cultural transformation. Atl openly mocked Vasconcelos who, in turn, denounced Atl as a "charlatan" and a name dropper.[15]

Vasconcelos's ambivalence about popular art, however, cannot be blamed on his conflict with Atl; instead it grew out of his broader view of popular culture. All popular practices, in his view, were corruptions of high culture, and hence a mere "parody of culture."[16] As such, the only way members of the popular classes could advance was "to acculturate themselves" to the ideas and practices of their superiors. Because popular culture was a mere corruption of high culture and true art never could "arise spontaneously from the people," it followed that handicrafts could never be true art. To the extent that Vasconcelos supported popular culture and handicraft, he did so because he saw them as bridges by which

to reach into the minds of the masses so as to help them cross over from backwardness to civilization. He also felt that folkways, while worthless in themselves, could provide fodder for the creation of a dignified and spiritually rooted national culture, which could be forged only by means of an orchestrated "intervention by the cultured artists" backed by state patronage.[17]

Vasconcelos advocated a form of cultural elitism similar to that espoused by the poet Salvador Novo, who today is revered as one of his country's literary luminaries. As did Montenegro, Rivera, Fernández Ledesma, and Enciso, Novo accompanied officials from the ministry on trips to the provinces to gain firsthand knowledge of the variety of Mexican traditions. In a journal entry describing one such journey, he critiqued provincial elites for perpetuating a bourgeois idealization of the very European-derived material clutter and manners that he claimed it took a revolution to begin to challenge in Mexico City. These provincials, he complained, pathetically aped a bad copy of a foreign copy, avidly "fill[ing] their houses with trinkets" and "bad art" and their heads with "ideas and conventions equally illegitimate and backward." The problem was not that they imitated foreign styles but that they did so poorly and artificially. Novo was a member of the aestheticist literary circle known as the Contemporáneos dedicated to keeping Mexico within the flow of European literary currents. He viewed himself and other cosmopolitan intellectuals and artists as uniquely capable of bridging both worlds. By his estimation, provincial elites, unlike himself, were ill equipped to do the same and therefore should embrace the Mexico around them and stop trying to pretend they were something they were not. He hoped that education might help them to elevate their tastes and learn to behave nationalistically so that they could become a positive model for those around them. This was the kind of regeneration and cultural elevation advocated by José Vasconcelos—a nationalist regeneration that was sympathetic to the masses, but which avoided sinking into what he saw as the morass of lower-class ignorance and provincial middle-class *cursilería* (kitschy tackiness).[18]

Vasconcelos and Best Maugard both drew upon the contradictory intellectual currents of classical liberal humanism and antirationalist romanticism. While Vasconcelos later would move further toward his antirational inclinations, during these years he cleaved closer to liberalism to view the masses, whether Indian or mestizo, as uniformly uncultured yet redeem-

able by Western humanism. Not surprisingly, he insisted that the highlight of the centennial was a performance by a European opera company. While Vasconcelos insisted that Western art and Greek classics should be used to elevate the depraved masses, Best, who found greater inspiration within antirationalist romanticism, advocated the adoption of rural indigenous aesthetics "as a base from which to move forward [and] evolve" so as to produce "our own expression" that is "genuinely Mexican."[19]

Despite these differences, Vasconcelos, Novo, Best Maugard, Zamora, and fellow travelers were united by their call for a transformation controlled by themselves and other "men of talent" and backed by the state. Within the project to promote popular culture, the main aesthetic alternative to Best and Vasconcelos came from an expanding group of artists and intellectuals that included Doctor Atl, Jorge Enciso, Roberto Montenegro, and Manuel Gamio (before his conservative turn; see chapter 4). These artists agreed with Best and Vasconcelos on the need for state leadership, but they rejected their views of popular art as merely a "germ" for the creation of a nationalist art of good taste; instead, they viewed vernacular art as the ultimate expression of primordial *mexicanidad*. The Exhibition of Popular Art organized by Jorge Enciso, Roberto Montenegro and Doctor Atl as part of the 1921 centennial events became one of the earliest public testaments to this perspective.

Indian Mexico

Today, art historians, collectors, *indigenistas*, and nationalists still look to the Exhibition of Popular Art of 1921 as one of the most important exhibitions in Mexican history and as the most remembered event of the centennial. Its historical importance is surprising considering that it was not even on the original centennial agenda. It came about only after planners had to cancel the industrial fair, which was to have been the centennial's centerpiece, and Enciso and Montenegro stepped forward with a proposal to fill the empty slot. Like Best's Noche Mexicana, their exhibition redirected the centennial away from a celebration of technological modernity, toward an ethnicized view of Mexican nationality.

At the time that Enciso and Montenegro, along with their artistic and political mentor Doctor Atl, won official appointment as the Comisión de la Exposición de Arte Popular (Exhibition of Popular Art Commission, hereafter "Comisión"), Atl was already one of the most well-known artists

in Mexico and Enciso and Montenegro were emerging as leading painters. Montenegro was born into an upper-middle-class family from Guadalajara. In Guadalajara and in Mexico City he studied under such luminaries as Antonio Fabrés and Germán Gedovius before beating out Diego Rivera in 1906 for a state scholarship to study art in Europe. In Paris his cousin, the famous poet Amado Nervo, introduced him into the bosom of the avant-garde. Of his time in Paris Montenegro commented: "The exhibitions of the Independents, the Fauves, the exhibits of Picasso, of Braque, they disrupted my plans." Compelled by this "intrepid new vision of painting," Montenegro found himself "swept up by the modernist current" and began to question all of his assumptions, not just about painting but about the very foundations of his aesthetic values and cultural assumptions. Unlike his mentor Doctor Atl, who eagerly joined Italian street marches and entered into the middle of Parisian debates, or Rivera, who threw himself into barroom brawls and political debates and became a leading Cubist, Montenegro remained narrowly aesthetic in his concerns. Even as he drew inspiration from the revival of popular traditions in the Catalonia region of Spain, where he passed some time, Montenegro had no interest in the social and political movements behind the aesthetic innovation he imbibed. In 1921 José Vasconcelos, as head of the Ministry of Education, wrote to him and other intellectuals and artists offering to pay passage if they would come help rebuild Mexico. After watching the revolution from across the Atlantic and fleeing from Paris to Spain to escape the ravages of World War I, he returned to his homeland.[20]

At the age of thirty-three Montenegro discovered that his experiences in Europe had altered how he looked upon his homeland. He saw it with new eyes, thrilled with its unique cultural traditions: "When I arrived [back in Mexico] everything was surprising to me. I found myself [as if] in an unknown country where everything caught my attention: the colonial architecture, the palaces, the churches, revealed to me new secrets. The indigenous people, their *artesanías*, their popular art, the outfits, the dances, the customs of which I was ignorant."[21] While mounting his first solo exhibition, hosted by the downtown gallery of the North American expatriate Frederick Davis (see chapter 3), Montenegro threw himself into learning more about the crafts that seemed to him to embody the nation's authentic soul. Davis, who dealt in both fine and popular art, eagerly guided Montenegro's new interest.

Montenegro's collaborator Jorge Enciso similarly hailed from the upper-middle class of Guadalajara, saw himself as a disciple of Atl's, and studied art in both Guadalajara and Mexico City before heading to Europe, where he stayed from 1913 through 1915. By 1921 Enciso was working for the government inspecting historical monuments and had earned a national name for himself, particularly for his drawings of indigenous people.

Like many of their contemporaries, Enciso and Montenegro advocated popular aesthetics out of a sense that theirs was a time of cultural transformation, when old norms had to be discarded and new, more "authentic," ones invented. They were not alone. Another advocate of this aesthetic reorientation was their fellow *jaliscience* Higinio Vázquez Santa Ana, who wrote about popular art, *corridos* (folk ballads), and *charrería* (the skills and artistry of horsemanship) during the 1920s and taught at the Escuela de Verano (see chapter 3), then, at the start of the 1930s, went on to serve as the head of the Departamento de Bellas Artes before becoming a priest at the end of the decade. Like Montenegro and Enciso, he claimed that he wanted to tear down old aesthetic canons in favor of new "ideas, elements, orientations" that were closer to the authentic spirit of Mexico.[22]

Enciso and Montenegro learned that they were not alone in their desire to display popular art as part of the official centennial celebrations. In fact, so many similar projects came forward simultaneously that it became almost inevitable. One of these proposals came from the newspaper *El Heraldo de México*, whose editors affirmed that the centennial "would not be complete without" an exhibition showing the arts of "those whose activities have contributed to defining the unmistakable personality of the Mexican people." The newspaper proposed to represent several artistic industries, with prizes for the best work in each category. Manuel Gamio's Dirección de Arqueología (Department of Archaeology) of the Secretaría de Agricultura y Fomento (Ministry of Agriculture and Development) similarly proposed an exhibition of "arte aborigen." It was to be the culmination of a series of research expeditions planned for such locales as Oaxaca, Jalisco, Nayarit, and Michoacán to collect objects that were "almost or completely unknown" in Mexico City, including regional clothing, furniture, crafted tools, and other domestic items that were "representative of the aboriginal civilization." Each team also would include a sculptor responsible for capturing composite likenesses of each "Indian type" complete with distinctive somatic features and clothing styles. None of these proposals, how-

ever, compared in boldness and originality to that envisioned by Enciso and Montenegro, and each eventually fell to the wayside.[23]

Their idea for the exhibition may trace back to 1914, when their mentor Doctor Atl led an unsuccessful effort to convince Félix Palavicini, who was the head of Public Instruction at that time, to award funds for an exhibition of "the work produced by the indigenous people of Guadalajara, Tonalá, Uruapan, and Toluca." At the very least, it goes back to March 1921 when Enciso and Montenegro, joined by another *tapatío* artist, Gabriel Fernández Ledesma, joined Vasconcelos on a tour of the countryside. When Vasconcelos saw them taking careful "notes on the local industries," he presumed that their intention was to "send fine artists to these regions of the country to" teach the craftspeople how to "improve" and refine their work.[24] Much to his surprise and probable dismay, they instead were conspiring to elevate these crafts as art in their own right.[25]

As they brought the exhibition together, Enciso and Montenegro made clear their objectives. First, they wanted to bring together popular art from every part of the republic so as to discern a common aesthetic foundation that, once revealed, might offer a basis for national cohesion. Second, they wanted to display examples of high-quality popular art. The structure of the exhibition, the tours, the docents, and the catalogue taught the audience that these objects were not curiosities or markers of cultural fragmentation and indigenous backwardness but instead were national art. Their third objective was to encourage urban middle- and upper-class visitors to admire, and then seek to possess, these markers of *mexicanidad*, in place of the *chucherias* (gimcrack or baubles) that Novo and others denounced. Demand for popular arts by a public willing to pay fair prices, they hoped, would bring economic uplift to the countryside and assure the survival of these arts, while at the same time fostering mutual understanding among the different sectors of society. One newspaper reporter captured part of the organizer's ambitions when he expressed his own hope that, with the exhibition, "the artistic sense of our people" finally might win the public attention and government support it deserved.

Their plan faced serious obstacles, not the least of which was that they had only three months to plan, research, collect, and mount an exhibition that was without precedent, and which they promised would be an aesthetic encyclopedia of the nation. Nowhere had collectors assembled an even vaguely comprehensive collection of the arts Enciso and Montenegro

now sought. They also confronted a lack of expertise. There simply existed no person, group, or agency with the kind of knowledge needed to amass such a collection. Very little was known about the languages or cultures of rural Mexico, much less about the diversity of popular art. A few people had carried out ethnographic studies in the nineteenth century, but these had been limited in scope. Some elite families possessed heirloom antique collections, especially of dowry chests, trays (*bateas*), and folk carvings, but their collections were small and limited to specific periods and regions and the owners knew little about their own possessions. A few late-nineteenth-century foreigners, such as the University of Chicago anthropologist Frederick Starr, collected crafts as evidence of the peasants' backwardness but knew little about the objects or the artisans. In the absence of existing assemblages or a reliable store of knowledge from which to draw, Enciso, Montenegro, and Atl got the ball rolling by contributing their own recently assembled collections and soliciting contributions from close associates. Montenegro then undertook a few minor collecting expeditions to areas he knew well, such as Tonalá and Pátzcuaro. They also enlisted the collections and skills of the North American art dealer Frederick Davis (see chapter 3), and of the Mexican ethnologists Miguel Othón de Mendizábal and Renato Molina Enríquez (see chapter 5) at the recently created Department for the Promotion of Indigenous Industries (Departamento del Fomento de las Industrias Aborígenes) of the Museo Nacional.[26] Even with this assistance, they were able to amass only a smattering of objects about which they knew little. Their solution was to turn to regional authorities within the provinces.

Enciso sent a circular that urged state governors and their employees to collaborate in this nationalist venture. He explained that the Comisión sought objects of popular art. These included items created for domestic use, "such as furniture, weavings, blankets, belts and runners, shawls, indigenous outfits, silk embroidery, woolens, . . . ceramics of all types of manufacture [including] baked clay, glazed, painted, engraved, lacquered, carved wood, furniture." In addition to these utilitarian items, he also sought "objects that could be classified as decorative, which would include toys [and] paintings." He urged them to send, at the Comisión's expense, "samples of the popular art" produced in their state "following the list given above."

To the Comisión's consternation, governors and their regional subordi-

nates reported that the *indígenas* in their states produced no art. Jorge Enciso sent a second missive in which he insisted that there was no region in the "vast territory" of Mexico where "the Indians do not offer manifestations of primitive art and talent, putting their hands to the products found in their native region." He explained that "these objects that they create, following the traditions of their ancestors and guided by their own artistic sensibility . . . are *works of art* esteemed by the national and international public [emphasis added]."[27] Locals familiar with their region's craft production expressed confusion over what the Comisión wanted: Did it want the cheap objects produced by impoverished Indians, or did it want works of art? This confusion frustrated Enciso, yet he had no choice but to rely on these local and regional contacts.

His efforts to create an encyclopedic exhibition of Mexican popular arts were stymied by these gaps that emerged between his own modernist validation of popular art (based as it was upon cosmopolitan notions of authenticity, collective unconscious, and the modern cultural nation) and local prejudice against "backward" Indians and their "curiosities." As had happened for Rafael Pérez Taylor in the construction of what he saw as a positive portrayal of the Mexican Indian during the India Bonita Contest, Enciso was learning that didacticism and specificity were vital to the construction of the subject of popular art. If his request was to make sense on the local level, he had to teach local mediators which crafts the Comisión considered valuable and why they should be thought of as art.[28]

Ironically, Enciso had to rely on local knowledge at the very moment he was attempting to transform local assumptions and power relations. He depended on local government authorities for information, the delivery of which threatened to affect local structures of power. The more local his contacts, the more imbricated they were in the political and economic structures of artisan production and marketing, and the more committed they were to the denigration of local indigenous people, and thus less willing to facilitate direct contacts between artisans and urban connoisseurs and markets. The act of collecting Mexican arts was not neutral; it was a process that had to navigate among global intellectual trends, central authority, and local politics and economic relations.

Organizers of the Exhibition of Popular Art focused mainly on a Mexican audience, but the declining buying power of domestic middle- and upper-class consumers, hobbled by the revolutionary upheaval and the

economic recession that followed, prompted the Comisión to reach out to foreign buyers. Enciso explained that since the Exhibition of Popular Art "will be attended by all the foreigners who will visit us for the occasion of the Centennial festivities, it offers the most practical and immediate means to revive our national arts: since for the first time the indigenous producers will have the opportunity to gain wide markets."[29] And so, even as Enciso focused on the domestic benefits of these arts and of the domestic promotion of a distinctive national identity that would incorporate "indigenous" popular arts as *ours* and as *national*, from the start he spoke across not only local-national divisions but also international lines.

The public, state officials, and the press celebrated the exhibition's inauguration on 19 September 1921 at 85 Avenida Juárez. Outside, flags, banners, and a military band announced the arrival of President Obregón and his retinue of foreign and domestic diplomats. Inside, visitors were treated to folksingers, Yucatecan dancers, Lerdo de Tejada's Orquesta Típica del Centenario, a lecture on popular art by Doctor Atl, and, following the example that Atl had set at the opening of the Mexican painting exhibition during the 1910 centennial, a *merienda* (afternoon snack) of fresh *tamales*, *atole*, and chocolate served from decorated booths similar to those that would be used at the Noche Mexicana the following week. The inauguration was by invitation only, but thereafter the exhibition was free and open to the public. Contemporary accounts suggest heavy attendance across social classes and by foreign visitors.

After enjoying a series of folk music performances and cultural dioramas, visitors followed guides through two floors of galleries crowded with handicrafts arranged by category: lacquer, ceramics, toys, weaving, wooden tools, paintings, and leatherwork. In place of the sparse walls typical of museum exhibitions, guests entered rooms jammed with objects arrayed on crowded shelves, stands, and tables, with textiles covering the walls. The arrangement deliberately evoked the curio shops and regional outdoor market stalls where buyers might encounter such objects for sale (see figures 11, 12, 13, and 14). The exhibition taught visitors to recognize "authentic" popular arts, and to identify them as "indigenous" and "muy nuestro." It also made clear that not just the objects but the entire way of life was on display; these crafts' value lay not in the visuality of the individual works but in the cultural wholeness of which they were part.

To emphasize Mexican popular art's distance from U.S. and European

11. Gallery view of 1921 Centennial Exhibition of Popular Art. Frances Toor, *Mexican Popular Arts* (Mexico City, 1939).

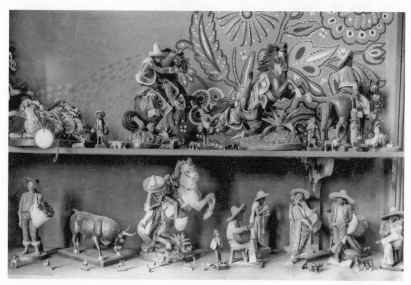

12. Gallery detail. Note the arrangement of items on shelves as they might be found in a market stall or curiosities shop. Also notice the painted wall, styled after the pottery of Tonalá, Jalisco. Archivo Fotográfico Díaz, Delgado y García, Archivo General de la Nación. Used by permission.

13. Gallery detail, showing lacquered objects, mostly from Michoacán. The next room, through the door on the right, was devoted to Olinaltecan lacquer. Archivo Fotográfico Díaz, Delgado y García, Archivo General de la Nación. Used by permission.

14. Photo of the exhibition showing Olinaltecan lacquered bowls and boxes, along with musical instruments and carved furniture. Notice the walls, which Montenegro modeled on eighteenth-century Olinaltecan *rayado* designs. Archivo Fotográfico Díaz, Delgado y García, Archivo General de la Nación. Used by permission.

influence—from which Mexican nationalists were trying to separate them-selves—the exhibition highlighted the indigenousness of the objects, their producers, and their users. This nationalist discourse held that artisans cre-ated these crafts not as commodities but out of a native impulse toward artistic creation and to fill their daily needs. Firmly rooted in the history and daily practices of the indigenous population, these arts supposedly represented authentic Mexico, rather than European forms draped with Mexican stereotypes or Aztec figures. This contrasted with the nation-alist paintings of the time, such as the work of Saturnino Herrán, which validated Mexican subjects by depicting them in conformity with Euro-pean modes of painting (see plate 5). A critic writing under the pseudonym Julian Sorel (who took his nom de plume from the lead character in Stend-hal's famous novel *The Red and the Black*) emphasized this point in his de-scription of an exhibited jug from Tlaquepaque on which was inscribed:

¡*Comadre*, when I die
make from my clay a *jarro* [jug]
from which to quench your thirst
and if after a sip you feel the clay cling
know it's the kiss of your *charro*.

¡Comadre, cuando me muero
haga de mi barro un jarro;
si tiene sed en él beba
y si al beber se le pega,
son los besos de su charro.

Sorel argued that these were the words of an authentic *charro*, not of a man dressed as a *charro*. This jug, like the arts on display, embodied the Mexico that, though long ignored and marginalized—in fact perhaps because of such marginalization—supposedly escaped contamination by foreigners and Porfirian *científicos*.[30]

The exhibition ignited public interest in the nation's "very exotic and original" popular art. As they learned to appreciate *artesanías* as *art* rather than as curiosities or ethnographic artifacts, "people of good taste" began to decorate parts of their homes "in the style of the Exhibition." Fami-lies with money decked out entire rooms as miniature exhibitions, while those of modest economic means confined *artesanías* to a special cor-

ner—practices that still endure.[31] And as the historian Enrique Florescano and the art historian James Oles have noted, the 1921 exhibition and its catalogue "set the canon for subsequent exhibitions of Mexican folk art, a canon that remains largely intact today" within the museum world.[32] The radical aesthetic vision of the exhibition reverberated also across elite art as it drew the attention of painters searching for modes of representation (rather than just new subject matter) rooted in the culture of the masses.[33]

Like Best's ballet, the exhibition also drew detractors. The critic S. Suárez Longoria quipped that even though a group of misguided artists might call these crafts "popular art" and put them in a museum, they nonetheless, remained mere trinkets and "curiosities." But even he conceded that the exhibition was an impressive achievement and a vibrant expression of a new direction for cultural nationalism.[34] In the end, then, even the harshest critics received the exhibition as a success because it offered what many saw as a startling revelation of the "real" Mexico and a vision for how aesthetics might contribute to national unification.

"La manera de ser del pueblo mexicano"

Roberto Montenegro and Jorge Enciso collected, curated, and promoted the exhibition, but their colleague and mentor Doctor Atl was the one who wrote the accompanying catalogue.[35] Not content to merely compile an inventory, Atl provided readers with a groundbreaking treatise on how to judge the value of art, the nature of the *campesinado*, and the essence of the nation.

After studying in the bosom of the European avante-garde from 1897 through 1903 Gerardo Murillo, as Atl was known prior to 1911, returned to his homeland energized by the philosophy and social movements he had engaged in Paris and Rome. Compared to the artistic fervent of Europe, the Mexican art world struck him as stagnant, so he dedicated himself to shaking things up. He argued that artistic regeneration lay not just in connecting to international modernism but in finding a way to do so through Mexico's own repressed cultural traditions. When the Porfirian system was at its zenith, he spoke of the need for cultural revolution and the need to overthrow stifling bourgeois convention. He spent long hours at the national art academy urging younger artists, including David Alfaro Siqueiros, José Clemente Orozco, and Saturnino Herrán, to work directly from

nature rather than in studios looking at photographs and to aspire to a distinctively Mexican mode of painting. Orozco, who would go on to be one of the greats of muralism, recalled that it was Murillo who prompted the rising generation to question the status quo, challenge the academy, and experiment with new approaches rather than conform to accepted ideas. It was at Murillo's urging that Saturnino Herrán left the studio to paint the faces and objects of Mexico, that Orozco ventured into the brothels and back alleys to witness the underbelly of the city, and that Siqueiros began to imagine that art could inspire a revolutionary consciousness.[36] Murillo convinced these rising artists that Mexico had its "own [cultural and artistic] personality that was as valid as any one else's. We needed to learn from the ancients and from foreigners, but we could achieve as much, or more, than they. It was not arrogance, but confidence in ourselves," Orozco later recalled, "an awareness of our self and of our own destiny."[37] Murillo urged the national art academy students to merge art and politics, and they embraced his vision.

In 1910 Murillo convinced them to demand that their art be valued alongside Spanish art in the Porfirian commemoration of the centennial, resulting in a landmark exhibition. After the fall of Díaz, Atl and his followers had hoped for a radical cultural opening, but when Madero's government proved resistant, Murillo, disillusioned, returned to Paris, where he threw himself aggressively into the fray of modernist debate. In 1911, shortly after his return to Paris, Murillo, as an overt statement of his right to define himself rather than be defined by convention or by Mexico's legacy of Spanish colonialism, rechristened himself in a pagan ceremony as Doctor Atl ("Atl" means water in Náhuatl).[38] In 1913 Atl threw himself into the Mexican revolution first as an anti-Huertista propagandist in Europe and then, after returning to Mexico, he managed propaganda and recruited labor unions for Carranza.[39]

When the violence of the revolution subsided, Atl assumed government posts, spearheading the Mexican mural movement and emerging as a dominant figure in the search for a Mexican aesthetic. He claimed disenchantment with the "isms" of the European avant-garde art world of which he had been part, charging that most modernists were charlatans and opportunists working in cahoots with gallery owners and art critics to manipulate public opinion and to hijack the category of "modern." Such

art, in his view, was the "product of the ideas of clever literary groups, art dealers of bad faith, and critics conspiring against the feeling and aesthetics of the collective," and antithetical to cultural regeneration.

Despite his bombastic rhetoric (which later degenerated into anti-Semitic and anticommunist rants), Atl did not abandon European modernism. In his search for Mexican authenticity he turned to Continental theories about intuition and the collective unconscious. Drawing intellectual inspiration from Immanuel Kant, Alfred Fouillée, Arthur Schopenhauer, Henri Bergson, and Georges Sorel, he argued that popular arts represented the most intuitive, and hence, the most genuine expression of the Mexican people.

When Alberto Pani invited him to write the catalogue for the Exhibition of Popular Art, Atl jumped at the opportunity.[40] His first edition of the catalogue found a ready audience among domestic and foreign intellectuals and artists and sold out almost immediately. Several months later Pani invited him to write an expanded edition. Whereas the first was a slim catalogue with short essays and few illustrations, the second edition became a several-hundred-page thesis on race, authenticity, and postrevolutionary populist nationalism.

Atl stated that "until now there has been no book to present, classify, or evaluate that which after revolutionary passion is the most Mexican of Mexico: the popular arts [lo más mexicano de México: las artes populares]."[41] This idea that popular art was "the most Mexican" aspect of Mexico and the "most characteristic manifestations of the way of being of the Mexican people [la manera de ser del pueblo mexicano]" became central to the art's valorization.[42] Moreover, because of the compelling manner in which Atl set out his assertions, his book remains one of the most influential and enduring works on Mexican popular art.

In 448 pages of text and lavish illustrations *Las artes populares en Mexico* constructed Mexican popular art as a transhistorical subject naturally delimited by, and cohesive within, the territory claimed by the Mexican state. It was unique in its attention to *contemporary* popular art rather than preconquest and colonial objects. Crucially, Atl excluded objects he judged to be excessively modern or foreign. He reasoned that because such crafts as the *talavera* (majolica) pottery of Puebla were not Indian in character, they did not reflect the Mexican popular spirit and therefore had no place in a catalogue concerned with the "great artistic sensibility" of "the

Mexican people," which he argued was "essentially Indian." Though some of the included crafts, such as metal or leatherwork, had originated abroad, Atl assured his readers that unlike *talavera*, these arts had been interpreted and transformed by indigenous hands, such that they now carried "the stamp and vigor of the Indian races," which rendered them authentically Mexican.[43] Unless they carried clear signs of Indianness, then, particular arts could not be considered truly Mexican. By emphasizing the centrality of contemporary indigenousness to authentic *mexicanidad*, Atl directly challenged the previously dominant Porfirian view of living indigenous practices as backward holdovers that stood outside of the modern nation.

Race and Indianness lay at the heart of Atl's promotion of *artesanías*. He saw Mexico as a mestizo nation, but its *mestizaje* presented a problem. The worthiness of the European side of this equation seemed self-evident. But the indigenous side was in need of definition and validation. According to the emerging nationalist discourse previously articulated by Manuel Gamio in 1916, to be truly Mexican one had either to be part indigenous or to embrace the idea that indigenousness was vital to the national consciousness.[44] Indigenous cultural influences provided the shared traits and collective distinctiveness that constituted a "true national culture." Rejection of contemporary indigenous people and cultures, while de rigueur prior to the revolution, was now criticized as a mark of unpatriotic xenophilia. Even so, the embrace of either Indianness or *mestizaje* did not, in itself, resolve the larger problem that even the staunchest advocates remained uncertain what, if anything, was worth admiring in Mexico's indigenous people.

As an avid outdoorsman who spent months at a time hiking the outback, Atl was more familiar with the countryside than were most of his contemporaries. But he knew few specifics about the inhabitants of these hills, flats, and valleys and cast a modernist optic of "the primitive" onto a broad array of objects and crafts by artisans who operated from a range of subcultures, some of them rural and some of them urban. He called them all "Indian." In his view, these "Indian" artisans, who he claimed created their art intuitively from their, and the nation's, collective racial unconscious rather than from artificial learning or by imitation of Europe, represented an unadulterated bastion of national authenticity. Atl stated that it "has not seemed appropriate to me to weigh down this monograph

with technical definitions, chemical analysis of the primary materials employed in Indian ceramics, or erudite depositions." Such details are irrelevant when "dealing with things that are completely spontaneous and that must be shown simply, since they are that way," that is, simple. "Erudite" analysis would "present them out of character," in Atl's view.[45] According to the exhibition and to Atl's catalogue, craft became art insofar as it stood as a natural, agentless manifestation of the nation's deep spiritual unconscious. While Atl validated both indigenous and mestizo art, he judged them both by the degree to which they preserved indigenous aesthetic roots, going so far as to insist that the "more Indian their producers" the more Mexican the crafts.

Atl's emphasis on Indianness, spontaneity, authenticity, collective unconsciousness, manual industries, and premodernity did not make him *anti*modern.[46] On the contrary, he saw such traits as providing Mexico with a distinct path *toward* modernization. He foretold that the "day is not far when most of the *manufacturas indígenas* will be substituted by products of mechanization." When that day comes, "this book . . . will have considerable importance" as a "testament to the intelligence and deep artistic sensibility of the Mexican people." Atl welcomed his country's belated modernization and expressed his faith that traditional artisans would play a key role in the construction of its future industrialization. Yet he also hoped that the best popular aesthetic traditions might be preserved.[47]

According to Atl, popular art resulted from craftspeople's intuitive passion for artistic creation, unencumbered by concerns about the market. He saw no better example of this ideal than the artisans of Tonalá, near Guadalajara. Atl claimed to recall a conversation with the Tonaltecan artisan Jicarías Jimón, who supposedly stated: "I paint because something inside me drives me to work with melancholy—and I paint to cover the surface of a jug. I want only one thing: to be able to decorate my jugs so as to give them as gifts, not to sell them."[48] That the artisan might have said this is questionable, but the fact that Atl claimed that Jimón had reinforced his own idealization of indigenous artisans as primitive producers isolated from modern commercialization.

For particularly "authentic" places like Oaxaca or Tonalá, Atl's catalogue juxtaposed photographs of artisans with images of their homes and *artesanías* (figure 15). Like the objects they made, the artisans, their homes, and their entire way of life became embodiments of the vital spirit of Mexican

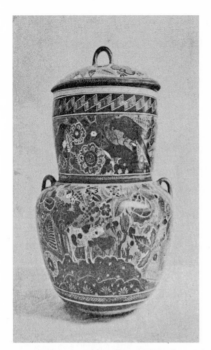

15. Jar by Amado Galván of Tonalá (left); the Tonaltecan artisan Ladislao Ortego (right), photographed similarly to the jar valorized as passive and authentic. Dr. Atl, *Las artes populares en Mexico*, 2nd ed. (Mexico City, 1922).

authenticity and collective unconscious. Atl contrasted the idealized artisans of Tonalá to those of Metepec (near Toluca), whom he criticized for their apparent lack of dedication to the joy of creation. Their concern with the market, which had "nothing to do with the spirit of these arts," supposedly had corrupted their crafts. Contrasted to Jicarías Jimón, the artisans of Metepec symbolized decadence and the wayward path that threatened all handicrafts and endangered the nation's pristine patrimony.

As his contrast between Tonalá and Metepec suggests, Atl distinguished between creating markets for popular art, which he favored, and creating popular art for markets, which he condemned. Authentic crafts were the result "of a particular way of being, intimately tied to the idiosyncrasy of the producers," such that "to touch them," to affect their appearance or methods of production, was "to destroy them." He saw popular art not as unchanging but rather as like a fragile ecological system in which one had to take care not to disrupt the natural evolution. He criticized the efforts of

those who tried to change these arts, such as by trying to return the ceramics of Tonalá to a pre-Hispanic state through the introductions of ancient Aztec and Mayan designs.[49]

Equally misguided, according to him, were elites' efforts to make the popular arts "evolve" into modern forms. He condemned the composer Manuel Ponce's creation of classical music based on popular tunes. One would presume that he similarly frowned upon the ideas of Best Maugard, Francisco Zamora, and José Vasconcelos. "Popular music," Atl asserted, "does not need to be dressed up, and the blanket of Oaxaca and the jug of Guadalajara do not need modifications." We should learn to appreciate "the works of the people just as they are" and "not try to transform them claiming a spirit of progress." The "indigenous industries cannot be changed or improved: they are what they are."[50] The only ways to save popular art was by helping artisans acquire primary materials, excusing them from taxation (so as to limit their need for cash), and creating urban marketplaces through which artisans could sell their art without the intervention of profiteering middlemen. Other kinds of assistance could "only result in prostitution of the Popular Arts."

Previously, art in Mexico had been valued primarily for its classical references, rationality, and highly refined skill. Atl veered from this trajectory more profoundly than did Best Maugard. He insisted on the need to esteem popular art for its independence from Western visual traditions, for its rawness and immediacy, and for its spiritual authenticity derived from the intuitive and unconscious impulses of the producers. True popular art had to be made for use by the people. Part of its genius, in fact, resided in the way communities transformed local materials in accordance with their distinctive worldviews and aesthetic ideals. He understood peasant and non-Western art as expressive of a creativity that did not originate from the individual artist. Such art did not result from mere technical process, and it expressed something larger than the will or consciousness of the individual. Mexico's handicrafts opened a window onto the soul of the nation because they supposedly embodied an entire collective history, a race, and a nation. As such, craft production could not be rationalized, and its aesthetics could not be improved upon.[51]

Though Atl's exhibition catalogue defended crafts as art, it did so by erasing real practices and denying artisans any agency in the process of creation or even in their own lives. This same individual who went so far

as to rename himself as a statement about his right to control his own identity saw no contradiction between his own declaration of cultural autonomy and his efforts to esteem popular art as the deep, unmediated, collective, and intuitive soul of the Mexican people. Doctor Atl's artisans did not learn, study, practice, refine their art, or make difficult economic and political decisions. Instead, they possessed innate skills as a result of being racially indigenous and culturally pristine. Signs of agency or of modern Western influence invariably detracted from their work's value. The perspective embodied in the Exhibition of Popular Art contrasted with that of the Noche Mexicana. But the exhibition's discourse was not inherently any more liberating for the artisan, who became burdened with romantic modernist baggage that denied economic or political agency for the artisan and for indigenous people more broadly.

Conclusions

The Noche Mexicana and the Exhibition of Popular Art offer insight into the uneven process by which handicrafts won validation as part of Mexico's inclusive primordialist national identity rooted in popular culture. The subject of Mexican popular art was created at the time when intellectuals were returning from Europe, bringing with them an eclectic mix of ongoing cosmopolitan conversations and intellectual problems that they had engaged in Rome, Paris, Barcelona, and New York City. Returnees looked upon their homeland through a novel intellectual prism that reveled in national distinctiveness.[52] Allied with the new state, they forged criteria by which to reassess the nature and value of art, the meaning of their nation, and the significance of indigenousness. What emerged was a new way of thinking about the indigenous population's place within the national community and its contribution to *mexicanidad*.

The search for Indian Mexico inspired a profound nationalist cultural reevaluation as intellectuals, artists, and researchers cut pathways into the countryside, propelled by metropolitan concerns for accumulating, systematizing, promulgating, and hierarchically ordering knowledge about the "real" nation in all its parts so as to forge a naturalized patrimonial canon. Through these efforts and the debates that accompanied them, intellectuals and officials were dogged by their own conflations between campesinos and Indians, and between indigenous and popular art. It would be a mistake, however, to think that there might have been some

way for them to have been more specific, to have worked with the "real" categories rather than with their own imagined categories and conflations. The search for fixed cultural and racial definitions, in itself, was part of the postrevolutionary impulse. Since the time of independence, the liberal state officially had erased the category of Indian (even as it continued to function in contingent ways in daily interactions).[53] When postrevolutionary nationalists set out to discover indigenous Mexico and promote it as central to the national identity, they ended up creating the idea of the contemporary Mexican Indian and struggled to define its boundaries.

Scholars and government officials have spilt much ink trying to figure out who was and who was not an "authentic" Indian, and how this segment of the population should be counted. People continue to yearn for fixed numbers, to be able to say that x percent of the population is "indigenous" and that the rest is not, but it is never that simple. As this chapter has demonstrated, indigenous is a slippery and profoundly contingent category and no amount of parsing can turn up fixed numbers. This slipperiness is not a problem to be solved; it is a direct outcome of the search itself, rooted in the cultural project born in the 1920s.

In the end, the Exhibition of Popular Art and the Noche Mexicana recognized neither indigenous people nor artisans as agents possessed of their own volition and able to define themselves, their art, or their destinies. Like the India Bonita Contest, neither of these events acknowledged that the rural masses might possess their own thoughts about their art, much less about the nation or their place within it. The exhibition did open markets for popular arts, which in the long term provided a net benefit for the artisans, but this came at the price of a narrow definition of what was acceptable within this market, based on restrictive definitions of authentic *mexicanidad* and indigenousness. The terms by which popular art was validated, as the coming chapters will show, would shape the evolving relationship between artisans, intellectuals, and the state.

THREE

\(2

Foreign-Mexican Collaboration,
1920–1940

In the 1920s and into the 1930s advocates of an ethnicized national identity lamented that their fellow Mexicans had less appreciation than did foreigners for "things Mexican." The art critic Justino Fernández recalled that during that era the interpretation of the country's history and culture was "a knock out fight between Indianists and Hispanophiles, with the foreigner acting as referee."[1] Such comments suggest that in the debates over a postrevolutionary national identity Mexicans' attitudes were far from monolithic, and foreigners were more than passive observers.

The Mexican middle and upper classes demonstrated ambivalence about the nationalist project to Indianize Mexican culture and about foreign involvement in such an effort. Celebratory images of indigenousness by the likes of Best Maugard, Doctor Atl, and Diego Rivera were matched by derogatory portrayals in the popular press. Figure 16 shows a typical cartoon depicting indigenous people in racist, negative terms, contrasting the "spring fashions" of the filthy, droopy-lipped, bumpkin indigenous couple and a chic white urban Mexican woman. Figure 17 takes aim at the foreigners who poured in to witness the unfolding nationalist project and at the lower classes they esteemed. The figure in the upper part of the cartoon is a middle-class Mexican man so disgusted by the filth of the panhandlers that he loses his appetite. In the lower part of the cartoon, by way of contrast, a foreigner enthusiastically photographs garbage. In fact, foreigners photographed not urban refuse but campesinos,

16. Cartoon contrasting the "spring fashion" of an indigenous couple with that of a young, white, urban Mexican woman. "Cómo se visten en primavera," cartoon, *El Universal Ilustrado*, 5 April 1928. Biblioteca Lerdo de Tejada.

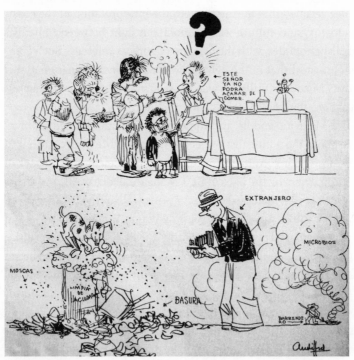

17. "This man will have lost his appetite" (above); "Foreigner" and "Trash" (below); *El Universal Ilustrado*, 3 March 1926. Biblioteca Lerdo de Tejada.

indigenous people, and folk practices and objects. By suggesting that foreigners mistake Mexico's garbage for something worthy, the author of this cartoon criticizes the foreigner and the popular classes while capturing the frustration of the middle and upper classes, who considered themselves their country's standard bearers of civilization but who now found themselves denounced by foreigners and by their own intellectuals and artists as less Mexican than the indigenous masses they had long berated. Some members of the middle class, moreover, felt stung by foreigners' tendency to generalize all Mexicans as indigenous, especially since they continued to pride themselves on their distance from Indians.

This chapter analyzes the role that foreign-Mexican collaboration played in the consolidation of a postrevolutionary ethnicized national identity, particularly in relation to the promotion of popular art as *muy mexicano*. It challenges common assumptions about nativist nationalism as a discourse that inherently defended national culture against the despoiling gringo invader. When the war broke out in 1910, waves of U.S. political tourists, writers, and artists headed south to witness firsthand the socialist potential of the popular revolution.[2] A second wave followed, comprising a more diverse group. Still largely on the political left, they came to see Indians and mestizos and to witness their incorporation into the postrevolutionary nation. These foreigners joined Mexican artists and intellectuals searching for authentically Mexican music, art, literature, and popular art. The interplay between foreigners and Mexicans in the postrevolutionary promotion of popular art challenges the way scholars and the public normally conceive of "foreign" and "national," and of imperialism and cultural sovereignty. Not only did many of today's assumptions about who Mexicans are as a people emerge more recently than is often imagined; they were forged in the fires of *transnational* political and cultural discourse by both Mexican nationals and foreigners. The chapter ends with a consideration of why and how nationalists of the 1930s and 1940s purged these transnational interactions from dominant narratives of Mexican cultural nationalism, leaving the impression of an introverted, self-contained, timeless *mexicanidad*.

Collaboration in the Nationalization of Folk Art

The first international exhibition of Mexican handicrafts, held in 1922, grew out of collaboration between leading Mexicans and Katherine Anne

Porter, who would go on to become one of the most important fiction writers in the United States. Recalling this event years later, Porter explained that in Mexico she had "attended, you might say, assisted at, in my own modest way, a revolution."[3] Her biographer Joan Givner explains that Porter grew up with a sense of rootlessness that she struggled to shake. Callie Porter, born into poverty and obscurity in central Texas and troubled by her humble and broken family, drew upon a mix of fact, hearsay, and fabrication to remake herself into the great writer Katherine Anne Porter, "an aristocratic daughter of the Old South and the descendent of a long line of distinguished statesmen." As a child in Texas she witnessed prejudice against Mexicans and was stung by other whites' condescension toward her and her family because of their poverty. Later in life, she drew upon this to develop a concern for injustice and an interest in better understanding Mexico. Givner compellingly argues that "all her life Porter wavered in her class identification, now agitating on behalf of downtrodden, exploited people, now speaking proudly of belonging to a slave-owning aristocratic class." To escape her poverty, Porter married young and moved to Lafayette, Louisiana. There she developed an interest in folk art. Though neither her first nor her subsequent marriages lasted long, her interest in folk art endured.

After years of moving across Texas, Louisiana, Denver, Chicago, and New York's Greenwich Village, and bouncing between journalism and the emerging film industry, she at last discovered a passion for fiction and the bohemian lifestyle. In 1920, while working as a publicity agent for a studio in New York City and publishing her first short stories, she met Adolfo Best Maugard, who entranced her with his theories of art. When Sergei Diaghilev's famous Ballet Russes came to town, Best Maugard interested the dancer Anna Pavlova in doing a Mexican ballet, with himself as set designer and Manuel Castro Padilla scoring the music. He recruited Porter to script the storyline, asking only that it be a romance set in Xochimilco. Porter spent long stretches of time with Best during the spring and summer of 1920 listening to him recount the history, culture, and art of Mexico as he painted the backdrops for the stage.[4]

Best introduced the aspiring writer to Mexican artists living in New York, and before long she found her way to Mexico City. The train ride filled her with a sense of adventure as she witnessed armed men on horseback and makeshift camps. She arrived in the capital in time to attend the

inauguration of President Alvaro Obregón on the first of December and was inspired by the hope for political and cultural reform. In Mexico she worked as a journalist and taught English at a girl's high school, but, more importantly, she at last found inspiration to fuel her creative writing.

Similar to what he had done in New York, Best introduced her into the artistic circles of Mexico City, beginning with Manuel Gamio, Jorge Enciso, Moisés Sáenz, and David Alfaro Siqueiros. She developed a fascination with the Yucatan Mayan radical governor Felipe Carrillo Puerto, who took her rowing in Chapultepec Park and dancing in the city. She gathered with these and other artists and intellectuals over breakfasts at Sanborn's in the Casa de los Azulejos, on outings to Xochimilco, and at parties in Cuernavaca, where she also mingled with other resident foreigners. Through this circle she deepened her engagement with the emerging vision of folkloric Indian Mexico.

After almost a year she returned briefly to Texas and then to Greenwich Village until she received a telegram informing her that President Obregón had offered a generous fee to write the catalogue and arrange the U.S. schedule for a traveling exhibition of folk art. She booked passage on the next steamer back to Mexico.[5] The artist Xavier Guerrero, who was the lead curator for the exhibition, envisioned it as a sequel to the 1921 Exhibition of Popular Art, and it was made up mostly of objects from that collection (see chapter 2). Born in the northern state of Coahuila, Guerrero, like many of his associates, studied art in Guadalajara and Mexico City. He would go on to become an important muralist and a communist activist. Best Maugard and Guerrero secured backing from the Ministry of Industry and were aided by a long list of collaborators that included the anthropologist Alfonso Caso, the leftist intellectual Vicente Lombardo Toledano, and the artists Jorge Enciso, Roberto Montenegro, Javier Lozano, Diego Rivera, Carlos Mérida, Miguel Covarrubias, and Juan Ixca Farías.[6]

En route to Los Angeles, the exhibition was held up by U.S. customs officials who argued that it was propaganda by the Obregón administration, which the U.S. State Department did not recognize at that time. To Porter's chagrin, Mexican officials compromised by agreeing to reclassify the objects as commercial goods, pay a tax, and allow a private Los Angeles gallery to sell them after a single showing rather than continue with the scheduled tour. Despite her frustrations, Porter recalled that when the exhibition of thousands of objects opened in November 1922 (just fourteen

months after the centennial exhibition on which it had been modeled), it was "an enormous hit" as "people poured into that place from all over the country and they bought all of these beautiful things." More than a week later visitation reportedly hovered at between 3,000 and 4,000 per day. Porter was angry that the gallery sold all the objects rather than tour them, but she was gratified when her catalogue was republished and distributed by the National Museum in Washington the following year.

The importance of the 1922 arts show and its catalogue lay not in the size of the audience but in what it reveals about the course of Mexican-foreign collaboration. Porter took sides in the Indianist-Hispanophile debate. In the catalogue she wrote that the "only vivid and quick artistic impulse" in Mexico "grew in the soul of the native." Following the lead of Atl, Gamio, and her exhibition collaborators, she argued that during the nineteenth century art and architecture had degenerated into second-rate imitations of French arts, with genuinely national sentiments surviving only among the marginalized indigenous peasantry.[7] Porter's presentation of Mexico's culture and arts was not a foreign-imposed reading but a synthesis of the interpretations put forward by Manuel Gamio, Xavier Guerrero, Adolfo Best Maugard, Felipe Carrillo Puerto, Moisés Sáenz, Jorge Enciso, Roberto Montenegro, and others, who themselves drew on transnational intellectual shifts tied to cultural relativism, nationalism, authenticity, and the collective unconscious. The difference was that Porter's catalogue was aimed at a foreign, rather than domestic, audience. And while enthusiastic about the cultural objectives, Porter did not share her colleagues' spirit of Mexican nationalism. Her experience with the exhibition, according to Givner, marked Porter's "first exposure to a coherent, consciously articulated aesthetic philosophy," which would guide her for the rest of her career. But her frustration in dealing with the government marked the beginning of her disillusionment with Mexico.

More broadly influential than Porter's effort was Frances Toor's magazine *Mexican Folkways*, which remains to this day one of the most cited sources among scholars dealing with Mexican popular culture, folk art, or indigenous history. Though Toor and Porter, who each arrived in Mexico at the age of thirty-one, clashed on a personal level in the latter part of the 1920s, they shared an Indianized view of Mexico within the country and countered negative stereotypes of Mexico in the United States. Toor grew up in Plattsburg, New York, completed her undergraduate and masters

studies at the University of California, and then taught high school Spanish on the West Coast. She came to Mexico in 1922 to attend the Escuela de Verano (summer school) at the National University. Though she never spoke of it in her own writings, some of her contemporaries noted that she was married to Joseph L. Weinberger. He was a North American and longtime expatriate who ran the Mexico chapter of the B'nai B'rith Jewish service organization that helped settle recently arrived Jewish immigrants from Europe and the Middle East. It is unclear whether Toor and Weinberger were married or simply partners, and, if they were married, whether they wed before or after her arrival—some sources have claimed that when she came to Mexico she was fleeing an unhappy marriage to a dentist. Information on Toor's personal life is scarce and unreliable. What is certain is that she found inspiration in the 1921 centennial Exhibition of Popular Art (which remained on display in various forms until after her arrival in Mexico) and its 1922 successor. Toor admitted that when she first arrived she had been "ignorant of what Mexico really" was, and that it was her encounter with these folk objects that first opened her eyes as she "grew ever more enthusiastic over the beauty" of Mexico's handicrafts. She was astonished to learn, moreover, that the "exhibition was a revelation to the Mexicans themselves" as much as it was to foreigners. The experience inspired her to learn "more of the country in which such humble people could make such beautiful things."[8]

Once she had decided to stay, she continued her studies in the Escuela de Verano at the National University. The Escuela de Verano was created in 1921 as the brainchild of Pedro Henríquez Ureña, who, though he hailed from the Dominican Republic, was accepted by Mexicans as one of their own. Born into a prominent family dedicated to education, humanities, and the arts, Henríquez Ureña would go on to be a pan-American intellectual, a friend to leading artists and thinkers across the Americas, and a university professor in Mexico, Argentina, and the United States. The Dominican first resided in Mexico from 1906 until 1913, during which time he completed his university education and, together with Vasconcelos and others, founded the famous antipositivist group known as the Ateneo de Juventud. After living in Cuba, the United States, and the Dominican Republic (until the U.S. invasion), he returned to Mexico in 1921, where he worked with the newly created Ministry of Education and in 1923 married Isabel Lombardo Toledano, sister of the leftist sindicalist Vicente Lom-

bardo Toledano. He stayed until 1924, when his friendship with Vasconcelos soured.[9] During his first stay, he became a critic of Porfirian positivism, and, with his return in 1921, he emerged as a proponent of cultural nationalism, which he argued had to grow out of both elite and popular traditions.

Henríquez Ureña created the Escuela de Verano as more than just a place for U.S. Spanish teachers to brush up on their language skills or for Mexican students to learn pedagogical method; he made it a gathering place for intellectuals to learn about and debate postrevolutionary cultural transformation. Those involved in the school aspired to change perceptions among both foreigners and Mexicans. Courses and field trips concentrated on the social transformation and cultural rediscovery of the country, with particular attention to new educational and cultural orientations and folkloric songs, dances, practices, and manual arts. The list of Mexicans involved with the school includes leading intellectuals and artists such as the educators Moisés Sáenz and Jaime Torres Bodet (the latter of whom in the 1940s through the 1960s would serve as minister of education and of foreign affairs and as an official in UNESCO); the art historian Manuel Romero de Terreros; the attorney Manuel Gómez Morín (who would later serve as rector of the National University and in 1939 found the Catholic conservative party Partido Acción Nacional, known as the PAN); the poets Carlos Pellicer and Salvador Novo; the archaeologist Alfonso Caso; the ethnologist Pablo González Casanova; the journalist Rafael Heliodoro Valle; the historian Jesús Silva Herzog; and the diplomat Ramón Beteta. Foreigners associated with the school included the Columbia University educator and philosopher John Dewey, the artist and art dealer René d'Harnoncourt, and, of course, Henríquez Ureña himself. By 1928, even Frances Toor had joined the faculty.

Inspired by the 1921 exhibition and by her experiences in the Escuela de Verano, Toor set out to create a new kind of magazine. During the planning phase, she explained to Gamio's Columbia University graduate school mentor Franz Boas her plans to "publish a magazine, to be called 'Mexican Folkways.'" She already had secured the collaboration of Gamio, Pablo González Casanova, Diego Rivera, José Clemente Orozco, and other artists and researchers, and, thanks to the intervention of Gamio, who served as undersecretary of the Ministry of Public Education, she secured a state subsidy. Toor originally planned to direct the magazine exclusively toward

a Mexican readership, but on the advice of Franz Boas, who had long advised Gamio to use his government post to encourage the study of Mexican folkways, she decided to publish it bilingually. With Toor as editor and Diego Rivera as art editor the magazine released its first issue in the summer of 1925 to much acclaim.[10] No other source did more during the late 1920s and early 1930s than *Mexican Folkways* to encourage an appreciation for the culture and arts of the Mexican countryside.

The magazine offered a forum for collaboration and helped replace urban fears of a rebellious, dangerous, savage backcountry with a celebration of folkloric culture and popular art ripe for discovery and exploration. *Mexican Folkways* also systematized an understanding of the countryside as a place of great diversity rather than one reducible to the stereotypes promoted by theatrical revues. Though edited by a foreigner, *Mexican Folkways* won credibility domestically because most of the contributors were Mexican, and because it contributed directly to the effort to collect and disseminate knowledge about the country's vernacular traditions and cast them as part of a coherent whole. In accordance with the ideals espoused by Gamio and others, *Mexican Folkways* presented the "real" Mexico as rural and indigenous, but it went a step further by emphasizing the variations in tradition, language, and culture.

Toor hoped to strike a balance between Gamio's holistic social scientific approach and Atl's idealization of intuitive cultural expression. She also tried to bridge the concerns of Mexicans and foreigners. As she explained, she wanted *Mexican Folkways* to describe "art, music, archaeology, and the Indian himself as part of the new social trends, thus presenting him as a complete human being." She enlisted contributors from the Escuela de Verano and beyond, including the anthropologists Manuel Gamio, Miguel Othón de Mendizábal, Pablo González Casanova, Ramón Mena, Alfonso Caso, and Carlos Basauri; the educators Esperanza Velázquez Bringas and Moisés Sáenz; the musicians Concepción (Concha) Michel and Manuel Ponce; the writers Salvador Novo and Genaro Estrada; the painters Doctor Atl, Diego Rivera, Miguel Covarrubias, Carlos Mérida, and Adolfo Best Maugard; the journalist Rafael Heliodoro Valle; and the photographer Manuel Alvarez Bravo. Foreign collaborators included the art historian and ethnologist Anita Brenner; the artists Jean Charlot and Pablo O'Higgins; the anthropologists Robert Redfield and Elsie Clews Parsons; the journalist Carleton Beals; the photographers Edward Weston and Tina

Modotti; the artist and art historian René d'Harnoncourt; and the architect and silversmith William Spratling.

The first issue made clear the magazine's orientation. Manuel Gamio contributed a piece titled "The Utilitarian Aspect of Folklore" that argued that to create effective laws and to modernize the country, government officials would need to learn more about the diversity of the population. In that inaugural issue, Esperanza Velázquez Bringas, attorney, educator, ardent advocate of cultural revolution, and head of the federal department of libraries, lauded the journal's goal of "divulging the traditions and popular arts as a tribute to the indigenous races." The Mexican American art historian and anthropologist Anita Brenner contributed an essay honoring the humble *petate*, the ubiquitous woven palm mat: "It is the symbol of the entire life of a Mexican Indian, the interpretation of his spirit" and "the heart of Mexico." Reacting against urban fears and prejudice, Pablo González Casanova tried to humanize indigenous people by refuting the common middle-class stereotype of Indians as incapable of romantic love.[11] The issue also carried Miguel Othón de Mendizábal's transcription of a *corrido*, along with advertisements for handicraft art shops, book stores, Buen Tono cigarettes, the Escuela de Verano at the National University, and the photography studio of Edward Weston and Tina Modotti. This emphasis on local distinctiveness and a culturally plural but ultimately unified nation continued throughout the life of the publication. By the end of 1927 the magazine had grown in quality and importance. Even President Calles praised it for "making known to our own people and to foreigners the real spirit of our aboriginal races and the expressive feeling of our people in general, rich in beautiful traditions."[12]

The magazine's approach and its status as a transnational cooperative proved to be its strengths but also its points of vulnerability. In 1925, before the first issue even hit the streets, Manuel Gamio found himself driven from his post in the Ministry of Education in retaliation against his efforts to expose the corruption of his supervisor, José Manuel Puig Casauranc.[13] This resulted in the suspension of Toor's subsidy. The poet José Frías (head of publications at the Ministry of Education) saved the magazine by appealing to Puig Casauranc and the new subsecretario Moisés Sáenz (who replaced Gamio). Puig and Sáenz not only restored the subsidy but they took on the entire cost of the magazine's production.

Things then went smoothly until 1931, when the new umbrella orga-

nization known as DMAAH (Departamento de Monumentos Artísticos, Arqueológicos e Históricos [Department of Artistic, Archaeological, and Historical Monuments]) took charge of all state-funded cultural institutions. Part of the DMAAH's mission was to challenge foreigners' domination of social and cultural research in Mexico (see chapter 4). As the government tried to harden the boundary between "Mexican" and "foreign," it cut all funding to *Mexican Folkways*, claiming that it was a foreign enterprise. Toor searched for funding north of the border, but patrons there refused on the grounds that this was a Mexican, rather than a U.S., project. The collaboration that had made the magazine transnational now left it without a nation. After a few more years of struggle and an irregular publication schedule, Toor conceded.

Though she was upset about *Mexican Folkways'* demise, Toor felt gratified that it had, in her words, "played an important role in the formation of the new Mexican attitude toward the Indian." Even if the revolution had yet to fulfill its political and economic promises, she wrote, "at least [the Indian] has been recognized as a human being. The new governing classes have discovered the value of the Indian just as the Industrial Revolution has discovered the value of the man in the street. They have realized that if Mexico is to progress, the masses of Indians, forming two-thirds of the population, must be taken into account."[14]

The magazine had contributed to the study and nationalization of rural vernacular traditions, defining these as indigenous, and affirming an ethnicized view of *mexicanidad*. As with Porter's catalogue, it would be a mistake to view *Mexican Folkways* as a foreign imposition. Both efforts emerged at a time of fluid collaboration when Mexican nationalist intellectuals, themselves only recently returned from extended sojourns abroad, felt like strangers in their own land as they discovered the wonders of its popular classes and landscape. For most of the 1920s into the 1930s, Mexicans and foreigners worked hand in hand to advance the ethnicization of Mexico's postrevolutionary national identity.

"I came away from Mexico and said to my friends . . ."

The historian Frank Tannenbaum, who spent much of the 1920s traveling and researching in Mexico, correctly observed that what distinguished contemporary Mexican intellectuals from their predecessors was their zeal for discovering the countryside and their view of Indians as the bedrock of

national culture.[15] These Mexican intellectuals became guides, introducing their countrymen and foreigners alike to the "real" Mexico.

Like Tannenbaum, the historian Hubert Herring found inspiration in what he viewed as Mexico's self-discovery. At the presidential inauguration of Plutarco Elias Calles in 1924, for example, he was impressed by the number of regionally attired mestizos and Indians in attendance, the regional music, and the overall atmosphere. He later recalled: "I came away from Mexico and said to my friends: The time has come when we of the North must take account of this people—we can no longer maintain our attitude of mingled indifference and contempt." He sought the support of like-minded colleagues including the pragmatist philosopher and education reformer John Dewey, the liberal political author Herbert Croly, and the economist Stuart Chase. Together they created the Committee on Cultural Relations with Latin America. Its first annual seminar, held in Mexico in 1926, attracted twenty members to meet with Mexico's "political leaders, her artists, her teachers, [and] her 'common man.'" By 1939 over 1,500 North Americans had attended these annual seminars, including lawyers, physicians, teachers, clergymen, businessmen, social workers, artists, and writers. According to Herring: "They have returned as interpreters to the United States. There is no record of the hundreds of articles printed, of the thousands of lectures given by them. But this group . . . has made Mexico live in the minds of many Americans." Faculty in these seminars included a cast familiar from the Escuela de Verano and *Mexican Folkways*, who turned the seminars into yet another fertile ground for intellectual cross-fertilization between the Unites States and Mexico.[16]

One of the founding members of the Committee on Cultural Relations with Latin America, Stuart Chase, had first traveled to Mexico on the advice of the painter George Biddle who later would draw on his Mexican art training to launch the Works Progress Administration's mural project. Chase spent time with Mexican and foreign intellectuals, scholars, and artists who introduced him to the "real" Mexico. In 1931, when the United States was sliding into the Great Depression, he recorded his findings in his best-selling book *Mexico: A Study of Two Americas*, illustrated by Diego Rivera. In the handicrafts of the "free villages" Chase believed he had found a counterexample to the "machine age" that he claimed asphyxiated the souls of workers in the United States and Europe.

Oblivious to the complex, often brutal reality of artisan life, Chase as-

serted that Mexico's craftspeople "work when they feel like it, stop when they feel like it, sleep when they feel like it." He contrasted this to the office and factory workers of the United States and England who, "working day and night for one hundred and fifty years, have never produced a tithe of the excellence in human goods to be found in one holiday market in one small city in the south of Mexico." Like many modernists who felt they had stumbled upon undiscovered and unspoiled corners of the world, Chase feared the impending impact of tourism: "My foreboding is concerned with the American tourist. In a few months (this in June, 1931) he will be able to drive his Buick clear through to Mexico City. Clouds of Buicks, swarms of Dodges, shoals of Chevrolets—mark my words, they will come. They will demand souvenirs to take back."[17] He urged Mexicans to protect these crafts from the degeneration that he argued accompanied commercialization.

Another widely read advocate of the Mexican project was the editor of the *Nation* and future governor of Alaska, Ernest Gruening. His *Mexico and Its Heritage* (1928), which drew on conversations with Mexican colleagues, interpreted Mexican society as a jumble of social groups, each caught in a different period of human cultural (not biological) evolution. He followed such guides as Gamio, Sáenz, and Henríquez Ureña to argue that in the years following independence from Spain, art in Mexico degenerated into a poor imitation of European, especially French, art as it became "the fashion" among the elite and middle class "to deprecate all things Mexican." He assured his readers that underneath the Hispanized surface, native traditions persisted and manifested themselves in all aspects of daily life and popular art, and he praised Mexicans' efforts to re-cover and protect this heritage.[18]

Gruening's protégée, the anthropologist and art historian Anita Brenner, took the celebration of distinctive Mexican art even further. Brenner had been born in Aguascalientes to European Jews who had settled in the United States in the 1880s, married in Chicago, and eventually moved to Mexico. In 1912, while Anita was a young child, her family fled to Texas when the U.S. consul in Aguascalientes advised U.S. citizens that the revolution had made the region unsafe. Raised and educated in the Lone Star State, Anita Brenner always felt out of place in both the Jewish and the non-Jewish communities. She completed three semesters of university education between Our Lady of the Lake College in San Antonio and the

University of Texas at Austin before leaving in 1923 at the age of eighteen to study at the National University in Mexico. Joseph Weinberger of the B'nai B'rith, who promised Brenner's family that he would keep an eye on her, introduced her into the Jewish community, including Frances Toor. Though Toor and Brenner later would become rivals, at that time Toor introduced her to other foreigners, such as the journalist Carleton Beals and the communist organizers Bertram and Ella Wolfe. She also brought her to breakfasts at Sanborn's restaurant in the Casa de los Azulejos, which was an informal meeting place for Mexican and foreign intellectuals and artists. Brenner began typing essays for Diego Rivera, who converted her to his pro-indigenous vision of Mexican culture, while Beals helped her enter the publishing world. In 1925 Brenner got a job as Gruening's research assistant. She helped with his upcoming book, introduced him into Mexico's intellectual circles, and set up his interviews. By 1926, thanks in large part to the French expatriate Jean Charlot, who had become a Mexican citizen, an assistant to Rivera, and a master artist in his own right, Brenner had established herself as a fixture in the cultural scene, hosting large dinner parties whose list of attendees read like a Who's Who. Within the cosmopolitan circle of foreign and Mexican artists and intellectuals in the capital city, Brenner for the first time felt comfortable in her own skin as a transnational Jewish intellectual woman.

Brenner translated her personal experience with artists and intellectuals into the first major account of what she coined the "Mexican Renaissance." In *Idols behind Altars*, published in 1929 and written with the collaboration of Jean Charlot, Brenner wrote that "in the span of one generation Mexico has come to herself" and has "discovered the suffering and hopes of its own people." She described the "scenic and racial beauties" of Mexico as still "largely unmapped, unexploited" and as distinct from "western civilization." Behind a Hispanic veneer, she argued, lay the uncontaminated indigenous culture that was the real Mexico. Like Best and Gamio, she felt that vernacular art offered the most sincere expression of the indigenous mindset and the aesthetic foundation for the creation of something cohesive and truly national.[19]

The photographer Edward Weston, like Stuart Chase, fell under the spell of Mexico. He confessed to his diary: "I should be photographing more steel mills or paper factories, but here I am in romantic Mexico,

and, willy-nilly, one is influenced by surroundings." To experience "greater authenticity" Weston abandoned downtown Mexico City for a rural Spanish colonial home with a large patio. The previous occupant had tried to make the home look more modern by adding wallpaper and other touches. Weston "laboriously" removed such additions and filled his refurbished colonial home with handicrafts, from *talavera* dishes to inlaid chests. Like Atl and Enciso before him, Weston judged everything he encountered by the degree to which it was "authentically Mexican" and he shunned anything that seemed to pander to European or North American tastes. Ironically, after restoring his leased Spanish colonial home, he abruptly abandoned it when he discovered that it could not receive a telephone line. He settled in a middle-class house in the center of the city, whose only rooms he found aesthetically acceptable were the servants' quarters.[20]

Most of these sympathetic foreigners shunned commercialization and scorned tourists, but some recognized in tourism an incentive for preserving Mexican distinctiveness. In 1931 Frances Flynn Paine, a tireless marketer of Mexican artists in New York City, suggested that Mexico might develop an economically vibrant tourist industry "by preserving the peculiar charm of the architecture and the customs and costumes of her many Indian tribes," and "at the same time she will be conserving the very best of her own inheritance."[21]

Mexican intellectuals shared this concern. In 1930 Manuel Gamio and the sociologist Lucio Mendieta y Núñez successfully lobbied for passage of a historical preservation law. To put their ideas into practice within the picturesque colonial mining city of Taxco, Guerrero, they recruited prominent full- and part-time residents including such familiar names as Doctor Atl, Adolfo Best Maugard, Jorge Enciso, Félix Palavicini, Hubert Herring, William Spratling, and Aarón and Moisés Sáenz, along with the architect Luis Barragán, the expatriate art dealer Frederick Davis, the lawyer Manuel Gómez Morín, and minister of education José Manuel Puig Casauranc. This group chartered Amigos de Taxco to draft and enforce a building code, monitor all architectural alterations or restoration, and call for burial of all telephone and electrical lines. It even prohibited vending booths, kiosks, and anything else that "violated the aesthetic."[22]

North Americans in Mexico took their cues for cultural interpretation from their Mexican colleagues, but they did not embrace the entire

range of concerns that preoccupied the Mexican intelligentsia. Instead, they sided with Mexicans who exalted indigenousness and they ignored or ridiculed Hispanophiles.

Marketing Mexican Authenticity

Foreigners, particularly North Americans, also used their pocketbooks and institutional connections to side with an Indianized Mexican nationality. Before 1910 Mexican antiques rarely circulated, but, with the revolution, financially devastated elites auctioned their heirlooms for much-needed cash. Frederick Davis, who had arrived in Mexico in 1900 to manage art sales at the Sonora News Company's Palacio de Iturbide outlet, stepped forward not only as a ready buyer but as someone who genuinely loved these heirlooms, many of which he acquired for his own collection rather than for resale. One interviewer of Davis recounted that "after 1910" a "flood of family treasures" came onto the market, "sometimes openly sold as collections, sometimes brought in secret by family servants." Together with a handful of other dealers, Davis brought to market lacquered dowry chests, blue-and-white *talavera* vases, hand-woven sarapes, and other treasures, which he sold to such prominent clients as the U.S. oil magnate Edward Doheny and the newspaper mogul William Randolph Hearst, as well as to Mexicans whose finances either had been spared by the revolution or had been amassed after the revolution (including a number of post-revolutionary politicians who preferred not to elaborate upon the sources of their newfound wealth).[23] North American interest smoothed the way for middle- and upper-class Mexicans to join in the celebration of these crafts as *muy mexicano*.

By the end of the revolution, Davis's business had branched beyond antiques into the humble products that artisans made for their own use or to sell in local markets. As his clients responded to his new offerings, he encouraged artisans to produce high-quality work and taught his customers—who included collectors, tourists, and Mexican artists and intellectuals—how to judge quality and to buy well-made crafts. Within a short time Davis had won recognition as a leading authority on *artesanías* and as a leading voice in the reframing of "curiosities" into "popular art" and had been instrumental in the 1921 Exhibition of Popular Art. He was quick to emphasize, however, that he was not alone in his appreciation and promo-

tion of these crafts, pointing to Ernesto Cervantes, whose shop down the road promoted "authentically" Indian blankets and textiles from Oaxaca.[24]

Davis made his gallery available for exhibitions by rising artists—and continued as a dealer for many of them—but the unique attraction of his business was its offering of high-quality antiques and contemporary crafts. In 1927 he took Count René d'Harnoncourt under his wing. By 1936 d'Harnoncourt would go on to work for the U.S. Arts and Crafts Board founded a year earlier at the urging of John Collier, and by 1944 he had joined the Museum of Modern Art in New York (where he became director by 1949), but it was in Mexico that he launched his career. In 1924 the post–World War I Czechoslovakian government had expropriated d'Harnoncourt's inheritance, prompting the destitute count to flee to Mexico the following year. Failing to find work as a chemical engineer, he tried his hand at a variety of odd jobs, including collecting antiques for a few wealthy clients. In Davis's shop he made a name for himself based on his skill as a collector, his ability to work with clients, and his "revival" of the lacquer industry of Olinalá (see chapter 8). Davis, for his part, was impressed by d'Harnoncourt's eye for quality and his aristocratic air, which he knew would appeal to clients.

Shortly after joining Davis's shop, d'Harnoncourt acknowledged the importance of foreign buyers. In the pages of a notebook he kept in 1927 he wrote: "The Mexicans who are interested in art objects are with very few exceptions members of the highly educated upper class, which is entirely broke and unable to buy . . . For Mexican stuff, one has only to figure with the foreign colonies and the tourists. The most important group among these are the Americans."[25] He also commented that "Mexico was really terribly exciting around 1928 and 1929; the nation's whole intelligentsia felt very strongly that this was a period of great social and artistic and intellectual revival. Add to that the fact that things were so picturesque—a lot of little revolutions were going on—and the result was a rather interesting unrest." Moreover, "America was just beginning to get interested in Mexico. Waldo Frank, Stuart Chase, and Elmer Rice had begun to come down. Fred Davis's store was the only place that took a real interest in the folk-art business, and, in a funny kind of way, it became the . . . headquarters" for the postrevolutionary intelligentsia.[26]

D'Harnoncourt undertook tireless treks into the countryside in search

of novel crafts for Davis's clients. One acquaintance remarked that "René's real talent appeared when he went out to buy for the shop. Astride tiny horses with his knees knocking his chin, he rode rocky trails to wherever good workmen were making things. Every village had its specialty. Gourd birds or straw toys. Lava corn-grinders. Heavy cotton in double weave. Painted jars."[27] D'Harnoncourt used Davis's willingness to pay high prices for quality as leverage to convince artisans to revive old techniques, to improve workmanship, and to draw inspiration from old designs. As word spread, artisans began to bring their wares directly to Davis's downtown shop. When an artisan offered a craft that d'Harnoncourt and Davis did not wish to buy, rather than simply reject the piece they explained why and suggested how the artisan might improve his or her work.[28]

Buyers who were willing to pay premium prices generally came to contemporary crafts by way of antiques, and they judged the antiques and the contemporary objects against similar standards. Artisans had to be astute producers and readers of trends in order to benefit from the subtleties of this niche market. By acting as links between the antiquities trade and contemporary artisans, d'Harnoncourt and Davis expanded the market for the kinds of popular arts that such Mexicans as Atl and Montenegro were keen to promote.

The Privileges of Discovery

In contrast to nineteenth-century explorers or the famous British modernist novelist D. H. Lawrence during his visit to Mexico in the 1920s, most of the expatriate artists and intellectuals in Mexico, including Toor and her many collaborators, did not claim to have discovered barbarism or even hot-tempered revolutionaries. Instead, they purported to have found peaceful Indians unselfconsciously celebrating their festivals, cutting corn, making art, and passively reproducing timeless folkways. They presented themselves as modern discoverers of this unknown Mexico who revealed that the purportedly savage countryside was in actuality a peaceable kingdom.[29] Not just anyone, however, enjoyed the privilege of claiming such discovery.

These travelers engaged the countryside as an aesthetic experience. We see this in the case of William Spratling, father of the Taxco silver industry, noted collector of Mexican arts and antiquities, and an expert on Guerrero's backcountry, who in recent years has been the subject of much

scholarship.[30] After his arrival in Mexico he published a number of articles on colonial architecture, then wrote a book titled *A Small Mexican World* (published many years later) in which he "wanted to picture normal life" in rural Mexico.[31] Spratling recounted the challenges of his journey down the Balsas River into the tropical wetland of northwestern Guerrero. He described this region, known as *tierra caliente*, as "a Mexico unknown even to the Mexicans," harboring within it the "country's physical unconscious. It is vast and fecund; forbidding and promising; it is practically unexplored and difficult to access. It is a tierra but slightly incorporated into the nation." The people, the trees, and the mud seemed to Spratling inseparable. Indians "emerge from the brown waters of the river—a symphony of tones of the same colour."[32] To his eyes, everything blended into an organic, aestheticized, and unrefined whole.

The vehemently anti-Marxist Spratling clashed with the left-leaning idealist Anita Brenner. But they ran in the same bohemian circles and they both viewed themselves as intrepid explorers. After a three-and-a-half-year hiatus from Mexico during which she completed her doctorate under Franz Boas at Columbia University, Brenner won a Guggenheim fellowship. With grant money in hand and possibly inspired by Spratling, she returned to Mexico in 1930 anxious to explore the art, culture, and geography of the "partially or completely unknown" southern state of Guerrero. During this expedition (planned, in part, by Spratling), she and her new husband, David Glusker, documented festivals and religious practices. Eager to refute the negative views prevalent in the United States, she constructed a narrative of rural Mexico as a peaceful land of art and folklore awaiting discovery. This image, carefully crafted in her published writings, was contradicted by her request to the government to carry firearms that she insisted were vital for self-defense in the countryside. After her journey through Guerrero she described the experience as "a bit of savage, primitive, glorious honeymooning."[33]

Víctor Fosado presents an instructive counterpoint to such figures as Spratling and Brenner. A working-class urban Mexican with little formal education, Fosado worked for a living since childhood. When finances thwarted his plans to study painting, he turned to colonial restoration. In 1918 Davis hired him to repair items in his shop. Then, impressed with Fosado's knowledge about modern handicrafts, Davis put him in charge of expanding the shop's offerings beyond antiques into contemporary crafts.

While Fosado brought his indispensable knowledge of crafts and an ability to navigate rural Mexico, he readily acknowledged that it was Davis, whom he lauded as a pioneer in redefining "curiosities" into "popular art," who taught him to value these crafts as *art*.

By way of his connection to Davis, Fosado became firmly integrated into the bohemian and artist circles of Mexico City, where he shared his interest in popular art and his passion for painting. Beginning in 1929 he collected handicrafts for the Museo de Artes Populares (MAP) founded by Moisés Sáenz and Roberto Montenegro (see chapter 5). By the end of the 1930s he had learned English and achieved sufficient economic success to establish himself as a minor collector of modern art. In 1943, with Davis's blessing, Fosado started his own business called "Artesanías Víctor," though he continued his consulting work for Davis and, in 1949, for the Instituto Nacional Indigenista's Museo Nacional de Artes e Industrias Populares (MNAIP), which opened to the public in 1951 (see chapter 6).[34]

Every bit as much as Spratling, Brenner, and d'Harnoncourt, or even Atl, Enciso, Covarrubias, and Montenegro, Fosado cut the figure of an adventurer out to discover and make known the "real" Mexico. But he seems never to have been considered an insider in the cosmopolitan and nationalist circle within which he moved. Anita Brenner later wrestled with the issue of her own insider/outsider status, but in a very different way. When the Mexican government offered her the Aztec Eagle Medal, the highest official honor available to a foreigner, she rejected it, insisting that she was not a foreigner. Some foreigners such as the Spaniards María Consea and Germán Bilbao, the Nicaragüense Francisco Zamora, and the Dominican Pedro Henríquez Ureña found ready acceptance as nationalist insiders, perhaps because they came from Spanish-speaking countries. But, despite her fluency in Spanish, her Mexican extraction, and her contributions to the forging of a postrevolutionary national identity, Brenner remained "foreign." Fosado, by contrast, was accepted as both an insider to *mexicanidad* and to the popular classes but, unlike Brenner, he never gained acceptance as a cosmopolitan nationalist. The reason for this involves issues of race and class.

Because Fosado had come from the working class, he had not been educated in the same milieu of privilege as had most of his colleagues. Collectors and scholars turned to him for advice but treated his knowledge as innate rather than acquired. In 1929, when Moisés Sáenz submitted a

list of potential advisors for a major show on Mexican popular arts to be financed by the Carnegie Foundation, he proposed Diego Rivera, Jorge Enciso, Roberto Montenegro, and almost two dozen other names (most of whom had never published anything on popular art—in fact, d'Harnoncourt himself never published anything on the subject until after he had been selected to head the Mexican Art Show of 1930–32), but not Víctor Fosado.[35] It was Fosado who had amassed many of these individuals' collections and who taught them the ins and outs of popular art, yet neither Sáenz nor others (such as the ambassador Dwight Morrow or Homer Saint-Gaudens of the Carnegie Institute of Fine Arts) ever considered him as a potential curator or even as an official advisor. They frequently credited Fosado with having taught them about popular art, but they held him up as a subject, not an agent, of the ethnicized nationalist discourse.

Working-class artists such as Amado Galván (the most celebrated ceramicist of Tonalá), Mardonio Magaña (an artisan "discovered" by Diego Rivera and subsequently hired in Mexico City to teach sculpture), or Juvencio Ayala (a pioneer in the revival of Olinalá's lacquered art)—despite being lauded as "true artists" by Rivera, Toor, and others—remained passive transmitters. Working-class collectors and craft-revivalists such as Fosado or Salvador Solchaga (who led the lacquer revival in Pátzcuaro) found themselves in a similar position. Though they matched or exceeded the other intellectuals in terms of knowledge and experience with the popular arts and even ran in the same social circles, they lacked the formal training, the familial and institutional connections, and the requisite presumption of privilege. They found themselves described by their peers as "Indians," with the assumption that their expertise came not from study or particular talent but had been passively acquired by the mere fact of their supposed Indianness.[36] Even those who actively validated indigenous Mexico, then, reinforced old patterns of ethnic and class hierarchy and kept "Indians" in their place as objects waiting to be discovered, exploited, and explained by others.

The Morrows in Mexico: Patronizing Authenticity

At the end of the 1920s U.S. ambassador Dwight Morrow and his wife Elizabeth Cutter Morrow helped push the validation of Mexican handicrafts into the highest levels of international society. Dwight Morrow arrived in October 1927 to repair U.S.–Mexican relations, which had degenerated

due to conflicts over oil, debt, and religion.[37] The previous ambassador, James Sheffield (1924–27), together with the U.S. business community in Mexico, had openly praised the deposed Porfirian dictatorship and dismissed postrevolutionary leaders as half-breed Bolshevik conspirators unfit to rule their own country. Mexicans, joined by sympathetic foreigners, denounced Sheffield and the oil industry. The journalist Carleton Beals, for instance, wrote that "class-pride, race-hatred, and provincial backwardness mark" the "narrow minds" of the U.S. business and diplomatic enclave whose members "despise the Mexican and his ways of living." The enclave countercharged that Beals, Gruening, Tannenbaum, Toor, and all the other North Americans who cavorted with Mexican "radicals" and peasants were Soviet agents and traitors to their own country.[38] When the U.S. government, oil companies, and yellow journalists failed to win public support for a military invasion of Mexico on behalf of U.S. oil companies, President Calvin Coolidge replaced Ambassador Sheffield, who had proven himself a firebrand and a racist, with his old Amherst College classmate and political advisor Dwight Morrow, who at that time was a partner in JP Morgan.[39] Within a short time, Morrow's disarming mantra of respect for national sovereignty won the cooperation of highly placed political, economic, and cultural leaders in Mexico.

The ambassador's political goals were aided by his and his wife's genuine love for Mexican culture, specifically the version of the national culture promoted by the postrevolutionary intelligentsia, that is, "Indian" and romantic Mexico. In Cuernavaca the Morrows purchased a colonial home from Frederick Davis and several adjoining lots, then hired a mason who under the supervision of Davis extended and remodeled their home. In a play upon the name "Morrow," they named their retreat Casa Mañana. According to his personal biographer, Dwight Morrow "came to love this house and garden more than he had ever loved a house before" and would "spend hours selecting objects of Mexican handicraft to decorate the rooms, or in placing Indian jars and water-pots at fitting distances upon the steps and terraces" (figure 18).

Dwight Morrow certainly enjoyed Mexico's popular arts and antiques, but it was Elizabeth Cutter Morrow, raised in the cultural circles of Cleveland and New England and educated at Smith College, who was the true enthusiast. She took frequent sight-seeing trips with prominent Mexican artists and intellectuals, including Moisés Sáenz, whom she echoed when

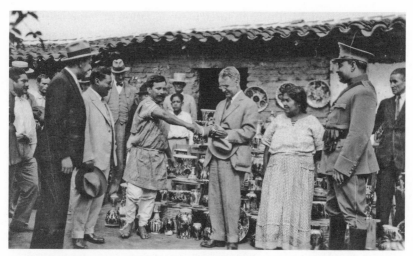

18. Dwight Morrow inspecting Oaxacan pottery, August 1929. Gelatin silver print photograph. Amherst College Archives and Special Collections. Used by permission.

she wrote that Mexicans were starkly divided among the "Indian majority," the "middling ruling classes," and the old-regime aristocracy. It was the "indigenous majority" that attracted her interest and which she viewed as the real Mexico. The Indian, she wrote, "is not a savage, but a person of artistic feeling with a real appreciation of beauty, and an innate politeness and gentleness."[40]

As the Morrows and other foreigners criticized Hispanophiles and celebrated folkloric Mexico, they lent legitimacy abroad to the claims by certain Mexican intellectual factions. They also acted as patrons validating nativist art within Mexico. Through Spratling, the Morrows commissioned Diego Rivera to paint one of his nationalist *indigenista* murals in Cuernavaca's Cortés Palace. Spratling's commission, together with fees that the Morrows paid him to collect popular art for their home, enabled him to launch his transformation of Taxco and of the silversmith industry. Near the center of the colonial town, he, like Morrow, purchased a picturesque house, which he turned into the headquarters for the silversmith industry and a mecca for Mexican nationalists and foreign sympathizers.[41]

Prominent Mexican artists and intellectuals, as well as foreign visitors, passed through Spratling's Taxco home and shop and listened to his tales of unexplored regions of Mexico, where childlike Indians were natural artisans who "lived simply" and "close to the soil." One might be tempted to

attribute Spratling's attitude to foreign exoticization or imperialist arrogance, but although undoubtedly there is truth to this (Spratling made no effort to hide his racism and paternalism), the fact is that he derived many of his views about Mexico from Mexican friends such as Diego Rivera, Roberto Montenegro, Jorge Enciso, Moisés Sáenz, and Doctor Atl. Moreover, Mexicans themselves often enlisted Spratling as an authority on things Mexican ranging from handicrafts to urban architecture.

One of the Morrows' main contributions to the transnational ethnicization of Mexican national identity was their patronage of the 1930–32 Mexican Arts Show supported by the New York Metropolitan Museum of Art, the Carnegie Institute of Fine Arts, and the American Federation of Arts. It was not the first international exhibition of the kind. It had been preceded by the Los Angeles exhibition for which Katherine Anne Porter had written the catalogue in 1922 and a for-profit exhibition staged by Frances Flynn Paine in her New City gallery in 1928. It was, however, the first major *public* exhibition, and certainly the largest and most important. Just as the centennial exhibition by Montenegro, Enciso, and Atl in 1921 set the tone for the early 1920s as well as revealing deep-seated tensions, so, too, did the 1930–32 exhibition contribute to the mood of its own time. Above all, it highlighted the role foreigners had come to occupy in shaping the cultural nationalist discourse, and the fault lines emerging within transnational cooperation.

The exhibition grew out of Dwight and Elizabeth Morrow's fascination with Mexican arts. Starting in her first weeks in Mexico in 1927, Elizabeth Morrow became a regular at outdoor markets and antique shops. Mexican artists and intellectuals guided her newfound interest, but she relied most upon her contact at Davis's shop, René d'Harnoncourt. Over the next three years he helped her assemble an impressive collection, drew illustrations for her children's book *The Painted Pig*, and helped decorate the Morrows' home with handicrafts and fine art. He passed time at Casa Mañana musing with other national and international guests about indigenous influences in Mexican art. During these gatherings he convinced a number of easel painters to contract with Davis's gallery. More importantly, he so impressed Moisés Sáenz with his knowledge, cultured manner, and personal amiability, along with his success at reviving various handicrafts in rural Mexico (see chapter 8), that the undersecretary of education commissioned him to curate several small exhibitions for the ministry.

Dwight Morrow became convinced that an internationally traveling exhibition might improve U.S.–Mexican public understanding. In 1929 he presented his idea to Frederick Keppel, director of the Department of Fine Arts at the Carnegie Institute, and Robert DeForest, lawyer and president of the Metropolitan Museum of Art in New York, and then hired William Spratling to draft a proposal for such an exhibition. After whittling the list of potential curators down to six, Dwight Morrow and Homer Saint-Gaudens of the Carnegie Institute of Fine Arts selected René d'Harnon-court.[42]

The Metropolitan Museum of Art initially had hoped to hire Doctor Atl as curator, based on the reputation he had won for his famous catalogue for the Exhibition of Popular Art in 1921. Atl already had his hands full launching the DMAAH (see chapter 4) and the Comité Nacional de Artes Populares (see chapter 5), so Saint-Gaudens hired d'Harnoncourt as curator and contracted Atl to write the catalogue. After Atl missed numerous meetings and deadlines, the Metropolitan Museum was in a bind. To avoid an international row the museum decided to pay Atl a large commission and give him formal credit at the preview opening in Mexico City but not to ask anything more of him. D'Harnoncourt therefore not only curated the show but also wrote the catalogue.

Though Atl was no longer directly involved, d'Harnoncourt overtly modeled his effort after Atl's earlier example.[43] The exhibition included fine as well as folk art but, following Atl's example, d'Harnoncourt included only those crafts that were "truly Mexican," by which he meant that their indigenous influences overshadowed those from Spain, Europe, or the United States. In June 1930 a preview exhibition opened in the main galleries of the Ministry of Education amid much official fanfare and with the attendance of leading intellectuals and dignitaries. Guests toured the galleries while listening to an orchestra play the nationalist compositions of Carlos Chávez, who at that time was all the rage in New York City.[44] The show subsequently moved to its primary venue, the Metropolitan Museum of Art in New York City in October 1930 (figure 19). It then traveled to other museums across the United States. At each stop it drew record visitation and high praise, such that its tour extended from eight to thirteen cities. The exhibition included easel painting by such leading artists as Diego Rivera, but critics and the public focused on the popular art galleries. This was the art that seemed most novel to the foreign audience, as it had

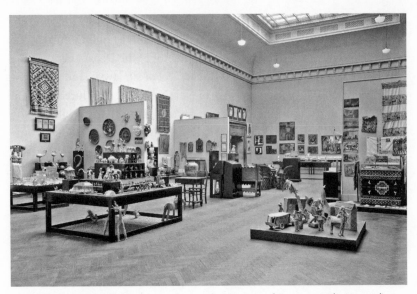

19. Mexican Arts exhibition, October 1930. Metropolitan Museum of Art, Image © The Metropolitan Museum of Art. Used by permission.

to Mexicans themselves a decade earlier. And it was this art that seemed to mark Mexico as a distinctive society, with its own niche in world civilization.

Through their own efforts, and through those they supported and patronized, the Morrows helped change the climate of U.S.–Mexican cultural relations, deepened U.S.–Mexican cooperation, and lent greater international legitimacy to the ethnicized view of Mexican national identity. They did not do it alone; they were able to make a difference precisely because so many other people, including d'Harnoncourt, were involved. In the text for the exhibition and in the speeches he delivered while accompanying the traveling show from 1930 through 1932, d'Harnoncourt stressed that the artisans were indigenous people from "remote parts of the country still unknown" and untouched by modernity, foreign influences, or "dehumanizing mass production." He readily admitted his intellectual debt to his Mexican colleagues, above all to Doctor Atl, who he claimed had taught him to understand and appreciate Mexican popular arts and the real Mexico.[45] By bringing together these layers of interpretation and collaboration Morrow and others deepened the transnational esteem for ethnicized *mexicanidad*.

But there was a problem. Despite Mexicans' involvement and d'Harnoncourt's showcasing of their ideas, the fact remained that, unlike the 1921 exhibition, in this show foreigners dominated the key roles ranging from conceptualization and funding to curating and promotion. This exhibition was the culmination of a long honeymoon of transnational cooperation, yet it brought that cooperation into crisis as Mexicans, astonished at the growing influence of foreigners in shaping *mexicanidad* and dismayed at the way this discourse had narrowed, took steps to take control over their own national heritage.

Consolidation and Erasure: Reanimating the Boundary between "Mexican" and "Foreign"

Scholars sometimes assume that the Mexican intelligentsia was privileged to the real Mexico while foreigners saw only what they wanted to see. But the boundaries between "foreign" and "national" interpretation of culture were neither as absolute nor as mutually exclusive as one might think. And Mexican cultural elites were not necessarily any closer to the "real" Mexico or to the popular classes than were resident foreigners. As the art historian Alicia Azuela has pointed out, even muralists, widely regarded as bridges across the popular-elite divide, often invoked popular groups not to genuinely connect with them but to promote themselves professionally and socially "within the new revolutionary order."[46]

Not only were Mexican cultural elites no closer to the masses than certain foreigners but they had worked symbiotically with those foreigners in the formation of a cannon of authentic *mexicanidad* during the 1920s and 1930s. Whether foreigners came from the United States, Spain, Central America, the Dominican Republic, or Central Europe, they aspired to speak with authority about the "real" Mexico. Sympathetic foreigners worked in close collaboration with Mexican colleagues to sift through, synthesize, and reinforce particular aspects of the postrevolutionary nationalist discourse. Mexicans often ascribed particular intellectual authority to foreign experts, and they sought legitimization through affiliation with foreign (especially U.S.) academic and research institutions.[47] Foreigners, in turn, sparred among themselves over the accuracy of their respective claims about Mexico and leaned on Mexicans' approval of their findings. The result was a symbiotic relation in which foreigners and Mexicans traded in access to markets, research funds, institutional affiliations, and

domestic and international respectability. Moreover, while it was Mexican intellectuals who drew foreigners' attention to the countryside, it was the foreigners' research within these settings that helped tie nativist nationalism to specific rural practices, rather than to the initially vague notion of "the Mexican Indian." Within this climate foreigners and Mexicans worked together to consolidate pro-indigenous and pro-peasant artistic and cultural impulses while marginalizing Vasconcelista Hispanophilia.

In the early 1930s the nature of this collaboration changed as Mexicans recognized a disturbing trend. The landmark Centennial Exhibition of Popular Art in 1921 had been controlled entirely by a small group of Mexicans recently returned from the bohemian circles of Europe, who brought their cosmopolitan ideas to bear upon their views of indigenousness and the nation. Then came the 1922 exhibition, organized by a broader circle of Mexicans with a foreign spokesperson and a foreign audience. The show of 1930–32 took all of this to the next level: Mexicans were involved, but in the background as advisors and sources of inspiration. Foreigners controlled the conceptualization, the process of collecting, the presentation, and even the explanation of indigenousness, popular art, and national identity. Nationalists celebrated the show's success and its embrace of handicrafts as a central component of the ethnicized national identity, but they were stung by its foreign control and by the fact that it overshadowed all of their own initiatives, not just abroad, but also within their own country (see chapter 4).

These anxieties were tied to broad concerns about the expansion of U.S. economic and political power during the interwar years. This growth in the power of Mexico's northern neighbor was matched by U.S. researchers' expanded activity across the globe. As a recent study of the linkages between empire and anthropology points out, "internationalization" created "new alliances; yet it also represents a potential threat to the extent that it encroaches on the interpretive monopoly" to which both "national intellectuals" as well as U.S. foreign researchers, each aspired.[48] Some mistrusted foreigners, wary that they might put the interests of the United States ahead of those of Mexico. The fact that the U.S. government and grant organizations (such as the Rockefeller Foundation) sometimes manipulated cultural policy to smooth the way for imperialist political policies, as argued by Alicia Azuela, might account for some of this suspicion.[49] More often, however, anxieties seem to have resulted from a general sense

that foreigners were gaining undue control over the construction of structures of knowledge that were supposed to serve the nationalist cause.

Even the artist Gabriel Fernández Ledesma, a major proponent of international cultural collaboration, sought to reclaim Mexicans' voices of authority. Younger than many of his colleagues, Fernández drew inspiration from several generations of artists including Saturnino Herrán, Atl, Montenegro, and Rivera, as well as from ethnologists such as Miguel Othón de Mendizábal. By the early 1920s he was teaching art courses in the Escuela de Bellas Artes and in various experimental schools and urging his students to draw their inspiration from popular art and indigenous culture. In 1923 he and his brothers Enrique and Luis founded a firm that marketed popular art, a business he maintained at least into the 1950s. In 1934 he would help found LEAR (Liga de Escritores y Artistas Revolucionarias, League of Revolutionary Writers and Artists), an internationalist art group that turned from communism to popular frontism as it advocated for the proletariat.[50] He also worked with Roberto Montenegro at the Museo de Artes Populares promoting handicrafts in Mexican and foreign markets (see chapter 5). Ledesma consistently argued that artists needed to develop accessible art forms and they needed to address the masses, whom he and others considered largely indigenous.

Ledesma had less international experience than his colleagues, but, like them, he had developed his ideas while steeped in the virtues of transnational cooperation. Yet he chafed at the inequalities within this cooperation. After he was promoted to head the publishing unit of the Ministry of Education in the mid-1930s, for instance, he protested that Mexican authors were disadvantaged because, whereas foreigners (by which he meant those from the United States) distributed their ideas through high-quality publications, Mexicans' editorial houses, in his view, suffered substandard editing, image reproduction, manufacturing, distribution, and promotion. Even in Mexico foreigners' books received wider distribution and readership than did those by Mexicans. Like Gamio, he also complained about the country's lack of adequate academic training facilities, the absence of private cultural foundations, and the lack of research money. All of this, he argued, put Mexicans in the position of having to rely upon foreigners even to learn about their own country.[51] He found this outrageous and unacceptable, and he was not alone.

By revising historical memory, Mexicans tried to reclaim their right to

define their own heritage. During the opening of the Mexican Arts Show in Mexico in 1930, Doctor Atl praised Dwight Morrow for his patronage, but he gave even more praise to the Mexican government and to Minister of Foreign Relations Genaro Estrada (who played no role in the event other than approving the travel of the items beyond Mexico's borders). Neither in the inauguration nor in any of his future discussions of the exhibition did Atl ever mention d'Harnoncourt. His stance reflected a growing tendency by Mexican artists and intellectuals to erase foreign contributions as a way to claim for themselves the exclusive right to define and speak for the real Mexico.

The power and perceived urgency of this historical revision was such that even the artist Rufino Tamayo, whose fame relied on the attentions of New York City art critics, began to denounce foreign influence. He urged the Departamento de Bellas Artes to purge rural art education of foreign influences. After touring rural schools he wrote that "it was truly painful for me" to see "spontaneous everyday artistic manifestations of the people" altered to conform to the "ridiculous guises of the city, and, *even worse, they showed the stamp of foreignness.*"[52] Tamayo was part of a selective amnesia, a growing tendency to judge "authentic" and folk traditions as worthy of preservation against the fox trot and souvenirs, even though in truth both "authentic *mexicanidad*" and tourist souvenirs were shaped equally by foreigners.[53]

Roberto Montenegro, one of the pioneers of the transnational exchange whose very interest in popular art was informed by his experiences in Europe, his reencounter with his homeland, and his dealings with Frederick Davis's shop, and who acted as an intellectual guide to many of the foreign sympathizers and researchers, also became an agent of this selective amnesia. During the 1920s Montenegro had praised the virtues of foreign-Mexican collaboration, but by the end of the 1930s he had become uneasy with the foreign presence and joined the effort to erase the transnational roots even of his own celebration of rural and indigenous traditions. In the catalogue for the international exhibition he helped curate in 1940, Twenty Centuries of Mexican Art, which showed at the Museum of Modern Art in New York City and at the Instituto de Antropología e Historia de México in Mexico City, he and Antonio Castro Leal chronicled the history of Mexico's popular arts and their vindication after the revolution. Their narrative conspicuously omitted Frances Toor, René d'Harnon-

court, and every other foreigner. Moreover, when they declared that the 1940 international exhibition was without precedent, they willfully ignored the existence of the massive Mexican Arts Show of 1930–32.[54] Though that exhibition had occurred only a decade earlier and had a profound impact on perceptions of popular art within Mexico and abroad, nationalists expunged it from official memory.

At the very moment they overtly erased the foreign presence, Mexicans continued to embrace the inflections that foreigners had contributed to the definition of authentic national culture. In 1921 Atl had stated as polemic that the indigenous peasantry embodied the real Mexico. By the time of the 1930–32 Mexican Arts Show, Mexican-foreign collaboration had transformed this polemic into an incontrovertible historical "fact." Montenegro and Castro Leal, like Tamayo before them, continued to claim this as a "fact," but they reframed it from something that had been elevated through Mexican-foreign collaboration to something to which only Mexicans were privy, and as a heritage that foreign cultural corruption now threatened.

Much of the concern about foreign interference was that it threatened to destroy "authentic" Mexican culture, but the critique of the foreign gaze sometimes shifted in the other direction, accusing foreigners of *overvaluing* folklore and tradition. This perspective came to the fore especially after the creation of the Instituto Nacional de Antropología e Historia (INAH) in 1938, which signaled the rise of official *indigenismo* linked to the state. As anxieties about whether Mexico was sufficiently integrated to assure political stability and economic growth receded into the past, *indigenistas*, who became disillusioned with the potential of indigenous culture, refocused their energies on de-Indianizing the population (see chapter 4). The clash between official *indigenismo* and the tendency among foreigners to esteem Mexico's subcultures became evident in a disagreement in 1946 between the U.S. anthropologist Robert Redfield, known for his studies of rural Mexico, and the Mexican investigative journalist Fernando Jordán, which has been recently recounted by Claudio Lomnitz. When Redfield expressed concern that the program for rapid industrialization proposed by the newly inaugurated president Miguel Alemán might threaten the ability of rural groups to preserve their distinctive cultures, Jordán hit back. He accused Redfield of assuming that Mexico "only has a proper form when it is viewed through the kaleidoscope of native costume, dance,

and through the survivals of prehispanic culture and the 'folkloric' misery of indigenous people. But if this is part of Mexico, it is not Mexico itself, and it is not what our nation wishes to preserve." As Lomnitz points out, the danger from the perspective of *indigenistas* bent on de-Indianizing Mexico in the name of modernization was that foreigners might "adhere to the Indian and reject the modern." *Indigenistas* also used their attacks on foreigners to discipline their fellow Mexicans, branding as unpatriotic those whose work advocated the value of Mexico's subcultures as worthy of preservation or as equal to "modern" urban society.[55]

This chapter opened with discussion of a cartoon from 1926 that contrasted a Mexican middle-class man horrified by the backward lower classes and a foreigner mistaking refuse for something worth photographing (figure 17). Though much had changed in the two decades that separated the cartoon from Jordán's comments, they share a discomfort with the ideas of esteeming rather than "civilizing," "de-Indianizing," and "modernizing" Mexico's subcultures; and they both blamed foreigners for a perspective that was fundamentally transnational.

Recognition of foreigners' roles in consolidating an ethnicized anti-imperial Mexican national identity calls into question the tendency to treat national cultures as closed monoliths. It resituates Mexican nativism in its proper cosmopolitan context, challenging dominant interpretations of the ethnicized national identity as either an inevitable product of the country's history or as constructed entirely by Mexicans somehow cut off from their cosmopolitan and transnational realities. It also prompts us to doubt the assumption that foreign involvement has always been at odds with "true" Mexican identity and national interests, or that national elites possess a greater understanding of, and sympathy for, their own masses. The historical unfolding of the foreign-national encounter in the construction of an ethnicized national identity resists such reductionism. While the emergence of a visual vocabulary for an inclusive and ethnicized *mexicanidad* cannot be understood isolated from this transnational context, it is important to keep in mind that, as it unfolded, at no point was it separable from economic and political inequality within Mexico and across international boundaries.

🌿

The Postrevolutionary Cultural Project, 1916–1938

If the cultural transformation born of the revolution was not created as a state project, then the question remains how and to what extent it became linked to the state and with what consequences. Much of the answer comes from an analysis of postrevolutionary concerns about political stability and state control. Around 1915, as the revolution broke down into factionalism, cultural leaders proposed that part of the reason things fell apart so thoroughly was that Mexico never had been a real nation. Integration of the population into a nation, according to the prominent politician and intellectual Luis Cabrera, was one of the most urgent yet daunting tasks for the country, and many of his contemporaries agreed.[1] A decade later, in 1926, long after the violence of the revolutionary war had ended, Manuel Gamio warned that too little was being done. Using art as a barometer for the broader problem, he complained that Mexico still "does not produce legitimate art because to be legitimate" art has to be "one's own, national, reflecting in intensified and beautified form the likes, pains, life, and soul of the people." He warned that "so long as" Mexico's "painters, sculptors, musicians" and writers continued to "nourish elitist tastes" rather than engage the cultural material of the masses, Mexican art would remain derivative and mediocre, the population would stay fragmented, the country would be vulnerable to another wave of upheaval and social disintegration, and the state would fail in its drive for modernization.[2]

Gamio delivered this assessment at a time of great hope but also enormous uncertainty. Under the presidency of Alvaro Obregón (1920–24) the state patronized artists and intellectuals on a massive scale. This gave the intelligentsia a stake in the success and stability of the new government, and it won for the state the support of an important sector of civil society. Obregón's successor, Plutarco Elias Calles, drew the intelligentsia even closer to the state at the same moment that he waged war against Cristero fighters, who in the eyes of state officials and their intellectual allies represented the most troubling extreme of peasant backwardness and a threat to their revolutionary vision. At the time of Gamio's statement, projects dedicated to the discovery and promotion of a distinctive national culture as of yet were little more than experiments.

Three years later, in 1929, the prominent educator Moisés Sáenz reiterated Gamio's concerns, but now with a greater sense of optimism. Perhaps heartened by the emerging renaissance, Sáenz now felt that Mexico at last had begun to move toward nationhood, thanks in large part to the arts. He declared, "Thank heaven here in Mexico," despite differences and fragmentation, "we have a common ground on which to tread, we have a music, we have a culture, we have a tradition. If words fail to unite, musicians, dancers, and painters will cast their spell and make us one." No doubt his view also reflected the changes in the political situation. When Obregón tried to return to the presidential chair in 1928, an assassin's bullet cut him short. The next year Calles created an official party called the Partido Nacional Revolucionario (PNR, which in 1946 would become the Partido Revolucionario Institucional, or PRI, which would dominate Mexico for almost seven decades). The new party did away with the need to negotiate fragile political coalitions, and during a period known as the Maximato (which would continue until the election of Lázaro Cárdenas to the presidency in 1934), Calles used this party to exert strong, though not absolute, control over his successors. To lend an air of legitimacy to his system of rule, Calles expanded state support for artists, researchers, and intellectuals who, for their part, eagerly sought state support for their endeavors. Nation formation moved hand in hand with the consolidation of a stable, centralized political system; and both state and nation formation counted upon strong backing by the intelligentsia.

As the intelligentsia and the state fed off of one another, Sáenz reiterated Gamio's insistence that for integration to succeed, Mexico needed an

ethnicized national culture. In 1916 Gamio had stated that "to incorporate the Indian we . . . must 'Indianize' ourselves a bit, to present him with our civilization already diluted with his own." Sáenz, in 1929, similarly insisted that the Indian and the "Mexican" each had to change to accommodate the other and, in the process, forge a new national culture.[3] Gamio and Sáenz hoped to cultivate and harness this ethnicized identity to construct a structure of national-popular hegemony directed by an emerging class of intellectuals backed by the power and structure of the postrevolutionary state that, together, would be capable of intervening into the lives of Mexicans at all levels of society.

This chapter argues that in the 1920s there was no powerful state twisting intellectuals' arms to serve its cultural project. Rather, it was intellectuals and researchers striving to win state support for their own initiatives. Only after they laid out their research goals and their methodology, and often not until their projects were significantly under way, did the state agree to lend them official support. By the end of the 1930s, after they had brought their project firmly into the state, these same intellectuals would find themselves marginalized by a newly empowered and expanding state—a state whose cultural and political hegemony they themselves helped construct.

The analysis traces the unfolding of this intellectual-state alliance and the institutions through which it operated. The most important such institution was the Departamento de Monumentos Artísticos, Arqueológicos e Históricos (Department of Artistic, Archaeological, and Historic Monuments, henceforth referred to as the DMAAH). Despite the DMAAH's importance it has received little scholarly attention. Because the DMAAH's archives had been lost for so long, existing scholarship simply skips over the evolution of major cultural institutions between 1930 and 1939, the years when they were all temporarily folded into the DMAAH. This chapter recovers the story of these institutions and the crucial role they played in the consolidation of a postrevolutionary state project of national cultural integration.[4]

Toward an Intellectual-State Alliance

The Mexican intelligentsia of the 1920s sought an institutional alliance with the state. Manuel Gamio stood at the forefront of this effort when, in 1917, he created the Bureau of Anthropology (Dirección de Antropología)

within the Ministry of Agriculture and Industry (Secretaría de Agricultura y Fomento). José Vasconcelos led the next major step when he oversaw the creation of the federal Ministry of Public Education in 1921, which became a haven within the state for intellectuals and artists to turn their ideas into action. His greatest legacy was the institutional framework he created and his willingness to incorporate even his fiercest critics. Gamio's influence, by contrast, came not from his institutions (most of which proved fleeting) but from the degree to which his ideas resonated with and influenced people around him, including those who staffed the institutions created by Vasconcelos. This complex period is not reducible to the positions of Gamio and Vasconcelos, yet an examination of their ideas and impact offers insight into the development of state cultural institutions in postrevolutionary Mexico.

Gamio came from a prosperous Mexico City family and was educated at the finest private schools. He developed an interest in the plight of indigenous people as a result of time he spent on his family's estate in Veracruz. After studying anthropology at Columbia University under the famous pioneer in theories of cultural relativism Franz Boas, Gamio achieved national prominence in 1916 with his book *Forjando patria* that called upon Mexican leaders to break with Europhilia (which Gamio argued could never lead to real national unity nor to enduring modernization) and instead to embrace the *campesinado* (which he argued was fundamentally indigenous) as the bedrock for the future.[5]

Gamio's proposals drew the support and praise of major cultural and political figures, including Alvaro Obregón (who would become president in 1920), and offered inspiration to scores of intellectuals and artists. A year later, as chief of the Bureau of Anthropology, he followed up with a report that declared that the state's ignorance about Mexico's population constituted a crisis. It was not that state leaders lacked interest, he argued, but rather that no one had ever before thought to collect such information. He outlined an ambitious plan by which his bureau would study virtually every population in Mexico—for which his own study of Teotihuacan, funded by the same agency, was to serve as a prototype—investigating not just their language and demographics but also things that had never before interested the state: food, habits, local forms of governance, "organic philosophy," religion, physiognomy, and popular perceptions of the world and the nation.[6] He hoped that such information might equip the govern-

ment to integrate the population, propel Mexico toward its own distinctive modernization, and forestall a repeat of the recent revolution.

Eager to convey his arguments to the general public, Gamio wrote frequent newspaper editorials; organized a multimedia exhibition displaying objects, music, and video from his studies in Teotihuacan; and in 1920 founded a journal called *Ethnos*. The purpose of the journal was "to draw public attention to the fact that there is a large majority of Mexicans about whom [the government] knows nothing." *Ethnos*, he declared, "will have achieved its highest purpose" when "national leaders, the central government, state governors, the press, churches, scientific and philanthropic organizations, and, above all, our fellow citizens become one with those" whom they previously disparaged and together forge a genuine nationality.[7]

The aspect of Gamio's vision that is most misunderstood today is his call for "homogenization." Scholars too often presume that Gamio in the 1920s called for the elimination of cultural heterogeneity, especially of indigenous cultures. Building upon this misapprehension, they then exaggerate the extent to which the postrevolutionary state quashed difference in favor of a supposedly single-minded project of uniform *mestizaje*.[8] Prominent students of Gamio such as Juan Comas and Miguel León Portilla have attempted to counter this entrenched misunderstanding.[9] As is borne out by a careful reading of his publications, archives, and correspondence, when Gamio called for homogeneity during the 1920s and the early 1930s he was not calling for the destruction of pluralism and regional differences. This would change at the end of the 1930s as he became disillusioned with indigenous peoples and backed "official *indigenismo*" as a form of draconian de-Indianization. But in the 1920s and early 1930s he used the term "homogenization" referring not to the elimination of difference but to the formation of shared cultural bonds. Similarly, his insistence on a common language was not a call for the elimination of indigenous languages but for everyone to learn Spanish as a lingua franca so that they might protect their rights and participate in national politics, and as a cultural conduit linking each segment of society to the rest of the population.

France, Germany, and Japan repeatedly emerge in Gamio's early writing as models of nationality attained thanks to what he perceived as their ethnic, linguistic, and cultural unity (which he sometimes refers to as race, language, and civilization). He makes clear his view that nations such as

Germany were integrated not because they were unburdened by heterogeneity but because they were able to find ways to bridge their cultural differences such that they came to share certain "sentiments, and aesthetic, moral, religious, and political expressions." Gamio praised them for having "achieved the miracle" of "unity and distinctive [national] character" while nurturing internal diversity. This was Gamio's aspiration for his homeland—an aspiration he shared with others, including Miguel Othón de Mendizábal, who suggested that the ideal outcome for Mexico was to unite all the people of Mexico economically, politically and culturally while preserving the unique characteristics of the many "small nationalities."[10]

What made Mexico different from Germany, Gamio argued, was the presence of indigenous and mestizo people (he blurred the line between mestizo and indigenous because he considered mestizos to be closer in culture to indigenous people than to Europeans). He claimed that these groups suffered from "deformed" traits that impeded their continued "cultural evolution." Under this category he placed religious fanaticism, certain folk medicines, resistance to public schooling, undemocratic political traditions, and so forth. These flaws, in his view, resulted from historical circumstances, not from inherent racial or cultural inferiority. He blamed centuries of colonialism, claiming that resistance against Spanish colonialism had enabled indigenous people to hold on to their cultures but only in tattered and distorted form, deprived of such key elements as a cohesive religious structure, organized education, statecraft, and the means for scientific advancement.[11] Such distortions, he claimed, had become exacerbated by a century of flawed efforts at development since independence. To fix this "retarded" and "deformed" culture, nationalists like himself needed not only to accelerate indigenous cultural evolution but also to carefully monitor and control this evolution. He was adamant about not repeating the Porfirian policy of forcing unilateral acculturation to European manners; instead, indigenous culture had to be corrected and made to evolve from its own foundations. Once corrected of their supposed cultural abnormalities, he argued, indigenous and mestizo groups could evolve rapidly, catch up with Western European culture, and contribute to the modernization and prosperity of Mexico. The nationalist task he set for anthropologists was to figure out which aspects of the subcultures in Mexico merited encouragement and which were deformities that might impede scientific evolution.[12]

He saw in postrevolutionary reconstruction an opportunity for the state to forge the population into a modern nation by intervening into local cultures so as to create points of linkage among them. The national culture, as envisioned by Gamio, was to be mestizo not through imposed uniformity but as a composite that incorporated a range of cultures. For such a national culture to emerge, the "Europeanized" elite needed to set aside its prejudice so as to appreciate and incorporate aspects of indigenous culture. At the same time, Gamio and many of those whom he inspired (including Sáenz) warned against Indianizing the nation any more than was necessary.

Gamio argued that for Mexico to achieve unity and progress, all its citizens had to receive an education. Reading, writing, and arithmetic were not enough; what was needed was a "holistic nationalist education" that would address all the needs of the community from reading and language to civics and farming and, above all, the creation of a shared understanding of Mexican nationality. As the historian Enrique Florescano has observed, Gamio made an explicit call for social engineering aided by the "science" of anthropology and by the public education system. Gamio referred to his plan as a "new conquest."[13] Whereas the Spanish conquest and nineteenth-century misrule had created deep distortions that continued to impede integration and modernization, under his "new conquest" the state would conquer the *campesinado* anew, but this time it would do it right, in such a way as to set the population on the road to progress.

José Vasconcelos laid out a different vision of how to unify and modernize Mexico. He is remembered for his leadership of the Ministry of Public Education (1921–24), his work toward the creation of a vast network of rural schools, and his role in the emergence of what Anita Brenner in 1929 would coin the "Mexican Renaissance." Gamio and Vasconcelos agreed that to elevate themselves, Mexicans needed to strive toward an ideal. Gamio argued that Mexico's ideal should emerge from the culture of the rural popular classes, redirected and perfected by modern science, above all, by anthropology. Vasconcelos, by contrast, drew upon the philosophy of Henri Bergson and Friedrich Nietzsche and the pan–Latin American idealism of the Uruguayan philosopher Enrique Rodó, combined with a faith in classic liberalism and Mexico's Hispanic heritage, to maintain that the requisite regenerative philosophical ideal had to be handed down by intellectual elites. He is remembered today for his publication *Raza*

cósmica (1925), which celebrated *mestizaje* as the way of the future, with Mexico at the vanguard. But his writings make clear that he bemoaned Mexico's racial mixture and that he did not believe his own theory, which he admitted was merely a mythology meant to boost self-confidence. In the end, his "raza cosmica" theory reinforced racist over culturalist thinking, and its celebration of racial mixture endorsed indigenous culture *only* on the spiritual level, not in terms of grounded practices.

The Mexican masses, in Vasconcelos's estimation, were incapable of changing their retrograde mindset on their own. Their uplift had to be managed by their moral and racial superiors, motivated by a desire to avert the threat of being overrun by ignorant, rapidly reproducing, inferior hordes. Even as he rejected positivism, Vasconcelos perpetuated, in a modernized form, nineteenth-century fears of the masses. In the nineteenth century Francisco Pimentel had warned of an impending race war that could be stopped only by unilaterally acculturating the masses into the "Mexican nation," defined as white and Europeanized. Vasconcelos harbored the same concern, but, whereas Pimentel threw up his hands in despair, he set out to educate the masses in reading, math, and science, along with modern philosophy and Western classic literature.[14] Even as Vasconcelos acknowledged Mexico's enormous diversity, he called for a form of education that he hoped would wipe clean the slates of students' minds so that they could be filled with the Hispanic ideals of the Mexican middle and upper classes.

Gamio and Vasconcelos agreed that only intellectual elites like themselves were capable of evaluating and "fixing" popular culture. Both men also recognized the enormous diversity of Mexico but, unlike Gamio, Vasconcelos ascribed no value to existing regional traditions or specific indigenous cultures since, in his eyes, the lower classes were uniformly backward and in need of the edifying values offered by Greek classics, Spanish culture, and modernist philosophy. He aspired to foment an authentically Mexican art and culture, but felt that popular traditions were to be endured only so long as they served as bridges leading the lower orders to higher civilization.

Disagreements between Gamio's anthropological proposal and Vasconcelos's spiritual ideal became vitriolic. In a clear jab at Vasconcelos, Gamio reproached "devoted Helenists who live and breathe Homer, who respect only the Classical traditions and the rhythmic proportions of the Parthe-

non." Diego Rivera made a similar critique in even harsher terms and in a more public and enduring forum. In a panel known as *Los sabios* from his mural cycle in the Ministry of Education, which created the stamp for Rivera's artistic style, the artist depicted his patron Vasconcelos as an effete pen-wielding pedant perched on an Oriental elephant. Rivera thus portrays Vasconcelos as distracted by elitist art and philosophy, with his back turned against the real struggles and aspirations of the largely indigenous masses hungry for justice (who fill the next panel in the cycle). An irony of Rivera's critique is that it was Vasconcelos's criticisms of Rivera's earlier art as insufficiently Mexican that had spurred (and paid) the artist to look more closely at the land and people so that he might develop a new aesthetic language for expressing *mexicanidad*. While Rivera allied himself with Gamio's vision rather than Vasconcelos's, Gamio and Rivera too had their differences. Gamio, for example, disapproved of Rivera's emphasis on labor and class, and of his promotion of socialism. He felt that socialism and class politics exacerbated rather than abated the problem of national integration and that labor unions benefited a small urban proletarian at the expense of the rural majority he considered the rightful beneficiaries of the revolution. Yet Rivera never turned against Gamio as he did against Vasconcelos.[15]

To understand why, it helps to revisit the role that Vasconcelos played in shaping state patronage. As the first minister of public education, from 1921 until 1924, he created a place for postrevolutionary intelligentsia within the state, but the success of his plans relied upon such leaders as Eulalia Guzmán, who was one of the many officials who translated Vasconcelos's vision into grounded and enduring institutions by laying out the practical framework, recruiting and training teachers, and creating and supervising artistic and educational initiatives. Eulalia Guzmán not only helped to create Mexico's cultural institutions; she also broke gender barriers within Mexico. Born in Zacatecas in 1890, Guzmán studied to be a teacher before becoming a school inspector for the Ministry of Education. She then rose to assistant head of the Department of Primary Education and Teacher Training (Departamento de Enseñanza Primaria y Normal) and taught anthropology at the International School of American Anthropology and Ethnology that Franz Boas created in Mexico. In 1926 she won a fellowship for graduate study in Germany. Upon her return in 1930 she did further graduate work in philosophy and archaeology under

the brothers Antonio and Alfonso Caso, then, in 1934, became head of the Archaeology Department of the National Museum, where she also served as a professor of pre-Hispanic pottery. For the next decade she participated in some of the country's most important archaeological excavations and took an interest in the study of history, which led to her appointment as head of the Office of History (Sección de Historia) of the Sociedad de Geografía y Estadistica. From 1937 to 1940 she traveled to London, Belgium, the Vatican, and Berlin searching the archives for documents and codices related to Mexico's early history. She identified, copied, and photographed thousands of documents, then deposited her work in Mexican archives. Throughout her life she represented her country internationally at feminist and scientific conferences. Today she is most often remembered for the controversy surrounding her claim in 1949 to have found in Ixcateopan, Guerrero, the remains of the last Aztec emperor, Cuauhtémoc, which brought her illustrious career to a close.[16] Just as the postrevolutionary cultural project was beginning to take shape, Vasconcelos left the ministry to embark on his ill-fated political career that would carry him to the extreme political right. Vasconcelos's influence came not from his ideas but from the fact that he created spaces within the state for others to put their own ideals into practice. It was figures such as Guzmán, whose ideals and strategies clashed with Vasconcelos's own sensibilities, who secured his institutional legacy.

Shortly after Vasconcelos's departure, Calles convinced Gamio to become assistant director of the ministry that Vasconcelos had built into one of the best-funded branches of the government. Gamio brought with him his Department of Anthropology, which became the Subdepartment of Contemporary Population and Territory.[17] The transplanted subdepartment announced plans for a cultural atlas of the nation that would map Indians' "physical characteristics, customs, folklore, eating habits, religious beliefs, style of home, industries, language, arts," and so forth. By demonstrating the "true situation of our Indians" the atlas would reveal both what had already been accomplished by the revolution and "what [was] left to do."[18] The department also sponsored field research, such as the expedition in 1925 headed by the leading anthropologists Miguel Othón de Mendizábal and Lucio Mendieta y Nuñez, which set out to study the vernacular arts of the Valley of Oaxaca. In a rebuke of what postrevolutionary intellectuals criticized as the Porfiriato's "pretty illusions" and "lies," Mendieta

y Nuñez explained that this research had "the purpose of undertaking a direct study among the Indians, so as to reach conclusions . . . based on reality itself."[19] Vasconcelos's and Gamio's activities demonstrate the extent to which intellectuals during the 1920s were able to create alliances with the state and use their official posts to shape policy and expand the state's realm of concern.

The road toward state institutionalization of the many cultural initiatives, however, was fraught with twists and turns. Though state support grew in the 1920s, it remained fickle and uncoordinated, leaving behind it a wake of half-done projects debilitated by underfunding, inconsistent priorities, frequent changes in leadership, and continually restructured priorities. Most state funding came from short-term grants. It was through such a grant in 1921, for example, that the composer Manuel Ponce was able to discover, collect, and classify peasant melodies and rhythms so as to "awaken a love for Mexican popular music."[20] In the absence of enduring institutions and reliable funding, intellectuals became connected to the Ministry of Education when Vasconcelos created a space and Gamio defined a postrevolutionary intellectual orientation, but state support for their initiatives depended on the whims of high-level officials who were transient in high offices. The cultural project advanced in a halting manner and left artists and researchers disunited and vulnerable, their funding precarious, and their long-term impact uncertain. By the end of the decade, their uncoordinated initiatives seemed to be floundering.

DMAAH: Consolidating the State Cultural Project

In the 1930s nationalist intellectuals and researchers finally translated their previously disparate initiatives into a coordinated state cultural project. The decisive moment came on 20 January 1930, when, during his last days in office, President Emilio Portes Gil signed an executive order that created the Departamento de Monumentos Artísticos, Arqueológicos e Históricos (Department of Artistic, Archaeological, and Historic Monuments). For the next decade the DMAAH offered intellectuals employment and reliable institutional support, which were no small prizes in an era of global economic depression. No matter where individuals might sit along the political spectrum, the DMAAH (run by a mixture of politicians, career bureaucrats, academic researchers, artists, and intellectuals) was happy to embrace them, so long as they followed its mission. This brought them

under the control and patronage of the postrevolutionary state and removed them from the ranks of potential political opposition.

The DMAAH's institutional genealogy traced to 1921, when the newly created Ministry of Education charged the existing Inspección de Monumentos with identifying, documenting, and protecting Mexico's preconquest and colonial architectural heritage.[21] The executive order of 1930 transformed this small department headed by Jorge Enciso into an umbrella organization responsible for overseeing all federally funded cultural initiatives and institutions that were not already part of the public schools, universities, libraries, or the Department of Fine Art (Departamento de Bellas Artes). The person who oversaw the creation of the DMAAH was none other than Doctor Atl, aided by the undersecretary of education Carlos Trejo y Lerdo de Tejada. The prominent archaeologist José Reygadas Vértiz (who is often paired with Manuel Gamio as one of the agents of the "golden period" of Mexican archaeology), soon replaced Atl as director, and Enciso was transferred to a new internal department called the Dirección de Monumentos Coloniales, which was similar to the pre-1930 Inspección de Monumentos. By gathering together various cultural institutions, the DMAAH, which remained part of the Ministry of Education, became an ambitious effort to oversee, study, and preserve the nation's contemporary and historic patrimony.[22]

The new institution bore some similarity to the Serviço Historico e Artístico Nacional (SPHAN) that later emerged in Brazil, except that the DMAAH preceded the SPHAN by seven years and it embraced a much more expansive view of the national patrimony. Brazil's SPHAN was closer in spirit to Vasconcelos's vision than to the DMAAH. As the historian Daryl Williams shows, the SPHAN intentionally "underplayed the importance of popular culture" and excluded the black and indigenous experience, embracing instead an "understanding of Brazilianness that tended to exalt the Luso-Catholic above all the other cultural traditions."[23] The DMAAH, too, celebrated the Iberian colonial heritage, such as in its exaltation of the architecture of Taxco and Guanajuato, as well as Mexico's pre-Hispanic past embodied, for example, in the pyramids of Teotihuacan. It did so, however, while pursuing the comparatively novel, even radical, study and celebration of popular culture and indigenous traditions, defining these as critical components of *mexicanidad*.

The importance of the DMAAH lay not in the long list of institutions

it absorbed but rather in what it did with these institutions. Rafael Pérez Taylor's stewardship of the National Museum under the DMAAH elucidates how the institution absorbed and channeled individuals' initiatives. A former member of the anarcho-syndicalist Casa del Obrero Mundial, editor of *El Universal*, coordinator of the India Bonita Contest 1921, and head of the federal Department of Fine Art, Pérez Taylor now joined the DMAAH with the task of restructuring the National Museum. He hired as section heads a host of intellectuals and researchers who helped him remake it from a staid hall of preconquest and colonial antiquities into a center for the study and interpretation of contemporary popular culture. He employed the artist Roberto Montenegro to catalogue the institution's growing collection of *artesanías* and to create a separate museum called the Museo de Artes Populares (see chapter 5). Fulfilling some of the aspirations of Gamio, Pérez Taylor ordered the museum's Department of History to redirect its energies from researching the biographies of nineteenth-century patriots to compiling a comprehensive calendar of folk festivals across Mexico. Responding to complaints by Gabriel Fernández Ledesma, Gamio, and others about the shortage of trained specialists capable of studying the rural population or of assembling, organizing, and displaying popular art, Pérez Taylor and his successor, Alfonso Caso, established training programs in anthropology, indigenous linguistics, national folklore, auxiliary sciences to history, and (by 1937) cultural tourism. They also created the Department of Ethnology and the Office for the Development of Popular Arts and Industries.[24] By 1934, the National Museum boasted stable programs for such initiatives as the compilation and study of locally produced maps from across the country; the creation of an archive of vernacular music, dances, songs and stories; the adjustment of the names and spelling of Mexican places to make them conform to "Indian norms"; and the continued sponsorship of studies of such folk art as the lacquer work from Uruapan, Michoacán, and Olinalá, Guerrero. These institutions established the National Museum as one of the most important components of the DMAAH in terms of its ability to unite individual intellectual aspirations, state patronage, and regime consolidation in the advancement of the postrevolutionary nationalist cultural project.

As shown in chapter 3, foreign influence in the study and promotion of Mexican national culture had become a source of concern among Mexican nationalists by the 1930s. One of the goals of the DMAAH was to counter

this foreign influence by offering Mexican researchers their first taste of a reliable domestic source of patronage. The result was an acceleration of research into indigenous languages, regional folk music, handicrafts, and other aspects of popular culture. By 1931, for instance, in response to the growing number of research expeditions led by such foreigners as Frank Tannenbaum, Franz Blom, Frances Toor, and Anita Brenner, the National Museum's Department of Ethnology dispatched its own cultural exploration of southern Mexico. Such efforts did not receive the level of sustained funding that foreigners enjoyed, but they marked an important effort to address the disparity.[25]

High expectations and a general sense of urgency about the need to compile comprehensive detailed cultural knowledge about Mexico's countryside prompted officials to overcome funding shortfalls by experimenting with creative, lower-cost alternatives to field studies. Building on his earlier experience with the Exhibition of Popular Art of 1921, Jorge Enciso, for example, appointed local authorities as honorary inspectors and subinspectors whose responsibility was to respond to surveys requesting information about local historic monuments and archive collections in their regions. Requests for local information as such were not new; Porfirian census takers, too, had circulated questionnaires in rural districts. But the Porfirians' questions were about commerce, railroads, industrial production, and literacy rates. They sometimes asked about race and language, but they had no interest in local folkways and aesthetics. Enciso's surveys, by contrast, asked for information about local historical buildings and natural settings, along with detailed qualitative information about rural cultures, religious and secular celebrations, and even local folktales. This interest in thickly describing local culture and aesthetics was a novel feature of the postrevolutionary state, and the emphasis on this broad range of narrative and qualitative data speaks to the importance ascribed to these cultural forms as potential means for narrating the nation.[26]

The DMAAH showed remarkable success on many fronts but its ambitions were too enormous to fulfill. As often happened to modernist dreams of the first half of the twentieth century, the DMAAH's ambitions outstripped achievable goals. What is important is that the effort was made, that goals were articulated, and that these goals were elaborated through a centralized and institutionalized structure. Through the DMAAH the government aspired toward the goal that Gamio had set out in 1916 to oversee

all cultural research and production so as to advance a coordinated, centrally controlled, and proactive effort to codify and unify Mexico's national culture, direct intellectuals' and researchers' efforts, and make the population known in new ways and with unprecedented depth.[27] It provided to intellectuals, artists, and researchers the institutional backing they needed to identify, document, codify, promote, and preserve thousands of buildings, sites, songs, dances, and craft traditions representing most periods, regions, and cultural groups in Mexico. It claimed these places, practices, peoples, objects (and the entire history and heritage they represented) as part of an organically unified national culture administered from Mexico City. Through the DMAAH intellectuals acted in the name of the state to fuse interpretations of vernacular traditions into a cohesive, and seemingly objective, epistemology of *mexicanidad*.

By the early 1920s researchers and artists dedicated to the promotion of vernacular traditions had earned their stripes by repackaging the fare offered by itinerant musicians, vaudevillians, and craft merchants plying their trades in the streets of Mexico City, Guadalajara, and other urban centers. Soon, however, such offerings smacked of overfamiliarity or, worse, seemed contrived, commercialized, and inauthentic. Members of the intelligentsia, allied with resident foreigners, rose to the challenge in the 1920s by casting themselves as bold adventurers willing to delve deep into the "unknown" countryside in search of greater authenticity, out of which they turned up a steady trove of musical and visual discoveries.

By the time DMAAH was created, the growing volume of studies on Mexico's regions and subcultures presented a new problem: too much information was being gathered too fast, without a clear plan for how to organize, structure, and present this knowledge. Information gathering, however, was only half of the process. Of equal importance were the efforts to synthesize the data conceptually and visually for public dissemination. The Exhibition of Popular Art from a decade earlier in 1921 had offered a model. Speaking of the dizzying array of arts that the exhibition introduced to urbanites, the art critic Julian Sorel had lauded its success at tracing out the supposed inherent coherence of this diversity. This seemed to him a reassuring contrast to the disorder and chaos of the craft market in Alameda Park in the center of Mexico City, where one risked being played for a fool—vulnerable, it seems, by virtue of ignorance about one's own country.[28] The exhibition's success at organizing these materials and presenting

them as evidence of unity in diversity, rather than as cultural fragmenta-
tion, stood as a model for the DMAAH's efforts.

The growing number of local cultures and aesthetics encapsulated
within the rubric of *mexicanidad*, and the growing detail in which they
were becoming known, threatened to overflow, to contribute to rather
than resolve what Sáenz had called Mexico's "ethnographic chaos." One
of the most important efforts to systematize knowledge about Mexico's di-
versity was the journal *Mexican Folkways* founded by the North American
Frances Toor (published from 1925 to 1937; see chapter 3). It was the first
comprehensive cross-disciplinary journal to promote rural aesthetics as
part of the nation's proud heritage rather than as embarrassing evidence of
backwardness. A number of short-lived Mexican journals (such as *Forma*,
México Moderno, *Nuestro México*, *Ethnos*, and *Música*) soon joined it, par-
ticularly once the DMAAH offered stable funding.[29]

In their desire to make the growing volume of information meaning-
ful to the public, DMAAH officials ordered museums to reorganize their
galleries to reflect the "true cultural geography" of the nation. It also cre-
ated regional museums throughout the country, many of which survive
today. Additionally, it underwrote publications, sponsored special exhi-
bitions and lectures, and hired technicians to study and record regional
music in the field so that the songs could be taught in the public schools
and performed in public venues. It created training programs, for example,
to teach public school teachers about the "real" Mexico, with the hope that
the teachers would then convey this information to students across the
republic. In her study of Mexican public education, Mary Kay Vaughan
describes teachers' uses of these diverse traditions, showing that the "re-
sult was a nationalization of popular culture as Náhuatl-speaking children
in Tlaxcala learned the Yaqui Deer Dance and the Tarahumara children
learned the criollo jarabe of Jalisco."[30]

The discoverers and promoters of the "real" Mexico working within the
DMAAH tried to transform rural cultural practices from what Raymond
Williams usefully describes as alternative practices that slipped past the
purview of the state and dominant classes, into what he terms "oppositional
practices." These were practices that were incorporated into the domi-
nant culture, thereby contributing to the emergence of stronger forms of
domination in the form of negotiated hegemony.[31] As a result, through the
DMAAH artists and intellectuals unwittingly taught state leaders new ways

to manipulate culture and aesthetics so as to bolster the popular legitimacy of the Maximato and successive administrations.

One outcome of this heightened interest on the part of the state came in 1935 during the populist presidency of Lázaro Cárdenas (1934–40), when the government published the *Enciclopedia Nacional Popular* (*Encyclopedia of the National-Popular*). The well-illustrated book was distributed to *campesinos* and the popular classes across Mexico on inexpensive newsprint. This book marked an effort to consolidate vernacular knowledge, link it to the state, and redistribute it as integrated, national, and unquestionably Mexican. It opens with a synthesis of national history followed by a five-page "Chronology of the Governors of Mexico from the Most Remote Times to the Present," in which the long history of changing cultures, empires, and regimes from the Toltecs to Cárdenas are presented as an unbroken "Mexican" political and cultural tradition.[32] The longest part of the book, almost five hundred pages of small type, consists of a nationalist almanac. Each month begins with calendrical, astronomical, meteorological, and agricultural information. Each day is labeled in Spanish and indigenous languages and includes information on a local festival from somewhere within the republic. It lists a recommended "Mexican dish for the day" (with a detailed recipe), a description of events that had transpired on that day in history, and information on folk-medicinal treatments for common ailments. Each day is also dedicated to a particular cause, ranging from the arts (such as the "Day of Popular Poetry"), to agricultural festivals (such as "Day of the Watermelon Festival"), to revolutionary reforms (such as "Day of Agricultural Bank Credit"). Throughout the book readers find explanations of popular traditions and lessons about particular legal rights and civic responsibilities.

The first of July, for instance, is listed as Lunes/Tochtli. This is followed by the day's place within the modern astrological year and the Aztec calendar, and then an assigned purpose to the day, in this case the "Day of the Indian," with a long explanation that begins: "One of our greatest shows of ingratitude . . . and biggest mistakes . . . has been our erasure and willful ignorance [concerning] the founder of our nation, the builder of our patria . . . and the source and direct creator of our modern well-being, of our national, industrial, and social development: THE MEXICAN INDIAN." The entry included a detailed explanation of the contributions Indians have made, and continued to make, to the nation and the ways they have been

wronged and marginalized, along with recent developments, most notably the state's convocation of the Congreso Indígenista. Next come common names that were to be honored on that day, patriots to be remembered, a Mexican dish for the day (in this case arroz con longaniza, estilo Colima, [Colima-style rice with sausage]), and a popular medicine from the Mexican pharmacopeia (in this case the Monacillo flower, used against tonsillitis, dysentery, and chronic diarrhea). The day closes with the time of sunrise and sunset. Most entries also offered such tips as how to deal with particular agricultural pests or how to store milk and offered suggestions for children's games or details about citizens' legal rights.

The *Encyclopedia of the National-Popular* offers much grist for analysis, but I want to stress just three points. First, this well-illustrated book, which President Cárdenas referred to as Mexico's "Nationalist Calendar," represents a remarkable effort to consolidate local knowledge and to redistribute it as integrated, national, and unquestionably Mexican. Its stated intent was to make accessible to every Mexican and every researcher "all the intimate aspects . . . of our artistic, historical, geographical, commercial, [and] industrial life, and all the marvelous facets of our traditions . . . vernacular customs and festivities." The encyclopedia's introduction explains that it was to serve as "a SYNTHESIS of LO NACIONAL, of all that is ours," and "a fount of information" that will deepen "the readers' love for" and knowledge about their nation.

Second, the encyclopedia erases individual contributions. This was part of a broader trend under Cardenismo, which gave intellectuals and researchers less leeway than they had enjoyed under Obregón and even during the Maximato.[33] Though this encyclopedia was the end product of many intellectual debates and researchers' investigations, it presents itself as a seemingly authorless, objective, and naturalized compilation of unmediated *mexicanidad*. Had it named particular authors, its account might come across as the argument of those authors, but with no authors it comes across instead as objective knowledge, as unquestionable truth. The only agent is the state, which appears as the natural embodiment of this *mexicanidad*. This leads to the final point: that this encyclopedia, like the DMAAH itself, concentrated in the state the powerful role of being the ultimate arbiter and defender of Mexican national identity.

Nationalists promulgated aesthetic and cultural information through such means as this encyclopedia, the museum displays, and folklore in-

struction, each of which contributed to the construction of a cohesive nation in which regional and ethnic differences became valued idiosyncratic manifestations of an organically unified *mexicanidad* rather than as devalued markers of cultural fragmentation. Through visual and aesthetic means cultural leaders acting through the DMAAH defined and affirmed indigenous and peasant cultures on the basis of their supposed essence and on such outward aesthetic manifestations as *artesanías*, dance, music, stories, food, clothing, and a "picturesque lifestyle."

In a recent study of ethnographic photography and picture postcards in Oaxaca, the historian Deborah Poole argues that Oaxaca represented an exception to the Mexican norm: that while the national trend of the 1920s and 1930s was to erase diversity in favor of a homogenous *mestizaje*, Oaxacans instead used visual imagery to affirm their regional traditions, which they presented as part of the rich diversity of the Mexican nation.[34] Poole is on the mark in her insightful analysis of the significance of what was happening in Oaxaca. But this analysis of the DMAAH suggests that Oaxacans' packaging of local identity as part of the larger national "unity in diversity" was neither as exceptional nor counterhegemonic as she suggests.[35] Rather, it typified the broad emergence of postrevolutionary cultural hegemony promulgated by intellectuals, manifested through visual aesthetics, and consolidated by the DMAAH as an official state project.

More research is needed to determine how the dynamic that Poole describes for Oaxaca occurred in other regions, but a consideration of various regional identities suggests an answer. Cultural elites in Puebla seem to have created a criollo identity to escape *indigenismo*. Veracruz elites embraced a white/mestizo identity in opposition to their region's Afro-indigenous heritage. Sonoran mestizos celebrated Yaqui dances but viewed Yaquis as conquered primitives against whom to judge their own non-Indianness. And *norteños* from Chihuahua and Nuevo Leon defined themselves in opposition to the "indigenous south."[36] It seems, therefore, that even if they may not have concurred with the ethnicized identity emerging from the central plateau, people constructed their regional identities in relation to this central identity, and that this process reinforced an ethnicized identity as the hegemonic cultural nationalist discourse. While further research into multiple regional histories would be necessary to confirm or dispute this hypothesis, the last part of this book does take up the question in relation to one region: the Montaña de Guerrero.

The Mexican case parallels other movements for "unity in diversity" in which postcolonial nationalists claimed that the formerly colonized population "formed a nation in spite of social, regional, and ethnic difference."[37] What makes the Mexican case instructively distinct from India and other territories decolonized during the twentieth century, and different from the model followed by much of the rest of Latin America at that time, is the manner in which it invoked a distinctly *ethnicized* model for this national identity. Mexicans took ethnicization beyond the level of Vasconcelista-style metaphysics into the grounded reformulation of national identity and cultural integration.

During the 1920s Mexico's intelligentsia had struggled in search of stable institutional backing. In the 1930s they found such stability within the DMAAH, which eagerly incorporated their efforts into the government to forge a compelling state cultural nationalist project. But intellectuals soon paid a price for investing their efforts so heavily in the state. They found their desire to pursue multiple lines of experimentation swamped by an intensely bureaucratic system and an increasingly top-down institutional structure. Moreover, while the state offered them gainful employment and the opportunity to put aspects of their cultural project into practice, it gained, in return, the ability to supervise the activities of most of the socially conscious Mexican intellectuals of the time and to use their energies to enhance its claims to revolutionary legitimacy.

Dissolution of DMAAH: A New Direction for Mexican Nationalism

Alan Knight has described the shift from the "radical and confident Cardenismo of 1936–38" to "the more cautious and diffident Cardenismo of 1938–40."[38] Even in its most radical moments, though, Cardenismo, according to Knight, was more jalopy than juggernaut. By this he meant that it was a makeshift regime built on improvisations and expedience. Analysis of cultural policies under the DMAAH confirm and extend Knight's analysis. It is important to note that Cárdenas did not create the DMAAH. He inherited it from the previous regime and he continued his predecessors' practice of using it to bring intellectuals, artists, and researchers into the state fold and to orient their diverse projects in conformity with the regime's goals. Both the DMAAH and Cardenismo were improvised "jalopies" that, because they aspired toward centralized control and national cultural integration, left indelible imprints upon society.

By the close of the 1930s the "Mexican nation" no longer seemed a distant aspiration; it had become a palpable reality. Mexicans no longer doubted that they possessed their own distinct culture, and they were confident that this culture could include indigenous and mestizo peoples (even if many continued to contest their own relationship to this hegemonic ethnicized heritage). And the Mexican and foreign public could now recognize by look, sound, and feel "authentic Mexicanness." With Cárdenas's subordination of the last of the regional caudillo separatists the state was firmly in control of its national territory. Any remaining opposition came in the form of political claims within, rather than in opposition to the state. Intellectuals of the 1940s felt sufficiently assured of Mexico's political cohesion that they no longer addressed the "Indian problem" as a national crisis that might erupt into a race war or another revolution, as it was viewed in the 1920s and early 1930s, but as a social problem plaguing a cultural minority. As the historian Arthur Schmidt notes, drawing on the insights of the anthropologist Arturo Warman, by the 1940s "the 'Indian problem'" had been reduced to "innumerable 'unique, particular, and concrete' matters that analysts assumed would be resolved by economic development."[39] As Cardenista political and economic radicalism retrenched after 1938, and as teachers were forced to withdraw from their insistence on socialist education, artists and intellectuals likewise pulled back from their previous objectives.[40]

At the end of 1938, Cárdenas officially dissolved the DMAAH and that for which it stood. What it had stood for was neither Cardenista socialism nor Popular Frontism but rather the ideal of achieving cultural integration through the celebration of the culture of the masses, mediated and defined by the cosmopolitan cultural leadership born of the revolution. The dissolution of the DMAAH did not mean a return to the fledgling, disjointed intellectual initiatives of the early decades of the century, ever in pursuit of state backing. Far from it. What emerged from DMAAH's ashes was an array of heavily bureaucratized institutions that set aside grand nationalist ambitions of social transformation in favor of stability, careerism, and specialization. This signaled a shift during the 1940s away from a form of nationalism that centered on collective action and interaction between the state and the peasantry toward a form of nationalism that emphasized individual careerism, party loyalty, and industrialization, along with personal engagement with such media icons as Pedro Infante and Dolores del

Río. This shift began not with the handing of the presidency from Cárdenas to Manuel Avila Camacho in 1940, as is often presumed, but with the final two years of Cárdenas's term, as the president hit the brakes on the reforms that faced growing opposition from conservatives (especially those based in Monterrey). Because the shift began even before Cárdenas left office, the transition toward the right did not seem as obvious at the time as it now looks with the benefit of hindsight, and this made it easy for some ardent Cardenistas to transfer their loyalties to avilacamachismo (Avila Camacho's comparatively conservative populism steeped in consumerism) in the early 1940s.[41]

Cárdenas's executive order in 1938 dissolved the DMAAH and rebuilt it from the ground up as the National Institute of Anthropology and History (Instituto Nacional de Antropología e Historia, commonly known as INAH).[42] The INAH was no mere replication of its predecessor. It took over all the departments, museums, and collections of the DMAAH but it steered them away from the previous mandate, away from control by the left-oriented Ministry of Education, and away from any lingering control by independent intellectuals, artists, or researchers. The DMAAH in the 1930s had brought independent-minded nationalist intellectuals into the state, but these intellectuals became frustrated by the impositions upon their freedom for experimentation and research. The INAH, by contrast, permitted more intellectual freedom, so long as intellectuals did not challenge the growing power of the institutionalized avilacamachista and alemanista state. Artists, intellectuals, and researchers abandoned plans for social transformation in favor of reliable funding for specialized, narrow social scientific research that carried no overt political message that might seem to question the PNR's (and then the PRI's) claims to be the legitimate steward of the ongoing revolution.

Fortunately for those involved, these institutional changes coincided with shifts within their own fields and conformed with their own professional and political goals. While the DMAAH had provided them a stable place within the state, they chafed under what they saw as its heavy-handedness. Because of this, by the time INAH emerged, intellectuals and researchers were eager for the new orientation, which resulted in a smooth transition in which most of them willingly staked out their own corner of research and professional activity. In 1935, for example, Rafael López (the poet known for his published commentaries from 1921 on the Exhibition of

Popular Art and the India Bonita Contest) spearheaded the creation of the Art Laboratory (Laboratorio de Arte), which subsequently attached itself to the National University as the Institute of Aesthetic Research (Instituto de Investigaciones Estéticas). The new institute promoted art history as a specialized discipline removed from the nationalist project of cultural integration that had previously animated the study of Mexican art. Other specialized institutions, as they extricated themselves from the larger social mandate of cultural revolution, contributed to the rise of official *indigenismo*. Prior to the DMAAH's dissolution, Alfonso Caso (who would become head of the INAH), Daniel F. Rubín de la Borbolla, and Miguel Othón de Mendizábal led an initiative to create a specialized center for the study of anthropology as distinct from the other disciplines. Their discussions led to the creation of the Sociedad Mexicana de Antropología, which attracted many of the anthropologists who had played leading roles in the nationalist efforts of the previous two decades. Between 1939 and 1941 a new generation of anthropological journals emerged that further fueled the rise of a narrow official *indigenismo* as a de-Indianizing ideology firmly linked to the state. These included the *Boletín Indigenista*, the *Revista Mexicana de Estudios Antropológicos*, and *América Indígena*. The period also saw the creation of the International Indigenous Institute (Instituto Internacional Indigenista, known as III), founded in 1942 after the famous Pátzcuaro Conference of 1940. These changes were all part of a trend toward specialization and disciplinary isolation, and away from the interdisciplinarity that had animated many of these same intellectuals during the 1920s and 1930s.[43] This splintering of broad social ambitions, as these cases make clear, began even before the DMAAH's official dissolution.

No longer driven by the goal of regional and national integration, studies of rural culture became merely a means for formulating state policy toward specific minority indigenous populations. Some of this shift in attitude toward the place of Indians in the nation may have derived from changes within Mexico City, including rapid demographic growth, less ethnic segregation, and a more uniform sense of urban *mestizaje*, all of which may have contributed to urban intellectuals' declining concern with indigenousness. What is clear is that, when sociologists and anthropologists turned their attention to Chiapas in the 1940s, they did not study highland Mayan practices as part of a crisis of nationhood nor as a source for nationalist regeneration, as they might have in the 1920s and 1930s.

Instead, they now treated them as isolated cases of Indian backwardness that, while a problem for that particular indigenous population and for Chiapas, did not present a threat to the nation as a whole.[44]

Far from causing the demise of the DMAAH, then, Cárdenas, in signing the law of 1938, gave his blessing to a transformation already under way. Cultural hegemony had been achieved and, though the media continued to idealize whiteness and while there remained a good deal of ambivalence about the ethnicized construction of national identity, Mexico had become one of the most culturally integrated countries in the world, certainly in Latin America. The next era of nationalist cultural production would belong less to formal state institutions and intellectuals than to the radio (which had grown steadily in importance since the 1920s), cinema, and television. Intellectuals could celebrate the fact that there was most assuredly now a Mexican nation with a deep ethnic character, and that it had been brought about in part through their efforts. They might have been less enthusiastic, however, about their own marginalization and by the ways the state had learned to manipulate and exploit this cultural nationalist discourse in ways that would cast a long shadow.

〜

The Museum and the Market,
1929–1948

The 1921 Exhibition of Popular Art had given handicrafts a place at the center of the emerging Mexican aesthetic. Though the state exploited this emerging aesthetic, it was hesitant to formulate a sustained policy toward handicrafts. Part of the difficulty was that the various factions that wanted the state to take a stand on the issues—intellectuals, state officials, and regional, national, and international merchants—found no agreement about objectives or methods. Their one point of commonality was their presumption that popular art should be handled from the top down, with artisans alternately as passive beneficiaries, agentless patrimony, instinctual producers, cheap labor, or victims of avarice. This chapter relates the story of why the state delayed so long before taking a position regarding how to market crafts, and why, when it did, it acted in a way that was detrimental to the artisans whom it claimed to serve. It also is an account of the role intellectuals played in this process and how they saw their efforts swallowed up by the state.

Part of the story revolves around the Museo de Artes Populares (Museum of Popular Art, MAP), which opened in 1929 and closed around 1948. Art historians, collectors, and cultural nationalists regularly acknowledge the MAP as foundational for the way we now think about Mexican aesthetics and state support for handicrafts. Despite its ubiquity in discussions of popular art, until now we have known little about the MAP beyond myth, rumors, and vague memories. The story of this institution reveals the difficulties that plagued

cultural nationalists in their efforts to shape state policy from the inside. It also highlights the degree to which intellectuals' difficulties resulted from their inability to reconcile their promotion of popular arts as bastions of "authenticity," on the one hand, with the commercialization on which handicraft promotion depended, on the other.

While it is easy to blame the state, it is important to recognize that the failure of the MAP also rested on the shoulders of intellectuals who insisted that handicrafts stood outside of the line of modernity and progress. They laid claim to a declensionist narrative in which the passage of time, the growth of markets, and the process of industrialization that brought prosperity to Mexico invariably inflicted damage upon the "authentic" cultural patrimony.[1] This unsustainable narrative of nationalist authenticity made it difficult for the MAP to justify its mission within the art world, much less in the marketplace. That said, greater culpability rests with state officials and private merchants who blinded themselves to anything that departed from a market-driven approach to national patrimony and who took a narrow, top-down view of the role that popular art might play in rural development.

Instead of an epic battle between two opposites (authenticity versus the market; preservation versus decadence; tradition versus progress; and so forth) as cultural nationalists and commercial dealers each claimed, it came down to a question of what economic, political, and cultural trade-offs people were willing to accept in the formulation of a state policy toward handicrafts and what mechanisms different factions had at their disposal for inciting state action. It was through these trade-offs that intellectuals, merchants, and government officials created today's state policies toward popular art and that we find the genealogy of modern-day assumptions about Mexican handicrafts.

Between "Price Lists" and "Authenticity"

Even as intellectuals and artists joined forces with the state, they had difficulty steering the course of this cooperation in relation to popular art. The earliest institution they created to support handicrafts was the Office of the Development of Popular Arts and Industries (Sección de Fomento de las Artes e Industrias Populares) headed by the ethnologists Miguel Othón de Mendizábal and Renato Molina Enríquez as part of the National Museum. During its three years of existence, which ended in 1923, it coordi-

nated field studies and sponsored direct interventions into majolica production in Puebla and the lacquered handicrafts of Uruapan, Michoacán, and also helped Montenegro and Enciso with the Exhibition of Popular Art in 1921 (see chapter 2).[2] When the Office of the Development of Popular Arts and Industries dissolved due to fickle state funding it was not clear what, if anything, would take its place, but there was a sense that whatever did emerge should grow not from this office but from the remnants of the 1921 centennial exhibition. It would take a decade to translate the enthusiasm of 1921 into the Museo de Artes Populares, and another four decades for the emergence of a workable policy. Efforts to define a state policy in relation to handicrafts were stymied by disagreements over whether national interests were served better by preservation of handicrafts as cultural patrimony, or by rapid and thorough exploitation of crafts for capital accumulation by private investors and tax revenues for the state.

Those who wanted to turn the 1921 collection into a museum had, first, to deal with the problem that much of the collection was lost by the end of 1922. Part of it traveled to Brazil for display in that country's centennial celebrations, from whence it never returned, and another part went to Los Angeles in 1922, where it was sold by a private gallery (see chapter 3). The Department of Fine Art of the new Ministry of Education kept the rest on display in the National University for several months, then packed it away in a storage room that bore the lofty title Department of the Permanent Exhibition of Popular Art (Departamento de la Exposición Permanente de Arte Popular).[3] No one was quite sure what to do with it.

Consumers, meantime, took a growing interest in crafts as art, decoration, and collectors' items. Prominent dealers such as Frederick Davis and Frances Flynn Paine continued to serve the high-end market, while others, such as Gabriel Fernández Ledesma, catered to a middle-class clientele (see chapter 3). The popular classes continued to buy crafts in the outdoor markets that dotted rural and urban Mexico, and tourists frequented "curiosity" shops that remade themselves as "popular art" stores. In the midst of this slow but steady growth, cultural nationalists failed to persuade the state to take the lead in coordinating this market so as to protect handicrafts' aesthetic and patrimonial integrity.

The most promising efforts during the decade came from Rafael Pérez Taylor, who in 1925, as director of the Department of Fine Art, backed a plan to install the remaining objects from 1921 as a museum in the former

Templo de la Soledad de Santa Cruz. He commissioned Diego Rivera, Roberto Montenegro, and Carlos González to paint murals throughout the building. To solidify the populist message the building also would offer spaces for community programming and adult education.[4] Funding and personnel shifts, however, cut short the plan.

As Pérez Taylor's plan foundered, dealers and investors groused about handicrafts' lack of standardization and about the difficulty of learning what kinds of craft were available or how to get hold of them. Lack of information and nonstandardized production, they insisted, were "killing the enthusiasm" for the new market. "American markets are ready to buy," but without "price lists, samples or catalogues of any kind," it was difficult to secure transactions on the wholesale level.[5]

In 1929 craft dealers were heartened when state officials chastised cultural nationalists, telling them that, instead of worrying about quality or about artisans' standard of living, "we need to recognize that success in any business venture comes from selling large quantities with very little profit per item."[6] The consul to Philadelphia agreed, adding that the boardwalks of Atlantic City and Ocean City were lined with merchants eager to sell Mexican crafts, if only they could be supplied in large quantities at cheap prices.[7] In direct opposition to cultural nationalists, who urged the state to protect the idiosyncrasies of handicraft production, dealers and State Department officials called for government intervention to standardize crafts into predictable lots, ramp up production, and drive down prices so as to sell popular art as cheap tourist trinkets.

This was the start of a bitter debate about how popular art might contribute to economic development. National economic policy had concentrated exclusively on such bulk exports as grain, ore, livestock, and petroleum. But in the mid-1920s officials called for greater economic diversification. Debates over the role that handicrafts might play in this diversification unfolded through official correspondence now found in archives, and, most notably, in the pages of the official publication of the Ministry of Foreign Relations, the *Boletín Comercial* (*Business Newsletter*, henceforth BC).[8] The consul in Boston complained that oil and henequen composed 90 percent of Mexican exports to his area. He suggested diversification into handicrafts. A particular attraction of handicrafts, he argued, is that they could stimulate a wide range of related economic activities required for their production.[9] His was one of many reports that encour-

aged the marketing of vernacular arts not as symbols of nationalist pride but as economic multipliers that could lead toward broad-based growth. Intellectuals had made a case for handicrafts' cultural importance, but what officials now proposed was something different. Henceforth the debate would focus on the question of what the balance should be between cultural nationalism and economic growth and between aesthetics and profits; and over how to divide the profits among dealers, artisans, and the state (in the form of tax revenues).

Nationalists pointed to the languishing 1921 collection as evidence of the state's failure to manage the nation's cultural patrimony, as dealers and consuls called on the state to take a proactive role in rationalizing production. Government officials, meantime, resisted taking action at all. The late 1920s was a time of political difficulty for the Mexican government because of the Cristero war and the assassination of Obregón. In the United States, even while part of the public was caught up in what Helen Delpar has called its "enormous vogue of things Mexican," politicians and the media debated whether the U.S. government should intervene in the religious and oil crises. It was at that moment that Ambassador Dwight Morrow proposed the Mexican Arts Show as a way to improve U.S.–Mexican relations (see chapter 3).

Riding the wave of interest created by the upcoming Mexican Arts Show, the undersecretary of education, Moisés Sáenz, teamed up with Doctor Atl and Roberto Montenegro to propose to President Emilio Portes Gil yet another plan to use the remnants of the 1921 exhibition as the core for a museum of popular art. To their delight, Portes Gil awarded them a grant of 420,000 pesos as seed money—an amount that exceeded the entire annual budget of most other cultural institutions in Mexico at that time—and staged a ceremony to announce the plan. His one condition was that they first help organize Morrow's Mexican Arts Show, to which they readily agreed.

On the surface, Atl and Sáenz seemed to share a common vision, but, as often happened in Mexico's intellectually heterogeneous renaissance, they discovered irreconcilable differences. Sáenz hoped to connect artisans directly to the market, provide them a Mexico City headquarters from which they could bridge rural production and urban markets, and help them create self-governed cooperatives that he hoped would operate like labor unions. Atl, by contrast, wanted to identify the most uncorrupted

forms of handicraft production, including Olinaltecan lacquer and Tonal-tecan ceramics, and market these while shielding their producers from what he saw as the corrupting influence of the market. Atl supported the proposal for artisan cooperatives, but as a vehement anti-Marxist he rejected the notion that they might function as self-governing labor unions filled with "exotic theories." Where Sáenz wanted to use handicrafts to ease artisans into modernity and national and international markets, Doctor Atl wanted to engineer the interactions between these two supposedly distinct domains so as to preserve artisans' worldview and protect their art from cultural contamination and aesthetic degeneration.

They settled their differences by separating into two distinct organizations. Atl's Comité Nacional de Artes Populares (hereafter Comité) would support artisan cooperatives, international traveling exhibitions, and an urban craft market, which he wanted to erect in the patio of the former Convento de La Merced—he wanted to keep the market within the former convento, where he had been living since 1920, so that he could supervise it personally. Atl had first proposed the Comité in 1926 but had been rebuffed by the Ministry of Industry, Trade, and Labor (Secretaría de Industria, Comercio, y Trabajo), the same ministry that previously, under Alberto Pani's influence, had published his catalogue in 1922. With Sáenz's consent, the Comité kept the 420,000-peso government grant as seed money, after which it was to become self-supporting through craft sales.

Atl agreed to oversight of his grant by the Ministry of Industry, Trade, and Labor, which at that time had come back into the hands of one of his allies, Ramón de Negri. But Atl's was an ill-fated endeavor. De Negri abruptly departed to serve as ambassador to Belgium and was replaced by Luis León, who was no ally. An ardent supporter of Plutarco Elías Calles, originally from Ciudad Juárez, and an important backer of the new PNR ruling party, León killed the Comité by funneling its budget to other parts of his ministry. Why he did this remains unclear. It may have been the result of personal or political clashes between Atl and León, or perhaps in retaliation for Atl's relentless criticism of Calles. Genaro Estrada, the minister of foreign relations who was a supporter of the arts and of Atl, intervened to save the Comité, but it was too late. In October 1931 the ministry announced the dissolution of the Comité "for lack of funds to support it."[10] A few months later, when Atl sat down to document the rise and fall of the organization, he angrily summarized it as an "effort on the part of individu-

als to protect and promote the vernacular industries, aided and abetted by the government, and destroyed by that same government."[11]

Sáenz, for his part, recruited Roberto Montenegro to help plan the Museo de Artes Populares, which he emphasized would "not sell anything, but instead would be exclusively to show all the articles that are typically Mexican." The MAP's mission statement, drafted by the undersecretary of education, Valerio Prieto, in consultation with Roberto Montenegro, stated that the museum would dedicate itself to teaching about and defending popular art through displays, publications, and educational programming. It also would develop extension programs to help artisans improve the quality and marketability of their art.[12] The MAP inherited the collection from the 1921 centennial exhibition along with its mandate for nationalist public education and aesthetic preservation. Unlike the Comité, which Atl hoped to make financially independent, the MAP was planned as a dependency of the Ministry of Education, under the control of the recently created DMAAH (Departamento de Monumentos Artísticos, Arqueológicos e Históricos). (For a full discussion of the DMAAH, see chapter 4.)

In his first progress report from the DMAAH, the undersecretary of education, Carlos Trejo y Lerdo de Tejada, claimed that the new Museo de Artes Populares contributed to the "mandate of the Revolution" by conserving Mexico's "genuinely national arts": "Up to now, the products of Mexican popular art, for lack of an integral understanding on the part of our governments, have been viewed as curiosity-shop objects, destined to be sold to the few foreigners who visit us and to the rare Mexican who still knows how to understand and esteem his own values. Snobbery is a hindrance to the promotion and development of our nationality. The objects produced by our popular artistic industries need sustained official support." Shortly after this report, the noted archaeologist José Reygadas Vértiz became head of the DMAAH. Initially he had misgivings about the value of an institution that focused on aesthetics rather than ethnology but soon was convinced and became an advocate for the museum.[13]

The intelligentsia seemed, at last, to have won state backing for a successor for the 1921 Exhibition of Popular Art. But the split between the visions of Atl and Sáenz had bequeathed to the MAP a distorted relationship to the market. In 1929, the same year the MAP was founded, Miguel Othón de Mendizábal complained that such efforts as the 1921 Exhibition of Popular Art, the 1922 Los Angeles show, and even his own Sección

de Fomento de Artes y Industrias Populares had been aesthetic and cultural successes but "complete failure[s] from the economic point of view." What was now needed, he argued, was a state-led economic intervention to "raise the prices while increasing demand for objects of popular manufacture." The ultimate goal, he insisted, had to be to "raise the miserable standard of living for the small popular producers."[14] Even at the moment that the MAP was created, then, its focus on aesthetics to the exclusion of economics already was coming into question.

The Bittersweet Zenith of the Museo de Artes Populares and the Lack of a State Policy

Frances Toor noted that as a result of the 1930–32 Mexican Arts Show organized by René d'Harnoncourt, "Mexican handcrafts . . . acquired an amazing popularity" in Mexico and the United States. She estimated that by 1939 the export business alone had grown from "something like ten thousand to many millions of pesos a year" as tourists took crafts "back literally by the carload," and even department stores in both countries began offering Mexican handicrafts.[15] Though no official statistics were collected at that time, and despite her overemphasis on foreign as opposed to domestic consumers, Toor's impression of a dramatic surge in consumer interest seems to have been correct. The question for the MAP was how it should position itself in relation to this market while still preserving its aesthetic-nationalist mandate.

Between 1931 and 1932 Montenegro expanded the MAP's collection by purchasing objects from Frederick Davis's shop, undertaking his own collecting expeditions, courting donations and the assistance of friends and associates, and absorbing the holdings of Atl's now-defunct Comité. Montenegro also enlisted the services of state governors, chiefs of military operations, and rural teachers from the Misiones Culturales (part of a teacher training program) and convinced the minister of education to write letters to regional officials on the MAP's behalf. In 1931 the Museo de Artes Populares even won its own budget line within the DMAAH, a rare feat in this period of economic recession and departmental belt-tightening, and something that eluded even the Museum of the Revolution. In addition to a generous budget for collection and exhibition, it got permission to hire six employees, and Montenegro enjoyed one of the highest salaries of

anyone at his rank. Compared to most public institutions in Mexico at the time, the MAP looked like a favored son with a secure future.[16]

Montenegro mistook this for the start of a clear policy toward popular art on the part of the state. Unfortunately, the state's favor lasted only as long as the Mexican Arts Show's U.S. tour. When the tour ended in 1932, so did the state's support for the MAP. Simple requests that had once moved to the top of the DMAAH's priority list became mired in bureaucratic channels, paralyzing the museum.

We see this in the refusal of the state to support Montenegro's request to escape the cramped ground floor in the Ministry of Education headquarters in favor of a proper exhibition space that could improve public visibility. After repeated requests, Montenegro finally won approval to move to the former Convent of San Pedro y San Pablo. But as soon as he ceded the galleries in the Ministry of Education building he discovered that, due to a shift in administration personnel, the DMAAH unwittingly had granted the same space to another department. With its old space in the Ministry of Education headquarters no longer available, and his new space in the convent occupied by someone else, the MAP was homeless. Montenegro slipped from outrage to dismay as he lost most of his staff. The MAP was demoted to Office of the Museo de Artes Populares (Oficina del Museo de Artes Populares), without any exhibition space or clear public mission. This would have marked the end of the MAP, except that for the next two years Montenegro drew on his considerable connections to slowly pull it back up.[17]

As in 1929 through 1932, it was international attention combined with friends in high places that would put popular art back on the state's agenda. At the start of 1933 the National Museum of Decorative Arts (Museo Nacional de Artes Decorativas) in Madrid invited Mexico to present its popular art. Former minister of foreign relations Genaro Estrada, now ambassador to Spain, handled the request personally. He forwarded to the Ministry of Education the invitation along with instructions that the exhibition be artistic rather than commercial or ethnographic. The request came at a moment when the composer Carlos Chávez and Montenegro's old collaborator Jorge Enciso occupied high posts in the Department of Fine Art. They agreed to back the request. When Montenegro submitted a budget, however, the comptroller (official mayor) of the Department of

Fine Art balked. There ensued a heated exchange among senior officials of the Ministry of Education, the Department of Fine Art, and the Ministry of Foreign Relations in which advocates of the MAP expressed disgust that Mexico, the only foreign country ever invited to exhibit at the prestigious Spanish museum, might decline the offer claiming poverty: it would be a national embarrassment. Finally, in May 1933 the request won approval.

Montenegro immediately departed for the countryside and by early June, after enlisting the help of close associates such as Rodolfo Ayala of the recently created Museo de Artes Populares of Pátzcuaro, Salvador Solchaga, who was leading the lacquer revival in Pátzcuaro, and Frederick Davis, the North American popular art dealer in Mexico City, he assembled an impressively comprehensive collection for display in Madrid.[18] Back in 1921 assembling this kind of collection in such a short order would have been unthinkable. But much had changed by 1933. There was now a definable canon of aesthetically and nationalistically important crafts. Moreover, intellectuals who in 1921 were only beginning to explore the countryside now seemed to know all the back trails and could quickly name the most important artisan communities in each state and explain why each was vital to aesthetic *mexicanidad*.

The Spanish success not only lifted the MAP out of its limbo; it led it to new heights. In September of 1934 the MAP won its own gallery space—not just any gallery space, but prime space in the newly completed Palacio de Bellas Artes on the Alameda, the most prized exhibition hall in the country. The Palacio paired the MAP with the Museum of Fine Art (Museo de Artes Plásticas) on the main floor, surrounded by murals by Rivera and Orozco, hoping to "channel national identity by defending and esteeming the art of the nation."[19]

The MAP at last seemed to be fulfilling the hopes that had been invested in popular art since 1921. Montenegro buoyantly outlined plans for professionally installed galleries, research archives, public events, a monograph series, and a dedicated budget for acquisitions.[20] The new head of the Department of Fine Art, the poet/politician Antonio Castro Leal, approved his request to hire eleven employees, including his protégé Gabriel Fernández Ledesma as assistant director. Castro Leal, who originated from San Luis Potosí and completed a doctorate at Georgetown University before serving as rector of the National University from 1928 through 1929, and who would go on to serve on the board of UNESCO and as a member of

congress, firmly backed Montenegro's efforts. He later collaborated with him in 1940 in the New York Metropolitan Museum of Art's Twenty Centuries of Mexican Art exhibition (see chapter 3). Ledesma set about drafting two monographs (one on Oaxacan ceramics and one on folk toys), created postcards, and established a photo archive. He also oversaw major acquisitions, many of which continued to be handled by Frederick Davis. Montenegro wanted the MAP to be more than a museum; he wanted it to become a research center on popular art. He culled through the archives of other branches of the DMAAH, consolidating documents that dealt with popular art, and he entered into negotiations to purchase the archives of Frances Toor, famous for her magazine *Mexican Folkways*, and of the photographer Manuel Alvarez Bravo. As soon as the new president, Lázaro Cárdenas, took office in December, Montenegro invited him to visit the museum and tour its offices.[21] Montenegro felt such confidence in the MAP's stability that he even donated his own private collection of masks, his most prized possessions.

Montenegro was about to discover that rather than the start of a bright future of the MAP, this was its short-lived zenith. In his personal copy of his book *Máscaras mexicanas* Montenegro scribbled: "The very day I delivered my valuable mask collection [100 masks plus 21 paintings] to the Palacio de Bellas Artes . . . that so and so named X informed me that I was no longer director of the Museo de Artes Populares. What ingratitude!"[22] Montenegro's indignation was shared by friends and colleagues who unsuccessfully interceded on his behalf.[23]

Documents tell neither the reason for Montenegro's downfall nor the identity of "X." Rumors still circulate that "X" may have referred to President Cárdenas, who purportedly acted out of homophobia. Another possibility is that Montenegro fell due to a scandal that ended in a legislative inquiry and the firing of Antonio Castro Leal. At the end of September 1934, political officials, eager to polish their own nationalist credentials, launched a congressional inquiry into the cost of the inauguration of the Palacio de Bellas Artes. Though Castro Leal had not broken any laws, they charged that at a time of national belt-tightening, his lavish spending exhibited Porfirian tendencies and a lack of patriotism.[24] The government fired him. A few weeks later Montenegro, who continued to support Castro Leal, also found himself out of a job.

Through the 1920s and early 1930s, cycles of national and international

attention delivered short-term boosts to cultural nationalists' promotion of handicrafts. But the state failed to formulate a consistent policy toward popular art. When the MAP enjoyed success it was due to fleeting international attention and the fortuitous alignment of supporters in key government posts. Under Cárdenas (1934–40), the state would at last clarify its policy in relation to popular art, but to cultural nationalists' surprise and dismay, and seemingly in contradiction of how one normally thinks about Cardenismo, it stepped in not in defense of cultural patrimony but in support of the investors and officials eager to rationalize production and depress prices.

Popular Art under Cárdenas

The Cárdenas administration set out to transform Mexico by activating the peasantry economically and politically while at the same time consolidating state power so as to contain not just the opposition but also its own rank and file. Scholars have noted, however, that even as it sometimes prioritized social reform over economic output (most arguably in the agrarian reform), President Cárdenas's government facilitated the expansion of capitalist markets as never before, fueling a form of broad economic growth that extended capitalist markets down into the base of society.[25] Government policy regarding artisans and merchants affirms the extent to which Cardenismo was neither as carefully orchestrated nor as unified in purpose as is often assumed. Inconsistencies in objectives, together with the tendency for individuals and programs within the government to work at cross purposes, were common. Yet it is important to keep in mind that, just because state policy was makeshift, that does not mean that it lacked impact.

By the end of the 1920s the state had entered the debate over popular art. At first it seemed to enter on the side of the cultural nationalists eager to defend the authenticity of popular art as national patrimony. After a short time, however, the growing chorus of dealers and consuls drew the attention of state planners toward the economic rather than the cultural importance of crafts. Officials saw in the market, which expanded as a result of the 1930–32 Mexican Arts Show, the possibility for a new stream of revenue.

In 1932 the government imposed a 90 percent export duty on craft exports. The tariff undermined the cultural nationalists' efforts to improve

quality and craftsmanship and to raise artisans' standard of living. It also disappointed dealers. In the absence of price elasticity in the souvenir and craft market, dealers could not afford to pass the cost of the new tariff onto the consumers. The only way to make up the difference was to depress the prices they paid to artisans and sell lower-quality crafts. When dealers complained about the new tax, state officials recommended that they take it up with the artisans by compelling them to accept lower prices for their work, use cheaper materials, invest less time per piece, invent new crafts that could be produced more easily, and employ flashier decorations and brighter colors so that objects could appeal better to "tourist tastes."[26] The Mexican consul in Boston, Filomeno Mata, backed the recommendations. In fact, in his view, they did not go far enough. He rebuked his countrymen for not being even bolder in their exploitation of "the curiosities market."[27] The government's response did not satisfy the dealers. What they wanted was not advice and taxes but state support for a sustained intervention to reorganize production. They soon got it.

In September 1934, two months before he turned the reins of power over to Cárdenas, President Abelardo Rodríguez signed a bill that created the National Cooperative of Mexican Vernacular Industries (Cooperativa Nacional de Industrias Típicas Mexicanas; hereafter Cooperativa), a private enterprise backed by state logistical support and a generous subsidy whose purpose was to "rescue the artisan industry." The government branch that proposed and managed the Cooperativa was the Economic Ministry (Secretaría de Economía Nacional), previously known as the Ministry of Industry, Trade, and Labor—the same one that two years earlier has quashed Atl's Comité Nacional de Artes Populares. Technically, membership in the Cooperativa extended to all artisans. In practice this was meaningless, since the only role these "members" were allowed was that of producers. All decisions remained in the hands of state officials and commercial houses. To nationalists' dismay, then, what the state created was neither an artisan cooperative nor an institution to protect the national patrimony but a state-subsidized merchant cooperative devoted to intensifying and reorganizing production.

The Economic Ministry inaugurated the Cooperativa with a gala attended by industrialists, diplomats, and government officials. The many artists and intellectuals who had spent years promoting and defending popular art received no invitations—the one exception was Rafael Pérez

Taylor, who came as the representative of the new Tourism Department (Departamento de Turismo).[28] The head of the Cooperativa was Enrique Pawling, an engineer who embraced the plan to apply a business model to handicrafts. Little is known of Pawling, though government documents show that he served in the Secretaría de Economía until his appointment to the Cooperativa, and then he springboarded into the petroleum and marine shipping industries.[29]

In December 1934 the Cárdenas administration inherited the recently inaugurated Cooperativa, just as it inherited the DMAAH (see chapter 4). The surprise, however, was that Cárdenas lent such strong support to a co-operative that so blatantly favored business. This complicates the general historical view of the Maximato as a period of retrenchment from revolutionary ideals, and of Cardenismo as a sudden break with the policies of its predecessor.

Throughout its existence the Cooperativa protected its image by remaining strategically vague about its operations. Documents and interviews, thankfully, offer insight into its operational strategies. The Cooperativa extended loans from the Economic Ministry to distributors in such provincial centers as Morelia, Chilapa, and Oaxaca City. These distributors then used this capital to provide low interest loans to subregional agents, who, in turn, directed the funds toward local *acaparadores* (combination loan-sharks and market cornerers). Armed with these low-interest loans, *acaparadores* made high-interest loans to artisans, who then had to repay them with handicrafts at depressed prices. Artisans desperate for cash to meet daily and emergency needs accepted these loans. Generally the artisans were unable to discharge the loan in a single cycle, so they had to take out a follow-up loan to buy materials for the second production cycle which they hoped, in vain, would free them from the *acaparadores*.

These *acaparadores* served the Cooperativa by depressing prices, pressuring the artisans to adhere to predictable production schedules, and taking charge of quality control. The *acaparadores* also solved the transportation problem. Transportation in areas known for craft production remained crude and would have presented a challenge to the Cooperativa. The *acaparadores* solved that problem by bringing the goods directly to Mexico City or channeling them through local and regional warehouses. The artisan, meantime, became locked in a self-perpetuating circle of debt to the local *acaparador*. (Chapter 8 describes in detail how this system

functioned in Olinalá.) The state and its business allies, therefore, used the Cooperativa to strengthen the very intermediaries whose control over local artisans cultural nationalists had hoped to break. It created, moreover, an economic relationship fueled by debt that would outlive the Cooperativa itself and which continues to frustrate promoters of rural development and advocates of popular art.

As the effects of the policies took hold, criticism of the Cooperativa mounted. To deflect some of the negative publicity the state-business venture renamed itself the Society for the Promotion of Mexican Vernacular Industries (Sociedad Impulsora de Industrias Típicas Mexicanas; hereafter Sociedad). This new name gave the appearance of a social mission. To bolster this façade the Sociedad built an annex onto its warehouse, which it named the National Exhibition of Vernacular Arts (Exposición Nacional de Artes Típicas). Though this was a commercial showroom, the Sociedad and the state created the misleading impression that it was a public museum. Displays included handblown glass, textiles, carvings, and ceramics from across the country. They also featured lacquered boxes and gourds from Olinalá (which the gallery incorrectly attributed to an unrelated artisan community, revealing its lack of familiarity with basic aesthetics, styles, and techniques of artisan production in Mexico).[30]

The Sociedad changed its rhetoric as well. Abandoning its language of hardnosed economics, it co-opted its critics' discourse of cultural patrimony and national identity, using this language to shroud rather than guide its practices. In 1938 a Sociedad spokesperson explained that the artisans "work for the delight gained from working with their hands to create something beautiful, and almost never think about the [economic] gain that their creation will bring them." Whereas Atl and others had developed this claim to emphasize the artistic value of the work, rooted in its supposed capacity to express the native authentic collective unconscious, the Sociedad used it to justify its own lack of concern for artisans' standard of living. After all, if the artisans were unconcerned with remuneration, why should the Sociedad preoccupy itself with such an issue? We see this strategy again when the Sociedad thanked the very cultural nationalists it excluded by backhandedly acknowledging its gratitude to "a few of our artists and more than a few foreigners who for love of the typical arts of our country have pulled vernacular treasures in from the most distant corners of the Republic for us to benefit." Starting in 1934, just before the fall of

the MAP, and continuing through the 1940s the Sociedad and other large commercial houses set the course for government policy toward popular art, sacrificing artisans' incomes in favor of raising the total value of the handicraft market and boosting commercial profits.[31]

The rift continued to widen between the rapidly growing low-end market for trinkets and the stagnating market for high-end handicrafts. This rift, however, did not map neatly onto consumers' perceptions. Middle- and working-class Mexicans, for example, shared tourists' interest in cheap handicrafts, but, whereas tourists typically saw these as trinkets, Mexicans endowed them with nationalist significance. It also mapped unevenly onto the rural and urban poor, who continued to purchase a variety of handicrafts to meet their daily needs. The poor needed low prices, but, because the items were utilitarian, they had to be of sound craftsmanship. As workmanship declined in the 1940s, these consumers turned to plastic and tin alternatives. Lacquered trays and bowls from Uruapan, for example, lost their water resistance as artisans, under pressure from *acaparadores*, shifted to cheaper materials and spent less time burnishing the finish. Ceramic jugs from Tonalá similarly became too fragile to transport water over long distances.

As cultural nationalists decried what they saw as the rampant commercialization and destruction of the national patrimony, merchants countered that the government needed to go still further. One such booster at the start of the 1940s celebrated that the emphasis was now on "orders for Mexican crafts in quantity" rather than on a preoccupation with aesthetics. But there was more to be done, he insisted. The goal should be to get Mexican crafts into "every five and dime store" in the United States. This, he argued, required that traditional handicrafts be altered to conform more thoroughly with "tourist tastes" by, for example, covering them with exotic-looking motifs borrowed from preconquest manuscripts.[32]

Even as the state allowed investors to set most of its popular art policy, it continued to finance the Museo de Artes Populares, however half-heartedly. In 1934, after Montenegro was fired and oversight of the MAP transferred from the DMAAH to Department of Fine Art, the museum's future seemed uncertain. Castro Leal was gone, and Carlos Chávez, who filled in for him, resigned after just a few months during an administrative shakeup. This left the MAP without allies. Leadership of the Department of Fine Art went to José Muñoz Cota, a Cardenista loyalist who had

served as official orator during the presidential campaign. The young essayist and orator remained at his post until 1937, when he left to serve as congressional representative for the Federal District. Later, starting in 1942, he would serve as former president Cárdenas's personal secretary.[33] José Muñoz Cota and the other new leaders of the Department of Fine Art shared none of their predecessors' enthusiasm for handicrafts.

Muñoz Cota slashed the MAP's budget, dismissed its entire staff (including Fernández Ledesma), and moved it from the main gallery of the Palacio de Bellas Artes into the claustrophobic top floor, accessible only by a tall staircase and a side-entrance elevator that rarely functioned. When supporters of the MAP complained to Cárdenas, Muñoz Cota countered sarcastically that the new space was more appropriate for the museum and had "dramatically improved" the "presentation of the objects." He filled Montenegro's post with the artist Antonio Silva Díaz, who, flummoxed by his own ignorance about popular art, quickly secured a transfer to another part of the Ministry of Education.

To replace Silva Díaz, President Cárdenas personally nominated a loyalist, Manuel Calderón. Though Calderón and Muñoz Cota shared a devotion to Cárdenas, they quickly found themselves at odds. Little information is available about Calderón outside of his activities with the MAP. He seems to have had some background in popular art, for, unlike his predecessor, he showed ample competence in the subtleties of collection management and understood the realities of rural craft production and the stylistic range across artisan communities. What he failed to understand, however, was that he had not been hired to be an activist on behalf of popular art, artisans, or the MAP but to quietly manage the museum as a marginal institution. Perhaps state officials sought to give the appearance of a counterbalance to their embrace of the merchants' cooperative. In any case, in acting as an advocate of the MAP Calderón exhibited a clumsy proactive style that repelled virtually every potential ally within the bureaucracy. At the same time, his constant criticism of the previous actions of Montenegro, Fernández Ledesma, Sáenz, Davis, and d'Harnoncourt alienated him from cosmopolitan artistic and intellectual circles.[34] He became politically and socially isolated.

Calderón hoped to animate the MAP as part of the broader Cardenista agenda. He tried to change the name from the Museo de Artes Populares to the Cooperativa de Fabricantes de Objetos de las Artes Populares (Co-

operative of Crafters of Popular Art). In his plan artisans would participate directly in the cooperative, whose functions would be divided between the museum and an artisan-run sales warehouse, which would market the crafts and negotiate fair prices for the craftspeople. State officials rejected the plan, possibly because it would have undermined the structure of production created by the state-subsidized Sociedad Impulsora de Industrias Típicas Mexicanas.

Calderón then tried a different pitch that addressed a highly publicized economic problem. The government was concerned about Japanese and Chinese knockoffs of Mexican crafts that were flooding the U.S. market. It would have been difficult to counterfeit crafts in the 1920s when the market was smaller and crafts carried distinctive styles and materials along with meticulous, often labor-intensive workmanship. But much had changed under the influence of the Sociedad and other independent commercial houses. Most crafts now were cheaply made. Some were newly invented products, such as leather snakes, ceramic toothpick holders, or three-sectioned plates. Others were traditional crafts that had been simplified in terms of workmanship and materials, such as bowls that previously had been hand-carved and lacquered using oils extracted from insects but which were now lathe-turned and decorated with glossy automotive paint. Freed from the burden of craftsmanship and local materials, handicrafts had become readily susceptible to mass production by Japanese and Chinese companies, who even stamped them with "Viva México" or "Hecho en México" and sold them for half the price. The Sociedad and other commercial houses found it difficult to compete in this race to the bottom that they themselves had ignited. Seemingly bereft of creativity, their only response was to drive production costs even lower by urging *acaparadores* to organize artisans into production lines. Manuel Calderón offered an alternative solution. He argued that the best way to compete would be to focus on authenticity and quality. He proposed that for a fraction of a peso per piece the Museo de Artes Populares could use a distinctive stamp to certify authentic crafts, while at the same time working through artisan cooperatives to improve quality. This would help the crafts as well as the MAP.

He expected praise for what he saw as an ingenious solution that linked the MAP to Cardenista objectives. The government, however, was not interested. One critic attacked the idea as misguided, reasserting that the only way to solve the problem was to cut labor costs further by compelling

artisans to produce their work on production lines, accept lower prices for their work, and use cheaper materials. He called upon the government to underwrite the reorganization of production, pass new legislation to crack down on dealers of "fake" Mexican crafts, and advertise to draw more attention to Mexican-made products.[35] Even Manuel Gamio sided with the dealers, arguing that Mexico needed to be open to any changes in production or materials that might help it to undercut the prices of Asian imitations.[36] The solution that won state backing, in the end, was a no-holds-barred drive to undercut the price of Chinese and Japanese competitors.[37]

In the meantime, department officials' treatment of Calderón degenerated into puerile mockery and sabotage.[38] When the respected dramaturge Celestino Gorostiza replaced Muñoz Cota as head of the Department of Fine Art, things grew even worse. In 1938, after several difficult encounters, Calderón complained directly to Cárdenas that Gorostiza was trying to squeeze the MAP out of existence. When Cárdenas demanded an explanation, Gorostiza denied the accusation and ridiculed Calderón.[39] Calderón was not just being paranoid, as Gorostiza charged. The documents make clear that Gorostiza actively undermined Calderón, but they do not illuminate his motives. Gorostiza was close to Montenegro, Fernández Ledesma, Enciso, and other supporters of popular art, which one might think would have predisposed him toward helping the MAP.[40] A complication, however, is that Montenegro wanted his old job back. He appealed to intermediaries to help him out and even wrote directly to Cárdenas asking to return.

Calderón gradually resigned himself to the fact that he would never transform the MAP into the kind of social and economic institution he envisioned, and so he turned his attention to museum management. He coordinated educational programming for school groups, launched a publicity campaign, and delivered public lectures and gallery talks. And, though he was short on funds as a result of the Department of Fine Art listing the MAP as one of its lowest priorities in its annual budget requests, he found creative ways to augment the collection, including letter-writing campaigns along the model established by Enciso in 1921 and repeated by Montenegro when the MAP was part of the DMAAH—though Calderón did it with notably less finesse. He also tried to compile lists of leading artisans in particular communities so that he could buy directly from the craftspeople, which he hoped would help the artisans while making their art more affordable for the museum.[41]

It would be a mistake to think that government neglect of the MAP indicated a lack of public interest. The museum enjoyed sustained growth in attendance and public visibility throughout its existence. The number of visitors fluctuated from a low of 968 in September 1936 to a high of 7,580 in January 1940, when it was permitted a short-term exhibition on the main floor. During a nine-month sample from February to October 1940, average attendance stood at 6,071 per month. A clearer idea of long-term trends in attendance can be attained by tracing a single month across a five-year span. In November 1935 attendance was 1,103. In November 1936 it grew to 1,314. A year later it was at 2,127, and by November 1940 attendance stood at 2,661, more than doubling in just five years. Some of this resulted from growth in the tourist industry, but the MAP relied less on foreign visitors than either its critics or supporters presumed. Tourists grew from 6 percent of the visitors in 1935 to 29 percent in 1940, but, even as the percentage of nationals relative to total visitors dropped from 94 percent to 71 percent in 1940, the actual number of Mexican visitors had shot up by 260 percent.[42] The primary audience, then, was Mexican, not foreign.

President Cárdenas's management of popular art through an alliance with business interests, rather than with artisans or cultural nationalists, might seem at odds with other aspects of his policy, in which he backed peasants and workers and clashed with *hacendados* and the industrial elite of Monterrey. While the state does not seem to have operated based on a clear plan, we can discern the logic of the Cardenistas' decisions. First, artisans were notoriously difficult to mobilize, and, unlike the peasants of La Laguna, they were not clamoring for state support of grassroots initiatives. To have tried to mobilize them prematurely might have wasted scarce resources on a doomed venture. Second, Cardenistas looked suspiciously upon handicraft supporters as Callista conservatives. As such, they greeted their ideas, and often their mere presence, with suspicion. Finally, even loyalists like Calderón failed to win support because, from the state's perspective, a policy that grew the market rather than protect the authenticity of handicrafts was more useful because it held the potential to convert rural artisans into industrial workers; force Indians out of their supposed isolation; increase the overall size of the economy through economic multipliers that reached down into the rural countryside; and, by focusing on exports, attract much-needed foreign currency.

Demise of the Museo Nacional de Artes Populares

From the 1930s through the 1940s, the Museo de Artes Populares stood as the only noncommercial vehicle for the promotion of handicrafts, but it operated from a position of marginality. In 1942, when the situation failed to improve under President Avila Camacho, whose brand of nationalism drew on cinema and commercial music more than on claims to authentic folklore and popular art, Calderón decided to transfer to a local library.[43] Montenegro's unrelenting appeals to the government to return him to the helm of the MAP at last paid off. When previous commitments delayed his return, he got a colleague to fill in for him: the art historian Salvador Toscano, remembered today for his work on precolonial art.[44] Officials from the Palacio de Bellas Artes persisted in treating *artesanías* as curiosities deserving nothing better than a cramped attic, but Toscano handled these challenges with considerably more skill than had Calderón, in part by getting well-placed allies to intercede on the MAP's behalf. They compelled palacio officials to address maintenance issues, won several thousand pesos to develop the collection, and even entered into partnerships with regional museums that the DMAAH had founded in Chiapas, Yucatán, and Campeche (see chapter 4). These triumphs, however, were minor and did not move the MAP back toward the position of prominence it had held in 1934 when it occupied briefly one of the two main galleries on the ground floor of the Palacio de Bellas Artes.

In August 1945 Montenegro at last returned in earnest, and he did so with a plan to put the Museo de Artes Populares back on its feet. Picking up where he left off in 1934, he presented an ambitious plan in which the MAP functioned as not just a museum but a research center attracting scholars from Mexico and abroad, sponsoring innovative fieldwork, publishing a monthly newsletter, and hosting academic and public lectures. He insisted upon a proper space where galleries could be arranged professionally following the standards "currently being developed in the United States."[45]

The tone of his appeal seemed hopeful but also cognizant that the time for the MAP as a leading institution of popular art may have passed. Most aspects of Mexican folklore had become heavily commercialized through movies, music, tourism, and mass-marketing. Officials saw no reason why handicrafts should be treated any differently. Typical was an official who

insisted that consumer demand showed no preference for quality, and therefore neither should the government. Small-scale, idiosyncratic production, once seen as Mexican *artesanías'* virtue, now struck many as its greatest shortcoming. As another official made clear, it was long overdue that Mexicans "forget about the individual artistic component" so as to move "toward mass production of handicrafts."[46]

Given the climate, it is not surprising that the Ministry of Education rejected Montenegro's proposed overhaul. Instead, the ministry put forward a plan to restructure the Museo de Artes Populares as part of the Dirección de Arte Popular Mexicana (Office of Mexican Popular Art), whose purpose would be to "orient the intensive cultivation of national folkloric traditions in literature, music, decoration, industrial and vernacular arts" and other expressions of "the Mexican spirit" toward profit-making enterprises. The proposal explained that the goal of the government was to facilitate the commercialization of Mexican traditions and, regarding handicrafts, to foster their mass production for bulk export. It added that a thorough reorganization of artisans into factory-style assembly would pave the way for the country's transition to industrialization. Montenegro expressed his horror and used all his resources to derail the plan.[47]

At last Montenegro accepted that the MAP had no hope of challenging market-driven dogma. He gave up trying to fix the museum and instead prepared it for a graceful death. Other longtime supporters shared his sense that the MAP had run its course and that it was time to start anew with a different institution. Gabriel Fernández Ledesma, who supported an activist role for the MAP, argued that for decades cultural nationalists had devoted themselves to studying and promoting the popular arts of Mexico. And what do we have to show for it? he asked. The sad truth, as he saw it, was "that while other parts of the world are caring for and jealously protecting their minor arts" Mexico has been busy destroying its own in pursuit of short-term profits. Because the state backed "monopolistic" commercial houses and local *acaparadores*, it was responsible, he argued, for the exploitation of "impoverished artisans." The state, in his view, shared the blame for the shift to "exotic objects that indulge strange tastes and whims" and which cheapen popular art and besmirch the reputation and self-esteem of Mexico. Fernández Ledesma charged that the state, by undermining the MAP at every turn, had reduced it to an inconsequential institution that no longer had any reason to continue.[48]

It is not clear when, exactly, the MAP closed its doors, though it may have closed to the public in 1947, moving its collection to storage.[49] Its last surviving public statement is an illustrated monograph on the museum's role in promoting popular art, published in 1948.[50] As Montenegro gave up on the MAP, he threw his support behind plans for the National Museum of Popular Arts and Industries (Museo Nacional de Artes e Industrias Populares, henceforth MNAIP). He joined the anthropologist Alfonso Caso to develop the MNAIP as an institution through which artists, intellectuals, and social scientists could gain access to state resources to advocate for the popular arts and rural artisans.

The twenty-first century has brought revived interest in popular art. As Mexico embraces new levels of globalization and mass culture, cultural nationalists see in popular art a way to preserve the nation's distinctiveness. Today promoters look to the Museo de Artes Populares with nostalgia. Its appeal does not come from its accomplishments, which were minimal, but from its stubborn insistence upon preserving Mexico's living cultural patrimony in the face of rampant commercialization, and its brief zenith in 1934 when it brought that message into the heart of the nation's premier art institution. How Mexico moved from the policies of the 1940s to the current-day revival, and with what trade-off and consequences, is the subject of chapter 6.

🌿

Formulating a State Policy toward Popular Art, 1937–1974

The craft centers of Uruapan in Michoacán and Olinalá in Guerrero both were dedicated to lacquer production. Both were early targets of metropolitan intervention after the revolution and were deeply affected by shifts in popular art policy during the 1920s through the 1950s. Yet Uruapan and Olinalá experienced these shifts in divergent ways because of their differing degrees of physical accessibility, local structures of power, and the extent to which their crafts served the daily needs of regional consumers (as opposed to collectors, tourists, and middle-class consumers). In the 1970s their different experiences at last converged through a single institution, the National Fund for the Development of Handicrafts (Fondo Nacional para el Fomento de las Artesanías, known as Fonart), founded in 1974. With Fonart's backing, artisans in Uruapan and Olinalá mobilized themselves into cooperatives to buy and sell collectively and for the first time found consistent markets that enabled them to ally with the central government as a way to contest their marginality in the local hierarchy.

The rise of Fonart would have been difficult to foresee during the 1930s and 1940s, when promoters of handicrafts as national patrimony seemed to be losing the confidence even of their fellow artists and intellectuals, some of whom went so far as to question whether popular arts possessed any transcendent value at all or whether they simply pandered to the lowest common denominator, perpetuating ignorance and "degraded sentiments."[1] If *artesanía* possessed no spe-

cial relationship to *mexicanidad* and if it expressed only the crudest, most embarrassing instincts of the uneducated masses, then, as some argued, nothing would be lost through unfettered commercialization and standardized mass production. As they stumbled to respond to such charges, promoters of popular art found themselves paralyzed by the commercialism that became triumphant in the 1940s and 1950s. This was the era of the "Mexican miracle," when many felt that industrial capitalism was lifting the country into the ranks of the developed world. At a time when cinema, music, dance, and other arts readily blended vernacular traditions with consumer culture, popular art advocates, with their romantic resistance to commercialization, seemed quaintly out of touch.[2]

These promoters' efforts to protect popular art from the forces of the market failed to win support even from artisans. The policies advocated by the Sociedad Impulsora had been disastrous on the local level (see chapters 6 and 8), but, from the artisans' perspective, isolation from the market was not a solution—their livelihoods, after all, depended on consumers' interest in buying their wares, and on their own abilities to interact with these consumers and to gauge their changing tastes. Artisans did not want protection from the market. What they wanted, instead, was control over the conditions in which they produced their art and over the terms of sale. They also sought an outside ally with the will and authority to help them break the stranglehold of local *acaparadores*. These, unfortunately, were not yet matters at the forefront of intellectuals' concerns.

To understand how intellectuals and the state moved from the fragmented policies of the 1930s–50s to the coherent approach of Fonart requires skepticism regarding the tendency among studies of Mexican history to base their periodization on presidential administrations. The political scientist Joseph Klesner correctly observes that studies of the post-1940s period have emphasized presidential regimes at the expense of studying the institutions through which state power operated.[3] A focus on administrations offers certain kinds of insights, but it can mischaracterize the timing and impetus for shifts in state policy. This was the case, for example, for cultural policy in the 1930s, as discussed in chapters 4 and 5, and it continued to be the case for popular art policy through the decades leading up to the creation of Fonart. While the succession of presidents is important, of equal or greater importance are institutions such as the Sociedad Impulsora, the MNAIP, the INAH and INI, Banfoco, and Fonart, which

carry across these administrations, and the people who shaped those institutions.

It was through these institutions that the state, backed by the intelligentsia and middle-class functionaries, negotiated a reconfiguration of the structure of hegemony. Analytic approaches that acknowledge hegemony as negotiated have richly informed studies of 1920s and 1930s Mexico but have had less impact upon the historical interpretation of the period after the 1940s, which too often unfolds as narrow political accounts of specific regimes.[4] Changes in the state's popular art policy invite an extension of this approach into the era of the "Institutionalized Revolution," with particular attention to the individual intellectuals and officials who left their mark upon these institutions, impacting both popular art policy and, through it, the lives of those who created these arts.

Voices of Dissent, 1937–58

In 1922 Doctor Atl predicted that industrialization would bring the demise of popular art. By the start of the 1940s, however, it was clear that popular art was not going to disappear. What now concerned cultural nationalists was not whether it would persevere but in what form. During the 1920s and 1930s they had aspired first to link Mexican identity to vernacular aesthetics, and to then convince consumers to buy these arts as symbols of *mexicanidad*. But by the 1930s and 1940s they became dismayed by the state-business alliance that seemed to them bent on intensifying the commercialization of crafts until it corrupted every aspect of their production and appearance. The Mexican consul Ignacio Pesquiera justified their concerns when he argued in 1949 that Mexico needed to look for ways to intensify even further the production and marketing of crafts. He celebrated that control of production at last had been wrested from artisans and the literati. What was needed now, he insisted, was to eliminate independent dealers and vendors. He argued that these had served their transitional purpose by helping the market to grow but now they stood in the way of large commercial houses that sought to integrate vertically from the *acaparadores* to warehouses and from distributors to storefronts and street hawkers.[5]

Though they seemed defeated, critics of the state-business alliance refused to capitulate. As early as 1937, Roberto Montenegro took his protest to the airwaves in an hour-long radio broadcast lambasting the "unsavory

economics of merchants with no conscience" whose greed destroyed Mexico's genuine arts, replacing them with imitation *sarapes*, garish renditions of *china poblana* outfits, and wool capes decorated with Aztec calendars. He continued that fortunately some arts had not yet been corrupted. These included "boxes of Olinalá, in the State of Guerrero, [produced with] arduous labor and emblematic of the most beautiful industries of Mexico." Such crafts, he argued, could serve as founts for regeneration, but only if the state and the public acted quickly, before merchants destroyed them, too, with "tacky designs" and "serialized production."[6]

Two years later, Frances Toor complained that the decline of authenticity might be justified if it brought prosperity to artisans, but it had not. Craftspeople's standard of living had eroded, she argued, because dealers pressured them to produce faster, in larger quantities, and at lower rates of remuneration. Outsiders, moreover, compelled artisans to produce "objects which are neither *popular nor art*" but which easily can be mass-produced, "as for example, luncheon plates with three divisions, with a cactus in one, a burro in another and a calendar stone in the third."[7] Montenegro's and Toor's concerns were well founded. As will be discussed in part II of the book, the case of Olinalá shows that *acaparadores* had entangled artisans in debt as a way to force them to increase their production, alter the styles, and lower their prices.

At the height of commercial triumphalism in the 1940s, others began to share this discomfort about what was happening to Mexico's handicrafts. The Spanish exile Alardo Prats accused the state of having co-opted the term "popular art," twisting it until it referred not to "authentic indigenous arts" but to cheaply made knickknacks manufactured specifically to sell in mass markets. The Oaxacan ethnologist and writer Enrique Othón Díaz agreed. He remonstrated against state and private investors for their supposed conspiracy to debase Mexico's handicrafts, charging that "private initiatives" driven by "ignorance and greed," such as the Sociedad Impulsora, were destroying artistic quality, exploiting artisans, and replacing authentic arts with tourist kitsch.[8] He warned that, unchecked, this would end in the extinction of the uniqueness embodied in the *lacas* of Olinalá, the textiles of Santa María (San Luis Potosí), the ceramics of Tlaquepaque, and other popular arts. Moreover, he argued that declining quality might result in the collapse of the market, leaving Mexicans doubly impoverished because they would be both unemployed and deprived of

their cultural patrimony. "Is there no hope of salvaging them from the inferno that is burning away the spirit of Mexico?" Othón Díaz asked. Five years later Natalia Valle added to this critique by raising questions about who benefited from the state's policies. She accused merchants and commercial agents of reaping huge profits while artisans suffered work speedups and a declining standard of living.[9] Like Montenegro, Prats, Toor, and Othón Díaz, she insisted that though popular art had been debased, still there remained founts of authenticity from which it could be regenerated. Yet even these founts might soon dry up, they warned. One particularly emotive critic declared that by producing in series, artisans were "closing off" the ancestral spring that feeds their "imagination, creative fantasy, joyful color and composition." The author urged fellow Mexicans to "counter this evil influence," so that artisans can "break down the wall of this prison and come out again to the open air of their landscape, of their lives and their work."

The rising tide of criticism took aim at specific state programs and raised doubts about the overriding assumptions that had driven state policy. Félix Angulo Castuñón in 1953 charged that artisans were "being killed" by the Almacén de Ventas de Objetos Típicos (of the Sociedad Impulsora de Industrias Típicas Mexicanas), whose galleries, according to Angulo Castuñón, were heaped with "examples of depraved trafficking." He called upon the state to lay out a new plan that might honor Mexico instead of leaving it looking like "a debased Indian, exhausted to the extreme, wandering aimlessly." A few years later the journalist Antonio Gazol called into question earlier claims that popular art was an inevitable casualty of industrialization. He pointed out that countries far more industrialized than Mexico had managed to modernize without extending the industrialization ethos to their popular arts. Modernization, he and others argued, demanded neither the elimination nor the industrialization of popular art.[10]

Retaking the Initiative: The Museo Nacional de Artes e Industrias Populares

Intellectuals did more than just criticize official policy: they formulated an alternative. The anthropologist Alfonso Caso led the way starting in 1942. Younger brother to the antipositivist philosopher Antonio Caso, Alfonso Caso won fame in his own right as an anthropologist and archaeologist and is best remembered for his work on the Monte Albán excavation in Oaxaca (1931–43). He taught law until 1930, when the DMAAH recruited

him to train archaeologists. From 1933 through 1934 he headed the National Museum, where he expanded on the initiatives set into motion by his predecessor Rafael Pérez Taylor (see chapter 4). When Cárdenas dissolved the DMAAH to create the INAH, Caso stepped in as INAH's director from 1939 through 1944. Later, in 1949, he would return to head the Instituto Nacional Indigenista. In 1942 Caso joined forces with Roberto Montenegro to put into practice the latter's call (from 1934) for an institution that combined a museum with a research center and offered technical extension programs for craftspeople and an advertising department to increase demand for "authentic" Mexican crafts (see chapter 5). Initially, they hoped to create such an institution by restructuring the Museo de Artes Populares.[11] When Montenegro returned to the helm of the MAP in 1945 he submitted a plan to transform it into the kind of institution he and Caso envisioned. The Ministry of Education's rejection of the proposal pushed Caso to draft plans for what would become the National Museum of Popular Arts and Industries (Museo Nacional de Artes e Industrias Populares, MNAIP), which for the coming decades would act as a key defender of popular art and of artisans.

As he laid plans for the MNAIP Caso insisted on the need to determine *which* crafts deserved protection as cultural patrimony and which were mere kitsch that should be abandoned to the market. Though Caso devised more than his share of baroque typologies for classifying handicrafts, he insisted that government policy should be based upon historical precedent rather than taxonomies. He looked to see which crafts had been included in past efforts to catalogue "authentic" arts. The most important of these, in his view, had been the 1921 Centennial Exhibition of Popular Art; the 1922 exhibition that traveled to Los Angeles; Atl's 1922 catalogue; the Museo de Artes Populares; and the 1940 New York show that he co-curated with Roberto Montenegro. By drawing on this historical perspective, Caso defined the MNAIP as the direct heir to the aesthetic discourses of the 1920s, and he disowned the Sociedad Impulsora and its Almacén de Ventas de Objetos Típicos as an illegitimate interlude—he also disavowed the foreign-organized Mexican Arts Show of 1930–32 (see chapter 3).

In 1949 Caso at last turned his plan into reality. At the start of that year he became director of the newly created Instituto Nacional Indigenista (INI), signed into law on 10 November 1948 by President Miguel Alemán in compliance with a pro-indigenous international treaty drafted at the in-

digenista conference in Pátzcuaro in 1940. In the founding mandate for the INI Caso inserted a provision that established the MNAIP to promote and protect "authentic" popular art—which he termed "indigenous art" to distinguish it from what dealers and the state had come to define as "popular art" and to stress its relevance to the INI. After a preview exhibition staged at the National Museum drew over 14,000 people, the MNAIP was inaugurated on 2 May 1951 in the former Convento de Corpus Cristi across from the Alameda. Part of the building served as a museum space and part as a sales annex open to wholesalers and the public. By reenergizing the link between indigenousness, popular art, and *mexicanidad*, Caso helped inspire renewed interest in popular art as an aspect of the nation's patrimony that merited protection.

The MNAIP stressed institutional cooperation. It even was overseen by a cooperative venture. The Instituto Nacional Indigenista (INI) and the Instituto Nacional de Antropología e Historia (INAH, the successor to DMAAH) joined forces to create the Consejo Nacional de las Artesanías, which was responsible for the creation and continued oversight of the MNAIP. The Consejo hired an advisory council composed of the intellectuals who had been excluded from commercially driven projects such as the Sociedad Impulsora. These advisors included Miguel Covarrubias, Jorge Enciso, Roberto Montenegro, Frederick Davis, Xavier Guerrero, and Adolfo Best Maugard. The make-up of the council reinforced the museum's intellectual lineage, but, unlike the MAP, which suffered institutional isolation, the MNAIP reached out to a range of other institutions. Beyond the INAH and the INI, it also collaborated with the Office of Tourism, the Ministry of Foreign Relations, the Ministry of Industry and Commerce, the Bank of Mexico, the National University, the National Bank of Foreign Commerce, and, after 1960, the National Bank for the Promotion of Cooperatives (Dirección de Turismo, Secretaría de Relaciones Exteriores, Secretaría de Industria y Comercio, Banco de México, Universidad Nacional, Banco Nacional de Comercio Exterior, and Banco Nacional de Fomento Cooperativo, respectively).[12] By drawing on such broad input, the MNAIP incorporated a range of perspectives and gave diverse constituencies a stake in its success.

Where the MAP's mission had reflected the 1920s drive to integrate the nation and to forge an ethnicized national identity, the MNAIP's spoke to the concerns of the 1940s and 1950s. The historian Alex Saragoza ar-

gues that as the national identity became thoroughly commercialized in the 1940s through cinema, advertising, tourism, popular music, television, and ballet folklórico, it became "less reliant upon the appeal of authenticity." Nationalist imagery shifted away "from essentialist cultural depiction to" an economically inspired pastiche of folkloric images that blended beach resorts, modern high-rises, and cheap goods and services for tourists. Similarly, Ricardo Pérez Montfort notes that in the 1940s and 1950s television picked up on the stereotypes that had taken form in the 1920s and repackaged them for broader consumptions as mass entertainment.[13] The MAP's old claims that popular art should serve as a vehicle for integration no longer seemed relevant. The MNAIP perpetuated its predecessor's treatment of popular art as an endangered aspect of the national patrimony that needed to be protected against commercialization (which, as Saragoza points out, became accentuated in the 1940s), but instead of situating its efforts in relation to national integration, it focused squarely on the question of how the state should manage the national patrimony.

In the MNAIP's first two months 32,376 visitors passed through its galleries. Its art store was thriving selling "authentic" objects, it commissioned the artist Miguel Covarrubias to paint a mural depicting a popular arts–based national geography of Mexico, and it invigorated artistic and national esteem for handicrafts.[14] Much of its success resulted from the leadership of its first director, Daniel F. Rubín de la Borbolla, and his assistant, Víctor Fosado (who previously had worked with Davis and d'Harnoncourt; see chapter 3). Rubín de la Borbolla had begun his career at the National Museum in 1931 and just before coming to the MNAIP he had served as director of the INAH's National Museum of Anthropology (Museo Nacional de Antropología). In contrast to Gamio and even to Alfonso Caso, he was suspicious of top-down large-scale social manipulation and blasted 1940s and 1950s style *indigenismo* as "the policy of a nation toward a conquered minority."[15] De la Borbolla was not willing to abandon paternalism toward artisans, but he did insist that they should be in direct contact with the market (though he preferred they interact with the high- and middle-end market, rather than the low-end market) and make their own aesthetic decisions (informed, naturally, by the advice of the MNAIP).

To refine its goals and measure its progress, the MNAIP needed hard numbers on the size and character of the popular art market. It finally got such statistics in 1955 when the National Bank of Foreign Commerce pro-

duced a study of the handicrafts market. Though the study was limited to officially reported sales, it delivered two key revelations. The first was that the popular art market, worth 163,200,000 pesos, was larger than people had realized. This did not include the informal market made up of fairs, street stands, and ambulatory vendors, which probably was at least as large as the formal market. The study, therefore, probably dramatically underestimated the economic importance of handicrafts, yet even the 163 million peso figure astonished officials.

Second, and more stunning, the study found that the vast majority of the end consumers of these officially reported craft sales were Mexican—inclusion of informal markets, no doubt, would have emphasized further the predominant role of Mexican consumers over foreigners. Foreign consumption dominated only in the high-end market, which made up a small part of the overall craft economy. Mexicans could console themselves in the knowledge that their national arts were not subject to foreign whims, as many had assumed. On the other hand, it lent a hollow ring to the tendency to blame *gringos* for reducing Mexican popular arts to cheap trinkets or for forcing artisans into serialized production, work speedups, and declining real incomes. The study confirmed de la Borbolla's argument that Mexicans had no one to blame but themselves for the sad condition into which the nation's popular art had sunk. Foreigners, who had been accused of debasing Mexican popular art, instead sustained the supposed last bastions of authenticity. Because the decline of crafts was a Mexican problem, the solution, de la Borbolla insisted, lay within Mexico, not with foreign tourists.[16]

By the early 1960s, the MNAIP bumped against its limitations. It boasted of major achievements: it had amassed an impressive collection (largely purchased thanks to the services of Frederick Davis, Víctor Fosado, and Roberto Montenegro), created regional workshops across central Mexico, formed a department of international exhibitions, organized regional craft competitions that awarded monetary prizes, and employed researchers to study ways to improve artisans' use of local materials. It provided technical and marketing assistance to over 3,500 artisans, from whom it annually purchased 1.4 million pesos worth of *artesanías*. It managed five other museums across the country and had cooperative arrangements with many of the Mexican states. It coordinated its efforts with other government agencies and sponsored international exhibitions throughout Europe and the

Americas, helped draft new legislation to protect popular art (including the founding of the Banfoco-Fideicomiso; see below), published research findings, and completed a national atlas of Mexican popular art, which had been a goal among craft promoters since the 1920s.[17] Most of all, the MNAIP had challenged the procommercialization boosters who wanted to industrialize most aspects of craft production.

Even as the MNAIP's accomplishments mounted and though it had strengthened the market for medium- and high-end crafts, Rubín de la Borbolla worried that it lacked the capital to free artisans from *acaparadores*. De la Borbolla knew that unless the MNAIP could become a guaranteed buyer, which was impossible with its current budget, it could not have a deeper impact. The case of Olinalá, discussed in later chapters, shows, for instance, that the MNAIP offered top artisans a market to sell some of their best work at higher profit margins, and it offered the rising generation of artisans the guidance and financial incentives to learn to produce high-quality craftsmanship. But it lacked the resources to buy in quantity or consistency sufficient for even the most talented of artisans to escape their cycle of debt to the local and regional *acaparadores*. Artisans could use the MNAIP to boost their income and to lessen their local vulnerability, but it did not provide a secure enough market for them to break out of the cycle of work speedups and declining incomes that had come to characterize craft production (see chapters 8 and 9). De la Borbolla lamented that sometimes it was not even worthwhile for the MNAIP to try to revitalize a particular craft or even "to test its commercial potential because the funds for purchases" were simply not available.[18]

Despite these limitations, the MNAIP expanded its list of allies to include pro-industrialists, who were giving up on the idea of transforming popular arts into a vital export. In 1958 one such pro-industrialist, Rudolfo Corona, denounced as preposterous the strategy that had been promoted over the past two decades that looked to "indigenous industries" as the "saviors of our economy." To accept the "defeatist idea" that popular arts could provide an enduring road to economic development for Mexico, "that we have no better option than to dedicate ourselves to exploiting the *petates*, the palm hats, homemade mezcal, boxes from Olinalá, and various other knickknacks, is to accept that the national economy [suffers from] an incurable illness." This should be "unacceptable to any Mexican." Corona concluded that "characteristic arts should be encouraged for the good of

some Indians and to conserve our cultural roots," but that it had been "a grave error to treat them as a key factor in our [national] economy."[19] His perspective would have been unusual for the 1940s, but was becoming widespread by the late 1950s. This bolstered the MNAIP and its claim to defend popular art not just for its economic value to the government and to dealers but for what it could contribute to artisans and the rural economy and, most of all, to national pride.

Despite public support and a string of successes, the MNAIP, like its MAP predecessor, was hampered by its reliance upon a state that with one hand acted as its greatest ally but with the other hand proved to be its worst enemy. While supporting the MNAIP, the government continued to fund projects such as the Sociedad Impulsora that directly undermined the MNAIP's mission by intensifying production, strengthening *acaparadores*, and depressing prices and quality.

Toward a Comprehensive State Strategy, 1960–74

In the 1960s the state responded to the public mood by moving toward a comprehensive strategy in favor of handicrafts as cultural patrimony. Adolfo López Mateos (1958–64) entered the presidency promising a shift to the left, but his violent repression of a railroad strike showed that he intended merely a selective use of populist policies as a way to reinforce the existing system.[20] As Mexico passed the tipping point from being majority rural to majority urban, López Mateos's administration launched a barrage of programs aimed at campesinos. Through direct government investment, expansion of the rural school system, and land reform the PRI hoped both to turn the peasantry into a strong base of party support and to slow run-away urbanization.

With renewed interest in rural development, and at the urging of INAH and INI, the Mexican congress in 1960 announced plans for a study that would lay the foundation for a consistent and comprehensive policy toward handicrafts. For several months the congress consulted with the National Bank for Economic Development (Nacional Financiera), the National Bank for the Development of Cooperatives (Banco Nacional de Fomento Cooperativo, known as Banfoco), the Foreign Commerce Bank, the Fund for Small Industry (Fondo de Garantía a la Pequeña Industria), the INAH, the INI, and the MNAIP. Then, after well-publicized visits to artisan communities, the congressional commission at last concluded that

what artisans most needed were low-interest credits and assistance with marketing. In hindsight these needs might seem obvious, and hardly requiring so much investigation, yet this acknowledgment marked a turning point in state policy. The congress announced plans for a system of credit, exhibition and sales outlets, and autonomous artisan cooperatives. Most importantly, it explicitly stated its intention to favor artisans over private dealers.[21] Before settling on a single policy to achieve these goals, the congressional committee advised testing through a number of pilot programs.

In 1961, after a year of pilot programs, President Adolfo López Mateos authorized creation of the Endowment for the Development of Arts and Crafts (Fondo de Fideicomiso para el Fomento de las Artesanías), backed by a five-million-peso endowment and a consortium of lenders. This endowment replaced the maligned Sociedad Impulsora de Industrias Típicas Mexicanas (Society for the Promotion of Mexican Vernacular Industries, discussed in chapter 5) that had been created in 1934. By this time the Sociedad seems to have declined in importance, perhaps because crafts no longer seemed a potential motor for national economic development, and because wholesalers no longer relied on state subsidies to maintain their networks of *acaparadores*. López Mateos placed the endowment under the management of Banfoco (which had conducted some of the research that led to the Fideicomiso's founding). Banfoco had been created in 1941 under President Avila Camacho and began operations in 1944 as a replacement for the defunct National Workers Bank of Industrial Development (Banco Nacional Obrero de Fomento Industrial, created in 1937), which López Mateos had headed earlier in his career. The purpose of Banfoco was to help rural workers form themselves into buying-and-selling cooperatives and to provide them with low-interest loans. López Mateos now looked to Banfoco to do for artisans what it had promised to do for other rural workers.

Unlike the Sociedad Impulsora, which had favored wholesalers over artisans, the Fideicomiso-Banfoco tried to address the concerns of both parties. Spurning the practice of relying on *acaparadores* to manage production and to keep prices down, Banfoco organized artisans into self-governing cooperatives to oversee quality control and distribute benefits. In August 1962 it opened an exhibition/sales gallery at the headquarters of the National Bank of Foreign Commerce. It invited exporters, wholesalers, and retailers to come see the different kinds of *artesanía* and to place

orders, and it guaranteed that the goods would be delivered on time and that they would be of the same or higher quality as the objects on display. It even covered the cost of packing, shipping, and Mexican customs.[22]

As a forward-looking compromise between the business community, the intelligentsia, and artisans, the Fideicomiso-Banfoco set out to reverse the declining quality and status of handicrafts, for which the state itself had been partly responsible, and to make it easier to fill orders. In this way, it earned the support of both artisans and wholesalers, while cultural nationalists praised it for working with, rather than against, the goals of the MNAIP.[23] The new institution signaled to artisans that, at last, they might look to the government as an alternative to the local *acaparadores*. Unfortunately, like the MNAIP, it did not buy on a scale sufficient to displace *acaparadores*.

Because the Fideicomiso-Banfoco lacked the capital and organizational structure to counter *acaparadores* within communities across Mexico, craftspeople initially doubted Banfoco's representatives' intentions and commitment. One of the first targets of the new policy was the artisan community of Olinalá, where *lacqueros* recount that only after repeated visits did Banfoco representative Carlos Romero Giordano win their trust and convince them to form themselves into a cooperative. Banfoco granted the new cooperative, which named itself Olinka, a revolving line of low-interest credit that the cooperative then redistributed to members. Banfoco also helped Olinka members participate in the annual Feria del Hogar (Home Fair), where artisans made direct contact with hundreds of urban wholesalers, collectors, and exporters.[24] A bigger change in craft production, however, would require more resources than even the Fideicomiso-Banfoco at that time could muster.

Following much public praise for Banfoco's management, in July 1963 President López Mateos doubled the size of the endowment to 10 million pesos.[25] But problems lay on the horizon. In the second half of the decade as the government spent lavishly in preparation for the 1968 Mexico City Olympics, the PRI found itself beset by a massive student movement that questioned its legitimacy. The student movement blossomed alongside an international wave of activism that extended from France to the United States, but its demands related specifically to the Mexican context. Beyond concerns about the universities, the students also called for an opening of the political system, more opportunities for the middle class,

and a response to the growing inequality born of the Mexican "economic miracle" of the 1940s through the 1960s. Ill equipped to deal with calls for democratization, the state lashed out against peaceful protestors, killing hundreds in Tlatelolco Plaza and taking thousands more as political prisoners, while President Gustavo Díaz Ordáz paternalistically upbraided the activists and accused them of being misled by outside communist agitators. Some of those who fled joined guerrilla groups in Guerrero and other parts of southern Mexico, and overall the crackdown set the stage for a larger crisis of legitimacy for the ruling party.[26]

Banfoco seemed to offer a reason for hope in the midst of an otherwise tarnished political system. This prompted yet another increase to 25 million pesos. But, like the rest of the government under the PRI, it suffered corruption and mismanagement. With the growth of the endowment from 5 million pesos to 25 million in only seven years one might expect to see Banfoco at last become a dedicated buyer for artisans, capable of undermining the control of *acaparadores*. But that did not happen. The problem was that in 1962 officials created a rule that allowed Fideicomiso funds to flow to any endeavor that they officially designated as "popular art." Soon the Fideicomiso was subsidizing factories producing such goods as brooms, mold-pressed porcelain knickknacks, and busts of Francisco Madero and José María Pino Suárez, rather than improving its support for artisan cooperatives. In the meantime, many of the monetary prizes that Banfoco was supposed to award to traditional artisans in competitions designed to provide incentives for high-quality craftsmanship instead went to privileged artists and to either *acaparadores* or else workshop owners who did little, if any, of the craftwork. By the end of the 1960s, even as the budget ballooned, Banfoco's support for artisans came to a standstill.[27]

Another problem was that, while Banfoco had been created in part as a result of the report of 1955 that revealed the size of the handicraft market, officials within the agency had lost sight of the second major finding of that report. Though the report had shown that most buyers were Mexicans, Banfoco's marketing, designed to convince buyers to prefer high-quality and "more authentic" crafts, focused exclusively on foreigners. One critic complained that because Banfoco failed to address the buying habits of Mexicans, who made up the majority of consumers of handicrafts, "within a few years the traditions will be lost, and all that will remain [of authentic popular art] will be memories and the lines written in books." Some

even accused Banfoco, like the Sociedad Impulsora it replaced, of relying on *acaparadores* rather than artisans organized into cooperatives, and of trying to transition artisans away from individual craftsmanship toward factory-line production.[28] In this context, cooperation between the MNAIP and Banfoco, too, broke down.

It was at this time in 1970 that Luis Echeverría entered the presidency. While serving as Díaz Ordáz's minister of the government he oversaw much of the repression of the student movement of 1968. As president he presented himself as a populist. Like López Mateos a decade earlier, Echeverría set out to heal divisions and strengthen the PRI by nudging Mexico toward the left; but, also like López Mateos, Echeverría readily authorized violence against those who demanded real change. The president ran into problems not just with student and labor groups but also with capitalists, who viewed him as a populist radical. The distribution of wealth in Mexico had become strikingly unbalanced. Echeverría's attempts to levy a tax on the wealthy succeeded only in rallying opposition by domestic and foreign businesses, which withheld investment, accelerating the economic downturn. To build an alternative base of support and to resuscitate the economy he promoted distribution programs aimed at the rural sector, hoping that by improving campesinos' standard of living, the state might increase the circulation of goods and thereby stimulate the sagging economy. His efforts failed to get the desired economic result. With an expanding public sector, a stagnant economy, and the refusal by the rich to pay taxes, Mexico increased the tax burden of the small middle class and assumed a rapidly growing debt.[29]

To try to lure back investors, the state intervened even more deeply into the economy to create what the political scientist Dan Cothran describes as "an infrastructure of protection that virtually guaranteed business its profits, rather than" let it "be subjected to the rigors of market competition."[30] Echeverría's administration extended this approach to worker and peasant cooperatives, including craftspeople, shielding them from the fluctuations of the market in an effort to increase their standard of living and stimulate the economy through consumption. In contrast to the popular art policy that had predominated from the late 1930s through the 1950s, Echeverría made efforts to buffer rural producers from laissez-faire economics.

As part of this program Echeverría called for the reform of Banfoco.

He entrusted the agency to his close associate Tonatiuh Gutiérrez and instructed him to overhaul the way it managed the Fondo de Fideicomiso para el Fomento de las Artesanías. In particular, Echeverría wanted Gutiérrez to energize efforts to organize artisans into "solidarity groups" to buy and sell collectively and assure a steady flow of fairly remunerated quality craftsmanship.[31]

Eager to rebuild the agency, and given a relatively free hand by the president, Gutiérrez reestablished cooperation between Banfoco and the MNAIP, with the latter, for example, responsible for organizing and judging craft competitions for Banfoco and displaying the winning objects that Banfoco purchased. Gutiérrez hired as consultants Víctor Fosado (whom he credits with having taught him to recognize "authentic" popular art), Frederick Davis, Rubín de la Borbolla, and, later, Carlos Espejel (who succeeded Rubín de la Borbolla as director of the MNAIP)—Montenegro played no role because he had passed away in 1968. More than simply offer advice, these individuals guided Gutiérrez on his travels to the countryside, introducing him to craftspeople and helping him understand their needs and accomplishments.[32]

By 1972, Gutiérrez had radically restructured Banfoco's operations. Funds stopped flowing to *acaparadores* and to the factories that officials had improperly designated as "popular art." To facilitate artisans' access to Fideicomiso funds, Gutiérrez removed the requirement that they put forth collateral or other kinds of guarantees. Banfoco now extended loans on faith, monitored by the governing council of each cooperative. If an artisan fulfilled the terms of his or her initially small loan, he or she received a rotating line of credit that increased in size with each cycle of successful repayment. The local cooperative, meantime, saw its budget increase proportionately. Conversely, if a borrower failed to pay, he or she lost eligibility, and the other members of the cooperative had to absorb the loss. This demanded vigilance and enforcement from cooperatives' governing councils. Banfoco also increased the use of exhibitions (both domestic and international), academic conferences, field research, official stores, and advertising to stimulate not only export markets but also domestic consumption of "the authentic artesanía of Mexico."[33]

The changes within Banfoco reflected a half century of state-mediated negotiation across social sectors, including artisans, government officials, intellectuals, and wholesalers. They also intersected with the administra-

tion's efforts to quell growing rural unrest. Echeverría contended with Marxist guerrilla movements led by disaffected middle-class youths, peasants, teachers, and laborers. Rather than address the rebels' concerns, his administration responded with repression, political disappearances, and torture—tactics that exacerbated tensions. To understand why the violence declined halfway through his term we need to look beyond repression toward the ways the regime renegotiated the structure of hegemony. (Chapter 9 addresses this argument in more detail, grounded in the case of Olinalá.) While scholars have stressed Echeverría's use of repression to counter this opposition, it also is important to recognize that he complemented these with policies such as agrarian reform and by offering university graduates jobs through which they could help shape and implement policies designed to benefit rural groups. The historian Samuel Schmidt notes that college graduates began putting their idealism into practice through various state agencies including Conasupo (the government network of rural stores), Banrural (which offered loans to peasant cooperatives), Inmecafe (which dealt with coffee growers), and others, to which I would add Banfoco.[34] By improving the operation of Banfoco, the administration brought idealistic middle-class workers as well as impoverished artisans into the Institutionalized Revolution.

The Fideicomiso proved so successful that it outgrew Banfoco. Beyond the Fondo de Fideicomiso para el Fomento de las Artesanías, Banfoco also managed fideicomisos for fishermen, henequen harvesters, gum tappers, and others. Gutiérrez argued to Echeverría that because popular art—whose market was driven by aesthetic and cultural concerns—was fundamentally different from these other products, and because the reformed Fideicomiso absorbed so much of Banfoco's energies, it should be spun off as an autonomous agency. Echeverría agreed, and in 1974 he created the Fondo Nacional para el Fomento de las Artesanías (Fonart) and put Gutiérrez in charge. This is the same institution that persists to this day as part of the Secretaría de Desarrollo Social (Ministry of Social Development), managing artisan cooperative and craft sales through outlets across the country.

Much of the success of Banfoco and Fonart can be attributed to the specific ways these institutions intervened at the local level. As I interviewed artisans from across the country they surprised me with their high praise for Echeverría, whose name so often is reviled among other social

sectors. Part of this can be explained by the fact that it was under his presidency that the artisans felt that Banfoco and then Fonart finally had really listened to them and addressed their concerns, respecting them not just as passive makers of national patrimony but as individuals. Through sustained interactions with artisans, and sometimes by developing friendships with them, Banfoco representatives such as Carlos Romero Giordano learned to see things from their perspective and worked toward goals they considered important. Moreover, during this period Banfoco and then Fonart did not restrict their interactions narrowly to craft production; they addressed the broad social and economic context in which artisans worked. They listened to what these communities said they needed, including drinking water, schools, and, on occasion, even roads, as in the cases of the Seri woodcarvers of Sonora, the Otomí ayate weavers of Hidalgo, and the Olinaltecan lacqueros of Guerrero (regarding the road to Olinalá, see chapter 9). Fonart even paid for academically gifted children of artisans to attend university in Mexico City, some of them all the way through medical school.[35] Each such intervention gave artisans a stake in the political system controlled by the PRI, won allies for the Echeverría government, and added to the negotiated structure of state rule.

In his study of Echeverría's presidency, Schmidt argues that Echeverría left office uniformly regarded as a failure, but he overstates his case. At a time of national crisis, the president's populist program won the allegiance of artisans along with segments of the professional middle class by looking back to the aesthetic and nationalist discourses of the 1920s and 1930s and rewiring these discourses to make them useful to the state in the era of the institutionalized, "frozen," revolution.[36]

Conclusions

From the collapse of the MAP through the creation of the MNAIP promoters of popular art grappled with the tension between their desires to protect handicrafts as patrimony, on the one hand, and their commitment to addressing the social and economic needs of artisans, on the other. Time and again, however, their debates were cut short and rendered irrelevant by capitalists who had the ear of state officials. Not until the early 1970s did the state draw upon a longer history of cultural negotiation with different sectors of society to find a sustainable balance between capitalist interests and nationalist patrimony, as well as between artisan agency and top-down

nationalism. By serving as the locus of this negotiation, Fonart helped re-negotiate the structure of hegemony by casting itself as the defender of authentic *mexicanidad* in a time of crisis.

Like its institutional predecessors, Fonart evolved. By the end of the 1970s it abandoned experiments that awarded housing and university scholarships to the children of artisans because officials decided that Fonart's purpose was not to raise the standard of living of artisans per se but to assure the reproduction of *artesanías* and encourage rural economic development. As this happened, Fonart revived 1920s-style paternalism—deciding what was good for Mexico's artisans *as* artisans, not as individuals—while also perfecting strategies devised by 1930s–50s pro-commercialization boosters. Its success at this balancing act has been a result of the fact that it learned to negotiate directly with rural artisans while organizing them into a base of corporatist support. This support has given the artisans a stake in the state and its institutions. Artisans' enduring devotion to Echeverría, however, never translated into support for the ruling party. When the PRD (Partido de la Revolución Democrática, or Party of the Democratic Revolution, the left-of-center opposition party) emerged in 1989, in fact, it found some of its strongest rural supporters among artisans and indigenous groups. Artisans, then, accepted Fonart and other state-affiliated organizations and they praised Echeverría, but they rejected politicians' efforts to transfer this into loyalty to the PRI.

PART II 🦋 **Alternative Narratives of Metropolitan Intervention**

The Artisans of Olinalá, Guerrero

Olinalá sits nestled in the Montaña de Guerrero, one of the most isolated, impoverished and indigenous corners of Mexico. Across the nineteenth and twentieth centuries, regional and local elites preyed upon the villagers' isolation and economic and political vulnerability, while keeping the central government at bay and thwarting almost every effort to improve the transportation system. Artisans, toiling far from the beaten track of tourists and collectors, struggled to get their art to market. On account of the town's isolation, outsiders' knowledge of Olinalá generally was restricted to what could be gleaned from its lacquered crafts and from imagination.

Given this isolation it might seem puzzling that Olinalá and its lacquered art ever came to national attention in the first place, and that it continues to serve as a potent symbol of ethnicized *mexicanidad*. Ironically, it is Olinalá's isolation that contributed to its prominence within the nationalist imagination. Postrevolutionary nationalists and collectors, who seem not to have ever visited Olinalá until Frances Toor made the arduous journey at the end of 1939, argued that Olinalá's isolation had saved its craftspeople from Porfirian corruptions, preserving it as an oasis of authenticity.[1] Though they knew little about the town or the artisans, they did know the main styles of Olinaltecan lacquer–*rayado* (etched) and *dorado* (literally "gilded," though used in Olinalá to mean "painterly"). Though they accepted both styles as authentic expressions of *mexicanidad* and of the indigenous capacity to assimilate and transform European influences, collectors saw *rayado* as the ideal symbol of Olinaltecan authenticity and *dorado* as a nineteenth-century degeneration. Whether they produced in *rayado* or *dorado*, Olinaltecan artisans seemed to embody the ideal of passive Indians whose art was shaped by intuition rather than by conscious decisions.

But how did craftsmanship and art markets look from the local level, from the point of view of the artisans whom cultural elites celebrated as *lo más mexicano de México*? The second half of this book reconstructs Olinaltecan experience on its own terms, as an alternative narrative. The historian Gyan Prakash has pointed out that reconstructions of the subaltern experience of nations and empires requires that we decipher narratives that neither affirm nor contest the dominant narrative but rather offer up

a different reading of history from the viewpoint of those who are silenced in the historical record.[2]

Reconstruction of this kind of alternative narrative cannot come from the elite record alone. The anthropologist Gerald Sider has noted that when dominant sectors (in Sider's case, "Westerners") engaged groups that they considered "Other" or alien, they tended to treat them as parrots who could speak back only what was spoken to them. All other utterances went unregistered or became either anomalous or unintelligible.[3] We witness such a situation in the relationship between metropolitan nationalists and Olinaltecan artisans. Nationalists generally remained blind to local identities and struggles that defied their own preoccupation with aesthetic authenticity and their desire to determine whether the artisans were or were not "real" Indians. Peter Hulme notes that, because a "monological encounter" tends to "masquerade as a dialogue" within the elite sources, it "leaves no room for alternative voices."[4]

Any effort to understand how events unfolded in Olinalá and to relate them to transnational constructions of Mexican nationality is complicated by the difficulty of separating local experience from the claims that cultural elites made about that experience, while at the same time remaining sensitive to the moments when the nationalist discourse and local experience converged to remake one another. Moreover, meanings ascribed to lacquer, ethnicity, and national identity, whether by cultural elites or by Olinaltecos, cannot be understood except as they relate to the construction, transformation, reinforcement, or contestation of relations of power. This makes it particularly important that the elite monologue not stand in for local experience. It is not enough to read elite texts "against the grain" because such a reading cannot, in itself, overcome the elite's practice of ignoring local actions or statements that did not conform to their own monological discourse. Reading sources against the grain stands the elite account on its head and can even open spaces for other forms of analysis, but as an interpretative strategy it cannot necessarily offer up "alternative" narratives. In other words, it challenges elite claims but has difficulty suggesting alternative narratives about what issues might have been most important from the local perspective.

With this in mind, the following chapters complement the elite-produced narrative with an array of local and mid-level sources. These include censuses, correspondence, political and land petitions, local and

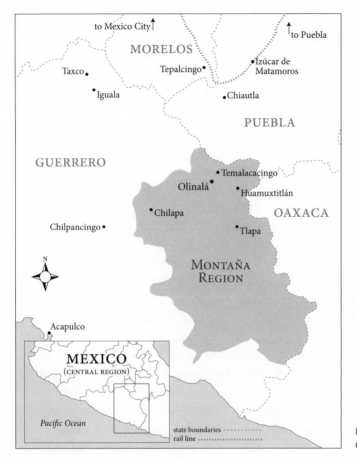

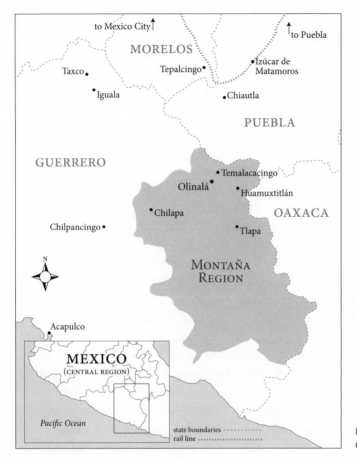

to Mexico City↑

MORELOS

to Puebla

Taxco•

Tepalcingo•

•Izúcar de
Matamoros

•Iguala

•Chiautla

PUEBLA

GUERRERO

•Temalacacingo

Olinalá•

•Huamuxtitlán

•Chilapa

OAXACA

Chilpancingo •

•Tlapa

N

MONTAÑA
REGION

Acapulco

MEXICO
(CENTRAL REGION)

Pacific Ocean

state boundaries - - - - - - - - - -
rail line ••••••••••••••••••••••••

Map showing
Olinalá

government maps, land records, police logs, tax and tithing records, birth and marriage records, travelers' accounts, ethnographic reports, and, importantly, the lacquered objects produced by the artisans of Olinalá. Oral interviews breathe life into these documents, making it possible to understand them in ways that would have been impossible otherwise. Good fortune has given many Olinaltecos long lives and good memories. In countless hours of interviews the lives of such artisans as the centenarian Concepción Ventura Pérez, known as Doña Concha, like much of the documentation from the earlier periods, emerge as fragments that cannot be pieced together into a coherent, singular, narrative. Their memories offer complex, often unexpected pieces of a puzzle that have to be carefully triangulated with other evidence to try to disentangle the history and

deduce the most plausible explanations and interpretations of historical changes within the community.

These chapters take particular interest in artisan agency and how artisans viewed themselves and their own roles as creators. Did they see themselves as anonymous reproducers of tradition, as elites suggested? What was the role of collectivism versus individualism in their act of creating and marketing their wares? How did they experience indigenousness? And how did they experience the changing articulation between nationality, indigenousness, and aesthetics? By moving between the elite narrative and local power struggles in Olinalá, and by tracing how processes filtered through multiple layers of local society, these chapters argue that the glue that integrates the nation around an ethnicized nationality is not simply a product of elite discourse, international markets, and state institutions. Rather, the strength of this integration lies in the linkages that local communities such as Olinalá built between themselves, the national, and the international, and in the ways nationalist discourses, art markets, and state institutions became imbedded and remade within local society.

Finally, before going any further, it is important to remember that this is not a community study in the usual sense. It is a study of how local, regional, national, and international processes intersected on the local level to impact the power relations that shaped the artisans' lives. In this context, the town of Olinalá emerges as a point where the local, national, and transnational flow together and where myth and reality intermingle to remake one another. As the following chapters will show, from the Aztec era through the conquest and into the nineteenth century, Olinaltecos used their art to mediate empire, region, nation, and ethnicity. But what was new in the twentieth century was the way the artisans, after the revolution of 1910–20, used their art to stake a claim as producers of national identity and as part of an inclusive and ethnicized nation. Their integration into the postrevolutionary ethnicized nation has come as a product of their struggle over the place and meaning of their art within their community and the nation and, eventually, from their claim that their art and bodies marked them as rightful beneficiaries of state-led transformation.

🦋

The "Unbroken Tradition" of Olinalá from the Aztecs through the Revolution

The revolution sent economic shock waves through segments of the old elite. To carry themselves through difficult times, some families sold heirlooms that had been passed down through generations. Dealers and collectors took a special interest in lacquered antiques from Olinalá. By the 1920s, nationalists, too, took an interest, particularly in the eighteenth-century chests, beautifully decorated in the *rayado* style. They esteemed these lacquered antiques—which they viewed as a synthesis between the preconquest and colonial eras—alongside contemporary Olinaltecan bowls and gourds that seemed ubiquitous among indigenous travelers in south-central Mexico, from Guerrero and Oaxaca up through Puebla, Estado de México, and Hidalgo. To their eyes these antiques and contemporary objects seemed to confirm that rural zones such as Olinalá, in contrast to urban areas, had maintained their cultural distinctiveness and thus could serve as founts for Mexico's cultural regeneration.

Postrevolutionary cultural elites understood Olinalá to be a place that always had been isolated from the state, modernity, and the market, where outside influences seeped in so slowly that indigenous people integrated them seamlessly into their naïve folkways and worldview. As elites fit Olinalá into their search for authenticity it became difficult for them to imagine an alternative narrative from below shaped around local understandings of art, ethnicity, social conflict, and revolution. It was not that elites were dim-witted but rather that Olinalá was physically isolated at that time and, as far as

they knew, had always been isolated. Moreover, their lack of direct contact with the town, due to its physical inaccessibility, made it easy for them to weave their own narratives. A view from Olinalá, however, offers a perspective that challenges aspects of the top-down view.

This chapter reconstructs an alternative narrative of the place of art in Olinalá from the preconquest era through the revolution. It argues that though Olinalá did suffer from isolation by the time of the revolution, it had not always been that way. On the contrary, Olinaltecos had a long history of using their art to mediate their relationship to the state and markets. As such, their art unfolded not as a naïve expression but through local-imperial/national interactions and grounded power struggles. This account is not a general or background history of the town; rather, the intention is to understand how *laqueros* used their art to mediate the intersections among local, regional, national, and transnational power structures.

Power and Place in Olinalá: From Aztec Tribute to Spanish Market

Olinalá owes it existence to Aztec imperial expansion. During the fifteenth century the Aztecs created this Nahua town as an imperial foothold within the ethnically Tlapaneco and Mixteco region now known as the Montaña. The town was to serve as a gateway through which the imperial capital of Tenochtitlán gained access to the tropical lowlands that lay beyond the Montaña, from whence the militarized traveling merchants known as *pochteca* derived such riches as jaguar skins and cacao. With an anchor of ethnic loyalists firmly in place, the Aztecs made Olinalá the head town of the administrative and tribute jurisdiction known as Quiyuahteopan. Olinaltecos' link to empire lay in their lacquered gourds, which they traded along imperial routes and rendered as tribute to the Aztec elite.

Along with quetzal feathers, cacao, and spices, the painted gourds of Olinalá ranked among the most treasured possessions of Tenochteco nobles, who used them as vessels from which to drink precious chocolate, the liquid gold of the Aztecs. So esteemed were the gourds that in public feasts only the highest ranked of those present were allowed to imbibe from these lacquered *xicalli*—others had to console themselves with elaborately decorated ceramic cups. Elites even took their gourds with them to the grave, having them placed like hats upon their heads for burial, perhaps to testify to their status and to provide a vessel for drinking choco-

late in the afterlife. In the central valley the use of exotic luxury goods was tightly regulated by sumptuary laws, but in Olinalá and its vicinity, gourds of widely varying quality seem to have been available for all classes of society.[1]

A second wave of Nahua migration followed the Spanish and Tlaxcalan conquest of Tenochtitlán in 1521. Fleeing Tenochtecos found refuge in Olinalá, and, in the process, remade the town's relation to the center and to its neighbors. These newcomers cemented the local dominance of Nahua culture, though it was now unmoored from the political and economic domination of the Aztec state. This also marked the beginnings of Olinalá's entry into the Spanish imperial orbit. Elders from the neighboring town of Temalacacingo preserve in oral tradition a story of their town's founding, which the writer Gutierre Tibón recorded during his visit in 1959–60. They explained to Tibón that the people of Olinalá and Temalacacingo descended from sibling warriors fleeing Tenochtitlán. One brother, Temalacatzin, founder of Temalacacingo, strongly opposed mixing with the Spanish conquerors. His sibling Olinaltzin encouraged such intermixture. For the elders of Temalacacingo this explained why Temalacacingo remained pure Nahua while Olinalá, despite its similar history, did not. A few years before Tibón recorded this story, the ethnographer Alejandro Wladimiro Paucic recorded a different version of the myth, told from the perspective of the elders of Olinalá. According to the Olinaltecos, two powerful Aztec *caciques* arrived in what is now Olinalá. They soon entered into a bitter rivalry that ended when Olinaltzin overcame Temalacatzin. The latter submitted himself to Olinaltzin's domination and cowered away to found Temalacacingo. According to this version of the tale, the Franciscans arrived soon after to lead the children of Olinaltzin to Christianity and the Spanish empire.[2] Though the two versions of the myth convey contrasting moral lessons about the power relationship between Olinalá and Temalacacingo, they both affirm Olinalá's reputation for openness to outside cultures (indigenous and nonindigenous alike), its role as the imperial gateway into the region, and its dominance over nearby Nahua communities, including Temalacacingo.

Invading Spaniards took notice of what Hernando de Alvarado Tezozómac, a descendent of Emperor Moctezuma and translator for the Spanish legal court, later remembered as the "brilliantly painted" gourds esteemed by the Tenochtecos. The Spanish chronicler Juan Suárez de Peralta de-

scribed them as "gourds that are like porcelain cups, large and small, richly painted" with "finely rendered colorful exteriors."[3] Despite taking notice of these lacquered goods, the Spaniards did not value them as had the Aztecs. The art historian Sonía Pérez Carrillo has conjectured that the absence of surviving objects from the late sixteenth through the early seventeenth centuries suggests that Olinaltecos ceased to produce lacquer, such that they had to relearn the craft in the eighteen century. But a focus on social and economic processes suggests otherwise.

As a reward for its nonviolent acquiescence to royal authority, the Spanish Crown in the 1530s renewed Olinalá's head town status, making it the administrative center of a República de Indios (an indigenous territory of the Crown) and granting it its own Catholic parish. By that time priests in the region reportedly were baptizing as many as 500 Indians per day.[4] The Crown granted the República de Olinalán (as it was known at the time) to the Spaniard Alonso de Aguilar as an *encomienda* (a trusteeship that permitted the grantee to exploit land, minerals, and people for his own profit). With no interest in the gourds and pigments that Olinaltecos had rendered unto the Aztecs, Aguilar demanded such items as gold and cacao, which Olinaltecos had to deliver directly to his home in Mexico City; and corn that they had to transport to his mines in Ayoteco (modern-day Chiautla, Puebla). After 1550, Olinaltecos even had to render laborers to work in the mines of Ayoteco and Chilapa.[5] When the natives rebelled against Spanish abuses in the hills just south of Olinalá, Viceroy Luis de Velasco, hoping to forestall any further uprisings, sent Don Gonzalo Díaz de Vargas of Puebla de los Angeles to investigate abuse on the Encomienda de Olinalán. In his 1556 report Díaz de Vargas found that the tribute demanded from Olinalán exceeded the republica's capacity, and he complained about abuse and overexploitation of the 1,555 *tributarios* (a *tributario* was defined as an indigenous head of household responsible for delivering his family's tribute).[6] Neither lacquered gourds nor the pigments and other raw art materials that had figured prominently on Aztec tribute rolls appear on Spanish tribute lists. But a closer consideration of Olinatlecan tribute suggests that lacquer existed between the lines.

The three main parts of Olinaltecos' tribute were corn, gold, and cacao; yet Olinalán had little arable land on which to grow corn, no gold to pan or mine, and a climate that could not grow cacao. How, then, did Olinaltecos acquire the goods that their *encomendero* demanded? The answer probably

lies in the town's lacquer production. Daniele Dehouve cautions scholars not to presume that just because tribute was paid in products rather than money that the products were produced locally. She argues that Spaniards demanded items that *montañeros* could acquire only through trade with the tropical Costa Chica.[7] Though Dehouve does not address Olinalá, her insights prompt speculation that Olinaltecos may have traded their lacquered gourds for tribute goods. Under Aztec rule Olinalá had served as the imperial gateway to the markets of the southwestern highlands and coastal zone. Under the Spaniards it probably continued as the gateway, but now Olinaltecos exchanged lacquered gourds for gold and corn from Tlapa and cacao from the tropics, which they then rendered to the empire.

Other evidence supports this hypothesis of continued production. In 1554 Fray Jerónimo de Mendieta wrote that the region's Indians of that time produced "cups made from certain kinds of durable gourds" that "grow on a certain kind of tree from the hot tropics. They used to paint these, and still paint them today, with diverse delicate figures and colors. And they are so durable that even 100 years in water would not fade or damage the lacquer."[8] In 1610 the Relación de Chilapa mentioned that Olinalá was producing lacquer, and that it had developed a new industry of cochinilla. These small insects were highly prized as a dye in Europe, and locally they were used to produce red lacquer. By the end of the 1500s, chocolate drinking had become the fashion in Mexico City and Spain. It was particularly a la mode for a host to serve guests from an authentic Mexican chocolate set. In 1652 the Spanish painter Antonio de Pereda y Salgado depicted such a set in a still life painting that included an elaborately lacquered gourd and chest that seem to have been produced in Michoacán (which, along with Olinalá, was a major producer of lacquer). Given the demand for such sets it is likely that Olinaltecan gourds served a similar purpose. Since no gourd from either Michoacán nor Olinalá from this period survives, it is impossible to know. Such a hypothesis, however, is made likely by the fact that Olinaltecan lacquer, more than that of Michoacán, had a history of close association with chocolate consumption.[9]

All these different sources suggest that lacquer production continued without interruption from the Aztec period into the Spanish era. Olinaltecos who traded their lacquer for tribute goods likely strengthened Olinalá's linkages across the region, and those who journeyed to Mexico City, Chiautla, and Puebla de los Angeles (which had political oversight over

Olinalá) to deliver their tribute and interact with the Spanish government maintained Olinaltecos' political, economic, and cultural ties to the colonial empire. By producing and marketing their crafts, *laqueros* learned to use their art to mediate the demands of the Aztec and Spanish colonial systems while building upon their town's importance as a gateway between the empire and the hinterland.

The Golden Age of Olinaltecan Lacquer

The eighteenth century marked what would come to be known as Olinalá's golden age. It was then that artisans created the wood boxes, dowry chests, and lecterns that survived into the twentieth century to capture the imaginations of collectors and nationalists. The scarce documents from this golden age suggest tentative insights about the roots of this artistic florescence and how it was affected by growth in the lucrative high-end market. A reading of the objects themselves is particularly revealing in this regard.

This was a time of demographic, political, and economic change. Olinalá's population collapsed due to epidemics, starvation, and flight to the southern Montaña to escape the forced labor drafts of the north. Between 1575 and 1743 the number of *tributarios* for Olinalá and Cualac declined from 2,100 to 1,113. This population collapse coincided with the exhaustion of the mines of Ayoteco. When the mines no longer needed labor or provisions, the *encomienda* of Olinalán reverted to the Crown, which transferred it from Chiautla to Tlapa, capital of the region now known as the Montaña de Guerrero.

Moreover, in the 1600s the colonial state began stripping the native elite of its privileges, thereby leveling indigenous society. This began with a reduction in the number of *tlatoques* (native kings). In the neighboring town of Cualac the *tlatoque* officially lost his status, and the town was reduced to an *estancia* (literally estate, but in this case referring to a subordinate administrative status) of Olinalá. This was followed by a ban on the native nobility's practice of demanding labor from *macehuales* (commoners). The Crown then removed the indigenous nobility's exemption from tribute payments, which lowered them to the same status as their former *tributarios*. Until this time the state had turned a blind eye to native violations of sumptuary laws that had been created to enforce the caste system, but in the 1600s it began enforcing these throughout the Montaña, prohibiting the native nobility from riding horses, carrying weapons, or dressing as

Spaniards. When the *tlatoque* of Olinalá flouted the law by going in public in an elegant Spanish outfit complete with sword, dagger, and harquebus, Crown officials arrested him.[10]

A colonial report from 1743 notes that at that time, long after most subjects across New Spain had shifted from paying taxes with merchandise to paying with cash, two groups in the Montaña received exemptions. These were the Mixtecos on the southwestern edge of the Montaña who paid in fabric, and the Nahua of Olinalá who paid in lacquered goods. The report notes that Olinaltecos regularly purchased chia seed (*salvia hispanica*) from neighboring communities to make the oil base for their lacquer, and that they traveled south on foot and beast to the Costa Chica to buy *jícaras en blanco* (undecorated gourds) to carry back to their workshops.[11]

The decline of the native nobility and the reestablishment of direct tribute were followed by a change in the town's ethnic composition. Spaniards, mestizos, *chinos* (as Filipinos were known), and *mulatos* began entering the Montaña at this time. For reasons that remain unclear, Spaniards and mestizos spread across the region, while *mulatos* and *chinos* concentrated around Tlapa and Chilapa. North of Olinalá in Puebla and south of Olinalá from Tlapa and Chilapa down through the Costa Chica these newcomers accumulated large tracts of land. But in the area around Olinalá they lived as *volantes* (drivers) running their livestock on common lands, acquiring only small plots or no land at all. According to Dehouve, these *volantes* continued to live this way until the twentieth century when the revolution devastated their livestock, forcing them to form small communities thinly scattered across the municipality.[12] A 1746 census reveals the ethnic changes wrought by this new wave of migration. It lists the population of the municipality of Olinalá as 2.8 percent Spanish, 53.8 percent mestizo, and 43.5 percent indigenous (mestizo, at that time, seems to have implied individuals of mixed ancestry as well as Indians who understood Spanish or who no longer were official members of the República de Indios).[13]

With an otherwise weak economic base outside of livestock, Olinaltecos found a niche in the production of the lacquered gourds that they sold in regional markets and continued to render in lieu of taxes. Demand for their goods exploded across the colony thanks to a rapidly growing population, expanding wealth of the New Spanish elite, development of a dense internal economy, a rising mixed race population, and acculturation of indigenous groups. Olinaltecos tapped into these markets through new

carpentry techniques and by adapting their decoration so as to trumpet their clients' wealth and good taste.

Many of these eighteenth-century items survive, but I have found only two that bear the dates of their creation. The earlier of these, housed in the Museo Franz Mayer, is a lectern dated 1760 (plate 6).[14] The carpentry reveals the use of European tools, and the lectern form suggests that it was for liturgical service. The materials and *rayado* style are typical of Olinaltecan production from the period. The hand-rubbed orange base coat known as *tlapetzole* contrasts with the three layers of red, green, and white lacquer. The artisans who made it would have applied each of these topcoats one at a time, etched the design, removed the negative space with a thorn attached to a turkey plume, and then thickened the lacquer by hand-rubbing it with specific recipes of pulverized minerals and buffing it with large wads of cotton. The technique was laborious and required years of apprenticeship and specialized knowledge as well as artistic talent. Visually, the lacquered design on the lectern is graceful and balanced and conversant with the *chinoiserie* and *mudejar* tastes that were in vogue at the time in Europe and among New Spain's elite. The workmanship suggests attention to quality and a discerning client willing to pay a premium price. It improvises upon European styles yet moves the design in a distinctive direction.

The second item, an election ballot box dated 1779 (plate 7), is of higher quality.[15] Whether the more sophisticated style and workmanship of this box is attributable to a broader refinement of workmanship, the abilities of the particular artist, or the price of the commission, we cannot know. The inscription on the lid tells us it is an election box, and suggests production for the Spanish market. This ballot box, like the lectern, has an exterior decorated entirely in the *rayado* style, with red, green, and white atop an orange base, and etched surface details. The interior of the ballot box has been sealed with a base coat of orange *tlapetzole*. Where flowering spikes predominated in the decoration of the lectern, this box combines vegetative grotesques and human figures executed in *rayado* on the exterior, with brushwork on the interior. It is unclear whether this brushwork was done by Olinaltecos at the time of creation or applied later by artists elsewhere. It also is unclear whether the date 1779 refers to the date of the box's creation, the date of the interior painting, or the year of some important election for which it may have been intended.

These two objects suggest the artisans' cultural engagement with and understanding of Spanish aesthetic tastes, cultural norms, social structure, and vocabulary of symbols and motifs. It is clear that during the eighteenth century Olinaltecos tapped into an elite market and that this was a time of creative innovation for local artisans. But it remains impossible to trace with certainty the local pathways and impacts of these innovations.

Documents offer little insight into how Olinaltecos tapped into the growing elite market or how this market affected the local social structure, but they do teach us about the town's lacquer techniques. This information comes to us by way of the Enlightenment and natural historians' penchant for recording their observations. In 1780 the Jesuit Francisco Clavijero, famous for his advocacy of natural science and refutations of European indictments of the Americas, described Olinalá's decorated *jícaras* and the "pleasant odor" of its lacquered chests, or *baúles*.[16] Our most important documented account, however, comes not from Clavijero but from an obscure Jesuit named Joaquín Alejo de Meave. New Spain at that time saw the rise of journals of natural science and philosophy among a small circle of Creoles. These New World Creoles, intent on claiming their place within the Enlightenment, walked a fine line between trying to impress Europeans and trying to elevate their own masses.[17] In 1788 the priest José Antonio de Alzate founded the most famous of these journals, the *Gaceta de literatura* (Journal of Literature). Alzate structured his publishing efforts around the argument that foreigners lacked the epistemological knowledge to comprehend the natural and human world of the Americas. True knowledge about "the many wonders found in our America," he insisted, came only from a lifetime of sustained observation and intimate experience.[18] As part of his effort to publish information about the "wonders of our America," Alzate commissioned Alejo de Meave, the parish priest of Olinalá, to write an account of the town's lacquer industry.

On 28 June 1791, Alejo de Meave published his brief account of Olinaltecan lacquer in Alzate's *Gaceta de literatura*.[19] We do not know the date of his arrival or departure from Olinalá, but his account suggests intimate familiarity with the lacquer industry. He informs us that along with Olinalá, thirteen other communities in the vicinity contributed to the lacquer industry. Olinaltecos processed a wide array of gourds, the most important being *jícaras* (*xicalli*) and *tecomates*, both still widely used today. The Jesuit provides excruciating detail about each of the different kinds of

gourds, how they grew and how they were harvested, the ways they were cut open for different uses, and the names—all of them Náhuatl—used for each configuration. He also explains the vegetable and mineral sources of all the oils, powders, and pigments employed by the artisans, and how they were processed.

In addition to his observations about the materials, Alejo de Meave offers insight into the gendered structure of production. He relates that women prepared the raw materials and created the base coat (*tlapetzole*), while only men did the decorative *rayado* and *dorado*. Olinaltecos marketed their goods principally in such regional fairs as the one in "Tecpatzingo" (Tepalcingo, Morelos) on All Saints Day. He informs us in detail how they packed and transported their goods, and that their crafts made their way to Mexico City and Puebla de los Angeles, and as far away as Madrid and Peru. Alejo de Meave explains that Olinaltecan lacquer was consumed by a broad segment of New Spanish society, from poor indigenous buyers to wealthy Creoles. In addition to the gourds, the artisans manufactured and lacquered carpentry products, including dowry chests, trays, stationery and pencil boxes, sewing boxes, linen boxes, side tables, lecterns, music stands, mantles, and bracket shelves. They decorated these with the materials and styles adapted from their gourds, making clear that even if these carpentry items were the most esteemed and lucrative lacquered items, they remained subordinate in quantity and design to the gourds destined for regional indigenous consumption. Alejo de Meave's description suggests that lacquer production was woven into the local social fabric of Olinalá, from gender roles to detailed knowledge about local plants and minerals, and that it remained bound to the Náhuatl language and Nahua culture. Unfortunately, while he offers detailed recipes for every pigment, Alejo de Meave is frustratingly silent about what percentage of the town engaged in lacquer production, the number of producers, their ethnic background and local status, and how they were organized socially, politically, or economically.

Other sources help us to place Olinalá's lacquer industry within the context of regional markets. Records from 1800 show that, of the 61 Olinaltecos who paid an *iguala* (transportation tax), 43 of them (70 percent) paid it to transport gourds, most likely from the humid Costa Chica (which lies to the south of the Montaña region and today continues to provide most of Olinalá's *jícaras*) or else transported decorated gourds to such markets

as Tepalcingo. In neighboring Cualac, whose merchants helped supply the needs of Olinaltecan artisans, nine people paid an *iguala*, five of them for gourds. Beyond Olinalá's immediate vicinity, the number of people who transported gourds drops to almost nothing. In addition to *jícaras*, Olinaltecos imported cotton, which they used to polish the lacquered finish. In 1792, despite its lack of a textile industry, Olinalá received 3.01 percent of all the cotton marketed through Ayutla. Other than *jícaras* and cotton, most of the other items used for the lacquer industry—pigments, *tierras* (different varieties of ground stone), oil pressed from chia seed, turkey quills, rabbit fur, and a range of other kinds of gourds—were produced locally, often by the artisans themselves.[20]

The objects and documents, despite their silence about cultural, social, and political dynamics, make clear that under eighteenth-century Spanish colonial rule Olinaltecos continued to innovate in styles and techniques and in the ways they engaged the growing markets. In contrast to surrounding areas, where communities dealt with Spanish colonialism by withdrawing into tightly bounded villages referred to in anthropology as "closed corporate communities," Olinaltecos seem to have maintained an openness and a dynamic, even fluid, Nahua ethnic identity that was shaped by local, regional, and imperial interactions and through the creation and marketing of their lacquered art.

"Backwardness of the Most Frightening Sort"

The nineteenth century was not kind to Olinaltecos. Whereas under the Spanish empire Olinalá had stood as an indigenous but culturally incorporative and dynamic center, during the nineteenth century Mexican elites looked down on it as backward, Indian, and incapable of fulfilling the ideals of universal liberal citizenship. In the aftermath of the Independence Wars (1810–21), economic stagnation set in across southern Mexico, hitting the Montaña particularly hard. National and regional elites viewed this lack of development as the natural, timeless stagnation of the Montaña's majority indigenous population.

This prejudice was made clear in 1848 during the Puebla congressional debates over whether to cede the district of Tlapan, as the Montaña was known, to the proposed state of Guerrero. Debate transcripts reveal the role of racism, ideology, and political pragmatism in the construction of the Montaña as a marginal zone. Congressmen argued that the people of

the region lived in a preconquest state of savagery amenable to neither civilization nor republicanism. Their "homes are miserable huts, their food is fruit picked straight from the trees, and the best of their population centers are but monuments to destruction and ignorance." One legislator asked: "What kind of distorted society would these people form among themselves, lacking as they are in the basic elements of civilization, finding themselves, to put it bluntly, submerged in stupidity and barbarism? What do they know of the rights and obligations that a social pact imposes upon its citizenry? What capacity do they have to fill the public offices and undertake high administrative functions? Would it not be a scandal to see their assemblies filled with rude, vulgar men, unfit to handle even the most trivial domestic matters?" He concluded that "all the horrible misery, all the contemptible ignorance, in short, all the destruction and backwardness of the most frightening sort" was found in the Montaña.[21] Such denunciations demonstrate how a region previously viewed as a gateway to riches and luxury had become, by the middle of the century, synonymous with Indianness, poverty, isolation, and backwardness.

The Mexican congress overruled the concerns of these legislators, creating the state of Guerrero in 1849 from territories shorn from Michoacán, Estado de México, and Puebla. Created three decades after the consummation of Mexican independence from Spain, Guerrero symbolized not an act of faith in the indigenous population but a political concession by the central government to the *caudillo* Juan Alvarez, who demanded it as reward for his role in the wars against Spain (1810–21) and the United States (1846–48). Guerrero became a ground for Alvarez to carry the banner of federalism in what was, in fact, a brutal struggle for power among local and regional warlords who defended their fiefdoms against one another and against the central government. In defense of these fiefdoms they also warded off infrastructural and economic development.[22]

Racist legislators and regional *caudillos* acted on their prejudice with concrete political and economic policies that pushed the indigenous people of the Montaña into the very backwardness that the Pueblan legislators had claimed was Indians' destiny. Beginning in the period known as La Reforma (1850s–60s) the state converted Church land and peasant commons into private property. Later, as a strategy to wrest Guerrero from regional anti-Porfirian *caudillos*, Díaz imposed as governor General Francisco Otalara Arce, who expropriated land from peasants and the Church

so as to put it into the hands of a new *ranchero* class that he hoped would be loyal to Díaz.[23]

In 1886 Olinalá still was a mix of commons and smallholdings, but the new local elite allied with regional officials to consolidate land. Three events that year set the stage for the completion of Olinalá's transition into peonage and introversion, and for the tensions that would make Olinalá a hotbed for indigenous insurgency during the revolution. First, Arce decreed that *campesinos* had only six months to show ownership of their commons and divide it into private lots or else have their land auctioned out from under them as *terrenos baldíos* (vacant lands). Though *vecinos* appear to have complied with the order, this did not stop local elites and prefects from taking their lands. In that same year, *rancheros* officially separated their territory from Tlapa to form an autonomous district known as Zaragoza. This freed Olinaltecos and others from outside control but left them even more impoverished, isolated, and subject to unrestrained abuse by the empowered *ranchero* elite. Finally, 1886 was the year the *campesinos* rose up against the Porfirian prefects whom they accused of colluding with local elites to falsely declare that peasant lands belonged to the Church, and thereby were eligible for expropriation.[24] The government quelled the rebellion, but tensions flared again in 1900 when fifteen aggrieved *vecinos* of Olinalá rejected the corrupt verdict of the local prefects. They wrote a letter directly to President Díaz denouncing Nicolás Rodríguez and Juan Andreu (father of the future Zapatista general and presidential candidate Juan Andreu Almazán).[25] The *vecinos* fought a losing battle against the alliance of an emerging *ranchero* bourgeoisie and a patron state.

Censuses from 1900 and 1910 offer a glimpse of the life of Olinaltecos. The heavily indigenous municipality had 5,566 residents. Of the 1,914 who lived in the head town, 850 were above the age of 15. Among these, 93 percent were illiterate and 44 percent spoke no Spanish, not even rudimentarily. Not a single foreigner resided within the municipality and, among the 23 residents born outside Olinalá, none was born farther than one of the adjoining municipalities. The few Olinaltecos who did receive an education locally did so through private tutors in the monastery of the Virgin of Guadalupe, atop Olinantzin Hill.[26]

Sugar, which had no previous history in the area, now dominated the economy. A group of *rancheros* had worked with the local prefect to gain control over most of the arable land in the small valley, which they planted

with sugarcane. At the top of this new oligarchy (comprising the members of the León, Patrón, Salgado, Acevedo, and Franco clans) stood Manuel Almazán. He controlled not only most of the land but also the storage houses, crushing mill, and boiling and cooling sheds upon which other oligarchs depended. Some oligarchs also monopolized food and livestock production and marketed milk and cheese, along with corn, chile, beans, and honey, though not in significant quantities. By 1910, the Almazán family held a tight grip over the region, reinforcing its place atop the local oligarchy through shared control over the land, the economy, and the municipal council, as well as through daily economic relations, intermarriage, *compadrazgo*, exclusive *cofradías* (religious associations), and political cronyism.

Eight out of every ten adult *vecinos* had been pushed into landless peonage. They did not accept the loss of land passively. When the corrupt courts failed them, they turned to violence.[27] In neighboring Morelos, where communities experienced a similar loss of land and conversion to peonage, the historian Paul Hart has found that the situation had remained calm until 1910, when the sugar economy fell into crisis and sugar producers became unable to employ the people they had displaced. Social unrest ensued.[28] Olinalá, whose sugar plantations operated as an extension of the Morelos and southern Puebla sugar complex, similarly faced unrest in the form of small rebellions, stabbings, beatings, and assassinations. Some of this violence grew out of rivalries within the oligarchy, but most reflected discontent from below, as *campesinos* struck back against intimidation, extortion, legal maneuvering, and land usurpation.[29]

The turn of the century was a time when railroads, communications, and commerce helped much of Mexico to become, in the words of Alan Knight, "stitched together to form regional, national, and even international markets." But as Jaime Salazar Adame points out, Guerrero was the only Mexican state that did not participate in Porfirian railroad expansion. And neither could it rely on its outdated and inadequate roads. As the most underdeveloped corner of Mexico's most underdeveloped state, the Montaña region became isolated as never before. The only way to move goods was to carry them on the backs of man and beast over steep, difficult terrain along washed-out trails. Under Aztec and Spanish rule, the region had stood at the crossroads of a lively trade; now the only thing that Olinaltecos transported commercially was *rancheros'* sugar, which they delivered to the railroad depot across the state line in Puebla.[30]

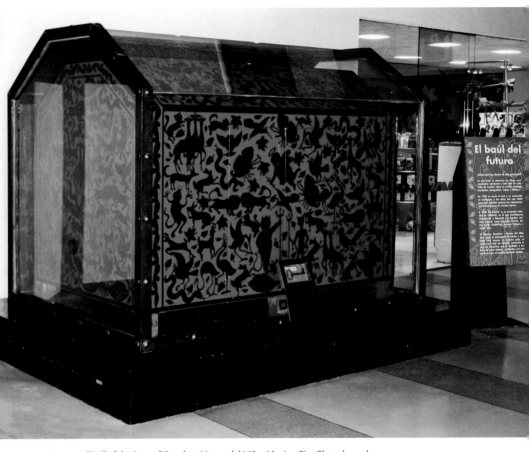

PLATE 1 "Baúl of the Future." Papalote Museo del Niño. Mexico City. Photo by author.

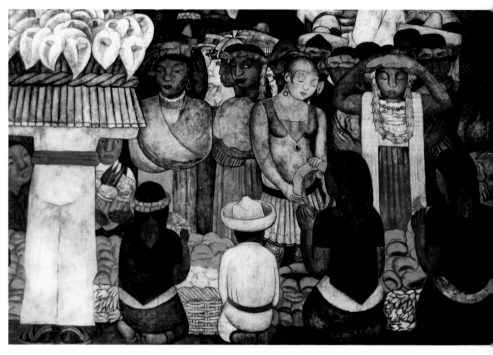

PLATE 2 Diego Rivera, detail of *Santa Anita*, mural panel, 1923–24, Ministry of Education, Mexico City. © 2008 Banco de México Diego Rivera & Frida Kahlo Museums Trust. Instituto Nacional de las Bellas Artes y Literatura 2008. Used by permission. Photo by author.

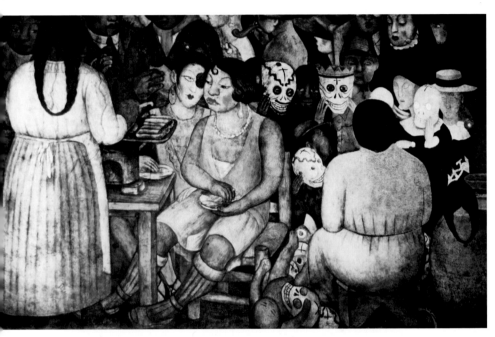

PLATE 3 Diego Rivera, detail of *Día de los Muertos*, mural panel, 1923–24, Ministry of Education, Mexico City. © 2008 Banco de México Diego Rivera & Frida Kahlo Museums Trust. Instituto Nacional de las Bellas Artes y Literatura, 2008. Used by permission. Photo by author.

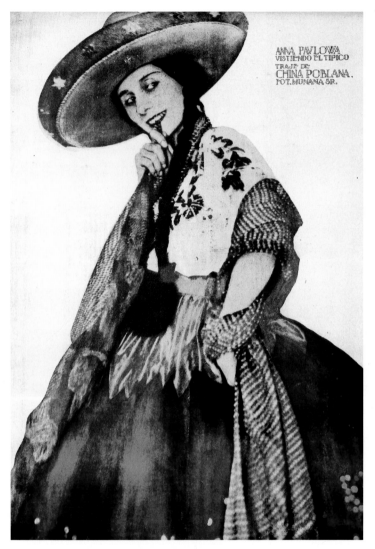

PLATE 4 Anna Pavlova as a *china poblana*, colorized photograph. Special color insert, *El Universal Ilustrado*, 16 September 1921. Biblioteca Lerdo de Tejada.

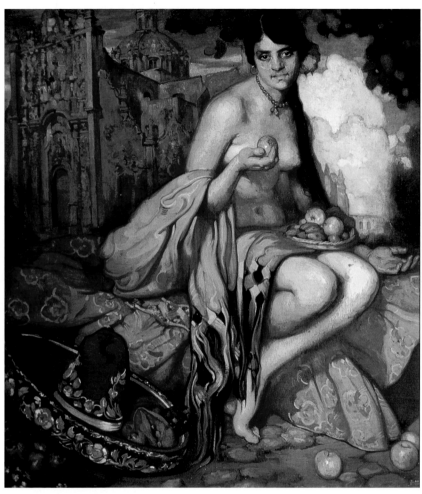

PLATE 5 Saturnino Herrán, *El Rebozo*, 1916. Museo de Aguascalientes. Instituto Nacional de las Bellas Artes y Literatura, 2008. Used by permission.

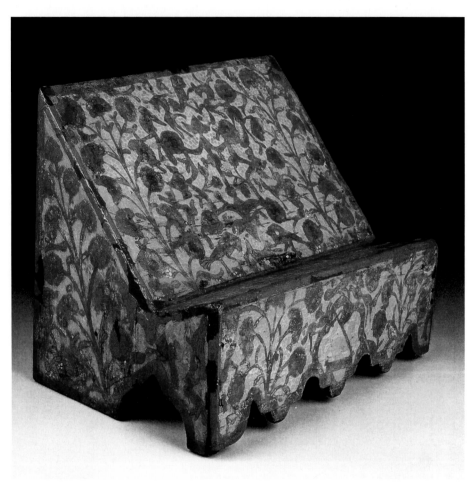

PLATE 6 Lectern, Olinalá, Guerrero, 1760. Item 04955. Museo Franz Mayer. Used by permission.

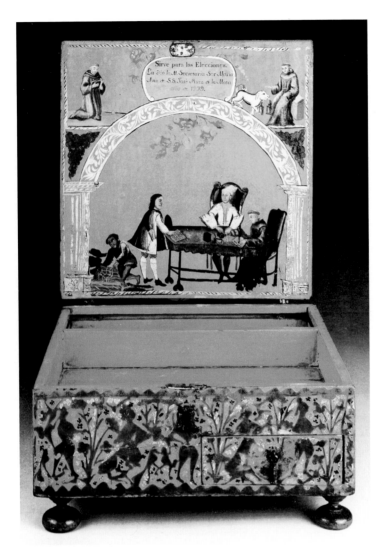

PLATE 7 Voting box, Olinalá, Guerrero, 1779. Item 05146. Museo Franz Mayer.
Used by permission.

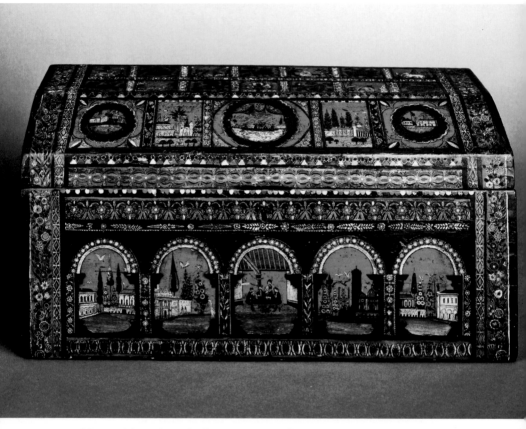

PLATE 8 *Baúl* (lacquered dowry chest), Olinalá, Guerrero, nineteenth century. Item 07859. Museo Franz Mayer. Used by permission.

PLATE 9 Almohadilla (*costurero*), Olinalá, Guerrero, nineteenth century. Item 07118. Museo Franz Mayer. Used by permission.

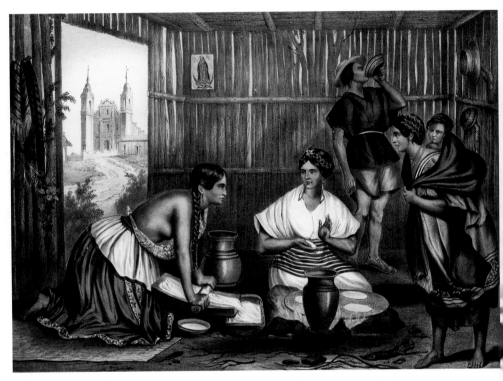

PLATE 10 *Las Tortilleras* (1848–50). Notice the man drinking from an Olinaltecan lacquered gourd. Item 1004227, Mellon 509, Yale Collection of Western Americana, Beinecke Rare Book and Manuscript Library.

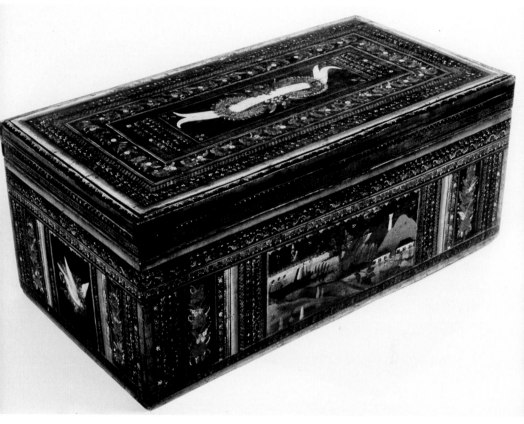

PLATE 11 *Baúl, dorado* style, Olinalá, late nineteenth century. AC 1955.561. Mead Art Museum, Amherst College, Amherst, Massachusetts. Gift of the children of Dwight W. Morrow (Class of 1895) and Elizabeth C. Morrow. Used by permission.

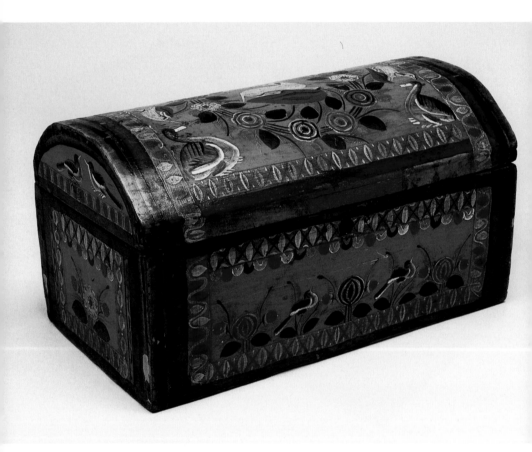

PLATE 12 *Cofre* (box), Olinalá, late nineteenth century or early twentieth century. AC 1955.564. Mead Art Museum, Amherst College, Amherst, Massachusetts. Gift of the children of Dwight W. Morrow (Class of 1895) and Elizabeth C. Morrow. Used by permission.

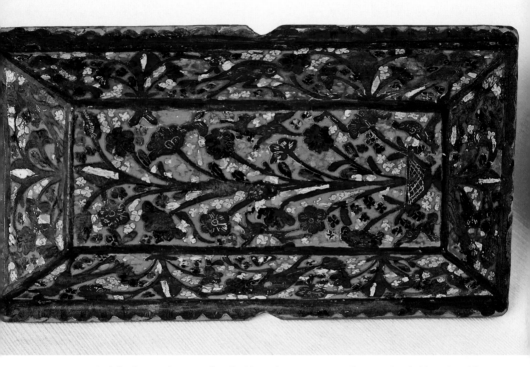

PLATE 13 Ayala family, carved tray; *rayado*, red, white, and green on orange; circa 1930. Asociación Amigos del Museo de Arte Popular (AAMAP), Ciudad de México. A. C. Guillermo Tovar y de Teresa. Used by permission.

PLATE 14 Ayala family, carved tray; *rayado*, green on red; circa 1930. Asociación Amigos del Museo de Arte Popular (AAMAP), Ciudad de México. A. C. Guillermo Tovar y de Teresa. Used by permission.

PLATE 15 *Jícara*. Unidentified artist; *rayado*, red, white, and green on orange; circa 1927. Asociación Amigos del Museo de Arte Popular (AAMAP), Ciudad de México. A. C. Guillermo Tovar y de Teresa. Used by permission.

PLATE 16 *Batea* (shallow bowl), Olinalá, circa 1930s. AC 1955.576. Mead Art Museum, Amherst College, Amherst Massachusetts. Gift of the children of Dwight W. Morrow (Class of 1895) and Elizabeth C. Morrow. Used by permission.

Caudillo politics and lack of communication infrastructure had forced Olinalá into introversion and deepening inequality. This was exacerbated by the Porfirian disentailment of the masses and creation of a local *ranchero* elite tied to the state. Rather than critique their own racism, cronyism, and failed economic and political programs, the Porfirian elites, like the mid-nineteenth-century Puebla congressmen before them, blamed the region's woes on the inhabitants' indigenous heritage. Isolation, indigenousness, and backwardness came to be seen as unchanging characteristics of the Montaña.

The Decline of Olinaltecan Lacquer in the Nineteenth Century

Artisans suffered from the same economic and political difficulties as their nineteenth-century neighbors, but they also faced their own challenges born out of the collapse of their industry. Following its wars of independence, Mexico descended into political instability and economic stagnation. This alone would have hurt the artisans, but the more serious blow was the new disdain of the middle and upper classes. Consumers took new pride in the Mexican landscape, regional stereotypes, and the archaeological Aztec past, but they shunned domestic aesthetics in favor of "universal" bourgeois tastes, and they rejected domestic crafts for manufactured goods imported from France, England, and the United States.

Faced with shrinking markets and falling prices, *laqueros* abandoned their labor-intensive, aesthetically idiosyncratic *rayado* style. They turned to *dorado*, which could be executed more quickly and in series and which was more in line with emerging elite tastes. As shown in plate 8, artisans responded to changing elite tastes by adopting the practice of copying urban architectural scenes from European prints. The only remaining trace of the eighteenth-century *rayado* aesthetic in this chest is in the arches and in some of the squares on the apex of the lid, decorated with chunky birds and animals. Ornately rendered *dorado*-style borders, mostly strings of flowers and egg-and-dart patterns, cover the green expanses. Objects such as this show how artisans merged the *rayado* and *dorado* into an aesthetic vocabulary that, while still distinctively Olinaltecan, accommodated elites' growing preference for overtly Europeanized modalities.

Artisans soon abandoned even these final traces of the *rayado* method in favor of *dorado*. For *rayado* objects, the *rayador* had to decorate one object at a time, layer by layer and line by line balancing the motifs across

the space as he (it always was a male) went. This method assured the distinctiveness of each object, but in an era fascinated with mass production, when prices were falling, the *rayado* was neither attractive to consumers nor cost effective for artisans. The advantage of *dorado*, and the reason it became more common than *rayado* at this time, was that it could be done by a team lined up alongside a row of a dozen or more boxes or chests, with one artisan adding a flower, another tracing a roofline, and so on until the series of nearly identical objects was complete, ready to be polished and shipped to market. The sewing box shown in plate 9 illustrates the impact of serial production, falling prices, and changing consumer tastes. The rapid brushwork renders simplified human figures and borders. Areas that in eighteenth-century *rayado* were populated by animal and vegetative grotesques here are graced by fanciful scenes of courtiers and soldiers. Pastel tones and a loose style, meantime, mimic the rococo *chinoiserie* that was in vogue.

The few remaining artisans who had not been pressed into peonage on the sugar plantations almost abandoned the production of boxes and chests. They focused instead on the lacquered gourds that they and their indigenous neighbors used as receptacles. One of the most widely circulating of their creations was the half gourd, with a red or black base coat and a central blue or white dot, or, for a slightly higher price, a painterly motif such as a swan or heron in the bottom of the bowl encircled by rings of blue and white. These were popular among indigenous consumers who used them as food and drink vessels that they could wear as hats during the journey to field or market. Mid-nineteenth-century prints of recognizably Mexican scenes, such as plate 10, often depicted indigenous peasants grinding corn and using these kinds of Olinaltecan drinking gourds. Later, in 1921, this same kind of gourd was handed to the India Bonita to visually affirm her indigenous authenticity (chapter 1, figure 5). These bowls sold at such low prices that their producers lived in deep poverty. And they reached a large consumer base, not because of artisans' physical mobility but thanks to peddlers who purchased these bowls at regional fairs and then resold them at distant locales.[31] Prior to the revolution, elites looked down on such objects as evidence of rural, indigenous backwardness.

By the end of the nineteenth century, Mexico's middle and upper classes shunned not only the *rayado* style but even Europeanized *dorado* production. Intellectuals such as José Antonio de Alzate and Alejo de Meave, eager

to esteem Mexico's own "wonders" by publicizing idiosyncratic arts, were men of the past. The remaining Olinaltecan *laqueros* now relied upon the sale of cheap gourds, yet some continued to show off their skill through the decorations of sometimes stunning *baúles* and boxes. As plate 11 shows, they moved away from the rococo designs such as that found in plate 9 in favor of densely layered borders and linear designs framing painterly depictions of animals borrowed from gourds and urban or garden landscapes borrowed from imported prints. By the start of the twentieth century, they had turned to objects such as the box in plate 12, with simplified yet graceful borders, flora, and fauna. Each of these design innovations reflects Olinaltecan artisans' efforts to adapt their work to consumers' changing tastes while flaunting their artistic talent, but in the end they found themselves overwhelmed by falling prices and by elites' preference for imported rather than Mexican-made luxury items.[32]

Olinatlecos, who for centuries had used their art to mediate their links to the outside world, declined into an isolated existence enforced by local elites and regional *caudillos*. Few Olinaltecos still participated in lacquer production, and perhaps no one recalled that the town's fortunes once had been intimately linked to craft production, much less that just a century and a half earlier their *pueblo* had been one of the most notable craft centers in New Spain. The world Olinaltecos now confronted was shaped by inequality, isolation, and the *zafra* (sugar harvest). Tax and church tithe records (Olinaltecos continued to pay tithes until the revolution) confirm that lacquer had become inconsequential to the overall economy. Only two or three families, including the Ayala and Navarrete clans, continued to produce lacquer. *Rayado*, which had fueled the lacquer industry in the eighteenth century, faded from local memory.[33] *Dorado* gourds sold in large quantities and low prices in regional markets. The urban middle class and modernizing elite of the Porfirian era, meantime, looked down on this mainstay of Olinaltecan production as embarrassing evidence of the country's rural indigenous backwardness.

Insurgency and Incineration

When historians speak of Guerrero's role in the Mexican revolution, most often what they have in mind is the bourgeois movement led by the Figueroa family from Huitzuco. The historian Alan Knight has shown that, as bourgeois reformers and *caudillos*, the Figueroas "sought to subvert the

political, not the social order." As such, "they aimed to roll back the frontiers of the power-hungry, centralising Porfirian regime and replace it by a form of traditional *caciquismo* run by themselves and their supporters."[34] The insurgency in the Montaña set itself in opposition to Figueroaists and rallied instead behind the Morelense populist Emiliano Zapata. The only base of support for Figueroa in the Montaña came from merchants and *rancheros*, including Manuel Almazán of Olinalá, whose political and economic fortunes derived from the disentailment of *vecino* lands and the dismantling of the peasant commons.[35]

For many Olinaltecan Zapatistas, the revolution offered an enlarged context for them to continue their struggle against the *ranchero* oligarchy that had robbed them of their land. *Campesinos* did not simply rise up as Zapatistas the moment they lost their land or when their wages on the sugar plantations fell below a certain level. Instead, they experienced a gradual process of radicalization through daily struggles against the *rancheros* and through conversations with Zapatista recruiters. One such recruiter was well known to the Almazanes: he was a member of their own family. Juan Andreu Almazán was born in Olinalá, but his parents moved to Puebla after the 1886 uprising against the prefects, including against his father's usurpation of peasant lands. Though later he would become a conservative presidential candidate in 1940, at the start of the revolution he emerged as a populist leader. His politics (along with those of his brother Leonides, who later became a progressive governor of Puebla) ran counter to much of the rest of his family. During his medical training he met the Maderista Aquiles Serdán, who was organizing in Puebla for the upcoming rebellion against Díaz. Government troops stormed the Serdán home in October 1910, killing the patriarch and his family, but not before Serdán had sent the young medical student to the Montaña with a shipment of weapons and orders to recruit for the coming uprising.

Andreu's mission was to mobilize not the *ranchero* bourgeoisie and merchant landowning class of which he was part but the indigenous peasantry. Andreu joined the Zapatista forces of José Salgado, the leading rebel from the Montaña to whom he had delivered Serdán's arms. Then, aided by a handful of *montañero* coreligionists, including Melquiades Nájera of Olinalá and Antonio Gálvez of Tlapa, he went from town to town winning adherents. After Serdán's death, Andreu left for Ciudad Juárez to rendezvous with Francisco Madero. The nineteen-year-old student's meeting

with Madero did not get him the additional arms he had hoped for, but it did win him recognition as a leader in the Maderista revolution and as an ally of the mounting indigenous insurgency of the Montaña. He returned to Guerrero where he and Nájera, together with another Olinalteco, Pedro Vivar, set up rebel training camps.[36]

In mid-1911, Manuel Almazán ordered the rural police to contain the growing Zapatista threat. When this failed, the government sent federal troops to hunt down rebels in the area. But, the more they squeezed the population, the more they drove peasants to the Zapatista camp. The Figueroaista government blamed the war on the "ignorance and illiteracy" of the indigenous majority, claiming, "We have always had a sadly elevated percentage of illiterates in Guerrero; especially in the Montaña in the east, populated by cave-dwelling barbarians, plagued by every form of vice that is induced by ignorance."[37]

Though Manuel Almazán and the rest of the oligarchs failed to quell the growing insurgency, they did manage to keep the Zapatistas from taking direct control over Olinalá. Almazán had the local police harass and arrest suspected Zapatista sympathizers. Zapatistas responded by storming the jail to liberate their allies. As the conflict intensified, so did recruitment. In April and May 1912 alone, the Zapatistas reportedly gained 1,200 soldiers just from the environs of Olinalá. From late 1912 through mid-1913, armed attacks, robberies, and murders in the vicinity ranked as the highest in Guerrero and there seemed to be no hope for a quick end to the violence. As Zapatista incursions became more organized and larger in scale, government-controlled towns such as Olinalá, Xochihuehuetlán, and Temalacacingo formed militias known as Security Commissions. In Olinalá the local oligarchy-financed Security Commission routed at least three major Zapatista attacks.[38] As word spread that the Zapatistas were preparing for a major offensive, government troops and town militias readied themselves.

Olinaltecos saw their lives transformed abruptly in 1913 when Morelense Zapatistas fell upon the town. The troops had attacked Huitzuco as the linchpin for their much-anticipated offensive. They suffered a surprising and humiliating defeat. Perhaps eager to embolden the remaining 800 troops with a quick victory after their failure, Emiliano and Eufemio Zapata turned toward Olinalá, from whence they had received an appeal to intervene against the Almazán family. On news of their approach, a fed-

eral official in Olinalá fled for Tlapa, taking with him a twelve-man guard, leaving only twenty-six federal soldiers to support twenty battle-hardened militiamen commanded by local *cacique* Luis Pantaleón. Most of the local elite, including members of the Almazán family, also fled.

Bullets started to fly in the morning. Over the course of the day and through the night, Zapatista losses mounted. Rather than a quick, morale-building victory, the attack on Olinalá was shaping up to be a repeat of the humiliation of Huitzuco. The tide abruptly turned when the Olinaltecan militia ran short of ammunition. Thirty of the defenders, including those who had been perched in the parapets atop Olinantzin hill, used the last of their cartridges to make an escape into the surrounding hills. The remaining guards who had been firing from the edges of town and from atop the tower of the parish church had no way out, so they ran for cover in the homes of family members. Zapata's frustrated and angry troops poured into the town, rounding up the few *caciques* that remained, looting their homes and businesses, and demanding forced loans. Hungry soldiers commandeered peasants' meager granaries, chickens, and anything else that could be eaten. They also ferreted out the remaining militiamen and anyone else suspected of supporting the government. A survivor from Olinalá recalled that one of the militiamen they pursued was the *laquero* Alberto Navarrete. Trapped in the middle of town, Navarrete took refuge in his mother's home. The Zapatistas dragged him and other militia members to the town plaza, then riddled their bodied with bullets.[39]

The beleaguered villagers hoped that this was the end of the destruction, but it was only the beginning. Soon after Zapatistas took the town, they learned that government reinforcements were at their heels. For reasons that remain unclear, Emiliano and Eufemio Zapata ordered their men to douse the entire village with petroleum and set it ablaze. Villagers ran screaming and weeping as their *chinantle* (wattle and daub with grass roof) homes, along with all the oligarchy's granaries, fields, commercial establishments, and sugar mill, burned. The fighting was dramatic as government troops poured into the town and the two sides fought amid the flames. The Zapatistas found an opening for retreat, but one column of government troops pursued them as another cut them off at the edge of town, forcing them up the steep side of Olinantzin hill. Zapatistas and Carrancistas scrambled on foot and horseback for the high ground. Gov-

ernment reports and local memories recount the sight of horses and men tumbling down, covered in blood. As soon as the Zapatistas had fled, the government troops also took their leave. To the villagers' eyes and by official accounts the death toll on both sides seemed staggering.[40]

The town lay in charred ruins, ravaged by the very Zapatistas whom villagers had called upon to defend them. All was destroyed, including the grain from the recent harvest. Bloated bodies lay scattered on all sides. Concepción Ventura Pérez recalls that some soldiers strewn upon the bloodied embankment were still alive and begged for water. All the *jícaras* had been burned, so she ran to the arroyo and scooped water into her hands. Time and again it drained between her fingers before she could reach the dying men. Most horrifying to her was watching the pigs wander back from the hills that night to eat the heads and limbs of the dead. The next day, to avoid disease, the exhausted and hungry survivors buried the bodies in the municipal clay pit. This brought an abrupt end to Ventura Pérez's family's trade as potters.

Over the next two and a half years, armies from both sides again and again struck the devastated town. Unable to reestablish the foundations of their power, and fearful of further Zapatista retribution, most of the oligarchy permanently relocated to Mixtepec (Puebla), Puebla de los Angeles, Mexico City, or anywhere else they had connections. Their cane fields lay burned, their stores looted, and their peons no longer in a position to serve them.[41] Out of the ashes of the old social order Olinaltecos would have to search for new means of survival.

Reborn from the Ashes: Local Revival for Survival

Ironically the Zapatista attack of September 1913 that devastated Olinalá also reconnected it to the larger world and triggered a local lacquer renaissance. As the starving population looked for ways to survive, some turned to collecting firewood, but there was little wood and fewer buyers. The hardest hit begged for stale tortillas from the few *vecinos* whose supplies the flames had spared or who received help from relatives outside Olinalá. They ate *pachote* grass and whatever edible roots they could unearth in the hills: "After the revolution passed, those of us who wandered about dying of hunger, what else were we to eat?" asks Ventura Pérez.[42] The crisis of 1913 could have dealt a death blow to this already struggling art, as it did

to Olinalá's sugar industry; instead, Olinaltecos turned to their art for survival.[43] It was out of the depths of desperation that Olinalá was reborn as a center of lacquer art.

Ventura Pérez recalls that members of the old oligarchy held on to most of its pastures and agricultural land but sold their burned-out homes and town lots. Outsiders from neighboring towns and some local families with outside connections bought the properties and opened new commercial establishments. They were betting on the future of Olinalá, which remained the municipal seat and the largest town in the region. For the time being, however, they had little for sale and almost no customers. Enterprising merchants turned to the town's *artesanías* as a foundation for commercial expansion.

Lacquered gourds were among the few things Olinaltecos could produce that had cash value yet were not capital intensive. To profit from lacquer, merchants would have to gain control over production, but the lacquer families marketed their own goods and had no need for the merchants. The merchants could introduce new producers, but this was difficult because, unlike today, when most artisans buy industrial ingredients, at that time they had to know how to manufacture every *tierra*, pigment, and thickening agent themselves and even gather their own raw material from the surrounding hills.

The two merchants who took the greatest interest in lacquer were Luis Acevedo and Roberto Lujan. They wrestled with ways to turn a profit in a town where few had money to buy anything; where the land still was monopolized by the prerevolutionary elite; and where those who did turn to crops used half of the harvest for their own subsistence while the other half went to the landlords or else was marketed by the Rendón, Almazán, and Salgado families. They would find the answer to their problem within the gendered structure of local society and of artisan production.

Women had more difficulty establishing themselves as sharecroppers or laborers, and they earned less for their work than did men. Many had lost brothers and fathers to the war, and even those who had not needed to found ways to add to the household income. They could sell firewood, wash laundry, make tortillas to sell at fairs and on the streets of Chilapa or Tlapa, or they could participate in lacquer production. The key for the merchants lay in those women who had trained in the artisan families' workshops. Female artisans were prohibited by gender norms from head-

ing their own workshops. This left them particularly vulnerable. In their desperation, they had little choice but to turn to the merchants. In the merchant workshops, women with skills trained others, further expanding the pool of cheap, skilled, female labor.[44]

Mostly the merchants relied not on women who were members of the main artisan families, such as the Ayalas and Navarretes, but on other women who, after the crisis of 1913, had learned aspects of lacquer production from the main families but did not possess enough skills within their households to operate an independent workshop. Concepción Ventura Pérez was one such woman, and her experiences offer a valuable perspective on the development of the lacquer industry. She was born in December 1900 into a family of potters. When the town filled their clay pit in 1913 with the corpses of revolutionaries, Ventura Pérez's aunts Rosa and Iladia Ventura turned to fellow artisans. They found work with *laqueros* applying the base coat known as *tlapetzole*. Doña Concha's cousin Benito Ventura started traveling to the Costa Chica to buy *jícaras*, which did not grow in Olinalá temperate climate, and then sold them to *laqueros*. As his sisters learned to mix pigments and create the *tlapetzole*, Benito, too, turned to the *laqueros*, who taught him the *dorado* technique, painting patterns as well as fish, birds, rabbits, deer, and flowers inside the lacquered bowls. Though they did not achieve high levels of mastery or refined knowledge, Rosa, Iladia, and Benito Ventura did learn enough to create their own small family workshop, selling their crude products to the merchants to complement income from other sources.

After the loss of the clay pit, Ventura Pérez's father turned to carpentry. When he died in a construction accident, his widow faced grinding poverty and the starvation of herself and her family. She distributed her children among kin, keeping only Concepción by her side. Together they begged, collected firewood, and made tortillas to sell in regional markets. After a time, Ventura Pérez learned from her aunts how to process *tierras* and oils to create *tlapetzole*. She worked with her aunts and cousin in their small family workshop until 1916, when her family hired her out to her cousin and godfather Luis Acevedo to pay off the family's debt. The merchant paid her 20 centavos per ten-hour day to make and apply *tlapetzole* in his workshop. Shortly thereafter, she left Acevedo's workshop to do similar work for Roberto Lujan.[45]

Lujan and Acevedo each hired economically destitute female artisans as

well as a few men. Each artisan brought his or her own skills to the work-
shop in exchange for wages or to pay off debt they had accrued for food,
supplies, and medicine. By the 1920s, even the old lacquer families fell into
debt to the merchants and had to send members to work for them. An
artisan family, for example, might need extra gourds or cotton, which the
merchants could sell them on credit, or else they might need medicine for
a sick family member, or a sack of beans to feed themselves through the
rainy season. The artisan family would then be required to send one or two
members to work for the merchant to pay off the debt. The result was that
merchants mobilized skills that otherwise would have benefited family
workshops. These merchants sold their production in regional markets, as
did artisans, but they also developed connections to market stall vendors
and ambulatory peddlers in Tlapa, Chilpancingo, and Mexico City.[46]

As the lacquer market grew crowded with producers, some artisans
developed innovative approaches. The Jiménez family practiced lacquer
into the latter part of the nineteenth century but had abandoned it long
before the revolution. Luis Jiménez's father returned to the craft in 1913,
but he followed his own creative inclinations, cutting gourds and fitting
them together to make birds, serpents, fish and whatever other animals
his imagination conjured up from the woody husks, or carving fruits from
pipirucha (the pith from a local plant), which he then lacquered. These lac-
quered sculptures were purely decorative and directed toward a low-end,
mostly indigenous market. As they attracted the attention of nationalists
and collectors in the mid-1930s, Jiménez's creations became emblematic
of authentic *artesanías* and appeared in many popular art advertisements,
including those for Frederick Davis's shop; and many artistic photographs,
such as those by Manuel Alvarez Bravo and Edward Weston; and in impor-
tant collections, such as the 1930–32 Mexican Arts Show. They would also
be copied by lacquer artisans in Michoacán. Some of these Olinaltecan
gourd and pipirucha figures are shown in figure 20.

Though these became compelling symbols of authentic Mexican popu-
lar art, they never developed much monetary value and the Jiménez family
remained marginal even among the towns' artisans. Luis Jiménez con-
tinued his father's innovation, and when Doña Concha married into the
family in 1930 she, too, learned to make *animalitos* and fruit. Concepción
and Luis combined their skills into a family workshop and even took in ap-
prentices from the nearby Nahua town of Temalacacingo. Some of these

20. Olinaltecan *animalitos*. Frances Toor, *Mexican Folkways* 4 (2) (1928): 109. Amherst College Archives and Special Collections. Used by permission.

apprentices carried their new skills back to Temalacacingo, where they pioneered their town's toy-making tradition (for more on Temalacacingo's toy industry, see chapter 8).[47]

Town elders emphasize that in the years between 1910 and 1930, lacquered boxes and dowry chests were rarities. At that time, Olinaltecan lacquer consisted almost entirely of gourds and bowls decorated in the *dorado* style. The only *laqueros* who produced boxes and chests, as far as they knew, were members of the Ayala and Navarrete clans, most of all Juvencio Ayala. In his family's workshop Juvencio learned not just one or two skills but the entire production process, including curing gourds, drying wood, carpentry, extraction of chia oil, creation of pigments, and detailed *dorado* applied with rabbit fur brushes in the styles shown in plates 11 and 12. As an independent artisan family, the Ayalas, like the Navarretes, marketed their own wares, and in light of the lacquer resurgence in 1913 they tried to guard their autonomy from the merchants. After the crisis that followed the town's incineration, as more and more of their fellow Oli-

naltecos turned to lacquered gourds for survival, the Ayalas, too, relied on these *jícaras*, but it was in the production of boxes and dowry chests that they would find their niche.

Conclusion

We know little about why indigenous consumers increased their demand for lacquered gourds after 1913, but it is clear that the market easily absorbed the upsurge in Olinalá's production. While gourds served the daily needs of the consumers of the region, it was the occasionally produced chests that most caught the imagination of the new coterie of collectors and nationalists. A dowry chest required more skill and time to produce than did a gourd and was harder to market on account of its size and price, but it brought higher profit margins and offered talented artisans an edge over the merchants who began to dominate the lacquer trade. More importantly, by marketing chests, Juvencio brought Olinalá into contact with changes on the national and international level.

These chests convinced collectors and nationalists that the town's artisans still produced in the manner of their ancestors and that their art embodied something historically transcendent about the nation. From their perspective, this art compressed the entire history of Mexico, from the Aztecs through the Spanish colonial era to the present, into a coherent transhistorical aesthetic. In 1920 Manuel Gamio argued that, through the revolution, the masses had affirmed their "right to be studied so that they might be known and strategically advanced in their social evolution."[48] Popular art advocates, adhering to this same ideal, esteemed contemporary Olinaltecan lacquer even as they hoped to cleanse it of supposed corruptions and set it back on the path of its distinctive aesthetic evolution so that it might contribute to the creation of a nationalist aesthetic and a culturally unified ethnicized nation.

As this chapter has shown, behind the elite-constructed image of a slowly degenerating local culture in which craftspeople passively carried on the traditions of their ancestors lies a dynamic history of artisan struggle and local revival. Cultural nationalists were unable or unwilling to imagine a history in which the lacquered arts were continually changed and then reborn through the agency and struggle of the artisans. Even though postrevolutionary intellectuals interpreted the revolution as a mandate from below, they treated it neither as a call for a popular plebiscite nor as a call

to arms against local injustice; instead, they saw it as an appeal for uplift and integration. By erasing the agency of the people, cultural nationalists claimed to have discovered what they were looking for: childlike, downtrodden indigenous peasants, naïvely clinging to tradition, silently awaiting the generous hand of the postrevolutionary elite to lift them up, to give them form, and to grant them a condescending dignity. Olinalá had become part of the broader canvas upon which nationalists projected the rural masses as a defanged indigenous population awaiting elite benevolence, and this came at the expense of acknowledging the grounded struggles that shaped artisans' daily lives.

\\(\ell\\)

Transnational Renaissance and
Local Power Struggles, 1920s to 1940s

Promoters of Mexican popular art in the 1930s treated it as com-
mon knowledge that René d'Harnoncourt had revived Olinaltecan
lacquer in 1927 while working for Frederick Davis. His success at
this revival contributed to his reputation and helped him secure the
post as curator of the Mexican Arts Show of 1930–32. It also con-
vinced John Collier of the U.S. Indian Arts and Crafts Board to hire
him in 1936 to spearhead a similar revival among native craftspeople
north of the border, which later aided his rise to the directorship of
the Museum of Modern Art in New York City. From the perspec-
tive of Olinatlecos, however, the revival of their craft had occurred
in 1913, not 1927. How to explain this disjuncture? The conflict-
ing views of the "revival" began to make sense when I learned that
the *rayado* style had disappeared from local memory in the nine-
teenth century. This led me to suspect that rather than having re-
vived Olinalá's lacquer industry, d'Harnoncourt merely resuscitated
this particular eighteenth-century technique. This also explains why
d'Harnoncourt, despite his use of the term "revive" to describe what
he had accomplished, persisted in describing Olinaltecan lacquer as
an unbroken tradition that linked the modern era to the colonial and
Aztec pasts.[1] Unaware that the industry he encountered in the late
1920s was the product of a local revival, he saw his actions as the first
major intervention in an industry that, from his perspective, had en-
dured passively over the centuries.

My hypothesis was confirmed by an obscure article that Frances

Toor published at the end of 1939 describing her visit to Olinalá. Though she had already spent fifteen years traveling widely throughout the country, this was the first and only time she made the difficult trek to Olinalá. She reported that the "Indians" there were "Aztec and fine artists" who had "abandoned for a long time" the *rayado* technique, but that "about ten years ago Count René de'Harnoncourt and Mr. Fred Davis discovered some old pieces and got the workers to renew it." Davis and d'Harnoncourt "bought all that the workers produced and paid them more for each *batea* [broad shallow bowls carved out of wood] than they are [typically] sold at retail."[2] Later I came across a statement by Stuart Chase affirming Toor's account. "By showing the Indians the old designs, by finding a readier market for the revived as against the debased [meaning the *rayado* as against the *dorado*] he has started an eddy in the other direction." Chase emphasized that "D'Harnoncourt did not teach, he only showed examples—and suddenly, mysteriously, something long dead came back to life."[3]

From the metropolitan perspective, d'Harnoncourt's revival of the *rayado* style signaled nothing less than the rebirth of Olinaltecan lacquer because it brought contemporary production into conformity with the style that nationalists and collectors idealized as authentically indigenous and *muy mexicano*. In both its antique and revived form, the *rayado* style consists of one layer of lacquer placed atop another. After designs are etched into the top layer, the negative space is scraped away to reveal the base coat, or *tlapetzole*, which often is of a contrasting color. *Rayado* built upon techniques the artisans already possessed, but it also called upon them to develop new skills and new stages of production. It soon acquired its own aesthetic norms and expectations and new avenues for creativity and innovation. The exaltation of colonial-era *rayado* and the style's reintroduction were at the center of the nationalists' and collectors' interest in contemporary Olinaltecan lacquer. And, as this chapter will show, its reintroduction had implications beyond what d'Harnoncourt or his nationalist colleagues could have recognized.

When I began my research on Olinalá my exposure to the elite-level documentation had predisposed me to ask whether the artisans were really indigenous, or whether they were mestizos constructed as indigenous by postrevolutionary nationalists and popular art promoters. I found that local history offered no easy answer. Just as it would be a mistake to view national identities as closed units, it also would be a mistake to think of

the artisan community as reducible to indigenous versus nonindigenous. A more accurate reflection of local reality requires consideration of how particular cultural formations emerged and articulated with one another.[4] Just as categories of "foreign" and "national" were often contingent and mutually constituted, tied to changing ways of contesting balances of power and perpetually in need of reanimation, so too were ideas of indigenousness and mestizaje in Olinalá.

The case of Olinalá demonstrates the degree to which local identities continually are remade through interaction with, but never reducible to, the dominant narrative. When subalterns appear within the historical record they often do so by strategically aligning their speech in relation to the elite discourses and in the context of existing power relations. As the historian Peter Guardino points out, subalterns learn to employ "the forms, arguments, and metaphors learned in dialogue" with cultural elites and the state. For the artisans of Olinalá this meant that they were heard to the degree that they and their art conformed to elite expectations of indigenousness. The historian Paul Nadasdy in his study of First Nation peoples of Canada points out that by engaging outsiders' expectations regarding their indigenousness, it was easy for such people to find themselves dragged into "positions that are not their own."[5] The benefit was that, when elite expectations and local practice aligned, subalterns could exploit such alignment to advance their grounded political and economic concerns; but when they clashed, it risked calling into question the validity of the subaltern group's preferred modes of interactions with dominant society. What ensued for Olinaltecos was not a clash between the view from above and that from below but a remaking of the two within the context of inequality and incomplete knowledge (even misunderstandings) on the part of both metropolitan elites and Olinaltecos. Negotiation unfolded through contestation over the form and meaning of artistic production and Indianness, over the nature of local-metropolitan interactions, and over who in Olinalá had power to mediate and benefit from these interactions.

This chapter is about neither d'Harnoncourt nor Mexican nationalists but the processes they set into motion within Olinalá. It traces the parallel development of art, state, nation, and market from the beginning of d'Harnoncourt's intervention in 1927 through the subsequent local boom, ending with the collapse of the local market in the 1940s. The study draws

heavily upon oral interviews with Olinaltecan artisans as well as first-hand accounts from outsiders who visited Olinalá during these years. The most important such outsider was the ethnologist Alejandro Wladimiro Paucic Smerdu, who visited the town periodically from the 1930s through the 1970s, meticulously recording details about production, changing pay rates, language use, and many other aspects of local life. Paucic, whose records now belong to the State of Guerrero, is a mysterious figure. Because his archive is rich in observations about many rural corners of Guerrero, researchers and archive staff have attempted to learn more about the man, but without much success. It is not known when or why he came to Guerrero, nor where he came from—though, based on his name, he likely emigrated from Croatia—and he died in 1980 never having been interviewed.[6] Despite how little is known about Paucic, his observations about lacquer production in Olinala are remarkably detailed and provide an invaluable resource. Drawing on Paucic, oral interviews, and a range of archival documents and published accounts, this chapter untangles the complicated impact that the ethnicization of Mexico's national identity had upon Olinalá. It considers also the ways artisans reshaped their place within the local political and economic structure, and within the imagined national community.

A Distant Revival

As Toor and Chase suggest, the cornerstone of d'Harnoncourt's strategy in Olinalá was to show antique objects to artisans. He explained to them the virtues of these pieces and asked them to produce new works with the same aesthetic sensibility and with the old techniques and materials. This was a strategy that he adopted from Jorge Enciso and Roberto Montenegro, who had used it to good effect while planning for the 1921 Exhibition of Popular Art. As Enciso explained: "We sent ancient models to Uruapan with all sorts of recommendations" in the hope that the artisans might create objects "without the terrible defects so in vogue." The effort, according to Enciso, had launched "a revival of this [Uruapan's] artistic industry," and, more recently, "Fred Davis and René d'Harnoncourt accomplished something similar with the artisans of Olinalá and certainly with magnificent results."[7]

Because Montenegro and Enciso had gone to Uruapan to work directly with the craftspeople, one might think that d'Harnoncourt similarly had

visited Olinalá. Few outsiders ventured to this small isolated community prior to the middle of the century, so a visitor bearing the count's six foot six inch stature and Austrian accent would likely have drawn some attention, particularly if he were working closely with artisans to revive their craft. That is why, when I went to Olinalá, I was surprised that not even the oldest artisans had ever heard of d'Harnoncourt nor did they recognize him from a photograph. It seems d'Harnoncourt may never have visited. This possibility is supported by the fact that nowhere in his voluminous archives or in his prolific publications does he mention a visit to the town or make any firsthand observations about it.

It is easy to understand his reasons for not doing so. He traveled widely through the countryside, but generally only in areas dense with artisan communities, such as central Oaxaca, the Lake Pátzcuaro region of Michoacán, the Bajío, Estado de México, and Morelos. He also tended to chart an itinerary that allowed him to ship goods by train. Olinalá offered none of these benefits. It was isolated in the sparsely populated northern Montaña de Guerrero that, aside from Olinalá's lacquer, produced little in the way of distinctive crafts. Moreover, as noted in chapter 7, the railroad network bypassed the Montaña de Guerrero, and a visit required a long, arduous trek. When Toor visited in 1939 she could travel along the new road linking Taxco and Chilpancingo, but the remainder of the journey involved several days on horseback and foot. Even today to get there from Mexico City requires an eight-hour drive over rough dirt roads, or else ten to twelve hours by a paved but sometimes washed-out route passing through Chilpancingo and Chilapa.

If d'Harnoncourt did not travel to Olinalá, how did he "revive" the industry? Pilar Fosado, daughter of Víctor Fosado, recalls her father talking about travels with d'Harnoncourt to the fair in Tepalcingo, Morelos. This is the same fair visited by Olinaltecos since as far back as the eighteenth century.[8] We know, moreover, that by the early 1930s a few Olinatlecos had gone from hawking lacquer at the fair to delivering some of their work directly to Davis's shop in Mexico City. It is likely, then, that René d'Harnoncourt carried out his revival from afar, probably initially meeting with artisans in Tepalcingo and then asking them to bring crafts directly to the capital.

While d'Harnoncourt provided few details about how he carried out the revival, he did give a Mexican reporter the names of two of the Olinaltecan

laqueros with whom he had worked. These were Guillermo Romano (León) and Andrés Rendón.[9] Like other artisans, the lucid centenarian Concepción Ventura Pérez had never heard of René d'Harnoncourt, but she did know these two artisans. They worked as *doradores* in the workshop run by the merchant Luis Acevedo in the 1920s, and, by the end of the decade, also as *rayadores*. Other artisans are clear that the first time they saw the new style was in the objects coming of out Acevedo's workshop. This suggests that d'Harnoncourt introduced his revival through a merchant's workshop, perhaps by sharing with Romano and León images of antique wares and the ancient techniques, recipes, and ingredients described in Alejo de Meave's eighteenth-century published account (see chapter 7).

Though d'Harnoncourt argued that artisans should benefit directly from sales, physical distance made it difficult for him to gauge the impact of his revival on the local level. This was complicated by the dominant view about artisans that d'Harnoncourt shared with much of his milieu. From d'Harnoncourt's perspective, which he elaborated upon in countless publications, an artisan was "unaware of his own individual style." Rather, "his eyes and hands unconsciously saw and reproduced in their own way," with the indigenous hands acting as passive conduits of a primitive unconscious. The artisan was a practitioner of what today we might term Bourdieuian habitus, creating his art "without presupposing a conscious aiming at ends or an express mastery of the operations necessary in order to attain them." By this formulation the "active presence of past experiences," rather than strategic or conscious calculation, guided the artisans, who passively inherited forms and normative practices in conformity with their and their community's worldview.[10]

This perception of artisans remains widespread today among collectors and promoters of popular art, and even among scholars; but it does not capture Olinaltecos' experiences. After d'Harnoncourt introduced *rayado* in 1927, the style spread rapidly within the community, not because of a suddenly awakened unconscious but because merchants and artisans embraced it as part of their struggle over access to knowledge, resources, capital, and markets.

Learning *Rayado* in Olinalá: Metropolitan Connections and Local Power Struggles

Through his ties to d'Harnoncourt the merchant Acevedo gained privileged access to a high-end market and the larger than normal profit mar-

gins paid by Davis. Locally, this placed him in the enviable position of being able to gauge elite preferences and tastes and to readily market his goods. Other merchants soon used their own capital to follow Acevedo's example, going beyond local fairs and peddlers to build connections with Davis and other urban dealers. Rather than sit idly by as they were cut out of the market, independent artisans, too, adopted the *rayado* style. The elder artisans Concepción Ventura Pérez, Isaac Helguera, Siriaco Escudero Mejía, and Josefa Jiménez recall that *rayado* was best mastered not in Acevedo's shop but by Juvencio Ayala, the independent artisan who had learned lacquer and carpentry from his parents.[11] Just as the life story of Ventura Pérez gives us insight into the renaissance of 1913, that of Juvencio Ayala offers a prism for assessing the revival of 1927.

Before the revolution *laqueros* were few in number and low in social status. When lacquer blossomed following the crisis of 1913, many of those who turned to the craft appear to have considered it a decline in their status, and so they readily returned to farming (generally as sharecroppers or as laborers) at the first opportunity. The longstanding stereotype of *campesinos* farming by day and creating crafts in the evening, or, alternatively, farming in the growing season and making crafts in the winter, did not hold true for Olinalá (nor, for that matter, Uruapan or Pátzcuaro).[12] A few did have access to small parcels of land to grow gourds and chia seed along with small quantities of corn, beans, and chile, but artisans generally devoted themselves entirely to their craft. Up through the first half of the twentieth century, in fact, Olinaltecos drew a distinction between those who farmed and those who did lacquer (a distinction that would exclude artisans from the agrarian reform of the late 1940s; see chapter 9).

Those families that stayed with lacquer production after the recovery of the agricultural sector were poorer than their farming neighbors. They dedicated themselves to lacquer partly out of choice and partly out of economic necessity. Though they did not yet have a strong group consciousness that they could draw upon to defend their collective interests, *laqueros* appear to have developed their own norms and signs of status related to craftsmanship and their own ideas of quality. And their craft seems to have involved the entire family. Even those who worked mainly in merchant workshops also produced work in small quantities within their own homes that they sold to other artisans, to merchants, or at regional fairs. Most of those who continued as craftspeople came from old artisan stock,

but some were newcomers. These newcomers adopted the techniques and cultural practices of the older *laquero* families, including punctuating each stage of a child's life by introducing him or her to a new stage of production, hiring out their children to other artisans or to merchants to pay off debt or to accumulate capital with which to initiate a new round of production, and having newlyweds live for several years in the home of the husband's parents so the new wife could learn the trade, or, if she already knew it, to adapt herself to the norms and styles of the husband's family. If the husband was a newcomer he might move in with the wife's family, as was the case when Josefa Pantaleón took a husband who had only recently learned the trade.[13]

Artisans typically married other artisans. Such was the case, for instance, when the potter-turned-*lacquera* Concepción Ventura Pérez married the *laquero* Luis Jiménez, as described in chapter 7. And it was the case for the marriage between Juvencio Ayala and Isadora Navarrete, both of whom came from some of the oldest lacquer families in Olinalá. Isadora Navarrete, who townspeople refer to as Doña Lola, was sister to Alberto Navarrete (killed by the Zapatistas during the revolution) and Abraham Navarrete (who, along with Juvencio, became a leading producer of *dorado*-style dowry chests after the 1913 revival). The marriage solidified the bond between the Ayala and Navarrete clans and combined the talents of two highly skilled individuals. Doña Lola brought to the marriage mastery of those stages of lacquer production defined as women's work—such as collection and processing of raw material, kneading of the chia dough, and the application of the *tlapetzole*—while Juvencio did the tasks defined as masculine—including extraction of chia oil, scraping of gourds, carpentry, and, most importantly, the *dorado* and, by the time of his marriage, the *rayado*.[14]

In the decades following the 1927 introduction of *rayado*, the complexity of the new style made it difficult to produce, and even harder to master. Owing to its difficulty and perhaps also to the fact that it sold at higher prices and was more esteemed by collectors, *rayadores* earned more esteem within the artisan community than did *doradores*. The artworks depicted in plates 13 and 14 are attributed to the Ayala family, and the work shown in plate 15 has an unidentified artist, and all three are dated from between 1927 and 1930. These three objects are of such remarkable quality, and done in such a style, that it would be tempting to date them from the

golden age of Olinalá. If these were from the eighteenth century, the *jícara* in plate 15, along with another *jícara* from the same collection, would be the only surviving examples of decorated gourds from that period. If, however, the attributions are correct, and these, indeed, are from between 1927 and 1930, as their owners claim, they would indicate a remarkable revival of craftsmanship and leave little doubt as to why the best *rayadores* won the respect of other craftspeople.[15] Though they gained social status within the artisan community, masters of *rayado* such as Juvencio Ayala or Andrés Rendón were not necessarily any better off economically.

During his visits to the town Alejandro Paucic compiled a list of all artisans considered "masters" by their peers in 1930. Consistent with what the oldest artisans from the town had been telling me in interviews, Paucic lists Ayala as in a class all to himself, as the best *laquero* in both styles. He also lists seven other "masters." Five of these achieved their "master" status for their work in *rayado*, including Andrés Rendón, who had introduced the new style through Acevedo's shop. Only two achieved their master status for their work in *dorado*: Rufino García who worked in both *rayado* and *dorado*; and Ysmael García, who worked not with gourds or boxes but with *tecuani* (human-jaguar; see figure 21), ritual masks that he carved from the wood known as *colorín* (*Erythrina americana*, also known as *zompantle* or naked coral) and decorated with lacquer, wood, leather, and boar's hair and teeth—a craft his descendents continue.

Paucic also tells us that in 1930 there were a total of six *instalados* (workshops capable of completing all stages of lacquer from beginning to end in-house with family or hired labor). He seems to exclude the various small scale shops operated by artisans who might spend their days working for Acevedo and their evenings producing at home with family labor. He does not list the location or head of any of the six *instalados*. He does, however, note that while an *instalado* might have many *oficiales* (hired hands who received either a wage or a piece rate), they took only a small number of apprentices (who, instead of a wage, received a percentage of the workshop's profits).[16]

When Ayala saw d'Harnoncourt revive *rayado* through Acevedo's shop, it seems that he took matters into his own hands. He mastered the new style, married Isadora Navarrete (who brought her skills, labor, and family connections), and soon was delivering his own *rayado* production directly to Davis's Mexico City gallery, where one might imagine d'Harnoncourt,

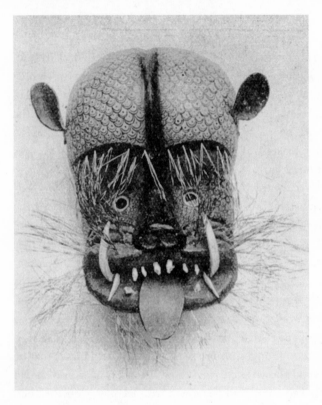

21. Lacquered *tecuani*
mask, Olinalá, 1920s.
Frances Toor, *Mexican
Folkways* 6 (2) (1929):
90. Amherst College
Archives and Special
Collections. Used by
permission.

Fosado, and Davis gave him detailed feedback about what they thought
was good about his work and what to improve. One of Frederick Davis's
photographs (figure 22), which accompanied an article that Jorge Enciso
published in *Mexican Folkways* in 1933, shows Juvencio Ayala with one
such delivery, which consisted of a dowry chest and a number of *palan-
ganas* (also known as *peribanas* or *bateas*), all beautifully executed in the
rayado style.[17]

Ayala was atypical for making direct contact with an urban dealer, and
he was among the few (and possibly may have been the only one) who by-
passed the merchants to buy some of his own *peribanas* in Mexico City
and to establish direct access with Davis's shop. He was even more atypical
in that, whereas other *laqueros* relied on carpentry shops and merchants
for boxes and chests to decorate, he made most of his own *blancos* (boxes
and chests to be lacquered).

Even though it was independent artisans who best mastered the *rayado*

22. Original caption: "Juvencio Ayala of Olinalá, with his latest work, in which he has faithfully revived the old designs in all their beauty." Frances Toor, *Mexican Folkways* 8 (1) (January–March 1933): 16. Courtesy of Yale University Library.

style, and although Ayala took steps to compete against merchant workshops, the merchants enjoyed key advantages. First, the complexity of the *rayado* process favored a division of labor that was easier to organize with hired help (*oficiales*) than within the family unit. Second, demand for *rayado* was idiosyncratic. This gave the merchants, who could meet with dealers such as Davis with regularity (except for during the rainy season), the advantage of steady capital accumulation, frequent turnover of goods, and regular interaction with buyers to gauge their tastes.

A third advantage for merchants came from the fact that the most profitable objects done in the *rayado* style were *bateas* (plate 16). The merchants largely controlled this trade. Locally, these carved wood trays were known as *bateas* or *palanganas*, but Olinaltecos also employed the term preferred by Mexico City dealers, who called them *peribanas* (named after a town in Michoacán known as a marketing center for carved trays). Dowry chests, or *baúles*, were more esteemed and valuable, but they required more time, labor, and materials. Moreover, compared to *peribanas* that could be stacked, *baúles* were difficult and expensive to transport and they were more likely to suffer damage during the long, arduous journey through the Montaña. Overall, *peribanas* offered higher profit margins,

entailed less risk of loss to damage, and required less capital outlay. They also enjoyed a brisk demand in Mexico City. The problem for independent artisans was that the lack of suitable trees made it impossible to carve *peribanas* locally. Merchants imported them from Michoacán via Mexico City and within a short time directly from Mexico City woodcarvers. Artisans recount how in the late 1920s through the 1930s Luis Acevedo would return with tall stacks of unfinished *peribanas*. After day-workers lacquered them in his shop, he would take them to Mexico City, then return with a fresh load of *peribanas en blanco*.[18]

Artisan families that ran their own *instalados* had several main options: borrow money at high interest rates from merchants so they could undertake the costly trip to the capital to buy their own *bateas*; buy *bateas* on credit from the merchants; concentrate their efforts on less capital-intensive (but also less profitable) gourds; or focus on the more labor-intensive and risky, dowry chests. Juvencio Ayala and Isadora Navarrete combined all these strategies, but most other artisans appear to have relied upon merchants or found themselves closed out of *batea* production (except when working as *oficiales* for the merchants).

Even artisans such as Ayala, who could compete against the merchants in the production of high-quality *rayado*-style chests and *bateas*, relied for their livelihood on gourds decorated in the *dorado* style, which they sold regionally at low prices. After 1927 the ideal was to combine high volume *corriente* production (which brought predictable, if low, profits) with a smaller stream of high-end goods (which entailed more risk but brought higher profits). This balance was difficult, and a shipment lost to floodwaters or a slight misreading of metropolitan tastes could spell disaster. Even the most talented and independent of artisans at times had to turn to merchants for loans, which they repaid with handicrafts or family labor that contributed to the success of their merchant competitors.

Competition between Merchants and Independent Artisans

Merchants and independent artisans competed on a terrain of shifting markets, idiosyncratic consumer tastes, geographical isolation, and fierce economic and political conflict. Artisans, moreover, did not act in solidarity. Group sentiment rarely extended past one's family or, in some cases, one's *instalado*. The male artisan's aspiration seems to have been to gain as much autonomy as possible by producing completely within his own

workshop and then selling his work directly at fairs, to dealers, or at fair prices to the merchants. To forestall dependency upon merchants, an independent artisan had to avoid needing their goods or services. The only way for him (only a male could have been considered independent) to do this was to have within his workshop women and youths to collect and process raw materials such as chia, pigments, and *tierras*. A male artisan operating alone could never achieve autonomy; he needed an entire family of skilled workers. Moreover, if he hoped to avoid having to hire *oficiales*, which often required loans from merchants to pay wages, he needed within his family people trained in each stage of production. And to market his own wares without taking out an expensive loan from a merchant, he needed to finish a production cycle with cash on hand for travel expenses. Artisans seemed locked into a losing battle. Even Juvencio Ayala, who possessed the skills and the in-house labor to complete the entire production process from beginning to end, sometimes had to turn to merchants for loans, dry goods, and occasionally even capital to start a new cycle of production or to finance a sales trip to regional fairs or to Mexico City. Independence, in this context, was a matter of degree, not an absolute, and those who had the most success worked in both *rayado* and *dorado* and in both high-end and low-end markets. Rather than group solidarity, then, artisans strove for autonomy. And while some of them did achieve a fair degree of autonomy up through the middle of the 1930s, it was never easy.

Local accounts, together with Paucic's notes from his visits to Olinalá at the time, make clear that, despite the obstacles during the early and mid-1930s, some male artisans maintained their own shops, shipped and sold their own wares, and negotiated rates with merchants. One of the ways artisans tried to protect their autonomy was by strengthening their ties to urban dealers and fair vendors. To help these artisans Manuel Calderón of the Museo de Artes Populares in Mexico City in 1933 and again in 1937 attempted to compile a list of the artisans in Olinalá, so as to help urban dealers bypass intermediaries (see chapter 5). Such efforts do not seem to have had much impact and artisans were on their own as they competed against merchant-run workshops.

Without minimizing the merchants' exploitation of their fellow townspeople, their often violent manipulation of local political and economic relations, and their use of debt to corner the local market and exploit their neighbors, it is important to recognize their crucial role during the late

1920s and early 1930s as a linkage between the growing but idiosyncratic high-end market. Absent merchants' frequent interaction with urban dealers, Olinaltecos would have had difficulty figuring out how to make their work convey the signs that collectors and nationalists expected to find in authentically indigenous popular art. And in the late 1930s it was merchants who made it possible for Olinalá to respond to the growth in demand for low-end products. As discussed below, this ballooned the size of the artisan population to half of the adults in the village. Like most kinds of middlemen or hingemen, the merchants gained power not just because of their access to capital but because they used that capital in such a way as to serve those above them and those below. The problem for the artisans was that once these middlemen gained this advantage, they exploited it to prevent competitors and subalterns from circumventing their authority. As middlemen, therefore, Olinaltecan merchants manipulated market connections and indigenousness to act as both facilitators and exploiters.

Merchants were not *laqueros'* only problem. Lack of roads and bridges, severe aridity followed by a long heavy rainy season that swelled streams and caused flash floods, and a precipitous, crumbly terrain, made travel within the northern Montaña de Guerrero difficult. Even if artisans managed to travel without incident, they, unlike merchants, rarely could count on guaranteed buyers. If the destination was Mexico City or if travel occurred during a dangerous time of the year, only males made the trip, but if they were going to regional fairs during a safe time of the year, the whole family might go. Often the women sold in the fairs while repairing nicks and dents and polishing the objects (figure 23) while males hawked in the streets of towns or villages or traveled to meet dealers.

Artisans negotiated merchandise exchanges with others along the road so as to diversify the goods they would sell in the next town or the next fair. They also might invest some of their income in dry goods and supplies that they hoped to bring back to Olinalá to feed their families, stave off debt to the merchants, or exchange with other artisans. In addition to Tepalcingo, Morelos, which was the most important regional marketplace, Olinaltecos also visited over two dozen other fairs. The number and importance of these fairs, however, declined during the 1930s and 1940s as tin, plastic, and glass became cheap alternatives to lacquered gourds and as the population in the Montaña stagnated.[19] This decline of the fairs and difficulty of travel

23. Olinaltecos demonstrating the *rayado* technique at market, 1930s. Frances Toor, *Mexican Popular Arts* (Mexico City: Frances Toor Studios, 1939).

and marketing, coupled with the competition from merchants capable of high-output of lacquered crafts at low prices, made it common for artisans to reach the end of the fair season with some of their merchandise still in tow and no choice but to sell it at a loss to anyone who would buy, so as to recuperate some of their costs and get cash to pay off debt and to initiate a new cycle of production.[20] In the face of growing financial risks and mounting debt artisans found it ever more difficult to market their own goods.

One of the ways artisans tried to gain room for maneuver was through the high-end market. Merchants had managed the town's introduction to the high-end market in 1927, but in the 1930s artisans brought a revival of their own. During the colonial era, Olinaltecos sometimes had employed the fragrant wood of the linaloé tree (*bursera aloexylon*) in their *baúles*, but based on comments by older artisans and objects in existing collections, they seem to have stopped using it back in the nineteenth century. In the mid-1930s the artisans either reintroduced it or stepped up its use— though it would not be until the 1960s and 1970s that use of linaloé would become widespread.[21] To use the trees in this way required human intervention in the months before harvesting, when strategically placed cuts

stimulated the growth of fragrant veins. At harvest time sawyers cut the trunk in such a way as to maximize surface exposure of these veins. Linaloé increased demand and price per piece within the high-end market. Unlike *rayado*, linaloé did not unleash major changes in marketing or production, but it did provide a way for artisans to raise the value of their work without increasing dependence on merchants. Moreover, because *laqueros* left the interior of linaloé *baúles* unlacquered, so as to release the wood's fragrance into the textiles stored within, linaloé saved on labor and materials. Its use alleviated master artisans' need to go into debt to the merchants and helped them fetch high prices.[22] In neither the short term nor the long term, however, did the introduction of linaloé present a serious challenge to merchant control.

Independent artisans held their own until the second half of the 1930s, when merchant-artisan relations underwent an abrupt shift. This shift was precipitated by new state policies that favored large-scale craft dealers at the expense of artisan producers. Merchants who previously had acted alone now became local agents of an organized commercial network based in Chilapa.[23] As discussed in chapters 5 and 6, the state provided funds that private investors channeled through regional and local agents or *acaparadores*. These *acaparadores* used these funds to entangle artisans in cycles of debt that assured a steady flow of products to the growing low-end market. Olinalá provides a context for understanding how this state policy unfolded on the ground and how it impacted artisans and handicrafts.

As merchants gained greater access to large buyers and to capital with which to make loans, they moved away from the workshop model. They learned that control over credit was more lucrative than control over production. They tightened their monopoly over the sale of dry goods, food, and craft supplies, then sold these goods at inflated prices on credit that often had to be repaid not in cash but with crafts. They also offered cash loans on similar terms. Artisans in desperate need of food, cash, or supplies sold their future work at far below normal market value. When making the loans, the merchants stipulated the style, materials, level of quality, and due date. This enabled the merchants to assure a steady stream of goods of predictable quality to agents in Chilapa, who then moved the crafts to Mexico City warehouses.

Roberto Lujan pioneered an ingenious refinement to this system. As he moved away from running a workshop, Lujan developed a peculiar piece-

work system in which he supplied an artisan with the materials necessary for a particular stage of production and a certain quantity of partially finished crafts. He then treated these goods as an interest-bearing loan. For example, after one artisan returned to Lujan a set of gourds that she had burnished for him, he would then "lend" that load of gourds to another artisan to apply the *tlapetzole*, or base coat. He would "lend" her also all the necessary pigments, tools, and *tierras*, along with a small cash advance. For each day that passed between the time he delivered the goods to her and the time that she returned the finished product, she owed accrued interest on the full value of all the tools and supplies, and on the value of the partially completed gourds. When she finally did return the gourds to him with their *tlapetzole*, he calculated her pay by starting with the price that he had agreed to pay her for lacquering the gourds, then subtracting the interest and the price of whatever materials she had used. The difference between these two amounts was what he paid her. If she was fast and lucky, she would earn a meager profit; if she were unlucky, she would end up owing him money, which she would have to pay off by taking another loan of partially finished crafts. The merchant then turned the gourds over to another artisan for the next stage of production, with all the same conditions. Once a load of crafts was complete, he sold it to associates in Chilapa. This putting-out method pioneered by Lujan attracted other merchants, such as Daniel Almazán, who previously had avoided dealing with lacquer but now recognized it as a great business opportunity.[24] The system benefited from consumers' growing indifference toward quality and workmanship during the late 1930s and 1940s, which gave the *acaparadores* more flexibility in their dealings with artisans.

This putting-out bore some similarities to earlier systems in Europe and the United States. But, whereas those putting-out systems developed as preludes to industrialization—leading to in-house contracting and then factories and assembly lines—in Olinalá merchants used it as a way to profit from the underdevelopment of their region within the context of national and international capitalism. The system in the Montaña therefore was not a classic example of putting-out, but something of a hybrid between pre-industrial putting-out systems, debt-peonage, and high-capitalist sweatshops.[25]

Seeing as one way *acaparadores* ensnared artisans was through debt in the form of supplies, one might expect craftspeople to avoid this by

manufacturing all their own materials. Unfortunately, it was not so simple. There were too many stages in the production process, and each one consumed so much time. This meant that at a moment when prices per piece were falling (as was the case from the mid-1930s through the 1940s) a workshop struggling to do everything in-house could not earn enough to survive. This becomes clear if we look at but one task: the preparation of gourds. Artisans differentiated among many different kinds of gourds: *jícaras*, *baúles*, *chirianes*, *tecomates*, *guajes*, and many others. The preparation of these gourds, though regarded as one of the simplest of artisans' tasks, was involved and time consuming. After acquiring the proper assortment of gourds in the Costa Chica, buying them from dealers, or growing some varieties themselves, artisans then submerged them in water for at least a month to cure. Failure to cure them adequately would result later in cracking, and soaking them too long deteriorated the surface of the gourd such that it bonded poorly with the lacquer. Some artisans tied together bundles and sunk them in pits that they dug in arroyo beds, while others created special wells in their patios at home. After curing the gourds, the artisans had to saw them in half (if they were to become bowls) or into whatever simple or elaborate shapes they would eventually take. They then scraped out the insides, and set the husks to dry at a controlled rate for four to five days, after which time they scrubbed the gourds and polished the inner and outer surfaces with burnishing stones to prepare them to accept the first layer of lacquer, or *tlapetzole*.[26] Artisans had not only to prepare gourds but also each pigment, each *tierra*, the chia oil, each burnishing stone, marking tool, cotton wad, and countless other tools, craft supplies, and packing materials. It was simply impractical for them to continue to do everything for themselves in an era when falling prices demanded greater output. To survive, even the most independent of artisans had to turn to the merchants for at least some of their supplies.

Merchants displayed ingenuity as they transitioned from direct production to control over supplies and debt. They coordinated a dizzying array of raw materials gathered from near and far. At first the merchants bought their supplies from local women, but they soon turned to regional suppliers who undercut local producers. By the end of the 1930s they were going even further afield, replacing local products with cheap commercial pigments, linseed oil (which they introduced as an alternative to the locally produced chia oil—using, at that time, a low grade of linseed oil that did

not adhere well to the wood), and plaster and dolomite to replace such local *tierras* as *tetzicaltectli*. The ironic outcome was that the very merchants who in 1927 had acted as purveyors of Olinaltecan authenticity, a decade later undercut the community's ability to comply with collectors' expectation that "authentic" crafts be made of local hand-processed materials.

Under such a system, the new challenge for the artisans was no longer to compete directly against the merchants but rather to try to minimize the chances of being crushed by expensive debt. It was at this time, at the end of the 1930s, that Alejandro Paucic, confirming what older artisans have described, observed that *acaparadores* had gained such control over the crafts that few artisans were able to market even a fraction of their own goods or to select their buyers.[27]

Gender Roles and Market Transitions

Lacquer production was highly gendered. Without an analysis of the gendered pathways of power and production it is impossible to understand how merchants exercised their control or how artisans contested such control. Certain tasks, usually laborious and tedious, were defined as feminine, and those that were more highly valued, creative, and varied were defined as masculine. Women made the lacquered object utilitarian (with waterproofing, for instance) and processed all the raw materials. In the context of 1920s and early 1930s ethnicized cultural nationalism, it was the tasks defined as masculine that determined most of the work's value. For this reason, when we talk about the nationalist and metropolitan validation of Olinaltecan lacquer, we are talking about a privileging of the men's contribution.

Gender roles are never fixed. They are continually challenged, negotiated, and redefined.[28] In contrast to the *dorado* style revived in 1913, which had only two to three stages beyond the *tlapetzole*, the *rayado* method introduced in 1927 required seven or more. Since these stages did not previously exist in the production process with which most craftspeople were familiar, Olinaltecos had to negotiate which of these stages would be defined as feminine and which as masculine and what kind of esteem and remuneration each would bring. At stake were Olinaltecos' definitions of manhood and womanhood, their relative levels of economic and social subordination and dependency, and the kinds of vulnerability and resis-

tance they could present. Because *laqueros* could extrapolate from practices related to *dorado* production and upon assumptions that pervaded local society more generally, gender norms for *rayado* production regularized fairly quickly.

Paucic's notes offer remarkable detail about the structure of labor, work rates, and remuneration. One notable feature was that male artisans' pay and prestige were tied closely to their demonstrated skill, which varied widely from one artisan to the next. Women's work, by contrast, provided little recompense in pay or reputation for skill and talent. Whereas Olinaltecos judged a man's skill as hard-earned and a mark of personal talent, they attributed variations in women's work to the quality of her raw materials and the particular process employed. A woman might be thought to possess a certain level of competence expected of all women artisans, but she was not celebrated for her unique mastery. Moreover, when women's skills added to the quality of a work, the prestige went not to that *laquera* but to the male *rayador* or *dorador* wise enough to have competent women helpers. The gendered structures that emerged around *rayado* did not improve women's economic leverage or social status, but they did offer her a greater variety of tasks. Rather then being confined to processing raw materials and applying the *tlapetzole*, a woman now could take part in some of the final stages of production, such as "thickening" the design created by the men, or waxing and buffing the final product. The greater number of stages that required female artisans meant that women, while still low paid and lacking in status, gained more room for horizontal movement among tasks or workshops. While for women *rayado* offered only horizontal options, for men it created opportunities to move vertically and to demand rates of compensation based on skill and talent. This led to a wide variation among men's compensation. The lowest-paid men earned the same as women for a ten-hour workday, but a skilled *rayador* working as an *oficial* could earn twice as much as the highest-paid woman.

Lest we exaggerate male artisans' economic leverage we should keep in mind that even the best *rayador* on the best of his days earned less than 10 percent of the daily rate d'Harnoncourt charged his clients for his collecting services. Even the most successful artisans, such as Juvencio Ayala, lived in grinding poverty.[29] Also, though a *rayador* earned more per piece than did a *dorador*, he did not necessarily earn more per day. This was be-

cause a *dorador's* income level was more likely to be maintained by high output, whereas a *rayador* could slow down and pay more attention to design and detail—provided his work was good enough and of the proper aesthetic to break through a certain market threshold.

The greater complexity of *rayado* as compared to *dorado* offered advantages to artisans, but a major drawback was that it was more capital and labor intensive. It also required access to a wider range of specialized skills. This was because the second layer of lacquer called for in *rayado* was of higher-quality materials and craftsmanship than the base coat. For a 45 cm diameter *palangana*, for example, application of the *tlapetzole* needed for both *rayado* or *dorado* could be accomplished by one female *oficial* and cost only .25 pesos in labor and materials. But application of the second coat necessary for the *rayado* style required a team of at least seven specialists. For maximum efficiency, a different person focused on each specialty (though, in a family workshop, where the pay for *oficiales* cut into the family income, individuals often specialized in two or more stages). Depending on quality, *rayado* added between .65 and 6.40 pesos to the production cost of each 45 cm *palangana*. This assumes that only two colors were being used (one for the base coat, the other for the design), but high-quality pieces used as many as five different colors. The entire procedure had to be repeated for each color, adding significantly to the production cost. Even the highest quality *dorado*, by contrast, never added more than 1.25 pesos to the production cost.[30] Production of *rayado*, then, demanded a much higher investment in capital and labor. High quality *rayado* brought more esteem than did high quality *dorado*, but not necessarily a higher income.

Production bottlenecks emerged at the point where men stepped in as *rayadores*. Female skills were widespread within the community and poorly valued, whereas it was hard to find a good *rayador*. Male artisans used this bottleneck as leverage to gain respect and higher wages. In most cases, the strategy worked. But in at least one crucial case it backfired and was what helped precipitate merchants' decision to abandon the workshop model in favor of the debt and piecework model described earlier. The backfire happened in Roberto Lujan's workshop just when he and other merchants began operating as *acaparadores* for agents in Chilapa. Frustrated by the *rayadores'* growing leverage, and cognizant of falling prices and of con-

sumers' declining interest in "quality," Lujan decided he would no longer hire *rayadores* at all. He outsourced *tlapetzole* and all other stages (except the *acabado* work, that is, the cleaning and polishing, which his wife did) to women and male adolescents and he learned to do his own *rayado*. He was not talented at *rayado*, but given the market's growing indifference to quality in the late 1930s, this was not a problem.[31]

From the late 1930s through the 1940s, the declining national attention to "quality" eroded male artisans' ability to leverage their skills. For the same daily rate as two highly skilled *rayadores*, a merchant could now farm out work to a half-dozen interchangeable semi-skilled *rayadores* and *doradores* who could churn out large amounts of low-quality goods. Moreover, the merchant could do so while making a tidy profit both from the interest paid by the artisan pieceworkers and from the final sale of the craft to dealers in Chilapa.

By the 1940s, when national wholesalers increased their pressure upon local *acaparadores* to drive down prices, artisans suffered a steady decline in their pay rates. Also, merchants, who likewise grappled with the impact of falling piece rates upon their own incomes, intensified their efforts to replace locally produced materials with low-cost industrial alternatives. Because the production of these raw materials long had been defined as women's work, this strategy most directly impacted women. Abstractly one might think that this may have freed women from poorly paid arduous aspects of production, but, because women had no other employment options, it instead undermined their already weak ability to negotiate compensation. Cheap industrial alternatives rendered women's work dispensable unless those women lowered their prices to compete with the new materials. The impact of these industrially produced alternatives on the physical crafts and their market is addressed later in this chapter. The thing to note for now is that as merchants introduced these new materials, the act of processing local raw materials became a cultural mark of extreme poverty, undertaken only by women from families who could not gain access to the capital or loans necessary to acquire labor-saving industrial alternatives. Ironically, even as their art departed from the nationalist ideal, the denigration and growing poverty of Olinalá's craftspeople made them more fully compliant with local definitions of indigenousness, which, in Olinalá as elsewhere in Mexico, remained linked to poverty and inefficient, even irrational, modes of production.

Declining Profits and Economic Immobility

Even as consumer demand for Olinaltecan lacquer grew in the late 1930s and 1940s, artisans' standard of living eroded. To meet the rising demand for crafts, merchants used debt to compel economically destitute townspeople to participate in lacquer production, but the declining prices, higher costs, and rising inflation prevented the artisans, old and new, from making a decent living. This section of the chapter explains why growth in consumer demand undermined, rather than increased, artisans' leverage and why it hurt craftsmanship. It also points to the beginnings of economic solidarity among *laqueros*.[32]

After a decade of relative stagnation, the town's population suddenly swelled in the first half of the 1940s by almost 50 percent to around 2,000 people. At that time, more than half of all Olinaltecos participated in the lacquer industry, and they did so in a wider diversity of ways than previously. Some townspeople combined piecework for the merchants with a few independently produced items that they sold at local markets, to other artisans, or to merchants. Others worked in multiple artisan workshops as hired help, did some piecework on contract and produced a few lacquered earrings made of small gourds that they sold on consignment with the help of independent artisans. In short, the possible ways of taking part in the market multiplied. Nevertheless, the sector that benefited most was the merchant class which, by this time, comprised about seven families. They built upon their ties to dealers in Chilapa; developed connections with other dealers throughout the area and in Mexico City, Puebla de los Angeles, and the growing tourist city of Acapulco; and, as described earlier, exploited artisans through debt and by tapping into gendered structures so as to extract crafts at depressed prices. Some centered their business strategy on crafts, but the more powerful and wealthy merchants treated crafts as only part of a broader economic strategy that involved livestock, crops, and transportation. And the wealthiest of the merchants avoided crafts altogether.

Artisans, meantime, contended with an increasingly crowded field at home and from the outside. As discussed in chapter 5, the simplification of designs and the decline in craftsmanship made it easy for dealers from as far away as Japan to flood Mexico and the United States with objects designed to mimic the appearance of Olinaltecan lacquer and other Mexican

crafts. Competition also grew closer to home. Temalacacingo entered the market thanks to *vecinos* who had apprenticed in Olinaltecan workshops, and thanks to well-intentioned teachers, eager to offer the people a means to support themselves economically, who taught them aspects of Olinatlecan lacquer techniques through the public schools.[33] Temalacaltecos tried to imitate Olinaltecan *dorado* gourds, but their knowledge of the materials and processes was too fragmented to sustain such an industry, so they focused on wood toys decorated with store-bought paint—this remains their market niche even today, though most recently they have also started to produce stunningly burnished gourds. Temalacacingo was not unusual. Paucic notes that throughout Guerrero and into Oaxaca and Chiapas outsiders were trying to convince communities to take up lacquer production as a strategy to alleviate poverty. As low-cost items flooded the market, Olinaltecos found they had to produce in even greater quantity and lower quality to survive. The diversification of ways of participating in the market, under these circumstances, did not open new opportunities. Rather, it was part of a desperate effort at survival by craftspeople stuck in a race to the bottom, and a symptom of the lack of other options within the local economy.

Artisans, ever on the lookout for ways to improve their situation, attempted to emulate the merchants. In fact, we see slippage on both sides, from both merchants and artisans. For some merchants—such as Daniel Almazán, who now dealt in crafts but, unlike Lujan or Acevedo, never established a workshop, and others, like Cirio León, who never dealt with handicrafts in any way—their status as merchants was unambiguous. For others, it was less stark. Luis Acevedo and Roberto Lujan, for example, both ran workshops during the 1920s and 1930s. As mentioned earlier, Lujan, even as he outsourced most of the production, acted as his own *rayador*. Moreover, during the late 1920s and early 1930s, some merchants seem to have presented themselves to metropolitan collectors and nationalists as indigenous artisans.

Slippage was more pronounced on the part of artisans. It became common for an artisan preparing for a long journey to take with him the works of other artisans so as to haul a full load. Such arrangements might be based on commission, outright purchase for resale, barter, or repayment of personal loans. As mentioned previously, sometimes these were part of reciprocal agreements by which an artisan preparing to travel might agree

to sell the work of fellow artisans. This gave nontraveling artisans a sales option outside of the merchants, and it gave the traveling artisans a commission as well as an opportunity to vary their offerings at fairs or in urban marketplaces. Artisans looked for similar opportunities on the road. While traveling, one might exchange lacquer for a load of *rebozos* (shawls), baskets, or bits of dry goods to sell along the way or upon returning to Olinalá. The end effect was that artisans tended to deal in a range of goods in search of market opportunities and in a vain effort to accumulate capital.[34] Despite such slippage, neither the documentation nor my interviews reveals a single artisan who successfully transitioned into the rank of merchant. Artisans were unable to marshal the capital that would have been necessary to bring large quantities of goods back and then to wait to sell them over the long rainy season. If they were lucky, they might bring back enough goods so as not to have to ask local merchants for loans, but they did not earn enough to establish themselves even as minor merchants or as lenders (except for small short-term loans to friends and kin). Despite the reality of economic immobility, independent marketing continued to attract artisans (and still does to this day), because it offered the dream of escaping the cycle of poverty and insecurity that seemed the inevitable lot of the craftspeople.

A Pyrrhic Victory

At the end of the 1940s, following years of struggle for the freedom to market their own goods, artisans finally got what they wanted, but it turned out to be a pyrrhic victory achieved only on account of the market for lacquer having become so unattractive. Prices for Olinaltecan crafts sank so low that local merchants shifted instead to the agricultural sector, where corrupted land reform had opened up new opportunities for profit (see chapter 9). Merchants continued to act as local high-interest lenders and as sellers of craft supplies, but they now expected repayment in cash. This not only allowed artisans to market their own goods; it compelled them to go out and do so aggressively.

As merchants abandoned the lacquer trade, so, too, did many *laqueros*. As will be more fully addressed in the next chapter, the artisans who remained active found themselves excluded from the ejidos created in the mid-1940s. They won control over the marketing of their crafts, but rather than the vibrant market they had encountered in the early 1930s immedi-

ately following d'Harnoncourt's revival, they now grappled with depressed prices, indifference toward quality on the part of most buyers, and a lack of a reliable marketing network—it is not clear why they did not sell to agents in Chilapa. And the irregularity of their contact with high-end buyers left them unable to gauge reliably collectors' expectations. To survive, artisans had to produce quickly, cheaply, and in bulk, and they had to have a fast turnaround in sales if they hoped to make any profit at all after paying their debt to the merchants. And, after they paid their debts, they still had to take out more loans to finance a new cycle of production.

To keep their debt at a manageable level craftspeople had to minimize their own costs. The only way to do this was to use low-quality materials. This meant that even as they regained control over the marketing of their goods, they were more dependent than ever upon the industrial substitutes that merchants sold on credit. *Laqueros* leaned on *dorado*-style gourds and small boxes that they could produce rapidly, in series, with minimal investment, and which could be quickly marketed at low prices in regional markets. They also abandoned carved *peribanas* in favor of cheaper rect-angular plywood trays, known as *charolas* or *bandejas*. Even for high-end goods, whose production had slowed to a trickle, artisans had little choice but to replace traditional materials with such industrial substitutes as gesso, aniline pigments, linseed oil, and ground dolomite. Overall, they concentrated on crafts that were cheap to produce and easy to transport and market and thereby tied up little capital and required only minor eco-nomic risk.[35] The trade-off was that such goods brought thin profit mar-gins and decreased opportunity for capital accumulation. This retreat to gourds, small boxes, and plywood trays, all decorated in the *dorado* style with low-quality industrial materials, was a conservative strategy that kept artisans locked into deepening poverty and dependence. Moreover, it af-forded few opportunities for them to hone or flaunt skills, which further depressed their social status locally—though I would argue that even the work they produced under those conditions often was quite beautiful.

The use of these industrial materials created quality-control problems. Indigenous consumers, upon whom *laqueros* now relied, bought lacquered gourds as drinking, serving, and storage vessels for liquids, or, in the case of gourds with lids, for storing powders that needed to be shielded from moisture. Yet the abandonment of chia and local *tierras*, along with simpli-fications in production, compromised this lacquer's impermeability. Arti-

sans tried to address this problem by introducing automotive wax, but this did not greatly improve water and weather resistance, and it offered a less durable gloss than did lacquer made with local *tierras*, chia oil, and careful stone burnishing. As lacquer quality declined, indigenous consumers turned even more to tin, glass, and plastic alternatives.

The cheap materials also cost artisans the trust of collectors, who now refused to pay high prices for objects that they justifiably feared might be made of questionable materials. The more craftspeople replaced *linaloé* with pine doused in fragrance (see chapter 9), abandoned chia oil in favor of low-grade linseed oil that did not adhere well to the woody surface of the gourds and trays, cut corners in the curing of their pine boards such that their buyers a few months later found their lacquered chests devoured by moth larvae eating their way out of the wood, and either replaced local *tierras* with industrial substitutes or accepted adulterated *tierras* from local producers (who themselves were cutting corners), the more the reputation of their craft suffered and the harder it became for them to command high prices.

Olinalá was not the only artisan community experiencing this kind of crisis of quality and reputation during the 1940s and the 1950s. As described in chapter 6, government policies and strategies by private investors took a toll across Mexico. Doctor Atl, who had spurred the resurgence of crafts in the 1920s and 1930s, correctly observed that beginning in the 1940s most crafts entered a dramatic decline in workmanship and artisans suffered an eroding standard of living. He wrote that "it is our responsibility to make the aesthetic lightning bolt of 1914–1940 strike again with even greater intensity and benefits." It was at this same time that the nationalist ethnologist Enrique Othón Díaz worried that the overall decline of crafts might encroach upon Olinaltecan lacquer, which he and others saw as one of the final bastions of authenticity, and wondered if there was any hope of "salvaging" popular art "from the inferno that is burning away the spirit of Mexico."[36]

The economic situation continued to drive producers from the market until the percentage of Olinalá's population involved in craft production seems to have dropped from more than half to 15 percent or less. Ironically, the decline in the number of artisans coincided with the proliferation of small, full-time workshops, which reached more than four dozen by 1950.[37] This seeming paradox resulted from the fact that, as production became

less complex thanks to labor-saving industrial materials, declining profits made it hard for a workshop to support many workers. Moreover, the simplifications introduced into the production process made large *instalados* unnecessary. Artisans who might have worked as *oficiales* instead struck out on their own. In 1930 a workshop had been expected to complete the entire lacquer process from beginning to end, but these new workshops each specialized in a particular stage of production. Sometimes they performed stages of production subcontracted to them by well-established *instalados*, other times they simply worked in conjunction with other small workshops, with each completing a stage of production before selling the partially completed objects to another workshop, until, in the end, a final product emerged ready for market. The proliferation of workshops, then, like the newfound marketing autonomy of the artisans, was not a sign of artisans' triumph but rather another effort to survive in the face of the deepening crisis and marginality of their industry.

As crafts lost their place within the nationalist imagination, artisans lost whatever local social status they had gained during the 1920s and 1930s. At the close of the 1940s Paucic noted that the "authentic folkloric industry" in Olinalá "is poorly remunerated" and "disparaged."[38] Today's artisans no longer suffer such low status, and they look back upon the 1940s through the middle of the 1960s as their low point. Families involved in livestock, farming, or trade, many of whom benefited from the agrarian reform and who linked masculinity to access to land, went so far as to refuse to allow their children to marry artisans, whom they ridiculed as *tlapetzolientes* ("those who stink of *tlapetzole*," a disparaging term that marked the artisans as indigenous, unwashed, and effeminate, since it was the job of the lowest ranked women to apply *tlapetzole*). Moreover, the artisans' poverty and low status marked them as more indigenous than other townspeople. The flip side of this situation was that artisans began to change how they saw themselves. As they grappled with new challenges and developed new strategies for survival, they began to think of themselves as a distinct and bounded social sector endowed with its own identity and interests within Olinaltecan society.[39]

Quality and Indianness in Olinalá

With a sagacity that would be lost later in the next two decades, a Mexican consul in New York City in 1933 recognized some of the complexities of

the market and of taste. The consul noted that a lively demand for popular art in the United States resulted from the success of the 1930–32 Mexican Arts Show at the Metropolitan Museum of Art, along with the public's fascination with the excavations at Monte Albán and frequent exposure to Mexican crafts in schools, clubs, churches, and bazaars. But the consul explained that there were peculiarities to the market that had to be understood. One of the things he emphasized was that the market for products of quality operated differently than the low-end market, but that the two were tied together. If the quality of high-end crafts were to decline, low-end prices would follow. He also noted how poorly expectations regarding quality were conveyed along the chain linking consumers to producers. He lamented how often artisans created pieces whose materials, workmanship, and price appealed to the collectors' market but whose style and taste responded to the cheap souvenir market. "Hybrid" pieces of this kind led to significant losses.[40] But what was quality? Why and how did artisans misread the market? To what degree was this misreading mutual? The meaning of quality and the question of who had the right to make such discernment and on what grounds, speaks to the interlinkages as well as the disjunctures between the local, the national, and the transnational, and it comes back to the question of Indianness.

The idea of "quality" was not merely an elite imposition. During the 1940s, even as other Olinaltecos looked down upon them and the market forced them to compromise in materials and craftsmanship, a core of artisans clung to an ideal of quality. Part of their aesthetics-versus-market dilemma is captured in a story shared by a number of artisans who came of age in the 1940s. According to this story, one day Juvencio Ayala was preparing to travel to the fairs to sell his work. As was often done, he took with him goods by fellow artisans. One of the artisans, Don X, was recognized as mediocre, but since he was a good friend, Ayala agreed to sell his work on commission.[41] At one of the rural fairs, Ayala laid out his merchandise but, embarrassed by the poor workmanship of Don X's crafts, could not get himself to bring those out. When the fair was ending, he still had not made a single sale. Then a costumer wandered over and lingered at the stall. After looking over all the merchandise he finally asked Ayala if he had anything else. Embarrassed, the artisan uncovered Don X's work. The delighted costumer bought several of them. This oft-repeated story of Ayala and Don X reveals the tension that artisans experienced between workmanship and

the market; between their own trained, discerning eyes and the seemingly undiscerning eyes of most buyers. One of the artisans who recounted this story explained what he saw as its moral: "That is how things happened, and [even today] people still do not know" how to differentiate good work from mediocre. From *laqueros'* perspective, to create quality work was to take a risk that might not pay off economically. Yet to be recognized as able and willing to make such a sacrifice initiated an artisan into an informal but mutually supportive circle of like-minded individuals.

Taste and quality were shifting and negotiated categories that involved the constant exchange of ideas, knowledge, and assumptions among artisans, middlemen, buyers, and metropolitan collectors and promoters. Olinaltecos, for instance, embraced the elite notion of *rayado* as generally of higher quality than *dorado*, and they also came to embrace as signs of aesthetic refinement the subtleties of style that elites saw as marks of indigenousness. Even within this seeming consensus, however, there was mutual misunderstanding. Collectors and artisans agreed that, rather than copy antiques identically, it was better to improvise upon these old aesthetic foundations. But whereas artisans saw their own improvisations as proof of their talent and creativity and of their ability to address subtleties of taste and refinement, elites saw them as passive, unconscious expressions of a collective worldview. As such, the expectation of controlled improvisation created opportunities but also a minefield for miscues and misunderstanding. Artisans continued to modify designs, merging their own evolving sensibilities with those of collectors, nationalists, and indigenous consumers. Some of these modifications found acceptance within the marketplace (such as the increased density of motifs and the diminution of negative space). But these same innovations taken too far, or the incorrect mixture of innovations, could end in disaster if the clash with elite tastes violated unspoken expectations of what counted as aesthetic authenticity. As the New York consul noted, too often a *baúl* representing a heavy investment of time and resources might not meet the aesthetic expectations of buyers and thus have to be sold at a loss. This could spell economic disaster for an artisan. With each passing year, fewer artisans were willing to take the risk. And the more precarious an artisan's economic situation, the less likely it was that he would have opportunities to become sufficiently conversant with current elite tastes, and the more likely that his effort would fail.

For metropolitan nationalists and collectors, despite their esteem for independent craftspeople and demonization of middlemen, these artisans' agency presented a problem. According to the way popular art was valued, craftspeople were supposed to be unselfconscious, passive creators. Unlike a canvas painting, whose value was tied to its author, popular art was supposed to be anonymous, created by "the people" out of a communal, timeless worldview. Part of the appeal of the rabbits, flowers, and other motifs that populated *rayado* designs was their aura of mystery and their seemingly passive invocation of the deep Mexico. Even today, some artisans develop idiosyncratic styles and motifs to individualize their work—Felicitas Ayala Martínez, for instance, does exquisite black on black *rayado* butterflies with small red highlights—but they will not do so too obviously, and they will not sign their work except on request because they know that evidence of individual agency usually will diminish the value of their products.

Negotiation of quality in Olinaltecan lacquer was tied also to the shifting terrain of indigenousness. In Olinalá, as in other parts of Mexico, indigenousness was a contingent category more often applied to others than to oneself. While language could serve as a marker of ethnicity for census purposes, in practice indigenousness was tied to a range of signs, strategies, status markers, traditions, practices, and modes of representation. Cultural identity applied to individual people not in a fixed sense, but to their strategies, practices, and relations to others at particular conjunctures. On the local level, moreover, indigenousness was linked to poverty and backwardness and to a lack of control over one's own destiny.[42] Artisans, following these criteria, were often viewed by themselves and others as indigenous, and their lacquered art as an expression of this indigenousness. At the same time, an artisan who mastered high-end *rayado* and maintained some form of autonomy from merchants would, by virtue of his decreased dependence, move away from local, demeaning definitions of indigenousness. More importantly, he used his art and his metropolitan interactions to construct and embrace alternative, positive understandings of indigenousness. In other words, he moved away from degrading local notions of indigenous toward an affirming cosmopolitan and nationalist definition.

The historical legacy of this discourse of indigenousness continues to permeate *laqueros'* identities. In 1997 during a conversation with the arti-

san Francisco "Chico" Coronel about town politics, I commented that I had always seen his town described as an indigenous village. He stopped me to clarify that he was not an *indígena*. Neither were any of the other artisans. They were all of "clean" blood, as he put it. Yet later, when we were talking about lacquer, he asserted the opposite, insisting that the art was entirely indigenous, and so were the *laqueros* who created it. His direct ancestors had been practicing this art since before the Spaniards arrived, he claimed. This seems like a contradiction, but it points, instead, to the contingent nature of indigenousness, and the degree to which it has emerged through the negotiation of local politics and elite nationalist discourses. As I learned from these and other conversations, artisans like Coronel rejected the indigenous label when it related to issues that were local, where indigenousness was considered a marker of cultural and social inferiority; yet they highlighted the indigenousness of their persons, their culture, and their art when appealing to nationalist sentiment in Mexico City or to dealers in the international art market.

There can be no simple answer to the question of whether the lacquer and its makers were (or are today) "really" indigenous. Any claim to resolve the issue or to give a clear answer to whether the artisans were authentically Indian or whether they were merely mestizos cast as indigenous by promoters of popular art would be disingenuous and deceptive.

To understand the local ethnic situation in Olinalá it might help to look at the results of an effort in 1930 to fix ethnic categories. The priest filling out baptismal forms in Olinalá had to categorize each child as Asian, black, white, pure Indian, or mestizo. He listed as pure Indian fifty-three of the fifty-four children baptized during the sample period of January through April 1930. This means that he listed as pure Indian 98 percent of the baptized children.[43] Olinaltecos would likely have agreed with this characterization of their ethnicity, for, compared to the priest, they *were* Indian. But compared to some of their neighbors they would have been considered mestizo, if for no other reason than that they lived in town and spoke some Spanish. Neither today nor in the historical record have I found an instance of any Olinalteco deploying indigenousness in a fixed, categorical manner, either in relation to themselves, or to others. Indigenousness was, and remains, a contingent category in Olinalá and on the national and transnational level. Compared to white urban elites from Mexico City or abroad, virtually everyone from Olinalá would have been considered, and

would have considered themselves, Indian. Yet they considered themselves less indigenous than nearby *campesinos*, and merchants considered themselves less indigenous than the artisans.[44]

Indigenousness was important not just abstractly or discursively but in the way it impacted the net of power relations that structured artisans' cultural, economic, and social opportunities. Olinaltecos learned in the 1920s and 1930s that the value of their crafts was intimately bound to Mexican cultural nationalism and ideas of indigenous authenticity. This meant that artisans and merchants had to confront the challenge of learning about and conforming to metropolitan expectations, even as they continued to police the contingency of ethnic boundaries and status on the local level. By the 1940s and 1950s, when the market moved toward cheap goods in large quantities, indigenousness on the local level lost much of its nationalist connotation and reverted to a primarily negative category. Yet it remained a complex, shifting indicator that artists navigated in the context of changing circumstances and contingent relations, never as a fixed ethnic or racial descriptor.

Conclusion: Making Mexico in Olinalá

The postrevolutionary nationalist imagination dramatically impacted Olinaltecos' lives. But local experiences were neither controlled nor fully embodied by postrevolutionary cultural nationalist discourse. As the art historian Karen Cordero points out, behind the elite discourse that validated *artesanía* as an authentically national art lies a dynamic historical reality that (until now) has remained unexplored.[45] By the 1930s, nationalist projects had become so thoroughly entangled with local struggles that to separate the national from the local would have been impossible. It was not that the ideas of Mexico City–based nationalists trickled down into Olinalá. Nor was it, as Ricardo Pérez Montfort argues, that a "fake" identity took the place of an authentic one as a form of "false consciousness."[46] Rather, it was that the markets, ideas, and institutions tied to the cultural nationalist movement fundamentally altered the terrain of local struggles and, in the process, tied Olinalá firmly into the emerging cultural nation. This did not signal homogenization, since the discourses deployed from the center took on different meanings on the local level, and it was not merely an imposition, since locals readily took advantage of these discourses. What it did indicate was the degree to which the postrevolution-

ary validation of popular art contributed to Olinalá's negotiated integration into an ethnicized, postrevolutionary Mexican nation.

While the interactions between nationalist elites and Olinaltecos animated the discourse of national integration and contributed to the emergence of Mexico's ethnicized nationality, the artisans had failed to use this discourse to alter the balance of power in their favor on the local level. By the end of the 1940s, they seemed to be going full circle, returning to the misery and marginalization of the prerevolutionary era. Even as Mexico became Indianized and *campesinos* became "Mexicanized Indians," the artisans had not found a way to economically or politically benefit from this cultural shift. The next chapter explores how the artisans at last forged group solidarity. Through these bonds of solidarity they harnessed an identity as the makers of an authentically indigenous nationalist art, demanded a new relationship to the state and the nation, and challenged their economic and political marginalization on the local level.

🌿

The Road to Olinalá, 1935–1972

"The *ricos* always win," lamented the Olinaltecan artisan Felicitas Ayala Martínez. But this time "the poor won." Like many of the town's artisans, Ayala Martínez saw the completion of the paved highway in 1973 as "a triumph for those from below" against the caciques.[1] Attainment of the road marked the moment when artisans at last managed to use their place within Mexico's ethnicized nationality to bypass the local oligarchy and forge their own cultural and economic ties to the central government in Mexico City and, in doing so, helped transform local society.

Before the highway was completed the artisans, despite their ties into an ethnicized Mexican nationality, had been unable to improve their economic and political status in local society. This chapter is the story of why this changed by the mid-1970s and how these changes continue to reverberate into the twenty-first century.

The Social Terrain of Olinalá: Violence, Isolation, and Inequality

One of the peculiarities of Guerrero is that the state archive in Chilpancingo holds no government documents. In the 1950s it had returned them to their municipalities of origin. When the archivist informed me of this unusual situation, I headed for the municipal hall in Olinalá. There I was shocked to learn that, as soon as Olinalá had won the return of its archives, the municipal president, Tomasa Patrón, ordered the four and a half centuries of documents burned. As a historian I was saddened by this loss of cultural patrimony and

frustrated by this unforeseen impediment to my investigation. When I dug deeper, however, I came to understand that the destruction of the archive was part of the narrative of how economic and political power operated in Olinalá.

As I met townspeople they informed me with suspicious eagerness that in Olinalá there are neither rich nor poor. Their claim was unusual given the obvious inequalities within the town, the blatant way some hold power over others, and the political and economic violence that occurs almost daily. I soon learned that Olinaltecos uphold the myth of equality only in public. Behind closed doors both the powerful and the powerless drop the façade. That Olinalá might be less than idyllic is not surprising. The entire state of Guerrero is notorious for the proliferation of violence and arbitrary use of power. And according to the Centro de Derechos Humanos de la Montaña Tlachinollan, in this state rife with human rights abuses, Olinalá ranks as among the worst municipalities. Still, older townspeople stress that, however bad the situation may be, it pales compared to the 1940s and 1950s. No one wants to reignite those smoldering animosities. The anthropologist Cathy Winkler recognized in 1980, after completing her fieldwork in Olinalá, that because "past feuds had left deep scars . . . on the people and their interactions," there is an almost excessive desire on the part of the townspeople to cultivate an image of their town as peaceful and united.[2] This compulsion was evident as far back as 1959–60, when Gutierre Tibón visited. Taking the claim at face value, he wrote that in Olinalá there "have never been exploiters nor exploited." There "are neither rich, nor poor. Life is modest, but everyone eats and dresses the same."[3] Rather than erase the quotidian climate of violence and inequality from the art, as Tibón and many folklorists and popular art collectors have done, we would do better to understand how local politics and art shaped each other.

Much of the conflict began in January 1944 when, following a year of careful planning, a group of *campesinos* and merchants brought the Agrarian Reform to Olinalá. In 1945 land surveys revealed that in this municipality of 9,012 people (2,393 of whom lived directly in the town of Olinalá), the Almazán clan, which had dominated the town before the revolution, still owned almost all the arable land and pasture. The Almazán family responded to the *campesinos'* request for land redistribution by dividing its holdings among kin to get their plot sizes below the 100-hectare minimum

required for expropriation. This maneuver won legal exclusion for all but 661 of their thousands of hectares. The state seized these 661 hectares and granted them to the peasants of Olinalá as an *ejido*. The Agrarian Reform commission, however, specifically excluded the *laqueros* as beneficiaries on the grounds that they "did not have as their primary occupation the working of the land."[4]

The Agrarian Reform in Olinalá became a tale of land distribution gone awry, clan vendettas, and artisan marginalization. In Mexico, general practice was for an elected *ejido* council to oversee land distribution. In Olinalá, however, the municipal president, who already wielded most official local political power, took control. As factions competed for control over the process, the office of the municipal president changed hands frequently and land claims and distribution became fraught with corruption and backroom deals. The interested parties coalesced into several major factions: peasants who hoped to use land reform to inaugurate a fundamental change within the local power structure; those who allied themselves with the Almazán clan in opposition to the land reform altogether; and several competing groups who tried to control the land distribution process as a way to expand the dominance of particular caciques.

Things got even worse after the initial distribution. Because the *ejido* was overseen by the municipal president with no checks or balances, *ejidatarios* were allowed to buy and sell land (or to lose it due to debt), as they would have with private land, with no safeguards against land accumulation. *Ejidal* lands were not the only source of conflict. The Almazán clan began to divest some of its holdings and the seven or eight leading postrevolutionary oligarchs jockeyed to gain ownership. The sudden availability of land through the *ejido* and through private sales ignited a scramble. Some plots changed hands frequently, and many Olinaltecos acquired land only to quickly lose it.

Land conflicts escalated into clan vendettas until violence and intimidation permeated local society. At the conflict's height in the mid-1950s, armed bands known locally as *ganchos* roamed the town ambushing "enemies," caciques shot opponents in their fields, and, reportedly, at one point the henchmen for one cacique rounded up a rival's entire extended family and executed them in the town plaza. In this climate of fear Olinalá won the dubious distinction of having the highest murder rate in Guerrero. While other towns with high murder rates were market centers in which

most of the victims and perpetrators were outsiders, in Olinalá the violence was endemic.[5]

It was at that time that Olinalá's municipal council won return of its archive so that Tomasa Patrón could light a match to it. The explanation that Olinaltecos offer for why the municipal president burned the archive was that, as a woman, she naïvely did what women do best, which is to clean. But the inescapable implication of the incineration was that without a paper trail, plaintiffs who had lost their land through usury and connivance no longer had any way to press their case. Far from the result of naïve ignorance, the flames that swallowed the past seem to have been a deliberate attempt to set Olinalá on the path of unchallengeable inequality. By the 1960s private land became concentrated in a few hands, and *ejidal* land, too, became concentrated and treated as though it were private property. As this happened, Olinalá became one of the most unequal municipalities in Guerrero in terms of access to land.[6] The incineration put an end to the worst of the violence, but the price was an inability to contest the basis for inequality or to redress past injustice.

Though some artisans fought and died in the vendettas, for the most part they remained on the margins of the conflicts because few of them had either private or *ejidal* land to dispute. Yet, the fact that violence had replaced politics meant that it impacted every aspect of Olinaltecos' lives and shaped artisans' economic and cultural strategies. As important as violence and intimidation were and as much as they permeated local interactions, they still were outweighed in artisans' lives by physical isolation and economic dependency.[7]

Daily life in Olinalá during the 1960s was difficult. The paralysis induced by the vendettas and land struggles extended into the education system. Since the nineteenth century the oligarchy had provided its children with a private Catholic primary education, after which some continued their studies in Puebla. But the majority of the population had no access to an education. Records from the Ministry of Education reveal that townspeople had struggled for years to get a public school. When they finally received it at the start of the 1960s, the oligarchy-controlled municipal government refused to support it, and members of the oligarchy seem to have intimidated the teachers and students, such that only a fraction of the eligible students enrolled, and among those who did enroll, only 32 percent attended. The school, meantime, occupied a half-built, almost furni-

tureless shack. The school inspector had commented in his reports on the sad condition of the schools throughout the Montaña, but the situation in Olinalá seems to have particularly upset him. Whereas every one of his reports on other schools ended with concrete suggestions for improvement, his report on Olinalá simply closes with the lament that "it is regretful that the Authority in Olinalá does not care about education."[8]

The government had classified Olinalá and its municipality as indigenous based on its reputation. To address social needs in indigenous zones, the Instituto Nacional Indigenista (INI) sent its agent Maurilio Muñoz to Olinalá. Muñoz was an Otomí Indian from the state of Hidalgo. During his early education he learned Spanish and became an ardent Cardenista. He then studied at the National University and won a scholarship from the National Museum of Anthropology (Museo Nacional de Antropología) to complete graduate studies in anthropology at the University of Massachusetts.[9] After his return to Mexico he spent his career as an advocate for indigenous issues within the INI at its coordination center in Tlapa, and as spokesperson for the Indigenous Foundation of the Valley of Mezquital and the Huasteca Hidalguense (Patrimonio Indígena del Valle del Mezquital y la Huasteca Hidalguense). After his visit in 1962 he affirmed Olinalá's indigenous designation based on the inhabitants' physiognomy, poverty, low levels of education, wattle and daub homes, poor hygiene, lack of access to water, frequent malnutrition, high incidence of alcoholism, and meager diet of corn supplemented by squash, beans, and *quelites* (*Chenopodium album*, a wild leafy vegetable known in English as Lamb's Quarters). Most Olinaltecos, too, considered themselves indigenous based on these same criteria.[10]

In his report Muñoz argued that the town's problems resulted from unequal access to land. He explained that all land in the area, including that which was supposed to be part of the *ejido*, was concentrated in a few hands and treated as private property. With few exceptions, those who did have access to land did so only as renters or indebted sharecroppers beholden to the local oligarchy. Agriculturalists, moreover, faced severe land erosion, and pests and disease destroyed a third of each year's crop. This left farmers deeply in debt to moneylenders and unable to meet the needs of their families. To make matters worse, the municipality's population, after a long period of stagnation, had doubled between 1940 and 1960, reaching 11,545. With no access to affordable credit and with so many

campesinos working as dependent sharecroppers, oligarchs found it easy to corner the local corn market, further adding to the misery of the population.[11]

Artisans rarely owned or had access to land, had been excluded from the agrarian reform, and generally held no livestock, not even hens. Because lacquer production stood outside of the equation of land and status, it was disparaged. Two of Juvencio Ayala's sons, Margarito and Dámaso, were unusual in that they acquired small plots of land, though Margarito owned his plot only for a few years before he lost it around 1951. Without access to land, most artisans continued to produce crafts year round as in the past, though a few temporarily combined craft production with sharecropping.[12]

From the point of view of the artisans, the main problem they faced still was Olinalá's isolation, which was imposed and continually enforced by regional caudillos and local elites.[13] Carlos Romero Giordano, who undertook the journey several times at the end of the 1960s on behalf of Banfoco, recalled that the land route from Chilpancingo took three eight-hour days by horseback. This showed no improvement over 1939, when Frances Toor visited the town (see chapter 8). To come from the other direction, by way of Huamuxtitlán, was so dangerous due to steep brittle terrain, flooding, and erosion that he judged it "would have been pure madness" even to try. Nevertheless, for artisans to travel the safer route via Chilpancingo favored by Toor and Giordano was simply too exorbitant in time and money; so they had to rely on the route of "pure madness" through Huamuxtitlán.[14]

Artisans found their situation complicated further by the difficulty of transporting fragile crafts. To manage the terrain and minimize the risk of breakage, artisans preserved the shipping methods that *laqueros* had employed since at least the eighteen century. After sorting their lacquered gourds by size, quality, and style, they packed each *pantle* (a group of twenty) into a *huipinada* (a tube made of reeds, corn husks, and grass), then tied the *huipinadas* into pairs to form *cañas* (pairs of *pantles*), which they wrapped first in fresh banana leaves, then in tightly woven *petates* (palm mats). They similarly stacked and wrapped boxes. Large *baúles* were more cumbersome because they had to be wrapped and loaded individually. Each mat-wrapped package made one *bulto* (package) ready for a month or more on the market circuit. They then loaded the *bultos* onto the backs of *tamemes* (human cargo carriers) or onto pack animals. Each

tameme carried *bultos* on his back with a *macapal* (a leather or woven-fiber strap) pulled across his forehead or upper chest. Paucic does not tell us how much each *tameme* carried, but each likely hauled a dozen or more *bultos*. For pack animals, Paucic notes that the artisans used special saddles that allowed each beast to carry 40 to 60 *pantles* (800 to 1,200 gourds). Artisans who lacked family labor to carry all their merchandise had to pay the cost of renting mules and *tamemes*. At each water crossing all the cargo had to be unloaded, floated across the water on special gourd-and-reed rafts, and then reloaded. They also had to unload at the end of each night and reload each morning. The difficulty of transportation meant that, if they were headed to Mexico City, the northern route through Puebla offered a key advantage over the Chilpancingo route: access to the railway (which was nonexistent within Guerrero). In Puebla artisans transferred their merchandise to train, then continued on foot to Mexico City, where they waited for their goods at the depot. If artisans were traveling within Guerrero, northwestern Oaxaca, or to Tepalcingo (Morelos), they needed cargo carriers for the entire journey.[15]

Through the 1940s and 1960s *laqueros* battled marginalization and isolation, but their lack of solidarity made it impossible for them to push for change. In time, they gradually would learn to act collectively, first through ad hoc mutualism, and ultimately by forming themselves into a formal producers' cooperative linked to the Mexican state. It is to this process that we now turn.

The Search for Markets and the Rise of Artisan Mutualism

For much of the country the 1940s and 1950s was the so-called golden age of emerging mass markets, industrialization, and rising middle-class incomes. But for the *laqueros* of Olinalá this was a time of decline. By 1963 laqueros had seen their real income fall to one quarter of what it had been in 1937.[16] They lived in wattle and daub huts with dirt floors, no access to water in which to bathe, and often did not have enough to eat. Things were worst during the rainy season, when, to avoid going into debt to merchants, they had to ration their food until, by the end of the season, they each ate as little as one tortilla per day. Elders note that the peasant sharecroppers at least had food but that they themselves did not have even that. Artisans *suffered as a group*, but they had not yet developed a system for *acting as a group*.[17]

The first traces of solidarity had come in the late 1930s. Rather than bring artisans together as a group, this early form of solidarity united small circles of artisans against one another. Perhaps concerned that they previously had shared their knowledge and techniques too openly with fellow townspeople, merchants, and outsiders, the artisans in the late 1930s moved toward secrecy and interartisan competition. Their interactions in the mid-1930s with a Mexico City hotelier remembered simply as Don Poli offer insight into how the new emphasis on secrecy and interartisan rivalry operated in relation to the search for new markets. During a visit to Huamuxtitlán Don Poli met up with some *laqueros* and agreed to start selling their *corriente* boxes and trays, which he transported to Mexico City with burros. Previously, artisans had gained access to dealers in the limited high-end market, but this was their first consistent nonmerchant-mediated access to Mexico City buyers dealing in the expanding *corriente* market.[18] To fill orders for Don Poli, artisans needed group cooperation. And to prevent merchants and other artisans from flooding Don Poli with crafts and thereby drive down the price he was willing to offer, they kept their connection with him a secret. Through Don Poli, *laqueros* experienced their first taste of the power of extending group solidarity beyond short-term arrangements and outside of narrow kin networks.

In the 1940s, as merchants withdrew from marketing, artisans found that the markets to which they had access were inadequate. Some of the best workshops continued to sell their high-end work to Casa Sanborn's (to which they had become connected through Frederick Davis) and, after 1951, to the Museo Nacional de Artes e Industrias Populares, but these markets were too small and high risk to support the *instalados*. To gain economic stability artisans needed large steady markets for their *corriente* and midrange production. Artisans, back in control of the marketing of their own wares, initially concentrated on six main fairs (one in Oaxaca, one in Morelos, and four in Puebla). But, as noted in the previous chapter, these fairs were in decline. To compensate, the *laqueros* expanded their connections to urban buyers.

The story of *laqueros'* relations with La Carreta in San Angel, on the affluent western edge of Mexico City, offers a window into how artisans built upon their earlier experience with Don Poli. At the time of my fieldwork La Carreta was an important market for all types of folk crafts, selling to Mexico's middle class and to tourists. Back in the 1930s, however,

it had been occupied exclusively by flower vendors. In the early 1940s the young Siriaco Escudero Mejía, godson of Juvencio Ayala, was in Mexico City hawking goods in the streets when he decided to visit the flower market. He prevailed upon a vendor to sell a few items on commission on the condition that, if buyers lacked interests, Escudero would stop bothering him. When the lacquer sold quickly the vendor agreed to become a dealer for Escudero's work. Other vendors at La Carreta soon emulated this success and La Carreta blossomed into one of the *laqueros'* largest buyers. Moreover, whereas other buyers were only interested in one level of quality, whether *corriente* or *fino*, the dealers at La Carreta bought work ranging from the most *corriente* to all but the most *fino*, with a particular taste for the midlevel crafts that artisans previously had difficulty marketing.[19] Initially a handful of *laqueros* kept the new market at La Carreta a secret, but they soon brought more craftspeople into confidence so as to assure a steady supply to meet growing demand. The difficulty for artisans was that, unlike sales to Don Poli, which they could manage from Huamuxtitlán on the eastern edge of the Montaña, dealers at La Carreta required that artisans deliver their production directly to Mexico City, which required expensive long-distance travel and loans from merchants. Despite this difficulty, in the coming decades *laqueros* gradually branched into other Mexico City markets, particularly Casa Legorreta, Casa Cervantes, and various vending stalls in the market at San Juan, and even into other cities such as Puebla de los Angeles and Acapulco, with a group of artisans coalescing around each new market opportunity.[20]

Information from artisan interviews regarding this period is fragmented since it was a time of group secrecy, with each artisan privy to some facts but ignorant of others. Yet a general picture emerges of multiple small and shifting solidarities. Rather than one large cooperative, the network functioned as a series of small unwritten agreements. An artisan still was focused on his own immediate interests, but he allied with one group of fellow artisans for one market opportunity, another set for another opportunity, and so forth. These different groupings overlapped, with each workshop involved in multiple opportunities.

As was the case for their agricultural neighbors, one of the artisans' largest problems in addition to physical isolation was lack of access to affordable credit. To get through the rainy season and to afford trips to fairs and Mexico City to market their goods, even the Ayala workshop had to

resort to local caciques who made loans at 15 percent interest per month. High interest rates made it difficult for artisans to invest the time and resources required for quality work, and it kept them indebted to money-lenders. Some tried to improve their situation by sending individual family members to work in the United States, but this offered only a partial solution since, to finance such travels, they had to borrow money from local moneylenders and the high interest rates absorbed much of what they earned north of the border.[21]

As noted in chapters 6 and 8, artisans had run into crisis in both *corriente* and high-end markets by the close of the 1940s. Quality had declined, and, as Muñoz notes, by the early 1960s the much-vaunted *rayado* had become a rarity. When the INI took an interest in Olinalá as an indigenous zone in the 1960s, its Museo Nacional de Artes e Industrias Populares (MNAIP) worked with *laqueros* to help them reconnect to the high-end market.[22] Similar to Rene d'Harnoncourt decades earlier, the MNAIP encouraged Olinaltecan artisans to look into their community's past for inspiration. *Laqueros* recall that the museum officials distributed photographs of antique *baúles*, promised to buy a limited number of high-end goods, offered small loans, and ran craft competitions that awarded cash prizes for the best works. This helped the artisans better tailor their workmanship for a high-end collectors' market. Unlike d'Harnoncourt, who had focused only on *rayado*, the MNAIP bought both *rayado* and *dorado* and encouraged artisan innovation and experimentation. Though the MNAIP could buy only a small share of the artisans' wares, it offered a new source for artistic revival and creative inspiration that contributed to the artisans' success across a range of markets.[23]

The problem, still, was Olinalá's isolation. To work with the MNAIP, artisans had to get themselves and their merchandise to Mexico City, and travel in and out of the Montaña was difficult, dangerous, time consuming, and expensive. The higher prices paid by the MNAIP, together with technological advances, opened to artisans a new option: air travel. Small three- to four-passenger aircrafts offered the first alternative to *tamemes* and mule trains. Air travel reduced what had been a three-day trip by horseback between Olinalá and Chilpancingo to twenty minutes, with another twenty-five-minute flight to get from there to Mexico City. What had been a month-long round trip—including preparation, travel, waiting at the train station for craft shipments, and time spent searching for buyers—

now took only a day.[24] It also avoided the many personal and economic risks inherent in land travel and exposed the lacquered objects to fewer risks of damage. But air travel was too expensive to replace land travel. Airfare from Olinalá to Cuautla in 1963 cost 100–125 pesos per person, plus an additional 100–125 pesos for each seat an artisan filled with crafts. The price to fly all the way to Mexico City might have been twice that. For an artisan to fly himself (only male artisans accompanied air deliveries) and a small load to Mexico City, then, would have been equivalent to four or five times the cost of his wattle and daub home or the equivalent of an entire season of field labor.[25]

Despite its high cost, and though it could not replace overland shipping, air travel did help the few artisans who marketed high-end work. It limited the time they were away from their workshops, avoided the hazards of overland transportation, and, for the first time, enabled them to ship goods at the height of the rainy season when all overland routes were flooded.[26] With the MNAIP buying all the items in each small shipment, artisans received a much-needed infusion of cash to carry through the rainy summer months; then, when the rains ended, they could send most of their production by way of the regular land route. Because an artisan could bring only a small load on a plane flight, air shipments tended to occur outside of the mutualist network, undertaken only by the best artisans whose workmanship could command the highest prices, and as part of a household or workshop strategy.

Though artisans had begun to market their goods cooperatively in the 1930s and 1940s, it was not until the 1950s that they expanded this mutualism into the realm of production. As prices continued to fall, male artisans from different workshops began engaging in reciprocal labor swaps to complete orders. This saved them from having to take out loans to hire expensive male *oficiales* and it allowed them to complete larger orders on a predictable schedule.

Much like the lacquer production process itself, this mutualism was highly gendered, as female labor was excluded from the reciprocal labor exchanges that bonded together workshops. Workshops run by master artisans swapped male labor, but, for female tasks, they continued to rely on poorly paid *oficiales*, often using cash loans from fellow artisans within their mutualist network. This gendered dynamic extended into the mutualist lending system. To alleviate the severity of their dependence upon

merchants and to earn some interest on their short-term surplus capital, master artisans made small loans to one another. But because these loans went only to heads of workshops, they excluded women. Female artisans also found themselves cut out from the practice by which artisans would transport and market one another's goods. In these ways the mutualist network enabled male artisans to defend patriarchy within their families and workshops—which their declining status within the community and the difficulties they faced financially supporting their families threatened to undermine—while reinforcing women's dependence and low wages. Mutualism, then, created the means for artisan solidarity but stifled the development of female-headed workshops and limited women's opportunities for social esteem. Moreover, the many small, specialized workshops that had proliferated in the early 1940s, but that had begun to disappear as the artisans who had recently come to the trade returned to agricultural production after the agrarian reform, either found themselves excluded from these exchanges or else played a subordinate role, in which their services were coordinated by the handful of firmly established family workshops.

In the 1950s master artisans began to draw on their mutualism to defend their collective interests. In the aftermath of the revolution craftspeople had allowed for the exchange of their skills with their neighbors within Olinalá and beyond. But now they began to guard the boundaries of their craft in guildlike fashion. This is illustrated, for example, in a story that artisans recount about a visitor in the 1950s who went around asking questions about techniques and gathering samples of artisans' *tierras*, tools, and pigments. As soon as the visitor departed, the artisans held a meeting. Concerned that he would use the samples and notes to create a competing lacquer industry elsewhere, they caught up with him in the mountains, relieved him of all of the materials and his notes, and then sent him on his way empty-handed.[27]

Woven through the mutualism of the artisans was a pursuit of quality. This pursuit could unite artisans around common ideals, but it could just as easily divide them as each strove to shine on his own. Margarito Ayala, son of Juvencio Ayala (who passed away in the early 1950s), became known as one of the most talented of his generation. When Gutierre Tibón visited Olinalá at the close of the 1950s he marveled at how explicit Margarito was about his aesthetic ideals. Margarito explained that artisans may be

poor, and life may be hard, but at least they can take pride in their commitment to quality, which he defined as doing work in the manner of his father, Juvencio. Others in his generation who shared his ideals included Antonio Guerrero, Juan García Jr., Eborio Jiménez, Dámaso Ayala Sr., and Liborio Escamilla. Together they formed the core of the mutualist network, but because they also competed against one another in the small high-end market, individual workshops continued to maintain secrecy about some of their clientele, market opportunities, and stylistic innovation.[28]

While the artisans' mutualism offered a means for some level of coordination, it was far from a cooperative. During his visits to Olinalá in the late 1930s and 1940s Alejandro Paucic had noticed that some of the artisans were beginning to cooperate in marketing, but they did not do so consistently or through a strong structure. In 1960, Tibón similarly noted that "strength comes from unity," but despite some level of mutualism, there still was "no unity among the artisans of Olinalá." His statement points to the limitations of the artisans' mutualism; most notably that it did not provide a mechanism for them to negotiate their interests collectively against moneylenders, merchant suppliers, urban commercial houses, or the government. Without a means to negotiate collectively even master craftsmen like the Ayalas, Juan García, or Liborio Escamilla were unable to reduce their dependence on merchants and moneylenders or to advance economically. But things were about to change. As Muñoz noted in his report in 1963, the artisans were feeling "the need to become organized" into a cooperative that, at long last, could "enable them to improve their currently low incomes."[29]

The Road to Olinalá: Solidarity, Identity, and the Neo-Nationalist State

The MNAIP had offered artisans guidance and it bought some of their high-end production but it lacked the resources to help *laqueros* challenge their marginality in Olinalá or to counter state policies that undermined their interests. Only with the reform of Banfoco's management of the Fideicomiso would this change. As one artisan declared: "With Banfoco began the revolution."[30] With this he referred to the fact that only with the reform of Banfoco, which led to the creation of Fonart, did the artisans feel they finally had succeeded in linking their interests with those of the postrevolutionary nationalist discourse and the self-proclaimed revolutionary state. The *laqueros* would use their alliance with the reformed Banfoco

and its successor Fonart finally to form themselves into an effective co-operative that relied not on secrecy and the pitting of artisans against one another but on solidarity and collective links to the central government.

One of the earliest ways that Olinaltecos benefited directly from the Fideicomiso-Banfoco was through the annual Feria del Hogar (Home Fair) in the early 1960s. While marketing lacquer in Acapulco, Roberto and Dámaso Ayala met a Fideicomiso-Banfoco representative who invited them to set up a stall at the month-long trade exposition. There they made direct contact with a national and international clientele and received advance orders for goods.[31] The annual event provided a relatively small market, but it was the beginning of the *laqueros'* relationship with the Fideicomiso-Banfoco.

Part of the long-term success of the alliance between artisans and Banfoco would come from the fact that the *laqueros* encountered it not as an abstract bureaucratic institution but as trusted names and faces. During the late 1960s Banfoco's Carlos Romero Giordano traveled regularly to Olinalá and got to know the *laqueros*. Artisans still delight in recounting how Romero Giordano befriended Margarito Ayala over a tense chess game that lasted late into the night.[32] Through countless such interactions, Romero Giordano earned their trust. He prodded them to organize themselves into a formal cooperative to buy and sell collectively and promised that, if they did create a cooperative, they would become eligible for low-interest loans. Though the artisans trusted him, they did not trust the Fideicomisa-Banfoco to live up to its promises. As discussed in chapter 6, their mistrust was justified. Despite efforts by such individuals as Romero Giordano, the Fideicomiso-Banfoco suffered from financial and institutional mismanagement.

This changed in 1970. The recently inaugurated president, Luis Alvarez Echeverría, declared a program of rural development and nativist nationalism and appointed Tonatiuh Gutiérrez to reform the Fideicomiso-Banfoco. Gutiérrez came from a prominent family and had attended university in the United States, where he majored in biology and became an accomplished swimmer who won two medals for Mexico in the Pan American Games of 1951. Before joining Banfoco he was director of exhibitions for the National Tourist Council of Mexico, where he helped market handicrafts. Through the council he had worked with Isidoro Cruz of San Martín, Oaxaca, to found and market Oaxaca's now-famous industry

of whimsically carved and gaily painted wooden animals known as *ale-brijes*.[33] When he came to Banfoco he immediately set about reorganizing its support for the arts. By the start of 1971, when the *laqueros* saw a clear, consistent policy emerge, seven or eight workshops representing seventy to eighty people agreed at last to form themselves into a formal coopera-tive governed by an elected council. They named their group Olinka, in honor of an anciently revered nearby creek.[34] Banfoco, for its part, bought members' art with regularity and in large quantity. It also offered them low-interest loans to renew each production cycle.

But the members of Olinka had their eyes set on something bigger than just another market. They hoped to use this new artisan-state alliance to win a road to free them from their physical isolation and to make them less subject to exploitation by the local merchant-usurers. From the arti-sans' point of view, most of their problems could be traced to the lack of communications infrastructure. The Fideicomiso-Banfoco promised to buy their art, but it still expected them to deliver their merchandise to the offices in Mexico City. What artisans wanted was a road to link them to the new Chilapa-Tlapa highway, completed only in 1965, from which point they could hire a truck up through Huamuxtitlán to the railway in Puebla en route to Mexico City or Puebla de los Angeles. Or they could travel west to Chilpancingo en route to Acapulco or Mexico City. The reform of Ban-foco had brought immediate improvement to the market, which, in turn, drew many Olinaltecos back to the industry, mostly working on specific tasks coordinated by the seventy or so members of Olinka. Artisans knew that without the road they would remain trapped in physical isolation and subject to the whims of the local oligarchy.[35]

The government celebrated the creation of Olinka by organizing a lac-quer competition. Romano Giordano and Tonatiuh Gutiérrez recognized this as an opportunity to gain publicity for Banfoco while at the same time providing artisans with an opportunity to present their petition directly to the president. They arranged for an award ceremony at the presidential mansion Los Pinos on 15 October 1971. The president's wife, María Esther Zuno de Echeverría, presented first, second, and third prizes to Margarito Ayala, Dámaso Ayala, and Bulmario González, respectively, and honorable mentions to eleven other artisans. The delegation then met in closed quar-ters with President Echeverría. Because Gutiérrez had already prevailed upon the president to order construction of the road, the meeting was

something of a formality in which little was said as the artisans presented themselves and their art to the president.[36] In their bid to break the grasp of the local oligarchy, whose political and economic power was reinforced by the physical isolation of the town, the artisans rested their appeal for a road not on the details of local inequality but on three assumptions that they, the Fideicomiso-Banfoco, and the president had come to share: (1) that Indianness held a special place in the nationalist imagination; (2) that the *laqueros'* art and ethnic bodies embodied this Indianness; and (3) that, as a nationalist, the president would act to defend Mexico's indigenous patrimony.

Within weeks of Olinka's audience with the president, road crews arrived in the Montaña. By the end of 1972 they inaugurated a dirt road that finally united Olinalá's *artesanos* with the nationalist state centered in Mexico City. The local oligarchy, led by the municipal president Eustorgio Salgado Venegas, had received no advance warning of what was transpiring and did not welcome the road. Throughout Guerrero caciques still opposed infrastructural development just as they had since the nineteenth century, seeing it as a threat to their political and economic control. In the 1970s, for example, Governor Rubén Figueroa Figueroa managed to halt construction of a commuter rail linking Mexico City to Acapulco because he was concerned that it would undermine his personal interests in the vehicular transportation of passengers and goods.[37] In the case of Olinalá, because the order for the road came directly from the president, the oligarchs' political connections were of no use in halting construction. Oral testimonies recount how the *ricos* (as locals refer to the oligarchy of that era) resorted to arson and sabotaged bridge construction equipment. I was unable to document these acts of vandalism, but whether real or apocryphal, they point to the heightened tensions of the moment. They also highlight the importance this road held as a symbol of the artisans' new relationship with the national government, and their elation at having at last bypassed the local oligarchs.

Beyond the nationalist appeal, Echeverría likely also had pragmatic political reasons to ally with the artisans. As opposition to his government grew among industrialists and among urban youth, the new president tried to increase the level of participation of other sectors, including the *campesinado* (see chapter 6).[38] Guerrero assumed particular strategic importance for the administration because, after the government repression of

1968, that southern state became the stronghold of a guerrilla insurgency. Rural groups' frustration at their inability to work through official channels contributed to this insurgency and to the radicalization of such peasant organizations as the National Peasant Confederation (CNC). Throughout Guerrero the government responded to such armed opposition groups as the National Revolutionary Civic Association (ACNR) by restricting civil liberties, stepping up repression of suspected supporters of guerrillas, and intensely militarizing the entire state.

Alongside the stick, Echeverría also held out carrots in the form of programs designed to help *campesinos* and to integrate them in the state structure. The reform of Banfoco-Fideicomiso was part of this strategy. Other national programs operating within the Montaña included Conasupo (the government network of rural stores designed to undermine the tight control of local merchants), Banrural (which offered loans to peasant farming cooperatives), Codisuco (which marketed milk at subsidized prices to the poor), and Inmecafe (which dealt with coffee growers, and, regarding the Montaña, was active only in Tlapa). As the political scientist Jonathan Fox points out, these new government agencies successfully channeled potential radicals into the institutional fold.[39]

In some regions Echeverría supplemented these programs with land redistribution, but in the northern Montaña land surveys showed that there was no land eligible for distribution. Moreover, as Armando Bartra argues, popular demands fueling guerrilla activity in Guerrero were not about land but about usury, debt, repression, corruption, and sharecropping exploitation.[40] By building a road to Olinalá the state found an alternative strategy to win rural support. By improving transportation for *montañeros* and loosening the local caciques' stranglehold, the government hoped to improve the lives of the rural poor, or at least integrate them into the state, such that they would not join the guerrillas' cause. Further, the road simplified military access to the region.

An alliance with artisans, then, promised a rural base of support to expand the central government's presence and limit the spread of the guerrilla insurgency. It also offered a context in which a government program could produce quantifiable improvements in rural living conditions. Moreover, this alliance enabled the state to break into an area where the local elite had long opposed its presence. In these ways, Echeverría's policies in relation to the *laqueros* merged his cultural nationalist politics, his

need to pacify Guerrero, and his effort to bring new constituencies into the state fold.

For the artisans, the arrangement affirmed their indigenous heritage and their place within the national community. Though most *laqueros* long ago had lost fluency in Náhuatl, they continued to embrace the language as an integral part of their identity and they took pride in the fact that all the terms related to their industry were in the native language. Their main connection to their indigenous heritage, however, was not language but the art to which they dedicated most of their waking hours.[41] Their interactions with metropolitan nationalists and collectors had made them acutely aware of the deep historical roots of their art and its place within the nationalist imaginary. They embraced this history, blending it with their own cultural and historical understandings until the local and the national became inseparably intertwined. Through their rituals of production, their avenues for creativity, and terms of contestation, the *laqueros* continually remade their narratives of collectivity, rooting themselves in a historical epic leading back to the Aztecs, celebrating the positive aspects of their indigenous heritage, and giving form to the discourses and relationships born of their national and transnational interactions.

Every time they applied *tlapetzole*, cut lines of *rayado*, uttered the Náhuatl names of their processes and materials, hauled their *pantles* of lacquered gourds and *petate*-wrapped chests upon their backs, and every time they presented their work to indigenous buyers in the countryside and metropolitan dealers in Mexico City, they reinforced the interdependence of their ethnic and national identities. Locally, they gave physical testimony to this identity and history when they made lacquered cups that they and other *montañeros* still use to swirl their chocolate and *atole*. And it was *laqueros* who made the elaborate human-jaguar (*tecuani*) masks for the Fiesta de los Masuchiles (celebrating San Francisco, the patron saint of Olinalá). And every few decades since the colonial era they have relacquered the walls, pillars, and altars of their parish church. The indigenous aspects of their art and the positive value they placed upon this indigenousness came from the particular ways the local, national, and transnational intersected through their art and lives. The artisans' view of their indigenousness as integral to the national identity became strategically useful as they appealed for federal intervention, yet it also was a discourse born of

grounded historical experience, reinforced through daily rituals and inter-actions.

While they embraced an indigenous identity, like most Mexicans they did so contingently. Though the national identity had become heavily eth-nicized beginning in the 1920s, the term *indio* continued to imply sub-ordination and unequal power. During daily interactions in the 1960s and 1970s, it still was more common to call someone else an *indígena* than to apply the term to oneself. To call someone an Indian was to declare their subordination, as was the case with urbanites who readily identified Olina-tecan artisans as Indians. It could also be used by an individual to affirm his or her own inferior status compared to another person. Anthropologists have found that, except for the local elite and trained professionals, *monta-ñeros* still identify themselves as indigenous compared to non-*montañeros*. They base this identity not only on language but also on their poverty and what they perceive as their own marginality, ignorance, and backward-ness as compared to Mexicans from outside the region.[42] Through their laquered art Olinaltecos in 1971 drew upon their interaction with the state and with national and transnational markets and discourses to claim an alternative indigenous identity, one that was affirmative, emotive, and nationalist.

The effect of the road and of the new connection to the central gov-ernment rippled across Olinaltecan society. Townspeople, for instance, formed a parent organization to support the school that the local oli-garchy had long opposed. Bypassing the intransigent municipal council controlled by caciques, they contributed their own funds to pay one of the two teachers and to maintain the school.[43] Olinaltecos also lobbied the bus company Flecha Roja to start service to their town, so that they might have an alternative to the monopoly over local automotive transportation that the local oligarchy quickly put into place with the completion of the road.

By the time Fonart took over from Banfoco in 1974 the alliance between artisans and the state had led to a dramatic rise in the number of *laque-ros*. Where there had been only six workshops in 1930, an increase to four dozen in 1950, and then a drop to fewer than a dozen in the early 1960s, by 1974 the number of workshops jumped to almost 200. Head of the MNAIP Carlos Espejel observed that by 1968, just before the creation of Olinka, the number of full-time artisans had fallen to about twenty, but by 1976 the

number had rebounded to several hundred. Even though travel still was not possible in the rainy season (except with the four-wheel drive vehicles that the local elite now acquired), and large sections of the road had to be rebuilt each year after the floods, the road and the new connections to the government made an enormous difference. Between 1968 and 1976 the prices artisans received for their crafts shot up between 50 percent and 300 percent, depending on quality, materials, and market.[44] Since the greatest increase was for good craftsmanship made from nonindustrial materials, artisans now had a strong incentive to improve their work.

These developments brought hope to a community grappling with population growth, severe land concentration, and an eroded landscape. Regular interaction with buyers gave *laqueros* the confidence to experiment with new styles, most notably *puntiado* (multicolored dots of commercial paint applied atop *tlapetzole*), and a form of *dorado* in which "dorado" is taken literally such that gold powder and gold leaf are applied to the surface of the *tlapetzole* of trays, gourds, and chests. Artisans also worked regularly with university extension programs, government advisors, and private organizations to improve quality, foster innovations, and seek out new markets in Mexico, the United States, Europe, and Asia.

Since 1970 women artisans have found new opportunities. Some benefited from the renewed demand for local materials. But the bigger change was that under Fonart, women for the first time found they could earn recognition as heads of workshops and as talented, creative artisans, rather than just menial labor. The inclusion of women came quickly, such that by 1971, when the reformed Banfoco first honored *laqueros* at the presidential residence of Los Pinos, the delegation included two women: Aurelia Ayala and Juana Patrón. Because this delegation presented the request for the road, this put these *laqueras* in an unprecedented position of authority, even if they did not act as the leaders of the group. Carlos Espejel similarly notes that, whereas in 1968 none of the major artisans were women, by 1976 Guadalupe Valdéz, Aurelia Ayala, "and others," were able to independently produce and market their own *laca*.[45] The new opportunities now open to women artisans did not immediately eliminate the local stigma against them acting independently. It still was difficult for female artisans to gain status on their own. Those who had the most success were widows or wives filling in for husbands who had migrated to the United States.

Even today the few women who head workshops find acceptance locally in large part because their status is validated by Fonart.[46]

While Fonart and the road improved the lives of artisans, the transformation of local society was not as deep as some had hoped. Government programs gained access to rural areas through what Jonathan Fox has described as a "divide-and-conquer" strategy in which it temporarily allied with one side, thereby forcing other factions to similarly court its support. In the absence of meaningful electoral politics this form of clientalism brought constituencies into the state structure, but it did so without fundamentally undermining the regional status of "the authoritarian regional elites."[47] This certainly was the case for Olinalá. After it had been brought into the federal sphere of influence through an artisan-state alliance, the previously reluctant local elite learned to benefit economically and politically from the situation. The oligarchs found market opportunities in the very shift they had opposed. They bought microbuses to move people between towns, and trucks to transport crafts and other goods. They once again became major buyers of *artesanías*, which they resold in Chilapa, Puebla de los Angeles, Mexico City, Taxco, and Acapulco. They also found new money-lending opportunities, helping artisans to make good on their payments to Fonart, lest they risk losing access to cheap government credit. Once the federal government gained a permanent presence through Fonart and other rural development institutions, it reached an accommodation by which oligarchs delivered votes for the ruling party while the state turned a blind eye to their manipulation of local politics and economics. Because the PRI became synonymous with the oligarchs, the artisans' exuberant praise for Echeverría did not translate into support for the ruling party.

Politics remains repressive, but less so than before. As the town grew, as people moved in and out with ease, and as the economy became more complex, the oligarchy had to adapt itself to new times and never regained the tight hold that it once had. Moreover, greater openness brought to Olinalá the ideal of democracy, if not the practice. In the 1990s, even as the PRI led Mexico toward authoritarian neoliberalism, *montañeros* grew more committed to using both the ballot box and international attention to try to change their political and economic situation. After Guerrero's Priista governor Rubén Figueroa Alcocer oversaw the massacre of peas-

ant protestors in Aguas Blancas in 1995, support for the oppositional PRD skyrocketed throughout the Montaña. Regional and local elites, including those in Olinalá, met these demands for democratization with repression, violence, and voter fraud. During the years of my field work (1997–99), frustration with government corruption and violence led some *monta-ñeros* toward a new wave of guerrilla activity. The state, in turn, seized upon the guerrilla insurgency to justify militarization and human rights violations. Military pickup trucks loaded with machine-gun-wielding young men regularly rumbled through the streets of town and patrolled the countryside, turning Olinalá into one of the dozen municipalities with the worst human rights record in the state. In 1999, despite guerrilla activity, intense violence, and heavy repression, Guerrero's elections enjoyed their largest turnout in the state's history.[48]

As the Montaña lurches toward democracy, Olinalá remains a difficult place. According to the 2000 census, the population of the municipality grew to 22,645. A human rights report from 2004 records that, among those over fifteen years of age, 51.1 percent were illiterate and 10.3 percent spoke no Spanish. Along with Chiapas and Oaxaca, Guerrero was one of the three poorest states in Mexico, and, among its seventy-seven municipalities, Olinalá ranked in the bottom third. The region has been named one of the twenty-six priority zones within Mexico based on the incidence of poverty, drug trafficking, migration, violence, and militarization, which combine to make life dangerous.[49] Though life remains difficult in Olinalá, the *laqueros* stress that they are no longer so helpless, because they are no longer as desperately poor and vulnerable. To affirm this, one artisan points out that many of them now own chickens, and sometimes even cattle, and that a few even have purchased small plots on which they have built adobe and cinderblock homes rather than continuing to live in rickety *chinantle* huts.[50]

Though the violence continues and though Olinalá is still poor and isolated with a weak market economy compared to most of the rest of Mexico, Olinaltecos seem unanimous in their opinion that things are far better than they were in the past. The number of Olinaltecos involved in the industry, meantime, has continued to grow. By the year 2000, 80 percent of adults participated in the production and marketing of lacquer, the number of workshops had risen to 1,000, about 400 of which were members of one of the eight cooperatives.[51] By all appearances these numbers have

held steady. One elder expressed a widely shared sentiment when he stated that Olinalá "has progressed thanks to the *artesanía*."[52]

Conclusion

When asked how "those from below" were able to beat the *ricos* "who always win," one artisan suggested that, while the *ricos* were masters of local and regional politics, they simply did not know the ins and outs of the national system. Her response points to a major shift in Olinaltecos' relations with the national government and with Mexican nationalist discourse. The opening of the road came as part of the artisans' long-term struggle to finally reap some of the benefits of the place their art had long occupied within the ethnicized nationalist imagination.

In January 1994, at the same time that the Zapatistas were rising up in Chiapas against NAFTA and in defense of indigenous rights, claiming that they were not just indigenous people but indigenous Mexicans who held a special place in the nationalist imaginary, the government awarded to Olinalá the 1993 National Arts and Sciences Award (Premio Nacional de Ciencias y Artes).[53] According to artisans, municipal leaders tried to pressure them to hand over the 200,000-peso prize, supposedly to finance town improvements, but the artisans did not trust them. More importantly, the *laqueros* felt that it was they who had earned the award, and it was they who should benefit from it. To prevent local elites from taking control of the funds, the artisans quickly distributed the money evenly among the 200 *instalados* that participated in Olinka at that time, urging each to decide how best to use their 1,000-peso share.[54] The award had gone the final step toward officially recognizing the town as part of Mexico's national patrimony. In contrast to the India Bonita discussed in chapter 1, who lost control over the money she won in recognition of her embodiment of the ethnicized nationality, the artisans of Olinalá demonstrated a new level of local self-determination. Their preemptive action, however, undercut any hope for using the funds for the creation of an enduring local institution to support their craft, which was something they had wanted.

In the decades since they won the road, *laqueros* have found themselves in a contradictory position in terms of ethnicity. The benefits of the road have gone disproportionately to the town of Olinalá at the expense of the rest of the municipality. As a result, a cultural gap has separated towns-

people and *campesinos*. Artisans have had to negotiate between their own changing sense of ethnicity, the increasingly mestizo identity of their town, the continued local denigration of indigenousness, and the national and international—and their own—celebration of the Indianness of their lacquer art. As early as 1976, Carlos Espejel conceded that the artisans were no longer necessarily Indian, yet their art remained indigenous and "entirely autochthonous," and thus, "one of our most valuable crafts that must be protected."[55] As *laqueros'* indigenous identity has become more ambiguous, their rural neighbors have embraced a positive cultural and political understanding of themselves as Nahua, Me'phaa (Tlapaneco), and Na'savi (Mixteco). According to the anthropologist Evangelina Sánchez Serrano, who studies indigenous communities near Olinalá, the conflict between the head town and its satellites has taken on characteristics of an ethnic conflict as political and economic inequalities intersect with ethnic differences.[56]

Artisans continue to train the next generation and express remorse at the thought that their craft might fade away. It is with a mix of satisfaction and sadness that they watch their children leave for Acapulco, Mexico City, Chicago, Los Angeles, or New York in search of better opportunities. This remorse on the part of Olinaltecos contrasts with the sentiments of practitioners of other crafts, such as the silversmiths of Taxco, the Seri ironwood carvers, or the Oaxacan carvers of colorful *alebríjes*. The anthropologist Michael Chibnik, for example, finds that though advertisers tout the woodcarving of Oaxaca's central valley as a timeless indigenous art, it—like the silversmithing of Taxco and the woodcarvings of the Seri—is of recent vintage and its makers feel no cultural commitment to their craft. Those artisans' detachment from the discourses that surround their art contrasts with the sentiments of the Mayan producers of *típico* crafts analyzed by the anthropologist Walter Little, who construct and deploy their indigenous identity within the complex web of social, political, and market relations that define their art as valuable because of its indigenousness. Similarly, though Olinaltecan *laca* and its meanings have been recreated continually over the years, and even though many *laqueros* understand when their children trade the life of an artisan for better opportunities, they are pulled by their art's entanglement with tradition, ethnicity, and nationality, which run deep and speak intimately of their place in Mexico's process of ethnicization and nation formation.[57]

As the definition of indigenous shifts on the local level, the place of Olinalá as a symbol on the national and international level also is in flux. Olinalá persists as a symbol of Mexico's multistranded ethnicized nationality, but, whereas in the 1920s elites managed these flows of transnationalism and cosmopolitanism, today many Olinaltecos manage these connections for themselves. Most households in Olinalá have a member who either lives, or has lived, in the United States. And artisans have learned to cultivate direct ties with dealers as far away as Germany and South Korea. Through ever denser and less easily controlled intersections between the local, the national, and the transnational, Olinaltecos and non-Olinaltecos are renegotiating the meaning of ethnicity, nation, and art and affirming lacquer's place within the nation's collective identity.

Today Olinaltecan dowry chests, gourds, and trays, exquisitely lacquered in updated renditions of the eighteenth-century *rayado* style as well as *dorado* and even *puntiado*, hold center stage in Fonart's showroom on Mexico City's Avenida de la Reforma. Each piece, with its price tag discreetly tucked under its base or deep in its interior, faces out the showroom window toward a past symbolized by the towering statue of the last Aztec king, Cuauhtémoc (recently relocated a few hundred meters to the east to make room for modern traffic flows), and a future embodied in the gleaming ultramodern mirrored skyscrapers. This art likely will endure as *laqueros* and *laqueras* improvise new ways to speak to the ever-changing place of Indianness in Mexico.

In 1922 the Chilean poet and future winner of the Nobel Prize for Literature (1945) Gabriela Mistral arrived in Mexico. For the next two years she traveled widely working with rural teachers, observing ceramic workers in Puebla and fishermen on Lake Pátzcuaro, and developing a literature curriculum for the public schools. When she left Mexico in 1924, she published the following poem.[1]

"Little Box from Olinalá"
I
My little box
from Olinalá
is rosewood
and jacaranda

When opened
it strikes me with
its Queen-of-Sheba
fragrance.

Oh, tropical
whiff of cloves,
mahogany
and copal!

I place it here
I leave it there,
down corridors
it comes and goes.

It boils from Grecian frets*
like a land of

"Cajita de Olinalá"
I
Cajita mía
de Olinalá
palo-rosa
jacaranda.

Cuando la abro
de golpe da
su olor de Reina
de Sabá.

¡Ay, bocanada
tropical
clavo, caoba
y el copal!

La pongo aquí
la dejo allá
por corredores
viene y va.

Hierve de grecas*
como un país

*Olinaltecan lacquer often had border decorations of Grecian frets.

nopal, deer,
and quail

Volcanoes
with sweeping napes
and the Indian profound
as corn.

Like so, they are painted,
like so, like so:
Indian fingers
or hummingbirds.

And, like so, it is
made perfectly
by the Aztec hand,
the quetzal* hand.

II
When night
is about to fall,
to protect me
from harm

I place it
by my pillow
where others
put their gold.

What beautiful dreams it
makes me dream,
makes me laugh
makes me weep . . .

Passed hand to hand
it carries with it the sea
the twin sierras,†
plowed fields.

nopal, venado
codorniz.

Los volcanes
de gran cerviz
y el indio agudo
como el maíz.

Así la pintan,
así, así
dedos de indio
o colibrí.

O así la hace
de cabal
mano azteca
mano quetzal.*

II
Cuando la noche
va a llegar
porque me guarde
de su mal,

Me la pongo
de cabezal
donde otros
ponen su metal.

Lindos sueños
hace soñar,
hace reír
hace llorar . . .

Mano a mano
se pasa el mar
sierras mellizas†
campos de arar

*The quetzal (*Pharomachrus mocinno*) is the colorful tropical bird whose long sweeping feathers the Aztecs valued highly, and who was tightly associated with the mythical feathered serpent Quetzalcóatl.

†The twin mountain chains that flank Mexico on the east and west.

One sees Anáhuac*	Se ve al Anáhuac*
shining again	rebrillar
the beast of Ajusco†	la bestia-Ajusco†
ready to leap.	que va a saltar.
And by the route	Y por el rumbo
that carries	que lleva al mar
Quetzalcóatl to the sea	a Quetzalcóatl
it will be reached.	que se va a alcanzar.
She gives me breath,‡	Ella es mi hálito‡
I am her bearer,	yo su andar,
she is knowledge,	ella saber,
I am conjecture.	yo adivinar.
And we stop	Y paramos
[to me it is] like manna	como el maná
where the road	donde el camino
becomes too hard,	se sobra ya.
where they shout	Donde nos grita
to us halala!**	su ¡halalá!**
the throng of women	el mujerío
of Olinalá.	de Olinalá.

With grace and power, and in an idiom that is cosmopolitan yet firmly rooted in place, Mistral's poem carries the reader from the intimate to the sublime, while linking the ancient past to the present. "Cajita de Olinalá" operates on multiple levels, but I want to draw out only a few points of observation. Though she wrote before the revival by d'Harnoncourt, Mistral's poem makes clear the extent to which Olinalá already had emerged as an intellectual, visual, tactile, and olfactory embodiment of the post-revolutionary nationalist perspective. Nationalist symbols abound: Quetzalcóatl, Aztecs, quetzales, Anáhuac, Ajusco, the twin mountain chains,

*The ancient Valley of Mexico.

†Nickname for a path leading up Ajusco mountain, known for its difficult ascent

‡Lost in translation here is the near double-entendre between "hálito," meaning breath or soft breeze, and "halito," meaning little halo, which deepens the sense of the author's vulnerability and the box's role as protector.

**An exclamation of encouragement, similar to "You can do it!"

along with copal, nopal, corn, and, above all, Indians. Olinaltecan lacquer emerges as intimately linked to each of these, as part of a unified cultural tapestry. The nation Mistral conjures is not parochial but expansive and cosmopolitan, invoking Greeks, manna, Christ figures (Quetzalcóatl and Queen of Sheba), and a modernist poetic style. The distinctive fragrance of *tlapetzole* unites time and space; linking the modern cultural nation to an ancient Aztec past, and traversing the width of the country. Something that Mistral could not have known, but that no doubt would have gratified her, was that the odor of *tlapetzole* that draws her senses into the real and metaphysical space of the ethnicized Mexican nation was created by the very women who, at the end of her poem, urge her to persevere, as they themselves have done, despite personal and worldly adversity.

Olinaltecan lacquer was one among many folk expressions that came to symbolize Mexico's ethnicized national identity. The flowing dresses and movements of *ballet folklórico*; *ranchera* music; *charros* and *chinas poblanas*; markets filled with *artesanías* ranging from textiles and pottery to lacquered gourds and whimsical toys; and women dressed in bright indigenous outfits—all of these populate nationalist and commercial images of Mexico. Together they lend a visual, aural, and experiential solidity to ethnicized *mexicanidad*. However, as Edward Said cautions in the epigraph introduced at the start of this book, one must resist presuming that there is something "fundamentally integral, coherent" and "separate" about the national "experience." To accept the images and sounds of Mexico as an unproblematic invocation of an organic national identity is to impose an essentialist understanding upon something that, in fact, is "both historically created and the result of interpretation" and is rife with "entanglements and dependencies on other knowledges." The chapters of this book have focused on the development of this nationalist aesthetic to understand how ideas of Mexicanness were historically constructed, and how they have been entangled with ideas of Indianness, modernism, and national integration, as well as with political and economic struggles.

The project initiated in the aftermath of the Mexican revolution to integrate the population around an ethnicized identity proved remarkably successful. As the historical sociologist Jorge Hernández-Díaz notes, on the eve of the revolution "Mexico was neither a nation nor a multinational state."[2] Yet by the 1940s it already was emerging as among the most integrated countries of Latin America. Intellectuals and state officials who

in the 1920s had wrung their hands over the country's cultural fragmentation now safely presumed that Mexico had achieved a compelling collective self and a high level of integration. Handicrafts, mediated on the national, transnational, and local levels, have played a role in this process and continue to stand as physical affirmations of the triumph of the postrevolutionary vision. What had been evidence of fragmentation became variations within a broader cultural unity of *mexicanidad*.

Postrevolutionary intellectuals and state officials embraced an ethnicized nationality. This did not mean that they were multiculturalists (far from it), but neither were they rabid homogenizers set on destroying indigenous culture. Oftentimes scholars too easily accept the trope of a single-minded postrevolutionary project intent on de-Indianizing the population so as to impose the ideal of homogenous mestizaje. Jorge Hernández-Díaz, for example, is correct that "after the Revolution the construction of a nation preoccupied the Mexican intelligentsia," but he is mistaken that "most intellectuals agreed that" this required homogenization and complete elimination of all traces of indigenousness. More accurate is Guillermo Palacios's well-documented finding for the early 1930s that "national integration did not mean the elimination of the 'other,' nor his conversion into the 'self' of modernist reflection, but the education of the 'other' so as to integrate him as a fundamental instrument for the final construction of an integrated nationhood." By complicating reductionist interpretations of postrevolutionary mestizaje, this study contributes to a growing literature that includes the work of Guillermo Palacios, Mary Kay Vaughan, Agustín Basave Benítez, and Alec Dawson.[3]

The postrevolutionary project, moreover, was intensely heterogeneous, with different arms of the movement sometimes actively at odds with one another, particularly over the question of how to integrate and "reform" the indigenous population. One thing that postrevolutionary intellectuals, officials, and reformers did seem to agree upon was the construction of the popular classes as passive Indianized subjects in need of reform and uplift for the good of the nation.

To argue that integration has been highly successful is not to suggest that there was some puppet master pulling the strings, duping the masses into accepting elite-constructed identities like some form of false consciousness.[4] The ethnicized discourse, together with the process of national integration, of which it was part, took hold where and when cul-

ture, politics, practice, and markets intersected in the lives of individuals, such that these individuals felt both connected to, and invested in, the discourse. Neither does calling ethnicization and integration a success imply Mexico's attainment of economic or political equality. On the contrary, one of the remarkable aspects of national integration is not that it occurred *despite* inequalities but that it has operated precisely *through* these inequalities. The persistence of inequality, deeply embedded within the ethnicized national identity around which the nation united, is apparent in the plight of Mexico's indigenous population and the emergence of contemporary indigenous movements.

Indigenous Movements of Today

After the revolution it was the intelligentsia, speaking on behalf of the popular revolution, that declared the indigenous presence and insisted that Indians should be made part of the nation. By the end of the century indigenous people were speaking for themselves, declaring their presence and laying claim to the postrevolutionary discourse. The construction of indigenous people as passive subjects awaiting uplift proved tenacious, but it has failed to exclude alternative narratives or prevent new ones from forming on the local level all across Mexico.

While much has changed over the decades, today's movements do not signal a complete rejection of the 1920s cultural project, as some scholars presume. On the contrary, they draw upon claims and assumptions born directly out of that era. To combat their social, political, and cultural marginalization Zapatistas and others pitch their demands not as universal liberal citizens but specifically as indigenous citizens who hold a special place in the nation.[5] The very idea that indigenousness is part of the nation rather than outside of it, and the claim that defense (rather than erasure) of Mexico's living indigenous heritage is a nationalist responsibility of the state, are an extension, not a rejection, of the postrevolutionary movement to ethnicize and unify the nation.

Despite the fact that indigenous movements draw upon the postrevolutionary nationalist discourse, they are at odds with the state's claim to be the inheritor of that discourse and defender of *mexicanidad*. This is revealed, for example, in that though it was government programs of the 1970s, 1980s, and 1990s that taught members of indigenous organizations the skills to represent themselves using new media, these organizations

have used these resources to become politically mobilized against the state. They have become fed up with a government that makes it impossible for them to get their needs met through existing institutions.[6] In his discussion of grassroots movements in Guerrero, Armando Bartra argues that to be marginalized is even worse than simply being exploited; it is to be dismissed as "socially extraneous" and "treated as excrement of the system" with no legitimate place within the "country, the continent, [or] the planet."[7] The neoliberal economic policies embraced by the state cast into irrelevance people who are neither major producers nor consumers of industrial goods and services. The Zapatista uprising and other indigenous movements represent an organized response against this economic, political, and cultural marginalization.

To argue that these indigenous movements do not signal a complete break with the postrevolutionary nationalist discourse is not to suggest that they do not propose anything new. To understand what is new, however, it is not useful to exaggerate the homogenizing impulse of the postrevolutionary cultural movement and then posit that the indigenous movement marks a break with that discourse. It is more fruitful, instead, to engage the complexity of the earlier discourse, and to consider in what new ways contemporary indigenous activists are tapping into it, and in what ways they are presenting challenges. Indigenous movements are counter-hegemonic, not because they reject the dominant cultural discourse of *mexicanidad*, but because they draw on an interpretation—a "selective tradition," if you will—of that discourse to argue for indigenous autonomy and self-determination. This directly challenges investors and politicians, who, since the 1990s, have tried to interpret the national identity in such a way as to justify atomized citizenship and the enshrinement of private property. As the anthropologist Lynn Stephen argues, militarization and state repression make clear that many of the most powerful political and economic actors "are not willing participants in reimagining the nation in alliance with indigenous movements."[8]

Though they draw on past discourses, indigenous organizations and their national and transnational allies do not seek to reactivate the 1920s and early 1930s discourse of unity in diversity. Instead, they want to remake Mexico into a genuinely multicultural nation. There is a major difference between "unity in diversity" and an ethnicized nationality on the one hand, and the new emphasis on multicultural nationality. Whereas the

old discourse was constructed around the presumption of indigenous passivity and top-down control, indigenous people now demand the right to assert their own agency and to use this agency to reimagine the form of the (multistranded-)nation. Whether such a direction has the capacity finally to redefine Mexican identity and reshape the terms of integration in such a way as to challenge enduring structures of inequality, or whether it will operate through, and reproduce, existing inequalities, is difficult to know. What is clear is that, though the proposal is not a break with the postrevolutionary discourse in the way that scholars have presumed, it nevertheless is a call for radical revision.

Popular Art in the Neoliberal Age

The triumph of the project to link *artesanías* to discourses of nation formation makes it easy for modern-day promoters to accept crafts as part of Mexico's living national patrimony and as testaments to the cultural diversity of the nation. In recent decades Fonart has expanded to help connect artisans to the growing handicraft market, and it still serves as artisans' primary link to the state. The MNAIP met a less auspicious fate. After the earthquake of 1985 destroyed the museum's home, its curators tried to keep going with a small temporary show in the building next door. But in November 1988 an electrical fire consumed most of its collection, including its exquisite examples of Olinaltecan lacquer.[9] Mexican artistic circles buzzed with plans to reopen the MNAIP. In 2003, however, President Vicente Fox of the PAN party, whose election in 2000 ended the PRI's seventy-one-year stranglehold on the presidency, dissolved the INI and replaced it with the Commission for the Development of Indigenous Peoples (Comisión para el Desarrollo de los Pueblos Indígenas), which effectively assured that the MNAIP would not reopen.

In the meantime, the National Bank of Mexico (Banco Nacional de México, Banamex, founded in 1884 and, since 2001, part of Citigroup) took the lead in promoting high-end popular art. In 1972, around the same time that Olinalá got its road and the government started lending its support to the indigenous movement, Banamex created the Banamex Institute for Cultural Development (Fomento Cultural Banamex, A. C.) to promote Mexican art and culture through publications, exhibitions, and grants. In 1995 the institute sponsored a major exhibition of popular art in the Palacio Iturbide, the former gallery of Frederick Davis. The show, Great Masters of

Popular Art (Grandes Maestros de Arte Popular), assembled some of the finest work by 150 master artisans, drawn from the "most representative" craft traditions. The success of that exhibition inspired Banamex to found the Program of Support for Popular Art (Programa de Apoyo al Arte Popular) in 1996, which continues as a major collector of high-end crafts and an important underwriter of publications, programs, and exhibitions and, in 2004, launched an initiative to support female indigenous artisans in particular.[10]

Most recently Banamex has helped underwrite the creation of an institution to fill the void left by the MNAIP. This new institution, which opened on the first of March 2006, is the Museo de Arte Popular (Museum of Popular Art, MAP). Unlike its namesake predecessor, which suffered from dependence on fickle state support, this new institution thus far is blossoming. Its home is one of the best-equipped museum buildings in Mexico and its exhibitions display a high level of professionalism and sophistication. Ironically, the neoliberal economic shifts that have made it harder for *campesinos* to make a living from their land, driven growing numbers into poverty, accelerated land privatization and environmental degradation, and marginalized the indigenous peasantry also have made possible the rise of the stable and highly professionalized Museo de Arte Popular.[11]

At the inauguration one sponsor called the MAP "a testament to the richness and diversity of our people." The former director of the MNAIP María Teresa Pomar emphasized the challenges craftspeople face in their daily lives, including poverty and ethnic discrimination. She cautioned that this museum alone cannot alter the lives of artisans nor bring them justice, but it can inspire visitors to embrace the diversity of Mexico and work for greater justice. Still unclear is whether the MAP will serve as direct heir to the 1920s discourse of unity in diversity and its assignment of indigenous passivity, or whether it can connect with the growing indigenous movement that demands social justice, self-determination, and a reconfiguration of Mexico's ethnicized nationalist imagination.

As Mexican children and their parents depart from the Papalote Museo del Niño in Mexico City's Chapultepec Park, they pass before the massive "Baúl of the Future" discussed in the introduction. Like Mistral's "Cajita de Olinalá," this dowry chest draws upon shared sentiments about the place

of Olinalá within the nationalist imagination. It encapsulates an understanding of Mexico as unified across time, from the Aztecs through the colonial era to today and into the future. It is an identity that is at once deeply historical, yet timeless. It links together Mexicans from across the country, yet finds its roots in a specific location. In the end, while the objects within the "Baúl of the Future" will reveal to the boys and girls of 2050 the specifics of children's lives from 1998, it is the chest itself that will convey to children of the next generation who they are, guiding them along the path of Quetzalcóatl and across the broad physical, historical, and cultural expanse of the nation.

NOTES

Introduction

1. Brading, *Los orígenes del nacionalismo mexicano*; Brading, "Nationalism and Monuments in Modern Mexico"; and Brading, *The First America*.

2. The term "alternative nationalism" in this context draws on the arguments of Florencia Mallon, *Peasant and Nation*.

3. Pimentel, *Memoria sobre las causas que han originado la situación actual de la raza indígena de México*, 200–218. Note: in the postrevolutionary era an effort by Francisco Bulnes to recycle such reasoning met harsh criticism. See Francisco Bulnes, "Las razas inferiores son funesta en el trabajo libre," *EU*, 1 March 1921, and Manuel Gamio, "Las pretendidas razas inferiores de México," *EU* 4 March 1921.

4. Brading, *The First America*; Caplan, "The Legal Revolution in Town Politics; Hernández Chávez, *Anenecuilco*; Ducey, "Village, Nation, and Constitution in Papantla, Veracruz"; Mallon, *Peasant and Nation*; Guardino, *Peasants, Politics, and the Formation of Mexico's National State*; Vázquez, ed., *El establecimiento del federalismo en México (1821–1827)*; Thomson, "Popular Aspects of Liberalism in Mexico, 1848–1888"; Hale, *The Transformation of Liberalism in Late Nineteenth-Century Mexico*; Tenorio, *Mexico at the World's Fairs*; Lomnitz, "Bordering on Anthropology: Dialectics of a National Tradition in Mexico"; Weiner, *Race, Nation, and Market*; and Chávez, *Los indios en la formación de la identidad nacional mexicana*. Conflicts between grassroots and elite liberalism were not confined to Mexico. See, for instance, Lasso, "Revisiting Independence Day." An explanation as to how movements for inclusion in the Andes lost ground can be found in Walker, *Smoldering Ashes*, 186–221, and Larson, *Trials of Nation Making*.

5. Tanenbaum, "Streetwise History," 128 and 135–47; Tenorio, "1910 Mexico City"; Needell, "Rio de Janeiro and Buenos Aires"; Field, Gournay, and Somma, eds., *Paris on the Potomac*; Benjamin, *La Revolución*, 121; Bonfil Batalla, *México profundo*; and Villoro, *Los grandes momentos de indigenismo en México*.

6. Fuentes, *A New Time for Mexico*, 66–67.

7. Velázquez and Vaughan, "Mestizaje and Musical Nationalism in Mexico," 95–99; Pérez Montfort, *Estampas de nacionalismo popular*; and Cordero Reiman, "Constructing a Modern Mexican Art," 10–13. On the place of nation formation within the broader context of nationalism and patriotism, see Knight, "Peasants into Patriots."

8. Pérez Montfort, *Avatares del nacionalismo cultural*, 40.

9. Gamio, *Forjando patria*, 7; Ohmstede and Rabiela, *Presencia del indígena en la prensa capitalina del siglo XIX*, 560; DGE, *V Censo General de Población*, 1930. Bonfil would take up a similar argument in his critique of the "imagined Mexico" in *México profundo*, which he contrasted with the "deep" indigenous, authentic, Mexico.

10. Gamio, *Forjando patria*, 36–39, and Gamio, "Las Pretendidas Razas Inferiores de México," *EU* 4 March 1921. Note: all translations from Spanish are by the author.

11. Sáenz, *Mexico*, 14.

12. Gamio, *Forjando patria*, 96; Gamio, *The Present State of Anthropological Research in Mexico, and Suggestions Regarding its Future Developments*, 14.

13. Olivier Debroise, *La pintura mural de la revolución mexicana*, 2d ed., quoted and translated in Novoa, "Offshoring the American Dream," 121.

14. Sáenz, *México integro*, 155–56; Vaughan, *Cultural Politics in Revolution*, 197. Also see Knight, "Racism, Revolution, and *Indigenismo*," 78–80, 105, n. 48.

15. Similar processes in other countries have been the subject of excellent studies. See Muratorio, "Images of Indians in the Construction of Ecuadorian Identity at the end of the Nineteenth Century"; de la Cadena, *Indigenous Mestizos*; Grandin, *The Blood of Guatemala*; and Jeffrey Gould, *To Die in This Way*.

16. This persists in current debates over "tradition" and degeneracy. See Kearney and Nagengast, "Mixtec Ethnicity: Social Identity, Political Consciousness, and Political Activism."

17. Palacios, "Postrevolutionary Intellectuals, Rural Readings and the Shaping of the 'Peasant Problem' in Mexico." Boyer, *Becoming Campesinos*, has described how rural people in Michoacán became "campesinos" and the political importance of this shift. On the continual recreation of identity and ethnicity, also see Smith, "The Production of Culture in Local Rebellion."

18. These quotes come from Stephen, *¡Zapata Lives!*, 85, which shows that even the best studies exaggerate the degree to which Vasconcelos's contemporaries accepted his ideas about race. A useful critique of historical studies that accept such a proposition is Dawson, "From Models for the Nation to Model Citizens."

19. Millán Chivite, *El costumbrismo mexicano en las novelas de la Revolución*, 139 and 150.

20. See, for example, Vaughan, *Cultural Politics*; and Palacios, "Postrevolution-

ary Intellectuals," 316. The term and analytical concept of "unity in diversity" comes from Prakash, introduction to *After Colonialism*, 9.

21. Cárdenas is quoted in Hernández-Díaz, "National Identity and Indigenous Ethnicity in Mexico." While Gamio's writing always contained a tension between cultural relativism and racism (see Lomnitz, "Bordering," 189), it was only in 1935, when he published *Hacia un México nuevo*, that he completely shifted toward a decidedly negative stance regarding indigenous people.

22. Stephen, *¡Zapata Lives!*, 87.

23. See, for example, Joseph and Nugent, eds., *Everyday Forms of State Formation and the Negotiation of Rule in Modern Mexico*; Dore and Molyneux, eds., *Hidden Histories of Gender and State in Latin America*; Mallon, *Peasant and Nation*; Rubin, *Decentering the Regime*; Thomson, "Popular Aspects of Liberalism"; Guardino, *Peasants*; Purnell, *Popular Movements and State Formation in Revolutionary Mexico*; Lomnitz-Adler, *Exits from the Labyrinth*; and Vaughan, *Cultural Politics*.

24. Benedict Anderson shows that modern "imagined communities" construct myths that place their origins far in the past. Deutsch, Armstrong, Hutchinson, and others argue that nations' claims to ancient histories are based on an objective reality: Deutsch, *Nationalism and Social Communication in the Foundations of Nationality*, and Armstrong, *Nations before Nationalism*. To a large extent debates over the recentness of nations have been shaped by differing understandings of what a "nation" is. See Connor, "A Nation Is a Nation"; "When Is a Nation?"; and "The Timelessness of Nations." Also see Weber, *Peasants into Frenchmen*. Weber's thesis regarding the lateness of French national integration has been the subject of considerable debate since it was first published, but, though it has been refined and nuanced, its fundamental view of the French nation as a relatively recent construct remains compelling.

25. Richard Graham has addressed this outside of Mexico. See Graham, "From State to Nation in Nineteenth-Century Brazil," and "Constructing a Nation in Nineteenth-Century Brazil." Note that Hobsbawm has argued that the movement from state to nation, rather than the other way around, was more common in Europe than has been acknowledged. See Hobsbawm, *Nations and Nationalism since 1780*, 10–12 and 96, and Hobsbawm and Ranger, *Invention of Tradition*.

26. Brading, "Monuments and Nationalism," 523. With good reason Brading refers to this as "creole patriotism," not "creole nationalism."

27. Tenorio, "Essaying the History of National Images," 71.

28. Knight, *Mexican Revolution*, 35.

29. Smith, "Dating the Nation," and Connor, "Timelessness of Nations." Most literature on nations and nationalism is Eurocentric and conflates the related concepts of nation and state, as well as of citizenship and nationalism, which limits

the usefulness of its analyses. Nevertheless, some authors demonstrate the kinds of historical and conceptual issues that can be addressed through a hermeneutic distinction between "nation" and "state," and also between "national identity" and "patriotism" (though I question the utility of some authors' overconcern with typologizing and litmus tests). For a list of useful studies of European and global nationalism, see López, "The India Bonita," 294, n. 6. On Mexico, see Miller, *In the Shadow of the State*, esp. 137; Knight, "Racism"; Vaughan, *Cultural Politics*; and Lomnitz, "Modes of Citizenship in Mexico." For a critique of the Eurocentricism of nationalism literature, see Chatterjee, *Nationalist Thought and the Colonial World*.

30. Anderson, *Imagined Communities*.

31. Said, *Culture and Imperialism*, 215 (emphasis added). Despite his insights, Said shares Anthony Smith's narrow focus on the elite, while adding the problematic assumption that the masses fell in line with the ideas of this elite.

32. Gruzinski, "Images and Cultural Mestizaje in Colonial Mexico," 54–55.

33. Gamio, *Forjando patria*, 39.

34. Pérez Montfort, "La consolidación del acuerdo estereotípico nacional, 1921–37"; Pérez Montfort, *Estampas*; Pérez Montfort, *Avatares*; Florescano, ed., *El patrimonio cultural de México*; Florescano, *Imágenes de la patria a través de los siglos*; and Vaughan and Lewis, *Eagle and the Virgin*. Studies of music build on the insightful approach to music presented by Guy Thomson's "The Ceremonial and Political Roles of Village Bands, 1846–1974."

35. García Canclini, "Los usos sociales del patrimonio cultural," 47. This consolidation, in fact, contributed directly to the subsequent emergence of a national (and nationalist) mass media and to the growth of tourism.

36. Said, *Culture and Imperialism*, xxv.

37. My use of the ideas of articulation and social and cultural formations builds on Stuart Hall's analysis of the writings of Antonio Gramsci. See, for example, Morley and Chen, eds., *Stuart Hall*, and Hall, "Race, Articulated in Society."

38. See Joseph, "Close Encounters"; Gewertz and Errington, "We Think, Therefore They Are?"; and Pratt, *Travel Writing and Transculturation*.

39. Sahlins, "The Nation in the Village"; and Sahlins, *Boundaries*.

40. Azuela, *Arte y poder*; García Canclini, *Arte popular y sociedad en América Latina*; García Canclini, *Hybrid Cultures*; García Canclini, *Las culturas populares en el capitalismo*; García Canclini, "Modernity after Postmodernity"; and Joseph, Rubenstein, and Zolov, eds., *Fragments of a Golden Age*.

41. Hutchinson, "Myth against Myth," 111.

42. Rodó, *Ariel*.

43. Lebovics, *True France*, 135–88; Hilton, *Russian Art*, 245–84; Brandt, *Kingdom of Beauty*; and Williams, "Splendid Crafts into Fine Art."

44. See, for example, Gamio, *Forjando patria*; Vasconcelos, *La raza cósmica*; Best Maugard, *Manuales y tratados*; Doctor Atl [Gerardo Murillo], *Las artes populares en México*; and Jerónimo Coignard (Francisco Zamora), "El valor efectivo de ballet mexicano," *EUI* 13 Oct. 1921): 32. Each of these authors idealized European countries' supposed level of integration, and presented them as models for what Mexico might achieve (though in its own distinctive idiom). Mexican elites' understanding of France as a united single people reflected the claims of the French state but contrasted with the reality of the relationship between Paris and its rural hinterlands. A vast and rich literature addresses this issue, beginning with Sahlins, *Boundaries*, and Eugene Weber's classic *Peasants into Frenchmen*. On the German effort to create a state that coincided with geographers' claims regarding the German ethnic nation, see Herb, *Under the Map of Germany*. On the broad dominance of this model of the modern cultural nation, see Spencer and Wollman, introduction to *Nations and Nationalism*, 3. On the much later integration of Spain, which drew on the Mexican postrevolutionary model, see Holguín, *Creating Spaniards*.

45. Quoted in García Canclini, "Modernity after Postmodernity," 26–27.

46. Fuentes, *New Time for Mexico*, 66–67.

47. There are literally hundreds of books and articles that focus all or in part on the lacquer of Olinalá. For the most part they are vague, not based on research, and primarily descriptive. Some are beautifully illustrated. The most important of these works, beyond those that will be cited elsewhere in the text, include Lechuga, *Lacas mexicanas*; Espejel, *Olinalá*; Toor, "Notas sobre las lacas"; Porfirio Martínez Peñaloza, *Popular Art of Mexico*; Monzón Estrada, *Artes y artesanías de Guerrero*; Oettinger, *Folk Treasures of México*; Molina Enríquez, "Lacas de México" and "Las lacas de Mexico"; Rubín de la Borbolla, "Arte popular mexicano"; *Artes de México* 11 (43/44) (1963): 4–20; de la Borbolla, "Imagenes del arte popular"; de la Borbolla, "Observaciones sobre el arte popular mexicano"; de la Borbolla, "Supervivencia del arte popular"; Coronel Rivera, "Animus populares"; Turok, *Cómo acercarse a la artesanía*; Toussaint, "Arte popular en México"; Winkler, "Olinalá, Where Tradition Flourishes"; Thiele, *El maque*; Sepúlveda, *Maque*; Castelló Iturbide, *El arte de maque en México*; and Castelló Iturbide, "Maque o laca."

48. González y González, *San Jose de Gracia*, xv.

49. Lomnitz-Adler, *Exits*, and Vaughan, *Cultural Politics*. On *fronterizo* identity vis-à-vis central Mexico, see Vila, *Ethnography at the Border*. Vila discusses *norteño* assumptions about their own exceptionalism and their opposition to the predominantly indigenous center. In southern Mexico, too, local variations intersected with centralized nationalist discourse. See Poole, "An Image of 'Our Indian'"; and Stephen, *¡Zapata Lives!*, xxxiv–xlv and 33–81.

50. González, *San Jose de Gracia*, xvii.

51. Foucault, *The Archaeology of Knowledge* and *The Discourse on Language*.

52. Novelo, "Las artesanías en México," 219.

Chapter 1: Ethnicizing the Nation

1. "El viaje de propaganda," *EU*, 2 March 1921; "Hoy se pública el decreto que crea la Secretaría de Instrucción," *EU*, 8 July 1921; "No quieren que se federalicen las escuelas," *EU*, 5 Sept. 1921; "60,000,000 de pesos para educación," *EU*, 27 Oct. 1921; and "El senado aprobó," *EX*, 6 Sept. 1921. Also see Vasconcelos, *El desastre*; Vaughan, *The State, Education, and Social Class in Mexico*; Vaughan, *Cultural Politics*. SEP was created by law in July 1921 and became a department with a functioning minister in November and December of that same year. See Fell, *José Vasconcelos*, 67–68. Other important government institutions founded during this time include the Department of Demographics and the Department of Geography, which were charged with culturally mapping Mexico. On the Summer School, see Álvaro Obregón, "El intercambio de estudiantes," *EU*, 21 May 1921; Puig Casauranc, *Addresses Delivered by Dr. J. M. Puig Casauranc at Columbia University*, 9; Toor, "Mexican Folkways; and Toor *Mexican Popular Arts*. Also see Delpar, *The Enormous Vogue of Things Mexican*, 18–20, 36; and Tenorio-Trillo, "The Cosmopolitan Summer, 1920–1949." On roads, see "La Secretaría de Comunicaciones en la celebración del Centenario," *EU*, 7 July 1921. Mexico had various kinds of roads from before the revolution, but few were capable of carrying automotive traffic or delivery trucks. Also see "La construcción de buenos caminos," *EU*, 13 March 1921; "El lunes proximo será inaugurado el Primer Congreso Nacional de Caminos," *EX*, 2 Sept. 1921; "Centenares de soldados dedicanse a construir," *EX*, 4 Sept. 1921; "En el Congreso Nal. de Caminos," *EX*, 8 Sept. 1921; "Cada día aumenta el uso de autos," *EX*, 11 Sept. 1921. For more on roads, also see Waters, "Remapping Identities." On the national tree, see "El ahuehuete en definitiva," *EX*, 4 Sept. 1921; "¿Cuál debe ser el árbol nacional?" *EU*, 1 July 1921; and "Se anima el concurso para elegir el árbol nacional," *El Demócrata*, 1 July 1921. Interestingly, an *El Universal* article announcing the debate over a national tree appears right next to five images of contestants for the India Bonita Contest.

2. See, for example, "La unión de los Mexicanos," *EX*, 3 July 1921; "El homenaje de la raza," *EX*, 20 Sept. 1921; Vasconcelos, *La raza cósmica*, and his contributions to *Aspects of Mexican Civilization*; and Benítez, *México mestizo*.

3. Bliss, "The Science of Redemption"; Zavala, "The India Bonita Contest"; and Piccato, "Urbanistas, Ambulantes and Mendigos."

4. Hamill, *Diego Rivera*, 8.

5. Fowler-Salamini and Vaughan, eds., *Women in the Mexican Countryside, 1850–1990*, xv; and Bliss, *Compromised*, 8.

6. Tapia Ortega, "Cara y cruz de un periodista mexicano." For an official history of the newspaper, see "Historia ampliada," *El Universal Online*, www.eluniversal.com.mx/pls/impreso/Universal.histamp, visited 20 Dec. 2001.

7. "La Apoteosis de la India Bonita: Breve historia del concurso en que triunfó María Bibiana Uribe," *EU*, 25 Sept. 1921; and "Para 1921," *EU*, 1 Jan. 1921. Palavicini founded *El Universal* in 1916 and subsequently founded the newspapers *El Globo* and *El Día*, and the magazine *Todo*. See "El programa de 'El Universal,'" *EU*, 1 Jan. 1921; "La Apoteosis de la India Bonita," *EU*, 25 Sept. 1921; Julian Sorel, "¿Por qué triunfó María Bibiana Uribe?" *EU*, 7 Aug. 1921. The India Bonita Contest dwarfed most previous public contests by the newspaper.

8. Antonio Pompa y Pompa, interview with Palavicini, typescript, 1984, caja 7, exp. 94, AHI-MG; also see Palavicini, introduction. In 1905 the United States had its first nationwide beauty contest, which was sponsored by a consortium of newspapers. Unlike the India Bonita Contest, U.S. beauty contests did not take on nationalist overtones until World War II. See Cohen, Wilk, and Stoeltje, introduction to *Beauty Queens on the Global Stage*, 4–5. In Mexico festival and agricultural queens were common by the late nineteenth century, but rather than formal beauty contests, these involved the appointment of the daughter of a prominent political or economic figure. This tradition was continued in 1921 with the creation of several centennial courts and the appointment of the daughter of Plutarco Elías Calles as official queen of the centennial festivities.

9. Knight, *Mexican*, 316–18; *Diccionario Porrúa: Historia, biografía y geografía de México*, 6th ed. (Mexico City: Editorial Porrúa, 1995), 635, 2697; González Casanova, *"Por la pantalla."* As Gonzales notes on p. 74, there are conflicting dates within the documentation concerning details of Taylor's life, including the years in which he became involved with the Madero campaign and with the Casa del Obrero Mundial.

10. Julian Sorel, "¿Por qué triunfó María Bibiana Uribe?" *EU*, 7 Aug. 1921; "La Apoteosis de la India Bonita," *EU*, 25 Sept. 1921; Jacobo Dalevuelta [Fernando Ramírez de Aguilar], "Algunos tipos con nombres de animales: Clasificación humana," *EU*, 28 Aug. 1921. For news coverage that combined this view of gatitas with an alternative view as potentially unhygienic and untrustworthy, see "¿Qué lleva esta 'gata' en la canasta: La vida o la muerte?," *EU*, 13 Oct. 1921.

11. "El Concurso de la India Bonita," *EU*, 2 Feb. 1921; "En Córdoba se ha formado un comité," *EU*, 26 Jan. 1921. A very small number of contestants did enroll themselves into the contest, but they were discussed as oddities. See, for example, "El Concurso de la India Bonita," *EU*, 19 May 1921. We see a similar process of urban-imposed "Indian" identities with the Zapatistas, whom the historian John

Womack shows did not initially present themselves as Indians but were immediately defined as such by government officials and in wartime propaganda. Womack, *Zapata and the Mexican Revolution*, 70–71.

12. "El Concurso de la India Bonita abarcará toda la República," *EU*, 25 Jan. 1921; "La Apoteosis de la India Bonita," *EU*; Julian Sorel, "¿Por qué triunfó María Bibiana Uribe?" 7 Aug. 1921.

13. See, for example, "Gran Concurso International de Belleza," *EU*, 1 March 1921; "Hoy conmemoran los americanos de México," *EU*, 4 July 1921; *Boletín de la Secretaría de Educación Pública* 1(3): 330–31. On the tehuana, see Sierra Torre, "Geografías imaginarias II," and Poole, "An Image," 67–68.

14. "Gran Concurso Internacional de Belleza," *EU*, 1 March 1921; and "*El Universal* fue el primer periódico de América que realizó el Concurso Mundial de Belleza," *EU*, 22 June 1921. Of course, like most kinds of elite popularity contests, the Miss Mexico contest was probably influenced by political and economic favoritism.

15. "Once candidatos," *EU*, 23 July 1921.

16. Rafael López, "Hebdomadarios," *EU*, [ca. 15 July] 1921; "Fue nombrado el jurado," *EU*, 12 July 1921.

17. Manuel Gamio, "Sugestiones sobre arte vernáculo," dated Jan. 1921, typescript, caja 8, exp. 25, AHI-MG.

18. "La apoteosis de la India Bonita," *EU*, 25 Sept. 1921; "La representante de la raza," *EU*, 2 Aug. 1921; Julian Sorel, "La India Bonita de México," *EU*, 25 Sept. 1921; Julian Sorel, "¿Por qué triunfó María Bibiana Uribe?" *EU*, 7 Aug. 1921; Manuel Gamio, "La Venus India," *EUI*, 17 Aug. 1921. Also see Cordero, "Constructing a Modern Mexican Art," 23; Pérez Montfort, *Estampas de nacionalismo*, 163.

19. The point here is not that the use of make-up, fashion, and consumer items was inherently liberating. As Theodor Adorno and Max Horkheimer showed long ago, and as Baudrillard has demonstrated more recently, there is nothing inherently liberating about such consumption and symbols. Rather, my point is that, however they might be related to issues of genuine liberation or implicit social imprisonment, these items, in the way they were used on a daily basis, offered the possibility to participate in the negotiation of taste (which Baudrillard shows is more important than Adorno had assumed) and to adopt certain fashions that made it possible to negotiate one's place within the social hierarchy. On this issue, see Bourdieu, *Distinction*. Also see Adorno and Horkheimer, "The Culture Industry"; Baudrillard, "The Ideological Genesis of Needs"; and Peiss, "Making Up, Making Over."

20. Julian Sorel, "¿Por qué triunfó María Bibiana Uribe?" *EU*, 7 Aug. 1921.

21. "María Bibiana Uribe de la Sierra de Puebla proclamada India Bonita de México," *EU*, 2 Aug. 1921. The article states that she was sixteen years old, but contest

organizers were intentionally misinformed by María Bibiana's family; she was fifteen years old. Rosa Zarate Uribe, interview, 24 Sept. 1999, Necaxa, Puebla. Confusion over her age and ethnicity even led one article to report that she was an eighteen-year-old "Meshica." See *EUI*, 4 Aug. 1921, quoted in Pérez Montfort, *Estampas de nacionalismo,* 163; and "La representante de La Raza," *EU,* 2 Aug. 1921.

22. Pérez Montfort, "Historia," 93 and 101–3; Fernando Aquino González et al., "Jacobo Dalevuelta—Periodista," http://www.oaxaca-travel.com/guide/cultural, visited 5 Sept. 2006.

23. Dalevuelta, "Mi entrevista con la India Bonita," *EU,* 2 Aug. 1921; Rosa Zarate Uribe, interview, 24 Sept. 1999; María Bibiana Uribe, taped broadcast interview, Radio Station XOJT, Necaxa, 1991; "La representante de La Raza," *EU,* 2 Aug. 1921.

24. Dalevuelta, "Mi entrevista con la India Bonita," *EU,* 2 Aug. 1921. According to her daughter, at the time she won the India Bonita Contest, María Bibiana Uribe, whose language was Mexicano (Náhuatl), did not become proficient in Spanish until later in her life. Rosa Zarate Uribe and Alfredo Zavala Zarate, interview, 24 Sept. 1999, Necaxa, Puebla.

25. Urban whites and mestizos frequently questioned whether indigenous people were capable of happiness, romantic love, and spiritual transcendence. Nationalists eager to integrate the nation argued that Indians, indeed, were capable of such emotions. See, for example, González Casanova, "The Magic of Love among the Aztecs."

26. Advertisements in *El Universal* and other newspapers; and "El Homenaje de la India Bonita," *EU,* 17 Aug. 1921.

27. "La India Bonita," *EU,* 11 Sept. 1921; "La India Bonita en Nueva York," *EU,* 20 Sept. 1921; "Fue nombrado el jurado," *EU,* 12 July 1921. The year prior to the India Bonita Contest, Esparza had gained fame among Mexico City music fans for his foxtrot "Plenitude," but it was the success of his song "India Bonita" that solidified his renown. See "Alfonso Esparza Oteo," http://www.fortunecity.es/salsa/rap/552/esparza.html, visited 5 Sept. 2006. Ironically, seven years later, the last sound Obregón would hear before the explosion of an assassin's bullet would be the music of Esparza Oteo.

28. On pulqueria murals' engagement with current events, see "La pintura de las pulquerías."

29. "Una revista genuinamente mexicana," *EU,* 31 July 1921; "El homenaje de la India Bonita en el Teatro Principal, ayer anoche," *EU,* 17 Aug. 1921; and de los Reyes, *Cine y Sociedad en México, 1896–1930,* 219.

30. Julian Sorel, "Los estrenos del sábado," *EU,* 16 Aug. 1921; and "La Apoteosis de la

India Bonita." A chinampa is a raised garden surrounded by shallow lake water. Agriculturalists used such gardens to feed the people of the Valley of Mexico since the days of the Aztec Empire. For a description of the play that relies on different sources and ties the plot more closely with the India Bonita Contest, see Ricardo Pérez Montfort, *Estampas de nacionalismo*, 164.

31. Julian Sorel, "Los estrenos del sábado," *EU*, 11 July and 16 Aug. 1921. On the emergence of a national cuisine, see Pilcher, *¡Que vivan los tamales!*

32. "La India Bonita: El gran éxito del Teatro Colón," *EUI*, 17 March 1921, 32–33; Birotteau, "Notas teatrales," *EUI*, 3 March 1921, 13; Jerónimo Coignard, "La India Bonita en el teatro," *EU*, 27 Feb. 1921; Ruffo (pseud.), "María Conesa," *El Universal Gráfico (de la tarde)*, 7 Jan. 1931; Alonso, *María Conesa*, 33–85.

33. "Hablando con los autores de Mexicanarías," *EU*, 28 Aug. 1921; and "Entrevista con el pintor Diego Rivera," *EU*, 21 July 1921.

34. Júbilo (pseudonym), "Pelados, chinas, payos, tehuanas . . . viva México," *EUI*, 29 Sept. 1921, 40. Another critic criticized the centennial for pandering to popular tastes, which they felt excluded self-respecting members of the middle class. See Rafael López, "Hebdomadarias," *EU*, 2 Oct. 1921.

35. "La idea nacionalista en las Fiestas del Centenario," *EU*, 24 Sept. 1921.

36. On the 1921 centennial events as a context for state formation and as a setting for competing narratives, see Lacy, "The 1921 Centennial Celebration of Mexico's Independence: State Building and Popular Negotiation." On the 1910 precedent as model and antithesis, and on the new role of anthropological perspectives, see Lemepérière, "Los dos centenarios de la independencia mexicana."

37. L-E-955 a 966, AHSRE. Also see "El Sr. Ing. Alberto J. Pani fue nombrado Secretario de Relaciones Exteriores," *EU*, 26 Jan. 1921; "El comité ejecutivo de la Fiestas del Centenario," *EU*, 14 May 1921; "Editorial: Nuestras iniciativas del Centenario y la simpatia popular," *EU*, 10 Sept. 1921. The central organizing committee was formed as follows: president, Emiliano López Figueroa; vice president, Juan de Dios Bojórquez; treasurer, Carlos Argüellos; secretary, Martín Luis Guzmán.

38. Humberto Ruiz, "La sociedad al día," *EU*, 4 Aug. 1921.

39. "María Bibiana Uribe, La India Bonita, reinó ayer en la bella fiesta floral capitalina," *EU*, 19 Sept. 1921.

40. Rosa Zarate Uribe, interview, 24 Sept. 1999; and María Bibiana Uribe, interview by Arturo Allende in *Cambio de la Sierra* (Huachinango, Puebla), 2 May 1991; "María Bibiana Uribe, La India Bonita, reinó ayer," *EU*, 19 Sept. 1921; "Gran desfile de carrozas," *EU*, 15 Sep. 1921.

41. Announcement, *EU*, 24 Sept. 1921.

42. "D. Andrés Fernández educará a la India Bonita," *EU*, 23 Aug. 1921; "D. Andrés Fernández y su esposa ofrecieron ayer una fiesta a la India Bonita," *EU*,

24 Aug. 1921; "La India Bonita es una abnegada madre," *EX*, 10 April 1922; "La Apoteosis de la India Bonita"; María Bibiana, interview by Guillermo Ochoa, televised, *Nuestro Mundo*, Televisa, 1987; María Bibiana Uribe, taped broadcast interview, 1991, Radio Station XOJT, Necaxa; Rosa Zarate Uribe, interview, 24 Sept. 1999; and Rosa Zarate Uribe and Alfredo Zavala Zarate, interview, 24 Sept. 1999; "Murió ayer 'La India Bonita,'" *EU*; María Bibiana Uribe, interview by Arturo Allende, in *Cambio de la Sierra* (Huachinango, Puebla), 2 May 1991; and "El último homenaje a María Bibiana Uribe," *EU*, 26 Sept. 1921. Most of the events for the crowning were repeats from a smaller coronation the previous month at Teatro Colón. See the Teatro Colón advertisement, *EU*, 28 Aug. 1921; "El último homenaje a María Bibiana Uribe," *EU*, 26 Sept. 1921; Rosa Zarate Uribe, interview, 24 Sept. 1999; and various photographs of the event in the AGN-AFEDEDYMG. While playing on the theme of *mestizaje*, the message also makes clear the subservient, marginalized, and largely symbolic role Indians were to play in the Mexican nation.

43. "El festival a la india bonita en Xochimilco, ayer," *EU*, 10 Oct. 1921; "Hoy se efectuará en el Teatro Lírico la fiesta en honor de nuestro compañero Hipólito Seijas," *EU*, 4 Oct. 1921; "La función a beneficio de La India Bonita en Puebla," *EU*, 9 Oct. 1921; and "La más solemne fiesta del Centenario," *EU*, 24 Sept. 1921.

44. "La más solemne fiesta del Centenario," *EU*, 24 Sept. 1921; "'El Universal' y sus concursos de Centenario," *EU*, special centennial insert, 27 Sept. 1921.

45. As Gyan Prakash has observed, despite elite efforts to form a nation-state out of a diverse population, "the subalterns were regarded as incapable of articulating the demands of the nation"; introduction to *After Colonialism*, 10. On power relationships and discursive agency, see Sider, "When Parrots Learn to Talk and Why They Can't."

46. On narration and aesthetics, see Hulme, introduction and chapter 1, *Colonial Encounters*; and Said, *Culture and Imperialism*. Pérez Montfort's "La consolidación," 153–65, examines the consolidation of stereotypes in postrevolutionary Mexico but does not engage the contested nature of the process or the larger question of how the nation was narrated.

47. "La gran fiesta de la India Bonita en el Colón," *EU*, 25 Aug. 1921; "Esta noche se repite en el Colón el homenaje a la India Bonita," *EU*, 26 Aug. 1921.

48. Peiss, "Making Up," 322. On consumerism as an avenue for gendering practices and for defining collective/individual identities, see de Grazia, introduction, 7–9; and Auslander, "The Gendering of Consumer Practices in Nineteenth-Century France," 83.

49. On the ideal of the "modern girl" as a transnational phenomenon that enabled women to exercise some control over their self-representation and to shift be-

tween national racial and ethnic ideals and pastiche cosmopolitanism, see Barlow, Dong, Poiger, Ramamurthy, Thomas, and Weinbaum, "The Modern Girl around the World"; and Hershfield, *Imagining la Chica Moderna*.

50. Rafael López, "El seis doble y La India Bonita," *EU*, 7 Aug. 1921.

51. Adriana Zavala, "De santa a India bonita," 172. Also see Zavala, "The India Bonita Contest," 277–306; and Apen Ruíz Martínez, "La India Bonita." On the policing of women's behavior in Mexico City, see Bliss, *Compromised Positions*, 7.

52. By 25 September, after subtracting *El Universal*'s cut, she had earned 7407.37 pesos from her various appearances. See "La apoteosis de la India Bonita," *EU*, 25 Sept. 1921 for the accounting. Add to this the many bills to theaters still outstanding, a number of appearances left to go, and the large number of noncash awards she received, such as jewelry, gold medallions, clothing, and products.

53. During the 1960s folklore revivals inspired India Bonita contests across Latin America in which the contestants were judged for their appearance, performance, deportment, and accoutrements. See Boreland, "The India Bonita of Monimbó," and McAllister, "Authenticity and Guatemala's Maya Queen." Also see Wendy Griffin, "Dia de Lempira Is the day of Lencan Pride," *Honduras This Week Online*, 28 June 1999; Wilder Pérez R., "Masaya elegirá a India Bonita y Reina Patronal," *La Prensa* (Nicaragua), 14 Sept. 2001; Leopoldo López Arias, "Eligen a reinas de Tata Chombito," *La Prensa* (Nicaragua), 26 Sept. 2001; and Sylvia Hernández E., "Se van calentando Fiestas de Masaya," *El Nuevo Diario* (Managua, Nicaragua), 8 Sept. 2001.

54. Elegantly discussed in Cañizares-Esguerra, "Postcolonialism *avante la letter?*," 100.

55. This does not mean, however, that indigenous women did not try to take control over their own bodies and use them as symbols of their modernity. We see this, for example, with indigenous women who entered themselves into the contest but dressed as modern women rather than as indigenous peasants. We also see it in the case of Oaxacan prostitutes who used photographs of themselves to claim their own ability to be modern. See Overmyer-Velázquez, *Visions of the Emerald City*.

56. Rafael López, "Un pretendiente difícil," *EU*, 23 Oct. 1921.

57. Francisco Bulnes, "Las razas inferiores son funesta," *EU*, 1 March 1921; Manuel Gamio, "Las pretendidas razas inferiores," *EU*, 3 March 1921; Martín Luis Guzmán, Letter to the editor, *EU*, 5 March 1921; Emilio Rabasa, "El problema del indio mexicano," *EU*, 8 Jan. 1921; "Editorial: Aspectos del Centenario," *EX*, 21 Aug. 1921; Francisco Zamora, "Pequeñas reflexiones," *EUI* 4(208): 29; José Vasconcelos, "Nueva ley de los tres estados," *EU*, 11 Sept. 1921.

58. This continued to be true into the 1970s, and even into the present. See Friedlander, *Being Indian in Hueypan*.

59. María Bibiana Uribe, interview by Guillermo Ochoa, televised, *Nuestro Mundo*, Televisa, 1987; "Un Gran Concurso," *EU*, 1 March 1921; "El Concurso Universal de Belleza," *EU*, 12 March 1921; "El día 30 de abril se clausurará," *EU*, 4 April 1921; "La mujer mexicana en el Gran Concurso Universal de Belleza," *EU*, 3 May 1921; "'*El Universal*' fue el primer," *EU*, 22 June 1921; "Mujer más bella de México," *EU*, 17 June 1921. Note: despite the claims of 1921 organizers, there had already been a Miss Mexico contest the previous year, and perhaps others even before that. The daughter of Plutarco Elías Calles was also crowned as a beauty queen in 1921, but unlike Miss Mexico María Mercedes de Manero or the India Bonita María Bibiana Uribe, she was declared queen by fiat rather than through a competition of any kind.

60. The confusion extends even to the local level, in her hometown. María Bibiana Uribe, taped broadcast interview, 1991, Radio Station XOJT, Necaxa; Rosa Zarate Uribe, interview, 24 Sept. 1999; Rosa Zarate Uribe and Alfredo Zavala Zarate, interview, 24 Sept. 1999. Also see "Murió ayer 'La India Bonita,' a causa de un paro cardíaco," *EU*, Sept. 1991; and María Bibiana Uribe, interview by Arturo Allende, in *Cambio de la Sierra* (Huachinango, Puebla), 2 May 1991. The two contests have become merged in discourse and memory. This merging, ironically, is contradicted by daily practices, and by portrayals in advertising, television, and beauty contests, which define the ideal Mexican as tall, thin, white, and blond.

Chapter 2: Popular Art and the Staging of Indianness

1. Atl, *Catálogo de las pinturas y dibujos de la colección Pani*.
2. Pani, *Una encuesta sobre educación popular*; and Pani, "The Sanitary and Educational Problems of Mexico."
3. Fell, *Años del Águila*, 56.
4. L-E-955 to 966, 1921, AHSRE; 104-C5, 1921, AGN; Vasconcelos, *Desastre*, 54–58; Atl, *Artes*, 7; "Hoy se publica el decreto," *EU*, 8 July 1921; "El comité ejecutivo," *EU*, 14 May 1921; and "Cómo esta integrado," *EU*, 19 July 1921. SEP did not yet exist, so Vasconcelos would not have been invited to appoint a representative, as he claimed. Plans for centennial festivities emerged first from the private sector, as *El Universal* and other newspapers organized events and contests, including the India Bonita Contest: see López, "India Bonita Contest," 291–328. Though the centennial tax was extremely controversial, it had strong support from the two major newspapers, *El Universal* and *Excélsior*, and it won several legal challenges: "Creación del impuesto," *EU*, 17 July 1921; "No es anticonstitucional," *EU*, 24 Aug. 1921; "Los que han pagado," *EU*, 20 Sept. 1921. The United States rejected the Obregón regime and sent no representative. On the individuals' backgrounds, see *Diccionario Porrúa* (1995), 209, 544. For a discussion of the

range of events that comprised the Centennial, see Lacy, "The 1921 Centennial Celebration," 199–232.

5. "Serán populares," *EU*, 15 May 1921; "¿Cuáles serán los festejos populares del centenario?," *EU*, 20 May 1921; "Aspectos del Centenario," Editorial, *EX*, 21 Aug. 1921. Distancing from 1910 was not unanimous among boosters but it was part of the official stance by the Centennial Committee.

6. L-E-1652, Libro de Actas, Acta no. 19, 16 June 1921, AHSRE; "Programa General," *EU*, 1 Aug. 1921; "Garden Party," *EU*, 25 June 1921; "La Secretaría de Comunicaciones," *EU*, 7 July 1921; "Centenares de soldados," *EX*, 4 Aug. 1921; and "La Noche Mexicana," *EU*, 6 Sept. 1921. On Chapultepec celebrations of the 1880s, see Wakild, "Naturalizing Modernity," 101–23.

7. F. Boas to A. Best Maugard, 8 Dec. 1926, APS-FB; A. Best Maugard, published interview, 1964, BMP/59, INBA; Best Maugard, *Album de colecciones arqueológicas*; and Cordero, "Para devolver su inocéncia a la nación," 12–13. For a discussion of Mexicans' interest in German and French vitalism, see Swarthout, *Assimilating the Primitive*, 2–20; and Jorge Loyo, "Adolfo Best nos dijo," *EUI*, 3 June 1926, 11.

8. "Otro éxito fue ayer," *EU*, 29 Sept. 1921; "La Noche Mexicana en el Bosque de Chapultepec," *EUI*, 29 Sept. 1921, 26–27; "Hoy se repite la Noche Mexicana," *EU*, 28 Sept. 1921; "Programa general," *EU*, 1 Sept. 1921; "La Noche Mexicana," *EU*, 6 Sept. 1921; "Programa oficial," *EX*, 1 Sept. 1921; Manuel Palavicini, "La Noche Mexicana," *EU*, 28 Sept. 1921; Frances Toor, "El jarabe antiguo y moderno," *MF* 6 (1) (1930): 32–33; Givner, *Katherine Anne Porter*, 146–47. Whether the first performance was in 1918 or 1920 is unclear, though the latter is more likely. Castro Padilla in 1921 also gained fame for his stage creation "Indio Bonito," and for his other work with Pereda.

9. A. Best Maugard, "Conferencia sobre México" (from a speech, 2 Oct. 1922, San Francisco), BMP/59, INBA; and José Juan Tablada, "La función social del arte" (xii) and Pedro Henríquez Ureña, "Arte Mexicano" (133), in *Manuales*; and Cordero, "Para devolver," 18.

10. Chatterjee, "Whose Imagined Community?," 242.

11. Ai Camp, "The National School of Economics and Public Life in Mexico"; Viviene Mahieux, "Cube Bonifant, una flapper en la crónica Mexicana," *El Universal Online*, 11 Nov. 2006, www.eluniversal.com.mx/graficos/confabulario/11-nov06.htm, visited 22 March 2007; and Paul Hampton, "What Trotsky on Mexico can tell us about Venezuela and Chavez," *Workers Liberty* 3 (10) (March 2007): 3.

12. Jerónimo Coignard (Francisco Zamora), "El valor efectivo de ballet mexicano," *EUI* (13 Oct. 1921): 32.

13. Coignard, "El valor efectivo." There also were Mexicans who, like their European

counterparts, looked to the urban, rather than the rural, masses. Mexican urban life, however, was not perceived as having the same level of urbanity or over-modernity as did Paris, Berlin, or New York. Groups that did try to give urban life this centrality were not widely embraced, and only today are they receiving attention in art historical circles. See Staller, "Mélies' 'Fantastic' Cinema and the Origins of Cubism"; Weiss, *Popular Culture of Modern Art*; and Cordero, "Constructing a Modern Mexican Art."

14. Hutchinson, "Myth against Myth," 113.

15. Vasconcelos, *Obras*, 766–67.

16. Quoted in Blanco, *Se llamaba Vasconcelos*, 80–81.

17. Vasconcelos, *El desastre*, 23, 56–57. This aspect of Vasconcelos's thinking is addressed also by Florescano, *Imágenes de la patria*, 310.

18. Salvador Novo (b. 30 July 1904), "Jalisco-Michoacán (1933)," *Viajes e ensayos I*, 676. On the policing of the boundary between high and low culture, especially during moments of major social and political transition, see Bourdieu, *Distinction*; Schor and Holt, introduction to *The Consumer Society Reader*; Levine, *Highbrow/Lowbrow*; and Williams, "The Dream World of Mass Consumption." On popular art and the boundary between high and low in Mexico, see Cordero Reiman, "Jerarquía socio-cultural y la historia del 'Arte Popular.'" On *cursilería*, see Valis, *The Culture of Cursilería*.

19. Vasconcelos, *El desastre*, 23, 56–57; Best, *Manuales*, 9, 17–18. As Swarthout points out, Vasconcelos, too, drew on antirationalist philosophers more than scholars acknowledge. See Swarthout, *Assimilating the Primitive*, 2–20.

20. Ortiz Gaitán, *Entre dos mundos*, 59. On Rivera in Paris, see Green, *Cubism and its Enemies*, 7–8.

21. Montenegro, *Planos en el tiempo*, 87; and Cordero, "La colección Roberto Montenegro." *Artes de México*, no. 14.

22. Vázquez Santa Ana, speech published as "Conferencia sobre el arte"; Vázquez Santa Ana, ed. *Canciones, cantares y corridos mexicanos*; and Bautista García, "Maestros y masons." On Vázquez, also see Pérez Montfort, *Avatares*, 50–52; and Montfort, "Historia," 94.

23. Juan del Sena, "El renacimiento de un arte autóctono," *EUI*, 31 March 1921; "Exposición de Artes Populares," *Heraldo de México*, 20 June 1921; "Exposición de arte aborigen," *EU*, 26 June 1921; Julian Sorel, "La Exposición Mexicana," *EU*, 25 Sept. 1921.

24. Vasconcelos quoted in Pérez Montfort, *Avatares*, 53.

25. Gerardo Murillo to Félix Palavicini, 19 Oct. 1914, quoted in Castellanos et al., 35.

26. "Quedó suprimido el Proyecto," *EU*, 5 June 1921; "Exposición de arte aborigen," *EU*, 25 June 1921; "La exposición de arte popular constituirá un acontecimiento: Ha comenzado a recibirse diversos objetos e algunas regiones de la República,"

EU, 8 July 1921; Atl, "Artes Populares de Mexico," typescript, unpublished 3rd ed. of *Artes populares en México*, box 4a, folder 2, BN-FR-Atl; Atl, *Artes*, 21–27; "El Pueblo tendrá acceso," *EU*, 2 June 1921; Gov. of Yuc., circ. 5075, 6 July 1921, leg. 680, AGY-PRG-CRMH (thanks to Sarah Buck for the Yucatán documents); L-E-1652, Libro de Actas, Acta 8, 3 June 1921, AHSRE; and Julian Sorel, "La Exposición Mexicana," *EU*, 25 Sept. 1921.

27. Gov. of Yuc., circular 5075, 6 July 1921; Jorge Enciso to Gov. of Yucatán, 13 July 1921; and Gov. of Yucatán to the Comisión Organizadora de la Fiestas del Centenario, 27 July 1921, legajo 680, AGY; "La Exposición de Arte Popular," *EU*, 8 July 1921.

28. Antonio Gramsci notes that every relationship of hegemony is necessarily an educational relationship: *The Antonio Gramsci Reader*, 348.

29. Jorge Enciso to Gov. of Yucatán, 13 July 1921, legajo 680, AGY.

30. "Ayer inauguró," *EU*, 20 Sept. 1921; "Programa general," *EU*, 1 Sept. 1921; "Fiestas del Centenario," *EU*, 19 Sept. 1921; "La inauguración," *EX*, 20 Sept. 1921; and Toor, "Mexican Folkways." On the use of typical food in 1910, see Lara Erizondo, "Gerardo Murillo, Dr Atl," 263; and Julian Sorel, "La Exposición Mexicana de Arte Industrial Popular," *EU*, 25 Sept. 1921. The serving of popular food in official events was not new. In the 1880s, for example, the government served 20,000 tamales and 10,000 liters of atole at the inauguration of Balbuena Park, a park intended for the working class. See Wakild, "Naturalizing Modernity," 116. To do the same for an elite event, as with the 1910 event, or as a broad-based nationalist event, as in 1921, however, was an overt political statement.

31. Atl, *Artes*, 22.

32. Florescano, *Imágenes*, 316; and Oles, "For Business or Pleasure," 20.

33. Azuela, *Arte y poder*, 331.

34. "Ayer inauguró," *EU*, 20 Sept. 1921; "Fiestas del Centenario," *EU*, 19 Sept. 1921; "La inauguración," *EX*, 20 Sept. 1921; Toor, "Mexican Folkways," 205–11; Atl, *Artes*, 21–22; Toor, *Mexican Popular Arts*, 11; and S. Suárez Longoria, "La exposición de arte popular," *Azulejos*, Oct. 1921, 29–30.

35. Atl later misrepresented his role, claiming that he had been the, or one of the, principal organizers of the exhibition and also claiming that others such as Diego Rivera, Adolfo Best Maugard, and Carlos Argüelles had helped organize it. See, for example, Arroyo, *El Dr. Atl. Paisajista puro*, 78.

36. José Clemente Orozco, "Autobiografía, captulo II," p. 24, typescript draft, n.d., box 6, folder 10, BN-FR-Atl.

37. Orozco, quoted in Arroyo, *El Dr. Atl. Paisajista puro*, 26–27.

38. Atl, "Mi verdadero nombre," typescript, box 1, folder 39, BN-FR-Atl; Sáenz, *Símbolo y la acción*, 6–7, 138.

39. Atl, typescript, "El mundo será Comunista," n.d., box 2, folder 41; Atl, type-

script, "La revolución mexicana y los mexicanos en París," n.d., box 2a, folder 94; Atl, typescript, "Primer Guión para la autobiografía," 1959, box 6, folder 5; n.a., typescript, "Notas de un serie de entrevistas," box 6, folder 9, BN-FR-Atl; and Orozco, *Autobiografía*, 40–45.

40. Sáenz, *Símbolo*, 310–11.
41. Quoted by María Teresa Pomar A., "Presentación," in Atl, *Artes*, ix.
42. Atl, *Artes*, 7 and 21.
43. Atl, *Artes*, 11–12 and 57.
44. Gamio, *Forjando patria*.
45. Atl, *Artes*, 15.
46. For insightful discussion of modernism and antimodernism, see Hughes, *Consciousness and Society*; Lears, *No Place of Grace*; Schorske, *Fin-de-Siecle Vienna*; Ecksteins, *Rites of Spring*; Graña, *Modernity and Its Discontents*; and Spengler, *Decline of the West*.
47. Atl, *Artes*, 22–23, 32–38, 41 and 444.
48. Atl, *Artes*, n.p.
49. Atl, *Artes*, n.p., 28, 110, 125, 135 and 150–153,
50. Atl, typescript, "Sobre las modas pictóricos," n.d., box 2a, folder 106; Atl, typescript with marginalia, n.t., n.d., box 4a, folder 10, BNA. Also see Juan del Sena, "El Doctor Atl conferencista," *EUI*, 2 Jan. 1921, 8–9; and Atl "Artes Populares de Mexico," unpublished 3rd ed., folder 2, box 4a, BNA.
51. Atl, *Artes*, n.p., 28, 46–47, 86, 110, 125, 135, 150–53 and 443–44.
52. Mexicans' intellectual and public fascination with what they considered the exotic qualities of their homeland is skillfully addressed in Sierra, "Geografías imaginarias II"; Cordero, "Para devolver"; Cordero, "Constructing a Modern Mexican Art"; and Cordero, "Del mercado al museo." Even as they sought to part ways with European traditions, they echoed the European fascination with the peasantry and the *volk*. See Silver, *Esprit de Corps*; Antliff, *Inventing Bergson*; Weiss, *Popular Culture of Modern Art*; Kedourie, *Nationalism*; Lebovics, *True France*. On Mexicans' eclectic use of various strands of European intellectual discourses, see Swarthout, *Assimilating*, 1–22. Mexican efforts would be echoed in subsequent years, in different ways by movements in the Caribbean, South America, and Asia. See, for example, Moore, *Nationalizing Blackness*; and Brandt, *Kingdom of Beauty*. Ironically, by turning their modernist vision toward their own peasantry they continued to parallel their European counterparts, who likewise turned away from internationalism toward a metaphysical view of their own primordialist nationality rooted in the peasantry.
53. For an insightful discussion of the contradictory way this functioned in Colombia, which had many parallels with Mexico in this regard, see Andrés Guerrero, "Redrawing the Nation."

Chapter 3: Foreign-Mexican Collaboration

1. Justino Fernández, *Textos de Orozco* (Mexico: UNAM, 1955), 112, quoted in Rodríguez Prampolini, "La figura del indio en la pintura del siglo XIX: Fondo ideológico," 217. Also see, for example, Rafael López, "Hebdomadarios," *EU* (ca. 15 July) 1921, and Pontón, "Las razas indígenas de México," 418.

2. See Delpar, *Enormous Vogue*; Tenorio, "The Cosmopolitan Summer," 224–42; Britton, *Revolution and Ideology*; Pike, *The United States and Latin America*; and Oles, *South of the Border*.

3. Quoted in Givner, *Katherine Anne Porter*, 15; and Kraver, "Laughing Best," 49.

4. Givner, *Katherine Anne Porter*, 17, 61–62 and 146–47.

5. Ibid., 148–65.

6. Porter, *Outline of Mexican Arts and Crafts*; Alfonso Caso, Bibliografía de las artes populares plásticas de Mexico," *Memorias del Instituto Nacional Indigenista* 1 (2) (1950): 84; Givner, *Katherine Anne Porter*, 167. At that time the Ministry of Industry was called the Secretaría de Industria, Comercio, y Trabajo, and soon after changed its name to the Secretaría de la Economía Nacional. At the time, Alfonso Caso served as undersecretary of the Ministry of Industry.

7. Givner, *Katherine Anne Porter*, 167; Porter, *Outline*; Oles, "For Business or Pleasure," 18–22; SICTTS to SRE, 7 Aug. 1922, folder 21-5-21, AHSRE; Caso, prologue, 84.

8. Givner, *Katherine Anne Porter*, 255; Toor, "Mexican Folkways," 208–9; Toor, *Mexican Popular Arts*, 10–11; Alvaro Obregón, "El Intercambio de Estudiantes con Estados Unidos," *EU*, 21 May 1921; Universidad Nacional de México, *Escuela de Verano*, 4; Universidad Nacional de México, *U.N. de México Escuela de Verano*, 18–19; Novoa, "Offshoring," 132, quoting William Barrien, dustjacket to Frances Toor's *Spanish for Your Mexican and Cuban Visits* (Mexico City: Frances Toors Studios, 1941); Azen Krause and Gugenheim, *Los judíos en México*, 162; and Argenteri, *Tina Modotti*, 93.

9. Febres, *Pedro Henríquez Ureña*; and García de Brens, "Pedro Henríquez Ureña."

10. Toor, "Mexican Folkways," 208–9; Toor, *Mexican Popular Arts*, 10–11; Gamio to Boas, 6 June 1917, box 1, folder 34; Gamio to Boas, 27 Feb. 1918, box 1, folder 35; Boas to Gamio, 24 July 1917, box 1, folder 31; Boas to Gamio, various, 1918–19, box 1, folder 50; Gamio to Boas, 15 April 1925, box 2, folder 21, AHI-MG; Frances Toor to Franz Boas, 1 April 1925; Boas to Toor, 9 April 1925 and 10 March 1927, APS-FB; and Gruening, *Mexico and Its Heritage*, 526–27.

11. Gamio, "The Utilitarian Aspect of Folklore"; Bringas, "Mexican Pottery"; Brenner, "The Petate, A National Symbol"; and González Casanova, "The Magic of Love among the Aztecs."

12. Quoted in Toor, "Nuestro Aniversario."

13. Various letters between Gamio and Calles, April 1925, box 2, folder 22–29, AHI-MG; Toor, "Mexican Folkways," 208–9; and Gruening, *Mexico*, 661.

14. Toor, "Mexican Folkways," 205–10; and Toor, foreword, *MF* 1 (1) (June-July 1925): 2.

15. Tannenbaum, *Peace by Revolution*, 182–83; and Tannenbaum, "Mexico," 132.

16. Herring, *The Story of the Mexican*; CCRLA, *Ninth Seminar*.

17. Chase, *Mexico*, v and 186–87.

18. Gruening, *Mexico*, x, 635–37, 652–53.

19. Glusker, *Anita Brenner*, 21–88; Monsisváis, foreword, *Anita Brenner*, viii-x; Brenner, *Idols behind Altars*, 314; "Entrevista con el pintor Diego Rivera," *EU*, 21 July 1921; and John Charlot, interview by Alfredo Zalce discussing Jean Charlot, July 27–28, 1971, Jean Charlot Foundation, Hawaii, http://www.hawaii.edu/jcf/OthersOnJC/, visited 7 January 2008.

20. Weston, *The Daybooks of Edward Weston*, 15–21.

21. Paine, "La Casita en Cuernavaca."

22. "Proyecto de ley del Lic. Lucio Mendieta y Nuñez y del Dr. Manuel Gamio para la conservación y estudio de monumentos y objectos arqueológicos de la República," 31 Jan. 1930, published in Olivé Negrete and César, *INAH, una historia*, 2: 847; and "Estatutos de la Asociación Amigos de Taxco," 1933, box 50, SSC-MFP.

23. Fergusson, *Mexico Revisited*, 304–6; Brenner, "The Davis Collection"; and Oles, *South of the Border*, 123.

24. Fergusson, *Mexico Revisited*, 307.

25. Quoted in Oles, *South of the Border*, 127.

26. Geoffrey T. Hellman, "Imperturbable Noble," *New Yorker*, 7 May 1960, 72.

27. Fergusson, *Mexico Revisited*, 306–9.

28. "Old Mexican Arts," *Christian Science Monitor*, 26 July 1930; and Fergusson, *Mexico Revisited*, 305–9.

29. Lawrence, *The Plumed*; Lawrence, *Viva y muera México*; Toor, "Mexico through Frightened Eyes"; Toor, foreword, *Mexican Folkways*; Florence Davies, "Mexico Shows a Friendly Art," *News* (Detroit, Michigan), 15 Oct. 1930; and *Boston Herald*, 25 Nov. 1930.

30. Major studies of Spratling include Stromberg, *El juego del coyote*; Cederwall, *Spratling Silver*; Littleton, *The Color of Silver*; Mark, *The Silver Gringo*; Morrill, ed., *William Spratling and the Mexican Silver Renaissance*; and Rubín de la Borbolla et al., *William Spratling*.

31. Spratling, *File on Spratling*, 36; Spratling, "The Most Mexican City"; Spratling, "Some Impressions of Mexico"; and Doctor Atl and William Spratling, "Mexico and the Ultra-Boroco."

32. Spratling, *A Small Mexican World*, 22, 28, 31.

33. Brenner, *Your Mexican Holiday*; Anita Brenner Glusker to SEP, 13 Dec. 1930, folder 329; Eduardo Vasconcelos to SEP, 22 Jan. 1931, folder 329, and José Reygadas Vértiz to SEP, 19 Jan. 1931, AHI-DMAAH; and Glusker, *Anita Brenner*, 139–48 (quote from 148).

34. Pilar Fosado, interviews, 12 May 1997, 29 Sept. 1998, and 10 Feb. 1999, Mexico City.

35. Sáenz to d'Harnoncourt, 21 May 1929 and 11 Dec. 1929, section 2, DHP.

36. On Solchaga, see Mario Valles, Sergio Cerda Valles, and Sara Angel Calderón, interviews, 17 and 18 June 1999, Patzcuaro, Michoacán; and Joseph Cloud, "Old Mexico," *Press* (Pittsburgh), 25 Jan. 1931.

37. For more on the political and cultural activities of the Morrows in Mexico, see López, "The Morrows in Mexico"; Collado Herrera, "La mirada de Morrow sobre México"; and Azuela, *Arte y poder*, 275–300.

38. Quoted in Delpar, *Enormous Vogue*, 17 and 40; see Melzer, "Dwight Morrow's Role in the Mexican Revolution," 162–63.

39. Ross, "Dwight W. Morrow, Ambassador to Mexico"; Ross, "Dwight Morrow and the Mexican Revolution"; Melzer, "The Ambassador *Simpático*"; Nicolson, *Dwight Morrow*; "Los títeres de Mr. Morrow," *El Machete*, June 1930; "Montes de Oca, lacayo del embajador," *El Machete*, July 1930; "El fracaso de Mr. Morrow," *El Machete*, Oct. 1930; Smith, *The United States and Revolutionary Nationalism in Mexico*, 263; and Visser, "Wall Street Agent or Amicable Diplomat?," 71–91.

40. Morrow, "Home Again." She expressed similar sentiments in "Our Street in Cuernavaca"; *Casa Mañana*; *The Mexican Years*; and her children's book illustrated by d'Harnoncourt, *The Painted Pig*. Note: much of Casa Mañana has been destroyed, but a portion of it recently was remodeled as a restaurant called "La India Bonita," named not after the 1921 contest but the mistress of Emperor Maximilian from the 1860s.

41. On Morrow's patronage, see, in the DWM Papers, box 18, folder 18; folder 23, box 25, folder 118; various, series I, box 7, folder 103; box 33, folders 37–38; box 43, folder 94–95; series III, box I, folder 1; series X, box 3, folder 81; box 4, folders 5, 60, 78, 79, and 129; Richard Garrison and George Rustay to DWM, Aug. 1930; J. Satterwhite to Garrison and Rustay, 6 Aug. 1930, series I, box 23, folder 35; DWM to Diego Rivera, 5 Dec. 1929; Allen Dawson to Mr. Dadbury, 29 Jan. 1930; Arthur Springer to Dawson, telegram, 22 Aug. 1930, series X, box 4, folder 60; Satterwaite to Springer, 11 June 1929; Spratling to DWM, 16 Aug. 1930; DWM to Spratling, 19 Aug. 1930; Spratling to DWM, n.d., series X, box 4, folder 129. Also see various letters between Elizabeth Morrow, Spratling and Carl Zigrosser, 1930–31, box 50, folder 890, SSC-MFP; Nicolson, *Dwight Morrow*, 338; Spratling, *Autobiography*, 32–42, 50, 60–61, 70–78; and Stromberg, *Juego*, 30–43.

42. See in the DWM Papers, Robert De Forest to DWM, 2 Dec. 1927, series X,

box 1, folder 167; and José Manuel Puig Casauranc to DWM, 19 Dec. 1927, series X, box 4, folder 5; Dawson to Spratling, 8 Nov. 1929, series X, box 4, folder 129; De Forest to DWM, 28 Aug. 1929; DWM to De Forest, 2 Sept. 1929, series I, box 18, folder 18; and DWM to Homer Saint-Gaudens, 17 Oct. 1929, series X, box 4, folder 79. Also see Spratling, *Autobiography*, 36; René d'Harnoncourt, transcript of interview by Isabel Grossner, New York City, 23 May 1968, OHR; and Geoffrey T. Hellman, "Imperturbable Noble." Private individuals who contributed to the exhibition included the Morrows, Frederick Davis, Roberto Montenegro, René d'Harnoncourt, the Sanborn brothers, William Spratling, Jorge Enciso, Miguel Covarrubias, Moisés Sáenz, Rafael Villegas, Frances Toor, José Zuno, Francisco Díaz de León, Manuel Rodríguez Lozano, and a number of long-established Mexican elite families.

43. Homer Saint-Gaudens to Doctor Atl, 18 Jan. 1930, box 8, folder 1b; Atl to Saint Gaudens, 17 Feb. 1930, box 8, folder 2; Atl to Saint-Gaudens, 14 and 17 March 1930, box 8, folder 3; Atl to Saint Gaudens, 30 April 1930, box 8, folder 5, BN-FR-Atl; and René d'Harnoncourt, transcript of interview by Isabel Grossner, New York City, 23 May 1968, Oral History Research Office, Columbia University, New York. For political reasons, the Metropolitan Museum formally presented Atl as co-curator at the opening in Mexico City and thanked him for facilitating the transfer of objects across the border.

44. EU, June 28 and 29, 1930; and Delpar, *Enormous Vogue*, 86–87.

45. "La Exposición de Arte Mexicano," EU, 29 June 1930; René d'Harnoncourt, transcript of interview by Isabel Grossner, New York City, 23 May 1968, OHR; Homer Saint-Gaudens to Frederick Keppel, 7 Sept. 1929, series I, box 18, folder 18, DWM Papers; Carnegie Foundation to Ezequiel Padilla, 20 Dec. 1929, section 2; handwritten page, section 4; marginalia by Sarah d'Harnoncourt, Section 6, DHP; d'Harnoncourt, *Mexican Arts*, xi and 3; and Toor, "Mexican Art, Music, and Drama." D'Harnoncourt expressed more of his views on Mexican popular art in the following articles that he wrote: "Four Hundred Years of Mexican Art," "Mexican Arts"; "The Mexican Exhibition"; "Las Artes Populares de Mexico," MF 6 (2) (1930): 56–65. For a fuller discussion of the 1930–32 Mexican Arts Show, the Morrows, the Rivera commission, and d'Harnoncourt's catalogue for the show, see the essays by Rick López, James Oles, Anthony Lee, and Susan Danly in *Casa Mañana*.

46. Azuela, *Arte y poder*, 330.

47. Pablo González Casanova to Franz Boas, 25 Dec. 1928; Boas to Gamio 22 April 1921, APS-FB; Boas to Gamio 16 March 1917 and 31 May 1917; Gamio to A. L. Jones, 1 March and 22 April 1921, AHI-MG; and Alanis, *Gabriel Fernández Ledesma*, 53.

48. L'Estoile, Neiburg, and Sigaud, introduction, 23.

49. Azuela, *Arte y poder*, 302–4.

50. Alanis, *Gabriel Fernández Ledesma*, 19–33; incorporation documents, 6 August 1925, roll 1, document 4, INBA-GFL; and Azuela, "El Machete and Frente a Frente."

51. Gabriel Fernández Ledesma to Alfonso Pulido, 9–10 Jan. 1939, INBA-GFL.

52. Rufino Tamayo, report on rural communities for SEP, typescript, 25 Oct. 1932, box 3168, folder 13–10–5–111, AHSEP-FSEP. Emphasis added.

53. See, for example, Enrique Altamirano Ferrer to Luis Sandi, 2 Jan. 1947, box 16 MAP, CENIDIAP-INBA.

54. Montenegro, Leal, and Covarrubias, *Twenty Centuries of Mexican Art*, 12, 14 and 110.

55. Lomnitz, "Bordering on Anthropology," 187–89, quote from 188.

Chapter 4: The Postrevolutionary Cultural Project

1. Cabrera, "The Mexican Revolution—Its Causes, Purposes and Results," 4; Galindo, *El mito de la patria*, 163–87; and Cabrera, "The Key to the Mexican Chaos," 11–12, 15.

2. Gamio, "The Education of the Indo-Hispanic Peoples," 52.

3. Gamio, *Forjando*, 96; and Sáenz, *Mexico*, 13–14 and 31. The best study of the Cristero conflict is Purnell, *Popular Movements and State Formation in Revolutionary Mexico*.

4. Even major studies focusing directly on cultural patrimony skip this period, jumping from 1921 to the creation of INAH at the end of the 1930s. See, for example, all the essays in Florescano, ed., *El patrimonio cultural*.

5. Basave Benítez, *México mestizo*, 124–25.

6. See Gamio, *El gobierno, la población, el territorio*; "Un gran impulso que recibe el estudio de las razas indígenas," *Excélsior*, 17 Feb. 1921; and Gamio, introduction to *La población del valle de Teotihuacan*, x–xii.

7. De los Reyes, *Cine y sociedad*, 2:109; Gamio, "Nosotros y nuestros hijos," *EUI*, 24 March 1921, 22; Gamio, introduction to *Ethnos* 1 (1): 10–12; "Reaparición de *Ethnos*," *Boletín de la SEP* (4) (2) (1925): 157–58; and "Quedó instalada la primera exposición de antropología," *EX*, 18 Jan. 1921.

8. See Swarthout, *Assimilating the Primitive*, 99–101; Lacy, "The 1921 Centennial," 215–16; Gutiérrez, *Nationalist Myths and Ethnic Identities*, 92–93; Stern, "From Mestizophilia to Biotypology," 192; and Poole, "An Image of 'Our Indian,'" 80–81.

9. Comas, introduction, xvi; and Miguel Leon Portilla, oral presentation, transcript, 15 March 1985, box 7, folder 90, AHI-MG. Scholars who have presented nuanced views on this aspect of Gamio's thinking in the 1920s include Nancy Stepan, *The Hour of Eugenics*, 150–151; Miller, *In the Shadow*, 139–42; Carmen

Martínez Novo, *Who Defines Indigenous?*, 62–64; and Florescano, *Imágenes*, 294–97.

10. Gamio, *Forjando patria*, 8; Othón de Mendizábal, "El problema social de las lenguas indígenas" and "El Departamento Autónoma Indígena de Mexico," *Obras completes*, 4: 179–80, 332.

11. Gamio first set this argument out in detail in *Forjando patria*, 23 and 103–7. He then reiterated it many times. See, for example, Gamio, "La raza indígena," *EU*, 24 July 1921. Though he claimed to reject racism, he continued to adhere to ideas consonant with eugenic theory.

12. Gamio, *Forjando patria*, 96 and 103–7; and Gamio, *The Present State of Anthropological Research in Mexico*, 14. For a useful discussion of the debates over which aspects of indigenous political culture were worth preserving, see Dawson, "From Models," 284–90.

13. Gamio, *Forjando patria*, 159–61; Gamio, "Anteproyecto del 'Instituto de Población Rural' de la Secretaría de Agricultura," typescript, 1939, box 6, folder 21, AHI-MG; Gamio, "The New Conquest"; and Florescano, *Imágenes de la patria*, 294–97.

14. Vasconcelos, *Aspects*, 3, 7, 37–38, 65, 91–92 and 101; Vasconcelos, *La raza cósmica*. Also see Villoro, *Los grandes momentos*, 239; and Vaughan, *State, Education and Social Class*, 239–66. Fear of the nonwhite lower classes was common among Mexican cultural elites, even those considered progressive. See, for example, "La raza indígena," *EU*, 24 July 1921.

15. Cardoza y Aragón and Rodríguez, *Diego Rivera*, plate 97 and caption; Hurlburt, "Diego Rivera," 53; Marnham, *Dreaming with His Eyes Open*, 159–60; Hamill, *Diego Rivera*; and Manuel Gamio, "The Mexican Federation of Labor is Conservative" [ca. 1926], typescript, folder 17, box 10, AHI-MG.

16. Blanca Jiménez, "Eulalia Guzmán (1890–1985)," *Actualidades arqueológicos: Revista de estudos de arqueología de México* 13 (July–Aug. 1997), n.p. The controversy has overshadowed Guzmán's other accomplishments. Despite her importance and the availability of her archives in the INAH, historians have yet to produce a good study of her life.

17. See *Boletín de la SEP* 3 (10) (Oct. 1925): 103 and 125–27; and Olivé Negrete and César, *INAH*, Volume 2: 30. After Gamio left the SEP in 1925 the Bureau of Anthropology fell apart. See Gamio to Boas, 27 July 1928, box 2, folder 35, APS-FB.

18. José Reygadas Vértiz to Pablo González Casanova, 24 Feb. 1931, folder 446, AHI-DMAAH; Lucio Mendieta y Núñez, "Publicación del atlas etnológico," *Boletín de la SEP* 4 (2) (1925): 157.

19. Lucio Mendieta y Núñez, "Estudio de las pequeña industrias y la situación de los habitantes del Valle de Oaxaca," *Boletín de la SEP* 4 (2) (1925): 156–57.

20. "El culto por la música nacional," *EU*, 2 Dec. 1921; and *Boletín de la* SEP 1 (4) (1923): 349.

21. At this point some began to refer to the new department as the Dirección de Monumentos Artísticos (Department of Artistic Monuments).

22. The new umbrella organization underwent various minor name permutations during its decade of existence, but its purpose remained intact. Atl and Carlos Trejo y Lerdo de Tejada, "Estudio general sobre el Departamento de Monumentos Históricos, Artisticos y Coloniales de la República," April 1930, folder 166, AHI-DMAAH.

23. Williams, *Culture Wars in Brazil*, 105, 191.

24. Olivé Negrete and César, *INAH* 2: 29–31; and Museo Nacional, *Guia oficial*. The earliest mention I have found of Pérez Taylor as director is in Pablo González Casanova to Franz Boas, 25 May 1930, APS-FB. On the organization of the photographs and the contract with Toor, see Dr. Atl, Informe mensual to SEP, Oct. 1930, folder 300; and Raygadas Vértiz to SEP, 9 Feb. 1931, folder 416, AHI-DMAAH. On popular art displays at the Museo Nacional, see Gallardo Bolanos and José Morales Escudero to Museo Nacional, 8 Aug. 1936, folder 507, AHI-ADM. On the Museo Nacional, see Debates on the founding of INAH, 20 dic., 1938, published in Olivé Negrete and César, *INAH* 2: 23–28; Luis Castillo Ledón to Head of DMAAH, 22 and 23 Sept. 1936; and Eugelogio Valdivieso, Ignacio M. del Castillo, and W. Jiménez, "Programa de las labores" [ca. Sept. 1936], v. 9, AHI-AHINAH. On the shortage of Mexican researchers, which persisted as late as the 1950s, see the letters between Gamio and Franz Boas, box 1, AHI-MG and APS-FB; Gamio, *Forjando patria*, 160–61, 173; Maldonado, "The Indian Problem"; Henríquez Ureña, "Revolución y la cultura," 34–35; Gabriel Fernández Ledesma to Alfonso Pulido Islas, 9–10 Jan. 1939, INBA-GFL; Alfonso Caso, 10 Jan. 1950 and ca. Jan. 1951; and Caso, Informe annual, ca. Jan. 1952, INI-IA.

25. Raygada Vértiz to SEP, 9 Feb. 1931, folder 416, AHI-DMAAH; Informe del Museo Nacional, 6 April 1931, folder 483, AHI-DMAAH; Enciso, "Pintura sobre madera en Michoacán y Guerrero"; Luis Castillo Ledón, "Trabajos realizados por la Dirección de Monumentos Prehispanicos del Instituto Nacional de Antropología e Historia, en el periodo comprendido de diciembre de 1934, a marzo de 1940," v. 19, AHI-AHINAH.

26. Guadalupe Nájera, circular, 9 Feb. 1932, folder 909; Jorge Enciso to Dr. Atl, head of the Department, 6 Oct. 1930, folder 244, AHI-DMAAH; Jorge Enciso, circular to Sub-Inspectors, 6 Feb. 1931, folder 3930, AHSEP-DMH; and Said, *Culture and Imperialism*, 215. On nineteenth-century surveys, see Circular núm. 5, 14 Jan. 1895, Sección de Fomento y Estadistica, Collección de Leyes y Circulares,

Xalapa, Veracruz. (I want to thank Raymond Craib for bringing this document to my attention.)

27. Carlos Trejo y Lerdo de Tejada and Doctor Atl, "Estudio general sobre el DMAAH," folder 166, April 1930, AHI-DMAAH; *Boletín de la SEP* 1 (4) (1923): 1; Atl, "Presupuesto para el año de 1931," v. 1, AHI-AHINAH; Atl to Homer Saint Gaudens, 30 April 1930, box 8, folder 5, BN-FR-Atl; Olivé Negrete and César, *INAH*, vol. 1.

28. Julian Sorel, "La Exposición Mexicana de Arte Industrial Popular," *EU*, 25 Sept. 1921.

29. Anonymous, "Propósitos," *Nuesto México* 1 (1) (1932): 5, cited in Vázquez Valle, introduction, *La cultura popular vista por las elites*, 8–9. Familiar names circulated through these various journals, including Pedro Henríquez Ureña, Doctor Atl, Alfonso Caso, Daniel Cosio Villegas, Federico Mariscal, Alfonso Reyes, Alfonso Cravioto, Genaro Estrada, Diego Rivera, Manuel Toussaint, Miguel O. de Mendizábal, Moisés Sáenz, Luis Castillo Ledón, Renato and Andrés Molina Enríquez, Manuel Ponce, Carlos Cháves, Roberto Montenegro, Pablo González Casanova, Jorge Enciso, Esperanza Velázquez Bringas, Salvador Novo, Gabriel Fernández Ledesma, José de J. Núñez y Domínquez, Rafael López, and Manuel Gamio. Most of these became part of the DMAAH. Bruce Novoa has argued that *Forma* emerged as a direct effort to create an entirely Mexican magazine similar to *Mexican Folkways*. See Novoa, "Offshoring," 129. Regarding the collection and use of knowledge by states, see Scott, *Seeing like a State*, 2–8.

30. Vaughan, *Cultural Politics*, 46, 60, 99, 103, 127–30, 184, 197–98; Leopoldo Kiel to DMAAH, "Programa de trabajos del Museo," 15 Jan. 1931, folder 367; and Jorge Enciso, Informe, 20 Jan. 1931, folder 380; SRE to SEP, 6 Nov. 1930; Vázquez to SEP, 24 March 1931; and Jorge Enciso to Reygada Vértiz, folder 423, AHI-DMAAH; Rubén Campos to Director of the Museo Nacional, 6 Sept. 1932, folder 1288, AHI-DMAAH; and various, 1934, box 3962, folder 46, AHSEP-BA. The potential income from national and foreign cultural tourism added impetus to the goal of culturally mapping the nation in visually accessible ways. For a study of how these claims about *mexicanidad* spread beyond Mexico's national boundaries among migrants, see López, "Forging a Mexican National Identity in Chicago."

31. Williams, "Base and Superstructure in Marxist Cultural Theory," in *Rethinking Popular Culture*, 416–17. This is also similar to James Scott's discussion of legibility and its implications. See Scott, *Seeing like a State*, 2–8. On Gramscian notions of negotiated hegemony, see Hall, "Gramsci's Relevance for the Study of Race and Ethnicity."

32. *Enciclopedia nacional popular de las actividades sociales, industriales, comer-*

ciales y agricolas de la República Mexicana; and José Raygada Vértiz to SEP, 9 Feb. 1931, folder 416, AHI-DMAAH. Notably, the ancient peoples of the valley were claimed as national, while the Maya and others largely were excluded from this nationalist chronology. For a fuller discussion of this tendency that carried over from the Porfirian era, see Tenorio, *Mexico at the World's Fairs*.

33. The intellectual effervescence under the Maximato also receives attention in Ortíz Gaitán, "Políticas culturales en el régimen de Plutarco Elías Calles y en el Maximato." Also see Olson, "Revolution in the City Streets."

34. Poole, "An Image of 'Our Indian.'"

35. For discussion of the role of the state and elites in shaping what on the surface appears as a counterhegemonic indigenous political identity on the part of the Mixtecos, see Martínez Novo, *Who Defines Indigenous?*

36. On Puebla and Sonora, see Vaughan, *Cultural Politics*. On *norteño* identity, see Vila, *Crossing Borders, Reinforcing Borders*.

37. Prakash, introduction to *After Colonialism*, 9.

38. Knight, "Cardenismo: Juggernaut or Jalopy?"

39. Schmidt, "Making it Real Compared to What?," 26.

40. Vaughan, *Cultural Politics*; and Palacios, "Postrevolutionary Intellectuals," 311.

41. Miller, *Red, White, and Green*, 38 and 52–54.

42. Ley de 31 de dic. de 1938, L.C.R. 545.3/340, box 898, AGN.

43. García Mora, ed., *La antropología en México* 8: 124–40, 177–94, 207–10, 296–305, 468–72, 509–28, and 588–92; I. I. I., Charter, 23 Aug. 1940, L.C.R. 533.1/1, box 684, AGN; and Lomnitz, "Bordering," 186–87. Note that these journals returned to interdisciplinarity in the late 1960s and the 1970s. Some made this shift as a response to renewed interest in Mexican national culture, folklore, and identity; others made the shift in search of new ways for critiquing the one party system.

44. Alfonso Caso to Pres. de la República 10 Jan. 1950; and Caso, Informe anual de actividades desarrolladas por el Instituto Nacional Indigenista durante el año de 1951, INI-IA. This shift was tied also to changing ideas of race, particularly the shift from neo-Lamarkianism, in which leaders felt they could direct the evolution of the people, toward a neo-Mendalist biotypology, in which social scientists abandoned the ideal of accelerated, controlled evolution. See Stern, "Mestizophilia to Biotypology," 195.

Chapter 5: The Museum and the Market

1. Errington, "La museografia de los objetos de los 'Pueblos Primitivos.'"

2. Miguel Othón de Mendizábal, informe de la Sección de Etnografía Aborígen, to dir. of the Museo Nacional, 4 Oct. 1921, box 9512, folder 399bis/3, AHSEP-

BA; Renato Molina Enríquez, "La cerámica de talavera de Puebla," *EU*, 1 May 1921; Renato Molina Enríquez and Rafael Cabildo, "Un impulso de la cerámica de Puebla," (dated 6 Jan. 1922) *Boletín de la SEP* 1 (4) (1923): 331–33; and O. de Mendizábal, "El fomento de las industrias populares," *Crisol* 1 (1) (Jan. 1929): 21–24, and 1 (2) (March 1929): 29–35. On the Sección de Fomento de las Artes Populares, also see *Boletín del Museo Nacional de Arqueología, Historia, y Etnología* vol. 1 (July 1922): 9; vol. 1 (Oct. 1922): 61; vol. 1 (Dec. 1922): 70; vol. 2 (April–July 1923): 37; and vol. 2 (April–July 1924): 150–51. Note: the final word of the Sección's title varied between "Populares" and "Aborígenes."

3. *Boletín de la SEP* 1 (4) (1923): 323–25; 1 (2) (1922): 65; 1 (3) (1922): 461–75. Also see Acta, 24 June 1922, fondo 3, legajo 8, folder 27; SDICT to SER (Secretario de Relaciones Exteriores), 7 Aug. 1922, fondo 21, legajo 5, folder 21, AHSRE; Timeline, FLG/28, INBA; José Vasconcelos, "El problema de México," *Boletín de la SEP* 1 (3) (1922): 511–32; and Alfonso Caso, "Bibliografía de las artes populares," *Memorias del Instituto Nacional Indigenista* 1 (2) (1950): 84. The only existing photographic inventory is incomplete and has many errors; moreover, it is not clear which, if any, of these items photographed in the 1950s were really from the original collection. See Photographs, CNCRPAM. Efforts to identify the objects once held by the museum are further complicated by the fact that over the years state officials pilfered the collection. See "Saquearon la colección de Roberto Montenegro," *EX*, 16 Dec. 1976.

4. "El ex-Templo transformado en Exposición de Arte Popular," *Boletín de la SEP* 4 (2) (1925): 53–55.

5. "Nuestra industria nacional," *BC*, ca.15 March 1925; n.a., n.t., *BC*, 20 Jan. 1926; "Articulos manufacturados," *BC*, 30 April 1925; and Renato Cantú, "Como vender curiosidades," *BC*, 20 Aug. 1927.

6. Mexican consul in Spain to Secretario de Relaciones Exteriores (SRE), April 1929, folder A02537, BLT-AE.

7. G. Meada y Fierro to SRE, Aug. 1929, folder A02537, BLT-AE; Meade y Fierro, "En los balnearios de Estado Unidos," *BC*, 15 Oct. 1929.

8. See R. Cantú Lara, "Curiosidades mexicanas en Nuevo Mexico," *BC*, 31 May 1925; José González Rul, "Manufactura mexicana," *BC*, 20 July 1927; Basilio Bulnes, "Artículos mexicanos en demanda," *BC*, 6 Jan. 1927; "Actividad en el comercio de curiosidades mexicanas," *BC*, 15 Dec. 1928; and Mexican consul in Dallas to SRE, 12 March 1929, folder A02537, BLT-AE.

9. Mexican consul in Boston to SRE, folder A02537, BLT-AE.

10. Atl, unpublished typescript for *Artes populares de México*, 3rd ed., n.p., box 4a, folder 2, BN-FR-Atl; "Mercado de manufactores populares," invitation to the inauguration, box 5, folder 6; Atl, typescript, "Primer guión para la autobiografía," 1959, box 6, folder 5; Atl, typescript, "Fragmentos de su autobiografía," ca. 1959,

box 6, folder 6; Atl, typescript, fragments from a draft of his autobiography, n.d., box 6, folder 8; and Antonio de la Fuente, notes from an interview with Atl, typescript, 1959, box 6, folder 9, BN-FR-Atl; Atl to Ixca Farías, 2 and 3 June 1930, folder 52, AHI-DMAAH; and various letters related to the Ex-Convento de la Merced, Jan. to Nov. 1922, box 3930, folder 3930/11, AHSEP-DMH; "Se creará un museo y un mercado de arte popular," *EU*, 17 Dec. 1929; "Se organizarán certámenes en el extranjero," *EU*, 26 Dec. 1929; and *Survey Graphic* 5 (2) (May 1924).

11. Doctor Atl, "La historia del Comité Nacional de las Artes Populares," unpublished typescript, 27 Oct. 1932, box 5, folder 5, BN-FR-Atl.

12. Moisés Sáenz to René d'Harnoncourt, 21 May and 11 Dec. 1929; Carnegie Foundation to Ezequiel Padilla, 20 Dec. 1929, section 2, d'Harnoncourt Papers; "Se creará un museo y un mercado," *EU*, 17 Dec. 1929; Doctor Atl, typescript, 27 Oct. 1932, box 5, folder 5; Homer Saint-Gaudens to Atl, 24 Feb. 1930, box 8, folder 2, and miscellaneous fragments of autobiographical writing, typescript, n.d., box 6, folder 8, BN-FR-Atl; and Valerio Prieto, implementation plan for the Museo de Artes Populares, folder 3, 15 Feb. 1930, AHI-DMAAH. These goals continue to inform the efforts of today's popular art advocates.

13. Carlos Trejo y Lerdo de Tejada and Doctor Atl, Estudio general sobre el DMAAH, folder 166, April 1930, AHI-DMAAH; *Boletín de la SEP* 1 (4) (1923): 1; Atl, "Presupuesto para el año de 1931," v. 1, AHI-AHINAH; Atl to Homer Saint-Gaudens, 30 April 1930, box 8, folder 5, BN-FR-Atl; Olivé Negrete and César, *INAH, una historia*, vol. 1; various, 1930–1931, folder 420, AHI-DMAAH; Montenegro, "Labores desarrolladas por el Museo de Artes Populares," *Boletín de la SEP* 9 (1–3) (1930): 110; José Reygadas Vértiz to Secretario de la SEP, 15 Jan. 1931, folder 3; Montenegro, circular, included with a letter to Reygadas Vértiz, 11 March 1931, folder 469; Reygadas Vértiz to Secretario de la SEP, 9 Feb. 1931, folder 416; Salvador López to Bellas Artes, 1931; Montenegro to Reygadas Vértiz, 27 Aug. 1932, folder 469; Acquisitions inventory from the Museo de Artes Populares, 25 Jan. 1933, folder 1499, Rubén Campos, report on the project to create the Museo Ethnográfico, 30 Oct. 1930, folder 283; Montenegro to the Secretario de la SEP, 15 Dec. 1930, folder 3; Jorge Enciso, Informe, 20 Jan. 1931, folder 380; José Reygadas Vértiz to Secretario de la SEP, 12 Jan. 1931; and Montenegro, memorandum, 10 Jan. 1931, folder 3, AHI-DMAAH.

14. Miguel O. de Mendizábal, "El fomento de las industrias populares, *Crisol* 1 (1) (Jan. 1929): 21–24 and 1 (2) (March 1929): 29–35; "Industrias populares," *El Nacional Revolucionario* [later changed to *El Nacional*], 11 March 1931; and "Las industrias populares deberán ser protejidas," *EU*, 11 March 1931. At this time, Mendizábal was director del Instituto de Investigaciones Sociales at the Universidad Nacional.

15. Toor, *Mexican Popular Arts*, 12.

16. Subsecretario de la SEP to Secretario de Hacienda y Crédito Público, 24 April 1930, folder 7; Carlos Trejo and Doctor Atl, Estudio General, April 1930, folder 166; and DMAAH budget for 1931, folder 252, AHI-DMAAH.

17. Montenegro, "Labores desarrolladas," 110; Valerio Prieto to Atl, 8 July 1930, folder 121; Montenegro, report on the activities of the Museo de Artes Populares for the month of Sept. 1930, folder 259; and Trejo and Atl, Estudio General, April 1930, folder 166; Montenegro to President Pascual Ortíz Rubio, 21 July 1930, folder 144; Francisco Carbajal, Secretario General de Gobierno de Toluca (Edo de México), to Montenegro, 19 June 1930, folder 77; José Reygadas Vértiz to Secretario de la SEP, 15 Jan. 1931, folder 3; Roberto Montenegro to José Reygada Vértiz, 1 Dec. 1931, folder 469; Ignacio Marquina to Jefe del Departamento Administrativo, 16 Dec. 1932; and Roberto Montenegro to SEP, c. 16 Dec. 1932, folder 1428; and Roberto Montenegro to SEP, 29 Dec. 1932, folder 1438, AHI-DMAAH.

18. Enrique Ortíz, to SEP, 16 Jan. 1932; Oscar Duplán to the Secretario de Industria (with a transcription of a letter from Genaro Estrada, Mexican ambassador in Madrid), 12 Dec. 1932; Montenegro to Enciso, 10 Feb. 1933; Luis Tijerina Almaquer to the Secretario de Relaciones Exteriores (SRE), various March through May 1933; SRE to Luis Tijerina Almaguer, various March through May 1933; Minister of the SRE to SEP, various March through May 1933; Montenegro to Bellas Artes, 6 May 1933; inventory list sent to Genaro Estrada [April 1933]; Montenegro to Carlos Chávez, 25 May 1933; Anonymous, memo, ca. June 1933; receipts, 1933, box 9512, folder 1281, AHSEP-BA; Montenegro, receipts and letters, 1933, folder 340, AHI-ADM; Mario Valles, interview, 17 June 1999, Pátzcuaro, Michoacán.

19. SEP, 50 años de artes plásticas en el Palacio de Bellas Artes, 20.

20. Entry for 22 Sept. 1934, Cronología de exposiciones en el Palacio de Bellas Artes, INBA-CI; "Visita a la sala de arte," La Prense, 2 Oct. 1934; Memorias de la SEP, 31 Aug. 1935: 343; Montenegro to SEP, 29 Dec. 1932, folder 1438, AHI-DMAAH.

21. Roberto Montenegro, informe, 21 Dec. 1934, box 9513, folder 39971bix/3; "Relación del personal del Museo de Artes Populares y de las Galerias de Pintura y Escultura," 7 June 1934, box 3958, folder 17–9–9–280/281; Eduardo Vasconcelos to Jefe del Departamento de Administración, 5 June, folder 17–9–10–10, box 3960; Head of the Departamento de Bellas Arts, informe, 1931, folder 17–9-9–116, box 3954; and Angel Carvajal to the Head of Bellas Artes, 16 Feb. 1935, folder 17–10–4–116, box 3975; Postcards, 1934, box 3959, folder 17–9–10–48, AHSEP-BA. Montenegro to Lázaro Cárdenas, 9 Dec. 1934, L.C.R. 135.2/71, box 101, AGN; Inventory of purchases by the Museo de Arte Popular from Frederick Davis [1934]; Montenegro to SEP, 5 June 1934; Antonio Castro Leal to SEP,

19 June 1934, Inventory, 20 June 1934, box 3930, folder 3930/8–16–21–2-222, AHSEP/SMHAC; and Fernández Ledesma, memorandum, 28 Dec. 1934, roll 1, doc. 15, INBA-GFL. Cárdenas does not seem to have taken him up on the offer.

22. Montenegro to Lázaro Cárdenas, 9 Dec. 1934, L.C.R. 135.2/71, box 101, AGN; Cantú Montenegro, interview, "Roberto Montenegro, primero en valorar la artesanía y tradiciones populares mexicanas," EX, 9 July 1972; Fernández, *Montenegro*, 19; Gaitán, *Entre dos mundos*, 78; Atl, unpublished typescript for *Artes Populares de México*, 3rd ed., pp. 14–15, box 4a, folder 2, BN-FR-Atl.

23. Atl, unpublished typescript for *Artes Populares de México*, 3rd ed., pp. 14–15, box 4a, folder 2, BN-FR-Atl; Cantú Montenegro, interview, "Roberto Montenegro, primero en valorar la artesanía y tradiciones populares mexicanas," EX, 9 July 1972; and various letters from 29 Dec. 1934 through 16 Feb. 1935, L.C.R. 703.2/40, box 1266, AGN.

24. "Destitución del Lic. Antonio Castro Leal," EX, 29 Sept. 1934.

25. Aguilar Camín, *In the Shadow of the Mexican Revolution*, 129–58; Anguiano, *El estado y la politica obrera del cardenismo*; Haber, *Industry and Underdevelopment*, 171–89; Warman, *Y venimos a contradecir*; Knight, "The Rise and Fall of Cardenismo"; and Joseph, *Revolution from Without*.

26. José Romo and Genaro Tamayo (Coahuila), Mexican Consul Report, "Los turistas no pagan derechos de importación"; n.a., Mexican Consul report, April 1932, folder A02539, BLT-AE; "Venta de curiosidades en la frontera," BC, 15 July 1930; "Demanda de curiosidades en Seattle," BC, 31 May 1930; "Exportaciones y demandas de las curiosidades mexicanas en la frontera," BC, 15 May 1930; "Ayuda a manufacturas de caracter nacional," EX, 27 May 1934; "Gran demanda," EN, 9 Oct. 1935; "Estados Unidos, mercado para curiosidades," BC, 31 Jan. 1930; Efrain Domínguez, "Ideas para nuevos artículos de curiosidades mexicanas," *Revista del Comercio Exterior*, October 1938.

27. Edmundo Gonzalez, Consul report (Detroit), BC, 31 July 1929; Filomeno Mata (Consul in Boston), "Como intensificar la exportación de 'curiosidades mexicanas,'" BC, 31 May 1930; and Consul report, "Muestrario de curiosidades mexicanas," Jan. 1930, folder A02539, BLT-AE.

28. "El Almacén de Ventas de Objetos Típicos," EU, 20 Sept. 1934; "Serán fomentadas las industrias típicas," *La Prensa* (San Antonio, Texas), 13 Sept. 1934; "Almacén de Ventas de Artículos Típicos," EU, 21 Sept. 1934; "Una exposición de los productos típicos," *La Prensa*, 19 March 1935; "Cooperativa de Industrias Populares," *El Economista*, 1 Feb. 1935; "Una decidida ayuda," EN, 7 Sept. 1934; and Federico Otero M. Cajero to the office of President Cárdenas, 3 March 1934, box 101, L.C.R 135.2/71, AGN. Also see folder M.A.C. 111/611, box 537, AGN.

29. See folder M.A.C. 111/611, box 537, AGN.

30. Virginia Huerta, "Una laudable obra," EU, 10 Dec. 1936; "La impulsora de artes

típicas," *El Día*, 29 Nov. 1935; "Inaguración de 'Industrias Típicas Mexicanas,'" *El Día*, 1 Dec. 1935; "Importante exposición," EU, 25 Feb. 1935; and "Se inauguró ayer," EN, 2 Dec. 1935.

31. "Nuevo campo comercial," EN, 11 Nov. 1935; "Productos típicos," EX, 22 Feb. 1935; "Gran interés en Estados Unidos," EX, 28 Jan. 1935; "Perspectivas comerciales," EN, 28 March 1938; and "Mercado para productos mexicanos," EU, 28 March 1937. The *Boletín Comercial* contains dozens of similar reports.

32. "Siguen pidiendo artículos mexicanos," *Novedades*, 11 Aug. 1942; Rudolfo Salazar (Mexican consul in Chicago), consul report, "Oportunidades para nuestros exportadores," *Revista del Comercio Exterior* (SRE), Aug. 1938; "Gran demanda de artículos de este país," EN, 17 Nov. 1941; and "Demanda comercial," EN, 11 Jan. 1943.

33. James Wilkie and Edna Monzón Wilkie, "Historia oral: Frente a la Revolución Mexicana 17 protagonistas de la etapa constructiva," *Mexico and the World* (web journal published by PROFMEX 7 (3) (summer 2002): http://www.isop.ucla.edu/ profmex/volume7/3summer02/introduccion_volumenI.htm, visited 18 June 2007.

34. Memorandum, Manuel Calderón to José Muñoz Cota, no date (ca. 1935), box 16, Museo de Artes Populares (MAP), CENIDIAP-INBA; Atl, unpublished typescript for *Artes Populares*, 3rd edition, 14–15, box 4a, folder 2, BN-FR-Atl; *Memorias de la SEP* (31 Aug. 1935): 423; Antonio Silva Díaz to head of the Departamento de Bellas Artes, 3 Jan. 1935, box 3970, folder 17–10–3–22, AHSEP-BA; José Muñoz Cota to Santiago de la Vega, 26 Dec. 34; Muñoz Cota to de la Vega, 31 Jan. 1935; and Ignacio García Tellez, to Jefe del Depto de Bellas Artes, 22 Jan. 1935; Manuel R. Calderón to José Muñoz Cota, 2 and 12 Feb. 1935, box 16, MAP, CENIDIAP-INBA. The CENIDIAP-INBA archive came to my attention thanks to an article by the art historian Karen Cordero Reiman, "Fuentes para una historia social del 'arte popular' mexicano: 1920–1950," in *Memoria* (Museo Nacional de Arte) 2 (1990): 31–55. At CENIDIAP I want to thank Patricia González, Claudia Jasso, and Esperanza Balderas for sharing their insights and facilitating access to the documents.

35. Calderón to President Cárdenas, 17 June 1937, box 16, MAP, CENIDIAP-INBA; various requests, internal correspondence, and responses, 1935–36, box 3992, folder 17–10–9–1/6/7/10 and 17–10–8-361/382/387, AHSEP-BA; "Productos típicos de México hechos en Japón," EX, 1 Aug. 1935; "Artículos de nuestro país falsificados," EN, 1 Aug. 1935; "Imitaciones de curiosidades," EU, 1 Aug. 1935; Andrés Landa y Piña, "Falsas curiosidades mexicanas," EX, 29 April 1937; Rudolfo Salazar (Mexican consul in Chicago), consul report, *Revista del Comercio Exterior*, Aug. 1938; "Articulos japoneses," EU, 6 March 1939; "Se da protección a nuestra industria autóctona," *El Nacional*, 12 March 1939; "Las curiosidades entran por Tijuana," *Gráfico*, 5 April 1939; "Consignación de las imitaciones," EN, 22 April

1939; "Temo que perjudica a nuestra industria," *EU*, 22 April 1939; "Nuestra industria típica en grave peligro," *EN*, 25 Feb. 1939; and "Siguen llegando del Japón," *EX*, 6 March 1939.

36. See Manuel Gamio, "Nuestras industrias típicas," *El Nacional*, 1 May 1936.

37. Calderón to José Muñoz Cota, 12 Feb. 1935; Calderón to Lázaro Cárdenas, 6 March 1935, box 16, MAP, CENIDIAP-INBA; and Calderón to Cárdenas, 12 April 1938, L.C.R. 536/9, box 756, AGN.

38. Calderón to Joaquín Haget, 18 Aug. 1935; Manuel Calderón to Secretario General (Yucatán), 29 July 1935; Calderón to José Muñoz Cota, 12 Aug. 1935; Calderón to Santiago R. de la Vega, 10 Dec. 1935 and 4 Jan. 1937; de la Vega to Luis Rodríguez, 24 June 1936; Calderón to Félix de la Lanza, 28 Jan. 1936; n.a., typewritten note with penciled marginalia, 23 June 1936; Calderón, informe, 4 Jan. 1937; folder 16, MAP, CENIDIAP-INBA; and Calderón, "Algo más sobre las artes populares en México," *El Nacional*, 7 Aug. 1935; and Calderón to Cárdenas, 20 May 1936, and de la Vega to Cárdenas, 24 June 1936, L.C.R. 702.1/45, box 1121, AGN.

39. Félix de la Lanza to Director of the Palacio de Bellas Artes, 9 May 1935; Calderón to de la Vega, 6 June 1935, box 3973, folder 17–10-3-283, AHSEP-BA; and Manuel Calderón to José Muñoz Cota, 20 Feb. 1935; Calderón to Félix de la Lanza, 15 Jan. 1937 and 27 March 1937; de la Lanza to Calderón, 26 March 1937, box 16, MAP, CENIDIAP-INBA; Calderón to Cárdenas, 12 April 1938; Celestino Gorostiza to Godofredo Beltrán (Oficial Major de la SEP), 12 May 1938; Calderón to Cárdenas, 11 June 1938 and 19 Sept. 1938; and Beltrán to Calderón, 13 Aug. 1938, L.C.R. 536/9, box 756, AGN.

40. Dauster, "The Contemporary Mexican Theater."

41. Calderón to Governor of Yucatán, 29 July 1935; Calderón to Presidente Municipal de Zacapoaxtla, Puebla, 19 August 1935; Calderón to Miguel Acevedo, Presidente Municipal de Olinalá, 21 Jan. and 23 Feb. 1937; Miguel Acevedo and Norberto Salgado, Secretario de Olinalá, to Calderón, 9 Feb. 1937; Calderón to Secretario General de Gobierno, Toluca, Mex, 16 March 1937, and Calderón to Odilón Avalos, Fábrica de Objeto de Vidrio, DF, 21 Jan. 1937, box 16, MAP, CENIDIAP-INBA.

42. Forms from the Secretaría de la Economía Nacional, "Visitantes a los Museos: Museo de Artes Populares," 1937–1942; and Calderón to José Muñoz Cota, 1 Aug. 1935 and 17 Jan. 1936, box 16, MAP, CENIDIAP-INBA.

43. Calderón to Director General de Educación Extraescolar y Estética, 2 Jan. 1942, box 16 MAP, CENIDIAP-INBA.

44. Roberto Montenegro to Lilio María Arrates, Panama, 2 June 1942; Salvador Toscano, Informe, Oct/ 1944; and Toscano to Director General de Educación Estética, 8 Oct. 1943, box 16, MAP, CENIDIAP-INBA. Toscano, *Arte precolombino de México y de la América Central*.

45. Montenegro to Directór General de Educación Estética and Oficial Mayor de la SEP, 13 Aug. 1945, box 16 MAP, CENIDIAP-INBA.

46. Consul report, "Curiosidades mexicanas," BC, April 1939; and A. Cano del Castillo, "Oportunidades que ofrece actualmente el mercado," BC, 5 May 1942.

47. Enrique Altamirano Ferrer to Luis Sandi, 2 Jan. 1947; Montenegro to Jefe del Departamento de Artes Plásticas, 6 Feb. 1947, box 16, MAP, CENIDIAP-INBA.

48. Fernández Ledesma, manuscript, n.d., roll 1, docs. 129–131, INBA-GFL; and n.a., FLG/28, INBA.

49. Cordero Reiman, "La colección Roberto Montenegro," quoted in Novelo, *Artesanos, artesanías, y arte popular de México*, 186.

50. Montenegro, *Museo de Artes Populares*, 4.

Chapter 6: Formulating a State Policy

1. Antonio Sánchez Torres, "Meditaciones breves: Arte popular," *Gráfico*, 26 Oct. 1938.

2. See Miller, *Red*; and the essays in Joseph, Rubenstein, and Zolov, eds., *Fragments of a Golden Age*.

3. Klesner, "Political Change in Mexico."

4. On the use of negotiated hegemony in the 1920s and 1930s, see, for example, Joseph and Nugent, *Everyday Forms*; Purnell, *Popular Movements*; Vaughan, *Cultural Politics*; and Lewis and Vaughan, eds., *Eagle and the Virgin*. Joseph, Rubenstein, and Zolov, *Fragments of a Golden Age*, opens the way for a nuanced approach to the post-1940s period, but it does not lend the same level of attention to institutions and state structures as do the studies that focus on the 1920s through the 1930s.

5. "Mejor organización del mercado típico," EU, 10 Nov. 1949.

6. Roberto Montenegro, radio address, transcribed as "Importancia de las artes folklóricas," EN, 24 May 1937.

7. Toor, *Mexican Popular Arts*, 12–14; her emphasis.

8. Enrique Othón Díaz, "Porvenir de las industrias populares de México," EN, 5 August 1945; and Alardo Prats, "Los tesoros artísticos en peligro," *Hoy*, 1 July 1944, 28–29.

9. Natalia Valle, "Luces y sombras de México," EN, 4 Jan. 1950.

10. "Rutas y Horizontes," EU, 2 July 1956; Félix Angulo Castuñón, "Debe organizarse la industria típica," EU, 13 March 1953; and Antonio Gazol, "La significación economica del artesanado mexicano," *Novedades*, 24 Oct. 1959.

11. Alfonso Caso, "La protección de las artes populares."

12. Caso, "¿Arte mexicano o arte en México?" and Caso, "El arte popular mexicano" (these were republished in Alfonso Caso, *La comunidad indígena* (Mexico: SEP,

1971), 215–38; Ley orgánico del Instituto Nacional de Antropología e Historia, promulgado el 31 de diciembre de 1938," published in Olivé Negrete and César, eds., *INAH, una historia*, 2: 38; and Carlos Romero Giordano, "Réquiem por un museo," *Mexico Desconocido Online*, adapted from *México en el Tiempo*, no. 3 (Feb.–March 1995), visited 13 June 2005.

13. Saragoza, "The Selling of Mexico," 108; and Pérez Montfort, *Avatares*, 31.

14. Alfonso Caso to Mexican President, 30 July 1949, INI-IA; and Alfonso Caso and Manuel Germán Parra, introduction and prologue, *Densidad de la población de habla indígena en la República Mexicana*. My thanks to Amado Mendoza and Angel Baltasar for orienting me in the Fondo Documental del Instituto Nacional Indigenista. Alfonso Caso to Mexican President, 30 July 1949, 10 Jan. 1950, 4 Aug. 1951, and ca. Jan. 1951; Caso, informe, ca. Feb. 1950; Caso, Resúmen de las actividades desarroyados durante el año de 1950 en el Instituto Nacional Indigenista, ca. Jan. 1951, INI-IA; Various, folder COMG/212, INBA; invitation card to Mexican President, June 1951, M.A.V., AGN; Romero Giordano, "Réquiem"; Caso, *Bibliografía de las artes populares*; and Martínez Peñaloza, "El folclore y las artes populares," 232–33.

15. "Museo de Artes e Industrias Populares," *El Día*, 3 Sept. 1983; "Reabrirán el Museo del INI," *EX*, 12 Jan. 1990; and INI, "Museo Nacional de Artes e Industrias Populares," brochure (Mexico: INI, ca. 1971), folder EC/M/109, INBA; Andrés Molina Enríquez to Reygadas Vértiz, 11 Feb. 1931; Reygadas Vértiz to Molina Enríquez, Departamento de Etnografía Aborigen del Museo Nacional, 17 Feb. 1931, folder 435; and Reygadas Vértiz, to Director of the Museo Nacional, 9 March 1931, folder 347, AHI-DMAAH; Romero Giordano, "Réquiem"; Rubín de la Borbolla, "El problema indígena de México"; Alanis Patiño, "La población indígena en México," 38.

16. "Ha surgido el arte popular," *EX*, 3 Nov. 1955; "Fuerte impulso a las artes populares," *EX*, 4 Nov. 1955; "Campo abierto," *EN*, 28 Nov. 1955; Rubín de la Borbolla, *Arte popular mexicano*, 278–90; Museo Nacional de Artes e Industrias Populares, proyecto de programa y presupuesto para 1953, 1952; de la Borbolla, "Estado general de las artes populares," typescript, 6 Jan. 1953, vol. 54, folder 14, AHI-AHINAH; and Fergusson, *Mexico Revisited*, 310–12.

17. Alfonso Caso, Informe de labores de agosto de 1960 a julio de 1961, ca. July 1961, INI-IA; Alfonso Caso, Informe annual de actividades desarrolladas por el INI durante el año de 1951, ca. Jan. 1952; idem, informe, 2 Aug. 1952, INI-IA; and n.a., "Orígen de la exposición de arte mexicano en París," 1952, vol. 50, folder 28, AHI-AHINAH.

18. Daniel F. Rubín de la Borbolla, "Estado general de las artes populares," typescript, 6 Jan. 1953, vol. 54, folder 14, AHI-AHINAH.

19. Rudolfo Corona, "Industria y curiosidades," *EX*, 27 June 1958.

20. Aguilar Camín and Meyer, *In the Shadow*, 185–86.

21. "Las industrias típicas," *EU*, 25 Jan. 1960; "Primeros pasos," *Novedades*, 15 Dec. 1959; and Viveros Pacheco, "Intenso apoyo a los a artesanos," *EN*, 3 Feb. 1960; Maximo Muñoz, "La prodigiosa artesanía de Jalisco," *EX*, 20 Feb. 1961; Angel Ferreira, a series of articles following the senate commission, *EX*, 24 Jan., and 1, 4, 7, 9, and 9 Feb. 1960; and "Informe al senado sobre artesanía," *EU*, 13 Sept. 1960; "La CONCANACO," *Novedades*, 4 April 1960; "No hay ni un estudio," *EX*, 28 April 1960; "Es vital el censo de la artesanía," *EU*, 9 May 1960; "Planes para refaccionar a los artesanos," *EN*, 14 March 1960; "Ayuda efectiva," *EU*, 6 May 1960; "Declina la artesanía mexicana pese a que tiene gran demanda en el mundo," *EX*, 26 June 1960; "La artesanía nacional puede traernos divisas," *Novedades*, 27 June 1960; "Se pone en marcha un plan," *Novedades*, 23 Jan. 1961; and "Esta listo el proyecto de ley en pro de la artesanía," *EX*, 27 June 1960.

22. "Se proporciona amplia ayuda," *EU*, 28 Jan. 1962; "Nuevo mercado," *Novedades*, 26 Nov. 1962; "Buen mercado exterior," *EU*, 15 April 1963; Gutiérrez, Gutiérrez, and Novo, *México*. Records do not reveal the ultimate fate of either the Almacén or the Sociedad.

23. "El nuevo Banco de Fomento Cooperativo," *EN*, 5 March 1941; "Con 10 millones de capital," *EN*, 23 Feb. 1944; "Informe a los accionistas del Banco de Fomento Cooperativo," *EN*, 1 May 1946; "El Banco Cooperativo reparte utilidades," *EX*, 30 May 1946; "Aclaraciones del Banco Cooperativo para pescadores," *Novedades*, 23 Oct. 1954; "Rechaza los cargos contra el Banco de Fomento Cooperativo," *Novedades*, 18 May 1955; "Carta abierta," *EX*, 26 Nov. 1957; "A la opinión pública," *EX*, 1 Dec. 1957; "Fondo de Fomento de la Artesanía," *EX*, 12 Sept. 1961; "Impulso económico a las actividades de los artesanos," *EN*, 19 Oct. 1960; "Por fin se hace justicia," *EN*, 13 Sept. 1961; "Comité para distribuir fondos a las artesanías," *Novedades*, 10 Oct. 1961; Alardo Prats, "Realidad y perspectiva de la artesanía mexicana," *EX*, 20 March 1962; "Útil crédito a la artesanía," *EU*, 30 June 1963; "Reciben fuerte impulso," *EN*, 1 July 1963; "10 millones del fondo cooperativo para artesanos," *EX*, 15 Oct. 1963; "Resurgirá la artesanía en nuestro país," *EX*, 16 Nov. 1961; "Resurgirá la artesanía," *EN*, 17 Nov. 1961; "Un millón de artesanos nacional serán beneficiados," *EN*, 12 Sept. 1961; Congressional Record, LIV legislatura, year II, Periódo ordinario, 24 April 1990, Diario no. 5, http://cronica.diputados.gob.mx/DDebates/54/2do/Ord2/19900424.html, visited 26 June 2007; "Editorial: Fondo Para el Fomento de las Artesanías," *El Popular*, 13 Sept. 1961; "Fomento de la artesanía," *EX*, 13 Sept. 1961; and Manuel Lerín, "Un fideicomiso," *EN*, 15 Sept. 1961; "La artesanía puede ser uno de los renglones más importantes para nuestro comercio exterior," *Novedades*, 28 Nov. 1961; "Alta importancia de la artesanía," *EX*, 15 Jan. 1962; "Varios paises," *Novedades*, 16 Feb. 1962; and "Más exportación de articulos de arte popular," *Novedades*, 22 April

1962; and "La artesanía nacional produce al país cuatrocientos millones de pesos al año," folder G01091, BLT-AE.

24. Felicitas Ayala Mejía, interview, 20 Jan. 1999; "Se presenta a Primer Salón de la Artesanía Nacional," EU, 12 Sept. 1960; "Alta importancia de la artesanía," EX, 15 Jan. 1962; "La artesanía y el arte popular," EX, 12 April 1962; Nidia Marín, "Tendrá Pátzcuaro un centro artesanal," EU, 28 July 1968; Arnulfo Uzeta, "La rendención de los artesanos," EX, 29 July 1963; "Créditos a artesanos de Michoacán," EX, 26 June 1963; and "Créditos para la artesanía nacional," EX, 17 April 1965.

25. Lucia Espinola Almanza, "La artesanía mexicana," EU, 21 July 1963; "Estímulo a los artesanos," EN, 16 July 1963; and "10 millones del fondo," EX, 15 Oct. 1963.

26. Zolov, "Showcasing the 'Land of Tomorrow; Rodríguez Kuri, "Hacia México 68"; and Blacker-Hanson, "'La Lucha Sigue!'"

27. Young Coral, "El Fondo aumentó," EN, 7 Dec. 1968; "Crearán el Palacio de Artesanías," EX, 22 Dec. 1968; "Protección para los artesanos," EU, 22 Dec. 1968; "Causa sensación el Gran Salón de la Artesanía," EX, 26 March 1968; "Amplio impulso," EX, 26 March 1968; "Inmensa," EX, 28 March 1968; Rubín de la Borbolla, *Arte popular mexicano*, 279; "Meta de la SEP," EN, 2 Feb. 1963; Otto Somarriba Salazar, "Notable exposición," EU, 29 Nov. 1962; "Nuevo concepto," EX, 22 March 1963; "Entrega de premios," EN, 23 March 1963; Frotino Ibarra, "Nacen un nuevo estilo," EX, 13 May 1963; René Tirado Fuentes, "Crédito al artesano," EX, 18 Jan. 1964, and "Explotación de artesanos," EX, 28 June 1972.

28. José Valderrama, "Duerme el sueño," *Novedades*, 30 May 1968; and "A punto de perderse," EU, 9 Nov. 1970.

29. Schmidt, *The Deterioration of the Mexican Presidency*; and Aguilar Camín and Meyer, *In the Shadow*, 164–203.

30. Cothran, "Pacification through Repression and Distribution," xv.

31. Schmidt, *Deterioration*, 75; and Tonatiuh Gutiérrez, interview, 28 June 1999.

32. Tonatiuh Gutiérrez, interview, 28 June 1999.

33. "Millón y medio de pesos en créditos," EU, 10 May 1971; Young Coral, "El Banco de Fomento Cooperativo," EN, 26 Dec. 1971; "La caída del dólar," EX, 15 Feb. 1973; "Donativo de 6.5 millones," EU, 3 March 1972; Manuel Méndez, "Las fresas y las artesanías," EN, 27 June 1972; and "Las Artes Populares," *Novedades*, 18 Aug. 1971.

34. Schmidt, *Deterioration*, 84–89.

35. Tonatiuh Gutiérrez, interview, 28 June 1999; and Felicitas Ayala Martínez, interview, 20 Jan. 1999. *Ayate* is a coarse cloth with an open weave made from the fibers of the *lechuguilla* plant and used by *cargadores* to transport cheap merchandise.

36. The term "frozen revolution" comes from Raymundo Gleyzer, *Mexico, the Frozen Revolution*, documentary film, 1972.

Part II: Alternative Narratives of Metropolitan Intervention

1. Atl, *Artes*, 11, and Toor, "Lacquer."
2. Prakash, introduction, 4–5.
3. Sider, "When Parrots Learn to Talk."
4. Hulme, *Colonial Encounters*, 6, 8–9, 12.

Chapter 7: The "Unbroken Tradition" of Olinalá

1. Dehouve, *Cuando los banqueros eran santos*, 32–33; Rubí Alarcón, "La encomienda de La Montaña," 429; Flores, *El tigre*, 22–23; and Coe and Coe, *True History of Chocolate*, 88–97. Bernardo de Sahagún described in 1565 the natives' lively trade in painted gourds, or *jícaras*, including the objects' prominence in the urban markets of Tenochtitlán (Mexico City). The *Codex Mendocino*, from 1547, along with Fray Diego Durán's *Historia de las indias*, from 1561 to 1581, and Hernando Alvarado Tezozómoc's *Crónica mexicana* from 1598 also point to the preconquest trade in pigments and painted *jícaras* delivered to Tenochtitlán as tribute. See Pérez Carrillo, *La laca mexicana*, 35–42; "Lacquer *jícaras* de calabaza en el México prehispánico," *Artes de México* 153 (19) (1972), 8; and Medina González, "¿Maque prehispánico?," 23. Dehouve refutes that Olinalá was the head town, claiming that the real head town lay three leagues to the northwest of Olinalá, and that it ceased to exist after the arrival of the Spanish. It is unclear whether Olinaltecos brought lacquer techniques with them when they created the town or whether they acquired them from their new neighbors. The fact that the names of all the materials and techniques were Náhuatl suggests that the colonists may have brought the craft with them. On the other hand, the distinctiveness of the Olinaltecan process and its reliance upon local materials suggest that production might have been endemic to the area.
2. Alejandro Paucic, "Geografía cultural," n.d., exp. 25, IG-AP; and Tibón, *Olinalá*, 139. On the violence that accompanied this conquest, which compelled flight, see Clendinnen, "'Fierce and Unnatural Cruelty.'"
3. Quoted in Pérez Carrillo, *La laca mexicana*, 11.
4. Martínez Rescalvo, *Reseña historica de la Montaña de Guerrero*, 27; Flores, *El tigre*, 30–35; and Muñoz, *Mixteca*, 15–16.
5. Pavía Guzmán, "Tlappan, una provincial guerrerense, datos y hechos históricos," 413; Alarcón, "La *encomienda*," 433–38; and Dehouve, *Cuando*, 100.
6. Cited by Tibón, *Olinalá*, 30–31.
7. Dehouve, *Cuando*, 101–2.
8. Quoted in ibid., 112.
9. On the Relación de Chilapa, see Dehouve, *Cuando*, 112. The Pereda y Salgado painting is reproduced in López, *Chocolate*, 49; and Cudding, "The Decorative

Arts in Latin America, 1492–1820," 110. The painting *Still Life with an Ebony Chest* is owned by the Hermitage Museum in St. Petersburg.

10. Dehouve, *Cuando*, 144 and 334.

11. Cited in ibid., 218–25.

12. Alarcón, "*La encomienda*," 439–40; Dehouve, *Cuando*, 49, 61–64; Muñoz, *Mixteca*, 18; Tibón, *Olinalá*, 27–30; Martínez, *Reseña*, 27–30; and Flores, *El tigre*, 37, 45.

13. Joseph Villaseñor y Sánches, *Teatro americano* (1746), cited in Muñoz, *Mixteca*, 16–20. He reports 372 families, but it is unclear whether this count is for the town, or for the República de Indios.

14. Inventory no. 04955, Museo Franz Mayer, Mexico City; Carrillo, *Laca*, 10–15; and León, *Los esmaltes de Uruapan*, 97 and 197.

15. Inventory no. 05146, Museo Franz Mayer, Mexico City; and Pérez Carrillo, *Laca*, 94–96 and 197.

16. Francisco Clavijero, *Historia Antiguo* (Mexico, 1780), 365, quoted in Pérez Carrillo, *Laca*, 118.

17. Cruz Soto, "Las publicaciones periódicas y la formación de una identidad nacional," 15–20.

18. José Antonio de Alzate quoted in Cruz Soto, "Las publicaciones," 20; and Cañizares-Esguerra, "Postcolonialism *avante la letter?*" 95–97.

19. Alejo de Meave, "Memoria sobre la pintura del pueblo de Olinalá."

20. Amith, *The Möbius Strip*, 353–54 and 435.

21. *Documentos relativos a las sesiones habidas en el Congreso del Estado sobre la agregación del Departamento de Tlapa para formar el nuevo Estado de Guerrero*, 8, 29 and 42, quoted in Pavía Miller, "Origen," 55–56.

22. Pavía Miller, "Origen," 55–58; Martínez Rescalvo, *Reseña*, 42–59; Salazar Adame, "La modernización"; and Bartra, "Sur profundo," 23. For a more optimistic interpretation of Alvarez, see Guardino, *Peasants, Politics, and the Formation of Mexico's National State*.

23. Salazar Adame, "La modernización," 250–56, 260–81 and 293; Martínez Rescalvo, *Reseña*, 63–67; Pavia Millar, "Origen," 70; Arce, *Memoria presentado ante la H. Legislatura del Estado de Guerrero*; Alvarez, *Memoria presentada al 8° congreso constitucional del estado de Guerrero*; and Cuellár, *Memoria presentada al congreso constitucional del estado de Guerrero*, volumes published in 1881, 1880 and 1979.

24. Martínez Rescalvo, *Reseña*, 66 and 69–70; Salazar Adame, *Movimientos*, 35; and Salazar Adame, "La modernización," 170–81 and 296.

25. Martínez Rescalvo, *Reseña*, 64; Salazar Adame, "La modernización," 283; and Dehouve, *Cuando*, 73.

26. *Periódico Oficial del Estado de Guerrero*, 5 Jan. 1910; DGE, *Censo general 1900*;

Concepción Ventura Pérez, interviews, 1999, Olinalá; Siriaco Escudero Mejía, interview, 23 Jan. 1999; Winkler, "Changing Power and Authority in Gender Roles"; and "Historia de la Parroquia de San Francisco de Asis, Olinalá, Guerrero de Dioces de Chilapa," AP-Olinalá. On the possible existence of a public school by early 1911, see *Diario Oficial*, 22 Feb. 1911, 3, though the report probably is inaccurate.

27. DGE, *Censo general 1900*; Juan Ayala Mejía, interview, 20 Jan 1999; and Ventura Pérez, interview, 21 Jan. 1999; Flores, *El tigre*, 62; Ventura Pérez, interview, 21 Jan. 1999; "Libro de la Archicofradia del Sagrado Corazón de Jesús," 4 Aug. 1911, APSFA/Olinalá; and Tithing records, 1886–1910, AP-Olinalá.

28. Hart, *Bitter Harvest*, 171–92.

29. *Periódico Oficial del Estado de Guerrero*, 30 April 1910–11 Feb. 1911; and Martínez, *Reseña*, 64–66.

30. Pavía Miller, "Orígen," 87 and 121–29; Knight, *Mexican Revolution*, 1: 80; Cárdenas de la Peña, *Historia de las comunicaciónes*; Ortiz Hernán, *Caminos y transportes en México*; Gojman de Backal, *Historia del correo en Mexico*; and Salazar Adame, "La modernización," 201, 218 and 223. On economic and infrastructural development in neighboring Morelos, see Hart, *Bitter Harvest*, 171–92.

31. Ventura Pérez, interviews, 1999; Josefa Jiménez Patrón de Ayala, interview, 25 Jan. 1999; Winkler, "Changing Power"; and Siriaco Escudero Mejía, interview, 23 Jan. 1999.

32. On changing Mexican tastes, foreign goods, and the general impact this had on Mexican manufacturing, see Chávez Orozco, ed., *La agonia del artesano*, 11; d'Harnoncourt, "The Mexican Exhibition," 134; Gamio, *Forjando patria*, 49, 144–49; Orlove, ed., *The Allure of the Foreign*; and Novelo, *Artesanías y capitalismo*, and *Artesanos, artesanias*, 118–22.

33. Ventura Pérez, interviews, 1999. On the disappearance of *rayado* and continuation of *dorado*, also see Molina Enríquez, "Lacas de México," 19; and Tithing records, 1886–1910, AP-Olinalá.

34. Knight, *Mexican Revolution*, 1: 307; and Womack, *Zapata*, 83–84. This parallels what was unfolding at that same time in San José de Gracia, Michoacán. See González, *San Jose de Gracia*.

35. Ravelo Lecuona, "La revolución guerrerense," 45–49, 74; and Jacobs, *Ranchero Revolt*, 7–12; 19, 25, 79–82 and 100.

36. Ravelo Lecuona, "La revolución guerrerense," 39–56, 107; Martínez Rescalvo, *Reseña*, 73, 88–89; López, *Historia de la Revolución en Guerrero*, 1: 41; Ravelo Lecuona, "Periodo 1910–1920," 121–22; and López, *Historia*, 1: 79–80.

37. López, *Historia*, 1: 153. The quote comes from *Periódico Oficial del Estado de Guerrero*, 20 April 1912.

38. *Periódico Oficial del Estado de Guerrero*, 3 and 10 May 1911; 29 July 1911; 30 Sept.

1911, 30 Dec. 1911; 3 Feb. 1912; 18, 20 and 30 April 1912; 1 and 25 May 1912; 27 Nov. 1912; 21 and 28 May 1913; 13 Sept. 1913; and 8 Nov. 1913; and López, *Diccionario geográfico, histórico, biográfico y lingüístico del Estado de Guerrero*, 132.

39. Martínez Rescalvo, *Reseña*, 89–90; López, *Historia*, 2: 99; Ravelo Lecuona, *La Revolución*, 387; Ventura Pérez, interviews, 21 Jan. 1999 and 17 March 1999; Guadalupe Rodríguez Torrez, interview, 30 July 1997; López, *Diccionario geográfico*, 332; and Tibón, *Olinalá*, 47–49.

40. López, *Historia*, 2: 99; Ravelo Lecuona, "La revolución guerrerense," 140; and Ventura Pérez, interviews, 21 Jan. 1999 and 17 March 1999.

41. Ventura Pérez, interview, 24 Jan. 1999; Luis Jiménez, interviews, 1999; *Periódico Oficial del Estado de Guerrero*, 22 Nov. 1913 and various 1916; López, *Historia*, 2: 99; López, *Diccionario*, 132; Ravelo Lecuona, "La revolución guerrerense," 140; and Knight, *Mexican Revolution*, 2: 60–61. The destruction has also been described in an interview with an unnamed Olinalteco who lost both parents in the disease that followed. Cabañas, "Olinalá, el pueblo que pinta."

42. Ventura Pérez, interview, 21 Jan. 1999.

43. Olinalá was not unique in this regard. Ocumicho, Michoacán had relied upon shoe manufacturing before it was destroyed by the revolution, after which it turned to ceramics, though it was not until the 1960s that Ocumicho's artisans developed a distinctive style. See Cécile Gouy-Gilbert, "El nacimiento de un arte tradicional," *Relaciones: Estudios de historia y sociedad* 6 (23) (Summer 1985): 39–104.

44. Ventura Pérez, interviews, 1999; Domitla Pantaleón, interview, 4 Aug. 1997; and Donasiano Ayala Mejía, interview, 19 Jan 1999, Olinalá. Only in the 1980s do we see the rise of female-headed workshops. Winkler, "Changing Power"; and my own conversations with local artisans.

45. Ventura Pérez, interviews, 17 March 1999, and 22–24 Jan. 1999.

46. Ventura Pérez, interview, 27 Jan. 1999; Josefa Jiménez Patrón de Ayala, interview, 25 Jan. 1999; and Domitla Pantaleón, interview, 4 Aug. 1997, Olinalá.

47. Ventura Pérez, interview, 27 Jan. 1999.

48. Gamio, introduction to *Ethnos*, 1 (1), cited in Comas, introduction, *Antología*, xiv; and "Reaparición de *Ethnos*," *Boletín de la SEP* 4 (2) (1925): 157–58.

Chapter 8: Transnational Renaissance

1. Chase, *Mexico*, 187; Elizabeth Morrow, "The Cause of Machineless Mexico," *Journal-Post* (Kansas City, Missouri), 9 Aug. 1931; d'Harnoncourt, "Mexican Arts," 19–20; d'Harnoncourt, *Mexican Arts*, 29; d'Harnoncourt, "Four Hundred Years," 71–72; and d'Harnoncourt, "The Mexican Exhibition," 134–37.

2. Atl, *Artes*, 11, and Toor, "Lacquer."

3. Quoted in Hellman, "Imperturbable Noble," 80.

4. My use of the ideas of articulation and social and cultural formations builds upon Stuart Hall's analysis of the writings of Antonio Gramsci. See Morley and Chen, eds., *Stuart Hall*; and Hall, "Race, Articulated in Society," 305–45.

5. Guardino, "Postcolonialism as Self-Fulfilled Prophesy," 251; Sider, "When Parrots Learn to Talk," 3–23; and Nadasdy, "Transcending the Debate over the Ecologically Noble Indian."

6. Paucic seems to have studied every rural corner of Guerrero and is regarded as having known Guerrero better than anyone else, but his interactions with other scholars remained minimal. In 1949, after he assembled a detailed map and encyclopedia about Guerrero, the Servicio Geográfico began paying him to keep his map and encyclopedia up to date. This seems to be part of the reason why he kept his materials organized as an archive and eventually passed them on to the State of Guerrero. He also founded an Indian school in San Luis Acatlán and in 1937 he wrote a letter to the federal Department of Indian Affairs offering his services. Accompanying the letter was a study he wrote concerning the Mixtecos in Guerrero, focusing on their views regarding mestizos and the government. He later published part of this study in the *Revista de Estudios Antropológicos* under the name Paw (which he seems to have created from the initials for Paucic Alejandro Wladimiro). Apparently impressed, the department employed him as its inspector in charge of the Montaña de Guerrero from 1937 to 1939. Ignacio García Téllez to Graciano Sánchez, Jefe de Dpto de Asuntos Indígenas, 12 Sept. and 9 Dec. 1937, exp. L.C.R. 533.4/27, box 685, AGN; Wigberto Jiménez Moreno, conference report, 16 Jan. 1949, vol. 42 (1948–1949), folder 16, AHI-AHINAH; Catalán Blanco, "El Archivo Paucic en la reconstrucción de la historia del Estado de Guerrero"; Paw (Alejandro Wladimiro Paucic Smerdu) "Algunas observaciones acerca de la religión de los mixtecos guerrerenses"; Paw, "La región oriental indígena de Guerrero y sus problemas actuales"; and Paucic, *Carta corográfica del estado de Guerrero*.

7. Enciso, "Pintura sobre madera," 4–34.

8. Pilar Fosado Vázquez, interview, 10 Feb. 1999, Mexico City; and Concepción Ventura Pérez, interviews, 21, 24, and 27 Jan. 1999, Olinalá; Alejo de Meave, "Memoria," 213–20; Gutierre Tibón, "Árbol de linaloé," *El Gallo Ilustrado*, 20 February 1994; Tibón, *Olinalá*, 92; and Hersch Martínez, Glass, and Álvarez, "El linaloe [*bursera aloexyslon* (Schiede) Engl.]: Una Madera aromática entre la tradición y la presión económica," 444.

9. "Se organiza la gran exposición," newspaper clipping, ca. June 1930, section 6, DHP.

10. D'Harnoncourt, "Mexican Arts," 5–22; and Bourdieu, "Structures, *Habitus*, Practices."

11. Isaac Helguera, interview, 22 Jan. 1999; Donasiano Ayala Mejía, interview, 19

Jan 1999; Dámaso Ayala Jiménez, interview, 25 Jan 1999; and Concepción Ventura Pérez, interviews, 21 and 27 Jan. 1999, Olinalá. Juvencio is also the only Olinaltecan artisan from the time of whom any collector took an individual portrait. See Enciso, "Pintura sobre madera"; and Lourdes Espinosa, "Olinalá de las flores," *El Gallo Ilustrado*, 20 Feb. 1994.

12. Francisca Tulais Urbina, interview, 15 June 1999, Uruapan; Leticia Valencia, interview, 16 June 1999, Uruapan; Carmelita Berber, interview, 17 June 1999, Uruapan; Sara Angel Calderón, interview, 18 June 1999, Patzcuaro.

13. Concepción Ventura Pérez, interviews, 1999; Conta Mejía Rendón, interview, 23 Jan 1999; Angel Rodríguez Navarro, interview, 23 Jan. 1999; Domitla Pantaleón, interview, 4 Aug. 1997; Emilio Reyes Reyes, interview, 4 July 1997; Juan Ayala Mejía, interview, 20 Jan. 1999; Donasiano Ayala Mejía, interview, 19 Jan 1999; Josefa Jiménez Patrón, interview, 25 Jan. 1999; Dámaso Ayala, interview, 25 Jan. 1999; and Cabañas, "Olinalá," 13–14.

14. Ventura, interviews, 1999. Note that Abraham Navarrete disappears from artisans' accounts and from the documents by the late 1920s.

15. These objects are from the Guillermo Tovar y de Teresa collection of the AAMAP, which has no record of the basis for the attribution. Some details of the attributions clearly are incorrect. The item in plate 15, for example, is listed by the museum as being from 1926, which was before the *rayado* revival and therefore cannot be correct. And the object in plate 13 is dated 1930 but is attributed to Juvencio's son, Margarito, who was either not yet born or at most was an infant. There are reasons, therefore, to question the dates and attributions. Yet, whether they date to the eighteenth century or to 1927–30, these are remarkable objects deserving of further provenance research and materials analysis.

16. Paucic, field notes, folder 471, IG-AP.

17. Davis's image was reproduced in Enciso, "Pintura sobre madera," 16. The gourd sculptures were probably by the Jiménez family, not Ayala, who likely included them in the delivery at Davis's request, since these were winning a healthy market among collectors of the time.

18. Ventura, interviews, 21 and 27 Jan. 1999; and Jiménez Patrón, interview, 25 Jan. 1999, Olinalá.

19. Paucic, typed field notes from Olinalá, folder 745, IG-AP; Rodríguez Navarro, interview, 3 Aug. 1997; Ventura, interviews, 1997–99, Olinalá; and Muñoz, *Mixteco*, 34–35. The municipality of Olinalá saw only a small population increase of 6.4 percent, from 5,849 in 1930 to 6,281 in 1940, and surrounding municipalities saw a decline.

20. Alejandro Paucic, field notes, folder 86ap304.6dem, IG-AP.

21. The fragrance of Olinaltecan lacquer is most famously celebrated in the poetry of Gabriel Mistral, "Cajita de Olinalá," published in 1924 as part of her *Tender-*

ness collection. In recent years the assumption has been that she is describing *linaloé*, but based on the specific words of the poem and the similes she draws, it is likely she is describing the odor of *tlapetzole*. If it is *linaloé*, the box she describes was likely an antique. In a published interview an unnamed artisan born around 1916 mentions that as a youth he used to collect tecomates and *linaloé* in the countryside to sell to artisans, but it is impossible to date when he did so, since the interviewer presents the interview as a highly romanticized narrative that collapses 1920 through the 1990s as a single, synchronic moment. Cabañas, "Olinalá," 13.

22. The dealer who prompted the use of *linaloé* may have been an Argentinian named Francisco Belasco Orilla, though it is difficult to determine from the interviews. Others have suggested that his name may have been Francisco Bartolo or Basola. Angel Rodríguez Navarro, interview, 23 Jan. 1999; Josefa Jiménez Patrón, interview, 25 Jan. 1999; Ventura, interview, 27 Jan. 1999; and Alejandro Paucic, field notes, folder 86ap304.6dem, IG-AP. Studies of forestry, *linaloé*, and Olinaltecan lacquer tend to assume erroneously the unbroken use of *linaloé* since the colonial era, but, though it may have been used in the eighteenth century, its use did not reemerge until 1935. See Muñoz, *Mixteca*, 100; and Hersch Martínez et al., "El Linaloe," 439–62, which explicitly links it to the indigenous authenticity of Olinaltecan lacquer and to national cultural pride.

23. Paucic, typed field notes from Olinalá, ca.1937–47, folder 745, IG-AP; Ventura, interview, 24 Jan. 1999; and Patrón de Ayala, interviews, 25 Jan. 1999, Olinalá.

24. Paucic, typed field notes, folder 745, IG-AP; Concepción Ventura Pérez, various; Juan Rendón Moyaho, 5 Oct. 1999; Josefa Jiménez, 6 Oct. 1999; and Isaac Helguera, 22 Jan. 1999.

25. On the historical development of putting-out systems and gender relations, see Blewett, *Men, Women, and Work*, 1–96; and Dublin, *Women at Work*, 1–74. On putting-out systems as a stage in capitalist production, see Faler, *Mechanics and Manufacturers in the Early Industrial Revolution*, 1–99; and Williamson, *The Economic Institutions of Capitalism*, 209–33.

26. Mastache Flores and Sánchez, *Entre dos mundos*, 130.

27. Paucic, typed field notes, folder 745, IG-AP.

28. See, for example, Stern, *The Secret History of Gender*.

29. Information on d'Harnoncourt's rate comes from Hellman, "Imperturbable Noble," 72.

30. Paucic, typed field notes, n.d., folder 745, IG-AP. A usefully detailed but static description of lacquer materials and their uses is offered in Castelló Iturbide and Martínez del Río de Redo, *Biombos mexicanos*, 155–57.

31. Ventura, interview, 24 Jan. 1999, Olinalá.

32. Toor, "Lacquer," 14–17. The net national inflation rate between 1934 and 1940 was 56 percent. This rate may have varied on the local level. Anguiano, *El estado*, 83.

33. Paucic, typed field notes from Olinalá, folder 745, IG-AP; Domitla Pantaleón, interview, 4 Aug. 1997; Ventura Pérez, interviews, 1997–99; and school inspector report, 19 May 1933, Temalacacingo, box 20, folder 9081, AHSEP-EP.

34. Paucic, typed field notes from Olinalá, folder 745, IG-AP; Rodríguez Navarro, 3 Aug. 1997; and Ventura, interviews, 1997–99, Olinalá.

35. Escudero Mejía, interview, 23 Jan. 1999; Hersch et al., "El linaloé," 439–62; Winkler, "Changing Power"; Paucic, typed field notes from Olinalá, folder 745, IG-AP; and Patrón de Ayala, interview, 25 Jan. 1999, Olinalá.

36. Paucic, typed field notes from Olinalá, folder 745, IG-AP; Doctor Atl, fragment of his autobiography, typescript, n.d., box 6, folder 8, BN-FR-Atl; and Enrique Othón Díaz, "Porvenir de las industrias populares," *EN*, 5 Aug. 1945.

37. Winkler, "Changing," 116; Muñoz, *Mixteca*, 160; and Juan Ayala Mejía, interview, 20 Jan. 1999, Olinalá.

38. Paucic, typed field notes from Olinalá, folder 745, IG-AP.

39. They began to coalesce into what Stuart Hall has described as a distinct and self-conscious "social formation." Building upon the theories of Antonio Gramsci, Hall argues that we cannot assume social groups exist based solely upon abstractly deduced affinities, such as class or religion. By "social formations" he refers to the need to investigate the historical processes by which particular groups of people come to form solidarities, and the way various solidarities intersect with one another. Hall, "Gramsci's Relevance for the Study of Race and Ethnicity."

40. N.a., consular reports (New York City), Jan. 1932, April 1933, and Jan. 1933; and Mexican consul in New York City, "Productos manufacturados," 1932, exp. A02539, BLT-AE. See also Enrique Ruíz (consul in New York), "La demanda de artículos mexicanos," *BC*, 15 May 1931; "México y lo mexicano de moda en N. York," *EN*, 9 March 1931.

41. Because this negative evaluation of the artisan in question might impact current-day artisans, I refer to the artisan simply as Don X.

42. Today some artisans—most notably Francisco "Chico" Coronel (who adds gold to his *dorado*-style boxes, trays, and gourds)—have developed idiosyncratic markets in which their signature enhances rather than diminishes the value of their work. This, however, is a recent development.

43. Baptismal records, Jan. to April 1930, AP-Olinalá.

44. Paucic, typed field notes, n.d., folder 745, IG-AP. For an insightful discussion of the complexities and ambiguities surrounding the meaning of "Indian" on the local level in Mexico prior to the vindication of native identity in the 1990s, see Friedlander, *Being Indian*.

45. Cordero, "Jerarquía," 239–42.

46. Pérez Montfort, *Avatares*, 67.

Chapter 9: The Road to Olinalá

1. Felicitas Ayala Mejía, interview by author, 20 Jan. 1999, Olinalá.

2. López, Caníbal, Cienfuegos, Flores, et al., eds., *Moviendo Montañas*; Bartra, "Sur profundo," 15–16, 69; Flores, *El tigre*, 84; and Winkler, "Changing," xxiv-xxv.

3. Tibón, *Olinalá*, 75; and Tibón, "Árbol de linaloé,"*El Gallo Ilustrado*, 20 Feb. 1994.

4. Exp. 23/20825–1, ARA-Mex; folder 1654, ARA-Chilp; Muñoz, *Mixteca*, 38, 57, and 143; and Sánchez Serrano, "Los espacios territoriales en la montaña de Guerrero," 170–71.

5. Tibón, *Olinalá*, 105–21; Muñoz, *Mixteca*, 57, 146–37; Isaac Helguera, interview, 22 Jan 1999; Siriaco Escudero Mejía, interview, 23 Jan 1999; Donasiano Ayala, interview, 25 Jan. 1999; Juan Ayala Mejía, interview, 20 Jan. 1999; and Winkler, "Changing," 69–73.

6. Tibón, *Olinalá*, 130; and Muñoz, *Mixteca*, 57.

7. Debates around Stern's *Secret History of Gender* have compellingly pointed out the potential as well as the limitations and pitfalls of relying upon violence and deviance as the basis for broader social analysis.

8. Felipe Astudillo Bravo, report on Olinalá, 14 Nov. 1962, box 5, folder 8335; letter 17 Nov. 1962, box 5, folder 8335; and school inspection report, 22 May 1972, box 55, folder 7, AHSEP-EP.

9. Enciclopedia de los Municipios de México, "Estado de Hidalgo: Tasquillo," http://www.e-local.gob.mx/work/templates/enciclo/hidalgo/municipios/13058a.htm, visited 9 July 2007.

10. Muñoz, *Mixteca*, 38–45, 111, 129–34; Tibón, *Olinalá*, 109–14; and Paucic, "Un encuesto análisis y algunos puntos de vista respecto al problema de La Montaña Guerrerense," unpublished report, April 1964, folder 745, IG-AP.

11. Muñoz, *Mixteca*, 26, 34–35, 49, 51–61, 77–83 and 129; and Alejandro Paucic, folder 86ap304.6dem, IG-AP. This population figure is for the municipality, not the town. Figures for the village are more difficult to acquire. In 1950, the population of just the town of Olinalá stood at 2,393 people, but I have not found an official count for 1960.

12. Muñoz, *Mixteca*, 102; Isaac Helguera, interview, 22 Jan 1999; and Juan Ayala Mejía, interview, 20 Jan. 1999.

13. Bartra, "Sur profundo," 13–74; Paucic, "Un encuesto análisis"; and Bustamante Álvarez, "La reconstrucción."

14. Carlos Romero Giordano, "Lacas de Olinalá," *México en el tiempo* 8 (Aug.-Sept. 1995): 53; Donasiano Ayala Mejía, interview, 19 Jan. 1999; and Muñoz, *Mixteca*, 29–32, 162.

15. Paucic, typed field notes from Olinalá, exp. 745, IG-AP.

16. This is based on figures compiled by Muñoz and by Paucic. See Muñoz, *Mixteco*, 102, and Paucic, typed field notes from Olinalá, folder 745, IG-AP. For insightful analysis of the golden age, see the essays in Joseph et al., eds., *Fragments of a Golden Age*.

17. Dámaso Ayala Jiménez, interview, 25 Jan. 1999; and Juan Ayala Mejía, interview, 20 Jan. 1999; Dámaso Ayala, interview by Lourdes Espinosa, published as "Olinalá de las flores," *El Gallo Ilustrado*, 20 Feb. 1994. My analysis draws on Stuart Hall's formulation of Gramsci's notion of social formations and articulation. See Hall, "Gramsci's Relevance for the Study of Race and Ethnicity."

18. Isaac Helguera, interview, 22 Jan. 1999; and Siriaco Escudero Mejía, interview, 23 Jan. 1999.

19. Siriaco Escudero Mejía, interview, 23 Jan. 1999.

20. Muñoz, *Mixteca*, 100–104; and Tibón, *Olinalá*, 71–74.

21. Muñoz, *Mixteca*, 77–78, 102; and Donasiano Ayala, interview, 25 Jan. 1999.

22. At the time of his visit to the town, Muñoz noted that only three workshops, with a total of twenty-two people, still produced *rayado*-style lacquer, the best of which, in his view, was the eight-person workshop run by Margarito and Dámaso Ayala, two sons of the late Juvencio Ayala. Muñoz, *Mixteca*, 100; and Josefa Jiménez Patrón, interview, 25 Jan. 1999, Olinalá.

23. Muñoz, *Mixteca*, 80–81, 167.

24. Romero Giordano, "Lacas de Olinalá," 53; Muñoz, *Mixteca*, 59, 131; Tibón, *Olinalá*, 13–15, 131 and 134; and Donasiano Ayala Mejía, interview, 19 Jan. 1999.

25. Prices come from Muñoz, *Mixteca*, 32, 59, 131.

26. Donasiano Ayala Mejía, interview, 19 Jan. 1999, Olinalá.

27. Donasiano Ayala Mejía, interviews, 1997–99; Siriaco Escudero Mejía, interview, 23 Jan. 1999; Angel Rodríguez Navarro, interview, 3 August 1999; and Esteban Ayala Mejía, interviews, 1997–99, Olinalá.

28. Tibón, *Olinalá*, 80–81.

29. Alejandro Paucic, field notes, folder 86ap304.6dem, IG-AP; Tibón, *Olinalá*, 166; and Muñoz, *Mixteca*, 167.

30. Juan Ayala Mejía, interview, 20 Jan. 1999, Olinalá.

31. Josefa Jiménez Patrón, interview, 25 Jan. 1999.

32. Felicitas Ayala Mejía, interview, 20 Jan. 1999.

33. Chibnik, *Crafting Tradition*, 27–29.

34. Dámaso Ayala Mejía, interview, 25 Jan. 1999; Felicitas Martínez, interview, 20 Jan. 1999; and "Créditos a cinco mil artesanos laqueros de la Sierra de Guerrero," *EN*, 7 Oct. 1971.

35. Felicitas Ayala Mejía, interview, 20 Jan. 1999; Esteban Ayala Mejía, interviews,

1997–99; Donasiano Ayala Mejía, interviews, 1997–99; Josefa Jimenéz Patrón, interview, 25 Jan. 1999; and Dámaso Ayala Mejía, interview, 25 Jan. 1999.

36. "Premios para varios artesanos de madera guerrerenses," and "Entregó la Sra. Echeverría Premios," newpaper clippings, folder 469ap745.5art, IG-AP; Felicitas Ayala Mejía, interview, 20 Jan. 1999; Dámaso Ayala Jr., interview, 20 Jan. 1999; and Tonatiuh Gutiérrez, interview, 28 June 1999, Mexico City. The honorable mentions went to José Coronel, Francisco Coronel, Vicente Fernández, Aurelia Ayala, Jesús Rendón, Miguel Pantaleón, Felipe Lemus, Justino Rendón, and Juana Patrón.

37. Bartra, "Sur profundo," 13.

38. Cothran, "Pacification through Repression and Distribution," xiv-xv.

39. Bartra, "Sur profundo," 28–30; Dehouve, *Cuando*, 310–11; Schmidt, *Deterioration*, 74–75, 88–89; and Fox, *The Politics of Food in Mexico*, 54–57.

40. Schmidt, *Deterioration*, 74–75; and Bartra, "Sur profundo," 26–27. On the shortage of land to redistribute, see files on Temalacacingo, Zacango, and Ocotitlán, Sección Ejidal-Dotación, ARA-Mex.

41. Tibón, *Olinalá*, 56, 81 and 152–53; Muñoz, *Mixteca*, 107; and Donasiano Ayala, interview, 25 Jan. 1999, Olinalá.

42. The situation in Olinalá is analogous to the situation in another part of Mexico as starkly analyzed by Friedlander, *Being Indian in Hueypan*. Negative views of indigenous identity have been challenged in recent years as some montañeros have begun to embrace their indigenous identities as a basis for demanding human rights. Canabal Cristiani, introduction, in *Los caminos de la Montaña*, 13–23.

43. School inspection report, 22 May 1972, box 55, folder 7, AHSEP-EP.

44. Espejel, *Las artesanías tradicionales en México*, 12–13, 29.

45. "Premios para varios artesanos de la madera guerrerense," 16 Oct. 1971; "Entregó la Sra. Echeverría a catorce artesanos de la laca, Gro.," news clippings, folder 86ap304.6dem, IG-AP; and Espejel, *Olinalá*, 13.

46. On the role of women in workshops, see Winkler, "Changing Power."

47. Fox, *Politics of Food*, 2.

48. Bartra, "Sur profundo," 57–69; Bartra, "Posdata," 418; and Centro de Derechos Humanos de la Montaña, *Décima informe*. On the broader spread of militarization, intimidation, and violence across Chiapas, Oaxaca, and Guerrero, see Stephen, *¡Zapata Lives!*, 317–28; and López, Caníbal, Cienfuegos, Flores, et al., eds., *Moviendo Montañas*.

49. Centro de Derechos Humanos de la Montaña, *Décima informe*, 18–20; Enciclopedia de los Municipios de México, http://www.e-local.gob.mx/work/templates/enciclo/guerrero/municipios/12045a.htm, visited 31 July 2007.

50. Siriaco Escudero Mejía, interview, 23 Jan. 1999; Angel Rodríguez Navarro, interview, 3 Aug. 1999; Dámaso Ayala, Jr., interviews, 20 Jan. 1999, Olinalá; Donasiano Ayala Mejía and Esteban Ayala Mejía, conversations, 1997–99, Olinalá.

51. Canabal Cristiani, "Estrategias de sobrevivencia y el contorno regional," in *Los Caminos de la Montaña*, 55; Donasiano Ayala, interview, 25 Jan. 1999, and Angel Rodríguez Navarro, interview, 3 August 1999; Paucic, field notes, folder 471, IG-AP; and *Así Somos*, broadsheet, 30 March 1996.

52. Cabañas, "Olinalá," 17.

53. Lourdes Espinosa, "Olinalá de las flores," *El Gallo Ilustrado*, 20 Feb. 1994; EZLN, "First Declaration from the Lacandón Jungle," Jan. 1, 1994; "El despertador mexicano, organo informativo del EZLN," Dec. 1993 made public on Jan. 1, 1994; and "Second Declaration from the Lacandón Jungle," June 1994, in Hayden, ed., *The Zapatista Reader*, 217–20 and 252–56; and EZLN, "Demands at the Dialogue Table."

54. Espinosa, "Olinalá de las flores."

55. Espejel, *Olinalá*, 33.

56. Sánchez Serrano, "Los espacios," 157–96.

57. Chibnik, *Crafting Tradition*, 242–43; and Little, *Mayas in the Marketplace*.

Conclusions

1. Mistral, *Ternura*; Quezada, prologue; and Quezada, "Cronología."

2. Hernández-Díaz, "National Identity," 72.

3. Hernández-Díaz, "National Identity"; Palacios, "Postrevolutionary Intellectuals"; Vaugan, *Cultural Politics*; and Dawson, "From Models." Dawson provides a judicious critique of the tendency within the historical literature to exaggerate de-Indianization and homogenizing mestizaje.

4. Cf. Pérez Montfort, *Avatares*, 11, 17–21, 67.

5. Stephen, *¡Zapata Lives!*, 316, 337–38; Hernández-Díaz, "National Identity," 74; EZLN, "Declaración de La Selva Lacandona"; Womack, *Rebellion*, 268; and EZLN, "Comunicado del CCRI-CG, Pliego de demandas, 1 de marzo." On the use of dominant tropes of indigenousness by indigenous people, see Nadasdy, "Transcending the Debate."

6. Hernández-Díaz, "National Identity," 74–76; and Wortham, "Between the State and Indigenous Autonomy."

7. Bartra, "Posdata," 420.

8. Stephen, *¡Zapata Lives!*, 342. This draws upon the idea of multiple selective traditions, as described by Nugent and Alonso in "Multiple Selective Traditions." For insightful comparisons of how nation, economies, and indigenousness have connected within movements in other parts of Latin America see Yashar, *Contesting Citizenship in Latin America*; García, *Making Indigenous Citizens*; War-

ren and Jackson, eds., *Indigenous Movements, Self-Representation, and the State in Latin America*; and Postero and Zamosc, *The Struggle for Indigenous Rights in Latin America*.

9. Carlos Romero Giordano, "Réquiem por un museo," *Mexico Desconocido Online*, adapted *México en el Tiempo*, no. 3 (Feb.-March 1995), visited 13 June 2005.

10. http://www.citigroup.com/citigroup/corporate/history/banamex.htm and http://www.banamex.com/esp/filiales/fomento_cultural.htm, visited 11 Aug. 2007.

11. Laura Gómez and Angel Vargas, "Exportar arte popular," *La Jornada*, 1 March 2006; Carlos Paul, "Preinaugurarán en marzo el Museo de Arte Popular," *La Jornada*, 24 Jan. 2005; and Audley, Papademetriou, Polaski, and Vaughan, *NAFTA's Promise and Reality*.

Archival Collections

Mexico

ABN-Necaxa Archivo de la Biblioteca Municipal, Necaxa, Puebla

AGN Presidencial Archives, Archivo General de la Nación (AGN), Mexico City

AGN-AFEDEDYMG Archivo Fotográfico Enríque Díaz, Enríque Delgado y Manuel García, Fototeca, Archivo General de la Nación (AGN), Mexico City

AGY-PRG-CRMH Archivo General del Estado de Yucatán, Fondo/Ramo Poder Ejecutivo, Sección Gobernación (1), Serie: Comisión Reguladora del Mercado de Henequén, Memoriales, Decretos, Peticiones, Quejas, Nobramientos, Solicitudes, Merida

AHI-ADM Archivo Histórico Institucional del Instituto Nacional de Antropología e Historia, Subdirección de Documentación, dependiente de la Biblioteca Nacional de Antropología e Historia, Serie: Archivo de la Dirección del Museo Nacional de Arqueología, Historia e Etnografía, Mexico City

AHI-AHINAH Archivo Histórico Institucional del Instituto Nacional de Antropología e Historia, Subdirección de Documentación, dependiente de la Biblioteca Nacional de Antropología e Historia, Serie: Archivo Histórico del Museo Nacional, Subserie: Archivo Histórico de INAH, Mexico City

AHI-DASF Archivo Histórico Institucional del Instituto Nacional de Antropología e Historia, Subdirección de Documentación, dependiente de la Biblioteca Nacional de Antropología e Historia, Serie: Departamento de Antropología–Secretaría de Fomento, Mexico City

AHI-DMAAH Archivo Histórico Institucional del Instituto Nacional de Antropología e Historia, Subdirección de Documentación, dependiente de la Biblioteca Nacional de Antropología e Historia, Serie: Departamento de Monumentos Artísticos, Arqueológicos e Históricos, Mexico City

AHI-DMN Archivo Histórico Institucional del Instituto Nacional de Antropología e Historia, Subdirección de Documentación, dependiente de la Biblioteca Nacional de Antropología e Historia, Dirección del Museo Nacional de Arqueología, Historia e Etnografía (MANAHE)

AHI-EG Archivo Histórico Institucional del Instituto Nacional de Antropología e Historia, Subdirección de Documentación, dependiente de la Biblioteca Nacional de Antropología e Historia, Archivo Eulalia Guzmán, Mexico City

AHI-MG Archivo Histórico Institucional del Instituto Nacional de Antropología e Historia, Subdirección de Documentación, dependiente de la Biblioteca Nacional de Antropología e Historia, Archivo Incorporado Manuel Gamio, Mexico City

AHSEP-BA Archivo Histórico de la Secretaría de Educación Pública, Departamento de Bellas Artes, Mexico City

AHSEP-DMH Archivo Histórico de la Secretaría de Educación Pública, Sección del Depto de Monumentos Históricos, Artísticos y Coloniales de la República, Mexico City

AHSEP-EP Archivo Histórico de la Secretaría de Educación Pública, Dirección General de Educación Primaria en los Estados y Territorios de la República, Mexico City

AHSEP-FSEP Archivo Histórico de la Secretaría de Educación Pública, Fondo de la Secretaría de Educación Pública, 1931–1947, Mexico City

AHSRE Secretaría de Relaciones Exteriores, Archivo Histórico "Genero Estrada," Mexico City

AP-Olinalá Archivo de la Parroquia de San Francisco de Asis, Olinalá, Guerrero

ARA-Chilp Archivo de la Reforma Agraria, Sección Ejidal-Dotación, Chilpancingo, Guerrero

ARA-Mex Archivo de la Reforma Agraria, Sección Ejidal-Dotación, Mexico City

BLT-AE Biblioteca Lerdo y Tejada, Archivos Económicos, Mexico City

BN-FR-Atl Gabinete de Manuscritos del Fondo Reservado de la Biblioteca Nacional de México (Ciudad Universitaria), Archivo de Gerardo Murillo Cornadó (Doctor Atl), Mexico City

CENIDIAP-INBA Archivos del Centro Nacional de Información, Documentación, e Investigación de las Artes Plásticas, Fondo del Archivo Histórico de INBA, Mexico City

CNCRPAM Centro Nacional Conservación y Registro del Patrimonio Artístico Mueble, Conaculta-INBA, Archivo del Museo de Artes Populares-Roberto Montenegro, Mexico City

IG-AP Instituto Guerrerense de la Cultura, Archivo de Ing, Alejandro Wladamir Paucic Smerdu, Chilpancingo, Guerrero (formerly in the archives of the Biblioteca AGORA-FONAPAS, "Carmen Romano de López Portillo," Chilpancingo, Guerrero)

INBA Biblioteca del Instituto Nacional de Bellas Artes, Archivo General, Mexico City

INBA-CI Biblioteca del Instituto Nacional de Bellas Artes, Archivo Histórico, Colecciones Especiales, Carpetas de Investigación, Mexico City

INBA-FG Biblioteca del Instituto Nacional de Bellas Artes, Colecciones Especiales, Fondo General, Mexico City

INBA-GFL Biblioteca del Instituto Nacional de Bellas Artes, Archivo Histórico, Colecciones Especiales, Fondo Gabriel Fernández Ledesma, Mexico City

INI-IA Fondo Documental del Instituto Nacional Indigenista, Informes de Actividades, 1949–1970, FD 09/45, Mexico City

MOB-CG Secretaría de Agricultura, Ganadería y Desarrollo Rural, Centro de Estadística Agropecuário, Mapoteca Orozco y Berra, Colección General, Mexico City

MOB-CM Secretaría de Agricultura, Ganadería y Desarrollo Rural, Centro de Estadística Agropecuário, Mapoteca Orozco y Berra, Colección Moderno, Mexico City

MOB-COB Secretaría de Agricultura, Ganadería y Desarrollo Rural, Centro de Estadística Agropecuário, Mapoteca Orozco y Berra, Colección Orozco y Berra, Mexico City

United States

APS-FB American Philosophical Society, Professional Correspondence of Franz Boas, Philadelphia, Pennsylvania. Microfilm.

DHP René d'Harnoncourt Papers, Archives of American Art, Smithsonian Institution, Washington, microfilm rolls 3830 and 3831.

DWM Dwight W. Morrow Papers, Amherst College Archives, Amherst, Mass.

OHR Oral History Research Office, Columbia University, New York.

SSC-MFP Sophia Smith Collection, Morrow Family Papers, Smith College, Northampton, Mass.

Newspapers and Periodicals

Mexico

Boletín Comercial [BC] (Mexico City)
Cambio de la Sierra (Huachinango, Puebla)
Día (Mexico City)
Economista (Mexico City)
Excelsiór [EX] (Mexico City)
Gallo Ilustrado (Mexico City)
Globo (Mexico City)
Gráfico (Mexico City)
Heraldo de México (Mexico City)

La Jornada (Mexico City)

Machete (Mexico City)

Mexican Folkways [MF] (Mexico City)

El Nacional [EN] (formerly *Nacional Revolucionario*) (Mexico City)

Novedades (Mexico City)

Periódico Oficial del Gobierno del Estado de Guerrero (Chilpancingo, Guerrero)

La Prensa (Mexico City)

Revista de Comercio Exterior (Mexico City)

Todo (Mexico City)

Últimas Noticias (Mexico City)

El Universal [EU] (Mexico City)

El Universal Gráfico (Mexico City)

El Universal Gráfico (de la tarde) (Mexico City)

El Universal Ilustrado [EUI] (Mexico City)

United States

Boston Herald

Christian Science Monitor (Boston)

Cleveland News

Journal-Post (Kansas City, Missouri)

New York Times

News (Detroit)

News (Savannah, Georgia)

Prensa (San Antonio, Texas)

Press (Pittsburgh)

Washington Post

Other

Honduras This Week (Honduras, online)

El Nuevo Diario (Managua, Nicaragua)

El Pais (Nicaragua)

La Prensa (Nicaragua)

Unpublished Interviews

Mexico City

Bibiana Uribe, María. Televised interview by Guillermo Ochoa. "Nuestro Mundo." Televisa. 1987.

Fosado, Pilar. Various interviews by author. 1997–99.

Gutiérrez, Tonatiuh. Interview by author. 28 June 1999.

Necaxa, Puebla

Bibiana Uribe, María. Radio interview. Station XOJT. 1991. Tape recording in private collection of Rosa Zarate Uribe.

Zarate Uribe, Rosa. Interview by author. 24 September 1999.

Zavala Zarate, Alfredo and Rosa Zarate Uribe. Interview by author. 24 September 1999.

Olinalá, Guerrero

Arnulfo. Interview by author. 2 August 1997.

Ayala Martínez, Felicitas. Interview by author. 20 January 1999.

Ayala Mejía, Dámaso, Jr. Interview by author. 20 January 1999.

Ayala Mejía, Donasiano. Interviews by author. 1997–99.

Ayala Mejía, Esteban. Interviews by author. 1997–99.

Ayala Mejía, Juan. Interviews by author. 1997–99.

Ayala, Víctor. Interviews by author. 1997–99.

Coronel, Francisco. Interview by author. 11 August 1997.

Escudero Mejía, Siriaco. Interview by author. 23 January 1999.

García, Miguel. Interview by author. 3 August 1997.

Helguera, Isaac. Interview by author. 22 January 1999.

Jiménez, Luis. Interview by author. 21, 22, and 27 January 1999.

Jiménez Patrón de Ayala, Josefa. Interview by author. 25 January 1999.

Mejía Rendón, Conta. Interview by author. 23 January 1999.

Pantaleón, Domitla. Interview by author. 4 August 1997.

Pérez Ventura, Concepción. Interviews by author. 1997–99.

Reyes Reyes, Emilio. Interview by author. 4 July 1997.

Rodríguez Navarro, Angel. Interview by author. 3 August 1997.

Rodríguez, Guadalupe. Interview by author. 30 July 1997.

Rosendo, Bernardo. Interview by author. 25 January 1997.

Patzcuaro, Michoacán

Calderón, Sara Angel. Interview by author. 18 June 1999.

Cerda Valles, Sergio. Interview by author. 17 June 1999.

Valles, Mario. Interview by author. 17 June 1999.

Uruapan, Michoacán

Berber, Carmelita. Interview by author. 17 June 1999.

Tulais Urbina, Francisca. Interview by author. 15 June 1999.

Valencia, Leticia. Interview by author. 16 June 1999.

United States

d'Harnoncourt, René. Transcript of interview by Isabel Grossner. New York City. 23 May 1968. Oral History Research Office, Columbia University, New York.

Published Material

Adorno, Theodor, and Max Horkheimer. "The Culture Industry: Enlightenment as Mass Deception." *The Consumer Society Reader*, edited by Juliet Schor and Douglas Holt, 3–19. New York: W. W. Norton, 2000.

Aguilar Camín, Héctor, and Lorenzo Meyer. *In the Shadow of the Mexican Revolution: Contemporary Mexican History, 1910–1989.* Translated by Luis Alberto Fierro. Austin: University of Texas Press, 1993.

Ai Camp, Roderic. "The National School of Economics and Public Life in Mexico." *Latin American Research Review* 10 (3) (autumn 1975): 137–51.

Alanis Patiño, Emilio. "La población indígena en México." *Obras completas*, vol. 1, by Miguel Othón de Mendizábal, 29–91. Mexico City, 1946.

Alanis, Judith. *Gabriel Fernández Ledesma.* Mexico City: Universidad Nacional Autónoma de México, 1985.

Alejo de Meave, Joaquín. "Memoria sobre la pintura del pueblo de Olinalá, de la jurisdicción de Tlapan, dispuesta por su cura propietario y juez eclesiástico don Joaquín Alexo de Meave." *La Gaceta de Literatura*, vol. 2, 213–20. Puebla: Puebla, 1831.

Alonso, Enrique. *María Conesa.* Prologue by Carlos Monsisváis. Mexico City: Océano, 1987.

Alvarez, Diego. *Memoria presentada al 8° congreso constitucional del estado de Guerrero.* Chilpancingo: Tipografia del Gobierno del Estado, 1881.

Amith, Jonathan D. *The Möbius Strip: A Spatial History of Colonial Society in Guerrero, Mexico.* Stanford: Stanford University Press, 2005.

Anderson, Benedict. *Imagined Communities: Reflections on the Origin and Spread of Nationalism.* New York: Verso, 1991 [1983].

Anguiano, Arturo. *El estado y la política obrera del cardenismo.* Mexico City: Era, 1975.

Antliff, Mark. *Inventing Bergson: Cultural Politics and the Parisian Avant-Garde.* Princeton, N.J.: Princeton University Press, 1993.

Arce, Francisco O. *Memoria presentado ante la H. Legislatura del Estado de Guerrero por el gobernador del mismo, General Francisco O. Arce, en cumplimiento de la fracción III del artículo 57 de la constitución local y leída por el secretaría del gobierno C. Nicolas G. Zozaya.* Guerrero: Imprenta del gobierno del Estado, a cargo de Alejo Venegas, 1870.

Argentieri, Letizia. *Tina Modotti: Between Art and Revolution.* New Haven: Yale University Press, 2003.

Armstrong, J. A. *Nations Before Nationalism.* Chapel Hill: University of North Carolina Press, 1982.

Arroyo, Antonio Luna. *El Dr. Atl. Paisajista puro.* Mexico City: Cvtvra, 1952.

Atl, Doctor. "Popular Arts of Mexico." *Survey Graphic* 5 (2) (May 1924): 161–64.

——. *Catálogo de las pinturas y dibujos de la colección Pani.* Mexico City: Universidad Nacional, 1921.

——. *Las artes populares en México.* Facsimile of 1922 ed. Mexico City: Instituto Nacional Indigenista, Museo de Artes e Indústrias Populares, 1980.

Atl, Doctor (pseudonym for Gerardo Murillo), and William Spratling. "Mexico and the Ultra-Boroco." *Architectural Design* (February 1928): 217–24.

Audley, John, Demetrios Papademetriou, Sandra Polaski, and Scott Vaughan. *NAFTA's Promise and Reality: Lessons from Mexico for the Hemisphere.* Washington: Carnegie Endowment Report, 2004.

Auslander, Leora. "The Gendering of Consumer Practices in Nineteenth-Century France." *The Sex of Things: Gender and Consumption in Historical Perspectives,* edited by Victoria de Grazia and Ellen Furlough, 79–112. Berkeley: University of California Press, 1996.

——. *Taste and Power: Furnishing Modern France.* Berkeley: University of California Press, 1996.

Azen Krause, Corinne, and Ariela Katz de Gugenheim. *Los judíos en México.* Mexico City: Universidad Iberoamericana, 1987.

Azuela, Alicia. *Arte y poder.* Mexico City: FCE, 2005.

——. "El Machete and Frente a Frente: Art Committed to Social Justice in Mexico," *Art Journal* 52 (1) (spring 1993): 82–87.

Ballerino Cohen, Coleen, Richard Wilk, and Beverly Stoeltje, eds. *Beauty Queens on the Global Stage: Gender, Contests, and Power.* New York: Routledge, 1996.

Barlow, Tani E., Madeleine Yue Dong, Uta G. Poiger, Priti Ramamurthy, Lynn M. Thomas, and Alys Eve Weinbaum. "The Modern Girl around the World: A Research Agenda and Preliminary Findings." *Gender and History* 17 (2) (August 2005): 245–94.

Bartra, Armando. "Posdata." *Crónicas del sur: Utopías campesinas en Guerrero,* ed. Armando Bartra, 413–428. Mexico City: Era, 2000.

——. "Sur profundo." *Crónicas del sur, 13–74.*

Basave Benítez, Agustín. *México mestizo: Análisis del nacionalismo mexicano en torno a la mestizofilia de Andrés Molina Enríquez.* Mexico City: FCE, 1992.

Baudrillard, Jean. "The Ideological Genesis of Needs." *The Consumer Society Reader,* edited by Juliet Schor and Douglas Holt, 57–80. New York: W. W. Norton, 2000.

Bautista García, Cecilia Adriana. "Maestros y masones: La contienda por le reforma educativa en México: 1930–1940." *Relaciones* 24 (106) (fall 2005): 219–76.

Benjamin, Thomas. *La Revolución: Mexico's Great Revolution as Memory, Myth, and History*. Austin: University of Texas Press, 2000.

Best Maugard, Adolfo, illustrator. *Album de colecciones arqueológicas*. Mexico City: Escuela Internacional de Arqueología y Etnología Americanas, 1911–12.

———. *Manuales y tratados: Método de dibujo: Tradición, resurgimiento y evolución del arte mexicano*. Mexico City: Secretaría de Educación Pública, 1923.

Blacker-Hanson, O'Neill. "'La Lucha Sigue!' ('The Struggle Continues!'): Teacher Activism in Guerrero and the Continuum of Democratic Struggle in Mexico." Ph.D. dissertation, University of Washington, 2005.

Blanco, José Joaquín. *Se llamaba Vasconcelos: Una evocación crítica*. Mexico City: Fondo de Cultura Económica, 1977.

Blewett, Mary. *Men, Women, and Work: Class, Gender, and Protest in the New England Shoe Industry, 1780–1910*. Urbana: University of Illinois Press, 1988.

Bliss, Katherine Elaine. *Compromised Positions: Prostitution, Public Health, and Gender Politics in Revolutionary Mexico City*. University Park: Pennsylvania State University Press, 2001.

———. "The Science of Redemption: Syphilis, Sexual Promiscuity, and Reformism in Revolutionary Mexico City." *Hispanic American Historical Review* 79 (1) (February 1999): 1–40.

Bonfil Batalla, Guillermo. *México profundo: Una civilización negada*. Mexico City: Grijalbo, 1994 (1987).

Boreland, Katherine. "The India Bonita of Monimbó: The Politics of Ethnic Identity in the New Nicaragua." *Beauty Queens on the Global Stage: Gender, Contests, and Power*, edited by Coleen Ballerino Cohen, Richard Wilk, and Beverly Stoeltje, 75–88. New York: Routledge, 1996.

Bourdieu, Pierre. *Distinction: A Social Critique of the Judgment of Taste*. Translated by Richard Nice. Cambridge: Harvard University Press, 1984.

———. "Structures, *Habitus*, Practices." *The Logic of Practice*. Translated by Richard Nice. Stanford: Stanford University Press, 1980.

Boyer, Christopher. *Becoming Campesinos: Politics, Identity, and Agrarian Struggle in Postrevolutionary Michoacán, 1920–1935*. Stanford: Stanford University Press, 2003.

Brading, David. *The First America: The Spanish Monarchy, Creole Patriots, and the Liberal State, 1492–1867*. Cambridge: Cambridge University Press, 1991.

———. *Los orígenes del nacionalismo mexicano*. Mexico City: Era, 1988.

———. "Nationalism and Monuments in Modern Mexico." *Nations and Nationalism* 7 (4) (2001): 521–31.

Brandt, Kim. *Kingdom of Beauty: Mingei and the Politics of Folk Art in Imperial Japan*. Durham: Duke University Press, 2007.

Brenner, Anita. "The Davis Collection." *Mexico This Month* 3 (9) (September 1957): 26–27.

———. "The Petate, a National Symbol." *Mexican Folkways* 1 (1) (June–July 1925): 14–15.

———. *Idols behind Altars*. New York: Payson and Clarke, 1929.

———. *Your Mexican Holiday*. New York: G. P. Putnam's Sons, 1932.

Bringas, Esperanza Velázquez. "Mexican Pottery." *Mexican Folkways* 1 (1) (June–July 1925): 9–10.

Britton, John. *Revolution and Ideology: Images of the Mexican Revolution in the United States*. Lexington: University Press of Kentucky, 1995.

Bustamante, Tomás Álvarez. "La reconstrucción." *Historia general de Guerrero*. Vol. 4. Mexico City: Conaculta, INAH, 1998.

Caballero, Manuel. "Revista de los Estados." *Primer almanaque histórico, artistico, y monumental de la República Mexicana*. New York: n.p., 1883.

Cabañas, María del Carmen. "Olinalá, el pueblo que pinta: Historia de uno de sus lugareños." *Historias de abuelos*, edited by Renato Ravelo Lecuona, 11–17. Chilpancingo: Universidad Autónoma de Guerrero, 1997.

Cabrera, Luis. "The Key to the Mexican Chaos." *Renascent Mexico*, edited by Hubert Herring and Herbert Weinstock, 11–12. New York: Covici-Friede, 1935.

———. "The Mexican Revolution: Its Causes, Purposes and Results." Address delivered 10 November 1916. *Annals of the American Academy of Political and Social Science* 69 (Supplement) (January 1917): 1–17.

Canabal Cristiani, Beatriz, ed. *Los caminos de la Montaña: Formas de reproducción social en la Montaña de Guerrero*. Mexico City: UAM-CIESAS, 2001.

Cañizares-Esguerra, Jorge. "Postcolonialism *avante la letter*? Travelers and Clerics in Eighteenth-Century Colonial Spanish America." *After Spanish Rule: Postcolonial Predicaments of the Americas*, edited by Mark Thurner and Andrés Guerrero, 89–110. Durham: Duke University Press, 2003.

Caplan, Karen D. "The Legal Revolution in Town Politics: Oaxaca and Yucatán, 1812–1825." *Hispanic American Historical Review* 83 (2) (May 2003): 255–93.

Cárdenas de la Peña, Enrique. *Historia de las comunicaciones y los transportes en México: El correo*. Mexico City: Secretaría de Comunicaciones y Transportes, 1987.

Cardoza y Aragón, Luis, and Antonio Rodríguez. *Diego Rivera: Los murales en la Secretaría de Educación Pública*. Mexico City: SEP, 1986.

Caso, Alfonso. "¿Arte mexicano o arte en México?" *Indigenismo* (1958): 123–26.

———. "El arte popular mexicano." *Mexico en el Arte*, 30 November 1952, 87–100.

————. "Bibliografía de las artes populares plásticas de Mexico." *Memorias del Instituto Nacional Indigenista* 1 (2) (1950): 83–85.

————. *La comunidad indígena*. Mexico: SEP, 1971.

————. "La protección de las artes populares." *América Indígena* 11 (3) (1958): 25–29.

Caso, Alfonso, and Manuel Germán Parra. Introduction and prologue to *Densidad de la población de habla indígena en la República Mexicana (por entidades federativas y municipios, conforme al censo de 1940)*. Mexico City: INI, 1950.

Castellanos, Armando, Monique Lafontant, Mirilla Lhuhi, and Alma Lilia Roura, "El Dr. Atl y la Academia." In *Dr. Atl (1875–1964). Conciencia y paisaje*. Edited by Jorge Hernández Campos et al., 29–36. Mexico: UNAM, 1985.

Castelló Iturbide, Teresa. *El arte de maque en México*. Mexico City: Fomento Cultural Banamex, 1981.

————. "Maque o laca." *Artes de Mexico* 19 (153) (1972): 33–81.

Castelló Iturbide, Teresa, and Marita Martínez del Río de Redo. *Biombos mexicanos*. Mexico City: INAH, 1970.

Castro Leal, Antonio. Foreword to *Twenty Centuries of Mexican Art*. New York and Mexico City: Museum of Modern Art, INAH, 1940.

Catalán Blanco, Juan-Carlos. "El Archivo Paucic en la reconstrucción de la historia del Estado de Guerrero." *Primer coloquio de arqueología y etnohistoria del Estado de Guerrero*. Mexico City: INAH, 1986: 565–83.

Cederwall, Sandraline. *Spratling Silver*. San Francisco: Chronicle Books, 1990.

Centro de Derechos Humanos de la Montaña. *Décima informe*. Guerrero: Tlachinollan-European Union, 2004.

Chase, Stuart. *Mexico: A Study of Two Americas*. Illustrated by Diego Rivera. New York: Macmillan, 1931.

Chatterjee, Partha. *Nationalist Thought and the Colonial World: A Derivative Discourse?* London: Zed for United Nations University, 1986.

————. "Whose Imagined Community?" *Nations and Nationalism*, Edinburgh: Edinburgh University Press, 2005.

Chávez Chávez, Jorge. *Los indios en la formación de la identidad nacional mexicana*. Mexico City: Universidad Autónoma de Ciudad Juárez, 2003.

Chávez Orozco, Luis, ed. *La agonía de artesanado mexicano: Papeles para la historia de trabajo*. Mexico City: Centro de Estudios Históricos del Movimiento Obrero Mexicano, 1977 [1958].

Chibnik, Michael. *Crafting Tradition: The Making and Marketing of Oaxacan Wood Carvings*. Austin: University of Texas Press, 2003.

Clendinnen, Inga. "'Fierce and Unnatural Cruelty': Cortés and the Conquest of Mexico." *Representations* no. 33 (winter 1991): 65–100.

Codding, Mitchell. "The Decorative Arts in Latin America, 1492–1820." *The Arts in*

Latin America, edited by Joseph J. Rishel and Suzanne L. Stratton, 98–143. New Haven: Yale University Press, 2006.

Coe, Sophie, and Michael Coe. *True History of Chocolate.* New York: Thames and Hudson, 1996.

Cohen, Coleen Ballerino, Richard Wilk, and Beverly Stoeltje, eds. *Beauty Queens on the Global Stage.* New York: Routledge, 1996.

Collado Herrera, María del Carmen. "La mirada de Morrow sobre México: ¿Preludio de la buena vecindad?" *Secuencia*, n.s. 48 (September–December 2000): 209–24.

Comas, Juan. Introduction to *Antología* by Manuel Gamio, ed. Juan Comas. Mexico City: UNAM, 1985.

Committee on Cultural Relations with Latin America. (CCRLA) *Ninth Seminar in Mexico.* New York: Committee on Cultural Relations with Latin America, 1934.

Connor, Walker. "A Nation Is a Nation, Is a State, Is an Ethnic Group, Is a . . ." *Nationalism*, edited by Anthony D. Smith and John Hutchinson, 36–46. New York: Oxford University Press, 1994.

———. "Timelessness of nations." *History and National Destiny: Ethnosymbolism and its Critics*, 35–47. Oxford: Blackwell, 2004.

———. "When Is a Nation?" In *Nationalism*, 154–159.

Cordero Reiman, Karen. "Constructing a Modern Mexican Art." *South of the Border: Mexico in the American Imagination, 1914–1947*, edited by James Oles, 11–47. Washington: Smithsonian Institution Press, 1993.

———. "Del mercado al museo: La valoración del arte popular, 1910–1915." *Salas de la colección permanente, siglos XVII a XX.* Mexico City: Museo Nacional de Arte, 1989.

———. "Fuentes para una historia social del 'arte popular' mexicano: 1920–1950." *Memoria* (Museo Nacional de Arte) no. 2 (1990): 31–55.

———. "Jerarquía socio-cultural y la historia del 'Arte Popular.'" *Arte y coerción: Primer coloquio del comité mexicano de historia del arte*, 237–242. Mexico City: UNAM, Instituto de Investigaciones Estéticas, 1992.

———. "La colección Roberto Montenegro." *Artes de México*, no. 14 (winter 1991): 61–69.

———. "Para devolver su inocencia a la nación (origen y desarrollo del Método Best Maugard)." *Abraham Angel y su Tiempo*, 7–19. Toluca: Museo de Bellas Artes, n.d.

Coronel Rivera, Juan. "Animus popularis." *Arte popular mexicano: Cinco siglos*, 11–18. Mexico: UNAM, Instituto de Investigaciones Estéticas, 1997.

Cothran, Dan. "Pacification through Repression and Distribution: The Echeverría Years in Mexico." *The Deterioration of the Mexican Presidency: The Years of Luis*

Echeverría, by Samuel Schmidt. Edited and translated by Dan Cothran, xi–xxvi. Tucson: University of Arizona Press, 1991.

Covarrubias, José Díaz. *Instrucción pública en México: Estado que guardan la instrucción primaria, la secundaria y la profesional en la República.* Mexico City, 1875.

Craib, Raymond. *Cartographic Mexico: A History of State Fixations and Fugitive Landscapes.* Durham: Duke University Press, 2004.

Cruz Soto, Rosalba. "Las publicaciones periódicas y la formación de una identidad nacional." *Estudios de historia moderna y contemporánea (México)* 20 (2000): 15–39.

Cuellár, Rafael. *Memoria presentada al congreso constitucional del estado de Guerrero.* Chilpancingo, Guerrero.: Tipografia del Gobierno del Estado, 1879.

———. *Memoria presentada al congreso constitucional del estado de Guerrero.* Chilpancingo: Tipografia del Gobierno del Estado, 1880.

———. *Memoria presentada al congreso constitucional del estado de Guerrero.* Chilpancingo: Tipografia del Gobierno del Estado, 1881.

Danly, Susan, ed. *Casa Mañana: The Morrow Collection of Mexican Popular Arts.* Albuquerque: University of New Mexico Press, 2002.

Dauster, Frank. "The Contemporary Mexican Theater." *Hispania* 38 (1) (March 1955): 31–34.

Dawson, Alexander S. "From Models for the Nation to Model Citizens: *Indigenismo* and the 'Revindication' of the Mexican Indian, 1920–40." *Journal of Latin American Studies* 30 (2) (1998): 279–308.

de la Cadena, Marisol. *Indigenous Mestizos: The Politics of Race and Culture in Cuzco, Peru, 1919–1991.* Durham: Duke University Press, 2000.

de los Reyes, Aurelio. *Cine y sociedad en México,* vol. 1, *1896–1930: Bajo el cielo de México.* Vol. 2: *1920–1924.* Mexico City: UNAM, 1993.

Dehouve, Daniele. *Cuando los banqueros eran santos: Historia ecónomica y social de la provincia de Tlapa, Guerrero.* Mexico City: Universidad Autónoma de Guerrero, 2002.

Delpar, Helen. *The Enormous Vogue of Things Mexican: Cultural Relations between the United States and Mexico, 1920–1935.* Tuscaloosa: University of Alabama Press, 1992.

Deutsch, Karl. *Nationalism and Social Communication in the Foundations of Nationality: An Inquiry.* Cambridge: MIT Press, 1953.

d'Harnoncourt, René. "Four Hundred Years of Mexican Art." *Art and Archaeology* 33 (2) (March–April 1932): 71–77.

———. "Las artes populares de Mexico," *Mexican Folkways* 6 (2) (1930): 56–65.

———. "Mexican Arts." *American Magazine of Art* 22 (1) (July 1931): 5–22.

————. "The Mexican Exhibition." *Design Devoted to the Decorative Arts*. Special issue on Mexico. (November 1930): 134–37.

————. *Mexican Arts: Catalogue of an Exhibition Organized for and Circulated by the American Federation of Arts, 1930–1931*. New York: American Federation of Arts, 1930.

Diccionario Porrúa de historia, biografía, y geografía de México. 6th ed. Mexico City: Porrúa, 1995.

Dirección General de Estadística (DGE). *V censo general de población 1930*. Mexico City, 1932.

————. *Censo general de la República Mexicana, verificado el 28 de octubre de 1900: Estado de Guerrero*. Mexico City: Secretaría de Fomento, 1905.

Documentos relativos a las sesiones habidas en el Congreso del Estado sobre la agregación del Departamento de Tlapa para formar el nuevo Estado de Guerrero. Puebla: Imprenta de José María Macías, 1849.

Dore, Elizabeth, and Maxine Molyneux, eds. *Hidden Histories of Gender and State in Latin America*. Durham: Duke University Press, 2000.

Dublin, Thomas. *Women at Work: The Transformation of Work and Community in Lowell, Massachusetts, 1826–1860*. New York: Columbia University Press, 1979.

Ducey, Michael. "Village, Nation, and Constitution in Papantla, Veracruz." *Hispanic American Historical Review* 79 (3) (August 1999): 463–93.

Ecksteins, Modris. *Rites of Spring: The Great War and the Birth of the Modern Age*. New York: Anchor, 1989.

Enciclopedia nacional popular de las actividades sociales, industriales, comerciales y agrícolas de la República Mexicana. Mexico City, 1937 [1935].

Enciso, Jorge. "Pintura sobre madera en Michoacán y Guerrero." *Mexican Folkways* 8 (1) (January–March 1933): 4–34.

Errington, Shelly. "La museografia de los objetos de los 'Pueblos Primitivos.'" *Tiempo y arte: XVII coloquio internacional de historia del arte*, 457–468. Mexico City: UNAM, 1991.

Espejel, Carlos. *Las artesanías tradicionales en México*. Mexico City: SEP, 1972.

————. *Olinalá*. Mexico City: Museo Nacional de Artes e Industrias Populares, 1976.

EZLN. "Comunicado del CCRI-CG, Pliego de demandas, 1 de marzo." *Rebellion in Chiapas: An Historical Reader*, edited by John Womack Jr., 269–275. New York: New Press, 1999.

————. "Declaración de La Selva Lacandona." In *Rebellion in Chiapas*, 247–249.

————. "Demands at the Dialogue Table." In *The Mexico Reader*, edited by Gilbert Joseph and Tim Henderson, 638–645. Durham: Duke University Press, 2002.

————. "First and Second Declarations." *The Zapatista Reader*, edited by Tom Hayden, 217–231. New York: Nation Books, 2002.

Faler, Paul. *Mechanics and Manufacturers in the Early Industrial Revolution.* Albany: SUNY, 1981.

Febres, Laura. *Pedro Henríquez Ureña: Crítico de América.* Caracas: La Casa de Bello, 1989.

Fell, Claude. *José Vasconcelos: Los años del águila: Educación, cultura e ibero-americanismo en el México postrevolucionario.* Translated from the French by María Palomar and Javier Manríquez. Mexico City: UNAM, 1989.

Fergusson, Erna. *Mexico Revisited.* New York: Alfred A. Knopf, 1955.

Fernández, Justino. *Roberto Montenegro.* Mexico City: UNAM, 1962.

Field, Cynthia, Isabel Gournay, and Thomas Somma, eds. *Paris on the Potomac: The French Influence on the Architecture and Art of Washington, D.C.* Athens: Ohio University Press, 2007.

Flores Félix, José Joaquín. *El tigre, San Marcos y el comisario.* Mexico City: Universidad Autónoma Metropolitana, El Colegio de Guerrero, 2001.

Florescano, Enrique, ed. *El patrimonio cultural de México.* Mexico City: CONACULTA, Fondo de Cultural Ecónomica, 1993.

———. *Imágenes de la patria a través de los siglos.* Mexico City: Taurus, 2005.

Foucault, Michel. *The Archaeology of Knowledge* and *The Discourse on Language.* Translated by A. M. Sheridan Smith. New York: Pantheon, 1972.

Fox, Jonathan. *The Politics of Food in Mexico: State Power and Social Mobilization.* Ithaca, N.Y.: Cornell University Press, 1992.

Friedlander, Judith. *Being Indian in Hueypan: A Study of Forced Identity in Contemporary Mexico.* New York: St. Martin's, 1975.

Fuentes, Carlos. *A New Time for Mexico.* New York: Farrar, Straus and Giroux, 1996 [1994].

Galindo, Miguel. *El mito de la patria: Estudio de psicología histórica aplicada a la República Mexicana.* Colima: n.p., 1920.

Gamio, Manuel. "The Education of the Indo-Hispanic Peoples." *Aspects of Mexican Civilization,* 129–154. Chicago: University of Chicago Press, 1926.

———. *El gobierno, la población, el territorio.* Mexico City: Departamento de Talleres Gráficos de la Secretaría de Fomento, 1917.

———. *Forjando patria.* Mexico City: Porrúa, 1992 (1916).

———. *Hacia un México nuevo: Problemas sociales.* Mexico City, 1935.

———. Introduction. *La población del valle de Teotihuacan,* vol. 1. Mexico City, 1922.

———. Introduction. *Ethnos* 1 (1) (1920): 10–12.

———. "The New Conquest." *Survey Graphic* 5 (2) (May 1924): 143–46, 192–94.

———. *The Present State of Anthropological Research in Mexico, and Suggestions Regarding its Future Developments.* Washington: Government Printing Office, 1925.

―――. "The Utilitarian Aspect of Folklore." *Mexican Folkways* 1 (1) (June–July 1925): 6–7.

Gamio, Manuel, and José Vasconcelos. *Aspects of Mexican Civilization*. Chicago: University of Chicago Press, 1926.

García de Brens, Lillian. "Pedro Henríquez Ureña: Perfil de un maestro." *Eme eme: Estudios dominicanos* 13 (76) (1985): 3–28.

García Canclini, Néstor. *Arte popular y sociedad en América Latina: Teorías estéticas y ensayos de transformación*. Mexico City: Grijalbo, 1977.

―――. *Hybrid Cultures: Strategies for Entering and Leaving Modernity*. Foreword by Renato Resoldo. Translated by Christopher L. Chiappari and Silvia L. López. Minneapolis: University of Minnesota Press, 1995 [1989].

―――. *Las culturas populares en el capitalismo*. Mexico City: Nueva Imagen, 1982.

―――. "Los usos sociales del patrimonio cultural." *El patrimonio cultural de Mexico*, edited by Enrique Florescano, 41–61. Mexico City: CONACULTA, FCE, 1993.

―――. "Modernity after Postmodernity." *Beyond the Fantastic: Contemporary Art from Latin America*, edited by Gerardo Mosquera, 21–51. Cambridge: MIT Press, 1996.

García, María Elena. *Making Indigenous Citizens: Identities, Education, and Multicultural Development in Peru*. Stanford: Stanford University Press, 2005.

García Mora, Carlos, ed. *La antropología en México*. Vol. 8. Mexico City: INAH, 1988.

Gewertz, Deborah, and Frederick Errington. "We Think, Therefore They Are? On Occidentalizing the World." *Cultures of U.S. Imperialism*, edited by Amy Kaplan and Donald Pease, 635–656. Durham: Duke University Press, 1993.

Givner, Joan. *Katherine Anne Porter: A Life*. London: Jonathan Cape, 1983.

Glusker, Susannah. *Anita Brenner: A Mind of Her Own*. Austin: University of Texas Press, 1998.

Gojman de Backal, Alicia. *Historia del correo en México*. Mexico City: Porrua, 2000.

Gonzáles, Michael, "Imagining Mexico in 1910: Visions of the *Patria* in the Centennial Celebrations in Mexico City." *Journal of Latin American Studies* 39 (2007): 495–533.

González Casanova, Manuel. *Por la pantalla: Génesis de la crítica cinematográfica en México, 1917–1919*. Mexico City: UNAM, 2000.

González Casanova, Pablo. "The Magic of Love among the Aztecs." *Mexican Folkways* 1 (1) (June–July 1925): 17–19.

González, Luis. *San Jose de Gracia: Mexican Village in Transition*. Translated by John Upton. Austin: University of Texas Press, 1972.

Gouy-Gilbert, Cécile. "El nacimiento de un arte tradicional." *Relaciones: Estudios de historia y sociedad* 6 (23) (summer 1985): 39–104.

Graham, Richard. "Constructing a Nation in Nineteenth-Century Brazil: Old and New Views on Class, Culture, and the State." *Journal of Historical Society* 1 (2–3) (winter 2000/spring 2001): 17–56.

———. "From State to Nation in Nineteenth-Century Brazil." Paper presented at the annual meeting of the American Historical Association, Chicago, 3 January 2003.

Gramsci, Antonio. *The Antonio Gramsci Reader: Selected Writings, 1916–1935.* Edited by David Forgacs. New York: New York University, 2000.

Graña, César. *Modernity and Its Discontents: French Society and the French Man of Letters in the Nineteenth Century.* New York: Harper, 1967 [1964].

Grandin, Gregory. *The Blood of Guatemala: The Making of Race and Nation, 1750–1954.* Durham: Duke University Press, 2000.

Grazia, Victoria de. Introduction. *The Sex of Things: Gender and Consumption in Historical Perspectives*, edited by Victoria de Grazia and Ellen Furlough, 11–24. Berkeley: University of California Press, 1996.

Green, Christopher. *Cubism and its Enemies: Modern Movements and Reaction in French Art, 1916–1928.* New Haven: Yale University Press, 1987.

Gruening, Ernest. *Mexico and Its Heritage.* New York: Century, 1928.

Gruzinski, Serge. "Images and Cultural Mestizaje in Colonial Mexico." *Poetics Today* 16 (1) (spring 1995): 53–77.

Guardino, Peter. *Peasants, Politics, and the Formation of Mexico's National State: Guerrero, 1800–1857.* Stanford: Stanford University Press, 1996.

———. "Postcolonialism as Self-Fulfilled Prophesy? Electoral Politics in Oaxaca, 1814–1828." *After Spanish Rule: Postcolonial Predicaments of the Americas*, edited by Peter Guardino and Andrés Guerrero, 248–271. Durham: Duke University Press, 2003.

Guerrero, Andrés. "Redrawing the Nation: Indigenous Intellectuals and Ethnic Pluralism in Contemporary Colombia." *After Spanish Rule: Postcolonial Predicaments of the Americas*, edited by Mark Thurner and Andrés Guerrero, 272–309. Durham: Duke University Press, 2003.

Gutiérrez, Natividad. *Nationalist Myths and Ethnic Identities: Indigenous Intellectuals and the Mexican State.* Lincoln: University of Nebraska Press, 1999.

Gutiérrez, Tonatiuh, Elektra Gutiérrez, and Salvador Novo, *México: Catálogo comercial, artes populares.* Mexico City: Fideicomiso para el Fomento de las Artesanías-Banfoco and Banco Nacional de Comercio Exterior, n.d.

Haber, Stephen. *Industry and Underdevelopment: The Industrialization of Mexico, 1890–1940.* Stanford: Stanford University Press, 1989.

Hale, Charles. *The Transformation of Liberalism in Late Nineteenth-Century Mexico.* Princeton, N.J.: Princeton University Press, 1989.

Hall, Stuart. "Gramsci's Relevance for the Study of Race and Ethnicity." In *Stuart Hall: Critical Dialogues in Cultural Studies*, 411–440.

————. "Race, Articulated in Society." *Sociological Theories, Race and Colonialism.* New York: UNESCO, 1980.

————. *Stuart Hall: Critical Dialogues in Cultural Studies.* Edited by David Morley and Juan-Hsing Chen. New York: Routledge, 1996.

Hamill, Pete. *Diego Rivera.* New York: Harry N. Abrams, 1999.

Hampton, Paul. "What Trotsky on Mexico can tell us about Venezuela and Chavez." *Workers Liberty* 3(10) (March 2007): 1–4.

Hart, Paul. *Bitter Harvest: The Social Transformation of Morelos, Mexico, and the Origins of the Zapatista Revolution, 1840–1910.* Albuquerque: University of New Mexico Press, 2005.

Hellman, Geoffrey T. "Imperturbable Noble." Interview with René d'Harnoncourt. *New Yorker,* 7 May 1960, 49–112.

Henríquez Ureña, Pedro. "Arte mexicano." Epilogue to *Manuales y tratados: Método de dibujo: Tradición, resurgimiento y evolución del arte mexicano* by Adolfo Best, 1–18. Mexico City: SEP, 1923.

————. "La Revolución y la cultura en México." *Revista de revistas,* 15 March 1925, 34–35.

Herb, Guntram Henrick. *Under the Map of Germany: Nationalism and Propaganda, 1918–1945.* New York: Routledge, 1997.

Hernández Chávez, Alicia. *Anenecuilco: Memoria y vida de un pueblo.* 2nd ed. Mexico City: El Colegio de México, 1993 [1991].

Hernández-Díaz, Jorge. "National Identity and Indigenous Ethnicity in Mexico." *Canadian Review of Studies in Nationalism* 21 (1–2) (1994): 71–81.

Herring, Hubert. *The Story of the Mexican Seminar.* New York: Committee on Cultural Relations with Latin America, 1939.

Hersch Martínez, Paul, Robert Glass, and Andrés Fierro Álvarez. "El linaloe [*bursera aloexyslon* (Schiede) Engl.]: Una Madera aromática entre la tradición y la presión económica." *Productos forestales, medios de subsistencia y conservacion: Estudios de caso sobre sistemas de manejo de productos forestales no maderables,* edited by M. N. Alexiades and P. Shanley, vol. 3, 440–462. Bogor, Indonesia: Center for International Forestry Research, 2004.

Hershfield, Joanne. *Imagining la Chica Moderna: Women, Nation, and Visual Culture in Mexico, 1917–1936.* Durham: Duke University Press, 2008.

Hilton, Alison. *Russian Art.* Bloomington: Indiana University Press, 1995.

Historia General de Guerrero. Mexico City: INAH, 1998.

Hobsbawm, Eric. *Nations and Nationalism since 1780.* Cambridge: Cambridge University Press, 1990.

Hobsbawm, Eric, and Terrance Ranger. *The Invention of Tradition.* Cambridge: Cambridge University Press, 1983.

Holguín, Sandie. *Creating Spaniards: Culture and National Identity in Republican Spain*. Madison: University of Wisconsin Press, 2002.

Hughes, H. Stuart. *Consciousness and Society: The Reorientation of European Social Thought, 1890–1930*. Brighton: Harvester, 1979 [1958].

Hulme, Peter. *Colonial Encounters: Europe and the Native Caribbean, 1492–1797*. New York: Routledge, 1992 [1986].

Hurlburt, Laurence. "Diego Rivera (1886–1957): A Chronology of His Art, Life and Times." *Diego Rivera: A Retrospective*, 22–115. New York: W. W. Norton, 1986.

Hutchinson, John. "Myth against Myth: The Nation as Ethnic Overlay." *History and National Destiny: Ethnosymbolism and its Critics*, edited by Monserrat Guibernau and John Hutchinson, 109–23. Oxford: Blackwell, 2004.

Jacobs, Ian. *Ranchero Revolt: The Mexican Revolution in Guerrero*. Austin: University of Texas Press, 1982.

"Jícaras de calabaza en el México prehispánico," *Artes de México* 153 (19) (1972): 5–14.

Joseph, Gilbert. "Close Encounters: Towards a New Cultural History of U.S.–Latin American Relations." *Close Encounters of Empire: Writing the Cultural History of U.S.–Latin American Relations*, edited by Gilbert Joseph, Catherine LeGrand, and Ricardo Salvatore, 3–46. Durham: Duke University Press, 1998.

———. *Revolution from Without: Yucatán, Mexico, and the United States, 1880–1924*. Durham: Duke University Press, 1988 [1982].

Joseph, Gilbert, and Daniel Nugent, eds. *Everyday Forms of State Formation: Revolution and the Negotiation of Rule in Modern Mexico*. Durham: Duke University Press, 1994.

Joseph, Gilbert, Catherine Legrand, and Ricardo Salvatore, eds. *Close Encounters of Empire: Writing the Cultural History of U.S.–Latin American Relations*. Durham: Duke University Press, 1998.

Joseph, Gilbert, Anne Rubenstein, and Eric Zolov, eds. *Fragments of a Golden Age: The Politics of Mexico since 1940*. Durham: Duke University Press, 2001.

Kaplan, Amy, and Donald Pease, eds. *Cultures of U.S. Imperialism*. Durham: Duke University Press, 1993.

Kearney, Michael, and Carol Nagengast. "Mixtec Ethnicity: Social Identity, Political Consciousness, and Political Activism." *Latin American Research Review* 25 (2) (1990): 61–91.

Kedourie, Elie. *Nationalism*. 4th ed. Cambridge: Blackwell, 1993 [1960].

Klesner, Joseph. "Political Change in Mexico: Institutions and Identity." *Latin American Research Review* 32 (2) (1997): 184–200.

Knight, Alan. "Cardenismo: Juggernaut or Jalopy? *Journal of Latin American Studies* 26 (1) (February 1994): 73–107.

———. *The Mexican Revolution*. 2 vols. Lincoln: University of Nebraska Press, 1986.

———. "Peasants into Patriots: Thoughts on the Making of the Mexican Nation." *Mexican Studies/Estudios mexicanos* 10 (1) (1994): 135–61.

———. "Racism, Revolution, and *Indigenismo*: Mexico, 1910–1949." *The Idea of Race in Latin America, 1870–1940*, edited by Richard Graham, 71–113. Austin: University of Texas Press, 1990.

———. "The Rise and Fall of Cardenismo." *Mexico Since Independence*, edited by Leslie Bethell, 241–320. New York: Cambridge University Press, 1991.

Kraver, Jeraldine. "Laughing Best: Competing Correlatives in the Art of Katherine Anne Porter and Diego Rivera." *South Atlantic Review* 63 (2) (spring 1998): 48–74.

Lacy, Elaine. "The 1921 Centennial Celebration of Mexico's Independence: State Building and Popular Negotiation." *¡Viva México! ¡Viva la Independencia! Celebrations of September 16*, edited by William Beezley and David Lorey, 199–232. Wilmington, Del.: Scholarly Resources, 2001.

"La pintura de las pulquerías," *Mexican Folkways*, 7, June–July 1926.

Lara Erizondo, Lupina. "Gerardo Murillo, Dr Atl: Semblanza estética," *Van Gogh, Atl, O'Higging: Expresión humana, esencia de paisaje*, edited by Lupina Lara Erizando, 261–269. Mexico City: Promoción de Arte Mexicano, 2006.

Larson, Brooke. *Trials of Nation Making: Liberalism, Race, and Ethnicity in the Andes, 1810–1910*. Cambridge: Cambridge University Press, 2004.

Lasso, Marixa. "Revisiting Independence Day: Afro-Colombian Politics and Creole Patriot Narratives, Cartagena, 1809–1815." *After Spanish Rule: Postcolonial Predicaments of the Americas*, edited by Mark Thurner and Andrés Guerrero, 223–245. Durham: Duke University Press, 2003.

Lawrence, D. H. *The Plumed Serpent*. London: Heron, 1964.

———. *Viva y muera México*. Mexico City: Diogenes, 1970.

Lears, T. J. Jackson. *No Place of Grace: Antimodernism and the Transformation of American Culture, 1880–1920*. New York: Pantheon, 1981.

Lebovics, Herman. *True France: The Wars over Cultural Identity, 1900–1945*. Ithaca, N.Y.: Cornell University Press, 1992.

Lechuga, Ruth. *Lacas mexicanas*. Mexico City: Museo Franz Meyer, Artes de México, 1997.

Lemepérière, Annick. "Los dos centenarios de la independencia mexicana (1910–1920): De la historia patria a la antropología cultural." *Historia mexicana* 45 (2) (October–December 1995): 317–52.

León, Francisco de. *Los esmaltes de Uruapan*. Mexico City: DAPP, 1939 [1922].

L'Estoile, Benoit de, Federico Neiburg, and Lygia Sigaud. Introduction. *Empires, Nations, and Natives: Anthropology and State-Making*, edited by Benoit de L'Estoile, Federico Neiburg, and Lygia Sigaud, 1–29. Durham: Duke University Press, 2005.

Levine, Lawrence. *Highbrow/Lowbrow*. Cambridge: Harvard University Press, 1988.

Little, Walter. *Mayas in the Marketplace: Tourism, Globalization, and Cultural Identity*. Austin: University of Texas Press, 2004.

Littleton, Taylor. *The Color of Silver: William Spratling, His Life and Art*. Baton Rouge: Louisiana State University Press, 2000.

Lomnitz, Claudio. "Bordering on Anthropology: Dialectics of a National Tradition in Mexico." *Empires, Nations, and Natives: Anthropology and State-Making*. Edited by Benoit de L'Estoile, Federico Neiburg, and Lygia Sigaud, 167–196. Durham: Duke University Press, 2005.

———. *Exits from the Labyrinth: Culture and Ideology in the Mexican National Space*. Berkeley: University of California Press, 1992.

———. "Modes of Citizenship in Mexico." *Public Culture: Society and Transnational Cultural Studies* 2 (1) (winter 1999): 269–93.

López, Héctor. *Diccionario geográfico, histórico, biográfico y lingüístico del Estado de Guerrero*. Mexico City: n.p., 1942.

López, Rick. "Forging a Mexican National Identity in Chicago: Mexican Migrants and Hull-House: 1920–1937." *Pots of Promise: Mexicans, Reformers, and the Hull-House Kilns, Chicago, 1920–1940*, edited by Cheryl R. Ganz and Margaret Strobel, 89–111. Chicago: University Chicago Press, 2004.

———. "The Morrows in Mexico: Nationalist Politics, Foreign Patronage, and the Valorization of Mexican Popular Aesthetics." *Casa Mañana: The Morrow Collection of Mexican Popular Arts*, edited by Susan Danly, 47–63. Albuquerque: University of New Mexico Press, 2002.

———. "The *Noche Mexicana* and the Exhibition of Popular Art: Two Ways of Exalting Indianness." *Eagle and the Virgin: Nation and Cultural Revolution in Mexico, 1920–1940*, edited by Mary Kay Vaughan and Stephen Lewis, 23–42. Durham: Duke University Press, 2006.

López, Rick, Beatriz Caníbal, David Cienfuegos, José Joaquin Flores, et al., eds. *Moviendo montañas: Transformando la geografía del poder en el Sur de México*. Chilpancingo: El Colegio de Guerrero, 2002.

López, Ruth. *Chocolate: The Nature of Indulgence*. New York: Harry N. Abrams, 2002.

López Victoria, José Manuel. *Historia de la Revolución en Guerrero*. Chilpancingo, Gro: Gobierno del Estado de Guerrero, Instituto Guerrerense de la Cultura, 1985.

Luna Arroyo, Antonio. *El Dr. Atl. Paisajista puro*. Mexico City: Editorial Cvtvra, 1952.

Maldonado, Eugenio. "The Indian Problem." *Mexican Art and Life*, no. 4 (October 1938): n.p.

Mallon, Florencia. *Peasant and Nation: The Making of Postcolonial Mexico and Peru*. Berkeley: University of California Press, 1995.

Mark, Joan. *The Silver Gringo: William Spratling and Taxco*. Albuquerque: University of New Mexico Press, 2000.

Marnham, Patrick. *Dreaming with His Eyes Open: The Life of Diego Rivera*. New York: Alfred A. Knopf, 1998.

Martínez Novo, Carmen. *Who Defines Indigenous? Identities, Development, Intellectuals, and the State in Northern Mexico*. New Brunswick, N.J.: Rutgers University Press, 2006.

Martínez Peñaloza, Porfirio. "El folclore y las artes populares." *Los estudios sobre el arte mexicano: Examen y prospectiva*, 232–232. Mexico City: UNAM, 1986.

———. *Popular Art of Mexico: The Artistic Creativity of the Mexican People throughout Time*. Mexico City: Lara, 1979.

Martínez Rescalvo, Mario O. *Reseña histórica de la Montaña de Guerrero*. Chilpancingo: Universidad Autónoma de Guerrero, 1990.

Mastache Flores, Alba Guadalupe, and Elia Nora Morett Sánchez. *Entre dos mundos: Artesanos y artesanías en Guerrero*. Mexico City: INAH, 1997.

McAllister, Carlota. "Authenticity and Guatemala's Maya Queen." *Beauty Queens on the Global Stage: Gender, Contests, and Power*, edited by Coleen Ballerino Cohen, Richard Wilk, and Beverly Stoeltje, 105–24. New York: Routledge, 1996.

Medina González, Isabel. "¿Maque prehispánico? Una antigua discusión." *Lacas mexicanas*, 21–29. Mexico City: Museo Franz Mayer, Artes de México, 1997.

Melzer, Richard. "The Ambassador *Simpático*: Dwight Morrow in Mexico, 1927–1930." *Ambassadors in Foreign Policy: The Influence of Individuals on U.S.–Latin American Policy*, edited by C. Neale Ronning and Albert P. Vannucci, 1–20. New York: Praeger, 1987.

———. "Dwight Morrow's Role in the Mexican Revolution: Good Neighbor or Meddling Yankee?" Ph.D. dissertation, University of New Mexico, 1979.

Millán Chivite, Alberto. *El costumbrismo mexicano en las novelas de la Revolución*. Seville: Universidad de Sevilla, 1996.

Miller, Michael. *Red, White, and Green: The Maturing of Mexicanidad, 1940–1946*. El Paso: Texas Western, 1998.

Miller, Nicola. *In the Shadow of the State: Intellectuals and the Quest for National Identity in Twentieth-Century Spanish America*. New York: Verso–New Left, 1999.

Mistral, Gabriela. "Cajita de Olinalá." *Ternura*. Madrid: Editorial Calleja, 1924.

Molina Enríquez, Renato. "Lacas de México, los baúles de Olinalá." *Forma: Revista de Artes Plásticas* 6 (1928): 19–21.

———. "Lacas de México: Los baúles de Olinalá." *Nuestra Ciudad* (1928): 24–27.

———. "Las lacas de México." *Ethnos* 1 (5) (1925): 115–24.

Monsisváis, Carlos. "Foreword: *Anita Brenner: A Mind of Her Own*," by Susannah Glusker, viii–x. Austin: University of Texas Press, 1998.

Montenegro, Roberto. "Folk Art." *Twenty Centuries of Mexican Art*. New York and Mexico City: Museum of Modern Art and the Instituto de Antropología e Historia de México, 1940.

———. *Museo de Artes Populares*. Mexico City: Ediciones de Arte, 1948.

———. *Planos en el tiempo*. Mexico City: n.p., 1962.

Montenegro, Roberto, Antonio Castro Leal, Alfonso Caso, and Miguel Covarrubias. *Twenty Centuries of Mexican Art*. New York and Mexico: Museum of Modern Art and the Instituto de Antropología e Historia de México, 1940.

Monzón Estrada, Arturo. *Artes y artesanías de Guerrero*. Chilpancingo: Universidad Autónoma de Guerrero, 1972.

Moore, Robin D. *Nationalizing Blackness: Afrocubanismo and Artistic Revolution in Havana, 1920–1940*. Pittsburgh: University of Pittsburgh Press, 1997.

Morley, David, and Kuan-Hsing Chen, eds. *Stuart Hall: Critical Dialogues in Cultural Studies*. New York: Routledge, 1996.

Morrill, Penny, ed. *William Spratling and the Mexican Silver Renaissance: Maestros de plata*. San Antonio: Harry N. Abrams, 2002.

Morrow, Elizabeth Cutter. "Home Again." *Charm* (May 1930): 61.

———. "Our Street in Cuernavaca," *American Mercury* 23 (August 1931): 411–18.

———. *Casa Mañana*. Croton Falls, N.Y.: Spiral, 1932.

———. *The Mexican Years: Leaves from the Diary of Elizabeth Cutter Morrow*. New York: Spiral, 1953.

———. *The Painted Pig*. New York: Alfred A. Knopf, 1930.

Muñoz, Maurilio. *Mixteca-nahua-tlapaneca, Memorias del Instituto Nacional Indigenista*, vol. 9. Mexico City: INI, 1963.

Muratorio, Blanca. "Images of Indians in the Construction of Ecuadorian Identity at the end of the Nineteenth Century." *Latin American Popular Culture*, edited by William Beezley and Linda Curcio-Nagy, 105–121. Wilmington, Del.: Scholarly Resources, 2000.

Museo Nacional. *Guía oficial*. Mexico City: INAH-SALVAT, 1988.

Nadasdy, Paul. "Transcending the Debate over the Ecologically Noble Indian: Indigenous People and Environmentalism." *Ethnohistory* 52 (2) (spring 2005): 291–331.

Needell, Jeffrey. "Rio de Janeiro and Buenos Aires: Public Space and Public Consciousness in Fin-De-Siècle Latin America." *Comparative Studies in Society and History* 37 (3) (July 1995): 519–40.

Nicolson, Harold. *Dwight Morrow*. New York: Harcourt, Brace, 1935.

Novelo, Victoria. "Las artesanías en México." *El patrimonio cultural de México*, edited by Enrique Florescano, 219–246. Mexico City: FCE, 1993.

———. *Artesanías y capitalismo en México*. Mexico City: SEP, INAH, CIESAS, 1976.

———. *Artesanos, artesanias y arte popular de México*. Mexico City: CONACULTA, 1996.

Novo, Salvador. "Jalisco-Michoacán" (1933). *Viajes e ensayos*, vol. 1, 667–688. Mexico: Fondo de Cultura Económica, 1996.

Novoa, Bruce. "Offshoring the American Dream." *New Centennial Review* 3 (1) (2003): 109–45.

Nugent, Daniel, and Ana María Alonso. "Multiple Selective Traditions in Agrarian Reform and Agrarian Struggle." *Everyday Forms of State Formation: Revolution and the Negotiation of Rule in Modern Mexico*, edited by Gilbert Joseph and Daniel Nugent, 209–246. Durham: Duke University Press, 1994.

Oettinger, Marion. *Folk Treasures of México: The Nelson A. Rockefeller Collection*. New York: Harry N. Abrams, 1990.

Ohmstede, Escobar Antonio, and Teresa Rojas Rabiela, eds. *Presencia del indígena en la prensa capitalina del siglo XIX*. Mexico City: INI-CIESAS, 1992.

Oles, James. "For Business or Pleasure: Exhibiting Mexican Folk Art, 1820–1930." *Casa Mañana: The Morrow Collection of Mexican Popular Arts*, edited by Susan Danly, 11–30. Albuquerque: University of New Mexico Press, 2002.

———. *South of the Border: Mexico in the American Imagination, 1914–1947 / México en la imaginación norteamericana*. Washington: Smithsonian Institution Press, 1993.

Olivé Negrete, and Julio César, eds. *INAH, una historia*. 2 vols. Mexico: Consejo Nacional para la Cultural y las Artes, INAH, 1995.

Olson, Patrice Elizabeth. "Revolution in the City Streets: Changing Nomenclature, Changing Form, and the Revision of Public Memory." *Eagle and the Virgin: Nation and Cultural Revolution in Mexico, 1920–1940*, edited by Mary Kay Vaughan and Stephen Lewis, 119–34. Durham: Duke University Press, 2006.

Olson, Patrice Elizabeth. *Artifacts of Revolution: Architecture, Society, and Politics in Mexico City, 1920–1940*. New York: Rowman and Littlefield, 2008.

Orlove, Benjamin, ed. *The Allure of the Foreign: Imported Goods in Postcolonial Latin America*. Ann Arbor: University of Michigan Press, 1997.

Orozco, José Clemente. *Autobiografía*. Mexico City: Ediciones Era, 1996 [1945].

Ortíz Gaitán, Julieta. *Entre dos mundos: Los murales de Roberto Montenegro*. Mexico City: Instituto de Investigaciones Estéticas, UNAM, 1994.

———. "Políticas culturales en el régimen de Plutarco Elías Calles y en el Maximato." *Arte y coerción: Primer coloquio del comité mexicano de historia del arte*, 193–204. Mexico: UNAM, Instituto de Investigaciones Estéticas, 1992.

Ortiz Hernán, Sergio. *Caminos y transportes en México: Una aproximación socio-económica: Fines de la colonia y principios de la vida independiente*. Mexico City: Fondo de Cultura Económica, 1994.

Othón de Mendizábal, Miguel. *Obras completas*, 6 vols. Mexico City, 1946.

———. "El Departamento Autónoma Indígena de México: Sus fines, su tactica y su organización." *Obras completas*, vol. 4, 331–38. Mexico City, 1946.

————. "El fomento de las industrias populares." *Crisol* 1 (1) (January 1929): 21–24; and 1 (2) (March 1929): 29–35.

————. "El problema social de las lenguas indígenas." *Obras completas*, vol. 4, 173–181. Mexico City, 1946.

Overmyer-Velázquez, Mark. *Visions of the Emerald City: Modernity, Tradition and the Formation of Porfirian Oaxaca, Mexico.* Durham: Duke University Press, 2006.

Paine, Frances Flynn. "La Casita en Cuernavaca: The Mexican Home of Dwight W. Morrow." *House Beautiful*, October 1931, 326–29+.

Palacios, Gullermo. "Postrevolutionary Intellectuals, Rural Readings and the Shaping of the 'Peasant Problem' in Mexico: *El Maestro Rural*, 1932–34." *Journal of Latin American Studies* 30 (2) (May 1998): 309–39.

Palavicini, Félix F. Introduction. *La patria por la escuela.* Mexico City: Linotipografía Artística, 1916.

Pani, Alberto. "The Sanitary and Educational Problems of Mexico." Address delivered 10 November 1916. *Annals of the American Academy of Political and Social Science* 69 (supplement) (January 1917): 22–26.

————. *Una encuesta sobre educación popular.* Mexico: Poder Ejecutivo Federal, 1918.

Paucic, Alejandro W. *Carta corográfica del estado de Guerrero–1949.* Mexico City: Dirección de Geografía, Meteorología e Hidrología, 1952.

————. *Geografía general del estado de Guerrero.* Chilpancingo: FONAPAS-Guerrero, 1980.

————. [Paw]. "Algunas observaciones acerca de la religión de los mixtecos guerrerenses." *Revista mexicana de estudios antropológicos* 12 (1951): 147–64.

————. [Paw]. "La región oriental indígena de Guerrero y sus problemas actuales." Unpublished manuscript, 1937.

Pavía Guzmán, Edgar. "Tlalpan, una provincial guerrerense, datos y hechos históricos." *Primer coloquio de arqueología y etnohistoria del Estado de Guerrero*, 407–422. Mexico City: INAH, 1986.

Pavía Miller, María Teresa. "Origen y formación (1821–1867)." *Historia general de Guerrero: Volumen III, formación y modernización*, 13–146. Mexico City: INAH, 1998.

Peiss, Kathy. "Making Up, Making Over: Cosmetics, Consumer Culture, and Women's Identity." *The Sex of Things: Gender and Consumption in Historical Perspectives*, edited by Victoria de Grazia and Ellen Furlough, 311–336. Berkeley: University of California Press, 1996.

Pérez Carrillo, Sonia. *La laca mexicana: Desarrollo de un oficio artesanal en el Virreinato de la Nueva España durante el siglo XVIII.* Madrid: Alianza Editorial, Dirección General de Cooperación Cultural, Ministerio de Cultural, 1990.

Pérez Montfort, Ricardo. *Avatares del nacionalismo*. Mexico City: CIESAS, 2000.

———. "La consolidación del acuerdo estereotípico nacional, 1921–37." *Eslabones*, no. 2 (July/December 1992): 153–65.

———. *Estampas de nacionalismo popular mexicano: Ensayos sobre cultura popular y nacionalismo*. Mexico City: Centro de Investigaciones y Estudios Superiores en Antropología Social, 1994.

———. "Historia, literatura y folklore 1920–1940: El nacionalismo cultural de Rubén M. Campos, Fernando Ramírez de Aguilar e Higinio Vázquez Santa Ana." *Cuicuilco* 1 (2) (September–December 1994): 87–103.

Piccato, Pablo. "Urbanistas, Ambulantes and Mendigos: The Dispute for Urban Space in Mexico City, 1890–1930." *Reconstructing Criminality in Latin America*, edited by Carlos A. Aguirre and Robert Buffington, 113–147. Wilmington, Del.: Scholarly Resources, 2000.

Pike, Frederick. *The United States and Latin America: Myths and Stereotypes of Civilization and Nature*. Austin: University of Texas Press, 1992.

Pilcher, Jeffrey. *¡Que vivan los tamales! Food and the Making of Mexican Identity*. Albuquerque: University of New Mexico Press, 1998.

Pimentel, Francisco. *Memoria sobre las causas que han originado la situación actual de la raza indígena de México y medios de remediarla*. Mexico City, 1864.

Pomar, María Teresa. Introduction. *Las artes populares en México*, facsimile of 2nd ed. (1922), vii-x. Mexico City: Instituto Nacional Indigenista, Museo de Artes e Industrias Populares, 1980.

Pontón, José María. "Las razas indígenas de México." *Anales del Museo Nacional de Arqueología, Historia, y Etnografía* 5 (1) (1930): 419.

Poole, Deborah. "An Image of 'Our Indian': Type Photographs and Racial Sentiments in Oaxaca, 1920–1940." *Hispanic American Historical Review* 84 (1) (February 2004): 37–82.

Porter, Katherine Anne. *Outline of Mexican Arts and Crafts*. Los Angeles: Young and McAllister, 1922.

Postero, Nancy Grey, and Leon Zamosc. *The Struggle for Indigenous Rights in Latin America*. Brighton: Sussex Academic, 2004.

Prakash, Gyan. Introduction. *After Colonialism: Imperial Histories and Postcolonial Displacements*, edited by Gyan Prakash, 3–17. Princeton, N.J.: Princeton University Press, 1995.

Pratt, Mary Louise. *Imperial Eyes: Travel Writing and Transculturation*. New York: Routledge, 1992.

Puig Casauranc, José Manuel. *Addresses Delivered by J. M. Puig Casauranc, Secretary of Public Education of Mexico, the 23rd and 24th of March 1926 at Columbia University, New York*. Mexico City: Talleres Gráficos de la Nación, 1926.

Purnell, Jennie. *Popular Movements and State Formation in Revolutionary Mexico: The Agraristas and Cristeros of Michoacán*. Durham: Duke University Press, 1999.

Quezada, Jaime. "Cronología." *Gabriela Mistral: Poesias completas*, 735–780. Mexico City: Andrés Bello, 2001.

———. Prologue to *Ternura* by Gabriela Mistral. Santiago: Editorial Universitario, 1989.

Ravelo Lecuona, Renato, "Periodo 1910–1920." *Historia de la cuestión agraria mexicana: Estado de Guerrero, 1867–1940*, 81–219. Mexico City: Universidad Autónoma de Guerrero, Centro de Estudios Históricos del Agrarismo en México, 1987.

———. "La revolución guerrerense." *Historia general de Guerrero*, vol. 4, 11–187. Mexico City: CONACULTA, INAH, 1998.

Rodó, Enríque. *Ariel*. Translated by Margaret Sayers Peden. Austin: University of Texas Press, 1988 [1900].

Rodríguez Kuri, Ariel. "Hacia México 68: Pedro Ramírez Vázquez y el proyecto olímpico." *Secuencia* 56 (May–August 2003): 37–73.

Rodríguez Prampolini, Ida. "La figura del indio en la pintura del siglo XIX: Fondo ideológico." *La polémica del arte nacional en México, 1850–1910*, edited by Daniel Schávelzon, 202–217. Mexico City: Fondo de Cultura Económica, 1988.

Romero Giordano, Carlos. "Lacas de Olinalá." *México en el tiempo*, no. 8 (August–September 1995): 50–56.

———. "Réquiem por un museo." *México desconocido online*, adapted from *México en el tiempo*, no. 3 (February–March 1995). Visited 13 June 2005.

Ross, Stanley, "Dwight Morrow and the Mexican Revolution." *Hispanic American Historical Review* 38 (4) (November 1958): 506–28.

———. "Dwight W. Morrow, Ambassador to Mexico." *Americas* 14 (1957–58): 273–90.

Rubí Alarcón, Rafael. "La encomienda de La Montaña." *Primer coloquio de arqueología y etnohistoria del Estado de Guerrero*, 425–440. Mexico City: INAH, 1986.

Rubin, Jeffrey. *Decentering the Regime: Ethnicity, Radicalism, and Democracy*. Dirham: Duke University Press, 1997.

Rubín de la Borbolla, Daniel Fernando. *Arte popular mexicano*. Mexico City: Fondo de Cultura Económica, 1974.

———. "Arte popular mexicano." *Artes de México* 11 (43/44) (1963): 4–20.

———. "Imagenes del arte popular." *La cultura en méxico: Suplemento de ¡Siempre!* 5 June 1963, iii–viii.

———. "Observaciones sobre el arte popular mexicano." *Estudios antropológicos publicados en homenaje al doctor Manuel Gamio*, 447–452. Mexico City: UNAM, 1956.

————. "El problema indígena de México." *Educación* (special issue) (June 1940): 97.

————. "Supervivencia del arte popular." *Artes de México*, no. 1 (October–November 1953): 50–64.

————, et al. *William Spratling*. Mexico City: Centro Cultural / Arte Contemporáneo, 1987.

Ruiz Martínez, Apen. "La India Bonita: Nacion y género in el México revolucionario." *Signos Históricos* 5 (January–June 2001): 55–86.

Sáenz, Moisés. *Mexico: An Appraisal and a Forecast*. New York: Committee on Cultural Relations with Latin America, 1929.

————. *México íntegro*. Mexico City: SEP / Fondo de Cultura Económica, 1982 [1939].

Sáenz, Olga. *Símbolo y la acción: Vida y obra de Gerardo Murillo, Dr. Atl*. Mexico City: Colegio Nacional, 2005.

Sahlins, Peter. *Boundaries: The Making of Spain and France in the Pyrenees*. Berkeley: University of California Press, 1989.

————. "The Nation in the Village: State-Building and Communal Struggles in the Catalan Borderland during the Eighteenth and Nineteenth Centuries." *Journal of Modern History* 60 (1988): 234–63.

Said, Edward. *Culture and Imperialism*. New York: Alfred A. Knopf, 1993.

Salazar Adame, Jaime. "La modernización." *Historia general de Guerrero*, vol. 3, *Formación y modernización*, 143–312. Mexico City: INAH, 1998.

————. *Movimientos populares durante el profiriato en el estado de Guerrero, 1886–1893*. Chilpancingo: Universidad de Guerrero, 1983.

Sánchez Serrano, Evangelina. "Los espacios territoriales en la montaña de Guerrero." *Los Caminos de la Montaña: Formas de reproducción social en la Montaña de Guerrero*, edited by Beatriz Caníbal, 157–196. Mexico City: UAM-CIESAS, 2001.

Saragoza, Alex. "The Selling of Mexico: Tourism and the State, 1929–1952." *Fragments of a Golden Age: The Politics of Culture in Mexico Since 1940*, edited by Gilbert Joseph, Anne Rubinstein, and Eric Zolov, 91–115. Durham: Duke University Press, 2001.

Schávelzon, Daniel, ed. *La polémica del arte nacional en México, 1850–1910*. Mexico City: FCE, 1988.

Schmidt, Arthur. "Making It Real Compared to What? Reconceptualizing Mexican History since 1940." *Fragments of a Golden Age: The Politics of Culture in Mexico since 1940*, edited by Gilbert Joseph, Anne Rubinstein, and Eric Zolov, 23–68. Durham: Duke University Press, 2001.

Schmidt, Samuel. *The Deterioration of the Mexican Presidency: The Years of Luis Echeverría*. Translated and edited by Dan Cothran. Tucson: University of Arizona Press, 1991.

Schor, Juliet, and Douglas Holt. Introduction. *The Consumer Society Reader*, edited by Juliet Schor and Douglas Holt, vii–xxiii. New York: W. W. Norton, 2000.

Schorske, Carl E. *Fin-de-Siecle Vienna*. New York: Random House, 1981 [1961].

Scott, James. *Seeing like a State: How Certain Schemes to Improve the Human Condition Have Failed*. New Haven: Yale University Press, 1998.

Secretaría de Educación Pública (SEP). *50 años de artes plásticas en el Palacio de Bellas Artes*. Mexico City: SEP, 1988.

Sepúlveda, María Teresa. *Maque: Vocabulario de materias primas, instrumentos de trabajo, procesos técnicos y motivos decorativos del maque*. Mexico City: INAH, Museo Nacional de Antropología, 1978.

Sider, Gerald. "When Parrots Learn to Talk and Why They Can't: Domination, Deception, and Self-Deception in Indian-White Relations." *Comparative Studies of Society and History* (1987): 3–23.

Sierra Torre, Aída. "Geografías imaginarias II: La figura de la tehuana." *Del istmo y sus mujeres: Tehuanas en el arte mexicano*, 37–59. Mexico City: Museo Nacional de Arte, 1992.

Silver, Kenneth E. *Esprit de corps: The Art of the Parisian Avant-Garde and the First World War, 1914–1925*. Princeton, N.J.: Princeton University Press, 1989.

Smith, Anthony. "Dating the Nation." *Ethnonationalism and the Contemporary World: Walker Connor and the Study of Nationalism*, edited by Daniele Conversi, 53–71. New York: Routledge, 2002.

Smith, Anthony, and John Hutchinson, eds. *Nationalism*. New York: Oxford University Press, 1994.

Smith, Gavin. "The Production of Culture in Local Rebellion." *Golden Ages, Dark Ages: Imagining the Past in Anthropology and History*, edited by Jay O'Brien and William Roseberry, 180–205. Berkeley: University of California Press, 1991.

Smith, Robert Freeman. *The United States and Revolutionary Nationalism in Mexico, 1916–1932*. Chicago: University of Chicago Press, 1972.

Spencer, Philip, and Howard Wollman. Introduction. *Nations and Nationalism*, 1–19. Edinburgh: Edinburgh University Press, 2005.

Spengler, Oswald. *Decline of the West*. Translated by Charles Francis Atkinson. New York: Oxford University Press, 1991 [1926].

Spratling, William. *File on Spratling: An Autobiography*. Boston: Little, Brown, 1967.

———. "The Most Mexican City." *Architectural Digest*, February 1928, 217–22.

———. *A Small Mexican World*. Foreword by Diego Rivera. Boston: Little, Brown, 1964 [1932].

———. "Some Impressions of Mexico." *Architectural Forum* 48 (1–2) (July–August 1927): 108, 161–68.

Staller, Natasha. "Mélies' 'Fantastic' Cinema and the Origins of Cubism." *Art History* 12 (2) (June 1989): 202–32.

Stepan, Nancy. *The Hour of Eugenics: Race, Gender, and Nation in Latin America.* Ithaca, N.Y.: Cornell University Press, 1991.

Stephen, Lynn. *¡Zapata Lives! Histories and Cultural Politics in Southern Mexico.* Berkeley: University of California Press, 2002.

Stern, Alexandra. "From Mestizophilia to Biotypology: Racialization and Science in Mexico, 1920–1960." *Race and Nation in Modern Latin America,* edited by N. Appelbaum, A. S. Macpherson, and K. A. Rosemblatt, 187–210. Chapel Hill: University of North Carolina Press, 2003.

Stern, Steve. *The Secret History of Gender: Women, Men, and Power in Late Colonial Mexico.* Chapel Hill: University of North Carolina Press, 1995.

Stromberg, Gobi. *El juego del coyote: Platería y arte en Taxco.* Mexico City: Fondo de Cultura Económica, 1985.

Suárez Longoria, S. "La exposición de arte popular." *Azulejos,* October 1921, 29–30.

Swarthout, Kelley. *Assimilating the Primitive: Parallel Dialogue on Racial Miscegenation in Revolutionary Mexico.* New York: Peter Lang, 2004.

Tanenbaum, Barbara. "Streetwise History: The Paseo de la Reforma and the Porfirian State, 1876–1910." *Rituals of Rule, Rituals of Resistance,* edited by William Beezley, Cheryl English Martin, and William French, 127–150. Wilmington, Del.: Scholarly Resources, 1994.

Tannenbaum, Frank. "Mexico: A Promise." *Survey Graphic* 5 (2) (May 1924): 129–32.

———. *Peace by Revolution: Mexico after 1910.* New York: Columbia University Press, 1933.

Tapia Ortega, Francisco. "Cara y cruz de un periodista mexicano." *Revista mexicana de ciencias políticas y sociales* 28 (109) (1982): 123–34.

Tenorio, Mauricio. "1910 Mexico City: Space and Nation in the City of the Centenario." *Journal of Latin American Studies* 28 (1) (February 1996): 75–104.

———. "The Cosmopolitan Summer, 1920–1949," *Latin American Research Review* 32 (3) (1997): 224–42.

———. "Essaying the History of National Images." *After Spanish Rule: Postcolonial Predicaments of the Americas,* edited by Mark Thurner and Andrés Guerrero, 58–88. Durham: Duke University Press, 2003.

———. *Mexico at the World's Fairs: Crafting a Modern Nation.* Berkeley: University of California Press, 1996.

Thiele, Eva-María. *El maque: Estudio histórico sobre un bello arte.* Morelia: Instituto Michoacano de Cultura, Casa de las Artesanía del Estado de Michoacán, 1982.

Thomson, Guy. "The Ceremonial and Political Roles of Village Bands, 1846–1974." *Rituals of Rule, Rituals of Resistance: Public Celebrations and Popular Culture in Mexico,* edited by William Beezley, Cheryl English Martin, and William French, 307–40. Wilmington, Del.: Scholarly Resources, 1994.

————. "Popular Aspects of Liberalism in Mexico, 1848–1888." *Bulletin of Latin American Research* 10 (3) (1991): 265–92.

Tibón, Gutierre. *Olinalá: Un pueblo tolteca en las montañas de Guerrero.* 2nd ed. Mexico City: Posada, 1982 [1960].

Toor, Frances. Foreword. *Mexican Folkways* 1 (1) (June–July 1925): 2.

————."El jarabe antiguo y moderno," *Mexican Folkways* 6 (1) (1930): 32–33.

————. "Lacquer." *Mexican-American Review* 7 (12) (February 1938): 14–15, 17.

————. "Mexican Art, Music, and Drama." *Mexican Folkways* 6 (9) (1930): 201–4.

————. "Mexican Folkways." *Mexican Folkways* 7 (4) (October–November 1932): 205–11.

————. "Mexico through Frightened Eyes." Review of D. H. Lawrence's *The Plumed Serpent. Mexican Folkways* 2 (1) (August–September): 45–46.

————. *Mexican Popular Arts.* Mexico City: Frances Toor Studios, 1939.

————. "Notas sobre las lacas." *Mexican Folkways* 14 (1) (1933): 3.

————. "Nuestro aniversario." *Mexican Folkways* 2 (2) (June–July 1926): 1.

Toscano, Salvador. *Arte precolombino de México y de la América Central.* Mexico City: UNAM, 1944.

Toussaint, Manuel. "Arte popular en México." *México y la cultura*, 295–308. Mexico City: SEP, 1961.

Turok, Marta. *Cómo acercarse a la artesanía.* Mexico City: Consejo Nacional Para la Cultural y las Artes, Editorial Plaza y Valdes, 1996 [1988].

Universidad Nacional de México. *Escuela de Verano: Cursos para estudiantes mexicanos y extranjeros, cuarto año.* Mexico City: Talleres Gráficos de la Nación, 1924.

————. *U.N. de México Escuela de Verano: Cursos para estudiantes extranjeros.* Mexico City: Galas, 1928.

Valis, Noël. *The Culture of Cursilería: Bad Taste, Kitsch, and Class in Modern Spain.* Durham: Duke University Press, 2002.

Vasconcelos, José. "Democracy in Latin America." *Aspects of Mexican Civilization*, 43–74. Chicago: University of Chicago Press, 1926.

————. *El desastre.* 4th ed. Mexico City: Botas, 1938.

————. *La raza cósmica.* Baltimore: Johns Hopkins University Press, 1997 [1925].

Vaughan, Mary Kay. *Cultural Politics in Revolution: Teachers, Peasants, and Schools in Mexico, 1930–1940.* Tucson: University of Arizona Press, 1997.

————. *The State, Education, and Social Class in Mexico, 1880–1928.* DeKalb: Northern Illinois University Press, 1982.

Vaughan, Mary Kay, and Stephen Lewis, eds. *Eagle and the Virgin: Nation and Cultural Revolution in Mexico, 1920–1940.* Durham: Duke University Press, 2006.

Vázquez Santa Ana, Higinio. "Conferencia sobre el arte." *Boletín de la SEP* 6 (9) (1927): 34–42.

————, ed. *Canciones, cantares y corridos mexicanos*. Mexico City: León Sánchez, [1926].

Vázquez Valle, Irene. *La cultura popular vista por las élites*. Mexico City: UNAM, Instituto de Investigación Bibliográficas, 1989.

Vázquez, Josefina Zoraida, ed. *El establecimiento del federalismo en México (1821–1827)*. Mexico City: El Colegio de México, 2003.

Velázquez, Marco, and Mary Kay Vaughan, "Mestizaje and Musical Nationalism in Mexico." *Eagle and the Virgin: Nation and Cultural Revolution in Mexico, 1920–1940*, edited by Mary Kay Vaughan and Stephen Lewis, 95–118. Durham: Duke University Press, 2006.

Vila, Pablo. *Crossing Borders, Reinforcing Borders: Social Categories, Metaphors, and Narrative Identities on the U.S.–Mexico Frontier*. Austin: University of Texas Press, 2000.

————. *Ethnography at the Border*. Minneapolis: University of Minnesota Press, 2003.

Villoro, Luis. *Los grandes momentos de indigenismo en México*. 3rd ed. Mexico City: Colegio de México, Fondo de Cultura Económica, 1996.

Visser, Timothy. "Wall Street Agent or Amicable Diplomat? A Reinterpretation of Dwight Morrow in Mexico, 1927–1930." Unpublished thesis, Amherst College, 2006.

Wakild, Emily. "Naturalizing Modernity: Urban Parks, Public Gardens and Drainage Project in Porfirian Mexico City," *Mexican Studies/Estudios Mexicanos* 23 (1) (winter 2007): 101–23.

Warman, Arturo. *Y venimos a contradecir: Los campesinos de Morelos y el estado nacional*. Mexico City, 1976.

Warren, Kay, and Jean Jackson, eds. *Indigenous Movements, Self-Representation, and the State in Latin America*. Austin: University of Texas Press, 2002.

Waters, Wendy. "Remapping Identities: Road Construction and Nation Building in Postrevolutionary Mexico." *Eagle and the Virgin: Nation and Cultural Revolution in Mexico, 1920–1940*, edited by Mary Kay Vaughan and Stephen Lewis, 221–242. Durham: Duke University Press, 2006.

Weber, Eugen. *Peasants into Frenchmen: The Modernization of Rural France, 1870–1914*. Stanford: Stanford University Press, 1976.

Weiner, Richard. *Race, Nation, and Market: Economic Culture in Porfirian Mexico.* Tucson: University of Arizona Press, 2004.

Weiss, Jeffrey. *The Popular Culture of Modern Art: Picasso, Duchamp, and Avant-Gardism*. New Haven: Yale University Press, 1994.

Weston, Edward. *The Daybooks of Edward Weston*, vol. 1. Edited by Nancy Newhall. Rochester, N.Y.: George Eastman House, 1961–66.

Williams, Daryle. *Culture Wars in Brazil: The First Vargas Regime, 1930–1945*. Durham: Duke University Press, 2001.

Williams, Louise Blakeney. "Splendid Crafts into Fine Art: Art Critics and National Identity in Britain and India, 1890–1914." Paper presented at the 120th annual meeting of the American Historical Association, January 2006.

Williams, Raymond. "Base and Superstructure in Marxist Cultural Theory." *Rethinking Popular Culture: Contemporary Perspectives in Cultural Studies*, edited by Chandra Mukarji and Michael Schudson, 407–423. Berkeley: University of California Press, 1991.

Williams, Rosalind. "The Dream World of Mass Consumption." *Rethinking Popular Culture: Contemporary Perspectives in Cultural Studies*, edited by Chandra Mukarji and Michael Schudson, 198–235. Berkeley: University of California Press, 1991.

Williamson, Oliver. *The Economic Institutions of Capitalism: Firms, Markets, and Relational Contracting*. New York: Free Press, 1985.

Winkler, Cathy. "Changing Power and Authority in Gender Roles: Women in Authority in a Mexican Artisan Community." Ph.D. dissertation, Indiana University, 1986.

———. "Olinalá, Where Tradition Flourishes." "Inside Home" (insert from the *Los Angeles Times*), 26 September 1982.

Womack, John Jr. *Zapata and the Mexican Revolution*. New York: Vintage, 1968.

Wortham, Erica. "Between the State and Indigenous Autonomy: Unpacking Video Indígena in Mexico." *American Anthropologist* 106 (2) (June 2004): 363–68.

Yashar, Deborah. *Contesting Citizenship in Latin America: The Rise of Indigenous Movements and the Postliberal Challenge*. Cambridge: Cambridge University Press, 2005.

Zavala, Adriana. "The India Bonita Contest: Gender, Tradition, and Modernity in Mexico City, 1921." *Seeing and Beyond: Essays on Eighteenth- to Twenty-First-Century Art*, edited by Deborah Johnson and David Ogana, 276–305. New York: Peter Lang, 2005.

———. "De santa a india bonita: Género, raza y modernidad en la ciudad de México, 1921." *Los debates en torno a la historia de mujeres y la historia de género*, edited by María Teresa Fernández Aceves, Carmen Ramos Escandón and Susie Porter, 149–187. Mexico City: CIESAS, 2006.

Zolov, Eric. "Showcasing the 'Land of Tomorrow': Mexico and the 1968 Olympics." *Americas: A Quarterly Review of Inter-American Cultural History* 2004 61 (2): 159–88.

Bonfil Batalla, Guillermo, 22

Brading, David, 13

Brenner, Anita, 107–8; Aztec Eagle Medal refused by, 114; discoveries in Guerrero of, 113; DMAAH response to research expeditions by, 140; *Idols behind Altars*, 108; insider/outsider status of, 114; *Mexican Folkways* magazine and, 103–4; in Mexican nationalist project, 18; on Mexican renaissance, 133

Bulnes, Francisco, 299 n. 3

Bureau of Anthropology (Dirección de Antropología), 129–30, 136

Cabrera, Luis, 127

"Cajita de Olinalá" (Mistral), 289–92, 297, 340 n. 21

Calderón, Manuel, 167–70, 241

Calles, Plutarco Elías: centennial celebration of 1921 and, 67, 305 n. 8, 311 n. 59; Doctor Atl's criticism of, 156; Gamio persuaded to join ministry of education by, 136; inauguration of, 106; on *Mexican Folkways* magazine, 104; Partido Nacional Revolucionario founded by, 128; at party for María Bibiana Uribe, 50; state patronage of artists and intellectuals under, 128

Campesinos. See Peasantry (*campesinos*)

Campobello, Gloria, 70–71

Campobello, Nellie, 70–71

Cárdenas, Lázaro: consolidation of state power under, 147, 162; cultural nationalists supported by, 20; dismissal of Montenegro from Museo de Artes Populares and, 161; DMAAH dissolved by, 147–48, 150, 180; DMAAH inherited by, 146, 164; *Enciclopedia*

Nacional Popular established under, 143–44; Maximato ends with election of, 128; on mexicanizing the Indians, 11; Museo de Artes Populares visited by, 161; popular art under, 162–70; transition toward right of, 146–48; Zamora on reforms of, 72

Carnegie Institute of Fine Arts, 115, 118–19

Carranza, Venustiano, 20, 33–34, 66, 87

Carreta, La (Mexico City), 270–71

Carrillo Puerto, Felipe, 99–100

Casa del Obrero Mundial, 34

Casa Sanborn, 270

Caso, Alfonso, 179–80; Escuela de Verano and, 102; Guzmán studies under, 136; as INAH head, 180; on indigenous versus popular art, 181; as Instituto Nacional Indigenista director, 180–81; international exhibition of Mexican handicrafts of 1922 and, 99; *Mexican Folkways* magazine and, 103; Museo Nacional de Artes e Industrias Populares and, 173; at National Museum, 139, 180; Sociedad Mexicana de Antropología and, 149

Caso, Antonio, 136, 179

Castro Leal, Antonio, 124, 160–61, 166

Castro Padilla, Manuel, 70, 98, 312 n. 8

Centennial of 1921: European opera company at, 76; organization of, 65–68; popular art projects suggested for, 78–79; *El Universal* float in parade at, 50–51, *51*

Cervantes, Ernesto, 111

Chapultepec Park, 68–69, 297

Charlot, Jean, 103, 108

Charros, 36; in *Antojitos mexicanos*, 47; at Noche Mexicana, 69–71; Orquesta Típica del Centenario dressed as, 52;

Covarrubias, Miguel, 99, 103, 181–82, 319 n. 42

Creoles, 2–3, 14, 209, 210

Cristero war, 128, 155

Croly, Herbert, 106

Cruz, Isadoro, 276

Cuauhtémoc, 136, 287

Cultural nationalism: authenticity and, 162, 261; Cárdenas allies with business interests rather than, 170; in centennial of 1921 events, 65; commercialization opposed by, 166; critics of state-business alliance from, 1937–58, 177–79; of Echeverría, 20, 279; versus economic growth, 154–55; Exhibition of Popular Art of 1921 and, 65, 86; Fernández Ledesma on failure of, 172; foreign influences purged from, 97; gender norms of, 247; local struggles altered by, 261–62; mass media in, 150; Museo de Artes Populares and, 152; nonstate actors in, 31–32; revival of interest in popular art and, 173; Sociedad Impulsora de Industrias Típicas Mexicanas and, 165; through focus on peasantry, 18–19; Vasconcelos as proponent of, 102

Davis, Frederick: in Amigos de Taxco, 109; *animalitos* used in advertisements by, 224; Ayala delivers work directly to, 237–39; Banamex exhibition in former gallery of, 296; as Banfoco consultant, 190; Calderón criticisms of, 167; connects Olinaltecan *laqueros* with Casa Sanborn, 270; d'Harnoncourt as buyer for, 111–12, 118, 229; Exhibition of Popular Art and, 80, 110; exhibitions held at gallery of, 111;

Fosado hired by, 113–14; high-end market of, 153; as link between antiques trade and contemporary crafts, 112; Madrid exhibit of Mexican popular art and, 160; marketing Mexican authenticity by, 110–12; merchants build connections with, 235; Mexican Arts Show of 1930–32 and, 319 n. 42; in Mexican nationalist project, 18; MNAIP and, 181, 183; Montenegro and, 77, 124; Morrows purchase home from, 116; Museo de Artes Populares buys from, 158, 161; Olinaltecan lacquered art delivered to, 233; photograph of Ayala of, 238, 239, 340 n. 17; popular art collection of, 80, 110; in revival of Olinalá lacquer industry, 111, 229–30, 232

Dawson, Alec, 293

Debroise, Olivier, 9

DeForest, Robert, 119

Dehouve, Daniele, 205, 207, 335 n. 5

Delpar, Helen, 155

Del Río, Dolores, 147–48

De Negri, Ramón, 156

Departamento de Monumentos Artísticos, Arqueológicos e Históricos (DMAAH), 137–50; ambitions outstrip achievable goals of, 140–41; Brazilian SPHAN compared with, 138; as bureaucratic and top-down, 146; Cárdenas's inheritance of, 146, 164; Caso trains archaeologists for, 179–80; consolidating state cultural project, 137–46; dissolution of, 146–50, 180; Doctor Atl in creation of, 138; establishment of, 137; foreign cultural domination challenged by, 105, 139–40; heavy-handedness of, 148; Iberian colonial heritage cele-

brated by, 138; institutional genealogy of, 138; in intellectual-state alliance, 129; Museo de Artes Populares controlled by, 157–59, 161; in National Museum restructuring, 139; regional museums created by, 142, 171; successor to, 148; synthesis of data by, 141–42; "unity in diversity" model of, 145–46

Dewey, John, 102, 106

D'Harnoncourt, René, 111; articles on Mexican popular art by, 319 n. 45; on artisans and style, 234; as buyer for Davis, 111–12, 118; Calderón criticisms of, 167; Escuela de Verano and, 102; as link between antiques trade and contemporary crafts, 112; as Mexican Arts Show of 1930–32 curator, 115, 119–20, 124, 158, 229, 319 n. 42; *Mexican Folkways* magazine and, 104; in Mexican nationalist project, 18; Montenegro ignores role of, 124–25; Morrow and, 118, 318 n. 40; as Museum of Modern Art director, 229; Olinalá not visited by, 232–33; *rayador*'s earnings compared with, 248; *rayado* style resuscitated by, 229–30, 234, 237; in revival of old techniques, 112, 118, 229, 232–34, 291

Díaz, Porfirio: Arce made governor of Guerrero by, 212–13; *campesinos* rise up against, 213, 218; census takers of, 140; centennial celebration of 1910 and, 50, 67, 69, 87; Conesa performs for, 47; popular revolution follows presidency of, 4; positive national narrative constructed under, 3; postrevolutionary intellectuals and, 7, 19–20; problem of nationhood delayed by, 13–14; railroad expansion under, 214; *ranchero* elite created by, 213, 215; unilateral assimilation policy of, 8, 33, 132; U.S. government and business community support for, 116

Díaz de Leon, Francisco, 319 n. 42

Díaz de Vargas, Gonzalo, 204

Díaz Ordáz, Gustavo, 188–89

Dios Bojórquez, Juan de, 67

Dirección de Antropología (Bureau of Anthropology), 129–30, 136

DMAAH. *See* Departamento de Monumentos Artísticos, Arqueológicos e Históricos (DMAAH)

Doheny, Edward, 110

Dorado style: artisans return to, 254; of Ayala and Navarretes, 236, 240; earnings for, 248–49; as men's work, 210; MNAIP buys, 272; new form of, 282; *rayado* style seen as higher quality than, 258; replaces *rayado* style, 215–17, 225; simplicity compared with *rayado* style, 247; Temalacaltecos attempt, 252; of Venturas, 223

Earrings, 251

Echeverría, Luis: artisans' devotion to, 192–93; Banfoco reformed by, 189–92, 276, 279; cultural nationalism of, 20, 279; meets with Olinaltecan *laqueros*, 277–79; repression employed by, 191; rural development program of, 276

Echeverría, Maria Esther Zuno de, 277

Economic development: Corona on popular arts and, 184–85; growth under Cárdenas government of, 162; inequality resulting from Mexican "economic miracle," 188; popular art in, 154–55

Education: attempts to improve Indians, 9–10; Gamio on, 133; India Bonita Contest of 1921 as education campaign, 37; in Olinalá, 266–67, 281; public, 30, 66, 130; teachers taught about "real" Mexico, 142; Vasconcelos as minister of, 66–67, 74, 77, 130, 133, 135, 137; Vasconcelos on, 134. *See also* Escuela de Verano (Summer School for Foreigners)

Ejidos, 253, 265–67

Elites: Acevedo caters to tastes of, 234–35; aesthetic orientation of, 15; artisans fail to meet aesthetic expectations of, 258; broad definitions of Indianness of, 11; connection to Mexican masses of, 59, 121, 126; Creoles and, 2–3, 14, 209–10; in cultural nationalism, 18–20, 22; decline of Olinaltecan nobility, 206–7; efforts to make popular arts evolve by, 92; Gamio on artists catering to, 127; Gamio on Europeanized, 8, 133; imported goods preferred to domestic by, 215; on indigenousness and modernity as incompatible, 59; intellectual, 133–34; local experience versus claims about it by, 198; as market for Olinaltecan lacquered art, 209; on Mexican nationalism, 13; Novo criticizes provincial, 75; Olinalá as viewed by, 201–2, 211–12; popular art collections of, 80; preying upon villagers' isolation and vulnerability by, 197; recovering indigenous essence by, 74; regional identities adopted by, 145; revolution sends economic shock waves through, 201; Spanish colonial perspective of, 68

Enciclopedia Nacional Popular, 143–44

Enciso, Jorge, 78; in Amigos de Taxco,

109; Ayala photograph accompanies article of, 238; in Exhibition of Popular Art, 76–82, 86, 153, 169; Gorostiza and, 169; as India Bonita Contest judge, 39, 41; as Inspección de Monumentos head, 138; international exhibition of Mexican handicrafts of 1922 and, 99; local authorities used to collect information by, 140; Madrid exhibit of Mexican popular art and, 159; Mexican Arts Show of 1930–32 and, 319 n. 42; on MNAIP advisory council, 181; nationalist aesthetic sought by, 48, 65, 78; Porter and, 99–100; in revival of old techniques, 232; Sáenz proposes for advisor for popular arts show, 115; Spratling influenced by, 118; state support for, 74; tours of countryside by, 75, 79; Weston compared with, 109

Endowment for the Development of Arts and Crafts. *See* Fideicomiso (Fondo de Fideicomiso para el Fomento de las Artesanías)

Escamilla, Liborio, 275

Escudero Mejía, Siriaco, 235, 271

Escuela de Verano (Summer School for Foreigners): and Committee on Cultural Relations with Latin America, 106; establishment of, 30, 101; as gathering place for intellectuals, 102; *Mexican Folkways* magazine and, 103; Mexicans involved with, 102; Toor studies at, 101; Vázquez Santa Ana teaches at, 78

Esparza Oteo, Alfonso, 45–46, 307 n. 27

Espejel, Carlos, 190, 281–82, 286

Estrada, Genaro, 103, 123, 156, 159

Estridentismo, 19

Ethnicized *mexicanidad*, 9; ambiva-

Fernández Ledesma, Luis, 123

Fideicomiso (Fondo de Fideicomiso para el Fomento de las Artesanías), 186–91; creation of, 186; Olinaltecan *laqueros* and, 275–78

Figueroa Alcocer, Rubén, 283–84

Figueroa family, 217–18

Figueroa Figueroa, Rubén, 278

Florescano, Enrique, 16, 86, 133

Folk art. *See* Popular art

Folk festivals, 139

Fonart (Fondo Nacional para el Fomento de las Artesanías), 24; artisan mobilization supported by, 175; coherent approach of, 176; creation of, 191, 275; as defender of authentic *mexicanidad*, 193; evolution of, 193; expansion of, 296; Olinaltecan lacquered art in showroom of, 286; Olinaltecan *laqueros* and, 276, 281–83; purpose of, 193; reasons for success of, 191–92; social and economic context addressed by, 192

Fondo de Fideicomiso para el Fomento de las Artesanías. *See* Fideicomiso (Fondo de Fideicomiso para el Fomento de las Artesanías)

Fondo Nacional para el Fomento de las Artesanías. *See* Fonart (Fondo Nacional para el Fomento de las Artesanías)

Food, popular, 69–70, 82, 144, 314 n. 30

Foreigners, 95–126; associated with Escuela de Verano, 102; Banfoco focuses on, 188; as discoverers of unknown Mexico, 112–15; DMAAH challenges research domination of, 105, 139–40; versus domestic consumption of popular art, 183; expan-

sion of U.S. economic and political power, 122; intellectual authority attributed to, 121; interest in revolution of 1910–20 by, 97; marketing Mexican authenticity, 110–12; *Mexican Folkways* magazine and, 103–4; popular derogatory images of, 95–97, *96*; reanimating boundary Mexican and, 121–26; in shaping *mexicanidad*, 95, 97, 110, 120–21, 126; symbiotic relation with Mexican intellectuals of, 121–22; tendency of to generalize, 97. *See also* Escuela de Verano (Summer School for Foreigners); Tourists

Forjando patria (Gamio), 8–9, 130, 303 n. 44

Forma (journal), 142, 323 n. 29

Fosado, Pilar, 233

Fosado, Víctor, 113–15, 182–83, 190, 233, 238

Fowler-Salamini, Heather, 32

Fox, Jonathan, 279, 283

Fox, Vicente, 296

Frank, Waldo, 111

Frías, José, 104

Fuentes, Carlos, 4, 6, 20

Gaceta de literatura (journal), 209

Galván, Amado, *91*, 115

Gálvez, Antonio, 218

Gamio, Manuel, 130; on art and national integration, 127–28; Asian knockoffs of Mexican handicrafts and, 169; Boas as mentor to, 41, 103; Bureau of Anthropology created by, 129–30; cultural atlas of Mexico of, 136; DMAAH aspires toward goal of, 140–41; driven from ministry of education, 104; on education, 133; exhibition of indigenous art proposed by,

78–79; *Forjando patria*, 8–9, 130, 303 n. 44; Gruening influenced by, 107; historical preservation law sought by, 109; on homogenization, 131; India Bonita Contest and, 29, 39–42; on indigenousness and national consciousness, 8, 89; on indigenousness as matter of degree, 10; influence of ideas of, 130; on integrating indigenous people, 8–9, 16, 129, 130, 132; joins ministry of education, 136; on lack of academic training facilities, 123, 139; on masses earning their right to be studied, 226; *Mexican Folkways* magazine and, 102–4; Montenegro fulfills some aspirations of, 139; on national integration, 129–33; on "new conquest," 133; on popular art and *mexicanidad*, 76; Porter and, 99–100; relationship to the state of, 20, 137; shift toward negative stance on indigenous people of, 10–11, 131, 301 n. 21; on socialism, 135; "The Utilitarian Aspect of Folklore," 104; Vasconcelos contrasted with, 134–35

García, Juan, Jr., 275

García, Rufino, 237

García, Ysmael, 237

García Canclini, Néstor, 16–17

Gatitas, 34–35, 47

Gazol, Antonio, 179

Gender: authenticity as gendered trap in postrevolutionary Mexico, 54–62; ethnicized national identity and, 32; group solidarity among *laqueros* affected by, 273–74; Guzmán breaks barriers of, 135; in Olinaltecan lacquered art production, 210, 236, 242, 247–50. *See also* Women

Glusker, David, 113

Gómez Morín, Manuel, 102, 109

González, Bulmario, 277

González, Carlos, 154

González Carrasco, Aurelio, 39

González Casanova, Pablo, 102–4

González y González, Luis, 22

Gorostiza, Celestina, 169

Great Masters of Popular Art (Grandes Maestros de Arte Popular) exhibition, 296–97

Gruening, Ernest, 107–8, 116

Gruzinski, Serge, 15

Guardino, Peter, 231

Guerrero: creation of, 211–12; democratization in, 283–84; guerrilla insurgency in, 278–79; infrastructural development opposed in, 278; in Mexican revolution, 217–18; as most underdeveloped state, 214; poverty of, 284; Taxco, 109, 112, 117, 138, 286; Temalacacingo, 203, 219, 224–25, 252; violence and arbitrary use of power in, 264. *See also* Olinalá

Guerrero, Antonio, 275

Guerrero, Ignacia, 40–41

Guerrero, Xavier, 99–100, 181

Gutíerrez, Tonatiuh, 190–91, 276–77

Guzmán, Eulalia, 135–36

Guzmán, Martín Luis, 67

Hall, Stuart, 342 n. 39

Hamill, Pete, 32

Handicrafts. *See* Popular art

Hart, Paul, 214

Hearst, William Randolph, 110

Heirlooms, 80, 110, 201

Henríquez Ureña, Pedro, 18, 101–2, 107, 114

Heraldo de México, El (newspaper), 78

Hernández-Díaz, Jorge, 292–93

Herrán, Saturnino, 15, 71, 85–87, 123, plate 5

Herring, Hubert, 106, 109

Hispanophilia, 95, 100, 110, 117, 122

Hispanophobia, 68

Historical preservation, 109

Hobsbawm, Eric, 301 n. 25

Homogenization, cultural, 131, 261, 293

Horkheimer, Max, 306 n. 19

Huelgera, Isaac, 235

Huerta, Adolfo de la, 50, 67

Huerta, Victoriano, 67

Hulme, Peter, 198

Hutchinson, John, 73

Identity, Mexican national. *See Mexicanidad*

Idols behind Altars (Brenner), 108

INAH. *See* Instituto Nacional de Antropología e Historia (INAH)

"India Bonita, La" (Esparza Oteo), 45

"India Bonita, La" (Lerdo de Tejada), 45

India Bonita, La (Sesto), 47–48, 52, 54

India Bonita Contest (1921), 29–64; agency denied indigenous people in, 35, 54, 94; Apotheosis of the India Bonita, *60*, 60–61; becomes common throughout Latin America, 58, 310 n. 53; as capitalist venture, 33; characteristics sought by organizers of, 37; Concurso Universal de Belleza compared with, 38–39; conduct of, 32–42; as conservative ideal of Mexican femininity, 57; as education campaign, 37; *Excélsior* denounces, 58–60; Exhibition of Popular Art compared with, 81; finalists in, 39–41, *40*; judges for, 39; López on, 56–57, 61–62, 149; make-up worn by contestants in, 38, 40, 42, 61, 306 n. 19; Mexican identity and, 62–64; for promoting *El Universal*, 31, 33; public announcement for, 33; public fails to understand "Indias" who were "Bonitas," 35–36; public imagination captured by, 31–32; recruiting contestants for, 34–38; represented in media and the arts, 42–49, 53–54; *Se Llamaba María* film about, 45; state's involvement in, 49–53; virginal image for, 58; white or *mestiza* entrants in, 36–37

Indigenismo: anthropological journals in emergence of, 149; Exhibition of Popular Art of 1921 and, 76; on foreigners, 95, 100, 126; of Gamio, 8–9, 16, 129–32; INAH signals rise of official, 125; Puebla elites create *criollo* identity to escape, 145; Rubín de la Borbolla criticisms of, 182

Indigenistas. See Indigenismo

Indigenous people (Indians): agency denied to, 35, 54, 56, 93–94; artisans marked as more indigenous, 256; authenticity as gendered trap in postrevolutionary Mexico, 54–62; at Calles's inauguration, 106; in Centennial Parade, 1910, *6*; change in attitude toward "Indian problem" of, 147; changing into mestizos of, 61–62; characterizations in popular press of, 37; Commission for the Development of Indigenous Peoples, 296; Concurso Universal de Belleza and, 38; constructed as passive, 57, 62, 293–94; contemporary movements of, 294–96; contingent nature of indigenous-

ness, 94, 259–60, 281; conversion to Christianity of, 204; in cultural atlas of Mexico, 136; de-Indianization of, 10, 125–26, 131, 149; d'Harnoncourt on, 120; Doctor Atl on artistic authenticity and, 89–93, 125; elite artists and, 74; ethnic identity of Olinaltecan artisans as, 230–31; excluded from nationalism by Creole elites, 2–3; foreign-Mexican collaboration in pro-indigenous viewpoint, 122; Gamio on integrating, 8–9, 16, 129–32; India Bonita Contest of 1921 and, 29–64; insurgencies in Olinalá by, 213–14; intellectuals' declining concern with, 149–50, 324 n. 44; kept in their place by intellectuals, 115; as least foreign element in Mexico, 9; liberal state erases category of Indian, 10, 94; melancholy attributed to, 45, 307 n. 25; *Mexican Folkways* magazine on, 103–5; modern Mexico contrasted with "backward Indians," 4; Morrow on, 117; in Noche Mexicana, 69–72; non-fixity of "Indian," 10–12; Olinalá classified as, 267, 272; in Olinalá population, 207, 213, 260–61; Olinaltecan lacquered art associated with Indianness, 278, 280–81, 286; Pérez Taylor on chasm between modern Mexico and, 54; popular art and the staging of Indianness, 65–94; popular derogatory images of, 95–97, *96*; postrevolutionary nationalists on, 7–12, 30–31, 93–94, 105–6; poverty and backwardness associated with, 259, 281; PRD supported by, 193; quality and indigenousness in Olinaltecan lacquered art, 256–61; Ramírez

de Aguilar's characterization of, 44; social and language barriers separate, 34; transformation of popular perception of, 63; women using their bodies as symbols of modernity, 59, 310 n. 55; as working-class artists, 115; as Zapatistas, 218. *See also Indigenismo*; Popular art

Indio Bonito, El (play), 47

Infante, Pedro, 147

INI. *See* Instituto Nacional Indigenista (INI)

Inmecafe, 279

Inspección de Monumentos, 138

Instituto de Investigaciones Estéticas, 149

Instituto Internacional Indigenista (III), 149

Instituto Nacional de Antropología e Historia (INAH): Caso as director of, 180; in oversight of MNAIP, 181; in popular art policy, 176–77; rise of *indigenismo* and, 125; study of handicrafts urged by, 185; as successor to DMAAH, 148–49

Instituto Nacional Indigenista (INI): Caso as director of, 180–81; dissolution of, 296; on Olinalá as indigenous, 267, 272; in popular art policy, 176–77; study of handicrafts urged by, 185

International exhibition of Mexican handicrafts (1922): as aesthetic success but economic failure, 157–58; catalogue for, 99–100; foreign influence in, 122; Porter and, 97–100; Toor inspired by, 101

International School of American Anthropology and Ethnology, 135

urban, 149; Vasconcelos on, 134. *See also* Mestizos

Mestizos: at Calles's inauguration, 106; change in attitude toward "Indian problem" of, 147; changing Indians into, 61–62; in common view of Mexican national identity, 29; Doctor Atl on indigenousness and authenticity, 89; ethnic identity of Olinaltecan artisans as, 230–31; Gamio on, 8, 41, 132–33; non-fixity of "Indian" and, 10–11; in Olinalá, 207, 260; Olinalá's increasing identity as, 286; seen as capable of balancing modernity and tradition, 59. *See also Mestizaje*

Metepec, 91

Metropolitan Museum of Art, 118–19, *120*, 161, 180, 257

Mexicanarías (skits), 46–48

Mexican Arts Show (1930–32), 118–21; American tour of, 119–20, *120*; *animalitos* in, 224; Caso disavows, 180; d'Harnoncourt as curator of, 115, 119–20, 124, 158, 229; Doctor Atl on foreigners and, 124; Doctor Atl's role in, 119, 319 n. 43; foreign control of, 122; for improving U.S.–Mexican relations, 155; interest in popular art spurred by, 158, 162, 257; Montenegro and Castro Leal ignore, 125; only "truly Mexican" crafts included in, 119; preview exhibition of, 119; private individuals who contributed to, 319 n. 42; state support for popular art ends after, 159

Mexican Folkways (magazine), 100, 102–6, 142, 225, 323 n. 29

Mexicanidad: aesthetic, 160; authentic, 94, 121, 124, 147, 182, 193; commercialization of national identity, 182; DMAAH on, 138, 141, 145; Doctor Atl on indigenousness and, 89; *Enciclopedia Nacional Popular* on, 144; growing number of local cultures in, 142; as historically constructed, 292; India Bonita Contest and, 62–64; *Mexican Folkways* magazine on, 105; MNAIP and, 181; in Noche Mexicana, 69–71; popular art seen as expressing, 70, 76, 79, 176–77, 293; postrevolutionaries on Indianness and, 44, 93; regional engagement with, 22; Rivera seeks language for expressing, 135; seen as self-contained and timeless, 97; state seen as natural embodiment of, 144, 294; vernacular aesthetics associated with, 15. *See also* Ethnicized *mexicanidad*

Mexico: A Study of Two Americas (Chase), 106

Mexico and Its Heritage (Gruening), 107

Mexico City: Alameda Park in, 141; Angel of Independence in, 4, *5*; La Carreta, 270–71; Olinaltecan lacquered art transported to, 210, 233, 269–73, 277; Palacio de Bellas Artes in, 160, 167, 171; Paris as model for, 4; Paseo de la Reforma in, 4, *5*, 68; recruiting India Bonita Contest contestants in, 34–35; María Bibiana Uribe in social circles of, 45

México Moderno (journal), 142

Michel, Alejandro, 46

Michel, Concepción (Concha), 103

Miss Mexico contest, 63, 311 n. 59

Mistral, Gabriel, 289–92, 297, 340 n. 21

MNAIP. *See* Museo Nacional de Artes e Industrias Populares (MNAIP)

Modernism: ambitions outstrip achievable goals of, 140; cultural anxieties underlying, 19; Doctor Atl and, 86–88, 90; intellectuals address national distinctiveness through prism of, 93, 315 n. 52; Montenegro influenced by, 77; in Noche Mexicana, 69; relating to postrevolutionary Mexico, 49; romantic, 73, 93; transnational and local dimensions of, 17–23

Modotti, Tina, 103–4

Molina Enríquez, Renato, 80, 152

Montenegro, Roberto, 77; Calderón's criticisms of, 167; death of, 190; d'Harnoncourt and Davis expand market for art promoted by, 112; dismissal from Museo de Artes Populares of, 161; in Exhibition of Popular Art, 76–80, 86, 153; Fernández Ledesma influenced by, 123; on foreign influence, 124–25; Gorostiza and, 169; international exhibition of Mexican handicrafts of 1922 and, 99; *Máscaras mexicanas*, 161; Mexican Arts Show of 1930–32 and, 319 n. 42; MNAIP and, 181, 183; modernism influences upon, 77; at Museo de Artes Populares, 114, 139, 155, 157–61, 169, 171–72, 180; Museo Nacional de Artes e Industrias Populares and, 173; nationalist aesthetic sought by, 16, 48, 65, 78; National Museum catalogued by, 139; on popular art and *mexicanidad*, 76; Porter and, 100; relationship to the state of, 20, 74; research center desired by, 161, 171, 180; return to Mexico of, 77; in revival of old techniques, 232; Sáenz proposes for advisor for popular arts show, 115; Spratling influenced by, 118; state-business alliance criticized by, 177–78; Templo de la Soledad de Santa Cruz murals of, 154; tours of countryside by, 75, 79

Morales, Josefa A. de, 37–38

Morrow, Dwight, 115–21; becomes ambassador to Mexico, 116; Casa Mañana of, 116, 318 n. 40; Fosado and, 115; helps change climate of U.S.–Mexican relations, 120; inspecting Oaxacan pottery, *117*; Mexican Arts Show of 1930–32 and, 118–19, 124, 155; in Mexican nationalist project, 18

Morrow, Elizabeth Cutter, 115–18, 120, 318 n. 40

Multiculturalism, 293, 295–96

Muñoz, Maurilio, 267, 272, 275

Muñoz Cota, José, 166–67, 169

Muralism: Biddle and Works Progress Administration project, 106; connection to the masses of, 121; Doctor Atl in development of, 87; MNAIP mural by Covarrubias, 182; Morrows commission Rivera mural, 117; Palacio de Bellas Artes murals, 160; Templo de la Soledad de Santa Cruz murals, 154; Vasconcelos in emergence of, 67

Murillo, Gerardo. *See* Atl, Doctor

Museo de Artes Populares (MAP) (created 1929), 151–73; aesthetic rather than economic focus of, 157–58; autonomous intellectual initiatives and bureaucratic state united by, 24; budget line approved for, 158; Calderón's role at, 167–70; Caso on authenticity of, 180; demise of, 171–73; demotion to Office of the Museo de Artes Populares, 159; Department of Fine Art takes control of, 166–67; DMAAH in control of, 157–59, 161; Exhibition

of Popular Art of 1921 as basis of, 153–55, 157; expansion of collection, 158; failure of, 152; Fernández Ledesma works at, 123; Fosado collects for, 114; as foundational for way we think about Mexican aesthetics, 151; gallery space obtained by, 160; list of artisans in Olinalá of, 241; Madrid exhibit of popular art and, 159–60; mission statement of, 157; MNAIP compared with, 181–82; modern namesake of, 297; Montenegro's role at, 114, 139, 155, 157–61, 171–72, 180; as research center, 161, 171; restructuring of, 172; seed money procured for, 155–56; staff dismissed and budget cut at, 167; state support ends at, 159; sustained growth in attendance and visibility of, 170; zenith of, 158–62

Museo de Arte Populare (MAP) (created 2006), 297

Museo de Artes Populares of Pátzcuaro, 160

Museo Nacional de Antropología, 182, 267

Museo Nacional de Artes e Industrias Populares (MNAIP), 179–85; achievements of, 183–84; allies of, 184; art store of, 182; authenticity and, 180–82; Banfoco and, 181, 189–90; building for, 181; collaboration with other institutions, 181; commercialization opposed by, 182, 184; congressional commission on handicrafts and, 185; destruction of, 296; Fosado consults for, 114, 182; lacking resources of, 184, 187; Montenegro in development of, 173; oversight of, 181; in popular art policy, 176–77; statistics on popular

art used by, 182–83, 188; works with Olinaltecan *laqueros* of, 184, 270, 272–73, 275

Museum of Modern Art (New York), 124, 229

Museums: Metropolitan Museum of Art, New York, 118, 119, *120*, 161, 180, 257; Museo Nacional de Antropología, 182, 267; Museum of Modern Art, New York, 124, 229; regional, 142, 171. *See also* Museo de Artes Populares (MAP) (created 1929); Museo de Artes Populares (MAP) (created 2006); Museo Nacional de Artes e Industrias Populares (MNAIP); National Museum

Music, popular, 92, 137

Música (journal), 142

Nadasdy, Paul, 231

Náhuatl language, 280

Nájera, Melquiades, 218–19

National Exhibition of Vernacular Arts, 165

National Fund for the Development of Handicrafts. *See* Fonart (Fondo Nacional para el Fomento de las Artesanías)

National identity, Mexican. *See* Mexicanidad

Nationalism: of Avila Camacho, 171; as blind to local identities and struggles, 198; concepts of state and nation conflated, 301 n. 29; contemporary indigenous movements and postrevolutionary discourses of, 294–95; elite versus mass conceptions of, 14; as entangled in local struggles, 261–62; of Exhibition of Popular Art, 82, 85; failure of national integration

Nationalism (*continued*)
and, 127; foreigners as nationalist insiders, 114; in India Bonita Contest, 31, 41, 53; infused into Conesa's plays, 47; intellectuals feel like strangers in their own land, 105; left-leaning artists search for nationalist aesthetic, 48–49; nationalist authenticity, 152; nativist, 97, 122, 276; neoromantic, 69; in Noche Mexicana, 69, 71; Olinaltecan lacquered art embodiment of, 291–92; popular art in nationalist imagination, 256, 278, 280; postrevolutionary nationalists on indigenous people, 7–12, 30–31, 93–94, 105–6; shift during 1940s of, 147–48; takes interest in lacquered work from Olinalá, 201; transnational interactions purged by nationalists, 97. *See also* Cultural nationalism

National Museum: Caso as head of, 139, 180; cultural exploration of southern Mexico by, 140; Guzmán as head of archaeology department at, 136; MNAIP preview exhibition at, 181; MNAIP restructuring of as part of DMAAH, 139; Rubín de la Borbolla at, 182; Sección de Fomento de las Artes e Industrias Populares and, 152–53

National Tourist Council, 276

National tree, 30

National University, 30, 67, 72, 101–2, 104, 108

Nation formation, 12–14; aesthetics of, 14–17; India Bonita Contest as lens for understanding of, 29; transnational and local dimensions of, 17–23

Nativism: as break with European cultural dominance, 18; cosmopolitan context of, 126; of Enciso, 39; for-

eigners' research into, 122; nativist nationalism, 97, 122, 276; returning expatriate artists in emergence of, 49; of Rivera, 32

Navarrete, Abraham, 236

Navarrete, Alberto, 220, 236

Navarrete, Isadora (Doña Lola), 236, 240

Navarrete clan, 217, 223, 225, 236

Navarro, Dolores, 35

Navarro, Javier, 46, 48

Neoliberalism, 283, 295–97

Nervo, Amado, 77

Noche Mexicana, 68–72; agency denied indigenous people by, 93, 94; Exhibition of Popular Art contrasted with, 93; *Fantasía Mexicana*, 70, 71, 72–73; folkloric emphasis of, 68; India Bonita Contest compared with, 65; as novel in scale, 71; state patronage for, 65

Novelo, Victoria, 24–25

Novo, Salvador, 75–76, 79, 102–3

Nuestro México (journal), 142

Nuestro Mundo (Televisa), 63

Obregón, Alvaro: assassination of, 128, 155, 307 n. 27; centennial celebration supported by, 67, 311 n. 4; at centennial parade, 50; at coronation of India Bonita, 29, 51–52; cultural nationalists supported by, 20, 128, 144; exhibition of folk art of 1922 and, 99; at Exhibition of Popular Art, 82; Gamio's proposals supported by, 130; Noche Mexicana and, 69, 71; Pani in cabinet of, 66; Porter at inauguration of, 99; satirical revues about, 48; state authority reestablished by, 30; Vasconcelos in cabinet of, 67

Ochoa, Guillermo, 63

Ocumicho, 338 n. 48

Office of the Development of Popular Arts and Industries (Sección de Fomento de las Artes e Industrias Populares), 152–53, 157–58

O'Higgins, Pablo, 103

Oles, James, 86

Olinalá: Agrarian reform in, 264–65, 267–68; archive burned in, 263–64, 266; in Aztec empire, 202–3; backwardness during nineteenth century of, 211–15; burning of, 220–21; cultural gap between townspeople and *campesinos* in, 285–86; decline of native nobility in, 206–7; democratization in, 283–84; d'Harnoncourt never comes to, 232–33; education in, 266–67, 281; elites' view of, 201–2, 211–12; in emerging cultural nation, 261–62; ethnic composition of, 207, 213, 260–61; as head town, 204, 335 n. 5; human rights abuses in, 284; indigenous classification of, 267, 272; indigenous insurgency in, 213–14; inequality in, 264, 266; interaction with the center, 21; interviews with Olinaltecos, 199–200, 232; isolation of, 197, 201–2, 217, 233, 268, 272, 284; land consolidation in, 213; map of region of, *199*; myth of equality in, 264; openness to outside cultures, 203; population changes in, 206, 242, 251, 267, 284, 340 n. 19, 343 n. 11; poverty of, 284; power and place in, 202–6; residents redefining themselves and their art in, 21; road to, 277–79, 281, 285; shifts in popular art policy and, 175; social terrain of, 263–69; in Spanish empire, 203–6; sugar be-

comes basis of economy of, 213–14, 222; Toor comes to, 197, 230, 233, 268; transnational connections of, 286; "unbroken tradition" of, 201–27; violence and arbitrary use of power in, 264–66, 284; young people leave from, 286; Zapatistas in, 218–21

Olinaltecan lacquered art: air transport of, 272–73; Alejo de Meave's account of, 209–10; *animalitos*, 224–25, *225*; artisans regain control of marketing of, 253–56; Asian knockoffs of, 251; Ayala in revival of, 21, 115, 225–26; in Aztec empire, 202–3; ballot box of 1779, 208, plate 7; "Baúl of the Future," 1–2, 297–98, plate 1; becomes inconsequential in over-all economy, 217; bowl in photo of María Bibiana Uribe, 42–43, *43*; La Carreta for marketing of, 270–71; cheap industrial alternatives to, 250; collapse of local market in 1940s for, 231; competition between merchants and artists of, 240–47; consumer demand undermines artisan leverage, 251–53; credit required by, 271–72; Davis in revival of, 111; dealers and collectors take special interest in, 201, 226, 230; decline in nineteenth century of, 215–17; decline in prices of from mid-1930s of, 246, 250, 253; declining standard of living for artisans of, 251, 269; densely layered borders and linear designs in, 217, plate 11; d'Harnoncourt in revival of old techniques, 112, 118, 229, 232–34, 291; dowry chests, 225–26, 239; Echeverría meets with *laqueros*, 277–79; ethnic identity of artisans of, 230–31; European and Asian dealers in,

Olinaltecan lacquered art (*continued*)
286; at Exhibition of Popular Art,
84; at Exposición Nacional de Artes
Típicas, 165; fairs for marketing of,
242–43; female artisans of, 222–24;
Fideicomiso-Banfoco and, 187, 275–
78, 282; Fonart and, 276, 281–83,
286; gendered structure of produc-
tion of, 210, 236, 242, 247–50; golden
age in eighteenth century of, 206–11;
gourds and, 216–17, 246, plate 10;
government-sponsored lacquer com-
petition, 277; group solidarity among
laqueros, 251, 262, 269–71, 273–75;
high-end market for, 209, 243, 272;
Indianness associated with, 278,
280–81, 286; *laqueros* excluded from
ejidos, 253, 265; lectern of 1760, 208,
plate 6; linaloé wood in, 243–44, 255,
340 n. 21; local oligarchs as major
buyers of, 283; local raw materials
replaced, 246–47, 250; low-quality
materials in, 254–55; merchants and
authenticity of, 242; merchants gain
control of production of, 222–26;
Mistral's "Cajita de Olinalá," 289–92,
340 n. 21; MNAIP offers market for
top artisans of, 184, 270, 272–73, 275;
as most Mexican of Mexican arts,
20–21, 197; Náhuatl language em-
braced by *laqueros*, 280; National
Arts and Sciences Award for, 285;
nationalism embodied in, 291–92;
new markets sought for, 270–73; new
opportunities for women *laqueras*,
282–83; new styles of, 282; as not
yet corrupted in 1937, 178; Olinka
cooperative of, 276–78; origins of,
335 n. 5; Paucic lists masters of, 237;
percentage of population involved
in, 255–56, 284–85; Poli's buying of,
270; price increases, 1968–76, 282;
for proposed museum of popular
art, 156; putting-out system of, 244–
45; quality and indigenousness in,
256–61; responses to changing elite
tastes of, 215, plate 8; revival of after
fire of 1913, 221–26, 235; rise in num-
ber of *laqueros*, 281–82; seen as fount
for cultural regeneration, 201; serial
production of, 216, plate 9; simpli-
fied borders with flora and fauna in,
217, plate 12; sources on, 303 n. 47; in
Spanish empire, 203–6; state alliance
with *laqueros*, 277–83; as symbol of
ethnicized *mexicanidad*, 197, 226,
285, 287, 292; training *laqueros*, 286;
transnational renaissance and local
power struggles in, 1920s to 1940s,
229–62; transport of, 210–11, 233,
242, 268–69, 272–73, 277; traveling
artisans of, 252–53; as used to medi-
ate empire, region, nation, and eth-
nicity of, 200, 202, 217; variety of ob-
jects, 210; as woven into social fabric,
210. *See also Dorado* style; Popular
art; *Rayado* style
Olinka, 277–78, 281, 285
Orozco, José Clemente, 86–87, 160
Orquesta Típica del Centenario, 52,
70, 82
Ortega, Carlos, 39, 41
Ortego, Ladislao, *91*
Othón de Mendizábal, Miguel: on
aesthetic successes but economic
failures, 157–58; expedition to Valley
of Oaxaca headed by, 136; Fernández
Ledesma influenced by, 123; *Mexi-
can Folkways* magazine and, 103, 104;
nationalist aesthetic emphasized by,

16; popular art collection of, 80; at Sección de Fomento de las Artes e Industrias Populares, 152; in Sociedad Mexicana de Antropología's creation, 149; on uniting people of Mexico, 132

Othón Díaz, Enrique, 178–79, 255

Paine, Frances Flynn, 109, 118, 153

Painted Pig, The (Morrow), 118, 318 n. 40

Palacio de Bellas Artes, 160, 167, 171

Palacios, Guillermo, 10, 293

Palavicini, Félix: in Amigos de Taxco, 109; campaign for national cultural unification, 33; Doctor Atl suggests indigenous art exhibition to, 79; as education minister, 33, 79; on godfather for María Bibiana Uribe, 52–53; India Bonita Contest initiated by, 31–33

Pani, Alberto, 16, 49, 66–67, 73, 88, 156

Pantaleón, Luis, 220

Pantaleón, Miguel, 345 n. 36

Parsons, Elsie Clews, 103

Paseo de la Reforma (Mexico City), 4, 5, 68

Patrón, Juana, 282, 345 n. 36

Patrón, Tomasa, 263–64, 266

Pátzcuaro, 115, 160, 235

Pátzcuaro Conference (1940), 149, 181

Paucic Smerdu, Alejandro Wladimiro, 203, 232, 237, 247–48, 252, 256, 269, 275, 339 n. 6

Pavlova, Anna, 18, 70, 98, plate 4

Pawling, Enrique, 164

Payno, Manuel, 3

Peasantry (*campesinos*): Cárdenas's policy on, 162, 170; Doctor Atl on indigenous peasantry as the real Mexico, 125; Echeverría's policy toward, 189, 279; exaltation of, 18; expropriation of land of, 212–14; farming and crafts combined by, 235; foreign-Mexican collaboration in pro-peasant viewpoint, 122; indigenousness associated with, 260; insurgencies in Olinalá and, 213–14; López Mateos's policy toward, 185; become "Mexicanized Indians," 262; neoliberalism effect on, 297; uprising against Díaz by, 213, 218; as Zapatistas, 218

Peiss, Kathy, 55

Pellicer, Carlos, 102

Pereda, Armando, 70

Pereda, María Cristina, 70

Pereda y Salgado, Antonio de, 205

Pérez Carrillo, Sonía, 204

Pérez Montfort, Ricardo, 7–8, 16, 182, 261

Pérez Taylor, Rafael, 33–34; on chasm between modern and Indian Mexico, 54; at Cooperativa gala, 163–64; in India Bonita Contest, 33–37, 39, 81; nationalist aesthetic emphasized by, 16; in National Museum restructuring, 139; permanent museum for objects from 1921 promoted by, 153–54; relationship to the state, 20

Peribanas (*bateas*), 230, 238–40, 239, 254

Perrín, Tomás, 52

Pesquiera, Ignacio, 177

Petate, 104

Pimentel, Francisco, 3, 134

PNR (Partido Nacional Revolucionario), 128, 148, 156

Poli, Don, 270–71

Pomar, María Teresa, 297

Ponce, Manuel, 92, 103, 137

Poole, Deborah, 145

Popular art: Asian knockoffs of, 168–69; authenticity of, 82, 85, 89–93, 97, 242; Banamex promotes high-end, 296–97; Brenner on, 107–8; under Cárdenas, 162–70; Chase on, 107; collections of, 80; Cooperativa Nacional de Industrias Típicas Mexicanas and, 163–65; criticism of national fascination with, 49; critics of state-business alliance from 1937–58, 177–79; DMAAH accelerates research into, 140; Doctor Atl on, 76, 88–93; in economic development, 154–55; Escuela de Verano as launching ground for studies of, 30; Exposición Nacional de Artes Típicas and, 164; Fernández Ledesma deals in, 123; foreign collaboration in nationalization of, 97–105; foreigners as discoverers of, 112–15; gap between high-end and low-end markets for, 166; growing consumer interest in, 153–54, 158, 162; Gruening on, 107; as inspiration, 74; Madrid exhibit of, 159–60; marketing of, as cheap tourist trinkets, 154; marketing Mexican authenticity in, 110–12; mass production of, 120, 168, 172, 176, 178, 183; *Mexican Folkways* magazine on, 100, 103–4; *mexicanidad* expressed in, 70, 76, 79, 176–77, 293; Morrows' collection of, 116–17; national atlas of, 184; in nationalist imagination, 256, 278, 280; in neoliberal age, 296–97; officially designated as, 188, 190; revival of interest in, 173; revolutionary validation of, 2, 16, 23; seen as outside of modernity and progress, 152; staging of Indianness and, 65–94; standardization lacking in, 154; state policy regarding from 1921–37, 151–53, 155, 158, 162–70; state policy regarding from 1937–74, 175–93; tariff imposed on craft exports, 162–63; transportation of crafts, 164; Vasconcelos's ambivalence about, 74–75; working-class artists of, 115; workmanship declines in 1940s of, 166, 183, 255. *See also* Departamento de Monumentos Artísticos, Arqueológicos e Históricos (DMAAH); Exhibition of Popular Art (1921); Fonart (Fondo Nacional para el Fomento de las Artesanías); International exhibition of Mexican handicrafts (1922); Mexican Arts Show (1930–32); Museo de Artes Populares (MAP) (created in 1929); Museo de Artes Populares (MAP) (created in 2006); Museo Nacional de Artes e Industrias Populares (MNAIP); Olinaltecan lacquered art; Sociedad Impulsora de Industrias Típicas Mexicanas

Popular food, 69, 70, 82, 144, 314 n. 30

Popular music, 92, 137

Porter, Katherine Anne, 70, 97–100, 118

Portes Gil, Emilio, 137, 155

Positivism: antipositivism, 66, 101, 102; Porfirian, 102; Vasconcelos rejects, 134

Prakash, Gyan, 10, 197, 309 n. 45

Prats, Alardo, 178–79

PRD (Partido de la Revolución Democrática), 193, 284

Premio Nacional de Ciencias y Artes (National Arts and Sciences Award), 285

of wedlock, 58; as proud of having been India Bonita, 58; resumes work as laundress and cleaner, 58; store-bought work uniform of, 60; as uneducated, 57–58; on *El Universal* float in centennial parade, 50–51, *51*; wins India Bonita Contest, 41

Uruapan, 54, 175

"Utilitarian Aspect of Folklore, The" (Gamio), 104

Valdéz, Guadalupe, 282

Valle, Natalia, 179

Valle, Rafael Heliodoro, 102–3

Vasconcelos, José, 66–67; ambivalence about popular art of, 74–75; artists and intellectuals brought back to Mexico by, 77; in Ateneo de Juventud, 66, 101; Brazilian SPHAN compared with vision of, 138; contradictory intellectual currents drawn on by, 75–76, 313 n. 19; cultural elitism of, 74–76; on education and Hispanic ideals, 134; embarks on political career, 136; in establishment of federal education system, 30, 66–67; Gamio contrasted with, 134–35; Henríquez Ureña and, 101–2; institutional framework created by, 130; masses feared by, 134; on *mestizaje*, 31, 300 n. 18; on Mexican pluralism, 62; as minister of education, 66–67, 74, 77, 130, 133, 135, 137; mutual antagonism with Doctor Atl of, 74, 92; Pani's plan for centennial celebration opposed by, 66–67, 311 n. 4; at party for María Bibiana Uribe, 50; philosophical influences on, 133; on postrevolutionary nationalism, 8, 303 n. 44; *La raza*

cósmica, 8, 133–34, 303 n. 44; at *La révolution au Mexique*, 67; on Rivera, 48; Rivera's depiction of, 135; in state patronage, 135–36; tour of countryside with artists of, 79; on unifying and modernizing Mexico, 133–36

Vaughan, Mary Kay, 9, 16, 32, 142, 293

Vázquez Santa Ana, Higinio, 78

Velasco, José María, 15

Velasco, Luis de, 204

Velázquez Bringas, Esperanza, 16, 20, 103–4

Ventura, Benito, 223

Ventura, Iladia, 223

Ventura, Rosa, 223

Ventura Pérez, Concepción (Doña Concha), 21–22, 199, 221–25, 234–36

Villegas, Rafael, 319 n. 42

Vivar, Pedro, 219

Volantes, 207

Volkgeist, 73–74

Warman, Arturo, 147

Weber, Eugen, 301 n. 24, 303 n. 44

Weinberger, Joseph L., 101, 108

Weston, Edward, 103–4, 108–9, 224

Williams, Daryl, 138

Williams, Raymond, 142

Winkler, Cathy, 264

Wolfe, Bertram, 108

Wolfe, Ella, 108

Women: *chicas modernas*, 55–57, 59; female artisans in Olinalá, 222–24; *gatitas*, 34–35, 47; new opportunities for *laqueras*, 282–83; *tehuanas*, 36, 47, 70. See also Beauty contests; *Chinas poblanas*

Xochimilco, 47, 70, 98–99

Zamora, Francisco (Jerónimo Coignard), 72; Doctor Atl contrasted with, 92; on European integration, 303 n. 44; *Fantasía Mexicana* defended by, 72–73; in Mexican nationalist project, 18; on Mexico's popular traditions, 62, 74, 76; as nationalist insider, 114

Zapatistas: contemporary, 22, 284, 294–95; identified as Indians, 305 n. 11; in Olinalá, 218–21; Pérez Taylor endorses, 34

Zarate Uribe, Rosa, 57

Zavala, Adriana, 57

Zolov, Eric, 18

Zuno, José, 319 n. 42

Rick A. López is an associate professor of history at Amherst College.

Library of Congress Cataloging-in-Publication Data
López, Rick Anthony.
Crafting Mexico : intellectuals, artisans, and the state after the revolution /
Rick A. López.
p. cm.
Includes bibliographical references and index.
ISBN 978-0-8223-4694-4 (cloth : alk. paper)
ISBN 978-0-8223-4703-3 (pbk. : alk. paper)
1. Mexico—Politics and government—20th century. 2. Popular culture—
Mexico—History—20th century. 3. Nationalism—Mexico—History—20th
century. 4. National characteristics, Mexican. 5. Mexico—Intellectual life—
20th century. I. Title. F1234.L87 2010
972.08'2—dc22 2010014578

Most diverse Native populations